ASMP

Professional Business Practices In Photography

SIXTH EDITION

ASMP

Professional Business Practices in Photography

SIXTH EDITION

ALLWORTH PRESS
NEW YORK

08 07 06 05 7 6 5 4 3

Published by Allworth Press

An imprint of Allworth Communications

10 East 23rd Street, New York, NY 10010

Cover design by Douglas Design Associates, New York, NY

Interior design by Sharp Designs, Lans!ng, MI

Page composition/typography by Sharp Design

Page composition by C.A. Brandes

ISBN: 1-58115-197-7

Library of Congress Cataloging-in-Publication Data:
ASMP professional business practices in photography.—6th. ed.
p.cm.
ISBN:1-58115-197-7
1. Photography—Business Methods. 2. Commercial Photography I.
Title: Professional business practices in photography. II. American
Society of Media Photographers.
TR581 .A86 2001
770'.68—dc21

2001003498

Printed in Canada

Contents

Acknowledgments

The American Society of Media Photographers, Inc. (ASMP) wishes to thank the following people who contributed to this book and to the *ASMP Business Bible*: *A Guide for Professional Media Photographers*, which was the foundation for this, the Sixth Edition of the *ASMP Professional Business Practices in Photography*.

- Editor: Peter Skinner (ASMP Communications Director)
- Production Coordinator: Cilla Skinner (ASMP Production Editor)
- Editorial Review: Woody Packard, Victor S. Perlman, Esq.
- ASMP Executive Director: Richard Weisgrau
- ASMP General Counsel: Victor S. Perlman, Esq.

Writers and Other Contributors

Andrew Berger, Bruce Blank, James Cavanaugh, James Cook, Ira Mark Gostin, Scott Highton, Bill Hurter, Pamela Kruzic, Don Luce, Jean Miller, Annette Laabs Paajanen, Victor S. Perlman, Esq., Maria Piscopo, Allen Rabinowitz, Roger Ressmeyer, Peter Skinner, Richard Steedman, Mark Tucker, Susan Turnau, Richard Weisgrau, Elyse Weissberg.

Information Providers and Other Assistance

Mikkel Aaland, Beverly Adler, Jay Asquini, Craig Aurness, Lee Balgemann, Annie Barrows, Janie Bennett, Lou Biscotti, Barbara Bordnick, Reagan Bradshaw, Matt Brown, Nancy Brown, Roy Buckner, David Budd, J. W. Burkey, Janet Swan-Bush, Dick Busher, Alan Carey, James Cavanaugh, Dwight Cendrowski, Bruce Cline, James Cook, Maura Damacion, Catherine DeMaria, Lisl Dennis, Beverly Don, Jim Drake, Dana Duke, Tom Egner, Alan Farkas, Enrico Ferorelli, George Fulton, Michael Furman,

Gary Gladstone, David R. Godine, Ira Mark Gostin, Paul Gottlieb, Daniel Grotta, Sally Wiener Grotta, Charles Hagen, Don Hall, David Harp, Matt Herron, Scott Highton, David Hiser, Cliff Hollenbeck, Robert Holmes, Ryszard Horowitz, Bill Hurter, Tom Hussey, Walter Iooss, Jeffrey Jacobs, Lou Jacobs, Jr., Mike Jensen, Lou Jones, Mark Kaproff, Greg Kinney, Kathleen King, Douglas Kirkland, Don Klumpp, Bob Krist, Ed Kashi, Frans Lanting, George Lepp, Harry Liles, Andrei Lloyd, Harvey Lloyd, Jerrianne Lowther, Don Luce, John M. Lund, David MacTavish, Alen MacWeeney, Jerome Magid, Jay Maisel, Tom Mason, Georgia McCabe, Forest McMullin, Sam Merrell, Robert Meyer, Jean Miller, Deborah Gray Mitchell, Gordon Munro, Ken Newton, Harrison Northcutt, Charles D. Ossola, Esq., Terry Pagos, Gloriana Palancia, Victor S. Perlman, Esq., Jim Pickerell, Robert Rathe, Michael D. Remer, Esq., Roger Ressmeyer, Les Riess, Anne Rippy, Herb Ritts, Bill Ross, Neil Sapienza, Henry Scanlon, Jim Scherer, Bob Schmolze, Brian Seed, Stephen Seeger, Michael Sharp, Robin Simmen, Jeff Smith, Rick Smolan, Richard Steedman, Amy Stone, Bill Straus, Laura Straus, Vince Streano, Randy Taylor, Rebecca Taylor, Scott Taylor, Jerry Tovo, Steve Umland, Frank Van Riper, Emily Vickers, Garie Waltzer, Richard Weisgrau, Connie Wolfe, Art Wolfe, Tom Zimberoff.

Introduction

Welcome to the Sixth Edition of the ASMP Professional Business Practices in Photography, a publication which represents the business knowledge of thousands of people. We trust that you will be able to apply some of that knowledge to your business.

Most of us became photographers because we love to create images, and this passion is a vital ingredient in any successful photographer's makeup. However, making photography your profession requires more than creative and technical excellence. Sound business principles must be learned and applied if you are to stay in business.

You must develop and implement marketing strategies, be adept at estimating and pricing, and learn how to effectively use the new technologies to make your business more efficient. Staying ahead of the curve in imagery is one thing; maintaining the edge in business is another. Also, as you might already know, there are people who will infringe on your copyrights and while we creators do have the law on our side, we must understand how to use the correct paperwork and write professional agreements to ensure that we retain our rights while providing fair service to our clients.

The majority of freelance photographers run small businesses; many are solo or two-person operations. The very nature of freelance photography tends to keep photographers in relative isolation and at times it can seem like you're trying to do it all yourself. Fortunately, there are professional trade organizations such as ours, the American Society of Media Photographers, to help you. Since its founding in 1944, ASMP has been dedicated to educating photographers in the business of photography and for more than a half a century has produced numerous publications, like this one, to achieve that goal.

This Sixth Edition of the *ASMP Professional Business Practices in Photography* follows the long line of ASMP books that have been produced over the years for the benefit of members of ASMP.

However, there are many other benefits for photographers who belong to professional associations such as ASMP. These include the camaraderie, the networking, and

the access to experienced professional colleagues who can help you grow as a photographer and a business person.

With forty chapters nationwide and members throughout the United States and in many other countries, ASMP does have an important international network of professional photographers. The Society was founded on the principle of photographers helping photographers. While our business has changed and evolved over the years since 1944, and there have been tremendous technological advances, ASMP has never wavered from its initial mission.

As a trade organization, ASMP cannot tell its members or other photographers how to run their businesses, and nor can the Society fix terms, conditions, or rates. However, ASMP can provide the information and the tools to help photographers in their business transactions. This book is one of those tools.

On behalf of the many people who have contributed to this publication, I wish you the best in your career and I hope that the information here helps you.

EUGENE MOPSIK
ASMP President 2000–2001

Editor's Note

As this edition of the *ASMP Professional Business Practices in Photography* was being finalized a new and major development in professional photography was taking place: the founding of the photographers' and illustrators' cooperative, Creative Eye. While ASMP was the catalyst in launching this new entity, Creative Eye will be operated by its own staff and board of directors. One very important aspect is that Creative Eye is open to all photographers and illustrators and it is a marketing and licensing option that should be considered. Learn more about Creative Eye by going to: *http://creativeeyecoop.com/.*

Creative Eye is an important entity in collective licensing, something which ASMP has espoused for many years and which was the basic principle behind the founding of the ASMP licensing program, the Media Photographers' Copyright Agency, MP©A. MP©A, as it was originally created—initially as a separate agency and subsequently as a program within ASMP—is no longer operating. However, the principles on which it was founded, and its pricing structure and photographer-friendly contract, have had a profound influence on the way Creative Eye will function.

Throughout this book we have endeavored to refer to MP©A in its current context. However, readers are advised to keep in mind MP©A's initial purpose and its role in the aforementioned development of Creative Eye when reading this publication. Of necessity, some references to MP©A—as in models of pricing structures and contract samples—will be as if it is still functioning. We have purposely not changed these references because the principles on which they were written still apply.

PETER SKINNER,
Editor

Chapter 1

The Business of Assignment Photography

Annette Laabs Paajanen and Peter Skinner

Assignment photography covers a wide spectrum of fields and while each specialty has its own requirements, numerous business details are common to many fields. Vital to any business dealing is making sure you and the client understand and agree on what the job entails, what the final product will be, and the terms of usage. Knowing what your costs will be, and what you have to charge to stay in business while producing what the client wants, are essential to any successful operation. Refer to the chapters on "The Art of Pricing and Estimating" and "Formalizing Agreements," which provide a wealth of information and sample forms which can be tailored to virtually every assignment, regardless of the field. Assignment photography is highly competitive, and constantly evolving. To succeed in it, professional photographers must be talented and skilled in photography and in business.

In general, "assignment photography" implies projects specifically commissioned by clients, while "self-assigned photography" means work done in the photographer's own interests for stock, experimentation, and promotion.

To succeed in assignment photography, it simply is not enough to take wonderful pictures. You have to know how to find your niche, how to market your images and yourself, and how to manage your business. Successful marketing is the key to sales. Sales keep you in business.

The competition in assignment photography is fierce and the number of practitioners has expanded. Also, the profession has no licensing or certification requirements; anyone can hang up a shingle. Photography has become a popular profession and many more institutions are offering courses.

Business education, unfortunately, is not a strength of most photography programs and this is where organizations like ASMP become so important to professional photographers. Economic conditions in recent years have meant tight money. Budgets are being scrutinized. Photographers have to know their costs and be able to justify the

value of their work to clients. They have to know how and what to negotiate. Because they lack the necessary skills and knowledge, many photographers unknowingly give away their work—which makes it difficult for everyone in the profession. It's hard to compete with someone who is losing money. As one sage noted, however, many photographers don't seem to mind losing money, but they do hate to see other people make money from their images. Thus the concern about electronic transfer of images. Certainly the technology to manipulate computerized images raises copyright issues, but the technology also facilitates the global expansion of markets. And, as photographers know well, things change and images will need updating. Just as photographers need not fear being replaced by machines, electronic imaging probably doesn't constitute a major threat either, if photographers take steps, just as they do in other media, to protect their rights.

The competitive nature of the business demands quick decisions and sound business judgments. You must be a shrewd financial manager, a savvy marketing and sales expert, an effective negotiator, an astute administrator, a skilled casting agent and an understanding employer—not just the person clients look to as the creative expert behind the camera.

Service

Competition is not all bad. Many photographers welcome it as an incentive to produce better images and to work more efficiently, providing better service to their clients. It is essential to remember that assignment photography is a service to business: the quality of that service will make a lasting impression, is as important as the quality of the images and the way you conduct your business.

Communication is critical—you and your clients must go into a shoot with the same expectations. Ensure all questions are addressed.

Professional Responsibility and Ethics

You need to be attuned to your clients' needs and objectives, both in the spirit and in the letter of your agreement with them.

For example, a photographer accepts an assignment to photograph a grandmother and grandchild for use in an advertising brochure by a pharmaceutical manufacturer. The client uses one photograph and returns the outtakes—one of which is similar to the image used in the brochure—to the photographer. Should the photographer offer the outtake photograph for advertising use by another pharmaceutical company? The answer is not simply a matter of legality and ownership of the outtake—the photographer owns the copyright—it is a question of propriety and ethics. The photographer has a responsibility to the client to make sure that the use of the image is protected to the fullest extent for the period of the license.

Ethical dilemmas like these have contributed to clients wanting to buy all rights.

Some photographers, particularly those new to the business, may be reluctant to bring up the complex-sounding rights issues. Clients, too, would rather not bother with figuring out when they can or cannot use an image. This problem is best addressed through education of both photographers and clients. It behooves you, as a professional, to know the ins and outs of rights and usage which this publication will teach. You also have to make it easy for your clients to understand these issues and to explain why it might not be in their best interests to buy all rights. This is part of the service and value offered by your business.

It's in your best interests to make sure your clients get full exclusive usage of images, including similar outtakes, for the full duration of the rights period. This hinges on the concept of "fairness." Just as photographers want to be treated fairly by clients, clients also deserve to be treated fairly by photographers. This is simply good business.

When you earn your living by taking photographs, you become a professional. Your work and manner of operation are judged by professional standards and, therefore, you must understand both the ethical and the business aspects of your profession. The way you conduct business helps set the standard for the whole profession. You can help educate clients about the business of photography. One way might be to send new and potential clients the ASMP brochure *On Buying Photography*. Your actions speak loudest so treat your clients as you want to be treated.

What it really comes down to is this: If you want dignity, respect, and compensation for what you do as a photographer, you must act in a professional, ethical, and businesslike manner. This does not minimize the importance of an artistic approach to your work, but don't overlook the practicalities that relate to ethics in a business setting—insurance coverage, legal matters, and business forms. (See chapter 6, "Formalizing Agreements.")

Most photographers really love their work. Therein lies a dilemma. Photographers often give their work away just for the opportunity to ply their craft. Unfortunately, being in business entails certain costs, and photographers who don't have a good handle on those costs may find themselves out of business. Few photographers go out of business because of their photography. Poor business skills are usually their downfall.

The pressure on photographers to deliver more service at lower prices can be tremendous. There is a trend for clients to seek concessions from all suppliers, including photographers who, because of their love for their work and, often, their lack of business skills, are particularly vulnerable. You must know your production and business costs and set fees accordingly. Ask for compensation which reflects your costs of doing business. Reasonable fee increases won't necessarily scare off clients. Other vendors raise their prices periodically to cover cost increases; clients are used to it. Don't be afraid to seek fair compensation for your work.

Business Skills

If you think being an assignment photographer will keep you behind the camera all the time, think again. More than 50 percent of your time will be spent dealing with universal business matters—sales, collections, billing, bookkeeping, management, and

other administrative operations. The reality is that only when those business skills bring in an assignment can the photographer practice the artistic and technical aspects of the profession.

Some skills can be obtained through paid consultants, others can be provided by reps and studio managers. But for the typical solo photographer, the skills have to be learned and developed to achieve success. Some required talents are obvious. You must coordinate, schedule, shoot, and deliver a job as promised. Other necessary skills include planning, estimating, marketing, promotion, sales, negotiation, administration, secretarial, and financial. These skills can be learned and ASMP, through its network of members and chapters, and this publication, can help you.

A most important skill is marketing. You can't afford to wait for the phone to ring. Although some photographers rely to a certain extent on others to sell their work, clients ultimately want to meet the photographer since this is the person they are hiring. You're going to have to take a break from shooting to sell your work.

Decide what kind of projects you want to do and for which clients you want to do them. Maybe you know an art director at an ad agency or a creative designer you'd like to team up with. Use your portfolio as your primary marketing tool. Find out as much as you can about the clients you're approaching. Determine what their needs might be and tailor your portfolio to reflect those needs. Clients in manufacturing, for example, won't be interested in soft-focused images of home interiors.

Some photographers take an even more aggressive approach by anticipating a client's needs. They will put together a detailed proposal outlining a project, including information on how this project can benefit the client.

Equipment and Facilities

Trying to do assignments without the proper facilities or equipment invites failure, or results in photographs of unacceptable quality. While you do need some basic pieces of equipment, it may be more prudent to rent, especially during the first few years in business. Rental costs often can be billed to the client. Initially, it's more important for an assignment photographer to invest in marketing than in lots of equipment. You simply shouldn't overextend yourself when starting, particularly since a typical investment in equipment ranges from $50,000 to $100,000, a formidable amount of money.

A problem bigger than the lack of equipment—which can be remedied through ingenuity or equipment rental—is a lack of interest. Accepting work that doesn't thrill you is common, and most professionals usually can muster enough short-term enthusiasm to do a good job. However, taking assignments you enjoy and that are within your capabilities is a better path to success. The fact is, you will generally do the best work on the jobs you like best.

Assessing your capabilities can be a daunting proposition. Many photographers work with consultants, others rely on hired sales representatives or "reps" to give them guidance.

Markets and Specialties

Assignment photography is a broad field that can be broken down into sectors which define markets in the broadest sense. Most assignments fall into one of three broad sectors: advertising, corporate, and editorial. Each sector is defined primarily by the purpose for which the photographs are used, not by the subject matter.

In dense markets, the only way to compete effectively may be to specialize in some way. However, to describe their work as strictly advertising, corporate, or editorial photography, might not be the best course of action for many photographers. In reality, the same level of skill is compensated differently in different sectors. Limiting yourself to one sector is going to limit your client base and your ability to operate in diverse markets.

For example, making a photograph for the editorial pages of a magazine often requires all the expertise needed to do the same shot for an advertisement. The demand for an excellent image may be identical. But, generally, you will get paid less for it when it's for editorial use.

In addition, pictures made for one purpose, such as an advertisement, may have many other uses. An advertising photograph might also appear in a magazine article or in the advertiser's annual report. With a proper contract in place, you should be paid for these multiple uses.

Regardless of a photographer's specialty, assignments are usually derived from five major sources: advertising agencies, design firms, public relations firms, client direct (including in-house marketing departments), and in the case of photojournalists, magazines.

The actual photographs may be the same from one market to the next, however, the practices of each business are a little different (as explained below). Each business services different needs for the end-user. In all but in-house marketing departments, the end-user is a client on contract for a specific period of time and budget. In some cases, companies may contract with all three types of marketing companies (ad agency, design firm, public relations firm) as well as have its own in-house marketing department. When soliciting assignments, it's best to investigate all sources of photo buyers that a company might have.

The following are the primary photographic markets with special considerations when doing business with each.

Advertising Agencies

Advertising agencies plan strategy, produce materials, and buy media for their clients. Media purchases that involve photography may include print ads (magazine and newspaper), outdoor (billboards and transit), and television.

In some cases, an agency will also be involved in the creation and distribution of collateral materials for the client, especially when it ties in directly with the total marketing concept. Such materials may include brochures, packaging, point-of-purchase,

and direct mail. (Because of the multiple uses that a photograph might have, you should be clear about what rights you are licensing to the agency.)

Larger agencies often have public relations sections who handle responsibilities associated with PR campaigns and often their efforts will dovetail with paid advertising in an overall marketing strategy.

Your contact for working with an advertising agency will be an art director who is responsible for details of the layout and art direction of the final ad. Some firms also have creative directors, which is a senior art director position, and art buyers, who negotiate contracts and estimates with photographers. When details of a shoot involve client coordination, you may have to deal with an account executive.

When working with advertising agencies be clear about to whom your bill should be sent and how soon it will be paid. It is often not the art director, although sending him/her a copy of the invoice would be a courtesy.

Design Firms

Graphic design firms are an ever increasing client base for photographers. These companies produce a wide range of collateral (non-advertising) material for their clients who have needs from almost all of the photographic specialties. Collateral material may include annual reports, brochures, direct-mail pieces, and even trade show displays. Design firms seldom involve themselves in media placement.

While large design firms are well-established in the communications industry, the advent of desktop publishing and sophisticated computerized design technology has resulted in an increase in the number of independent graphic designers. These smaller firms, or sole operators, constitute an important and growing source of business for photographers, especially in smaller markets.

Even though it's common for a client to attend shoots, the designer will be the photographer's principal contact and director. In such cases, an independent graphic designer would perform a variety of roles—as the art director, art buyer, and production coordinator for example—and will work very closely with the photographer on both creative and business aspects.

Billing could be either direct to the client, or to the designer, depending on what arrangements are made prior to the assignment. In either event, make sure you know to whom the bill is sent.

Public Relations Firms

The role of public relations firms is varied, and essentially is to enhance communications between their clients and the people those clients want to reach. These firms use a wide range of methods to get their client's message across, from products (brochures, press kits and releases, newsletters) to events (trade shows, product "roll outs," press conferences, and audiovisual presentations). And photography is used extensively.

Because public relations companies focus on publicity and promotional activities, it is unlikely that your photography will be used in advertising. But be sure that fact is

established ahead of time. Editorial uses of photographs for press releases are most often published without credit or use fee to the photographer. Therefore, be sure to include a blanket editorial usage in the fee and do not expect further compensation.

Your contact in a public relations firm typically would be an account executive whose job is to arrange the details of the shoot. It is not uncommon for the account executive to be absent from the shoot.

In-House Agency/Client Direct

Large corporations will often have in-house marketing departments who hire photographers directly. They may function similarly to design and public relations firms creating annual reports, newsletters, company magazines, brochures, and even advertising. These corporations might also have in-house creative departments who hire photographers. With large companies, the buyer of photography could be a marketing director, director of public relations or corporate communications, or a graphic designer. Again, be clear which person or department should be sent the bill.

Start-up companies, particularly in smaller markets, will often produce their own publications and advertisements at first. Often these clients will place great responsibility on the photographer to turn concepts into reality, with the barest of thumbnail sketches to work from. In some cases you could do your client, and yourself, a great service by suggesting a graphic designer be hired. Entrepreneurs might know their business well, but they might not know how to get their message across visually.

If there is any concern about the solvency of a company, it would be wise to check its credit background, and to get a substantial advance.

Professional photographers usually find that they are drawn to certain types of photography more than others. These types of photography, called specialties, describe the nature of the subject matter and include areas such as still life, fashion, people, architectural, industrial, sports, and medical photography. Although each specialty requires a unique approach using specific equipment, they can all exist in any market of assignment photography. For example, a portrait could be used as an advertising image, a corporation's annual report cover, or as an editorial illustration.

In order to become a successful assignment photographer, you must be honest about your capabilities. Determining what you are able to do best and what you like to do is very important. Working on jobs that you literally detest or are ill-equipped to handle will almost surely ruin the job and your reputation as an honest presenter of your capabilities. Do that too often and your business may also be in ruins.

Markets

Advertising photography

Advertising photographs are used to sell a product or service. The photographs appear in many different types of media including magazines, newspapers, direct-mail pieces, point-of-purchase displays, package design, billboards, posters, catalogs, television, and World Wide Web pages. Electronic media, including CD-ROM and multimedia, is

expanding market.

The costs for media space are paid for by the company which sells the product or service. The photographer's contact, however, is usually the company's advertising agency or in-house advertising department.

Normally, photography for advertising purposes is assigned to a photographer by an art director, who also produces a layout (varying from rough sketches to comprehensive four-color illustrations). The art director gives the layout to the photographer as a guide for the illustration.

For a "rough" layout, a photographer may be asked to determine the spatial relationships and style within the image. A "tight" layout, on the other hand, may require the photographer to reproduce the illustration with precise rendering of the elements within the image. In either case, a photographer may be asked to shoot variations of the layout to provide the art director with a choice of images.

If you are ever asked to copy, either totally or substantially, a layout that includes an actual photograph taken from, for example, an ad in a source book, don't! It's illegal. Photographer, agency, and client are all liable in the case of copyright infringement. Explain the facts of copyright, and the penalties for infringement to the art director. (See chapter 7, "Copyright.")

Advertising photographers must have the creative ability to translate the idea of the layout, whether rough or tight, into photographs of real people, scenes, and objects. Sensitivity to nuances in the look of models, clothes, props, and backgrounds is essential, as is the technical expertise to position and light all the elements needed to achieve the final image. The photographer's taste and ingenuity will be apparent in most assigned photographs, which explains why many art directors are very particular about selecting the photographer.

The business of advertising photography has become increasingly complex, attributable to higher production costs, higher model fees, and drastically increased media costs. Because more money is at stake, there is greater concern about liability and awareness about legal rights. Usually, photography for an ad or ad campaign is assigned only after the advertising agency and client have agreed on a total strategy for direction, design, and media placement.

Budgets are carefully developed, approved, and controlled, usually under the watchful eye of the art buyer, the person hired within an agency to relieve art directors of negotiations, estimates, forms, releases, and paperwork.

All assignments should have a written estimate or assignment confirmation. Based on the art director's layout, the estimate is provided by the photographer. The written estimate includes the creative fee and all the production expenses required to produce the assignment. It is designed to protect both the photographer and the client from misunderstandings about the scope of the assignment. (For more information, see chapter 3, "The Art of Pricing and Estimating.")

Use/reproduction rights: Photography fees were once loosely based on a percentage of the media buy for the ad being produced. Now that media costs have escalated far beyond what is considered acceptable photography costs, fees are most often based on the primary use of the work, with additional compensation for additional uses there-

after. Production charges are calculated separately.

To reduce the possibility of misunderstanding, the use of the work being prepared should be spelled out in writing, for example: "Photographs of product X intended solely for magazine test market for six months." The specific usage should be included on the estimate, on the assignment confirmation or purchase order, on the assignment delivery memo, and again on the final invoice.

Copyright protection is not granted for the "idea," but rather for the "expression" of the idea. Thus, it is the photographer—not the client—who owns the copyright in the resulting image. Users of photography are increasingly asking for ownership of photography on the line of reasoning that, "We're paying for the pictures and therefore we're entitled to own them," or, "We need to ensure exclusivity; you can't use them anywhere."

Often, such users seek ownership by way of "work made for hire" agreements, or "all rights" (sometimes called "buyout") agreements. These all result in the photographer's surrendering of rights, ownership, and control in the creation and, ultimately, of the opportunity to realize additional income from future uses of the work.

ASMP has long sought to educate both users and photographers that the user, more often than not, simply does not need to own all rights. Instead, both sides should look realistically at what rights are really needed by the user, and what fees should be paid to the photographer for those rights.

Corporate/Industrial

This area of photography covers an extraordinary amount of ground because it requires the use of many forms of photography for a wide variety of purposes.

A corporate/industrial photographer's work can encompass every conceivable kind of photography—illustration, photojournalism, still life, portraiture, studio and location—anything from photographing a company's product for a catalog to shooting portraits of the chief executive for an annual report. Corporate/industrial photographers also shoot for brochures, promotional literature, audiovisual programs, annual reports, and in-house publications, typically called collateral material.

Photographers in this field generally enjoy a great deal of freedom in image design and they get much satisfaction in forming close working relationships with corporate employees. They should be capable of interacting and directing a wide range of people, and be able to make them feel comfortable in front of the camera. Corporate/industrial photographers also need to be experts at making mundane subjects—for example, manufacturing plant interiors—into an exciting image.

Assignments in the corporate/industrial field are made either by the corporation or, increasingly, by a design firm or public relations agency engaged by the corporation to manage a particular publishing project. On a major item such as an annual report, a designer or art director will usually consult closely with its corporate client before making the final selection of a photographer.

This field may involve shooting dramatic illustrations of consumers using a company's products or services. It also often includes photographic coverage of the client's corporate activities and its facilities. For major corporate clients with nationwide or

worldwide operations, the result often is a heavy travel burden for the photographer. To a lesser extent, the field also embraces the studio photographer whose assignment may be to illustrate the client's products and/or services for an annual report or for other publications.

Corporate/industrial assignments are executed normally on a day rate or on a creative fee basis plus all expenses. In a few situations, particularly those involving studio still lifes, the photographer's rate may be determined on a per shot basis. The field is idiosyncratic in that one or two big jobs can make a tremendous difference in total billings for a year.

Because highly detailed layouts from an art director or other administrator are not common, broad coverage of the site in the form of a shot list is usually desired and should be based on carefully considered general visual concepts. Considerable preparation and coordination with the client's line employees, plant managers, and executives are frequently involved and often result in long hours. Reimbursement for expenses reflects these operating factors.

Multiple locations, often requiring complex lighting capabilities and heavy equipment, plus extensive technical demands and coordination, often make it necessary to hire an assistant. Most clients recognize this and accept the assistant's fee and expenses as reimbursable items. It is advisable also to set down estimates for food and hotel expenses. (See chapter 3, "The Art of Pricing and Estimating," for examples of expenses involved.)

Photographers in this field customarily get all travel expenses paid in advance. It's also common to get one-third of estimated expenses for any assignment in advance, with another third paid halfway through and the final third paid upon completion.

In addition, given the nature of these assignments, the photographer is normally compensated for travel and scouting expenses, other prep and editing demands, and layover and standby days. For example, two shooting days sandwiched between three travel days (one day going out, one day between the two locations and one day to return) is an unprofitable assignment unless a reasonable fee is paid for travel time. ASMP surveys show that compensation for travel appears to vary from a full day's fee to 50 percent of that fee, depending on the circumstances.

Additional compensation for unusually long hours is common. This is true particularly in those instances where a photographer's professional responsibility may involve a series of days that begin before dawn and end only after evening setup shots, or following long hours of planning for the succeeding day's shooting.

Usage: All uses beyond those for which the assignment was initially undertaken require additional compensation to the photographer. This is a clear, acceptable practice—but always get it in writing.

For example, photographers invariably negotiate additional payment when a client decides later that photographs taken for, and used in, a recruiting brochure would also be desirable for a paid advertisement or annual report. Similarly, photographs taken for one particular year's annual report should not be used in another year's report (or in a paid advertisement) without further compensation to the photographer.

It is crucial that the photographer and the client have a clear understanding, in writ-

ing, of ultimate use before an assignment is executed. Getting credit for published images is another issue. Photographers get credit for annual report work in the back of the book about half the time, and rarely get credit next to their work unless it is their only photograph in the book; other formats—even newsletters—may be more problematic. The client needs to be educated on industry practices, and the potential legal implications if they deviate from these well-accepted practices.

While many photographs taken in the corporate/industrial field might not be suitable for sales to stock agencies, photographers should always be prepared for this possibility for further earnings. This is why they should, as much as practical, get their own releases—which use the term "anybody photographed"—from employees. This should be agreed upon with the client and negotiated as a non-exclusive shoot before getting releases. This is an important liability issue: If employees don't like the photograph that was used, they can sue. Also, if a division gets sold (not an infrequent occurrence), releases held by the company can get misplaced or lost all too easily.

Photographers also should be cautious if asked to sign any documents when preparing to shoot, for example, in a manufacturing plant. While the stated purpose of the document may be to protect the company from having trade secrets revealed, the document's practical effect may be to negate the photographer's copyright by requiring that any images (mainly drawings or sketches) be turned over to the company.

Editorial Photography

(Also see Photographers' Resources/White Papers at *www.asmp.org*.) Editorial photography is visual reporting of personalities or events to illustrate general interest and specialty stories and information in magazines, books, calendars, newspapers, television programming, posters, and, more recently, on the Internet. Photographers in this field enjoy fairly independent working situations with little control exercised over what they do on the job.

The field is divided basically into two categories. The first is photojournalism in which the photographer tries to tell a story in pictures. The goal is to produce a photo essay through a series of photographs taken over an assigned period of time, and assembled at a later date by the assigning publication. The photojournalist tries to be a "fly on the wall" so that events are not influenced by the camera's presence. Documentary photography, which is similar to photojournalism, portrays the events and aspects of daily life in photos taken for social purposes.

Part of the appeal of photojournalism is its immediacy. This is a field which appeals to photographers who thrive on working under demanding conditions and who possess the ability to solve problems often with few resources. It requires special talents and aptitude.

Because many aspects of doing business in this field are unique, ASMP has created the Photojournalism Specialty Group to address specific concerns. Photographers particularly interested in photojournalism should make contact with ASMP for more information on this specialty group.

The second category, photo illustration and portraiture, involves creating photographs that visually describe the ideas, concepts, or personalities in a story.

One trend in recent years has been the changing role of some editorial assignments from that of photojournalistic to one of photo illustrative. Photographers must often be able to capture the essence of a story with a single image rather than with a series of photos. Illustrative portraits make up a large chunk of the editorial business.

Editorial photography can necessitate extensive travel; it's not uncommon to be on the road half of the year. And as with general travel photography, this takes a lot of planning, particularly for international work. Good sources of information are consulates, visitors bureaus, film commissions, and photographers based in those countries.

Photographers who specialize in editorial work for magazines also advise maintaining close contact with editors and photo buyers who have given you assignments. These people develop their own source of suppliers and if they change jobs, as many do, invariably they refer to their resource list in their new job. By keeping in touch, you increase your chances of obtaining work from the publication they move to. And there is also the possibility of continuing to get work from the publication they left if you make contact with their replacement. In this field, as in many others, success can depend to a great extent on knowing the right people.

Releases, which are usually not necessary for editorial work can be difficult to obtain in some situations. However, if editorial photographers think the images might have resale potential in brochures or advertising, they should try to get releases.

It's also smart for photojournalists to get a script from clients outlining in writing the major points wanted in the story. This avoids costly miscommunications. It's essential to keep copies of photo captions sent to magazines, in case the subject sues because the published captions are inaccurate. Captions are important and should include the basic who, what, where, when, and why and other pertinent information which could boost sales potential.

Fees and expenses: When negotiating fees with a client, be specific about what that fee encompasses. As outlined in the following section on usage there are established guidelines in this market. But with the emergence of electronic magazines and other products, such as CD-ROM, and other on-line uses, photographers are urged to check agreements to ensure payment for additional usage will be made. Some magazines may try to avoid additional usage payment for their on-line editions—and other secondary uses—by not mentioning them in their agreements. It's okay to change an agreement, so don't sign anything you're not happy with until you're satisfied with the language. Also, the practice of charging a less-than-minimum fee, with the understanding that an additional fee will be charged if the project is published, is a form of speculation that experienced photographers avoid.

Photo illustration might require more time spent preparing for the shoot than shooting. Photographers should weigh this when they determine their illustration fees. They also need to project what else—stylists, hairdressers, wardrobe, special lighting, other equipment and props, studio space, and models—should be in a budget, besides prep time, film, and processing. A photo illustrator's expenses may be much like those of the advertising photographer, which is why all parties should have at least a rough estimate of expenses in order to avoid surprises and misunderstandings.

Customarily, all expenses necessary to complete the assignment are billable to the

client. For the photojournalist, the principal items (in addition to film and processing) often are travel related: transportation, hotels and meals, and long-distance phone calls. The fees and expenses of an assistant might also be included for major assignments which involve complex scheduling and lighting setups.

Because of the increased costs of supplies and services today, it's a smart business practice for photographers to obtain an advance before beginning an assignment. A rule of thumb is that if an assignment will take longer than a week or involves special expenses such as airfare, hotels and rental cars, the client should provide an advance.

Usage: The long-established tradition in editorial photography is that the client's basic fee covers one-time use in the designated publication in its primary territory and language (for example, one-time English-language North American rights). All other rights, including copyright, belong to the photographer. Ensure that all usage rights are agreed on in writing. Experienced editorial photographers advise getting, at the very least, a confirmation of fees and usage from the client before an assignment. Simply ask the client to fax that information on his or her letterhead.

This limitation on use is critical for professional freelance editorial photographers, since rates for this field are considerably lower than for advertising or corporate clients. Resale income is vital to the photographer's financial well-being, given the relationship between overhead costs and the current editorial rates, whether by day or by page. This is consistent with the principle that artists are entitled to own the results of their creative efforts—a position solidly backed by the Copyright Act. (See chapter 7, "Copyright.")

Credit and credit lines: It is part of the historical contract between editorial clients and editorial photographers that pictures are given an adjacent credit line. Both photojournalists and photo illustrators have the right to legible credits next to each photograph (or on the contents page if their photo is the magazine's cover). Having the credit adjacent to the photograph is the most widely accepted practice. This helps photo researchers recognize photographers' work.

The form of credit line is also important. Many photographers use a proper copyright notice: "© [or 'Copyright' or 'Copr.'] year photographer's name." The year indicates the year of first publication.

This notice indicates clearly that the copyright belongs to the photographer, and defeats the defense of "innocent infringement"—a defense which can significantly reduce the amount of damages that a photographer can recover. With today's proliferation of scanners and transmission of pictures by modem, the adjacent copyright notice is more important than ever before.

The issues of placement and form of credit line are regarded as important by the entire profession. Many photographers state their requirements on business forms or stamp the back of their prints with this line: "Adjacent credit to read: © (or 'Copyright' or 'Copr.') year photographer's name. Failure to provide such shall result in triple billing."

The purpose of this is to ensure proper credit and to protect against the real loss of income that can result from omission, rather than to provide additional income. Traditionally, the credit line has been deemed part of the value received by the pho-

tographer because it helps to ensure the image's residual value.

For the illustrator, additional and crucial credit may be needed for any suppliers. Clothes, manufacturers, stylists, resort locations, transportation companies, and others often provide goods or services—either for no charge or at reduced rates—in exchange for appropriate credit on the editorial pages of the publication in which the photographs appear. These arrangements can add up to great savings, but photographers shouldn't make guarantees to suppliers about credit arrangements. Photographers usually have no control over what ends up in print and should just have the supplier make arrangements directly with the publication. As a general rule, however, this practice might best be avoided by photographers.

Specialties

In the following section are examples of several specialties and the nuances of doing business in them. This is not intended as a comprehensive list of all specialties and how photographers ply their craft within them, but will give photographers an insight into specialties such as aerial, architectural, fashion and beauty, nature and wildlife, publicity/promotional, sports, still life/product/food, and travel photography. The principles of doing business in these fields can be applied to many others.

As an example of the number of fields open to photographers, ASMP members list almost sixty specialties. These are: advertising, aerial, agriculture, animals, animation, annual reports, architecture, automobiles/trucks, beauty, biomedical, catalogues, celebrities, children, computer generated, corporate/industrial, documentary, editorial, entertainment, executive portraiture, fashion, features, film, fine art, food, forensic, glamour, graphics, historical, horses, human interest, illustration, interiors, landscape, marine, multi-image, multimedia, medical, nature, nudes, panoramics, people, performing arts, personalities, photojournalism, portraiture, products, public relations, scenics, scientific, special effects, sports, still life, stock, television, travel, underwater, video, and wildlife.

Aerial Photography

This is a demanding specialty which, because of the expense and potential danger involved, allows no room for errors, and no tolerance for inexperience.

Aerial photographers must make rapid decisions, and must learn to solve problems under unusual circumstances—and deal calmly with any potential hazards. The physical risks are significant, but the reward is seeing the earth as few others do. Clients can include real estate developers, construction companies, cruise lines, airplane manufacturers, museums, hotels and airlines, and recreation and sports complexes, who expect distinctive photography for advertising, brochures, magazines, and books.

While aerial photographers who work with organizations such as cruise lines and international hotel chains can spend up to half of each year traveling, the majority of practitioners usually work closer to home. Often they piggyback assignments, photographing for two or more clients at the same time, and also shoot stock.

If working internationally, planning and confirming all of a trip's myriad details—hotels, flights, translators, and people who will work on the shoot—are essential

facets. Time spent on these details in advance, however, means that location time can be spent taking pictures, rather than solving logistical or personnel problems. Similarly, a shoot in one's backyard should also be well scripted so no important subject matter is overlooked.

Technical and practical concerns: Photographic equipment must be in top working condition at all times; it might be impossible to fix or replace in remote areas. Have all equipment cleaned and lenses checked for alignment every six months or so.

Aerial photography requires some specialized equipment. Zoom lenses are useful because they allow for a quick switch of focal lengths, and a gyro-stabilizer is a great help in keeping cameras stable at all speeds, and compensating for aircraft motion.

Safety is paramount and aerial photographers need to be able to determine which aircraft is most suitable in a particular situation. On location, they must evaluate the flying capability of the available light plane or helicopter and determine if weather poses any problems. They also need to know what safety gear they'll need while aloft, particularly if, for example, they plan to hang out of the aircraft, or for extended overwater flights.

Because of the expense, clients need confidence in the photographer's ability to do the job. Also, the photographer and the client and the creative director must agree on what the assignment entails and its goals. On location the photographer will need to coordinate logistics with people, such as cruise ship captains, hotel managers, and especially the pilots.

Fees and budgets: Aerial photographers command a creative fee reflecting several elements: the scope, complexity and risk involved, which will impact the time needed to complete the assignment; purchase rights and usage required by the client; and the photographer's experience and reputation.

Advances are necessary because of the time required for assignments. For some expenses, clients are billed directly, after the photographer approves the invoice.

Because of the extraordinary expenses in this field, the photographer and client should go over a proposed budget very carefully and make sure they agree on all details. Budgets should reflect all expenses but should also allow for unforeseen expenses. Here are some points to consider:

Production time: To cover, for example, logistical details and editing slides later. If the client isn't billed directly for this time, it should be a part of the fee.

Weather days: It's best to agree on a fair estimate of extra days with the client.

Special equipment: The photographer and the client need to decide who will pay for special items that might be needed, such as a gyro-stabilizer, land or marine radio use, special lenses or camera bodies or camera maintenance charges.

Aircraft estimates: Be aware that fees for helicopters and light aircraft rented in countries outside of the U.S. will probably be higher. Estimate accordingly. Include travel time to and from the aircraft base.

Film: Allow for plenty of film and processing, because of the need to bracket a lot.

Insurance and liability: The client should pay for liability and insurance coverage costs, which will vary from assignment to assignment. Aerial photography can be dangerous and it is important to make sure you have full insurance coverage for medical

or death. Before undertaking an aerial assignment ensure that your policies cover you or your employees and be aware that some policies have clauses stating that injury or death resulting from unscheduled flights are not covered. This could include flights chartered for aerial photography. Also, photographers are advised to check with both the client and the flight operator to determine what insurance coverage is in place for injury, death or liability. Some photographers injured in aircraft crashes have found, after the fact, that the flight operator has had minimal coverage. Inquire before you fly—from your insurer and from the client and flight operator. Also, many experienced photographers make a point of informing their clients that they (the photographer) have liability coverage and carry proof of that coverage. This is a professional approach, for all assignments, not just aerial.

Assistant's wages/fees: Up-to-date information of overtime, which will be inevitable, should be kept so the client can be billed accordingly.

Air time is expensive, but the client might be willing to pay for scouting time, particularly for a large advertising campaign. If possible, the photographer should, at the very least, have time budgeted to scout the area on foot to get familiar with the landmarks. If specific colors or images are required for the photograph, the budget may need to include having a car and driver on call. Photographers should always have a backup plan in mind as conditions in the sky can change quickly; they also should be ready to take advantage of those conditions to get the unexpected image.

Aerial photography terms for assignment contract: Aerial photography can be affected by a number of factors including, but not limited to, climatic conditions, Federal Aviation Regulations, pilot safety requirements, aircraft performance, and certain local laws. The photographer's judgment as to the safe and effective execution of all aerial photography must be followed. If for any reason the original layout or design cannot be followed, client may request that photographs not be made. In any event, the client is responsible for all costs incurred on the flight. For a number of reasons, under some circumstances, a person's expectation from aerial photography may differ from the actual photograph that is taken. Although the photographer will use every effort to insure that the aerial photograph will correspond to client's expectations, such aerial photography must be purchased as shot, even if there is a deviation from the original layout or design.

Architectural Photography

Successful architectural photographers often excel in many related areas or they might specialize in one particular segment. As an example, some may be adept at photographing interior design, industrial locations, and commercial spaces. Others may have more experience with architectural models, exteriors, aerials, or construction documentation. Still others may be versed in special lighting, styling, or residential spaces. Each area requires special skills and equipment. In some cases, a client with a multifaceted assignment might choose to work with one photographer or collaborate with several, depending on the project at hand.

One of the prime requirements of an architectural photographer, apart from proficiency in all technical aspects, is the ability to be an integral member of the marketing

and creative team. The photographer must be able to understand the client's needs and communicate them verbally and visually. Aspects that the client will, or should, take into consideration when selecting a photographer will include creative talent, professionalism, compatibility, specialized equipment, enthusiasm, and experience. Be aware that in architectural photography you will be dealing with other professionals, ranging from architects and engineers to advertising and marketing people, so your ability to work with a wide cross section of people, and understand their needs, will be vital.

Pricing an architectural assignment requires great attention to detail, and factors to be considered include what images will be required—format, film (transparency or negative, black and white or color prints, or digital files), usage, deadlines, and site logistics, such as access to the location. Many an assignment has been jeopardized because someone forgot to ask for a key to get into a building!

In determining a fee, keep in mind that your price is determined according to the nature of the work and the client's usage requirements. When the images are used to document and promote design services, rather than to advertise products or commercial services, the fee structure is lower. As the use broadens or the number of images to be produced increases, so does the photographer's fee and the costs associated with the assignment.

Elsewhere in this publication is more information on pricing but, in general, factors that affect your fee include the anticipated use of images, the photographer's creative talent and experience, production time, equipment, facilities, and staff. Don't overlook charging for services in addition to the photography itself, which could include such things as pre- and postproduction time, meetings with the client's staff, and all other time-consuming elements. The more complex an assignment, the greater the fee is likely to be.

Architectural photography often has multiple purposes, so be sure you take this into consideration. Potential uses could be portfolios, printed brochures, award submissions, editorial reproduction, corporate publications, advertisements, and Web pages. Ask if color copies will be used in marketing materials. Will the images be scanned for the client's archives or for other future use? Be sure that the client specifies the sizes and quantities that will be needed.

Considering the number of professional services that may be incorporated into a major construction project, it's logical that many architectural assignments may be commissioned by more than one client. So, if more than one client contributes to the cost of the assignment, a higher photographic fee should be stipulated because the images will be used more extensively.

Clients will often want to enter photographs of their projects in contests or are asked to provide images for editorial uses. Ask your client if this is a consideration, and point out that permission for uses beyond what is agreed on in writing must be obtained from the photographer, who owns the copyright to the images.

Because architectural photography is so multifaceted and complex, ASMP has established a special interest group of architectural photographers which has its own online, members-only ListServ. Additionally, an informative brochure, titled *Commissioning Architectural Photography: A buyer's guide for working with architectural photogra-*

phers, is available from ASMP. Much of the information here is based on that guide.

Photographers particularly interested in architecture should make contact with ASMP for more information on this specialty group.

This area of specialization involves photographing manmade structures for illustrative purposes. Typical clients include architects, interior designers, contractors, engineers, developers, the hospitality industry, plus numerous manufacturers of products such as furniture, lighting, carpeting, and building materials. Client usage varies from portfolios and display boards to brochures, editorial, and advertising in trade or consumer media.

Architectural photographers need a sense of composition, sound technical skills because of the wide variations in lighting and spaces, and extreme patience (waiting for the right weather and lighting conditions). They must also be particular about details (they might have to pick off every dead leaf from a tree). The physical demands of location work and heaving lighting equipment require good health and strength (or at least a strong assistant).

Usage and fees. Many clients for this type of work commission photography only occasionally, and some degree of client education regarding rights and usage often is required. It is also not unusual for first-time clients to be naive about the time required to photograph interiors, especially in mixed-lighting conditions, and in large, complex spaces. Also, clients should be clear about copyright ownership belonging to the photographer.

Just as in other specialties, fees are based on a combination of a creative fee and usage. For example, photographs taken for hotel brochures should command a higher fee than the same photographs taken for an architect's portfolio; this reflects the type of usage and the value of the image to the client.

As with other specialties, most architectural photographers have a minimum creative fee that is based on experience, talent, capital investment, and overhead, plus a desired profit margin.

For architects and interior designers it is customary to grant a non-exclusive license to use the photographs for portfolios, display, slide presentations, self-promotional brochures, awards competitions, and editorial usage. Photo credit, including your Web site address if you have one, should accompany photographs used in this way. Make sure your client understands that allowing magazines to use your images beyond what is agreed on in writing, is not permissible without additional fees.

Fees charged for advertising usage of architectural photographs are based on the same criteria used for any other type of photography, namely placement, number of insertions, length of use, exclusive versus non-exclusive use, and the like. (See chapter 3, "Pricing and Estimating.")

It is extremely important to obtain a property release, and a model release when appropriate, for any image with resale potential. While many images at first glance do not appear to have resale value, they may, in fact, have tremendous resale potential. Without adequate releases and permissions, however, many sales are impossible and you may be needlessly cutting yourself off from future income.

It is not uncommon for two or more clients (say, the architect and a supplier) to share

usage of a shoot and to split the total cost. Since the usage is increased and the time required to service these clients is increased, it is customary to charge a higher-than-normal fee for this situation. With similar usage for all parties, a typical surcharge might be 30 percent of the creative fee for two clients, 50 percent for three clients, and so on.

Typically, the photographer retains the exclusive right to license usage of photographs for commercial use to any third party. This right should be made explicit in the contract in order to avoid any possible confusion. Such third-party sales represent a significant source of income for most architectural photographers, and should never create a conflict of interest with usage by the commissioning client. A good working relationship with the client will help ensure that any third party requests for usage will be referred to the photographer.

Fees for usage by third party clients are comparable to fees paid by the commissioning client, or higher if warranted by usage. These fees also may reflect the cost to recreate the photographs, and the photographer's experience and reputation.

Catalog Photography

There are two main areas of catalog photography: fashion and product. Potentially lucrative, extremely hard work, and laden with pitfalls, is how some practitioners describe this specialty. The number of photographs used in catalogs is enormous but before taking the leap into this specialty there are some considerations.

If all your work comes from one or two large clients, you will be expected to be available at all times, at short notice, otherwise clients will call other photographers. This will leave little time for marketing yourself to other clients, or servicing smaller clients you might already have. Also, large companies going out of business often take their suppliers—including photographers—down with them. And a store might suddenly decide to install an in-house photography department. If you lose a major client, for whatever reason, you suffer a double blow: loss of immediate business, and time lost trying to find new clients.

Of course there are advantages to having large clients, including, regular work, big projects, and potentially good income.

Catalog photography is used primarily in a company's direct-mail marketing campaigns but there can be overlap with some of the same photographs used in advertising. It is important to know exactly how the photographs will be used before submitting an estimate. (See chapter 3, "The Art of Pricing and Estimating.")

Because of the variety of photography, with speed being essential, the catalog shooter must be proficient with all formats of equipment, have strong lighting skills on location and in the studio, be able to follow a layout, and be comfortable working with people and products. Being able to perform under the intense pressure of tight deadlines—and usually for long hours each day—is a must. Catalog photography at its most hectic is incredibly demanding.

The work can be in the studio or on location (nearby or distant) and each involves its own pricing structure. Once the job moves away from the photographer's studio, travel, accommodations for the photographic crew and models, per diem, and other costs associated with location work, figure into the total fee.

The models used in catalog fashion photography are usually hired through an agency by the client and usually bill directly. At times the models' fee will be billed through the photographer's studio who will pay the agency.

Practitioners in fashion work stress the importance of having excellent relationships with model agencies. In addition to performing their obvious role, agencies can also help in business areas such as knowing clients' paying habits, and keeping an eye out for unauthorized use of photographs.

Catalog fashion photography fees are usually based on the number of shots taken during a day. Typically, the store or client's art director will project how many days a shoot will take and the photographer will negotiate a fee based on completing the job within that projection. Some clients will expect a certain number of shots to be completed each day, say, in the range of eight to ten. This figure will vary depending on the complexity of each photograph.

Because fashion photographs have a limited life span, in the vicinity of three months, their re-usage value, as stock for instance, is limited. Also, models' fees are high and are paid by the client. To use fashion photographs for other reasons, you would have to pay a model fee. These factors must be weighed into the photographer's fee and many catalog fashion shooters, while admitting it's preferable to retain rights to the pictures, will negotiate the sale of all rights and will charge accordingly.

Having determined the extent of the shoot the photographer will submit an estimate with a full description of the job. On its acceptance an advance, usually a third, is expected. Another payment of a third is expected at some point during the project—this depends on the total projected length—and the balance is due within thirty days of completion.

If reshoots are necessary, for reasons other than equipment or other technical problems, the client is expected to pay an extra fee. This should be clarified, in writing, before the job starts.

Trends: An increasing amount of catalog photography, especially of products, is being photographed digitally and while conventional photography, particularly of people, still plays a significant role in this specialty, vastly improved digital equipment is changing how catalog photographers work.

The advantages of digital photography for product work include not only the speed with which images can be made but the elimination of several steps from original image to printed page which are involved with conventional photography.

To remain competitive in catalog work, and because many clients are now requesting images in digital form, more studios are becoming electronic and this transition will increase as manufacturers continue to improve image capturing equipment. Obviously, this requires considerable investment by studio owners, a factor which will be have to be weighed when considering the viability of becoming an electronic studio.

Fashion and Beauty

To succeed in this highly competitive field, several mandated skills are vital: an intense interest in fashion and beauty, and the ability to create a distinct style—a look. Breaking into this field is not easy, but once in, photographers often have freedom to use their

own interpretation to convey style.

The field is segmented according to how business is conducted. The three major areas—defined basically by usage—are advertising, retail, and editorial. They share some common areas, but each has its own compensation and peculiarities.

Advertising: As in other specializations, this pays the most because of the value of the image to the client. One image, which may take several days to make, is often the goal.

Retail: When shooting for stores, photographers often use day rates and space rates, which generally fall between advertising and editorial rates. The photographs are usually for flyers and catalogs and newspaper advertising.

Editorial: Some photographers have seven-figure contracts with magazines. Usually based on the size of the photograph, however, editorial rates pay the least amount of money—both to photographers and to models. The images can offer great advertising for photographers because of the photo credit. Advertising and retail clients often use magazines to seek photographers—and models—who can produce the "look" they want, which then leads to assignment work.

Much contemporary fashion/beauty photography entails shooting for catalogs, something many photographers used to denigrate. They felt the work was too stultifying, because the items had to be shown exactly as they looked. Photographers now have more freedom, with the result that many of the photos are image pieces. A few upscale catalogs even give credit lines. Wholesale or manufacturers' catalogs also provide work for photographers in this field.

Fees and usage: Usually creative fees in fashion/beauty photography are similar to those in other fields: they're determined primarily by usage. Advertising work commands the highest fees, editorial jobs pay the least, and retail rates fall somewhere in between. However, within this framework there is much deviation. Fees are fluid; advertising photographers who are in demand can get paid a tremendous amount of money, while others get paid significantly less. Fees for catalog work vary substantially, depending upon the client and the type of catalog.

As in other areas, fashion/beauty photographers—whether editorial, retail, or advertising—bill certain expenses and production charges to clients. Some of these items include assistants, stylists, hairdressers, location scouting, props, sets, transportation, hotel, meals, and film and processing. Photographers do not normally bill for models, however. Clients—ad agencies, companies, or magazines—take care of selecting (although photographers may make recommendations) and booking models. The clients also negotiate fees and pay the model agency directly.

Magazines, when travel is necessary, typically make all the arrangements, book hotels and transportation, and give the airline tickets to the photographer and crew.

While fashion/beauty photographers retain the copyright of all images (unless there is an agreement stating otherwise), releases from the models must be obtained for resale of images. Also to be considered is whether a release is required from the fashion designer. And the licensing agreement between the models and the client should be checked to ensure there is no conflict. Generally, resale of fashion is usually limited by time—fashions become outdated—while beauty photographs tend to have greater

longevity. It should be noted that models sometimes demand residuals from resales so this aspect should be clarified from the outset.

Trends: This field is undergoing changes including the fact that photographers are moving away from studio ownership, which entails tremendous overhead costs, especially in the fashion and cosmetic areas. Many photographers are finding it expeditious to rent a studio as needed. This gives the flexibility of having access to different studio space and facilities to meet different needs.

Not being tied to studio space also allows fashion/beauty photographers more flexibility to take advantage of growing opportunities internationally. The field is becoming more global, particularly in fashion and cosmetics, and fashion photographers may spend up to half of the year out of the country. European editors tend to give more stylistic freedom to photographers, and the resulting images often lead to work in the U.S.

The global trend has spawned an international way of doing editorial business. The client takes care of all the myriad pre- and post-production details, and the photographer travels to the foreign country with cases of cameras, shoots in a rented studio, and gets paid a creative fee and goes home. While some clients will offer to handle film and processing, photographers should discourage this. Clients should pay for film and processing, but photographers should supply film and control processing to ensure quality.

A practice first common overseas but now gaining popularity in the U.S. is for clients to coordinate the logistics and pay models' and assistants' fees. Traditionally, most photographers prefer to use their own assistants and crew with the client paying their fees but now it is not unusual for clients to rent and pay for the studio, book the models, provide transportation, and provide everything else needed. This trend was introduced to the U.S. by the large department stores.

Nature and Wildlife Photography

The attractions of this specialty—being in the great outdoors photographing flora, fauna, and spectacular scenery—might lose their gloss after a few hard truths hit home: (1) there's fierce competition from established, dedicated practitioners; (2) working conditions can often be arduous and uncomfortable; and (3) the financial rewards might not meet your needs.

Nature photographers, who must have incredible patience and often mechanical aptitude in building special equipment or making repairs in the field, can lead the life of a vagabond. They might spend half the year in the field—anywhere from rain forests to Arctic tundra—and much of the rest of the time marketing their work, preparing for the next trip, and in general, taking care of business.

The most successful practitioners have a background in nature or biology, and know where to find what they want to photograph—often with the help of scientists, biologists, or environmentalists. The field grew from a hobby among a small group of photographers with a love for nature. It has exploded in the last ten years as growing concern about the environment and nature became an important and socially desirable issue. The field is dominated by a handful of professionals possessing business acumen and photographic skills. Their work is driven by a desire to bring nature to people; their

intent is to help preserve it.

Business concerns: Major markets in this field include national magazines, nature books and, to a lesser extent, advertising. Nature photographs often have strong resale value, and stock sales can provide significant income, particularly after photographers get established. Typical stock sales would be for calendars, posters, cards, wall decor, and murals. Nature images generally don't get outdated and lend themselves to international publishing opportunities.

An office per se isn't really needed; photographers just need to be available to clients by fax or phone, have access to mail or courier service, and be able to get to an airport.

An all-terrain vehicle or one that enables the photographer to stay out in the field for extended periods of time, such as a camper, trailer, or van, often is useful. Film and processing costs are usually high because photographers in the field can't do snip tests and the nature of their work makes reshoots unlikely. Therefore, they tend to use a lot of film.

Travel, especially to foreign countries, brings its own difficulties. Photographers might need to figure out the logistics of moving equipment to a remote area on a small plane. They may also need to be able to work through customs and maneuver around bureaucracies that may be less than receptive to the photographer's presence. (See Travel Photography, below.)

If a nature photographer lands a specific assignment, expenses such as airfare, hotel, meals, and film and processing should be paid in advance by the client.

Depending on the area of nature photography, equipment and technical skills vary. Some nature and wildlife shooters simplify their approach, relying on available light and basic equipment, somewhat akin to photojournalism. But minimal equipment might not be good enough to compete. Others go to great pains in preparing for a shoot—such as building platforms high above the ground to photograph tree dwellers—and use sophisticated lighting and special lenses to achieve their goals.

Some specialties include landscape, usually the domain of large format equipment; macro, where special close-up equipment is essential; and general wildlife, for which long lenses are usually required. Investment in equipment—quality lenses, auto focus cameras, and electronic flash—can be extensive and expensive.

Hobbyists abound in this field because nature photography is a good excuse to get outdoors. It's an expensive hobby, however, so people look for ways to make money. The result is a depressed market for stock sales.

This explains why photographers in this area also tend to be involved in a multitude of diverse projects—giving lectures, teaching classes, leading photo tour groups, writing columns, and publishing books—with the goal of boosting their livelihoods.

Use and releases: Fees are generally based on usage. For editorial photographs, the going rates and practices in the editorial field apply. Although advertising assignments in this field are rare, sales of stock for advertising use are growing. Part of the reason for this is the desire for companies to portray themselves as nature friendly.

Because of the subject matter many practitioners don't bother with releases. Most photographs are taken outdoors; there's no one to sign in most situations. Photographs including people will have greater stock sales potential if released, and cannot be used

for advertising unless released. If you rent animals and hire the services of a handler, ensure that you obtain releases.

National and state park services are also exerting greater restrictions on commercial photography in parks. Permits are usually required if the photographer has special needs such as crowd control, or does something different from other visitors. Rather than risk problems, you are advised to check restrictions on photography with the park authorities. Permits, if required can be obtained from either the National Park and Wildlife Service, or from a state park service, depending on who controls the park. Application for permits can take time to process, so inquire well before you intend making commercial photographs.

Publicity/Promotional Photography

This field is a hybrid of all the sectors of photography, incorporating elements of advertising, corporate, and editorial photography. It demands separate treatment, however, since it has some of its own peculiar practices.

Publicity/promotion pictures are used by producers, press agents, public relations firms, corporate directors of communications, and individual talents handling their own public relations. Clients often are associated with theater, television, sports, dance, film, tape, politics, book publishing, music, and, to some degree, general corporate activities.

Photographers need broad skills to succeed in this field, because they have to work in a wide range of settings, from on location in the workplace to a table top in a studio. Many practitioners can be found in smaller markets, where they need to do considerable educating of clients about rights and usage.

Financial considerations: Financially, this field incorporates elements of both photojournalism and the more commercial pursuits. Assignments may be seen by the client as satisfying purely commercial objectives. Nonetheless, to the photographer, these journalistic elements are present:

- The work is likely to appear in a wide variety of print and related media, frequently as illustrations used with reviews or similar editorial copy.
- The work is editorial in nature, often involving coverage "in performance" or in a portrait setting. Accordingly, the practices that have developed reflect a compromise between the wider use negotiated with clients in some of the more commercial specialties, and the limited one-time-use-only terms (and accompanying reuse income for the photographer) normally associated with editorial photography.

What this boils down to is this: in public relations assignments, fees may be more modest than in other commercial assignments, so reuse income is important for the photographer.

The photographer's ability to achieve publication in the right places can be a factor in determining who secures an assignment particularly with "special" still coverage on motion pictures. Avoid making guarantees about publication and press prospects, since final editorial judgment can be made only by the publication itself.

Usage: Photographers in this field often try to get clients to focus on usage when

discussing fees, in an attempt to move away from the concept of day rates. Under current practice, a photographer's basic fee usually covers only these client uses: press kits; brochures; and certain editorial use in newspapers, trade publications, television, and local poster displays.

Publication is restricted to announcements, reviews, and other editorial situations where the subject of the photographs is mentioned specifically. The permitted duration of usage is normally for the life of the event, which for ballet or opera is the season or engagement, and for politics is the current campaign. Remember that in politics, especially during a campaign, business is traditionally done on a COD basis. A losing candidate might not pay bills after the election. For a book promotion or jacket, limitation pertains to the precise title and edition involved, and is limited to the specific photographs agreed upon for use.

Other uses normally result in additional or reuse income to the photographer from the publication, electronic medium, etc., that uses the material. Examples of media that typically may be charged for reuse of photography include:

- Publications: General-circulation magazines and major Sunday supplements. (Note: Most major magazines and Sunday supplements expect to pay separately for all uses.)
- Television: Additional fees are usual for any editorial use, such as documentary-type features, not referred to as part of the photographer's basic fee.
- Commercial offshoots: These include program books, T-shirts, album covers, and book jackets that are not part of the initial assignment.
- Advertising: Paid national ads, nationally distributed posters and similar uses normally command additional fees. Local ads, however, are a gray area. Although sometimes permitted without extra charge (as part of the initial shooting fee), it is becoming more common to negotiate additional fees for such uses.
- Individual talents: Photos shot for the public relations client generally command additional use fees. Also, an author may pay more for publicity uses of shots taken initially for book jackets. Practically speaking, however, restrictions on usage in this area are difficult if not impossible to enforce. Local newspapers often use publicity photos without credit lines; in such situations, particularly in smaller markets, it might be detrimental from a business standpoint to take action against either the client or the publication. Photographers have to walk a fine line when negotiating these issues.

Credit lines: Adjacent credit line, preferably in proper copyright form (© year photographer's name), should accompany every use. Furthermore, many experienced photographers state on all forms that omission of, or incorrectness in, the credit is subject to triple billing. Protection of the copyright on a book jacket requires placement of the copyright notice on the jacket itself. A book jacket is considered a separate work which is not part of the book proper.

Negatives and transparencies: All negatives and transparencies should be returned to the photographer immediately after use.

Usage notice: It is customary (and advisable) to require a statement of use on the

front of each photograph—on an overlay or on the border—in press kits, etc. This notice, together with the notice to the client of liability for any violation of usage restrictions, is important to prevent unauthorized use in publications.

Photographers in this area should get both property releases and model releases from corporate employees, or at least keep the company's releases in their own files for safe-keeping. Even though this might be difficult to do from a diplomatic standpoint, getting a release at the time of the photo shoot can prevent problems with disgruntled former employees who, for example, might be unhappy about being included in a photograph used in a brochure which might be an offshoot from the original assignment. Signed releases also put the photographer in the position of being able to take advantage of any potential resale opportunities.

Sports Photography

Because many aspects of doing business in this field are unique, ASMP has created the Sports Photographers Specialty Group to address specific concerns. Photographers particularly interested in sports should contact ASMP for more information on this specialty group. The information in this section provides an overview of doing business in the field.

This primarily editorial field appeals, obviously enough, to photographers who love and understand sports. If you don't find sports exciting, or know little about them, this is probably not for you. But the stiff competition in breaking into sports photography indicates that many do thirst for the thrill of photographing the action and making a living from it.

If you have an intimate knowledge of sports—or a particular sport—and have a knack for knowing where the action is going to be, and have photographic skills and quick reflexes, you've probably got some of what it takes. But stepping right into the big time is unlikely and access to major events can be difficult unless you're willing to photograph from the stands. A better bet is to start photographing local sports where you can get better access. Your market could be the local paper, or high school or college magazines.

Once you've developed contacts and have tear sheets with credits, your chances of getting press credentials and opening doors to bigger events and athletes are better.

Developing your photographic skills takes practice. So does developing your business skills and in this field you are in essentially the same freelance market as any other editorial shooter. Stock sales for sports—especially released images, and those symbolic in nature (power, speed, etc.)—can be more lucrative than the original assignment. Some veteran sports photographers make considerably more income from sales of sports personality photographs used by sponsoring companies than for their editorial work.

Investment in equipment can also be expensive. Before taking the plunge seek advice from veteran sports photographers. Newspaper photographers usually have the experience to advise on ideal equipment combinations for different sports.

The working arrangement you have with clients will depend on how well you know them. A long established client with tight deadlines might require you to submit

unprocessed film so it can be processed and edited immediately, and potential future selects kept on file. Some photographers see this system as an advantage as it means the client might use more material. However, it does reduce the control you have over your pictures.

Electronic transmission of sports, and other news photographs, might also demand quick processing by someone other than your own lab. Be aware of these possibilities before an assignment.

Sports assignments come under the same basic guidelines as editorial work. For example, releases for editorial purposes are not usually required but if an unreleased sports photograph is later used for an ad or promotional purposes, it could lead to legal problems. If such a use develops, or is anticipated, get a release.

Sports advertising photographs, especially of prominent athletes, are usually arranged—and set up—through an advertising agency. If photographs taken in competition of an athlete or team are to be used for advertising, releases from the individuals—and often from the league or competition organizer—must be obtained. Currently, a major concern is the move by sports leagues to limit access to events and to control licensing of images. ASMP is fighting for photographers' rights in this regard.

Still-Life, Product, and Food Photography

Still-life and food photography are usually studio assignments requiring special lighting and camera equipment and skills. The field incorporates some aspects of both advertising and editorial photography.

Clients can include corporations, advertising agencies, and design firms with photographs likely to be used in advertising, magazines, and cookbooks and on food packaging.

Still-life photography entails shooting inanimate objects, including food. A food photographer is assumed to be capable of shooting still life, but a still-life photographer is not assumed to be able to work with food.

While most of the work is table top within the controlled environment of a studio, it can require a larger set or be on location. As is true with many assignments, the successful still-life photographer must be able to visualize the final image and ensure that all the elements are on hand for the shoot. At times the client might provide only a vague idea for a layout leaving the photographer to control creativity.

Special requirements: The business of still-life photography is like the business of advertising or editorial photography in production planning requirements, shooting expenses, and usage and fees. Studio space and equipment are basic requirements and a food photographer has the added investment in kitchen appliances and utensils.

Photographing food often requires additional specialists or equipment whose costs are billed to the client. These could be:

- Food stylist/home economist—the most critical need is for a food stylist and perhaps an assistant stylist hired directly by the stylist. Some stylists shop for food, while others rely on shoppers. Food stylists charge day rates and get overtime.
- Food shopper—another critical crew member is a food shopper who knows butchers and produce people, and where to get food year round. Sometimes a

shoot will have to be scheduled around the availability of the food which some-times has to be shipped in.

- Prop stylists—buy or rent props. At times a prop maker might be called upon to design special items.
- Appliances and kitchen—special-purpose equipment such as deep fat fryers, addi-tional refrigerators, freezers, and ovens are often needed and these can be rented.

The elements of food photography are difficult to control. Food moves and changes, unlike, for example, a piece of jewelry. Every food has a different life span so art direc-tors, food stylists, and photographers have to rely on their ingenuity and problem-solv-ing experience. Veterans in this field recommend that photographers not try to style food themselves.

Productions for shooting food can be complex and practitioners liken it to a con-trolled explosion: everything has to be ready at the climactic moment and the photog-rapher has to catch that moment. Props, lighting and camera angle are all arranged, and then the food is placed in the set.

This might not be the end of the photo session, which can take hours longer than anticipated—accidents happen and food is unstable—and requires great patience. The cheese pull on a pizza doesn't last long, for example, and the photographer might use many pizzas before getting *the* shot.

Food stylists have many tricks of the trade to make the subject look good enough to eat, and this is standard and acceptable practice. However, if a photograph is of a par-ticular product, say a hamburger with a stated amount of meat, ethically the photograph must be of that product with all the correct ingredients.

Usage and fees: Advertising work, the largest part of this specialty, commands a greater fee than editorial work. As with other assignment photography, usage is impor-tant. A shot for a national ad campaign will require a larger fee than one for trade pub-lications. Copyright, unless negotiated otherwise, belongs to the photographer, who negotiates limited rights with the client for a specific duration.

Standard usage for packaging images is unlimited exclusivity, usually for one year and sometimes up to five years.

Cookbooks can provide photographers with a good publicity vehicle. Often photog-raphers will team up with a writer and stylist on these projects and, while they may not always be a big money maker, the variety of work can comprise an excellent portfolio. Food photography for cookbooks and magazines is basically editorial work, with the photographer getting a credit line but commanding less pay than for other uses.

Travel Photography

This might also seem an ideal way to make a living: make photographs of exotic places, stay in plush resorts, and have all expenses paid. But it's not that simple. Successful travel photographers combine a love of travel (and the ability to cope with all the atten-dant stress) with the vision to see familiar places in fresh ways. They must have all-round photographic skills and business/marketing acumen to exploit every possible market from each trip.

And they must be capable of working solo—being the producer, stylist, and lighting expert. Being able to function independently comes with the territory—the client or photo editor might be thousands of miles away. Attention to detail both pre-trip and while on location is vital.

While it might sound paradoxical, within this specialty being a generalist is necessary. Landscapes, cityscapes, night scenes, people, food, interiors, architecture—all come within the domain of the travel photographer. What buyers usually look for is "freshness"; a new way of seeing old subjects.

There is demand for travel images, in fact it's huge. But so is the supply. And payment, for what is largely an editorial market, is not. This is why the travel shooter must glean every possible sales outlet from each assignment.

Veteran travel photographers will usually develop a network of clients and notify them whenever making a trip. Hotel chains, or airlines, with tourist facilities in different countries might need new pictures. Marketing imagination is vital.

Be familiar with cultural and political taboos when in foreign countries. Taking photographs is not a right, and crossing a cultural boundary could lead to abuse—or worse. The U.S. Government offers advice on international travel, including warnings about potential dangers, which can be obtained by calling the State Department's Citizens Advisory Center in Washington, D.C., at (202) 647-5225.

Experienced photographers who can work their way through bureaucracy, who are familiar with cultures of foreign countries, and who can be working soon after arriving at a destination, are valuable to clients, and can command higher payment. Gaining that experience might require initial self-financed assignments. Some travel shooters augment their income by leading workshops and tours, but this too is an undertaking for experienced travelers.

The commercial market, especially in tourism, pays better. Clients such as cruise ships, hotels, airlines, credit card companies, banks, and, to a certain extent, car rental agencies use photos for capability brochures or advertisements. Major tourist organizations occasionally need work done for travel brochure photographs.

Travel is expensive, which puts time at a premium—your own if it's a speculative trip, the client's if it's an assignment. Travel photographers don't relax much. Clients expect them to work fast and to be cost-effective, one reason why assistants are rarely hired for editorial assignments.

For photographers on assignment, travel expenses (airfare, hotel, meals, local transportation) generally are covered by the client. Other expenses that should be covered include film and processing, special equipment or props, models and shipping. Clarify and agree on these issues before the assignment begins and negotiate for advances on all assignments—commercial and editorial.

As in other fields, travel clients are seeking more rights. Check the wording on every contract, even those with established clients because travel photographs have potential for stock sales and you don't want to limit that potential.

Be careful of sending travel photographs to foreign clients. Violation of rights in some countries might be hard to combat and it might be better to channel those sales through a stock agency.

Generally, travel images for editorial use don't require releases and many magazines don't ask for them. Releases do increase the potential for advertising stock sales, and photographers are advised to obtain them. A supply of simplified releases in the language of the country you are visiting is a good insurance. However, many people, especially in foreign countries, might not understand the concept of releases, and language and other barriers might make it impractical to obtain releases. Also, in some cases, your subjects might be illiterate and unable to read a release, even in their own language. For these reasons, veteran travel photographers with an eye to stock sales will often hire models. Making people unidentifiable is another way to circumvent the need for a release.

Shooting on location: As the name suggests, this involves working away from the photographer's home environment and can be as simple as setting up an executive portrait in the office next door, or as complex as an advertising assignment in a foreign country.

Specializing in location work usually means that the photographer doesn't have a studio or the studio is a base to produce from rather than in.

Location photography and travel photography have much in common. They both require thorough planning of logistics, and practitioners are usually people who relish the challenges of problem solving, often without the convenience of on-the-spot suppliers and resources.

As one shooter said, survival in location photography is a great experience. And veterans in the field usually have extensive check lists, based on their experiences, to ensure that slip-ups and oversights occur only once. These check lists, or production guides, are used to walk the shooter through the job long before arriving on location. Every detail from film and equipment to personnel, transport, accommodations, and visa requirements must be checked.

Getting advances to cover all expenses for the trip is vital. Travel costs, especially for a group, are expensive and photographers should not have to subsidize them. Clarify with the client, before the shoot is completed, such things as costs that require pre-payment and bills to be paid on location.

Frequent communication is necessary for the smooth operation of all stages of the project. Some photographers recommend prior meetings with all the people who will be working on location. Everyone must know what to expect and what is expected of them. Brief meetings at the end of every day on location are useful for evaluating the day's work, and for making final preparations for the next day.

Clients also need to know what to expect. All details, financial and otherwise, should be in writing. How will weather problems be handled? What transport will be needed on location? What accommodations? Rent for storage space for equipment, access to phones, fax machines, or computers, and meals all need to be arranged and agreed on.

Confirm everything by fax the day before leaving for the shoot. This is a reminder and also makes sure everything is in order. Include information on whom to expect, the schedule, the number of pictures, number of rooms needed, and transportation requirements.

Personnel requirements vary with each assignment, but a typical assignment would

include a production manager to set up the project and to make sure it runs smoothly, an assistant, a stylist, a location scout, models, and a hairdresser. These can be either full-time employees or freelancers, preferably experienced in location work. Depending upon the project and the client's relationship with the photographer, the art director might also be there.

Often location shooters will have experienced personnel as a nucleus of a crew and train new people on less demanding shoots.

Photographers need to be aware of security while on location. An assistant may be assigned to stay with the equipment at all times, even sleeping in the same room with it. Exposed film may be locked in a special case which stays with the photographer at all times. Hiring local guides or guards, particularly in unfamiliar territory, is another alternative.

Many photographers maintain that it is far preferable to pay excess baggage charges rather than to travel to a distant location and not have what is needed. They suggest taking twice as much as estimated in equipment, film, batteries, and walkie-talkies. Make arrangements to purchase extra film locally. Carry a medical kit, any necessary notes from doctors, and well-labeled prescription drugs. Some photographers have crew members trained in cardiopulmonary resuscitation and prefer good swimmers.

It is helpful to have a local company representative assigned to work with the entourage. This person can help solve problems and be a liaison with local vendors and others. Deal with well-known and established companies when renting cars or contracting for other services. Ask other photographers for recommendations on reliable suppliers. This is where ASMP colleagues can be great resources.

Because of the physical demands of travel, it's suggested that the location crew arrive the day before shooting begins. This allows them to be better rested and to scout the location ahead of time. Experienced photographers schedule a day off after three- or four-days' work. If the job entails more than one location, have an assistant travel to the next stop a day ahead of time to smooth the way and to make last-minute arrangements.

Location work can be in any of the major markets. Advertising clients, which traditionally pay higher fees, include credit card companies, banks, hotels, major tourist organizations, communications companies, software companies, recreational companies, and airlines.

Editorial clients include primarily magazines and some newspapers. Depending on the use, compensation is commensurate with either advertising or editorial rates.

Foreign travel: Any location work is demanding but traveling internationally requires special preparations. Some photographers even hire language tutors before going to a foreign location. They want the production staff, if not fluent in the local language, to at least be able to communicate. This helps them to get greater cooperation from local people and keep staff out of trouble. They also want staff to know something of the culture and to respect its customs, such as: who do you tip and how much, what behaviors to avoid, what is acceptable attire? Attention to these details can make the shoot go much smoother.

Paperwork to be done ahead of time includes passports, visas, insurance, and per-

mits to bring equipment into the country. Location veterans suggest that because of its immediacy, fax is the best way to handle this paperwork. It also saves time and money making phone calls, and written communication can avoid misunderstandings.

Ensure that all paperwork—equipment lists with make and serial numbers, passports, visas, and driver's licenses—for all personnel is easily accessible, and that officials will be able to inspect your equipment against your lists. Check if a carnet, an official document covering equipment to be taken in and out of a country, is required. A carnet can also save you hassles when returning home, especially if you took new equipment. Before departing the U.S., let Customs officials know what equipment you are taking with you, otherwise you could have to pay duty when you come home.

If possible, have the client write, in the local language, a letter of introduction to the local company representative explaining who you are, that they should assist you, and to call the home office with any questions. Also carry a letter of introduction from your banker addressed to a local banker in case you need extra currency or other financial services.

Virtual Reality Photography

In recent years a new technology has emerged, one for creating and displaying virtual reality (VR) images for multimedia. VR photography is a complex and highly specialized field, which has opened a whole new market for photographers who have the ability to compose and light an entire environment so it records properly on film and digital media, and to do so with little or no "off camera" positioning of supplemental lights. One of the leading experts in VR photography is San Francisco Bay area photographer Scott Highton (*www.highton.com*) who has written numerous papers and articles on this specialty.

Highton said that in 1994, Apple Computer introduced QuickTime VR—the first and most successful consumer-oriented technology designed to immerse viewers in a virtual photographic environment, and allowing them interactive movement through it. Viewers can look up, down, and 360 degrees around, zooming in or out at any point, and can also virtually "pick up" objects to see them from any angle.

As Highton points out, the technical aspects of VR are multifaceted, and the photographer must have a technical understanding of every step of the process, including node selection (the location from which an image is shot), film (media) choice, lens selection, camera alignment, lighting control, subject positioning, scanning, digital processing, assembly, sequencing, and end-user interfaces. VR photographers must be systematic and precise in their approach, and possess a filmmaker's sense of continuity.

Multimedia projects are generally collaborative efforts involving a team of experts. In a nutshell, there is no such thing as a small multimedia project. Production in this field is far more complex than traditional print work. If you contemplate entering—or are already working in—VR, do not lose sight of the value of your work to the client. Keep in mind that the value of VR, as in all commercial photography, is based on the cost and expense of doing the work, the skill, talent, and reputation of the photographer, as well as the value that the client receives from this work and how it will be used.

Usage and fees. Some VR producers charge on a per-node basis (a cost for each

view photographed), but experienced VR practitioners point out that pricing by the node can be flawed. As an example, a client's original concept that might allow ten to twenty nodes to be shot in a day might be slowed down by technical problems, or the job becomes more complicated than originally envisioned, resulting in far fewer nodes being completed. Pricing should reflect time and costs involved, and the value to the client. Do not ever become known as a "cheap" shooter or you will have difficulty ever shaking that reputation. It is far easier to negotiate your prices downward once you are established and have volume to support lower fees than it is to negotiate them upward from a too-low start.

Since this is a relatively new field, photographers should seek advice from those who have experience before pricing any project. However, don't set your prices based solely on what someone else charges. As in all pricing, consider factors such as your overhead, your investment in equipment, and your own time. Do not overlook the time involved in assembly and postproduction; charge accordingly. Ask your client a lot of questions about usage: Will the images be used on multiple corporate Web sites, distributed on CD-ROM or even used in broadcast video? What is the proposed duration of usage? Be sure you retain all rights to your VR work, as there is a growing demand for stock VR imagery, and VR panoramas are quite frequently and effectively used in traditional print media.

Trends. The virtual reality industry has resulted from a merging of traditional print media, motion picture/television and personal computer industries. While exciting and filled with potential, virtual reality is fraught with conflicts between these industries, particularly in their business models. Clients coming from the traditional print media will generally understand usage and are willing to license usage as needed. However, those coming from the motion picture/television side are more accustomed to work for hire and full rights ownership agreements.

As large media corporations continue to merge, the content that is created for one will usually be sought for repurposing by the other branches or divisions of that conglomerate, and the pressure for full rights transfer from authors and photographers will increase. Remember that your work is your legacy, and, for most photographers, represents your retirement. If you give it away now, be sure that you are compensated adequately.

Better yet, propose to clients who want full ownership of your work a better option, such as unlimited use for a given period, including embargoes against your selling your work for them to their competitors. Most clients who wind up owning the work of their photographers eventually destroy it when it becomes outdated, without contacting the photographer beforehand. At that point, the work is lost forever, and you do not even possess it for historical reference. Look for the win-win agreements that benefit both you and your clients and that keep ownership of your work in your hands.

As online bandwidth and newer technologies develop, expect to see VR photography expanding into full motion video, so that the viewer can see a live action scene interactively, rather than a static one. The demand for compelling VR imagery, whether static or motion-based, is only expected to increase as interactive video channels and high bandwidth Web delivery proliferate.

The Photographer/Agent Relationship

The primary function of an agent or representative is to secure assignment work for the photographer or to arrange sales or licenses of the photographer's existing stock pictures. Some agents work solely on securing assignments. Others handle only stock pictures. And there are agents who do both.

Basically, there are two kinds of agents: individuals and stock houses. The individual representative (or "rep") may handle the everyday affairs of the photographer—like the personal manager of, say, an actor. But usually the rep's emphasis is on securing jobs for the photographer—the way the actor's agent does. There may also be some effort to sell existing stock material.

Once a photographer's gross income from fees amounts to somewhere in the neighborhood of $75,000 to $100,000, operating costs often begin to rise geometrically. This can be frightening. It can bankrupt the photographer. This situation obviously has to be watched with great care. An aware representative can help to control the situation generally and, in particular, make sure that all job-related expenses are included on estimates and invoices.

The extent of the rep's authority is a private contractual matter between him or her and the photographer. That authority should be clearly spelled out in the agreement between them.

A stock agency, on the other hand, is an organization that handles the work of numerous photographers. It can be an entity of as many as several hundred people, or as few as two or three. It maintains extensive subject-oriented files of existing stock photographs. The stock agency, of course, seeks to license the use of that file material as widely as possible.

It is essential to keep close contact with a representative. Photographer and representative should have regular discussions regarding the trend of assignments and financial progress.

Among the first things to be thoroughly understood in a photographer-representative relationship are the applicable fees and specific markets worth aiming for. A good representative should know these fields. Likewise, a photographer should be realistic about which markets are suitable and which are not. Any photographer worth a representative's selling effort is an individual with something positive to offer visually. A good representative sells the unique qualities of that person.

Doing Business

Representatives are the contacts with the art directors and other originators of photographic assignments. Most important, the representative's job includes ironing out all financial details in advance in the hope that those matters will not encumber the photographer/client relationship. Representatives must therefore be highly professional in their dealings, much as photographers are required to be, in matters such as meeting deadlines and having deliveries ready as promised. (In many cases, representatives make the deliveries themselves to protect the account and to get a quick reaction. It is to both the photographer's and the representative's advantage to deliver prints, trans-

parencies, etc., personally.)

Freelance representatives who operate their own businesses normally finance themselves. They also usually gravitate to representing photographers of reasonable status within their area of business experience, and ones with whom they are compatible. At this time there probably are more photographers looking for good representatives than representatives looking for good photographers. Yet some of the highest-level representatives will also add that the appearance of exceptional new photographic talent is equally hard to find. Actually, representing may offer a swifter financial advance for an intelligent and creative and/or patient person than photography itself, and, where the representative works closely and creatively with the client, it is a satisfying profession.

It is normal for a good, busy representative to employ other people. But it is absolutely necessary that the representative personally devote enough time to each photographer to make the association worthwhile. In some cases, it may also be worthwhile for the photographer to provide the representative with office space, perhaps file space, and perhaps a telephone. In this case, the representative remains responsible for payment of all his or her expenses, including telephone calls.

Assignment Representative Contracts

The sample photographer/assignment representative contract at the end of this section does not establish a single uniform standard. That would be impossible given the varying circumstances under which photographers and their reps work together. Each time this sample contract form is used, it should be negotiated individually. Minor modifications can take care of any particular approach the photographer or representative has in his or her association. The contract entered into must be fair to both parties. As with other important documents, it may be useful for the photographer to seek expert guidance from an attorney or other advisor.

The following information refers to both the photographer's and the rep's primary areas of concern in the course of their working relationship and provides an essential background for understanding the technical contract details in the sample contract form that follows. The discussion indicates the variety of ways a particular topic may be handled in the contract itself, especially in the areas of commissions, house accounts, promotional expenses, and termination.

Commissions

Although 25 percent of the fee has become the generally accepted percentage a well-established representative receives, there are other rates and forms of agreement. Some very successful photographers have their representatives working for a salary, some for a salary and a percentage bonus. Some agreements are made at 20 percent and less; some grant a higher percentage on out-of-town accounts, perhaps another 2½ to 5 percent because of higher telephone and service costs.

As a yardstick, a representative's fee in the New York market on television commercials is usually 5 to 7 percent of gross billings.

Remember that an advance or "draw" against future commissions, unless clearly documented as a loan, might be legally considered a salary and may be nonreturnable.

Taxes and social security may have to be paid on this. It is a situation worth avoiding by proper documentation.

House Accounts

House accounts are primarily those clients the photographer has been working with before any relationship with the new representative. They are often not commissioned, or they are commissioned at a lower rate than normal for a specific period of time.

In addition, lower paying accounts such as magazines would probably best be reserved by the photographer as house accounts, or commissioned at a lower rate. So should lower paying television editorial work, experimental film editorial work—and, in fact, experiments of most sorts. If, however, house accounts are not commissioned at all, they may be neglected and die for lack of attention. To make sure this does not happen, it might be a good idea to cut the representative in on house accounts from the start, although at a lower fee—some arrangements simply provide a continuing commission at half the usual rate (sometimes less) for house accounts. This often continues until it is clear that the photographer and representative are going to be together for a while. Thereafter, often within six to twelve months, the house accounts may become fully commissionable.

A representative with a long successful record may insist on full commissions from the beginning. This is a matter of negotiation. But retention of house accounts by the photographer is insurance against the representative in the early months of a relationship.

Other arrangements provide for an increase on house-account commissions in steps based on percentages of increases in the photographer's overall billings. (For example, starting the commission on house accounts at 10 percent—or on any level, for that matter—and increasing it by 5 percent increments with each 10 percent increase in the photographer's total billings, up to a 25 percent maximum commission). While the particular percentages must be negotiated individually, the principle can be applied to a variety of situations.

In any event, until photographer and representative have been together for a substantial period (perhaps a year or even longer), the photographer may wish to exclude house accounts from commissions following any termination. The reason for this is simple: the representative was not responsible for initiating work from those clients and may not yet have a major impact on the continuity of their work. Of course, if the facts are to the contrary, then the termination clause will have to reflect that.

Naturally, a representative receives no commission on those expenses which are normally billed to the client above the photographer's fee, such as props, models, travel, living on location, messengers, set construction, film and processing, stylist, and hairdressers.

There are occasional jobs—these are rarities—on which photographer and representative must come to an understanding on expenses that must "come off the top" of the fee (before calculating the commission) because, for example, unusual equipment is required or unusual setup or location searches may be involved that cannot be fitted into the client's budget. A representative who has bitten the bullet by bringing in an out-

size job will be aware of the difficulties, and this problem should be thrashed out between photographer and representative before shooting. In special cases with unusual problems, the client should be informed in any event. Generally, such expenses are charged to the client, who should be aware of them before shooting or billing.

There must be a clear understanding between photographer and representative on jobs undertaken on a flat-fee basis. The occasional benefits in doing things this way should not be lost through misunderstanding about the expenses that must come off the top before the commission is calculated. A photographer who knows costs will be able to make a fair estimate of the expenses. Honesty and fairness must prevail, because blowing expenses up out of all proportion does not fit well in a relationship that can be terminated on a simple thirty-day notice.

Representative's Territory

If a photographer or studio engages more than one representative, the areas of work and territories should be spelled out carefully. Reps should rarely, if ever, approach the same agencies; it is certain that they should not be seeking the same accounts. Space is allowed in the sample contract Section 2(a) for such specifics as: New York market, Los Angeles market, San Francisco or Chicago markets; U.S.A., foreign, and even some agencies under certain conditions. Space is allowed in the contract's Section 2(b) to list such specialty specifics as: advertising, editorial, industrial, and television.

Invoicing

In general, the photographer is personally investing time and advancing expenses in producing the work, and therefore, should be the one to bill, to collect, and to handle the books. The photographer must also be scrupulous in paying the representative as soon as money is received. This is a contractual obligation. Where a photographer is too inexperienced to run a balanced set of books, the representative should handle the money and billing.

The representative should be consulted on bills, and wording should be carefully watched. The representative should acquaint the photographer with the idiosyncrasies of each client. For example, some clients do not like to see "messengers" on the bill; some insist it be called "shipping." In one instance, an item of $150 for "lumber" was entered as "lunch" by the photographer's accountant. It was caught by the account executive—luckily a friend—but if the item had reached the client it could have been the end of a fine account.

Promotional Expenses

In most cases, promotional expenses—such as mailers, directory advertising, etc.—are shared between photographer and representative. There are various ways to do this. Some split it 50-50, others make it 75-25 in accordance with the typical fee split.

At least one leading photographer ties in-house accounts and promotional expenses in this way: the photographer reasons that it is best to have the representative exert maximum efforts with all accounts, whether they are new ones or established house accounts. Accordingly, that representative receives 25 percent on all advertising

accounts, including the house accounts. However, partly as a trade-off, the photographer also reasons that the representative has the parallel responsibility of bringing in all the assignments and paying whatever promotional costs are required in that regard. Accordingly, that representative does in fact pay 100 percent of all promotional expenses.

Termination

A photographer-representative contract based on a thirty-day period of notice of termination is obviously only going to exist for an extended period if each party to it is studiously correct in his or her dealings with the other. "There are problems in the whole relationship of photographer-representative," as one articulate representative put it. "The problem reps face is the unsuccessful photographer . . . the problem for photographers is the unsuccessful rep." There is nothing this discussion, or the sample contract, can do for those problems except perhaps lead to a graceful termination without litigation.

The termination clauses of the sample contract form contain the best advice obtainable from those who work actively in the field. Plan only to enter into an association that has a good chance of enduring. Either party can terminate on thirty-days' notice, but a short, scrappy association is simply a waste of valuable time and money to both. Make a fair contract and follow it carefully.

Termination involves some of the most sensitive issues in the photographer-representative relationship. In most situations, the representative is entitled to some compensation, usually reflecting substantial efforts to secure certain accounts that have at least a reasonable chance of remaining with the photographer for awhile after termination.

On the other hand, if that compensation is excessive it could harm the photographer's ability to secure another representative, while the representative may have no such problem in securing another photographer.

In addition, unless the relationship extends over a reasonable period of time (probably one to two years or possibly longer), the question arises whether the representative should be sharing in any of the original house accounts after termination unless special services were rendered respecting certain of those accounts. Another possible way to handle this is to provide for a reduced commission on house accounts on termination after the photographer and representative have been together for a reasonable period.

It is often stated that the representative is entitled to receive full commission for six months on accounts that are active at the time of termination after the photographer and representative have been together for a reasonable period. This is an oversimplification, if, when the relationship first began, the active accounts were the result of earlier efforts made by the photographer or by a past representative.

Accordingly, for approximately the first year it is often agreed that the commissions on termination shall be limited to approximately a three-month period, increasing by regular intervals to a maximum of six months after a period of around two years (with special rules, as appropriate, for house accounts). This type of situation obviously has

to be individually negotiated in every instance. It is important because it protects the photographer against excessive demands after an early "breakup" while protecting the key long-term relationship for the representative.

Another possibility is to compensate the representative at full commission on all house accounts from the beginning of the contract and to provide, as a trade-off, for no compensation whatsoever after termination.

Whatever the final arrangement, it is the photographer's responsibility to stick to the agreed-to financial terms scrupulously. It is the representative's responsibility to return the portfolios and samples immediately upon termination.

Note: If there is no agreement, either written or oral, then the employment of the agent is deemed "at will" and no termination compensation may be called for. This may need the advice of a local attorney.

Sample Contract Between Photographer and Representative

AGREEMENT made this _____ day of _____ (year)_____, by and between [Photographer's name and address] (hereinafter referred to as "Photographer") and [Representative name and address] (hereinafter referred to as "Representative"). The parties agree as follows:

1. Definition of terms

As used for the purposes of this agreement:

(a) The term "Active Account" is defined as follows: An account is an active account when it generates assignments currently; it is either a product worked on, an art director worked with, or the original individual buyer for whom assignments have been initiated. An account may be a single order or a continuing campaign. An active account must consist of assignments initiated or assignments done within a period of (six) (twelve) months.

Upon the initiation of an assignment of any sort, oral or written, that constitutes an order for work, an account becomes active.

(b) The term "House Account" is defined as follows: A house account is an active account reserved to the Photographer or to the studio, from which the Representative is restricted in service of solicitation and on which the Representative does not receive commission, but with specified conditions may receive partial commission. When full commission is given the account is no longer a house account.

(c) The term "Library Account" refers to a general assignment which is undertaken on the basis of payment per picture use, where the pictures are to be paid for by the client for current use and are intended to be used and paid for by the client in the future, as well. A library account assignment represents an income source which extends in to the future and which, therefore, generates future commissions for the representative.

(d) The term "Stock" is defined as follows: Stock refers to photographs taken either independently or on assignment on which publication or use rights revert to or are retained by Photographer or the studio after use or rejection of the original stock. Stock rights belong solely to Photographer or the studio.

2. Representative shall use his or her best efforts to solicit assignments, contracts, and other work for the Photographer.

(a) Representative shall work in the following geographic territory: _____

(b) Representative shall represent the Photographer in the following fields of work: _____

3. During the term of this agreement, Representative agrees not to represent any other photographer [Option: any photographer other than those enumerated on an attachment to this Agreement] without the written consent of Photographer. Photographer shall not use one or more other representatives in the territory and the field(s) described above without first obtaining the written consent of the Representative.

4. The following are house accounts:

a. _____

b. _____

c. _____

d. _____

Sample Contract Between Photographer and Representative

AGREEMENT made this _____ day of _____ (year)_____, by and between [Photographer's name and address] (hereinafter referred to as "Photographer") and [Representative name and address] (hereinafter referred to as "Representative"). The parties agree as follows:

1. Definition of terms

As used for the purposes of this agreement:

(a) The term "Active Account" is defined as follows: An account is an active account when it generates assignments currently; it is either a product worked on, an art director worked with, or the original individual buyer for whom assignments have been initiated. An account may be a single order or a continuing campaign. An active account must consist of assignments initiated or assignments done within a period of (six) (twelve) months.

Upon the initiation of an assignment of any sort, oral or written, that constitutes an order for work, an account becomes active.

(b) The term "House Account" is defined as follows: A house account is an active account reserved to the Photographer or to the studio, from which the Representative is restricted in service of solicitation and on which the Representative does not receive commission, but with specified conditions may receive partial commission. When full commission is given the account is no longer a house account.

(c) The term "Library Account" refers to a general assignment which is undertaken on the basis of payment per picture use, where the pictures are to be paid for by the client for current use and are intended to be used and paid for by the client in the future, as well. A library account assignment represents an income source which extends in to the future and which, therefore, generates future commissions for the representative.

(d) The term "Stock" is defined as follows: Stock refers to photographs taken either independently or on assignment on which publication or use rights revert to or are retained by Photographer or the studio after use or rejection of the original stock. Stock rights belong solely to Photographer or the studio.

2. Representative shall use his or her best efforts to solicit assignments, contracts, and other work for the Photographer.

(a) Representative shall work in the following geographic territory: _____

(b) Representative shall represent the Photographer in the following fields of work: _____

3. During the term of this agreement, Representative agrees not to represent any other photographer [Option: any photographer other than those enumerated on an attachment to this Agreement] without the written consent of Photographer. Photographer shall not use one or more other representatives in the territory and the field(s) described above without first obtaining the written consent of the Representative.

4. The following are house accounts:

a. _____

b. _____

c. _____

d. _____

At any time hereafter, if Photographer is solely responsible for obtaining an account, said account shall become a house account.

5. Representative's commissions shall be as follows:

a. Advertising _____

b. Stock _____

c. House Accounts _____

d. Library Accounts _____

d. Editorial _____

6. Commission shall be calculated against the net photographic fee; i.e., the photographic fee exclusive of expenses chargeable to the client. In the event that a "flat fee" shall be set, the net photographic fee shall be that remaining after actual expenses directly relating to the specific job have been deducted.

7. Representative's claim to commissions shall arise when the Representative obtains a new assignment from an active account, subject, however, to Photographer's acceptance and completion of the assignment. Representative shall have no claim to commissions if for any reason Photographer refuses an assignment or if, after accepting it, Photographer does not complete the assignment.

8. Representative shall pay his or her own expenses, including telephone, entertainment, delivery, and general business expenses.

9. Billing shall be made in accordance with subparagraph [specify (a) or (b)] below. In the event an election is not made, subparagraph (a) shall be deemed to have been adopted.

(a) Photographer shall be responsible for all billing, shall be named in all purchase orders, and shall provide Representative with monthly statements, or copies of all bills rendered, for accounts Representative has serviced. Upon reasonable demand, Representative shall have the right to examine Photographer's bills and receipts for accounts Representative has serviced. Payment to Representative shall be made within 10 days of receipt of moneys.

(b) Representative shall be responsible for all billing and for all purchase orders on accounts for which he is responsible, and shall provide Photographer with monthly statements, or copies of all bills, for all accounts which Representative has serviced. Photographer shall be named in all billing. Payment to Photographer shall be made upon receipt of moneys. Upon reasonable demand, Photographer shall have the right to examine the Representative's purchase orders, bills, and receipts on all accounts Representative has or is servicing for the Photographer.

10. Both Photographer and Representative warrant that each has now in effect, and agrees to maintain during the term of this agreement, personal liability insurance with coverage in the amount of at least $100,000.

11. The relationship between Photographer and Representative shall be that of independent contractors, and nothing contained herein shall constitute this arrangement a joint venture or partnership.

12. Photographer retains the right to refuse any assignment obtained by the Representative.

13. Photographer shall not be bound by any representations or statements made by Representative unless Representative is specifically authorized by Photographer to make such statements or representations.

14. Photographer agrees to provide Representative with samples of work, to replace same as they deteriorate, and to provide a reasonable amount of fresh work from time to time.

15. Representative shall not acquire any rights in any of Photographer's work, and shall return any and all of said work on Photographer's demand.

16. This agreement shall terminate 30 days after receipt of written notice of termination given by either party, subject to the provisions of paragraph 17.

17. Termination

(a) Upon termination, Representative shall receive commissions from all active accounts as provided for under this agreement for a period of _____ months; however, on library accounts Representative shall receive commissions for a further period of _____ months. Representative shall be entitled to no other or further commissions, or remuneration of any kind.

[Alternative]: Upon termination, Representative shall receive commissions from all active accounts as provided for under this agreement for a period of _____ months. After this agreement has been in effect for _____ months, the period for such commissions shall be extended by an additional _____ months [optional: and commissions will also be paid on house accounts at the reduced rate of _____ percent for _____ months]. On library accounts, Representative shall receive commissions for _____ months. Representative shall be entitled to no other or further commissions or remuneration of any kind.

(b) If Representative is replaced with a new representative, notwithstanding paragraph 17(a) above, at any time after termination the parties shall have the option to mutually agree in writing as follows: Upon the effective date of an agreement between Photographer and a new representative. Representative shall receive half commission. Such Entitlement shall last for the period from the effective date of Photographer's agreement with the new representative until the final date for termination compensation as provided above in this agreement. Such mutual agreement between Photographer and Representative shall specify those accounts from which Representative shall be entitled to receive half commission. In the event of such mutual agreement, Photographer shall provide in the agreement with the new representative that all such specified accounts shall be serviced by the new representative for the duration of Representative's payment period. In the event of such mutual agreement, Representative shall not be entitled to any other or further commissions or remuneration of any kind.

(c) Notwithstanding paragraphs 17(a) and (b) above, at any time after termination the parties may mutually agree in writing to provide for a cash settlement which shall discharge all obligations and duties owed to each other under this agreement. Under this cash settlement procedure, Representative shall relinquish all rights to any future commissions payable under this agreement.

(d) In the event Representative shall have been responsible for billing under paragraph 9(b), upon termination Representative shall supply Photographer on demand with copies of all outstanding purchase orders and bills.

(e) Upon termination, either party shall have the right to notify third parties of the termination of this arrangement.

18. Any controversy or claim arising out of or related to this contract or the breach thereof shall be settled by arbitration before a single arbitrator in the City and Sate in which it has been executed in accordance with the rules of the American Arbitration Association or, at the election of both parties, in accordance with the rules then obtaining before the local Joint Ethics Committee, if any. In either instance, the award rendered may be entered in any court having jurisdiction thereof.

19. This agreement is personal to the parties and is not assignable by either party, unless the assignment is to a corporation in which the assignor is and remains the majority stockholder. This

agreement shall be binding upon and shall inure to the benefit of the respective heirs, legal representatives, successors, and assigns of Representative or Photographer.

20. This agreement constitutes the entire understanding between the parties and no modifications shall be of any force and effect unless made in writing and signed by the parties hereto.

21. Notice shall be given to Photographer at _____

and notice shall be given to Representative at _____

Notice shall be deemed received on the date of personal delivery thereof, or two days after the date of mailing such notice by U.S. Mail.

22. Both parties agree to execute and deliver such further documents as may be necessary or desirable to effectuate the purposes of this agreement.

23. This agreement shall be governed by the laws of the State of _____

Photographer: _____

Representative: _____

Date: _____

City and State: _____

Sample Notice of Termination

Under Paragraph 16

To: Chris Representative

Please be advised that I am giving you notice of termination of our agreement of _____ _____ (date), and that thirty days after your receipt of this notice our agreement is terminated.

Unless we enter a further agreement providing for termination payments to you under paragraph 17(b) or 17(c) you will be paid in accordance with paragraph 17(a).

At the end of thirty days, please return to my studio all my art work which you now have.

[Since you have been doing the billing, please turn over to me within 30 days copies of all outstanding purchase orders and bills.]

(Pat Photographer)

Sample Agreement

Under Paragraph 17(b)

_____ (date),

To: Pat Photographer

I understand that our agreement of _____ (date), (was) (will be) terminated on _____ (date), which is thirty days after my receipt of notification of termination from you.

I further understand you have entered into an agreement with another representative, (Mr.) (Ms.) _____ and that (he) (she) will start working as your representative on _____, (year)_____.

In consideration of my release herewith of all claims which I may have against you on account of commissions or otherwise, you agree to pay me half commission from _____ (date), until _____ (date), on the following accounts:

1. _____
2. _____
3. _____

I also understand that you have arranged to have your new representative service these accounts during the above period.

If this letter sets forth your understanding, please sign below and return the signed carbon to me.

By your signature you will acknowledge receiving copies of the following bills and purchase orders which had been made by me on your behalf:

1. _____
2. _____
3. _____

Sincerely yours,

(Chris Representative)

Accepted and Agreed to this _____ day of _____ (date)

(Pat Photographer)

Sample Agreement

Under Paragraph 17(c)

To: Pat Photographer

I have your notice of termination of _____ (date)

In accordance with Paragraph 17(c) of our agreement of _____ (date) , I hereby release and discharge you from all claims which I now have under that agreement, in consideration of your payment to me of $_____, receipt of which I hereby acknowledge.

Sincerely yours,

(Chris Representative)

Accepted and Agreed to this _____ (date)

(Pat Photographer)

Guidelines for Assistants

by Pamela Kruzic

The following is a compilation of responses that the author received after posting an inquiry on the ASMP members-only forum at (www.asmp.org) combined with her own experience as an assistant.

Information providers: David Budd, Alan Farkas, George Fulton, Ira Mark Gostin, Tom Hussey, Jeffrey Jacobs, Deborah Gray Mitchell, Harrison Northcutt, and Michael Sharp.

Edited by: Ira Mark Gostin and Michael Sharp. Special thanks to Jerrianne Lowther and Roy Buckner.

Working with an experienced, professional, commercial photographer can be both exhilarating and exasperating. If I had to pick one thing that it takes to succeed as an assistant, it would be an unequivocal dedication to the successful completion of the project. You will receive none of the credit, except possibly from the photographer who recognizes and praises your contribution. The rewarding experience involves the intrinsic satisfaction associated with taking part in the creative process and helping to overcome and resolve the numerous problems encountered in a photo shoot. At the end of the day, you may be dirty, tired, wired, scraped, pinched, and punchy. On the other hand, some projects may be so low key and enjoyable that getting paid seems a little peculiar. One day it is setting up for forklifts and backhoes, the next it is wedding cakes and ribbons, or celebrities and CEOs. It is this type of variety that makes each day a new and exciting adventure.

There is one aspect to be aware of when working with a photographer for the first time. Initially, your every move will be watched. It may seem that he is finding fault with everything you do and the way you do it. Don't defend or argue. This usually originates from the fact that the photographer is watching to see that his very expensive equipment is being handled properly, and also trying to help you do your job better. Once he is comfortable with your capability, this will subside.

Another aspect to be aware of is that the photographer is under a great deal of stress. He carries the responsibility for the project's success. The more professional photographers are less likely to let pressures affect the treatment of their team, but it can happen. Not that anyone should accept verbal abuse, but if you are spoken to sharply or abruptly at times, it may be from pressures that you are not aware of. Just move on. Hurt feelings, grudges, and anger just get in the way of your concentration.

An assistant may be able to avert some problems by simply noting and interpreting small details in the photographer's actions. For example: If the photographer walks across the room to set down his drink instead of next to the shooting area, then obviously don't set your drink in the shooting area. On the other hand, just because the photographer gives a lens cap a toss into the camera case, this is not permission for the assistant to do the same. Just use common sense and pay attention.

Remember: An assistant is a part of a team, a tool that the photographer uses to achieve his vision. You are not there to talk about yourself. That was done when the

photographer hired you. No chattiness with clients, art directors, or the like. Common courtesy and pleasantries are fine, but remember that your purpose is to be there for the photographer and to do everything within your power to help him or her attain the artistic goal and not to interfere with a smooth shoot.

Attitude/Attributes

Above all else, an assistant must have a positive attitude, including a sincere desire to be there, a willingness to learn, and enthusiasm for the project.

Be a listener; be flexible, efficient, punctual; be able to follow instructions; be aware of what is going on; be motivated and show initiative. You must be able to swallow your pride—it is not a question of "if you will catch it," just when. Whether it is your fault or not, you might as well get over it and move forward.

Anticipate what is going on, what will be needed next. Figure out what is threatening to go wrong and prevent it from happening. Remember good manners and be politically correct. Also important is compatibility. Try to be amiable: Sometimes it works, sometimes it doesn't.

Communication

Try to get an understanding of what is expected of you. Each photographer has different requirements and expectations. Talk to him; build a relationship. Know when to speak and when to be silent. Chattiness is deadly. Most likely you will miss something important if your lips are flapping. Be aware that sometimes you will be listening between the lines, to subtleties.

Don't assume. If you're not sure, ask. Better to ask and feel stupid than not to ask and be stupid, and possibly destructive. Be discreet: If you need to let the photographer know that something isn't right, don't announce it to the whole set. There is a time and a place for everything; figure out when and where that is. A good photographer is alert to his team and will usually be able to recognize that you need to tell him something.

Preparedness/Tools

Wear the proper clothing for the job, and ask beforehand. Also, ask about the nature of the job. Some of the tools you should have in your kit are a sharpie pen, a watch, a fanny pack, a small pad for notes/instructions, a survival tool, Band-Aids, aspirin, and, for emergencies, some cash ($20–$40) and a quick snack and water.

A more advanced kit might include: a small flashlight, various tapes (black photo, white, double-sided), a plug-in electrical circuit tester, work gloves, dual timers/clock for timing Polaroids, and various hand tools.

The A.S.H.: This is an *Adjustable Sense of Humor* that can be set to fit each photographer's personality. Don't forget to bring it.

Safety

Think. Don't run around impulsively. Move carefully and decisively. Protect equipment from theft and damage. Use downtime to repair, organize, restock, check cords, and clean up the set. Protect against trip hazards, such as cords, stands, or wires. There are certain ways to set up stands and hang cords. Your carelessness could be quite expensive to the photographer.

Skills/Technical

Be alert to what is happening or is not happening with the equipment. Be attentive to sync cords, recycle times, strobes firing, gels, reflectors, stands, props. Watch that slaves don't get blocked. Notice where gear comes from and put it back in the same place, the same way. Keep equipment clean and organized. Put things back in cases instead of around the set so they are less likely to get lost.

The following advanced skills are things to consider only if the photographer has requested your added participation. Never touch the camera unless instructed to do so.

For 35mm—check that shutter speed is not too fast for sync. For medium/large format—pull dark slide, check that sync cord is connected. Make sure the f-stop and shutter speed are correct for the film being used. Be able to load various formats of film.

Cameras differ and a photographer can review any peculiarities of his equipment. If you have to be taught, don't expect to be paid full rate. Count shots and be ready for roll changes. Put roll numbers on the film and keep the Polaroids in one place. Keep track of exposures and pertinent technical data, model releases, materials used as required by the photographer. Make sure all cameras are unloaded at the end of the shoot (double check that they are rewound before opening the back).

Never shoot while the photographer is shooting, unless you're requested to do so.

Business

Keep track of all receipts and reimbursable expenses to include with the invoice—mileage, tips, and similar expenses—and make sure they are legible.

Have your invoice ready to present at end of the shoot. Include on the invoice the following: client name, shoot date, your address, telephone number, and Social Security number. (Some photographers will ask to have your invoice mailed or faxed to them within a specific time frame. Omission of this information will delay your payment.)

Practice confidentiality when it comes to clients and photographers. Gossip is for busybodies, not professional assistants.

Ask for the photographer's business card. It helps to have contact information (for a variety of reasons) and can give you ideas when you begin to look at designing your own stationery.

Finally

This is vital: Always remember that you were hired by the photographer to assist. You were not hired to promote yourself, tell the client how you would do a shot, or discuss money matters around the client or the art director.

Chapter 2

The Business of Stock Photography

Andrew Berger, James Cavanaugh, James Cook, Victor S. Perlman, Esq., Peter Skinner,
Richard Steedman, Susan Turnau, and Richard Weisgrau.

Simply stated, stock photography is existing photography: that which is available for licensing from photographers or their agencies for specific uses. Buyers who see what they want in catalogs—print or electronic—or from submissions they have requested, have the advantage of knowing what they are getting. From that aspect it is risk-free photography for buyers, or licensors. For photographers, however, stock photography is not risk free. It involves investing time and money in planning, creating, editing, inventorying, and marketing images that might never sell. Elsewhere we will examine what it takes to get into and produce stock. At this juncture photographers should be aware that while stock photography offers the attraction of freedom from shooting to the specific needs and deadlines of assignments, it is fiercely competitive and has been made more so by the advent of royalty-free images whose quality has increased.

Under the impact of television, many mass-market picture magazines lost readership in the late 1960s. Photographers found new and burgeoning markets created by smaller circulation, special interest publications, and today there are probably more magazine titles in bookstands than ever before. Additionally, the Internet has created another huge and expanding global market. Other markets include textbook publishers, poster and greeting card publishers, and other paper product companies.

Creatives are increasingly turning to stock images to cope with the pressures of time and budget. Common uses of stock are sales promotion/collateral /brochures, followed by advertising, direct mail, annual reports and corporate literature, point of purchase displays and exhibits, presentations, comps, packaging/covers, Internet/CD-ROM/multimedia, and editorial/publication design.

Today, most users of stock are in tune with electronic technology and an increasing

number are using a digital method for search, selection, and/or delivery of stock visu-
als. However, while digital selection and delivery is gaining wider and accelerating
acceptance, many buyers still prefer the traditional print catalogs and other print mate-
rial to find stock images. Regardless of how the photographs are found, demand for
stock images is high and many buyers like the versatility and convenience of stock.

Photographers involved in stock photography, or who are hoping to enter this field,
should be aware that while markets are there, creative talent and prolific production
alone are no guarantees of success in this business. The successful stock photographer
is invariably a good business person, one who understands what makes a salable stock
photograph and how to create that image, and who possesses the marketing acumen to
get images into the most lucrative marketplace. The business is not for the faint of heart.
It is fraught with risk, demands hard work, and requires an acute perception of visual
communications and trends.

There are optimistic people who are emphatic that smart photographers capable of
fulfilling market demands and providing excellent service to clients and agents face
limitless opportunity and rewards. There are others, many of whom are veterans of the
industry, who warn that stock photography no longer offers the future that it once did.
In their view, the major adverse factor is the consolidation of the industry—the
"merger/acquisition mania"—that put millions of stock images under the control of two
major entities, Corbis and Getty Images. They do not dispute the growth of the stock,
nor the huge revenues being generated. Their contention is that the revenues, and prof-
its, are not benefiting photographers as much as they are the agencies and their share-
holders.

The growth of the industry, the proliferation of photographers eager to capitalize on
new and seemingly insatiable markets, unprecedented consolidation and acquisition of
agencies by huge conglomerates, the enormous influence of the Internet and worldwide
electronic marketing and sales, and the streamlining of delivery systems have taken
stock to new levels of sophistication. This success has both strengthened stock's posi-
tion as an industry and diluted many individual photographers' revenues. There is an
oversupply of photographers working in stock. But industry experts say that surpris-
ingly few, perhaps only several hundred, photographers supply a large percentage of all
stock worldwide. The message is pretty clear: The opportunities are increasing if you
shoot the right subjects and have the right marketing and delivery systems.

Photographers maintain that CD-ROM clip art has affected the generic subject mar-
ket to such an extent that only model-released people are worth spending production
funds on photographing. This in turn will, they say, create an oversupply of released
people. Some stock specialists are turning to creating digital products to augment their
stock, and many, even those who shot nothing but stock for years, have gone back to
seeking assignments.

New technologies, a proliferation of new print media, the overall strength of the U.S.
economy and the increase in advertising revenues have all contributed to a huge demand
for images. Optimists predict the multimedia market will make up in volume for the
drop in price per image, and photographers capable of creating powerful pictures with
style and flair will command top prices.

A huge impact on stock—and communications generally—has been made by the advent of the Internet. Internet marketing, sales, and delivery systems, and the rapidly increasing use of World Wide Web pages by photographers, are having an enormous effect—and creating greater potential—on the industry. (More on this, how to develop a presence on the Internet, and copyright and pricing issues will be discussed elsewhere in this book.)

Industry authorities also say that while the complexion of stock has changed, developments of several years ago continue and new ones have emerged. These include:

- Greatly increased quality. This has never been more true. Buyers maintain that the quality of stock is very high: The variety is so wide and diversified that virtually every picture they need can be found in stock. This is not surprising considering the caliber of photographers whose work is available as stock.

- In the past stock photography was essentially a numbers game. The more images you had out there, the more revenue they would generate. While this might still be true, the current market demands greater emphasis on the quality of images as distinct from sheer quantity. In other words, it is better to have 100 great images in the market than 1,000 average images.

- Increased market. In addition to the traditional markets, the new technologies have created many more markets and, according to industry pundits, their demand for images will be huge. Agencies have become more aggressive in reaching these markets and competition is driving their efforts. Additionally, there is a growing number of niche markets, special interest publications, and short-run publishing ventures, all of which need images.

- New marketing techniques. These are more sophisticated and while most agents say that traditional methods of print catalogs, source books, and direct mail are essential, new channels of communication, such as faxes, CD-ROM, online services, and the Internet are providing access to potential buyers on a larger and increasing scale.

- The consolidation of agencies has led to the emergence of smaller, boutique agencies and groups of photographers establishing their own agencies or cooperatives. These smaller agencies, who can carve niche markets and service them quickly, can profit from the larger agencies' concentration on mass markets with high volume sales.

- Many photographers are increasing their efforts at selling their own work. The advent of CD-ROM catalogs and print catalogs for individual photographers, as distinct from catalogs for agencies, has provided photographers with other avenues for selling their own work. Also, increasingly, photographers are marketing via the Internet. Individuals' Web sites are becoming more professional, comprehensive, and user-friendly. Their potential increases as buyers become more conversant and at ease with searching via the Internet.

- Increased competition. Long gone are the days when stock comprised primarily of assignment outtakes. Thousands of photographers are trying to cash in on stock and the field is overcrowded.

- Established agencies are harder to get into. This is even more so with the con-

solidation of agencies. Many agencies are severing ties with large numbers of photographers and returning their work. Many of these larger agencies, and other agencies as well, have set limits to the number of photographers they will represent. However, there are still openings for photographers who are willing to shoot high-quality, well-targeted images with a fresh, different look.

- More agencies are requiring exclusive contracts. While this posed a problem for photographers in the late 1980s and early '90s, many of the top stock producers now have no qualms about going exclusively with one agency. Agencies cite the need to provide buyers with rights to an exclusive usage and the wish to avoid conflicts and legal problems. Also, agencies invest heavily in market research, which they share with their photographers and don't want this information to benefit other agencies.

- Production stock is replacing assignment outtakes. Many of the top stock photographers create productions and, with them, all the detail and logistics that go into a major shoot. They hire models, set builders, designers, and stylists.

- Another trend is that of large agencies using their own in-house staff photographers to create stock, which is not only owned by the agency but also competes with the photographers that the agency represents. This has posed the dilemma of freelance photographers finding themselves in competition with in-house–produced images created by the very agencies that are supposed to be representing these freelancers.

- The advent of CD-ROM clip art photography. The proliferation of the clip art disk continues, and many agencies that once decried its presence are now competing in this market. Photographers claim, and justifiably so, that clip art has eroded the market for generic stock—sunsets, clouds, travel, and the like. However, others say that despite initial fears about clip art disks damaging the stock industry, they appear to have filled demands of low-end markets and in fact might have steered nonstock buyers toward traditional stock when the quality of clip art photography did not meet their needs. There are photographers who maintain that their own efforts in clip art have been profitable and claim that its emergence has created new markets for their work.

Clip art disks have been a catalyst and, as one agent said, are "giving us a wake-up call, making us more aware that we have to produce better, more exciting images to stay ahead of what's available on clip disks." Conversely, many individual photographers are emphatic that the emergence of CD-ROM clip art has damaged their sales. As the quality of unrestricted material on CD-ROMs rises, there could be greater adverse effects on stock photography.

Stock veterans maintain that while they don't like the advent of CD-ROM clip art disks, their advice is, "Don't get involved with them, but get used to them, and make your work better than what's available as clip art." There is also the feeling that top-end buyers want their product to look different, and clip art will eventually all look the same. ASMP has advised photographers to avoid licensing all rights for clip art disks. But, there are photographers who have turned to clip art and say it has been a profitable

venture. The question that ASMP asks of these photographers is, "At what expense to the rest of the industry and their colleagues?"

In the last few years, the entire stock industry has undergone dramatic change. The growth and development of the stock picture business, which provided photographers with significant and surprisingly consistent income from their pictures, seem to be no longer. Whereas once, and even during recession periods, stock usage grew and most photographers saw little drastic downturns in their stock income, the world is a lot different now. No longer is it "gravy" or found money.

In a nutshell, stock is no longer an "on-the-side" business for photographers who want to make serious money. It is competitive, complex, and what was once traditional and acceptable stock might now be past, and more in the domain of the CD-ROM clip art market.

There are still many photographers for whom stock is an adjunct to their assignments and many photographers have stock as a significant and sometimes major part of their business. At the top of the stock tree are those who shoot it exclusively, treating stock shoots as assignments with all the attendant logistics and budgets. But an increasing number of former specialists are either dropping out of the business or returning to assignments. Huge drops in stock revenues—by as much as 40 percent or more—have been reported to ASMP and as the trend to consolidation continues, this could continue as well. A Chinese adage states: "May you live in interesting times." Stock photographers do!

Photographers are feeling the pressure from agencies to sign exclusive contracts; some photographers who have several agencies and also market their own stock have faced contract termination for not acceding to the demands of agencies that want exclusivity. Also, the trend of larger agencies acquiring smaller ones has resulted in photographers being subjected to the contractual requirements of the parent agency. Agency acquisition and control of content have become a major factor, with millions of dollars being spent in those areas.

ASMP's advice is that photographers should realize just how valuable their copyright is and retain control of their work and the rights that go with copyright ownership. It is no coincidence that millions of dollars are being spent by companies to acquire and control copyrights. So, there seems little doubt that stock photography as an industry will prosper. The main question is: How will individual photographers fare?

Several years ago an agent summed up what was needed to succeed in stock photography: brains, talent, hard work, and a business plan. That is still true. Also true is one other fact: To make big money, you have to shoot pictures that are great pictures. The markets are growing, as is the competition. It's possible to make a good living from shooting stock but not without a lot of hard, smart, and focused work backed up by sound business principles.

The following perspective on stock photography by Tonawanda, New York, photographer Jim Cavanaugh casts lights on the industry.

Future Stock—We know about the past; what's ahead?

by James Cavanaugh

When stock photography exploded in the 1980s and more photographers began producing stock pictures to capitalize on this market, the influx of huge numbers of images created a radical change in the entire field. For the first time, supply began to exceed demand. Stock agents, who began to see strong competition, had to look for ways to set themselves apart from the competition. One of their first strategies was the publication of stock catalogs. This brilliant marketing tool placed thousands of images from a stock agency on buyers' desks and allowed them to select images and get approval without having to request a submission from the agent. The agencies that used catalogs quickly found that a disproportionate percentage of their sales, in some cases as high as 80 percent, came from their catalogs. It was obvious that, to compete, agencies had to produce catalogs.

However, these catalogs presented several problems. For one thing, they were expensive to produce and distribute. The agencies solved that problem by shifting the cost burden to photographers. They began to assess photographers a catalog fee for each image that was included. These fees could be as high as $300 per image. They rationalized to the photographers that this fee was minimal, since the catalogs were responsible for a much higher percentage of the total sales. They assured photographers they "would get their money back." And, after all, they did not have to pay the money up front. It would simply be deducted from future sales!

The second problem was that images similar to those that appeared in the catalog may be at competing agencies. This was because many early stock photographers probably were represented by several agencies. The solution was to start the process of having photographers sign exclusive contracts.

This sent shock waves through the stock industry. Photographers were upset, but most stock agents followed the trend and demanded exclusivity. While a number of high profile photographers were not forced to give up multiple agency representation, new photographers had no choice. The majority of photographers who were with agencies were also given no choice when their contracts came up for renewal.

It was ironic that the agents could represent whomever they wanted but the photographers could not have the right to retain multiple representatives. The reason given was that the stock agents had to protect their client's exclusivity to a license. But one must ask, "What about protecting the photographer?"

Various forms of exclusive licensing rights were often granted without any consultation with the photographer. In many cases the stock agents would cut off potential future income from a photographer's image without consulting him.

By the early 1990s, the marketplace had become saturated with images. Supply clearly exceeded demand. Yet, spurred on by the success stories touted by stock agents and their star photographers at major seminars and in the trade press, photographers continued to produce stock images at a record pace.

To stay competitive, stock agents pushed photographers to continually increase the production value of their stock photographs. Professional models, big sets, stylists,

location scouts, props, even the hiring of an art director, were being demanded by the large agencies. Nothing short of a full-scale advertising production seemed acceptable. Some photographers were spending tens of thousands of dollars on a single stock assignment.

Escalating production costs and much tighter editing by agencies combined to produce the situation where stock photographers were spending more to create images but fewer were getting into agency files or into catalogs. And with so many images out there, it became a buyers' market, with a downward spiral of prices.

It also became harder for new photographers to get into agencies; as a result, there was a huge supply of images looking for a market. This had a tremendous impact—mainly adverse—creating thousands of royalty-free images, commonly referred to as clip art.

With the advent of CD-ROM drives on computers, and easy-to-use and widely available graphics software, the stage was set. The bait offered by clip art companies to photographers was money up front and a royalty on additional sales. In return, photographers would let their images be sold on royalty-free disks.

Objections by the photographers who said they did not want their images used for any reason without an appropriate fee were addressed through assurances from the clip art companies that the new market would consist of "low-end" users. The images would not be used in any important way. They also told the photographers they would not lose traditional assignment or stock sales to clip art because these low-end users are the ones that could not afford stock or assignment photography in the first place. That, as it turned out, was not true!

The clip art companies began waving cash in front of photographers to entice them to produce images for the royalty-free market.

Clip art frightened stock agents and they all got together to denounce it as the doom of the stock photography business. Then, they immediately cut their prices even more to compete with this new threat.

Within a year, stock agents begin to make statements such as "You cannot expect to be in the stock business for the long haul and not deal with clip art on some level." One by one, the stock agents began to offer clip art as "a small part of the mix." In just a few short years, clip art has changed the landscape forever. Disgruntled former agency photographers or new photographers looking to get a quick return poured images into the clip art producer's products. They looked at the short-term gain and not the expense of the long-term consequences. Many photographers, who were still with agencies, gave in to agency clip art products to boost sagging sales returns.

Stock agents rationalized that photographers did not care if they got $1,000 from one sale or $1 each for a thousand sales. They are wrong. We do care! And I question whether photographers have received $1 each from a thousand sales.

Clip art has also changed stock photography in a more fundamental way. Many buyers now perceive photography simply as a commodity that they can buy from a direct mail catalog or even online. There is a sense among a growing number of buyers that all photography should be, or already is, royalty free! This is especially true of young art directors and corporate marketing people. These are the buyers who are establish-

ing the "practices of the trade" for our future.

Stock agents, not wanting to be left out in the cold, have gone deeper and deeper into clip art. Clip art has also followed the same formula that stock agents followed in the 1980s to gain market share: Provide better quality images and cut the price. It is a successful market strategy, and the use of clip art continues to grow at a stunning pace.

Stock agents still try to hang on. The only weapon they have left is to cut their prices even more, go deeper into clip art, and try to get any part of the market they can. As prices continue to go down, costs must also go down. Again, the burden is placed on the photographer. A number of agencies have presented new contracts to photographers that have cut the split they give to photographers to 40 percent of net fees. Today, the average stock photographer receives only about 30 percent of his actual license fees. Plus, photographers pay all their own production costs.

As prices have fallen and competition has increased from clip art, many agencies have not been able to hang on. Now, a handful of "mega agencies" are on an insatiable acquisition binge. Even the large, well-established stock agencies are being taken over.

The mega agencies have found new ways to cut costs. Several of the giants are hiring staff photographers to produce stock. This way, the agency owns the images and has no future commissions to pay. The giants have also been busy buying the entire life collections of photographers, historical collections, and estate collections—again with the single goal in mind: If they own it, they don't have to pay any future commissions.

It has also been reported that at least one large agency is hiring staff photographers to replicate the style, or even some of the specific images, of some of the agency's largest traditional producers. With these work for hire "image clones," they no longer have to send out the traditional producers' work on submissions or in catalogs. This way, they keep the entire fee and no longer have to pay the traditional photographer.

What is driving this? Some of the big and major agencies are now publicly held companies. Unlike the photographer-owned stock agencies of the past, these public corporations answer to their shareholders. Their shareholders are concerned with only one thing—return on investment. They are not concerned about the financial status or security of the photographers. They only want to beat the stock market index.

Does all this spell an end to the career of photographers? It may! However, I don't think so. But things must change. Photographers and other content providers must take back control and make significant changes today.

The copyright laws of the United States and many other nations place the ultimate control of intellectual property directly in the hands of the original creator. We do have the final say on how, when, and where our photographs are used and for how much.

The quandary still exists in matching sellers and buyers. The answer, I believe, lies in technology. We are keenly aware of the quantum advances in computer power, Internet and Intranet technology, and increasing communications bandwidth that now allows anyone with a computer to be instantaneously connected with anyone else with a computer anywhere in the world.

The technology in our hands today is remarkable compared to what we had in 1995. However, it is primitive compared to what we will have in 2005. But how will this help photographers and buyers get together?

With today's technology, it is easy for a photographer to have a Web site with hundreds or even thousands of her images available online and accessible to buyers. The trick is pointing buyers to your site or having them find your site by using Web search engines. It is disconcerting, however, when you initiate a search and Yahoo tells you that it has found 127,000 matches!

While it is possible to match buyers and sellers on the Web today, it is not easy. Bandwidth is improving, but still slow for most. However, I am confident that technology will solve these problems with rapidly increasing telecommunications speed, along with the dawn of sophisticated search software that searches the Web for images rather than text.

These solutions are in the future. However, there is an answer available today: collective rights licensing. ASMP fully supports any and all collective rights licensing and established a collective rights licensing program, the Media Photographers' Copyright Agency, MP©A, which emerged as an attractive alternative for photographers. MP©A members marketed and licensed their work on the Internet through the Media Image Resource Alliance, MIRA, which is now owned by the recently-founded photographers' and illustrators' cooperative, Creative Eye.

To benefit from collective rights licensing programs, photographers must keep control of their images. We must keep the market from being flooded. We must control the value of our own work.

We must keep our images out of the hands of clip art companies and clip art stock agencies. To survive, they need content; without content, they will be gone. The only way they can get the content they need is if we photographers give it to them. If we let them have our images, we lose control of our destiny and our opportunity in this new marketplace.

Keep in mind that the demand for images has never been higher. There is abundant opportunity. However, to profit from this opportunity, we must take back and keep control of our images and work with collective rights licensing organizations. If we do these things we will have a bright future. ASMP stands ready to help

Getting into Stock

A word of warning: Competition in stock photography is fierce and getting more so. The consolidation of the industry has changed the face of stock photography forever. This is not a field for the faint-hearted or, if you want to really succeed, for photographers not willing to make a commitment. On the surface, stock photography sounds like the ultimate in photographic freedom. Travel, photograph what you want, when you want, no clients to satisfy, no art director dictating the parameters of the shoot, deliver your images to your agent, and the money rolls in. Sound easy? Perhaps. And there are some photographers—very few—to whom the above description might apply.

Those who are successful stock specialists would probably be among the first to concur that stock does have innumerable advantages and benefits. But for the majority, the

harsh realities of stock photography are vastly different, and no photographer who ventures into this field should have illusions regarding just how competitive it is, or how expensive it can be to be competitive. And it is expensive to get into stock.

Photographers established in other fields but who want to expand into stock have an edge in this area; they have covered the initial investment in equipment and have the technical skills. Also, practitioners who market stock as an adjunct to assignments also have a decided advantage. But even veteran photographers who specialize in stock are quick to point out that it takes constant work to stay competitive. Consider the analogy of a steam locomotive: It takes a huge amount of energy to get started and you've got to keep stoking the boiler to keep it going. "The markets are changing all the time, trends come and go, and there are so many more photographers wanting to capitalize on stock. Even though there are new marketing opportunities and sales are up, there are so many people trying to get a slice of the pie. "It's harder now than before and to be successful you really have to be committed and shoot smart," said one photographer who shoots stock exclusively and is represented by one major agency.

Some authorities point out that, even on a tight budget, the serious stock professional cannot survive on less than $50,000 a year; $100,000 is a more practical figure to aim for. To generate $100,000 in stock annually could require an initial investment of well over $100,000, and probably closer to $200,000.

It will cost even the best photographer thousands of dollars to buy into stock. Consider this: The best producers struggle for at least five years, sacrificing two or more days a week for stock, plus every extra dime their assignment work makes them.

Photographers should be very critical and analytical about what it costs them to produce stock. Because most are "part timers," they probably don't have a realistic financial picture of their stock photography. The occasional check is nice, but does their stock make a true profit?

Casual stock photographers rapidly fill the travel, scenic, and other generic files that age slowly, and much of the content in those areas is now the domain of high-quality clip art. Dedicated stock producers work primarily in subjects that are more of the moment, such as released people, technology, and skylines. While the generic files are being filled by the casual shooters, or have been replaced by royalty-free images, the serious producers have to keep reinvesting to stay ahead.

The rewards are there for photographers who approach stock as a business venture that needs a business plan, a good product, and a marketing strategy, whether that be through an agency exclusively, a combination of being with an agency(ies) and selling their own work, or selling their own work.

While many aspects of stock have changed, there are also many constants reflected in the following general comments from people in the industry. These should help provide insight into the potential and pitfalls and might help photographers weigh their situation before making the decision on whether stock, in some form or other, is for them.

- Success depends on producing stock consistently. Set self-assignments, week in and week out. Assign yourself and keep doing it.
- My cost for a production can range from $1,000 to $5,000. If, from a production, I get ten good images that sell consistently for say, three years, I can get three or

four times the investment of the shoot. After producing like this, week after week, sales become significant.

- Agencies are always in need of new talent, people who can photograph in new and refreshing ways. But it is harder for photographers to get into established agencies unless they can bring in something new. Most agency files are full of the timeless, generic subjects and many are thinning their files of these images. The consolidation of the industry has also pushed many photographers out of the larger agencies.

- It just doesn't pay to shoot some subjects anymore—there are just too many of them—unless they are really spectacular examples of that subject (e.g., sunsets, clouds, general scenics). But pictures of something like lifestyle, with a documentary approach, are in great demand.

- Many agency files may be obsolete because they don't reflect the cultural and ethnic diversity of the United States. This does create opportunity for photographers.

- The sweeping and constant change in styles—dress, business equipment, and so on—creates a constant demand for images.

- It's going to be harder for the generalist to make a living. Much of the general, or generic, material is now available on CD-ROM clip art disks.

In other sections of this publication, the intricacies of doing business in stock are detailed and photographers interested in either getting into the field, or learning more about working in the field should read carefully the sections on working through agencies, and marketing your own stock. That information will give you a greater appreciation of what is involved. To reiterate what is stated elsewhere in this publication: Stock is not for the faint of heart nor the noncommitted. It's a tough business

Producing Stock

The making and marketing of stock photographs has grown to such a prominent role in photography today that an understanding of "stock" is essential for the professional.

A stock photograph is by definition one that already exists and is available for licensing by the copyright owner or an authorized agent.

The copyright owner of a stock photograph, under the Copyright Law of 1976, is the creator of that image, unless it was made in collaboration with others and an agreement to that effect was made in writing. The agent is generally an established stock photo library or occasionally the photographer's professional "rep." The term "to license" (the casual term used in the trade is "to sell") a stock photograph means to grant specific and limited rights to the licensee or user (the trade term is "buyer") in return for an agreed on fee ("price"). The picture remains the property of the copyright owner and, after the necessary time for use by the buyer, is returned to the stock files, where it is again available to be licensed.

The typical stock file of a photographer contains material from three primary sources: (1) photos that the photographer has financed, usually with the intention of put-

ting them on the market as stock; (2) photos generated through cooperation between the photographer and photo agency under varying financial arrangements; and (3) photos that originate as assignments and have been returned after fulfilling the original client's needs. Also, there is an increasing trend among large agencies to have work produced in-house by staff photographers under work-for-hire arrangements. Submissions to stock agencies have shown a decided shift away from assignment outtakes toward the first type: photographs produced specifically for stock.

Self-assigned photos enjoy the advantage of being custom-made expressly for the stock file. Here the photographer has the opportunity to incorporate all the qualities of subject, style, and format that go into making a superior-selling stock image. The advantage to the photographer, of course, is complete freedom of creation, but it must be weighed against the burden of working without a fee.

The subjects in assignment photos are selected for, and sometimes by, the client and are photographed in a style and format consistent with the client's purposes. The creativity and energy of the photographer are channeled to that end. It is only secondarily that these photos are later adapted to a different role—that of stock photographs. The photographer or agency selects from the existing "take" those images that will sell to stock buyers. However, as mentioned elsewhere, outtakes from assignments have decreased as a source of stock.

What Makes a Good Stock Photo?

In actual practice, a top-selling stock photo can come from either source: custom-made for stock or simply edited from an assignment. What determines its success is the photographer's understanding and awareness of what makes a good stock photograph. Certain stock images definitely sell better than others. Experienced stock agents agree that some photographers are able to produce these images more consistently than other photographers. There are photographers who simply seem to be "naturals" when it comes to pictures that sell well from a stock file, but more often their success is the result of deliberate study and knowledge of the market. There is a shift toward photographs made for stock due to their higher volume of sales. There is no single formula that can be applied to all the variations of good stock photos, but there are common ingredients. Among those qualities are the following:

Universality. The "ideal" stock photograph may well be one that shows a classic subject or concept in such a clear and graphic way that it triggers a common emotional response in the widest variety of viewers. Ideally, this message would transcend differences in age, sex, race, or ethnic background. Like a classic actor, the photograph would be capable of playing any number of roles and, as a consequence, would enjoy steady employment.

For example, a warm and intimate photograph of an attractive mother and young daughter reading a book by the soft glow of a lamp in a comfortable living room might well be used to illustrate the theme of "security" in an ad for a utility company, "education" in a direct mail brochure for an encyclopedia, "single parenting" in a magazine

article, or "togetherness" in a mural hung in the headquarters lobby of a corporation that makes fine papers for books. The photograph should carefully exclude anything—such as a distracting, eye-catching name brand—that would limit the universality of the image.

Information. The unique ability of photographs to convey accurate and believable information is a quality highly valued by stock photo buyers, such as textbook publishers as well as users outside the educational field. The adages "A picture is worth a thousand words" and "Seeing is believing" still ring true.

When the purpose of a photograph is to impart information, the camera approach should usually be straightforward and direct, with broad, even lighting and sharp, understandable details, best described as "photographic reality." Anything that distracts from the subject itself, such as an overly artistic style that shouts the presence of the photographer, interferes with the purpose and effectiveness of the image. For example, a photographer visiting the temples of Thailand might well be fascinated by the abstract patterns made by tropical vines trailing up a temple wall, but the straight shots of monks in saffron robes going about their daily routine would probably be more successful as stock pictures.

Flexibility. A stock photograph that takes into account the requirements of a wide variety of buyers has the obvious potential for repeat sales. The market for stock is diverse and expanding rapidly. Buyers such as advertising agencies and producers of annual reports appreciate the high quality of stock photos, and they may, for example, need empty space in a photo, where they can drop in a product picture, company log, or advertising copy. Photographers who keep up-to-date and follow the market automatically tend to produce images with flexibility. They also know their photos must be "released" and that they should not be readily identifiable as to location.

Technical excellence. There is no room in today's stock photo file for anything less than images of professional quality. The competition is fierce, and buyers insist on technical excellence—in lighting, exposure, and sharpness.

Many of the world's hottest photographers are making their photos available as stock and, knowing their name is on each image, guard their reputation by editing tightly. They also know that the art director buying a stock photo today could well be the same one making an assignment tomorrow. And they are aware that stock photos that receive a credit line, as in books and magazines, also become a sort of extended portfolio, leaving no place in the portfolio for technically flawed photographs.

The above qualities—universality, information, flexibility, and technical excellence—are all pretty much within the control of the photographer. There are countless photographers who can produce a successful photograph, the end result of good photographic skill, visual imagination, and personal taste. But in the commercial world of stock photography, producing a fine picture is only half the equation. The other half—and this is essential—is that the photograph must be of a subject that is wanted by buyers—the magazine editors, textbook publishers, and advertising agencies who phone in with their "want lists" of subjects they need and are willing to buy. "What sells" is primarily a factor of the market, but for the photographer interested in stock photography, it is vital.

Subjects That Sell

Producing stock images can be approached from almost opposite viewpoints. One photographer may analyze the market for stock photos and tailor images to fit this knowledge. Another photographer may be deeply involved in specialized assignments and view "stock" as a residual use of the work. For this photographer, knowledge of the market for stock photographs would be a low priority.

Stock agencies vary just as widely in their philosophies. Some agencies feel that photographers produce their strongest, and therefore most salable work, by concentrating on subjects they personally find compelling. Their attitude is that "good photographs sell." Typical of the kind of photographer who might follow this advice is the one who sets aside a week or so to do intense shooting of what he likes, in his own style, to create images that reflect his style. It might not be typical stock, but can, and often does, find its way into markets. It also provides the photographer the opportunity to shoot for himself rather than be dictated to by the commercial requirements of stock. Be warned, though: There are few photographers with the talent and style to make a success of this approach. Other agencies are continually advising their photographers about what photo subjects potential buyers are requesting. The assumption is that the photographers are willing to shoot specifically for the market. There is no right or wrong, but the photographer who is intrigued with the concept of stock photographs and is exploring ways to fit stock photography into his or her career will almost always have a corresponding interest in what sells.

"What should I shoot—what topics will sell?" used to be the first question asked by a photographer entering the stock business. Stock has reached a level of sophistication where it is no longer enough to ask what to shoot and expect a list of sure-fire, money-making answers. Trends change fast. Today, more than ever, it is essential for the photographer to research the market and know what's happening. You must keep current on trends in business, society, and the world. Clues to changing trends are all around you—in news magazines, in business journals, on television, on the Internet, and even in the streets.

Concept. Subject matter is only one, relatively unimportant, aspect of a photograph—concept may be the most important, according to some industry experts. When shooting for stock, figure out what idea you want to convey, what thought or emotion the photograph might symbolize. Relationships among people are very important to the message of the photograph. What can you convey by their gestures? Intimacy, power, caring, anxiety?

Watch the style of what's being published. You need to know the ways in which to shoot as well as the subjects themselves. If you're interested in selling to the advertising market, collect current ads and analyze the photographs used. Understand the lighting style, use of color, and look of the models. Watch what's "hot" in television advertising. But a word of caution: Don't try to duplicate these images as they appear, or you will be guilty of copyright infringement. Instead, come up with a new interpretation of the concept in your own style.

Be aware that information on what sells can also steer you down the wrong path.

Learning that model-released people pictures generate the most money might tempt you into thinking that your best opportunities lie there. What you might not know is that you would be competing with some of the top photo-illustrators in the business, photographers who have been doing this type of stylized assignment work for years. And this style might not be natural to you. Be true to yourself. Don't ask what's the most lucrative area. Ask what it is that you do best, what excites you.

With current trends, find the area where your style is most applicable and create concepts that you want to communicate. Then consider the actual subject that will convey the concept. Remember: concept first, then subject matter.

The market for stock photos, ranging from typical family situations to the exotic or erotic, seems to be almost unlimited. To get just an inkling of its breadth, study the magazines in the periodical room of a public library, leaf through a current set of encyclopedias, or examine the photos used on packages in a supermarket or drugstore, and ask yourself if these photos might have come from someone's stock file. Or, for a preview of what you will see in the immediate future, read the "want lists" that come into the stock agencies: "people taking inventory in a health food store," "a horizontal color of a small-town scene with a lonely dog," "a haunted house," "sonar equipment," "Las Vegas at night," "released camping scene using a pyramidal-shaped tent," "pretty girl rowing on still water," or "classic American doorways."

The market for stock photographs is indeed diverse and at times delightfully unpredictable. Keep in mind that royalty-free images on CD-ROM disks have cut huge swathes into the generic scenic and other traditional markets including one of the long-standing major fields—travel. And the quality of RF has increased dramatically, so it's no longer a poor relative of traditional stock. This does not mean that there is not constant demand for images that will command good prices and one still hears stories of photographers making lucrative sales from such generic subjects as a deserted tropical beach, a sunset, or a telephoto image of a full moon. But, those instances are getting rarer and veterans say that, to be successful, stock photographers must break out of the mold, and this advice truly applies to travel photography.

While advertising does offer better prices, don't overlook the potential of the editorial market, which is diverse. Images that sell in this broad market can range from sports and politics to recreation, environmental issues, tourism subjects (people and places), and people doing things. Pictures of model-released people always have great sales potential, and these images can fall into the more lucrative advertising market, but you will be competing against the best shooters in the industry if you go after this market.

While the following categories are in demand, one of the best ways to judge what to photograph is to ask your agency for their want lists. Listen to what your agency suggests and then photograph subjects that interest you. That, in a nutshell, is the simple route to shooting success.

People. The emphasis here is on human relationships—people relating to each other, to their environment, or directly to the viewer. As human beings, we are intensely interested in other people, and the most successful of these pictures will prompt an immediate recognition and emotional response from the viewer.

The "people" pictures most in demand show everyday situations, which,

strangely enough, are often overlooked. Stock agents consistently report that good, current, model-released people pictures are in short supply.

Family. These are people pictures made in such a way that the viewer automatically assumes the subjects are members of the same family. There is a demand for both the pleasant and the stressful and for all nationalities and ethnic backgrounds.

School and education. This subject category not only consists of structured classroom and campus situations from elementary school through and beyond college, but also includes informal learning in the home, playground, or museum.

Careers. This overlaps with industrial subjects but emphasizes the people who work in occupations and professions ranging from medical/scientific, to marketing and media, to banking and government. In this field, health care and care for the aged, medical and dental professionals and their patients are also important subjects that are constantly in demand.

Leisure time. Upbeat photographs of the many ways we use our discretionary time and spend our discretionary income are in constant demand. Pictures of the world at play are used in magazines to report on current interests and lifestyles and in the commercial market to sell products related to a leisure activity. "Photographs of people enjoying themselves," is how one agency editor described her needs.

Industrial. This category can be thought of as pictures of the world at work—manufacturing, building, harvesting, servicing. As stock, industrial pictures are most salable if they are generic rather than specific to either a location or a corporation; for example, a dramatic picture of blast furnaces will be usable to more buyers if it reads as "heavy industry U.S.A.," rather than "U.S. Steel, Pittsburgh." The assembly line at a particular computer plant in California might be photographed so it symbolizes all "high-tech manufacturing," thereby expanding the market for the photo beyond that particular company.

Also in heavy demand in the industrial category are pictures of people at work: engineers, safety directors, and industrial scientists, as well as farmers, fishermen, and heavy-equipment operators. These pictures, too, should lean toward the symbolic and, of course, be model-released.

Sports. This is yet another subject category where the stock photo is used to project a message other than the sport itself. Sunday's newspaper sports section may show the winners of Saturday's sporting events, but on Monday stock photo buyers want sports pictures because they can graphically illustrate themes such as "fast start," power, speed, grace, teamwork, endurance, elation, risk. Thanks to television, people of all ages and economic classes are knowledgeable, even expert, on sports they have never played or even seen live. Sports appeal to all elements of society, and images of sports have become something of a universal language. Stock photographers who realize the thematic possibilities will not limit themselves to pictures of winners. Established professionals in this field can make good money by licensing images of sports personalities to the subjects' sponsors. The advantage of this approach is that the sponsors invariably will have their endorsees' releases and

permissions as part of their contracts.

Travel. Travel photos, especially candid shots of indigenous people, are still in demand. A picture showing the dress of the women in Madras, India, for example, might be needed for a book on clothing fashions, or an airline advertising its new service to Chicago might want a dramatic view of the city's skyline (and don't forget that city skylines change as new buildings sprout). These are expected uses, but travel images are also frequently used to symbolize mystery and adventure or perhaps the well-deserved good life for retirees. They can be used for their explicit subject content or the dreams they conjure up in the viewer's imagination. Classic images of New York, Paris, the South Sea islands, or the ruins of Greece have obvious use as illustrations of appealing travel destinations, but they can also be used to provoke an emotion.

For buyers of travel photos, it makes good economic sense to seek out stock images. Unfortunately for many travel photographers, this often means buyers turn to royalty free as their source of more common subjects. Some agencies are trimming down their travel files and are not taking new submissions unless they are of specifically sought subjects. However, buyers in this market know that financing an assignment to another country or even just another state can be extremely expensive, especially when only a single photo or a limited number of photos is going to be used. The high cost of travel—plus the fact that even when you are on location outstanding travel photographs are dependent on weather, seasons, and other elements of chance—makes stock files the source of first choice.

At the same time, travel photographs are the category in largest supply— almost every photographer visiting Paris makes a version of the Eiffel Tower. An art director needing this subject can make a few phone calls and within a day or two be able to select from a hundred different angles under almost every weather condition, and many are probably available on royalty-free disks.

Backgrounds. In packaging and advertising especially, there is a constant demand for mood-setting background photographs against which product pictures and printed copy can be displayed. These pictures—sunsets, oceans, rolling mountains, fields of wildflowers—are like background music in that they create a mood but don't compete with the main message, the product. The proliferation of CD-ROM clip art disks has affected the generic image market and backgrounds definitely fall into this category. However, photographers continue to report sales in this area, but it's not a market that experts advise new photographers to spend a lot of time on.

Fads and trends. These pictures are of the latest fashions, activities, or ideas to capture the imagination of the public. The C.B. radios of the past, for example, have given way to the cellular phones, laptop and handheld computers of the present. The photographer who is interested in and sensitive to the passing fancies of society has to be nimble in getting photos into the stock picture pipeline while interest is on the rise.

The above list of popular stock photo subjects is informative and interesting as a guide, but it must be remembered that it is only a summary of the total market

of hundreds of thousands of sales by thousands of photographers annually. At best, the individual photographer is capable of supplying only a very small percentage of this total. To be successful, you don't have to follow the market. You can, and probably should, stick with the photo subjects that interest you most.

Future trends. In planning stock shooting, it is important to consider future trends that will affect social and economic aspects of our society. These changes will influence the need for and selection of stock photographic subject matter. To be able to project, even in a general way, changes in demographics, trends, and markets is a valuable boost to any stock producer.

For example, the population of people aged over fifty has risen dramatically. This should translate into an increased demand for good stock photographs of people in that age category. At the same time, the country is going through a mini-baby boom, with a growing population of children. The young adult as the ideal market target is giving way to the child and the elder. Obviously, as products and services are created to reach this expanding consumer market, there will be a corresponding demand for good stock photographs of appropriate subjects.

Studies of demographics can be used to project future trends in geographic population density and may therefore help in predicting which type of regional environment will be a popular subject in the future. For example, if the population of reclaimed desert areas is growing at a significant rate, then it may be wise to add photographs of that environment to your file.

Photographs of ethnic diversity are increasing in demand. Demographics of the United States have changed the situation dramatically. For instance, the number of different languages spoken in this country—more than 100 in New York, and about 60 in New Jersey alone—indicate the cultural mix of people who read magazines published in languages other than English and who watch TV broadcast in those same different languages. This indicates that photographs of people with different ethnic backgrounds—either alone or in a mixed race environment or multi-ethnic families—will be in demand.

Other subjects that agents seek constantly are alternative lifestyles, such as gay couples and families; middle-aged people; and people of all ages using computers and accessing the Internet. Technology is changing at a faster rate than ever before, and the demand for photographs of users of the new technologies will probably increase. Whether you photograph technology directly as your subject or use it as background material, thus saying "up to date," an awareness of the current and future popular technologies is important.

Projecting future trends is not always so simple. But information on demographics and age distribution is easily obtained through government and academic reports. Newspapers, news magazines, scientific journals, and business and literary magazines can also be meaningful keys to shooting for the future. An informed photographer stays current, which adds greatly to the value of his or her stock file. If you have a subject in mind, contact your editor and ask for her opinion.

Shooting for Stock

Learning not just which subjects sell but how to shoot for stock may be the most critical aspect of the process for today's stock photographer to consider. Many photographers whose major stock experience has been in channeling assignment outtakes to their agencies have a transition to make if they wish to maintain a competitive edge in today's market. They need to understand what's involved in shooting just for stock and to develop their own style for doing so.

A commitment to excellence is one ingredient for success. Assignment shooters starting to produce stock on their own sometimes fail to realize that anything less than an all-out effort will cripple their ability to succeed.

The debate about shooting for stock is endless. Some maintain that shooting just for stock, with only the dollar value in mind, can be deadening to the photographs produced. These people bemoan the sausage-factory mentality that turns photographs into a product. Others, who promote stock production as the wave of the future, state that shooting for stock can be challenging and even more demanding of the photographer's creativity and intellect than assignment photography—that it can produce imaginative, lively, and salable photographs.

Speak with any agency and you will be told that there is constant demand for fresh imagery that exudes a new approach to old subject matter. The answer seems to be to choose for yourself among the touted best-selling concepts (or the advice given by your agency) to find subjects that excite you visually and intellectually. By creating stock as if it were a portfolio piece, you can accomplish both goals.

Many photo agents state that what they are looking for, in addition to talent, is the photographer's brain; they seek intelligent, aware photographers who watch the market trends. They advise that if you plan to produce stock, first "think" stock. Understand the needs of the market, use the most current research, and analyze the current successful stock seen in ads, brochures, and magazines.

It can be useful to study a particular photo and, by decoding its message, learn what made it successful. Be careful not to be too strongly influenced by the actual execution of a photograph or of inadvertently "copying" it. You could be open to charges of copyright infringement if you make a version that is substantially similar to the original. Assignment photographers are aware that they may not replicate a photograph in an art director's layout for the same reasons. Besides running into ethical and legal questions, the photographer who does derivative work is also shortchanging his or her own creativity. A useful exercise when analyzing a good stock photograph is to identify the concept and find a better, more imaginative way to express this concept.

Shooting and editing overlap, and knowledge of the market affects both phases of stock photography. Mental editing is a continuous process that goes on even as the photographer shoots. As you gain experience, you will develop your own insights, but there are some common maxims:

• The adage of placing empty areas in a photo, especially at the top and bottom, to allow an art director to superimpose type or product pictures effectively, is no longer universally true. It depends to a large extent on the picture. Some leading photographers

use out of focus areas in the background as "open space" design elements. The empty-area rule still has its place but for many subjects "Shoot tight!" has become the advice. Let the area of central focus carry the message.

- Whenever possible, make both horizontal and vertical views of your subject. Stock photos often have to fit preconceived layouts rather than the other way around. Vertical pictures are particularly useful. It may not be the most natural way to hold a camera, but magazines, books, and posters are usually in a vertical format.

- Whenever possible, vary the focal length of the lens, or move in and out, giving the art director a choice. The photo that "works" best in a given application is the one chosen for purchase.

- Be careful not to date the photos by dress, cars, and the like.

- Use "real" people who are attractive. Look at published images and get an idea of the people being used in them. For example, unattractive people do not sell travel destinations or some products, but weather beaten, craggy faces could be perfect for some uses.

- Keep backgrounds simple and generic, compositions straightforward and graphic.

- Always get model and property releases. They greatly expand the marketability and profitability of a stock photo.

- Make "similars" in the camera when possible; that is, shoot several identical frames. Dupes are particularly valuable in stock photography, especially if you are using several agencies in different parts of the world. Also remember that chromes are fragile and cannot survive many trips to the separator without suffering wear and tear.

In addition to creating in-camera "similars" whenever the subject lends itself, some stock photographers make lab dupes on their most salable stock. By sending out these dupes instead of originals, they hope to cut down on the problems arising from loss or damage. Scanning images for electronic transmission of images, either via modem or on disk, has become a huge part of the entire photography industry, including stock, and can replace sending dupes. It's common practice today for buyers to request that images be sent via the Internet so the originals, or any film for that matter, need never leave the photographer's studio or office.

When having dupes made, be sure to inquire about your lab's policy on copy work. Materials marked with a proper copyright notice should never be copied without proper permission but, in practice, unauthorized copies are often made. These "copies" include duplicate slides and larger duplicate transparencies, copy slides and larger copy transparencies, and copy prints made from original slides or transparencies and from various forms of flat art. Some labs are unaware of copyright law and its importance to photographers. Others know about copyright law but are reluctant to risk offending a customer by asking about permission to copy. Some professional labs will require a release to be signed by the customer authorizing the lab to copy the material and absolving it of legal responsibility if an infringement occurs. Often this "reproduction release" is that customer's first experience with copyright concerns and may cause further

inquiry into the subject. The best way to protect yourself is to make sure your lab is fully informed about copyright problems and considerations. Protecting the photographer is ultimately in the best interest of the lab. Many labs now display the common "When it's created it's copyrighted" signs and also are enforcing a policy of requiring authorization before copying a photographer's work.

The adjacent ASMP-created *Authorization to Reproduce Copyrighted Photography* can be used to give the lab permission.

Authorization to Reproduce Copyrighted Photography

Granted to: _____ (Laboratory)

As copyright owner of the photographic material described herein, I hereby authorize the above-named laboratory to reproduce the following materials:

The authorization is granted for the sole purpose of allowing the laboratory to deliver the authorized reproductions to the following client:

No reproduction rights are granted to said client by this authorization. Such rights are granted only by separate written license in accord with the terms and conditions contained therein.

_____ Signature of Copyright Owner

_____ Date

Another consideration in shooting for stock is the type of color exposure most satisfactory for reproduction. For many years film underexposed by about a one-third stop that gave rich, saturated color was preferable to an overexposed, washed-out chrome. New printing techniques, however, are raising questions about this. The "Guidelines for Photographers" put out by National Geographic Traveler magazine suggests this: "Because modern electronic scanners can produce better results for reproduction working from a lighter exposure, the longstanding tendency to go for strong shadow areas and rich color saturation with darker exposures should be abandoned. When bracketing, think over rather than under. The printed result will be much better and more satisfying to all." As more clients begin to use electronic printing methods, it will be important to rethink old preferences and determine the type of exposure most widely requested.

Breathing Life into Old Images

Most stock photographers have thousands of images in their files that have never been published. Not too long ago, those photographs probably would've stayed in those files until disposed of. But new technologies—scanners, software for image manipulation—have made it possible for photographers to create new images from elements of the old. Adding or deleting elements of an image, enhancing color, blurring, and other creative

retouching have helped resurrect old photographs and made them into marketable contemporary stock images. This is not for everyone, but for those who enjoy manipulating images on a computer, the opportunity to turn those old slides into revenue is there.

Editing Stock

Editing—eliminating unsuitable images—is a two-step procedure, one following the other. The first step—and the photographer should be decisive and ruthless here—is to discard images that are technically deficient—poorly exposed, not sharp, badly lighted. Buyers of stock photography today, more than ever, expect top professional quality.

The second editing step, which is much more subjective, is selecting those images that, in your judgment, belong in a stock file. This is especially important when editing assignment outtakes for stock. You must judge the content and composition of each photo from the viewpoint of a wide variety of buyers—editorial art director, annual report designer, or sales director of a hotel chain. You can improve your skill at editing by consciously studying stock photos that have already been used. In each case imagine yourself in the position of the art director/buyer. What were her needs? Why was this particular photo selected? What did the photographer do to produce an image that satisfied those needs?

Many, if not most, photographers are not the best editors of their own work, so it can be worthwhile to turn to professional editors for help. Paying a freelance editor to select images for your stock files—whether you intend to send them to an agency or market them yourself—can be a good investment.

Captioning

If the stock photography maxim "The more complete the caption, the more salable the picture" is true, then many photographers are guilty of limiting their income by not captioning their pictures fully. Buyers differ in the type and amount of information they need, but a single word like "Rome" or "sailing" or "grandmother" is rarely enough. Since you don't know who the eventual buyer is going to be, it stands to reason that you should caption for the type of buyer who needs the most. Generally, this is the editorial user who, in turn, is going to need a caption for the magazine, book, or newspaper.

Journalism schools teach that a well-written newspaper story always answers the questions of who, what, where, when, why, and how. Answering the same questions with your picture caption (unless the answer is self-evident from just looking at the picture) is sound advice. Put yourself in the position of various buyers and provide answers to the questions they might ask. The first question is usually "Where?" and if your files or those of your stock agency carry a lot of travel pictures, you might start with the country then narrow down to the exact location, as in United States, Texas, Midland, Lazy Cow Ranch, corral. Location is a common method of specifying picture requests and a common method by which stock photos are filed. It may also be useful to include

a "concept" title, if that's applicable. In any event, common sense will dictate what and how much information is desirable. The thing to remember is that it pays (in dollars) to do the job properly.

Photojournalists, who are old hands at providing this type of information, usually write a detailed master caption sheet as soon as they return from an assignment, using notes they have made on location and the maps, calling cards, telephone directories, brochures, and other reminders they have collected. This master caption sheet is then referred to when the time comes to write captions on photographs selected for the stock files. It is filed and available should a buyer need more or different information from that included on the mount. For a master-caption file system to operate smoothly, an accurate numbering system is necessary and particularly helpful if a chrome is returned from the separator mismounted, unmounted, or in such condition that the original caption has been destroyed or obscured.

Other photographers use a tape recorder for making in-the-field voice notes for each photograph, or series of photographs, and keep a cross-reference notebook for the counter number on the tape recorder. Obviously, when you return from a trip, it does take time going through the tape and transferring the information onto paper.

You or your agency will develop a system of labeling the photograph with such information as caption, copyright notice, agency name, file number, and model release information. Since stock photographs are usually sold as individual pictures, it is necessary to caption each individual image and each lookalike fully and completely.

These days, the best solution is to use computer-generated caption labels. There are numerous programs available that offer several lines of information front and back so there is no excuse for badly labeled slides. Computer-generated labels are a great help in saving time when multiple captions with slight variations are needed on each chrome. On the label you can include such additional information as availability of model or property releases. Also, professional labs often offer a labeling service so standard information, such as your copyright notice, year, name, address, phone and fax number can be printed onto your slide mount. Inquire if your lab has this capability.

Another reason for taking special pains with your captions is to minimize exposure to a claim of libel. Briefly, libel is injury to one's reputation. An accurate caption on a photograph is one of your best protections against such liability. If the ultimate user of the photograph changes your caption or deletes it and inserts his or her own, chances are good that the user, not you, will bear any resulting liability.

Photographers who do not think of themselves as journalists dread captioning and view it as a tedious bore. Yet it can be very beneficial to your growth as a photographer, for the very process of captioning gives you the opportunity to examine your work critically, two weeks or two months after a shoot, when you can be more objective about its merits or see angles that might have been missed or techniques that might have made for a better photograph. Being forced to take a good second look at your work is one of the hidden benefits of preparing stock photographs.

A related issue is protection of slides. The majority of experienced professionals use cardboard mounts and archival plastic, twenty-pocket sleeves. Individual "Kimac" plastic sleeves are added to any transparencies leaving the studio to a client. Larger-format

slides are similarly protected with plastic sleeves. However, today many photographers are scanning their images and sending electronic files so valuable originals do not leave the studio.

Shooting, editing, and captioning are only a fraction of the work in stock photography. What has become obvious in today's competitive environment is that marketing makes up the lion's share of the job. You must set up an effective system that will lead to getting your stock photos before the eyes of prospective buyers. The principal systems used by photographers to market their stock photographs—selling stock photos themselves, using a stock agency, or setting up a personalized combination of both—are discussed elsewhere.

There are certain basic elements to be included on all photo labels. Many photographers consider the following to be essential:

- Copyright notice: © year of first publication and photographer name[1]
- "All Rights Reserved" (for protection outside the United States)
- Identification (can be incorporated with caption)
- Caption information/identification (who, what, when, where, and how)
- Model release on file, or MR[2]
- Model release file number, or MR#
- Property release on file, or PR
- Property release file number, or PR#
- No release, or NR
- Photo file ID number, serial number, or bar code number. (If slide is going to an agency, the agency will provide their number.)

Additional information that many photographers consider important for their labels:

- Assignment client (Mobil)
- Restrictions on client (no permission, oil industry) or time limit
- "Over" (for two-sided captions, so information on reverse is seen)
- "Model release possible" or "Property release possible" (used by some photographers to indicate that they can be in touch with subject to get a release)

Also, as more photographers establish a presence on the Internet, including your URL on your captions is worth considering, especially for stock images you are sending out from your own studio. If you are submitting images to an agency, ask if that information should be included.

[1] All information with legal significance should appear on the front of the slide. This includes ©, date, name, and property and model release information. Some photographers, especially when using a computer or typewriter, use parentheses instead of a circle around the "c" in the copyright notice. While this style may be adequate, it is best to either hand-draw a circle or to type or print out the word "copyright."

[2] The abbreviation "MR" is widely used to save space on slide mounts and is understood by experienced photo buyers, but it is safer to write out the full "model release on file."

Semiotics and Advertising Photography

Semiotics, which has been called the "science of the sign," offers a way of analyzing nonverbal signs. Semiotics does not tell you *what* to think, only *how* to think and how to probe beneath the surface. It tells you what things signify.

Advertising today has become less overtly product-oriented and more emotional and nonverbal in its approach. Ads rely heavily on visual images as emotional triggers to bond the consumer to the client's product or service. An emotional impact is thought to be more persuasive than attribute arguments.

A photographer who wants to create successful advertising photographs needs to read, interpret, and master the "signs" used in the advertising world to stimulate consumption. This type of analysis has been called "psychological semiotics," or iconology, or simply image decoding.

For the stock photographer, the purpose of all this is to help create more effective selling messages. To be truly effective, images should have a strong association with values and attitudes already held by consumers. The images should contain symbols that evoke a strong positive "resonance"—the feeling that a particular object or place in a particular context can acquire a universal significance.

Techniques in Nonverbal Communication

Color coding. Every color has meaning and symbolism. Experience has shown that color has psychological meanings and associations for everyone and can affect human behavior and response. Mental associations with a color can trigger deep physiological responses and psychological changes in attitude and behavior. (See chart on color associations.) Something to keep in mind, though, is that colors can mean different things to different cultures. Colors signifying bravery or strength in one culture could mean cowardice or weakness in another. With the global market of stock today, this aspect could affect your sales. If you work with international agents, it is suggested that you ask about colors in their cultures.

Styling. Perceptive propping and dress. By putting objects or clothing into the photograph that are recognized as powerful symbols—icons that resonate and connect with values, attitudes, and associations already held by viewers—the photographer will be rewarded by a favorable reaction to the image.

Gestures/body language. A great deal can be read into a photograph by reading the gestures of the players in the picture. We can sense caring, loving, victory, defeat, anger, and the like by observing people's facial cues and body positions. This is an area too often neglected by photographers. Photographers need to concentrate more on directing their subjects to deliver emotionally charged performances. It is important to note that inanimate objects, such as trees, old sagging barns, or skyscrapers, have a quality of gesture that gives them meaning beyond their physical existence.

Proxemics. How close are people when they interact socially? Control of this spatial relationship can enhance the expression and emotional meaning of photographs, but it is widely overlooked. Photographers should make it a habit to look at ads featuring people interacting and notice the position of their heads, hands, and bodies. Drawing a

circle around the action area that encompasses the heads and hands of the players will call attention to the dynamics of the spatial relationships. In short, get your people in close. Get them to touch. Pack the shot with emotion.

Cinema verité. Grain and black-and-white photography trends come and go. These techniques are supposed to evoke feelings of integrity, sincerity, and reality in the consumer—the concept that journalism doesn't lie. The idea is to give the selling message the look and feel of the real thing, as a slice of everyday life.

In addition to understanding techniques for nonverbal communication, you need to be aware of certain important concepts.

- Togetherness
- Wholesomeness
- Family
- Friendship
- Caring
- Sincerity
- Integrity
- Teamwork
- Self-pride
- Patriotism/pride in America
- Emotion and sentiment

An understanding of semiotics and these traditional values will strengthen your visual vocabulary. (The information on semiotics and color coding is based on research provided by Richard Steedman, founder of The Stock Market, which was sold to Corbis. Steedman is now director of photographer relations for Corbis.)

Color Associations

1. High illumination implies hot, active, and comic situations.
2. Low illumination implies emotional, tense, tragic, melodramatic, and romantic situations.
3. High chroma implies emotional, tense, hot, comic, and melodramatic situations.
4. Warm hues (red, orange, and yellow) imply active, comic situations, leisure, recreation, and the like.
5. Cool hues (green, blue, violet, purple, and gray) imply tragic and romantic situations, efficiency, work, etc.
6. Warm colors refer to action, response required, spatial closeness.
7. Cool colors refer to status, background information, spatial remoteness.
8. Gray, white, and blue refer to neutrality.
9. Pink has the effect of decreasing aggression and reducing physical strength. It reflects the new romanticism—we look through rose-colored glasses when we want to feel optimistic.

Marketing Your Own Stock

The decision to undertake the day-to-day licensing of reproduction rights to your own photos (informally called "selling stock") rather than using a stock agency should not be taken lightly. Selling stock yourself can be financially productive and an enhancement to your professional life, but only if you are well prepared and go into it for the right reasons. Some industry analysts say that those who benefit from marketing their own stock are the exception and that the photographers who go furthest are those who concentrate on what they do best: shooting. However, it is an important alternative today, now that there are fewer openings for photographers in the established photo agencies. Still, you should consider the pros and cons carefully to find out if you have the inclination or the personality for such an undertaking.

Red: The color of extremes in human nature
POSITIVE ASSOCIATIONS (love and courage)

Engenders a sense of warmth

Courage, valor, bravery

Love, passion (Valentine's Day)

The heart

Emotions (extreme)

Joy and happiness

Proven manhood and prowess (*The Red Badge of Courage*)

Symbol of revolution

Color of aristocracy

Red Letter Day

Red Cross

Hot line (red telephone)

Negative associations (extreme passions and vice)

War (Mars: God of War)

Lust (scarlet women)

Rage/anger

Revenge/hatred

Anarchy (negative view of revolution)

Hot/fire

High anxiety/immediate action required

Murder/blood

Red-handed

Stop/danger

To see "red"

ADDITIONAL COMMENTS

Top color in rainbow

Exposure quickens the heart rate/enrages the body

Color thought to hold the key to all knowledge (the Philosopher's Stone)

Green: The color of life and love
POSITIVE ASSOCIATIONS

Life/love (planet Venus)

Spring (rebirth of new life)

Vegetation (green planet Earth)

Nature/fresh

Vigor

Immortality

Faith/hope

Plenty

Victory

Fertility

Money/stability

Emotional balance

Go; safe; okay

Gullible

Green hands

Youth/inexperience

Green thumb

Green berets

Irish national color

Refreshing (mint cool)

Playing fields

Lawns (status symbol)

NEGATIVE ASSOCIATIONS

Mold/decay/rot

Poison (arsenic)

Nausea

Envy/jealousy

ADDITIONAL COMMENTS

Ambivalent hue (decay; life)

Most restful color on the eyes (surgeon's
gowns)

Used in most camouflage (Robin Hood)

Represents tranquil, quiet lifestyle (being in
nature and rural areas)

Blue: The color infinity and tranquility

POSITIVE ASSOCIATIONS

Royalty (blue blood)

Blue ribbon (winners)

Blue chip (secure)

Soothing/tranquil

Spiritual/heaven/cosmos

Infinity

Sky (blue skies)

Ocean

Vast exposure

Optimism

Ford corporate color

IBM corporate color

Tranquility to isolation

Boy child

Bluebird of happiness

Tenderness

Music (the blues)

Fashion (denim)

Blue suede shoes

Labor (blue collar)

NEGATIVE ASSOCIATIONS

Blue mood/sadness/sorrow

Blue gown; blue humor; blue movies

Cool; cold (blue with cold)

ADDITIONAL COMMENTS

Calming effect/lowers blood pressure

Corporate qualities of reliability

Yellow: The color of hope, joy, wealth, and enlightenment

POSITIVE ASSOCIATIONS

The sun/life-giving

Gold/earthly wealth

Wheat fields

Cheerful/joyful

Richness/splendor

Glory/power

Spring flowers

Yellow pages

Hertz corporate color

Sunflowers (Vincent van Gogh)

Kodak corporate color

NEGATIVE ASSOCIATIONS

Sickness (yellow fever, color of quarantine
flag at sea)

Cowardice

Yellow journalism

Caution: warning, slow, test

Age (yellowing with age)

ADDITIONAL COMMENTS

Young children choose yellow to represent
"happy"

Quickly perceived

Makes people feel optimistic

White: The color of truth, purity, and peace

POSITIVE ASSOCIATIONS

Light/airiness/space

Truth

Innocence

Peace (white dove)

Purity/virginity (white weddings)

White magic (for good)

Modesty

Clean/ultra-clean (clean rooms)

Unadulterated

Ivory soap (99 percent pure)

The White House

White smoke (election of new pope)

Negative associations

Cowardice (white feather)

Surrender (white flag)

Fear of hospitals and doctors

White elephant (burdensome possession)

ADDITIONAL COMMENTS

Often paired with black to create tension
between opposite forces, such as good
(white)/evil (black)

Black: The color of mystery and power

POSITIVE ASSOCIATIONS

Elegance

High fashion (basic black)

Formal (black tie)

Classic

Expensive

Black Label scotch

Professional cameras and equipment

Power/powerful

Authoritative

Night (rest from day's labors, beauty of
the night)

NEGATIVE ASSOCIATIONS

Ominous/gloom

The unknown/mystery/void

Night/darkness (fear of)

Black: negative associations

Death/mourning

Depression of mood, mind, spirit

Black magic (for evil)

Black knight

Blacklist

Blackmail

Blackball

Black market

Black sheep

ADDITIONAL COMMENTS

One of the colorless colors; it is the negation
of color;

a powerful force in the world of high-fashion
chic;

used by adolescents to express defiance of
society (rockers, punks, and Hells Angels).

Almost all photographers, during the first year or two of business, experience the incidental sale of one of their existing photographs for an unexpectedly nice fee. They then realize that the photographs in their files are very valuable if made available to buyers at the right time. The idea of more such sales is very appealing, and the natural inclination is to think about setting up some way to consistently exploit picture files in this way.

There are decided advantages in making a deliberate, rather than casual, business decision to sell your own stock rather than work through a photo agency. Many photographers do it, but don't be misled into thinking it is going to result in quick or easy money. A worthwhile stock operation—which means satisfied buyers, repeat business, significant volume, and continuing income—requires the investment of a lot of time and energy, not to mention a solid file of first-rate images. It also requires patience and a meticulous mind. By its very nature, marketing your own stock is a long-term investment and a business of details that doesn't lend itself to halfway measures.

Selling stock efficiently requires setting up well-thought-out, well-organized sys-

tems and then maintaining them with careful and constant attention. It really entails setting up another business in addition to your assignment work. Many established assignment photographers have an assistant, partner, or spouse whose primary business function is just to run the stock business. Other photographers, with flexible shooting schedules, are able to see to it themselves between jobs. Whatever your situation, and your personality, give the decision careful and serious consideration.

Perhaps the first thing to do is to make an accurate assessment of your files and examine your expectations. If they are unrealistically high or your images not suitable to the stock market, you could end up wasting your time; if your expectations are reasonable and you succeed, you might be able to choose between assignment photography and producing and selling just stock.

Advantages

Many photographers who sell their own stock have made that choice for a variety of reasons. They have said that they:

- have found that the contacts they develop in selling stock often lead to assignments;
- like selling and marketing and feel they are in a better position than anyone else to develop the right selling strategy for their own material;
- believe that even after expenses, they will net more money selling stock themselves than by splitting fees with an agency;
- believe that the best way to learn how to shoot successful stock photos is to become involved in selling them;
- have learned that their personal involvement in submitting photos and dealing with buyers results in a higher percentage of sales than when they rely on an agency or third party;
- believe (especially if they are specialists or have high-profile reputations) that buyers who want their work will come to them directly;
- believe, if they are specialists, that they have a better idea of their market than any agency would;
- want to control where their images will be reproduced, and where their credit line will appear; they are not comfortable delegating this responsibility to the staff of a stock agency;
- fear that if they join a stock agency, they—and their images—will get lost in the crowd;
- think that the four- to five-year standard agency contract plus the one- to two-year picture retrieval period is too long a commitment; and, finally,
- simply enjoy the tasks that are part and parcel of selling stock photos themselves.

Disadvantages

There are decided disadvantages to selling your own stock photography, primarily due to the endless details inherent in the job. Unfortunately, these don't hit home until a year or two into the career of most starting photographers. Typically, they sell their own material while establishing their assignment business. It's only if they're successful in both areas—assignment and selling stock—that they run headlong into the drawbacks of:

- erosion of shooting and personal time
- concentration on business and administration
- need for meticulous organization
- need for investment in additional equipment, space, and staff
- time involved in training others to handle stock files
- need to keep replenishing stock rather than experimenting with new photographic ideas (these are sometimes mutually exclusive)
- uncertain financial return.

The last point is especially critical. You must accurately assess the real financial return from the stock side of your business. Many photographers have rushed headlong into selling their own stock without determining whether they can actually make money at it. A high turnover and large volume of business do not indicate that you are making a profit. The photographer who does not carefully calculate the costs involved in selling stock could end up being no more than a conduit of funds.

The key is that in selling stock you never "catch up." The process is ongoing: An active and successful stock photo business is like an endless conveyor belt. On any given day there can be a dozen or more submissions at one or another stage in the progress toward a potential sale, and each stage requires monitoring, decision, and action. The more successful you are, the more requests that will come in and start their demanding journey along the belt. To get an idea of how demanding, consider the following review of the steps in the process.

Steps in a Stock Sale

1. **The request.** You may receive requests for stock pictures over the phone, in personal visits from buyers who may select directly from you file, or in writing, via a "want list" sent through the mail, by fax or over a computer network. For phone inquiries, a form is often used to record and confirm details, and the skill and experience of the person taking the request can decisively affect the appropriateness of the photos selected for submission. This person can also prevent wasted effort by inquiring first about budgets, describing the photographer's general fee structure, stating delivery terms, and explaining research and holding fees and how they are applied.

2. **The "pull."** After the request—which will sometimes be quick, simple, and specific and other times subjective and more complex—is analyzed, the photo files

are searched and a selection of possibilities is pulled. These are winnowed to a reasonable number and "logged out" in your record-keeping system. (If you don't have dupes or scans and wish to send them out instead of originals, this is the time to have them made.)

3. **The delivery memo.** Each photo in the submission is then listed on a consignment or delivery memo that goes out with the pictures, and a duplicate is kept in your files. Many photographers (and agencies) have a light box/photocopying setup that they use to make a visual record of each submission. Two photocopies are routinely made—one for the client, which accompanies the submission, and the other for the photographer's (or agency's) file. These records are invaluable if a loss occurs.

4. **Invoicing the research fee.** If the buyer has called to request a specific image for purchase, the bill is usually sent along with the submission. Otherwise, many established photographers enclose a bill for a research fee along with the delivery memo and pictures—usually for about $75 per submission, which helps cover administrative costs (and discourages buyers who are not serious). This fee is sometimes deducted if a sale above a minimum amount (often $200 to $250) results. Be aware that many agencies do not charge research fees, a trend started by a major agency, which others followed.

5. **Packing.** Protection of your pictures is a priority, along with making sure all the correct images and paperwork are enclosed. Most photographers sandwich their photos in corrugated cardboard, then put the package in a padded envelope for further protection. Others use professionally designed labels and preprinted outer containers to show that they value their work and to ensure well-packed returns.

6. **Delivery.** How the package of submissions is delivered to the buyer (in person, by messenger, by mail, by courier, or transmitted electronically) will depend on deadline, location, and cost, but the number-one concern is the safety of your images. Choose a system that allows you to track the package, and always get a receipt. Most photographers have worked out preferences for various situations, but occasionally buyers will specify a service, sometimes even giving an air-courier charge number so that delivery charges will be billed directly to them. Electronic transmission of images is becoming more prevalent, especially in cases where the buyer has already selected the photograph and only one or a few are to be sent.

7. **Record keeping.** All records covering each submission must be carefully entered in your system, which might include a log book, a chronological register to facilitate follow-ups, an alphabetical file by buyer's name, or any other system that can tell you the exact status of each picture in your files or out on submission.

8. **Returns.** When the first group of rejected pictures, or "returns," comes back, they are checked off on your copy of the delivery memo, inspected for damage, and logged back into your photo files. Some photographers discourage unauthorized use by sealing mount edges with labels that read, "Layout fee charged if mount has been cut."

9. **Additional returns and holding fees.** As additional reject pictures are received, the same procedure is followed. It is not unusual for art directors to go through

several picture-editing meetings before making a final selection. If holding fees are warranted, they are billed immediately.

10. **The negotiation.** Once one or more photographs are selected for use, the exact price and rights—if not already determined—are agreed on, after a discussion covering size, print run, distribution, format, time of usage, and other factors. Remember that there is no need to rush into quoting a price. Take your time, get all the information, consult with colleagues if necessary, calculate your price, and call back with a figure—and range, including the minimum—in mind. Negotiation is key to your financial success in stock.

11. **The buy.** The client sends a billing request or formal purchase order, which you check against your negotiation notes, resolving any discrepancies.

12. **The invoice.** You prepare and mail an invoice specifying licensing rights, payment terms, copyright credit line, and other terms and conditions, and requesting tearsheets of the published image.

13. **The payment.** When you receive payment, examine the check for any "fine print" conditions, mark it off against your invoice, enter it in your bookkeeping system, and deposit it in the bank, making sure that any holding and research fees have also been paid.

14. **The final return.** When your photographs are returned after use, inspect each carefully for damage and check them off on the original delivery memo, which has remained in your "pending" file.

15. **Cleaning and remounting.** A transparency is usually removed from its mount in the reproduction process, so make sure it has been returned to its own mount, that the mount is in reusable condition, that the transparency is clean, and that the caption and file information on the mount has not been obliterated by art director's or printer's instructions.

16. **Refiling.** Return the image to its proper place in your photo file, ready for another stock submission.

Setting up a Filing System

The need for organization at every step along the route to a stock sale is obvious. The first step—important for the foundation of any stock business and for estate purposes, too—is the organizing, editing, and filing of the photographs themselves. Without a workable system, you won't be able to put your hands on an image when you want it; you won't be able to return it to its proper place; and you will certainly lose track of who has which photograph. The first rule, therefore, is this: Know for certain where every image is at all times.

There are various approaches to setting up a system, but it is probably wise to study the systems that other, successful photographers have developed. Experience is the best proof of a system's workability. If you file your pictures under one system for even a couple of years and then find it unwieldy, you face a formidable and discouraging task in switching to another. So it is worth the time spent to be sure your system will work

the first time around, or to adjust or change it as soon as you see a better way.

A stock photographer's filing system consists of three parts: (1) housing—the physical bins, drawers, dividers, folders, mounts, and other materials in which photos are kept; (2) identification—the system under which they are filed and identified, both with marks on each photo and in separate written or computer listings and/or descriptions; and (3) paperwork—the record-keeping files that include a photographer's model release file, caption information file, promotion materials, stock photo lists, delivery memos, correspondence and billings with clients, copies of expense receipts, and so on.

A good filing setup should provide a number of benefits:

- quick and easy classification for identifying and filing each photograph
- safe storage
- easy entry and retrieval of images
- flexibility, to allow for expansion and contraction as subjects change over the years
- simplicity, so others can understand and use it quickly
- adaptability, so it can be transferred to a computer.

Choosing a Classification System

This is first and most important, since the decision you make will, to a certain extent, determine the physical equipment you'll need for housing your files as well as the logging effort you'll make in keeping track of everything in your files thereafter.

Some photographers use a numbering or coding (combinations of numbers and letters) system. A well-designed system can identify every image individually, providing accurate traffic control to and from buyers; it can ensure quick and accurate return of the image to its assigned place in the photo files; and it can tell you the subject matter, the date the photo was made, who the original client was, whether there is a model or location release, or almost any other bit of information you might want to incorporate.

A good numbering system can also save your sanity when it comes to retrieving pictures. There is nothing more maddening or disheartening than getting a request, knowing you have the ideal picture, and then spending hours locating it. Aside from the emotional fatigue, the loss of money is staggering if you go through this futile activity many times a year. An effective numbering/coding system is critical.

Although many professionals and photo agencies believe that a good numbering system is the most accurate way to keep track of your images, there are a few successful stock photographers who function well without any numbering system. It will be necessary for you to analyze your business needs and style to determine how best to set up your files.

In making a decision regarding a numbering system, consider the size of your file. Is it small enough at this stage to adapt easily to a numbering system? Or is it so large that beginning the process of numbering would be a staggering affair? If the latter is true, then you might consider random numbering (bar codes work well here) for images being logged out. That numbering would be used just for tracking and record keeping. In this way the photographer who has a file so large that it would be prohibitive to number can still reap the benefits of tracking by number. Under this system, however, a cod-

ing device or method for refiling would still be needed.

As you'll see from the examples that follow, creating a system is just a matter of analyzing your needs and developing codes to fit them. If you use a computer—and you should be if you're selling stock—make sure your system is adaptable to computerizing: Numbers and number sequences should read left to right, and the information these numbers represent should progress from the general to the specific. Not to be overlooked are bar codes, which are more error-free than writing or typing numbers by hand.

Numbering by subject category. This is a handy and versatile system that allows for a large variety of subjects and great depth of coverage. You begin by assigning numbers to broad general categories like People (1), Travel (2), Technology (3), Transportation (4), Sports (5), and so on. You can do this even if you don't yet have material in some of the areas. You can also be more specific, using Men (1), Women (2), Children (3), Crowds (4), and so on.

Keep in mind that your filing and numbering system should accommodate "concept" categories (such as cooperation, teamwork, pride, or trust). This can be handled through a cross-reference system, but if you have a significant number of photographs that fit the concept approach, it is a good idea to design them into your main file.

There are many sources of file categories—some in computer programs designed by photographers—that you can adapt for your needs, and there's no need to set up lots of empty categories until you have images to put in them. A computer program for photographers may save you a lot of energy if you find one that works with your subject file. If so, it's one wheel you won't need to reinvent.

The point now is simply to start a system that has room in it for growth. You do have to establish categories for the images you have. One simple way is just to make piles on a large table putting "like with like." Those become your categories.

Assign easy-to-remember low numbers to categories in which you specialize or expect to do a lot of shooting. Then create a second rung of number codes, this time more specific, so that under Travel (2), for instance, #1 could be India, #2 China, #3 Southeast Asia, and so on. You could add another rung, if you have an extensive travel file, perhaps using letters for the names of cities or states, such as (for India) Calcutta (A), Bombay (B), Delhi (C), Madras (D), Bangalore (E), and so on. Or you may prefer a rung by subject matter, such as Religious Festivals (A), Street Scenes (B), Architecture (C), Transportation (D). This is how you set up your file drawers and what you mark on each photo. Finally you can also note on the photo the date of the shoot and the number of the photo in the shoot, to get a complete code like 2-1-B-3901-20, which translates as *Travel/India/Bombay* (alternatively, *Street Scene*)/shot March 9, 2001/20th photo in set. Or to put it another way:

Subject category for Travel	2	General
Subcategory for India	1	Specific
Sub-subcategory for Bombay	B	More specific
Date of shoot	3901	Even more specific
Individual photo in set	20	Unique

You can also add a rung for clients, especially if you do most of your work for a few of them.

Work out your categories this way on paper and see what makes the most sense for you. The trick is to assign numbers according to where your material will fit on the "ladder." Then if you have 200 photographs edited from a trip to the Yucatan but have no other scenics in your file, you can still assign accurate numbers simply by putting your material in the right place on the ladder:

Scenics	9	No scenics in file but number assigned anyway
Subsection for Mexico	1	No other Mexico in file but number assigned
Sub-subsection for Yucatan	1	Your new photos
Date of shoot	5301	
Individual photo in set	1–200	Number of each photo

Thus the numbers for your Yucatan pictures are 9-1-1-5301-1 (through 200).

To use this system, you need to keep a separate "code bible" listing each number and what category it represents (see earlier example). A looseleaf binder is probably the best choice, or a set of files in your computer, with a page assigned to each general category on which you can add subcategories as you shoot them or as the category becomes too large and you separate it into two smaller ones (*Indian Religious Festivals*, for example, could be subdivided into *Hindu* and *Buddhist*).

The system really shows its advantages in the file drawers. You can easily put both the name and the number on the drawer and folder labels; for example, a drawer for Sports (5) and inside a section for NFL Football (5-1) and folders for Dallas Cowboys (5-1-B), and so on. No matter what words are written out, each folder must bear the full number code for its category. This allows it to easily be replaced by a new assistant, who can simply follow the numbers. However tempting it may be, don't overload your system with codes. Keep it simple, or you may end up with dozens of folders in your files and one photo in each. Remember that every category you add to your code is another number that has to be written on each image and typed onto delivery memos and other records relating to it.

Numbering by date. This is a system that provides an exact chronological reference plus a unique, never-repeated number: 32301-18, for instance, would stand for the date the picture was made (March 23, 2001) plus the number of the individual photo in the set (18). Additional digits or letters can be added for more information. Basically this system is the reverse of the subject-category system above, which always concludes rather than starts with the date and photo number.

Using a Job Book

If you're creating a stock file out of assignment work and use one of the systems above, your code will tell you where to put the picture in your files and the day it was shot, but unless you include a client code—which adds to the already long number—it won't tell you who the client was, where the scene was shot, circumstances that might be

important for captioning, or restrictions that might affect submissions. Many assignment photographers keep a chronological job book. A typical entry might read: *6/20/01 Maimonides Hospital, Div. of parapsychology, ESP research, Pfizer*. Since the date in the photo's code number leads straight to this reference, anyone having access to the code bible, the photo files, and this book has a complete history of every image in the files.

Model and Property Release Coding

The letters *MR* and/or *PR* should be added to a picture's code or otherwise marked on the mount or computerized label or black-and-white print to indicate that there is a model or property release on file. The releases are usually kept separately (see "Supporting Paperwork" below).

Cross-Referencing

A single photograph can show a wide range of subject matter and at the same time illustrate a mood, theme, or concept. Such images make very good stock because they can fill a variety of stock requests, but they're a problem to classify since they can only be in one file at a time. The solution is to follow your instincts and file the image under the most obvious heading, the one that comes most immediately to mind.

Then if you have a photocopier, put a copy (marked with the original's code number) in each of the other possible files so that researchers looking there can see it and know where to find the original. Another system is to use a sheet of 8-1/2" x 11" paper in a color you won't use for anything else, print up a stack with the bold legend "See also: _____," fill in the number of the original, and put the sheets in the alternate files. This same cross-referencing approach is well suited to the computer.

Take, for instance, a photo of a woman eating a taco on San Antonio's famous River Walk. If you're a general editorial photographer, you might file it under U.S.A., Texas, *San Antonio, the Southwest*, or another designation for that area. You could then put "see also" sheets into Street Scenes, Ethnic Food, Urban Redevelopment, or other categories you have already established. But if you're a food specialist, you might immediately put the photo into your *Food, Mexican* category and place "see also" sheets into the *Texas, Southwest, Lifestyles, Street Scenes*, or other folders. If within the take you have a few close-ups of the woman gazing pensively at the river, you could cross-reference them under *Mood*. In any case, when the time comes to retrieve it, you'll unconsciously know where to look for the picture and its code will tell you where to refile it.

The key to a valuable cross-reference system is follow-through. It's worthless if it's not kept up-to-date.

Supporting Paperwork and Record-Keeping Files

Model releases, property releases, and other documentation relating to photographs are critical—you can lose picture sales without them. They are usually kept in a release file of their own, filed by the code number you've assigned to the shoot or the individual photo; or, like some photographers, you may prefer to use a sequential MR numbering system. You're far more likely to be able to find the model release for a photo you took

three years ago under the photo file number or the MR number than under the name of an individual model. Caption information and other materials relating to the picture can be kept in a "Backup Information" file, also by code number.

The other paperwork files specific to stock are the logging in/logging out records that must be kept every time a photo leaves your file or returns to it. Photographers with a large volume of business usually assign a consignment number to the delivery memo and enter it in a log book. When a photograph goes out, these are the only records that show where in the file it came from and where it went, so they are vital. (This is also the tedious part of stock selling and one reason for the increasing popularity of computers and bar codes.)

You automatically log out any photos you send to clients when you fill out the delivery or consignment memo that accompanies them, keeping a copy for yourself, and log them back in as they return. Keep your copy of the delivery memo in your client account file. If you have a photocopier, this is when you would make a visual record to go in your files and to accompany the delivery memo. A popular method is to place a very strong light (a gooseneck lamp works well) above the machine and copy with the copier top open, which will yield a record of the information on the slide mount plus a recognizable black-and-white image of the slide. If you don't have a photocopier, simply photograph your images on a light table, overexposing 1-1/2 stops from what your camera meter indicates. This way you will be able to see the image on the film as well as read the caption on the mount. (However, this convenience must be weighed against the possible damage to transparencies over a long period time. Those knowledgeable about archival storage warn against the repeated use of strong lights in projectors or photocopiers. A piece of quarter-inch-thick Plexiglas over the surface of the copier will reduce the potential damage.)

It's also smart to create a "photos out" folder (or box or three-ring binder), and keep it handy for constant review. In it, put a second copy of all your delivery memos; keep them together this way, and you'll have an ongoing, up-to-date record of everything that's out, where it is, and how long it's been out. You can even use an accordion file with slots for the months of the year; put your delivery memos in it and you can see at a glance how many months old they are. (Even after the photos come back and you've logged them in, you might find it interesting to save the delivery memos and at the end of the year do an analysis of how many photos you sent out and how many you sold.)

If you want a record in the photo files as well as the logging files, make place holders as recommended in the method for cross-referencing. For large-format pictures, pick a different color paper, print a stack with the bold legend "photo out" fill in the code number of any picture you remove from a folder, note the number (or date) of your consignment memo or the client's name, and put the sheet in its place. When you refile the picture, destroy the place holder. For 35mm slides, 2"-square cards serve the same purpose by holding the slide's place in the pocket of the plastic slide sheet. This system, used by many agencies, gives a quick visual check on where each slide is— through client name listed or the consignment number. The cards can be ordered from most small printers, who will cut card stock to size for a modest fee.

In addition, you'll have the same files as other businesses: active client files for jobs

on submission or awaiting payment or the return of photos; other client files for your completed jobs; and the business's own financial files (bank, expense, insurance, equipment, tax, and other records). Your accountant or financial specialist can advise you on how to set these up, and there are also business software programs for photographers if you have a computer.

Tax Records

In order to comply with tax record-keeping requirements, particularly when faced with an audit, it is essential to keep accurate and detailed expense records. These thorough records are also essential in order to run a sound business. Without good records to track your costs and sales, you will find it impossible to assess the profitability of your stock operation. Careful records will enable you to analyze which types of stock are selling best so that future stock shots can be planned on an economic as well as aesthetic basis. Computerized business software has made record keeping more efficient, but regardless of what system you use, ensure that accurate records are maintained. Any photographer who has been through an IRS audit will appreciate the wisdom of maintaining good records. If you are in any doubt talk to an accountant or tax expert.

Physical Filing Setup

Your stock-selling setup equipment should include, besides file cabinets and folders, a computer, a copier, a fax machine, light boxes, plastic filing sheets, and all the stationery, labels, forms, and packing materials you need for taking stock requests and sending out submissions.

Price is not the only factor to consider, even at this stage. "Safe storage" is a prime benefit your system needs to offer, along with ease of retrieval. These are directly related to the quality of your equipment. You'll be in and out of file drawers hundreds of times a month. Don't get anything that's unstable or cumbersome to use. There are other considerations as well.

If you, as an active professional, have chosen to sell your own stock, it means that you are going to spend a good portion of your working time among your file cabinets, light boxes, office machines, telephone, desk, and packing table. Photographers tend to appreciate and want quality equipment, and it therefore seems wise to buy the highest-quality materials and equipment you can afford—to go first class for your own pleasure and to support both your personal image and your stored images. What you acquire now should literally last a lifetime.

Temperature and humidity are extremely important to the health and longevity of your photographic images. Photo-storage areas should be cool, dry, and free from dust and harmful light, especially the overexposure of color materials to sunlight. Individual image sleeves or twenty-per-page slide holders should be archival quality—made of material free of impurities. You can also store 35mm color in metal boxes with a baked-on enamel finish (as wood leaches acid). Boxes work particularly well for photographers who file by number—slide pages commit you to categories, while boxes are convenient for numerical retrieval. If you had a card/computer file with key words such as "Santa Barbara, beach, California," the computer would show which numbers fit, and

retrieval could easily be made from the numbered boxes. As long as you set up a storage system that respects the fragility of color transparencies, twenty years from now you'll have the pleasure—and profitable business—of selling pictures that are just as rich and color-saturated as they are today. Many photographers scan their best images and use these for stock sales and storage. Valuable originals are rarely handled after scans have been made.

With all its parts in place, your photo filing system will be freestanding and offer the flexibility, adaptability, ease of retrieval and replacement, and other virtues you need. To make it really work for you, you must now respond with good work habits; your filing system, no matter how well designed, will stutter badly if you don't promptly refile pictures that return from a submission. Returned photographs that are "temporarily" stored in desk drawers are as good as lost when it comes to filling an urgent phone request from an ad agency.

As you work with your photo file over a period of years, it will expand here, contract there, and possibly take on for you some of the characteristics of a living and friendly organism. The file will no doubt need some modification and fine-tuning, but if it is well designed and both you and it are flexible, it will be a pleasure to work with.

Marketing

Somewhere out there an art director is pacing up and down in a small cubicle wondering where to find the classic chrome showing a man in a red flannel shirt who is trout fishing in New England. At the same time you are sorting through the latest film from the lab and you pause at some photos you made from a covered bridge showing a red-shirted man lifting a fish into his net. The problem is, you don't know that the art director in the cubicle wants to use that photo in a major ad campaign, and he or she doesn't know you have just the picture that's needed. The solution to this dilemma is called marketing—letting buyers know what is in your files and getting it out to them.

Finding Buyers

Established assignment photographers just starting a stock file may use their assignment clients as a base for their stock marketing efforts. However, the way to find a wide range of buyers is to reach them by mail. This extends your possible market as far as courier services—or the post office—will take it. There are established lists of photo buyers and source books that you can use to develop your mailing list. Assembling and maintaining it will be a continuous process.

You will probably want to start with a small mailing list, and build it as you increase your capability to handle additional clients. You should begin your mailing list with local clients, ad agencies, designers, and other photo buyers in your area. As your business grows, you can increase your list. Your list should not grow to the point where you become unable to maintain contact with your clients. You will probably want to review your list every year or so, deleting names that don't show activity, and adding new clients that do. Your goal should be to send a promotion or mailing to your list at least

four times a year. From the start, your choice of names should follow a deliberate marketing strategy of aiming at buyer groups, industries, or geographic areas that interest you the most or to which your work is suited.

Once your stock business is established, you may choose to advertise in one of the source books or directories available that are distributed to photo buyers. Make very careful comparisons of the page or space rates of the books being considered to be certain that you are spending your advertising budget wisely. Compare the cost per column inch among the books, as well as that charged to your colleagues for similar space in their photo agencies' catalogs to determine the going rates.

Some promotional book publishers seek to market your images directly to photo buyers. If they ask you to sign a contract, have it checked by your lawyer. Be wary of any agreement that would limit your ability to offer exclusivity to a client or prevent you from joining a photo agency that has exclusivity as a requirement. You should also be concerned about your copyright and make sure that it can be protected under any such marketing program.

If possible, check the mailing lists for these books before signing up, to find out how many photo buyers they reach and whether those buyers are the market for the kind of work you do. Also keep track of the new business this or any other kind of advertising or promotion brings in so that you can evaluate the return on your investment and determine the best places to spend your promotional budget.

Every avenue of making contacts or finding buyers should be explored. You may have the most desirable—and salable—photographs in the world, but unless you put energy into marketing them, they may never reach that art director in the cubicle.

Niche Marketing

If you decide that selling your own stock is for you, niche marketing is well worth exploring. Niche, or micro, marketing operates on the principle that it is more productive to identify and serve the potential buyers of a specific and limited range of interest than to try to sell a wide range of material to a wide market. And if you are a specialist, niche marketing makes even more sense.

For instance, if you specialize in a segment of a sport, say fishing, you might have a great deal of excellent fly-fishing material. By making an effort to identify potential buyers of these pictures—calendar publishers, fishing magazines, advertising agencies that represent manufacturers of fly-fishing equipment—the niche marketer is on the way to finding outlets for his work. The information can be found in most public libraries' reference sections or on the Internet.

The next step would be to make an inexpensive promotional mailer with impact and send it to the identified buyers. Initial impact, to get the message across that this source of images is something special, is essential. The mailer must stand out. Such an approach identifies the photographer as a specialist in an area of interest to the recipient. That is a nice position to be in when trying to make a sale. It also leads to quick recognition as a source of relevant images and assures continuing consideration and the chance to build a relationship. Good niche marketing is an excellent way to build long-term relationships between client and stock photographer, which leads to better reten-

tion of clients. Retaining satisfied clients is easier than trying to find new ones.

And if you decide that you don't want to sell your own stock, the niche marketing approach can also be a successful way of getting into an agency and filling a need within that agency—provided there is assurance that the agency will actively market your specialty. A drawback to having a small specialty in an agency is that the agency might concentrate more on promoting its files of more popular subjects. Of course, you could start to shoot the more profitable subjects, but that would make a crowded market even more crowded.

The message is simple: Is niche marketing for you? If it is, you might want to consider whether greater control over the marketing and sales of your work is called for. If not, you might want to consider whether the traditional stock agency is best suited to your needs.

Using the Internet and CD-ROMs

The Internet and the World Wide Web have also created a huge marketing arena for photographers—on a global scale—and harnessing the Web is covered elsewhere in this book. The number of photographers creating their own Web sites is increasing rapidly and this does pose one major marketing issue—how to get buyers to your site. The Internet is not a replacement for traditional marketing methods, but it does complement the tried and true systems, such as advertising and direct mail. Remember to put your Web address (URL) on all printed pieces, including stationery, and make potential buyers aware of your Internet presence.

And while exchange of pictures and online delivery systems will increase, some industry authorities maintain that the usage of digital media such as Photo CDs will increase stock usage because of the proliferation of CD-ROM based multimedia products. Similarly, photographers are able to make their own Photo CDs for promotion and niche marketing. Traditional print materials, such as brochures, flyers, and catalogs for direct mail marketing, are here for the foreseeable future, but as more buyers become fluent in the new technologies, so will photographers be able to use disks and CD-ROMs to send out or promote their Web sites for clients to view and order work.

The Photographers' Cooperative

Cooperatives can be a viable method of marketing stock and generating assignments for a small group of photographers. With the consolidation of agencies, smaller, niche (or boutique) agencies have reemerged as an alternative and cooperatives are among those possibilities. There are several advantages inherent to a general pooling of resources including sharing administrative costs, office equipment, and marketing materials as well as having a local support group of like-minded photographers.

Depending on the scope of its operation, a cooperative can market story ideas to magazines, target specific clients, notify potential clients if any of its members are traveling to a certain country(ies) or region, and work in collaboration with photographers to generate work or market ideas. In essence, it's structured to help the photographers who are the principal shareholders. Members are able to travel on assignment knowing that a system is in place to take care of business in the photographers' absence.

Established photographers, who have a large collection of work whose re-licensing potential has not been fully exploited, might see a cooperative as an ideal way of selling stock and creating assignments within the intimacy of a small business comprised of friends and colleagues.

One of the most successful small photographers' cooperatives was Photographers Aspen, founded in 1984 by a trio of leading editorial assignment shooters. Paul Chesley, David Hiser, and Nicholas DeVore III became aware of the value of stock and wanted to combine their resources to market their work. (Note: In early 2001, Photographers Aspen merged with another successful stock and assignment agency, Network Aspen, and the new entity operates as Network Aspen. However, the principles of the Photographers Aspen model as a cooperative are still applicable.)

While the modus operandi of a cooperative will vary depending on its member photographers, their specialties, and location, the guidelines used by Photographers Aspen provide a model for others. ASMP thanks Janie Bennett, Photographers Aspen's former director--who helped found the cooperative and steered it from inception to becoming a leader in its field--for supplying this information.

The most important ingredient, and without this there's little to be gained by pursuing the idea, is a spirit of cooperation. The personalities involved must be compatible. This is not something which can be defined by a contract. It's an intangible, a factor which the cooperative's founders will recognize if it exists, in them initially and then with new photographers who join. The founders of Photographers Aspen were motivated by wanting to market their images for stock and were eager to cooperate to achieve that goal.

Fortunately, about the time they wanted to explore the possibilities of doing this, Janie Bennett arrived in Aspen. This highlights the importance of another vital ingredient--a capable individual who is not a contributing photographer, but who understands and enjoys the business and has marketing skills.

Photographers Aspen, hereafter referred to as PA, operated with five member photographers and four to six office staff, most of them part timers. When started, PA was funded by a quarterly contribution from each photographer to cover expenses. Income from sales went independently to the photographers. Photographers received 50 percent with the other 50 percent being used to run the operation. Janie Bennett points out that 50 percent was necessary for administrative and marketing functions. In this business the profit margin is slim, especially if the cooperative reinvests in technology and marketing.

Based on PA's experience, and appreciating the aforementioned essential components, here are some guidelines for a photographers' cooperative.

- The member photographers must have a collection of work that can be accessed.
- Establish guidelines for funding the operation.
- Consult an attorney but leave your options open. Don't be in a rush to draw up legal agreements until there is indication the cooperative will get off the ground. In PA's case, Bennett feels that launching into legal aspects too soon could have created a lot of extra pressure and stress, diverting the PA founders from their main objective. Based on a strong desire to get stock images into the market, PA

evolved without a formal business plan or legal agreement among its founders. Eventually, when the operation matured--and because of liability issues--PA became a corporation. However, the principals of a cooperative are advised to determine this facet of their business based on their own situation and personalities. The above approach worked for PA; it might not be appropriate for others.

- Have a photographers' admission and dismissal policy. Criteria for admitting new photographers could include such things as their collection of work, their willingness to contribute material regularly, and their being in synch with the spirit of the cooperative. Everyone must agree to their admission. PA did not set a limit on the number of photographers.

- Dismissal could be based on such factors as lack of work contributed and personality conflicts. Ensure the possible reasons for dismissal are clearly outlined and agreed to in writing.

- Establish procedure for ending a business relationship, whether its dissolution of the cooperative or for "paying out" a departing photographer based on his share value or other criteria. Get legal advice on establishing this procedure. Also have guidelines for a reasonable time to return a member's work if they leave the co-op.

Creating Mini Catalogs and Portfolios

The new technologies have given photographers the ability to customize letterheads, invoices, and other stationery by importing images into word processing and printing the text and pictures on desktop color printers. In the same way, photographers can create short-run promo sheets, even mini-catalogs to send to clients. This is an excellent way of keeping in touch. The quality depends on the resolution at which the photographs are scanned and the printer, but the results can be excellent and very suitable for target marketing of stock. Sending clients samples of new work has been made more convenient, and this is a great way of keeping your name, and your stock file, in front of them. Also, the quality and permanence of color prints made this way are improving with each new generation of scanners, printers, and inks, and the cost of this equipment is surprisingly low.

Preparing a Mailing

The photo market is like any other supply-and-demand situation, once you've located the potential buyers and let them know what you have to sell. The first step in marketing your stock is sending out a list of your stock photo subjects—an inventory of the types of images you have available to license. List your subjects by category, in alphabetical order, and be reasonably detailed. Don't list every shot, but don't list just "Sports" either. Under "Sports" put "NFL football" or categories like "Training: Dallas Cowboys, New York Giants," "Playoffs, 1995: San Francisco 49ers, Dallas Cowboys," and so on. This will let buyers, who are rarely looking for just a picture of a football game, know exactly what you have for them. It's also important to include concept categories on your list, so you can attract buyers who may not need a subject-specific picture, but rather a symbolic photo for a brochure, ad, or poster.

Print your list in an attractive, readable format and use good-quality paper, since it may be kept on file by buyers and referred to when they are seeking pictures in your subject areas. Prepare your list carefully and accurately. It can serve you in many ways as a promotion piece, a constant reminder that you exist, a notice of your areas of interest and specialization, an overall picture of you as a photographer, and a time-saver for both you and the buyer when it comes to picture requests.

Prepare a cover letter highlighting your career accomplishments, awards, and published credits to accompany the mailing of your list. Include tearsheets or reprints as examples of your photographic style and ability. As your business grows, consider printing special promotional mailers showing recent additions to your stock file or highlights from it. These periodic mailings are just as important as the self-promotion you do for the assignment side of your business. Remember that you are competing with the glossy catalogs and other high-powered marketing techniques of the major photo agencies.

Ask buyers to send you their "want lists." If they are anywhere near you, invite them to make personal visits and inspect your files, or ask for an appointment to show them your work.

Shipping Photographs

It's always been a dilemma: What is the best, most economical way to send your valuable images to an agent or a client? When shipping to a client—regardless of whether you are sending dupe slides or images on a disk—the solution is usually to obtain from them their delivery service number and charge it to them, making sure that it must be signed by a recipient.

A delivery service, such as Federal Express, is the preferred method of delivery in most cases, but it can get expensive and there are other alternatives.

Insurance is always a concern and photographers are advised to ask the delivery service what options are available. Some services will insure irreplaceable items, such as original slides, up to a maximum of $500 per shipment.

One veteran stock producer ships virtually everything to his agencies via registered mail. The important thing is registered, as distinct from certified. Registered mail is signed for by everyone who handles it, and in the event of loss, a trace to the last signatory is possible. With certified mail, a receipt of delivery is sent to the sender but no tracking en route is possible.

When shipping to international agents, send material as registered, small packets marked as "Press Material, No Commercial Value" (to avoid duties if any value is stated on customs forms). Also, it is wise to send only dupes internationally, unless there is a specific demand for originals. If shipping registered, small packages internationally, ask the post office what is the maximum weight or size of a small packet that can be sent to the recipient's country. Some nations have different regulations concerning this.

Of course, digital transfer of images has replaced some traditional shipping of images, but most photographers will still ship slides by either U.S. Postal Service or by delivery service at some stage.

Updating

As you add new images to your files, you should update your stock list—or completely revise it if necessary—and send out new mailings. Some photographers prepare a series of shorter subject lists, each customized to the needs of a different client group. These more sharply targeted lists, especially if sent frequently, project an image of vitality by keeping your buyers informed of your latest photographic ventures while sparing them the necessity of reading through a long list of subjects they may never be able to use.

Other Marketing Techniques

In addition to the traditional stock lists and photographic mailers, some photographers are making imaginative use of their marketing budget by sending buyers everything from personalized tote bags to calendars featuring their work. One specialist in aerial photography sent out miniature balsa plane models for art directors to assemble—with his name emblazoned on them, of course. Consider what items might suit your style of photography and your marketing budget. And don't overlook the importance of having your Web site address on everything you send to buyers. If you have added new material or incorporated a new feature into your Web site, let buyers know.

Learning by Doing

As stock requests come in by phone, mail, computer network, or personal visits, you will develop your own sales skills and techniques. You will learn to listen carefully, ask the right questions, understand the needs and practices peculiar to the various sections of the market, and become efficient with your own and the buyers' time. You will learn that buyers respond to interest in their needs, appreciate your efforts to help, and respect honesty and professionalism. You will learn to negotiate a fair price and to say no without offense. You will learn that, as an individual photographer, you can rarely match the volume or the range of the files of a good stock agency, but you can offer instead a photographer's eye and experience in the field, and a proprietor's personal interest. You will learn that experienced buyers are quick to size up the quality of a photo file, and that it pays for you to be forthright. You will learn that buyers generally love photography, appreciate photographers, and make good friends. And you will probably learn to be a better, and more professional, photographer.

Meeting Buyers' Needs

Experienced photo researchers and art buyers do most of their business with photographers and stock agencies that fulfill the following five broadly defined needs:

1. **Technically excellent photographs.** The day when stock files could comprise "seconds" and pictures with flaws is long gone. Success in today's market requires top aesthetic and reproduction quality. Even if its subject matter is just what is needed, a picture won't sell if it is under- or overexposed, soft in focus, scratched, or dirty.

2. Continuous flow of a variety of subjects. Picture buyers need continuing sources of wide varieties of images they can call on for a steady flow of material. Occasional one-shot transactions don't keep them, or you, in business.

3. Deep coverage in one or two areas of specialization. Some photographers specialize in one or two subjects or photographic techniques, and their expertise and reputation attract a narrow but faithful range of buyers who need that specialty. Such photographers may not do a large stock business, but their specialization ensures a certain income, as well as prestige, as a source for a rare type of image.

4. Convenient location or easy access. No photo buyer has the time to walk through the wilderness or leave twelve phone messages to reach you and your file. Stock requests are often part of the "hurry up and wait" syndrome, and buyers want to know immediately if you have the image they want. If you are not in a metropolitan area populated by buyers, you must be very easy to reach by phone or e-mail and be able to offer overnight delivery. Having your own Web site can facilitate being found more easily by buyers and can also provide them with easy viewing access. If you have a specific collection of images for a client to view, you can set up a section of your site for that purpose and give the URL to the buyer.

5. Professionalism and good service. Buyers will not return to a photographer who is habitually late in delivery or doesn't follow up on requests. They just can't afford to chase after photographers who don't provide good service. This is what professionalism is all about. You can also show it in other ways, from prompt paperwork to making things easier for your client whenever possible. For instance, if you're responding to a long "want list," where the buyer will be getting a volume of pictures from many sources, organize yours so that they are keyed directly and logically to the want list. This courtesy will be appreciated and may give you an edge when it comes to picture selection and future requests.

Using Forms

Form agreements are essential in running a good business. Written documentation has the advantage of spelling out the respective obligations and responsibilities of the client and the photographer. Forms provide accurate written records and go a long way toward eliminating misunderstandings.

The forms in chapter 6, "Formalizing Agreements," cover the basic form agreements used in the industry: model and property releases, delivery and delivery/invoice memos. These are only examples, and, if used, should be modified to suit your own business needs.

Selling your own stock photographs can be an interesting, productive, and effective way of getting your work into the market—or it can be a tedious and wasteful experience that drains away your money, time, and enthusiasm. Your skill in setting up a file and marketing system, plus your tolerance for the necessary detail work, can make the difference between success and failure.

The steps and information outlined here give just a small indication of what is involved in the daily practice of selling stock. For some photographers, it is an excit-

ing challenge; for others, a bore. If the idea intrigues you, talk with other photographers, as much about the problems and satisfactions as about the filing systems and money to be made. Talk to those who tried selling, gave it up, and are now with stock agencies. Visit and talk with agencies. In other words, don't just drift into it; know exactly what you face before making a commitment.

Determining the Value of your Photos

Under the law, customers will be held liable for materials they receive that they had asked to be sent, since they have had an opportunity to reject the materials or the document that may have been attached to the same, but instead chose to keep them. In determining value, recent New York cases have taken into account a broad spectrum of factors, including "technical excellence, the selective eye of the photographer, his prestige and earning level, the uniqueness of the subject matter, established sales or use prices, group value of individual images and frequency of acceptance by users" (Hoffman v. Portogallo, Inc., Index No. 1910/85, Supreme Court, New York County [1987]). This broad-based approach has resulted in recoveries for photographers in the range of $1,000 to $1,500 per transparency.

Photographers can provide in their paperwork for a stipulated valuation of each photograph. Such valuation can and should be an amount that the parties agree is fair and reasonable—the figure of $1,500 is often cited for this purpose. It must be understood, of course, that whatever the amount stipulated, in litigation it will ordinarily be necessary for the photographer to establish that such amount bears a reasonable relationship to the provable value of the photograph—in the manner described in the preceding paragraph.

Care and Handling of Transparencies

A New York stock agency sends out a sheet to new clients which contains the information below. You might consider using something similar in your delivery memo.

Transparencies are extremely vulnerable, and the fee for irreparable damage is the same as for loss and can be $1,500 to $2,000 each. The following preventive measures will reduce the incidence of damage.

1. Transparencies are very vulnerable to:
 - Heat, which melts them
 - Light, which fades them
 - Liquid, one spill could ruin dozens
 - Cigarettes—whoosh!
 - Fingernails and pencil/pen points, which can scratch
 - Fingerprints, which can remain forever, impossible to remove
2. So please always keep them in their plastic "Kimac" sleeves. Never remove them.
3. Keep them in "color" envelopes to alert staff that valuable originals are inside, or in envelopes with cardboard, but no sharp closures.
4. Never put coffee or any other beverage on the same surface where you examine

transparencies. Beware of falling cigarette ashes as well.

5. When viewing transparencies on a light box, don't lean on them with your elbows.

6. Resist pointing out your favorites with a fingernail or sharp pencil.

7. Don't mark or stick anything onto or over the cardboard mounts, which could obscure critical caption information.

8. Don't leave transparencies on a light box, in a projector, in direct sunlight, or near a radiator, and when possible, don't photocopy them without putting a 1/4" Plexiglas shield over the glass first.

The life expectancy of a transparency is affected by heat and humidity. In an air-conditioned building, it should enjoy considerable longevity, but one drop of coffee or touch of a fingernail could bring an untimely end. Many thanks for your consideration, awareness, and protection of those in your care

.

Rules for Returns

Your transparencies are your stock in trade, just as cars are for a rental company. They can go out and come back, but, unlike cars, once damaged they cannot be repaired but are gone forever. Your photographs are more than the product of your labors—they are your aesthetic and intellectual property—so you must do everything you can to protect them while they are in your care, and inspect them carefully when they are returned to you. Here are the things to watch for and guard against:

1. **Set up a returns box.** You must set aside one place, such as a "returns box," in your studio where all returned slides go until they are properly checked in. If you leave them lying around, you can forget to check them in and file them or even send them out again. And if you don't have a foolproof system ensuring that you will always check in all slides every time, you won't be able to be absolutely positive you don't have a picture when the client claims to have returned it. And you need to be certain in order to press the issue.

2. **Check for mixed mounts.** This is a recurring problem. Printers remove slides from mounts in order to make color separations, then sometimes return them to the client in the wrong mounts. Often clients don't catch the mistake (nor do some agencies) but simply count the number of returns and log them in without actually looking at the images. They return or refile them according to the caption or code on the mounts, and the mismounted slide is virtually lost until or unless someone wants what the mount says it is and discovers the error. So always check returns visually as well as by ID number. When submitting photos, send a photocopy if you can—and keep one yourself—showing the images as well as the information on their mounts. Use your copy to check the images when they are returned.

3. **Inspect for scratches and damages.** Do not sign any delivery memos from clients, printers, agencies, or anyone else sending or returning your slides to you until you have inspected the slides carefully. Here's how to check for scratches: At first glance, an image may look fine. To double-check for quality, place a black card

about 2" x 3" in size on your light box. Hold the slide about a foot above it and position the image to line up with the card. This "dark field" illumination technique will bring to light serious damage that you might have overlooked. (There has been an increase in damage because, in some laser-scanning separation processes, an oil is used that stays on the transparency and makes it extremely vulnerable to damage by attracting dust onto an image already softened by the oil. Eventually, the oil is rinsed off chemically, but it is often too late to prevent damage.)

Storage of Slides

When you consider the amount of time and money you have invested in your stock files, it becomes obvious that the images deserve special treatment, handling, and storage.

Most photographers store their slides in archival slide pages, hung in file cabinets for the bulk of their file. Some keep their most valuable images in fireproof cabinets, which will prevent fire damage up to a certain temperature.

The longevity of films—that is, the age at which colors fade—used to be a major concern, but new and improved films and digital storage have alleviated some of that concern. Some photographers suggest making copies of highly prized images—either duplicate transparencies or scan them—and store the originals in archival conditions.

There are steps you should take to preserve your images. The two major concerns are temperature and humidity. The colder and dryer the storage area, the better for your film. At freezer temperatures, fading is almost arrested.

For day-to-day working, and where there is constant access to files, here are some suggestions:

- Store slides in archival pages.
- Store the pages vertically in hanging file folders in baked-enamel, steel cabinets.
- Keep room temperature and humidity moderate. Air conditioning is desirable, especially during warm, humid periods.
- Avoid strong paint fumes, raw wood surfaces, and high-sulfur–content industrial gases.
- Don't smoke in your slide storage area. Tobacco smoke stains surfaces it touches, including photographs.
- Avoid slide pages made of PVC, and other unstable plastics.
- Don't stack pages in piles—the heavy pressure can cause images to stick to pages.
- Keep slides away from excessive light, especially sunlight but also projectors or light boxes.
- If you intend to project slides, have dupes made and use them in your slide presentations.

For long-term archival storage, put slides in a freezer at 0°F (–18°C). Low relative humidity, in the 30–35 percent range, is recommended. Low relative humidity can be

maintained by using moisture-proof storage envelopes.

A comprehensive book on the subject is *The Permanence and Care of Color Photographs: Traditional and Digital Color Prints, Color Negatives, Slides and Motion Pictures*, by Henry Wilhelm and Carol Brower (Preservation Publishing Co.; Phone: 515/236–5575; ISBN: 0-911515-00-3).

Also available, free from Eastman Kodak, is *Storage and Care of Kodak Photographic Materials*. The document's code number is 390403. To obtain a copy, call (800) 242–2424. While this is a Kodak publication, the information is applicable to any film.

Choosing a Stock Agency

Many photographers have made the decision to market their stock images through an established stock agency rather than deal with all the paperwork and follow-up. For them, using an agency has proven to be a successful way to realize financial rewards for pictures that might not otherwise reach the marketplace.

The decision to pursue agency representation is an important one and requires considerable thought and research. There are, of course, advantages and disadvantages to using a stock agency. Also keep in mind that it is not as easy as it once was to find and get into the agency that is right for you and your pictures. There is increasing competition among photographers, as overcrowded agencies are becoming more selective and as more agencies are being acquired by major corporations as consolidation sweeps through the industry.

While getting into the top agencies is harder, there are more new agencies beginning to appear, and this does provide an opportunity for photographers to get into stock. But, new agencies are going to have their own battles carving niches in this very competitive business.

In this section are many factors to consider when choosing an agency, and one question that should be asked is this: Is it realistic to expect to receive all the information you request from an agency? This was posed to several leading agencies and the consensus is yes—if the agency is interested in representing you. As is mentioned in the section called "How to Choose an Agency" below, don't expect to walk into an agency without their having any knowledge of you or your work and have every question you ask answered. They simply don't have the time to do this.

However, once an agency is interested in you, you deserve, and can expect, honest answers. And will these answers really be indicative of the relationship once it starts? Time will tell, but before signing any contract, be fully aware that a bad contract can be disruptive to your business. It may even put you out of business. A good agency, a good contract, and a good business relationship, based on a creative and business partnership, can be wonderful for a stock photographer. There are many successful photographers who will attest to that.

Study the model ASMP stock photography contract and the MP©A agreement, and before you sign anything, ask if your intended agency's contract is similar to it. Signing a contract is a major commitment, and the majority of problems concerning agencies

that photographers bring to ASMP could have been avoided at the contract stage. Most of the agency contracts that ASMP sees don't meet minimum standards of the model ASMP contract.

How an Agency Benefits You

- Increased earnings: A stock agency is in constant touch with a wider range of market contacts than you are likely to reach on your own. More important, photo buyers know each agency and call regularly with photo requests. What the agency offers you is an established reputation in the marketplace and a range of contacts it might take you years to develop.
- Full-time availability. A stock photo agency is always available for client requests. While you may be out on a photo assignment or business trip, it is there to answer calls and sell pictures for you.
- Clerical service. The agency handles the tiresome paperwork, freeing you to shoot new photographs. Logging, filing, remounting, and invoicing are extraordinarily time-consuming, as well as costly.
- Partnership in the stock business: A good agency can help you develop your direction in shooting for stock and can guide you in needed photo topics and salable style. Most provide "want lists" and share valuable market research, so you can be aware of current requests and gear your shooting accordingly. Additionally, good agencies are able to stay current with their marketing and electronic distribution efforts.
- Higher prices: Professional staff at good stock agencies use information gleaned from continuous daily contact with clients to maximize licensing prices. They know what different usages are worth to their clients and they can be more objective than photographers in the negotiation process, since the photos are not their own. Even considering the percentage paid to the agency in commission costs, many photographers find that their share of the license fee is often higher than what they would have charged had they been making the deal themselves.

Drawbacks to Using an Agency

- Commission costs: Most agencies keep 50 percent of the reproduction fee. It's important to remember, however, the work the agency saves you and the overhead it carries to be in a location convenient to clients. Of course, you may prefer to keep 100 percent of the sale income and do all the work, including all the marketing. It is sometimes possible to use an agency and sell stock yourself if you are scrupulous about any conflict—although today more agencies are requiring exclusive contracts.
- Exclusive agency contract: This kind of contract limits your options to sell stock in other geographic areas with additional agencies and could limit your ability to

sell your own images.

- Loss of control: Once a photo is entrusted to the agency, you leave the decision making to the agency representatives. With few exceptions, you no longer have a say in where your work is sent and how it is used. The agency selects which pictures are sent out, negotiates the deal, and agrees on the price. You learn the results when you get the sales report.
- Volume sales: Photographers often complain that their agencies give discounts on volume sales, which reduces the amount per photograph the photographers receive. Ask your agency if it gives volume discounts.

If you decide that using a stock agency is the route for you, the most important step you will take is the first one: finding the most suitable stock agency. It is not so easy or casual as it once was. There are so many photographers looking for agencies that the agencies have become very selective, and you may not be accepted by your first few choices. You must then consider whether to wait until your collection and reputation grow or look carefully at some of the newer agencies, many of which are doing an excellent job.

How to Choose an Agency

In one sense, when you put your pictures in the hands of a stock agency, you are putting your children out for foster care. You want to feel that they'll be tended carefully, sent out into the right part of the world, nurtured to realize their greatest potential, and finally be able to support you in your old age.

Naturally, as a business person, you want to reach agreement with the foster parent about your children's importance and potential. You're aware that this is a process that may take years. For these reasons, you want to find an agency where there is an atmosphere of shared interests, of free exchange of information, of trust in both financial honesty and marketing judgment, and of collaboration. Your own personal needs and market targets are going to make a difference in your final choice, but the best indicator is that indefinable but very real sense of being at home, in a place that's right for you. How do you find this place?

Choosing a stock photography agency to represent you involves a process of research that combines self-understanding and knowledge of the field. Because the relationship is so much like a partnership, a "marriage" if you will, you should go into it with your eyes open and a full understanding of your own and the agency's needs, wants, and conditions. Anything less could result in problems later on.

The first step is to begin with self-examination. Edit the selection of images that you plan to submit for evaluation, grouping them by subject and eliminating any that have technical flaws or need excuses. Often, as editors are looking at a prospective photographer's work, they are barraged with a steady stream of explanations of the work, including comments such as, "I couldn't shoot from the position I wanted because there was a wall, a tree, etc."; or "The light wasn't great that day, but isn't that an interesting shot?"; or "The models brought their own clothes—I would've dressed them

in . . . " Your submission should need no explanation or excuses.

Make sure that what you show is your best work. There is no reason to show more than one frame of a particular shoot, unless the shots make up a definitive editorial series. Even when you are visiting an agency in person, select your work as if you were dropping off your stock portfolio or delivering it by courier. Just as selecting work for an assignment portfolio, include only your very best work. Then, once you have captivated the interest of the editor looking at your work, you can set up an appointment for a more in-depth review.

Use brand new, clear vis sheets for presenting your samples. Remember, as editors get their first impression of your transparencies with their professional, sharp, loupes, any dirt or hair on your chromes or in the sheets will be magnified as well. Absolutely do not send old transparencies, no matter how beautiful the subject matter, if there is any fungus growing on the film. Make a reproduction-quality dupe instead and show that. Agencies must be on guard for fungus, as it can spread and infect a whole collection.

Make sure that your entire package is professional looking and don't forget to include your name and address. Every agency has a place where it stores submissions that were received without a return address, and sometimes without the photographer's name. Stamping your slide © Smith is not enough identification.

Finally, wait until you know that a stock agency is specifically interested in you before you submit your stock agency "questionnaire" to the editor or agent. While you have every right to know what to expect from an agency, keep in mind that busy editors do not have the time to answer a general questionnaire from every photographer, though they will be happy to discuss every detail with the photographer they would like to represent.

The next step is finding out where you fit. What do you want the stock agency to do for you—what "image" do you want to project to the world? Agencies have distinct characters, and the one you choose can have as much to do with your career as your style of photography. Remember: You're dealing with your professional reputation, your pictures, and your "eye." Where do you want to see your work? What kind of photography—and other photographers—do you want to be associated with?

These factors should be weighed when determining which agency to join—in many cases, it may come down to a question of style, and the choice you make may color how the world views you and your work.

How do you discover the agency that matches your needs? First, you should realize that although stock agencies are all in the same business, they each go about it in a fairly distinct way. It is no understatement to say that agencies have personalities and that these personalities are, in large part, determined by the individuals who run the business. Their particular styles—and the real distinction between different agencies— should become apparent as you do your research.

There is a great diversity of sizes among agencies. There are big, small, and mid-sized agencies. Some have forty employees and others only two. It's said that larger stock houses, which have sales people on the road and printed catalogs, will bring in more cash faster. It's also said that smaller agencies take a more personal interest in their photographers and promote them more diligently. Another view is that a photog-

rapher starting out should go and grow with a new agency. As you can see, the choice depends on your personal needs and requires investigation, not assumptions like "bigger is better" or "smaller is more intimate."

There are agencies that accept 35mm color only, while others welcome black-and-white in addition to color or prefer large-format style and size.

Comparing your work to published samples of stock agencies' files is an excellent way to narrow down the list of agencies you intend to approach. One such stock agency directory is *The Stock Workbook*, published by Scott & Daughters.

Agencies are located all over the country and serve a variety of markets. Some have a longstanding reputation in the field, while others are just beginning with aggressive marketing and the latest in sales technology. Keep in mind that despite the increased competition to get into any agency, there is always demand for new talent—the picture-buying market is in a growth period and requires a constant flow of fresh material.

Certain information will help you narrow your field of choice of stock agencies, such as:

1. Agencies that are in your geographical area: You might want to start with agencies that are close to home, although in this day of overnight express services it's certainly less important than it once was to have an agency right around the corner. Clients visit agencies in person less and less, and once digital transmissions become the standard method of submission, the location of the agency will not matter at all. Regional agencies used to market only within a set boundary. This is no longer the case for most agencies. With courier services and high-speed telecommunications, it's possible for every agency to operate worldwide from any location. This also presents a new set of problems for U.S. agencies that do not have exclusive arrangements with their photographers. Sometimes, foreign agencies start selling work in the United States by photographers who have signed with U.S. agencies. More of this back-door marketing could result in more conflicts.

 A point to keep in mind is that the most important part of searching for an agency is not location, and it's not even subject matter. Probably the most important element is the creative partnership. Can you talk to someone in the agency to get feedback on your work? Do they give you ideas about what to shoot? Will they help you explore your own ideas so you can produce more marketable stock? Each agency has its own personality. Find one that suits you best.

2. Agencies that market pictures in your specialty: Agencies can be eliminated from consideration if they don't accept the type of pictures you have to sell. For example, if your stock is weighted toward the recreational-leisure market, you won't be right for an agency that specializes in industrial pictures.

3. Agencies that serve the particular markets you want to sell to: There are agencies that concentrate on supplying images to specific markets, such as educational, medical, high-tech, news, or celebrity accounts. If you have a substantial number of people pictures, but none of them are released, you should check out editorial-type agencies. Released people pictures, on the other hand, might make more money for you with a stock house interested in the advertising markets.

4. Agencies that serve the geographical area where you want representation: Some

smaller agencies serve only a limited geographical area and don't mind if you have contracts with other agencies outside that area. If your files consist mostly of local subjects—skylines, local architecture and points of interest—then a local agency, large or small, is the best way to go. However, keep in mind that acceptance will depend on your material being up-to-date and more interesting than what they already have on file.

5. Agencies that are new versus older, established agencies: You have a better chance of having more pictures selected by a new agency that hasn't filled its files than with an older, established agency. However, if you sign with a new agency that does not have a track record of success, you cannot know how long the agency will stay in business, thus putting at risk everything you have invested. If you do sign with a fledgling agency, be sure you know the owners and feel confident that they understand the stock business.

Observing the photographer/agency credit lines on pictures in publications in which you would like to see your work is another way of pinpointing the agency for you. It can also be an indication of the style of picture the agency keeps on file and sells. A trip to a library to leaf through different kinds of periodicals can be very informative.

Perhaps one of the most important sources of information is your peers. The experiences that other photographers, art directors, and picture buyers have had with various agencies are firsthand pieces of information that can help round out your research on an agency. When you attend photographic meetings and seminars, or just in the course of your daily business, put the word out that you're considering X, Y, or Z agency and then listen. You might be pleasantly surprised, or you might hear stories that make your hair stand on end. Ask the picture buyers in your field which agencies are their first three choices when they need a particular shot and why. Although some tales might need to be taken with a grain of salt, you'll begin to get an impression of how different agencies do business.

The most valuable information may come from your own assignment clients. Ask them which photo agencies they use and why. If their reasons for naming an agency are top quality and good service, you've gained an important insight. In fact, your clients should top your list of best sources for information about a photo agency, which are:

- Clients
- Other photographers
- ASMP publications and meetings
- Photo credits and tearsheets

Keep in mind that the reputation of an agency is important not only because it affects sales but also because it reflects on you as a member photographer. Your name becomes associated with that of the agency. The realities of what occurs after the initial agency-photographer courtship are what should interest you. The way an agency really deals with photographers and their pictures is of vital importance. A disregard for either could affect your entire career.

Do you want an agency with a highly targeted market focus, or one that serves gen-

eral markets? Do you need monthly rather than quarterly payments? Do you require tearsheets? Do you expect reports on exactly where the pictures are used? Do you value regular "want lists" notifying you of pictures wanted immediately by the agency? Do you desire a consulting type of relationship with the agency, or one that leaves you alone to follow your own instincts?

What you're doing is narrowing your focus, finding the dozen or so agencies closest to your "ideal" profile. Once you've arrived at a broad list, try to narrow it again to five or six. You might discover new factors as you go through the process. For instance, does the agency have foreign sales connections? Do agency representatives refuse dupes? Do they have special buyers for your work?

Once you've compiled a list of prospective agencies, make preparations to visit them. Contact them first to learn about their interview procedures and, before you go prepare your questions and portfolio because these visits are very important. Put together a fair and representative selection of your work in the style and numbers preferred by each agency. Caption your photos as if they were going right into the agency files that day. Don't show anything you wouldn't want published—don't lead the agency, and ultimately yourself, down the wrong path. You are going in as a professional, and your portfolio should reflect that fact.

Your first visits might be to the agencies closest to you; the next, to those on your list that have the best recommendations and where your specialties or favorite subjects seem to fit best. At the time you make an appointment with an agency, put in a request for a tour of the operation. Don't arrive assuming you will be ushered around if you haven't advised the agency of your desire beforehand.

When you make your initial contact, be frank about the fact that you're researching agencies. Ask for and discuss a sample contract; take it home and study it. Compare its provisions with the ASMP prototype in this book. Consult a lawyer. Talk it over with other photographers who have stock agency experience. If there are clauses that are offensive, get the help of your lawyer to work out alternatives that will satisfy your needs. Be realistic and be prepared to negotiate, even to compromise. For each agency, measure for yourself what you stand to lose as well as gain.

If you are prepared and businesslike, you should expect agency personnel to be as frank with you as you are with them. But remember: No business person can afford to spend an enormous amount of time interviewing you. Follow-up appointments will give you time to digest the information obtained on your first visit. And remember that the research you do while trying to find the right agency is just the beginning. Once you have signed with an agency, it's important to continue a careful analysis of its performance and yours.

Your knowledge about an agency will be greatly enhanced by giving it a good looking-over on your tour. You are a photographer and should know how to use your eyes. Refer to the "What to Look for" list provided in this section and make mental notes of what you see. A large stock house dealing mostly with advertising clients might have an impressive reception room, and an agency serving the lower-paying editorial markets might have more modest premises, but those are not necessarily indicators of the volume of business the agency handles. You have to look closer to gauge the prosper-

ity of an agency and the care with which it handles images.

The answers to the questions you ask should confirm your research and assumptions as well as fill in the gaps in your knowledge of the agency. It can be helpful (especially in agencies with large, departmentalized staffs) to talk with the editor of incoming material and the picture researcher who chooses pictures to send out. They can be specific about the image of the business.

On the business side of the operation, the watchword is communication—the exchange of information. Remember: You are investigating an enterprise that may be quite new to you, one to which you might be entrusting your valuable images. Don't be hesitant—make straightforward and vigorous inquiries. At the same time, the agency wants information about you: how you work, what subjects you like to photograph most, your plans and aspirations for the future.

The way a stock agency looks at your samples may be quite unlike what you're used to in assignment work. In general, don't expect much comment. The agent is trying to figure out whether the work you are offering, or seem capable of producing in the future, will make money for the agency over a period of time. If the answer is in doubt, some alternative directions might be pointed out to you; perhaps another agency will be recommended.

One very selective agency has a submission guideline that states its position quite succinctly: "Unfortunately, we are also unable to give free critiques, career guidance, or commiseration on the financial woes of photography. We urge photographers not to take rejection by us as any kind of comment on the merits of the work, but solely on its usefulness to us right now." Some of the top producers in stock photography have occasionally been turned down by agencies and have gone on to be very successful with other agencies.

Another very selective agency lists the qualities it looks for in a photographer and includes originality, a quality that should not have to be spelled out, and commitment, which is every agency's continuing problem with photographers. Big promises, little delivery!

So, for a good, long-term relationship in the stock business, each party needs to understand the other's needs and accept them. Listen to your instincts: If you find yourself uncomfortable with any part of the setup, say your polite good-byes and go on to the next agency on your list.

When you arrive at the point in your search where you feel a sincere interest in working with a particular agency, it's quite proper to ask for the names and phone numbers of one or more of its photographers. When you call these other photographers, be straightforward and clear about why you are calling, stick to the business at hand, and respect their confidences. In the final analysis, the stock agency is a go-between matching photographers and buyers, and your queries about a particular agency will help you in making a decision.

The ultimate question you should be asking yourself is this: Do I want this agency to handle my pictures? A good agency-photographer relationship is based on trust, and, ideally, this sense of trust should run deep. If problems arise, a photographer's first recourse is likely to be his or her personal relationship with the agency. This is espe-

cially true in terms of intangibles, such as the agency's aggressiveness in pushing its photographers' work, its efforts to keep its photographers up-to-date on the needs of the market, and its care in physically handling irreplaceable originals.

You should feel confident that the agency will support your career plans and goals, and that it will go to bat for you in other ways, such as going to court to sue for damages to chromes or for infringement of copyright.

At the same time you should realize that you, the photographer, are accepting what can only be described as a "calculated risk" when you physically deposit your photographs in the files of a stock agency. Insurance against loss or damage, even if it were available, would be prohibitive in cost for either of you. Consequently, in typical contracts, "gross negligence" is the only basis of agency responsibility, and it behooves you, before deciding on an agency, to satisfy yourself that reasonable and professional care is being taken in the handling of images.

An interesting dilemma is surfacing as more working photographers become involved in the ownership of stock agencies. On the one hand, all the photographers contributing to the agency benefit if, as a consequence of ownership by a photographer, the agency's philosophy and procedures reflect the love and respect of photographs that a photographer is bound to have. On the other hand, the realization that the owner's photographs are in the same stock file as yours can leave a little nagging doubt, if the owner has a substantial percentage of sales. The question then is, What percentage of sales are by the owner of the agency or members of the staff? When the number is relatively small or inconsequential, there is no cause for concern. Even if the percentage is as high as 25–50 percent, the degree of risk (of favoritism to insiders) is reduced by the professionalism and quality of the agency. The policy of the agency should always be to send appropriate selections that answer the client's request and that are the agency's best offering, so it can make the sale. Certainly, agencies can't stay in business on research fees (many don't even charge those anymore), nor will they stay in favor if they send their clients stacked submissions using work of favored photographers, if the work is not appropriate for the client's request.

Another important question is whether the agency offers any of its photographers contracts with "guarantees." If it does, then it may succumb to pressure to license the work of those photographers at the expense of the rest. Any agency that pushes the work of a particular photographer, be it the owner or someone else, risks its reputation with clients. The only solution, if this situation exists in an agency that interests you, is an open and above-board discussion before any contract is signed. The agency, too, will welcome it.

It is also important to find out how much competition within the agency you'll face from other photographers who have a specialty similar to yours. Will you be one of two or three specialists in aerial photography, or does the agency plan to take the work of every good aerial photographer it can—thus diluting the strength of your work within the file?

Another emerging concern is the competition being created from within agencies by in-house or work-for-hire photographers who produce stock images that are owned by the agency. This is particularly worrisome to photographers, since conglomerates that

have acquired other agencies direct their staff or work-for-hire photographers to produce stock images that might be very similar to those already in their files. Some photographers have complained that their own agencies have produced work almost identical in style and content to their own, thus virtually eliminating any chance of sales of freelancer-created photographs. This practice means that the agency is no longer representing its photographers but is in direct competition with them. Find out if your intended agency produces such in-house images.

Also investigate foreign representation. Numerous U.S. agencies work directly with foreign agencies and thus can offer an expanded potential market for your work. If an agency does offer this service, find out what checks they have on the foreign agencies and how they handle foreign sales. It is also possible to deal with foreign agencies directly yourself, but it is important to find out as much as you can about these agencies before you enter into any agreements.

After you've done all the research, take some time to consider the best course. Presumably, you've explored more than one agency and have a basis for comparison. In the end, you should want to work with the agency and have a real feeling of support and enthusiasm for, and from, the agency you choose.

Some photographers choose to go with more than one stock agency, citing geographical and specialty considerations. Such a decision needs to be discussed openly with all concerned. It's important to avoid any conflict of interest, especially when it comes to the selling of certain rights. It's crucial to nurture a sound relationship with a primary stock house, and the issue of giving material to one agency after signing with another is a touchy one that is best resolved through communication before the fact.

It is definitely not permissible—in fact, it's unethical—to offer a second agency material using a pseudonym, even if you think that the work does not conflict. Discovery of such dealings could result in public exposure and difficulty in obtaining representation with any reputable agency in the future. If you want to work with more than one agent, be frank with each of them, up front.

Keep in mind that exclusivity in agency representation seems to be the wave of the future. Agencies that insist on having an exclusive contract cite the various difficulties in negotiating complex and lucrative photo sales without being able to guarantee the media or time restrictions that the photo buyer requests. Additionally, some authorities maintain that electronic media, such as CD-ROM and digital transmission of images, make representation by more than one agency redundant. Imagine a client calling several agencies only to receive the same material by electronic transmission (at his expense) or searching a CD-ROM catalog only to find the same photo popping up based on his search criteria. The result? He would get prices from each and license from the cheapest. This is not a good situation for the photographer.

Non-exclusive contracts can also hamper the agency's ability to make deals with foreign agents, some of whom would be breaking the laws of their country if they claimed exclusive representation when, in fact, the photographer had photos in several other agencies. Also keep in mind that Europe, considering the European Union (EU)—and, in fact, the world—is becoming a more united market, especially because of the advent of electronic media and transmission.

In addition, some agencies spend time and money helping their photographers develop a stock career and in the process share valuable market research that, they argue, might benefit a second or third agency if their photographers were not under an exclusive contract. Hitch your wagon to one star is their advice.

Some agencies, however, are quite content with non-exclusive contracts, even of images, and will allow photographers to sign on with other agencies. This suits photographers who choose not to put all their eggs in one basket. The "star" agencies can handle only so many wagons. This has become even more prevalent with consolidation within the industry, and some photographers who have long enjoyed representation by an agency have suddenly found their contracts not being renewed and their images returned. Finding another agency and starting from scratch can be very difficult. So each photographer must find a workable solution for his or her own business circumstances.

Some photographers have said that finding the right stock agency is like finding a good doctor. Some stock agents liken the intimacy of the relationship to marriage. Whatever the analogy, it's clear that a common thread to the arrangement is trust. What makes photographer-agency relationships work is personal compatibility, confidence that all parties are working toward shared goals, and agreement about professional standards and ways of working.

Remember that when you give your images over to a stock agency, they'll probably be in its files for many years. Take your time, and keep searching until you find an agency that gives you the feeling of trust as well as one of professionalism and good marketing skills. Then, go into the relationship with the idea of making it one of mutual satisfaction and profitability.

What to Look for When Visiting Prospective Agencies

1. Is the location of the agency convenient to visits by buyers? Is business conducted by mail and messenger?
2. Is there a reception area? a receptionist? Are photographs on the walls?
3. Is your first impression on entering the premises one of professionalism?
4. Do visiting buyers have direct access to the photo files? Are there separate viewing rooms for clients, and are buyers serviced on a one-to-one basis?
6. Are there signs of food and liquids in the picture-handling area? Is it clean?
7. Are good image-preservation practices observed? Is the photo-file area dry and cool? Are color transparencies unnecessarily exposed to sunlight? Are archival-quality materials used?
8. Are the furniture and equipment of good quality and in good repair?
9. What kind of protective packing is used to protect photos leaving the agency by mail, by messenger, or by researcher? Does the finished package look professional?
10. Does the agency use registered and Express mail and bonded couriers?
11. Do you get the impression that the agency staff members are talented and respect

photographs? Do they act and talk as though they were committed to the agency?

What to Ask

1. Do you publish a catalog? What do I have to pay to have my work included? Are my catalog costs deducted from commissions? Are the deductions from the specific image sale or from my total catalog costs? In other words, if a catalog image doesn't sell, am I charged for its inclusion in the catalog? Does the agency have a Web site and how do agency representatives select the images that are promoted on the Internet?

2. Will I be required to participate in advertising sponsored by the agency?

3 Are photo buyers charged a research fee? Is it deductible from the reproduction fee, and in the event of a sale, is the photographer's commission calculated on the total amount the buyer paid?

4. Are "holding fees" charged when buyers keep material beyond a specified time, and does the photographer get a share?

5. Do you secure assignments? How much is your commission?

6. How much do you charge buyers for lost or damaged chromes? What percentage goes to the photographer?

7. If dupes are made of my chromes, who pays for them? How much? Are these the actual costs? Do you charge subagents for dupes? What happens to the dupes if I leave the agency?

8. What happens to my photographs if there is a change in agency ownership? Bankruptcy? Death of the owner?

9. Is my permission required before you agree to a buyout?

10. If you sell in foreign countries, what copyright protection do I have? Also, are tax credits from foreign sales passed on to photographers? Some countries have a tax credit agreement with the United States to avoid double taxation. What bookkeeping procedures are in place to ensure that these credits benefit the photographers as well as the agency? Given the global market for stock photography, this is an important issue.

11. How do you maintain contact with photographers?

12. How many photographers do you represent? How many are major contributors? Will you supply me with their names?

13. How many color images do you have on file? How many black-and-white? How often do you edit the files for outdated material?

14. How many images does the most successful photographer have on file? Approximately how much money does this photographer net per year?

15. What market area (advertising, editorial, books, magazines, etc.) are you strongest in?

16. Which agencies are your strongest competitors?

17. Do your files contain photos by agency staff or owners?

18. Do you work with foreign agencies? If so, how often do you visit them? What are your accounting procedures for foreign sales? Are funds from foreign agencies kept in a separate escrow account?

19. How many years is your contract?

20. Does your contract contain a "first in/first out" provision? (This means that the time-period provision of the contract applies to each picture individually, starting on the date each photo actually enters the agency files.)

21. Is the renewal provision in the contract an automatic one, binding the photographer to an additional contract period automatically, unless the agency is legally notified within a certain time period?

22. Can I see a typical sales statement? Does it specify the rights that are granted and the fee for each sale? Is the buyer identified? Is the photograph identified? Is one person responsible for bookkeeping?

23. May I have a copy of your delivery/invoice form? Are the terms comparable to those on sample ASMP forms?

24. Does the agency have a photographer relations group to voice photographers' concerns and suggestions to agency management?

25. What fees, apart from agency commissions, does the agency take from its photographers?

26. Is the agency involved in producing clip art, royalty-free CD-ROM disks?

27. Does the agency produce CD-ROM catalogs, and if so, what protection devices are used to prevent infringement?

28. What agency reports are regularly available for review?

29. Does the agency provide regular want lists?

30. Are volume discounts given, and are they a normal part of doing business?

31. Do you send photographers their money monthly or quarterly? Are sales reported when they are made, or paid for?

Questions to Ask About Catalogs

Because catalogs represent such a high percentage of sales, as much as 50 percent, photographers should know about the agency's catalogs. You should ask about the number of pages in each catalog and the frequency of publication; ask if the agency produces catalogs covering specific categories (e.g., industry/science, nature and wildlife; lifestyles; people) and what the normal print run and circulation is (within the United States and internationally).

Also ask how the catalogs are being delivered to clients; what the agency estimates the longevity of the catalogs to be; whether any individual photographer has an advantage in the catalog.

The following DO's and DON'TS, provided by Susan Turnau, the former president of the stock agency Sharpshooters Inc., which was acquired by Corbis, constitute valuable advice.

DO have a realistic idea of your work.

DO your homework—research which agencies are most likely to file your work.

DO send for submission guidelines first.

DO follow instructions to the letter.

DO send reprints from trade directories or other printed promotion pieces as a first "teaser" with a letter.

DO present only your very best photos. (Remember the old advertising slogan, "The quality goes in before the name goes on.")

DO make sure your presentation is clean, orderly, and attractively packaged.

DO make sure your name and return address are included, as well as return postage or courier account number, as required.

DO ask clients, as well as peers, which agencies they prefer for material like yours.

DO find out about the agency's payment records—are they up to date in payments?

DO make sure you understand the contract. If you don't, or if it is in "legalese," take it to your attorney.

DON'T send unsolicited material to agencies unless you don't care to have it returned.

DON'T promise to send a new stock shoot each week if you aren't set up to produce it.

DON'T promise to send new submissions only to have your agency call ten times to get you to send the package.

DON'T ask your agency to help you with what you should shoot, only to ignore its advice and shoot something entirely different than what was discussed.

DON'T call your agents to see what's out to clients and then keep bugging them to see if the clients have decided yet.

DON'T call continually to see how much money is on the books so far for this payment period.

DON'T expect miracles. If your work isn't good enough to get assignments, chances are stock buyers won't want it either. Aim for constant improvement. Even photographers at the top can't afford to just get by with shots that are "okay for stock."

DON'T spend all your income from stock for living expenses or vacations. Put some of it aside to bankroll future shoots.

Where to Start Looking for an Agency

In addition to asking fellow photographers, clients, editors, and others in the industry about agencies, there is another valuable source: trade associations established by agencies. In the United States, the principal group is PACA, the Picture Agency Council of America, whose goal is to develop uniform business practices within the stock photography industry, based upon ethical standards established by PACA. The organization serves member agencies, their clients and their contributing photographers. PACA publishes a directory of its more than 100 member agencies and from this can be gleaned some basic information about each agency, its specialty, and principal contacts. (At the end of this section are listed several international agency associations.)

The Stock Workbook also lists numerous agencies, including some international ones. Another source of agents, and buyers, is the *Photographer's Market*, published by Writer's Digest Books, 1507 Dana Avenue, Cincinnati, OH 45207.

Several countries also have agency associations. To make contact with a foreign agency, get in touch with the association and request a list of its member agencies.

A very useful European group is CEPIC, which is an umbrella organization for about eleven national associations in eight European countries—France, Germany, Great Britain, Italy, Norway, Spain, Sweden, and Switzerland. CEPIC represents the interests of more than 600 photo agencies and libraries and some 30,000 photographers. Lists of its member associations and agencies can be obtained by contacting CEPIC (see below).

The following will help photographers reach a large number of agents.

- Picture Agency Council of Ameria (PACA)
 P.O. Box 308
 Northfield, MN 55057-0308
 www.stockindustry.org
 Phone: (800) 457–7222; Fax: (507) 645–7066

- Japan Photo Agency Association
 Orion Press
 1-13, Kanda Jimbocho
 Chiyoda-ku, Tokyo, 101, Japan
 Phone: 3 3295-1402; Fax: 3 3295-1430

- Coordination of European Picture Agencies (CEPIC)
 Teutonenstr. 22,
 D—14129 Berlin, Germany
 www.cepic.org
 Phone: 49 30/804-85-420; Fax: 49-30/816 994-35

Internet Stock Photography Information

Think of a topic on stock photography, including agencies, and chances are you can find it on the Internet.

Elsewhere in this publication is more information about stock and the Internet, but photographers should be aware that learning to use the search engines on the Internet (Yahoo, Lycos, Excite are examples of search engines) is the key to accessing information. Also, there are search engines that will go through all existing search engines to find information.

There are many excellent stock photography sites and online forums on the industry but because Internet addresses change, and sites are continually being updated, we have not listed specific Web addresses (URLs) here.

Most pages have links to other sites and accessing the page of a major corporation—film or camera manufacturer—will invariably provide links to other sites, including those specializing in stock photography. Another starting point could be Web sites of leading schools of photography. Try searching for "stock photography" and undoubtedly you will find a multitude of options.

Once a good site is located, it will probably have links to other sites, so you can cruise endlessly if you want to. To save time, and make efficient use of the Internet as a resource, it's advised that you be as specific as possible in your search.

Working with an Agency

Perhaps the most important aspect of cementing a long-term relationship with an agency is to treat the alliance as a creative partnership. One of the main complaints most agents have about their photographers is that they don't listen to what the agency needs. Agents send out want lists that go unheeded. Photographers who use the lists—create shooting scripts that not only encompass the subject matter but also reflect the photographer's own vision and style, and then produce the sought-after images—are on the way to successfully working with their agent—and making money.

Most successful stock photographers who use an agency work closely with that agency. They update their files regularly, and they listen carefully to suggestions from agency personnel. A successful relationship takes commitment and concentration.

Another usually overlooked facet of working with an agency is to promote your association with the agency. For instance, one leading agent comments that when photographers have articles written about them, they fail to mention their agencies. Agencies are always looking for ways to promote their photographers, but they cannot reach everyone. To have an agency mentioned in an article can boost sales.

Helping Your Agency Help You

Here are some tips provided by prominent stock agency owners and managers:

- Be as businesslike with your agency as you are with your own clients.
- Organize your submissions as your agency photo files are organized to speed your material into the pipeline—and earn more money sooner.
- Add new material consistently. You can trigger a sharp increase in sales this way.
- Edit your shoot before submitting. Your work will get into files faster. (And the editor in charge of reviewing your submission will love you for it.)
- Include complete and accurate captions. They can double the value of your stock photos.
- Provide model and property releases. They are money in the bank.
- Work with your agency. This should be a creative business alliance with equal partners and equal responsibilities.
- Pay attention to the agency's shooting advice. They are in touch with the market every day.
- Stick to your strengths and apply them to the agency's want lists.
- Be realistic about your expectations.
- Listen.

The photographers who make top money follow the advice above. There is no magic formula for success in stock; rather, it is a combination of many factors, including commitment and working closely with the agency personnel who have great insight into what the market needs.

Stock agency personnel work with dozens, sometimes hundreds, of photographers. And they work with stock images and buyers all day, every day. Most are actively in touch with colleagues throughout the industry and the world. The following advice is

based on the extensive experience of leading agency personnel. Heed this advice, apply it to your situation, and it will enhance your chances of succeeding in a very competitive field.

Expectations. One of the frequent questions photographers ask is how much annual income to expect from a stock file. Your agency can help you arrive at a realistic estimate, but keep in mind that it's an estimate. If you are new to the agency, allow at least twelve months for a tentative evaluation and two years or more for a dependable assessment. Not even the best agent can guarantee exactly how your stock will sell in the future. There are too many unpredictable variables: market trends, the popularity of a particular shooting style, hot subjects, social trends, big individual sales, a recession, and so on. Over a few years these variables can cancel each other out—but you never know for sure.

Your agency can, however, evaluate your competition. It knows how many other photographers within the agency, or within the field, have material similar to yours. They can also help you analyze your work. Do you have sufficient images of subjects currently in demand? Does your style fit contemporary market requirements? One agent comments: "A big downfall of many stock photographers is not analyzing their own work realistically. They seem to lack an overall perspective of the field."

Another criticism is that photographers do not really understand stock and lack the insight that agencies have, based on thousands of photo requests. True, photographers can see in catalogs and major advertising examples of thousands of stock photographs, but what they don't see are the brochures and trade publications where most stock is sold.

This can lead to both a misunderstanding of what will sell, and unrealistic sales expectations of their own work.

So, let your agent help. Don't be defensive when submissions are rejected. Listen and learn; it can influence how successfully you shoot stock in the future. You and your agent are, or should be, a team and if a photographer shows a willingness to learn and shoot images based on the agent's input, the agent will be more willing to work closely with you. You should analyze your stock before choosing an agency, but it's an ongoing process. Set goals. If they are realistic, your energy can be spent in meeting them, not in quibbling with the agency.

Shared responsibilities. Attitude plays a key role in maintaining positive, ongoing relationships. If you and your agency acknowledge that you are equal partners, you will accept equal responsibilities. For instance, you will appreciate that a "wait-and-see" attitude after an initial submission of 500 images is not the way to enhance the alliance. It is not a one-way street. You must continue to contribute and build your files if you want to maintain a productive relationship.

It's imperative that you work with your agency. It should not be an adversarial relationship. Make sure your agency is doing its best to sell your work, but also ensure that you are doing all you can to help your agency. You should have, and should expect, close contact, honesty, and openness with your agency.

Good agencies are open to photographers' grievances and complaints; at one agency a photographer is asked to act as a "photographer liaison" each year. He or she is part

safety valve/part ombudsman, passing on photographers' concerns to the agent. Informal mediation is accomplished, doors are left open, and a climate for creative ideas is produced. When seeking out an agency, you should inquire if such as mechanism exists.

Professionalism. Treat your agent as you would your client. One agency complains that some photographers wouldn't stay in business if they treated their clients the way they treat the agency. And with today's competitiveness, slipshod business methods just won't cut it. Don't expect agency staff to do the "drudge work" of sorting through a bag of unedited, uncaptioned images. Agency staff time spent redoing photographers' work benefits no one. In fact, most agencies would probably return work submitted in this fashion and request that it be supplied in a more professional way.

Editing and organizing. An intelligent edit, organized by categories similar to the agency's system, will simplify the agent's job and get your pictures into the market faster. The less energy the agency has to put into organizing a chaotic submission, the more time it can spend on marketing the work. Also, it's preferable to send new material that gives in-depth coverage of each subject. Include different views of the same subject, with verticals, horizontals, close-ups, and details. Although single shots that are excellent will always sell, a mixed bag of subjects is less valuable for an agency file than good coverage of one topic.

Captioning. Agents say that photographers who have not worked in the selling end of the business don't understand the value of captions. They maintain that a full and accurate caption can often be the deciding factor in selling a picture competing with an equally good shot that is vaguely captioned. With the computerized captioning and labeling systems available today, there is no excuse for captions not to be professional and complete. It's a tedious task, but the photographer who wants to compete should make every effort to caption images accurately and completely. When on location, keep notes that you can refer to later—don't rely on memory. And, agents urge, don't be a one-word caption writer, trusting your memory when and if the picture is sold. There might not be time to contact you, especially if you are on an assignment and the client has a tight deadline. In captioning, follow the journalism guide of who, what, where, when, and why for each picture. Trying to piece together the information of a long stock shooting trip after the event can be difficult; important information can slip through the cracks. Some photographers keep track of where they've been by noting the route information in color on a map of the area; specific subjects shot (e.g., monuments, icons) are noted on the map in another color. The details are cross-referenced in a notebook and at the end of the trip all the information is there, including film numbers. The systems used are individual choices but the message is this: Support your images with detailed captions.

Model and property releases. Releases dramatically increase the sales potential, and value, of your stock. Without a release, images that have identifiable people cannot be used for advertising, which pays better than editorial. Even if you are in a foreign country, it's advisable to obtain a release if you can. Veteran stock shooters who travel frequently will often take releases in the language of the country they're visiting, or have a translator or guide explain to people the reason for the release they're sign-

ing. It can be difficult to have an English-language release signed in a foreign country. If your agent has a subagent in the country(ies) you're visiting, have the agent translate your releases and take a supply with you. At a time when stock is being used globally, releases are more important than ever. Of course, if your material is intended for editorial purposes only, generally a release is not needed. Agents agree that photographers should get them, file them, mark *MR* or *PR* on the mount, and, above all, be truthful. To falsely state that you have a release could land you, and the agency, in legal hot water. Each agency has its own system for recording and confirming the existence of model releases. The ideal, from the agency viewpoint, is to submit a photocopy of the release with the picture.

Fresh material. It is not uncommon for photographers to run hot then cold. They start by submitting an exciting selection of work, promising more to come, but then leave the agency waiting. If you think of your agency file as an investment portfolio to which you add consistently, you'll keep your agent happy and see better sales results. Although practitioners agree that in today's market the best stock comprises powerful, unique imagery, the business is still essentially a numbers game, especially over the long haul. The larger the number of excellent pictures on file, the larger the numbers on your sales reports. But sheer volume of images on file does not mean more sales. It is far better to have 100 really great pictures in the market than 1,000 mediocre ones of which a few might sell occasionally. Part of the photographer's responsibility is to keep supplying fresh material and a steady flow is preferable to one major deluge. The agency wants a constant influx of new material. Keep in touch with the agency, request want lists, pick out needed subjects, and request guidelines. Most agencies supply want lists periodically. Ask your agent what sells and what doesn't. But don't just talk—follow up! Agents insist that if you supply the photographs requested, your chances of selling are increased.

Work that doesn't sell. If you think your sales are off, don't hesitate to ask your agent why. But raise the issue in a positive way. Don't go on the offensive, grumble, or complain. There's a good chance the agency will be able to analyze the problem. Keep in mind that it's in the agency's interests to sell your work. And it costs them money to file your material, too. Here are some reasons that your work is not selling. Be honest, and ask yourself if they apply to you, especially if you've been with an agency a few years.

- **Sparse coverage.** Do you send broad enough coverage of a subject? Random good shots from all over the world seldom do as well as images that cover a topic in depth. That good, single image could be out when a buyer is looking, and without back-up there's no sale. Most agencies maintain that the broader your coverage of a subject, the higher your odds of selling.

- **Second-rate transparencies.** Do you send your agency your seconds, thirds, or dupes? If you keep those precious firsts at home, just remember that you're competing against many photographers who shoot just for stock and who put first-quality work in the files. One leading agent comments: "If you are not willing to give your agency quantities of originals, you are shortchanging yourself. Agencies cannot afford to make multiple dupes of your originals, and perhaps you can't

afford to pay them to do it or do it yourself. The solution is to shoot more in-camera originals. If your agency has foreign offices or affiliates and distributes sixty frames of a shot, you could plan to shoot enough film to give them two rolls of similars of each situation. It's less expensive and less trouble than making dupes, and better quality to boot. This is commercial photography. If you can't stand the idea of letting clients use your original transparencies, your work doesn't belong at a stock agency—it belongs in a gallery or museum. Certainly, sometimes there is clearly one frame that works best, and if that is the case, reproduction dupes, while costly, must be made."

- **Atypical photographs.** Once it could've been argued that if images were so original or unusual that they didn't fit easily into generic categories they were hard to sell. But agents now stress the importance of breaking out of molds. "Our clients want to see classic subjects shot in new ways," said one. And another used travel photography as an example, encouraging travel photographers to work with models, guides, and translators to create new icons of familiar subjects. "The good travel photographer does not look at the location just for what it shows, but works to make it an icon, using either talent brought in for the shoot or sets up a situation with local people," said the agent. The highest money-makers, agents say, are pictures in the mainstream of market trends. Currently released people pictures, especially those with ethnic mixes, are much in demand.

All these factors are usually discussed at the beginning of a relationship with an agency, but somehow the idea does not sink in until they start to affect the photographer's pocketbook. Once the realization hits that the photographer's participation can definitely affect the success of stock sales through an agency, cooperation can blossom.

Most agencies and photographers work together toward a productive relationship that is mutually beneficial. To ensure that success, remember that agents are human; treat them with respect and they'll work hard for you. Don't waste their time with special demands. Instead, listen to what they need and follow through on their advice. Help them and you help yourself.

Keeping Tabs on Your Agency

The first step to evaluating if an agency is doing its best for you is to be sure your expectations are realistic. Placing stock photographs with an agency is a long-term investment. Most photographers agree that it takes at least two to three years to evaluate how well an agency is working for you. And that's provided you are doing all you can to help your agency.

Just as there are questions to ask about an agency before you join it, there are questions about its ongoing performance. The points outlined earlier in this chapter, under the heading "What to Ask," suggest what you should look for. But remember, it's almost impossible to check everything in an agency. Trust has to be the underpinning of a relationship. Just remember: It's a creative and business partnership. If you supply the agency with good material, it will work to sell it.

Combining Stock Agencies with Direct Selling

Many photographers do sell their own work as well having it represented through agencies. There are advantages to this approach, and some photographers are very successful using it. Those who do, and have multiple agencies, say they've never experienced a conflict in which a client sees the same image in two different sources and pits one against the other in a price war. How photographers apportion what goes to whom varies. The problem of whether an agency gets originals or dupes also arises, and some have solved this by providing high-quality 70mm dupes of 35mm originals. Before embarking on this course—having expensive dupes made—ask your agency what they prefer.

Here are some of the advantages to selling stock directly as well as using one or more agencies for stock sales:

1. Increasing your income. Combined selling can be a way of fully exploiting your stock. It provides a way for you to increase the potential market for your images, including clients you have developed yourself, as well as those cultivated by the agency. It also allows you to be a stock entrepreneur, which can be a challenging and satisfying part of your overall business.

2. Stabilizing your income. Many photographers feel that as a stock agency grows, increasing the number of its photographers, an individual photographer's sales suffer because his or her pictures become a smaller percentage of the agency's total file. Selling directly gives a photographer the opportunity to stabilize the total stock income by increasing his or her own efforts in areas where the agency's sale of work has diminished.

3. Retaining house accounts. In some cases, photographers have built up contacts before getting involved with an agency, and it may make good economic sense not to surrender these accounts to an agency that will fulfill the same function. It's not easy to give up a settled relationship with a house account, or turn it over to someone else.

4. Keeping up contact with the client. Stock sales can generate assignments simply because you have direct contact with the picture buyer, something that rarely happens when your stock is sold through an agency. In some cases, you may be able to provide a shot from your files when an assignment is subject to bad weather or seasonal conditions. Also, you may pick up information that could lead to a lucrative assignment. As a direct stock supplier, you can keep in touch with a client, generating sales, sending out stock updates, and making appointments to show new stock images. Additionally, you can offer different images or formats, such as black and white, that your agency may not handle.

5. Maintaining image control. Many photographers feel that certain special pictures should be protected and want the control that direct selling affords. They choose to market these selected pictures themselves, some of them portfolio pieces, only to markets they deem appropriate.

 Photographers who work with more than one agency maintain there are additional advantages to this arrangement.

6. Covering diverse markets. Multiple agency affiliations can provide specialized

representation in different markets. For example, some agencies might concentrate on editorial, some on corporate. By being with several agencies, a photographer can get a spread of agencies.

You might choose a specialty agent to handle sports, animals, or feature stories plus another more general agency. Or you might divide the country into geographical areas and guarantee your West Coast agent exclusivity in that area, and make similar arrangements with agents in New York, the Midwest, and the South. Most large agencies, and many smaller ones, have relationships with foreign stock agents, but you can arrange separately with an agent of your choice in Tokyo, Paris, or London, thereby gaining more direct control as well as a larger percentage of revenue. However, one agent urges photographers to keep in mind that if your agency has a catalog that it distributes to its foreign affiliates, it won't include your work since there would be conflicts in those countries where you have made your own arrangements. Unless you can print and distribute your own catalog, or you are included in each of your foreign agent's catalogs, you will lose income. Additionally, you will lose the U.S. sales you would have made had you been included in the agency's catalog.

7. Diluting any problems. With multiple agency affiliation, if a problem arises with one agency, it doesn't affect the photographer's relationship with other agencies. If you're with one agency only, and become dissatisfied, you have to break off the entire relationship.

8. Clarifying an agency's strengths. According to some photographers, using several agencies can enable you to make clearer judgments about how your work fits into the marketplace. When talking with agencies, it might be difficult to determine exactly what their strengths are and how these dovetail with your strengths. With more than one agency, certain patterns might emerge. If your pictures don't sell with any of your agencies, your photography might not be up to par, and, if this is the case it behooves the agencies to let you know why. But if your pictures do better with one agency than another, it could be the agency, or it could be that your pictures fit their area of concentration.

Disadvantages. One of the reasons you put your work in an agency is to remove all the paperwork attendant to stock sales. By doing both, you're presented with the problems of both: satisfying an agent and your own clients can be an emotional drain.

And as one leading agent points out, you are also placing clients in a position to call your agency for a shot, and if they don't like the price, to call you as well. Unless you and your agency have very firm positions about who can handle the deal, and unless you both charge the same price, you will be opening the door to a steady stream of "beggar" clients who want to improve the deal in their favor, with an end result of less money for you.

Of course, some photographers who have multiple agencies and sell their own work, maintain that the situation outlined above is unlikely to occur, but the possibility exists and is worth taking into consideration.

A major danger of selling stock yourself is that it can become an obsession, steal-

ing time and energy from your primary role—shooting photographs. This is one reason many leading stock specialists have chosen to sell only through agencies and in many cases sign exclusive contracts with major agencies with international networks. That way the photographer can concentrate solely on producing photographs that the agency knows are in demand. One photographer in this category, who several years ago was a staunch proponent of multiple agencies, said that selling direct could also mean diluting the quality of your submission to the agent, since you might keep images for your primary files that might sell if they were with the agency.

Selling stock through more than one stock agency presents special problems. There is the added office work of pulling selections and preparing slides for various agents. Although your income may increase, you need to calculate how much you really gain after you deduct such hidden costs as your own valuable time.

Perhaps one of the major disadvantages of multiple agency relationships is characterized by the analogy to the person who is "playing the field" and, in the course of dating many people at the same time, never gets close to anyone.

Another major problem with multiple affiliations is that many agents now require an exclusive contract. They will not take you on unless you give them exclusive rights to market your work. These agents believe that without an exclusivity clause their hands are tied from a negotiating standpoint. They can't, for example, guarantee a client that the image isn't being used elsewhere. Additionally, these agents are reluctant to share their hard-earned market research information with someone who may take this knowledge to a competitor.

From a client's point of view, there is also a disadvantage to multiple representation. A client who sees the same image from three or four agencies—and pays a research fee to each—is bound to resent it. As many agencies now don't charge research fees, that aspect might not be the problem it once was. However, for whatever reason a client might resent seeing the same image from different sources, which could result in loss of a sale.

If you do decide to use several agencies, be certain that each agent understands your arrangements and concurs. Negotiate a degree of exclusivity that satisfies you both. If you submit duplicates to more than one agency, be sure that each is aware of this in order to avoid a conflict if a client wants to buy rights of exclusivity beyond the standard "one-time only."

Making it work. Combined selling requires a certain degree of sensitivity to and awareness of the needs of your agency(ies). It's important to be frank and open about your situation with whomever you do business in the stock field. Conflicts can arise and there should be an open channel for their resolution.

Here's an example of multiple affiliations that works: Photographer X has a split personality. Her usual assignment is shooting sports, covering professional football and basketball games as a stringer for several sports magazines. She gets stock rights to this material and has developed extensive files of sport personalities in action. But her real passion is nature photography and she spends every spare moment out in the wild, shooting animals, especially small baby animals, about which she intends to make a book. What does she do about stock? She signs contracts with two agencies, each with

its own specialties. The sports photos go to an agency that specializes in that field, and the animal shots to another. There is no conflict at either agency; in fact, with each one she has a "subject exclusive" contract.

To one degree or another, most stock photographers have experienced selling stock themselves, even if it's only the occasional sale of a specifically requested picture. Combination selling on a committed and professional level means duplicating the services offered and the selling steps followed by your agency. What first appears tempting should be examined carefully and honestly. Ask yourself if you really want to be involved in both producing and selling stock or concentrate on being a prolific and successful producer, leaving the selling to someone you trust.

Pricing Stock Photography and Negotiating Fees

Stock photography is primarily a commercial business. As with any business, it requires organization, production, marketing, filing, and, ultimately, pricing, with which many photographers feel uncomfortable. But while negotiating prices might not be the photographer's forte, the health of any business depends on sales at prices sufficient to keep the operation profitable. After all, that's what you're in business for—to make a profit.

The keys to successful negotiating and the principles of pricing stock are covered in chapter 4, "Negotiating Fees and Agreements," and you are advised to read that chapter thoroughly. That chapter also includes advice for negotiating fees in assignment photography. Additionally, chapter 3, "Pricing and Estimating," includes much valuable information on all the facets of estimating fees, which can be applied to pricing stock. Also, refer to chapter 5, "Rights and Value: In Traditional and Electronic Media," which contains much information on value and pricing structures. Electronic media should be regarded as new markets for publication and, as such, should be based on industry standards of usage, volume, and other accepted practices. In chapter 5, examples of the pricing system developed by the Media Photographers' Copyright Agency (MP©A) are given and these can be used as a guideline.

A prime consideration in pricing stock is to appreciate the value of the image(s) to the client's project. As part of the information-gathering process, prepare yourself to understand a client's advertising budget for media buying. If you know what media or magazine your clients advertise in, you can obtain their rate cards. Since the effectiveness of an ad may depend on the impact of your photograph, you should know how much the client is prepared to pay for the ad space. Keep in mind that the client may be looking at a media buy of about $250,000 for a double-page spread in four-color. Knowing the cost of media will help you charge a fair fee.

A basic principle in pricing is this: The larger the total budget of the entire project, the more the buyer should be able and willing to spend for the photograph. The stock market has three broad categories, each with a developed price range of its own.

Advertising. This is usually the highest-paying use of stock photos because of the high cost of buying media space, the immediate profits realized, and the revenues the photograph will help create if the advertising is successful.

Corporate/Industrial. The use of photography in company annual reports, promotional trade shows, public relations, recruitment booklets, and the like is a less direct form of advertising and promotion than consumer advertising. Thus it usually has a more moderate budget.

Editorial. This use is defined as photographs that run in magazines, in books, or on TV for their illustrative or informational value. The budget of an entire project may be large but many pictures might be required, so the per-page budget may be relatively modest.

Internet usage. In essence, pricing for Web page usage is no different from print media usage. You should ask as many questions as possible: What size image will be seen (1/8 screen, 1/4 screen, etc.)? Is it going to be on the opening page or further back? For how long will the image be on the site? Is the site owned by a small company or a huge corporation? And how many visitors, or "hits," does the site receive per month (or are expected during the time your image will be displayed)? One photographer who has been quick to take advantage of the Web is Seth Resnick of Boston. He emphasizes that photographers should not overlook the fact that advertising rates on the Web are not low. Many sites may be free to the consumer but not to the advertiser. In fact, in many ways the Web is like television and, as we all know, television advertising commands hefty fees. This is an extremely important concept when it comes to pricing images. Large corporations do have budgets in place to pay industry prices for stock photography on the Web.

Determine your bottom price. Once you have established this, never go below it. That way you not only are taking steps to maintain your own business's profitability, but you are also contributing to the health of the stock industry. Don't be afraid to say *no* if the price offered does not meet your minimum.

Before arriving at a price, regardless of the medium in which your image(s) will be used, ask the client every conceivable question about the usage and take detailed notes. For example, if the use is advertising, ask what consumer magazines or trade publications the photograph(s) will be used in and their circulations. Go as far as calling the magazines and asking what their advertising rates are. This will give you an idea of the amount being spent in the entire campaign. Ostensibly, your images are a valuable part—possibly *the* most valuable part—of the advertisement, so you should be compensated accordingly. Above all, don't give a price immediately. Get all the facts, evaluate them, and determine an equitable price. Don't be pressured into giving a price on the spot. It could well be that you might have to explain to an inexperienced buyer the rationale you have used to determine a fair price.

If you are inexperienced in pricing stock photos, there are several sources of advice. These include:

- Photographers who specialize in stock. Experienced colleagues are usually happy to share their knowledge of the business, especially when it comes to maintaining equitable prices. It's in all photographers' interests to maintain fair prices. Also, some authorities in the field will provide pricing guidelines for a fee. That has come about simply because they found much of their time was being spent providing advice, and charging a fee helped compensate them for that time and

service.

- Your stock agency. Ask the person who specializes in the agency's sales for the market you need information about, e.g.: if it is a potential advertising sale, ask that person's advice.

- Pricing guides or software, such as the popular fotoQuote program (*www.fotoQuote.com*). The initial investment in a pricing guide could be recovered in one sale.

- Surf the Net. The Internet, if used intelligently, can be an excellent source of information on a multitude of subjects, including stock photography. There are several stock photography forums on the Internet and also numerous Web pages featuring stock photography. While ASMP cannot endorse such sites, photographers should explore all options in creating their own pricing structure and systems. An online resource can be found at *http://photographersindex.com/stockprice.htm* and photographer Seth Resnick has created an in-depth, online guide for stock photography pricing at *www.sethresnick.com/price/price.html*.

Stock and the New Technologies

The Internet has emerged as the one single development to have the biggest impact on stock photography. This massive and far-reaching communications system has revolutionized the way business is done in stock. What is happening and what will ultimately happen are open to conjecture, but the tremendous interest in the Internet, the thousands of people worldwide who are connecting daily to the system, and the huge amounts of money being spent by large corporations in developing a presence on the Net and the World Wide Web, highlight the value major high-tech players and individuals alike are placing on it.

And how do stock photographers take advantage of the Internet? As with the advent of most technology, Internet use for business transactions, including marketing and licensing photographs, will increase as more people become comfortable and more adept in taking advantage of it. The traditional ways of finding images—calling for submissions from photographers and agencies, and searching through printed catalogs—will still remain, but the Internet has made it possible for buyers to select images online and for photographers to deliver the same way. Online searching and requesting images will accelerate, and in this regard the playing field has been made more level: Individual photographers have a medium to market their work on a global scale at much lower costs than before and in that sense can compete with major suppliers.

Also, advertising on the Internet is growing and advertisers are licensing images for use in Web pages. This is a new and increasing market for stock, and one that commands good prices. Refer to chapter 5, "Rights and Value: In Traditional and Electronic Media."

Photographers are advised to base pricing for electronic media on the same criteria as for print. Such factors as size, duration of license, and distribution, which are criteria for traditional usage, are applicable. Also, keep in mind that publishers with sites on

the World Wide Web are charging high advertising rates. So, photographers should not discount the value of their work used commercially on the Internet.

The Computer in Business

Refer to chapter 8, "Electronic Technology," as this explores the importance of using computers in your business. The computer is a valuable business tool for tracking sales, maintaining records, invoicing, customizing forms, communicating via e-mail, and a multitude of other uses. Harnessing computer technology can help business people be more efficient and profitable. It's hard to imagine any business today running without assistance from computers.

Some excellent software programs written specifically for photographers are now available and, if used efficiently, these can make your business more orderly. As a business person, you need to take advantage of any tool that can make your business more profitable.

Key Areas for Applying Technology

- Creation of stock images
- Image correction—alteration, manipulation
- Storage of digital information
- Research and delivery
- Licensing and protection

Creating and Correcting Images

Some stock photographers shoot images specifically for combining with other photographs, using one or more elements to create entirely new pictures. They shoot subjects such as city skylines or clouds with specific, final, computerized images in mind.

Before buying expensive imaging equipment, ask yourself if sitting in front of a computer, possibly for long stretches, manipulating stock images, is what you really want to do. It might be more efficient, and profitable, to hire an expert in this field to handle image manipulation for you. If you like darkroom work and all the intricacies of dodging and burning on paper, the chances of your adapting to computerized manipulation probably are greater. If you'd rather make photographs with a camera, then computerized manipulation might not be for you.

Here are some advantages to computer manipulation:
- Flaws can be removed, retouched.
- Color can be corrected.
- Colors of models' clothing can be changed.
- Elements from different images can be combined.
- Fantasy photos can be created.

Storage of Digital Information by James Cook

Film-based images are converted to digital form by scanning. The scanning can be done by a service bureau (this used to be done by a lab). Or you can purchase your own scanner and digitize images for yourself. Either has its benefits and its disadvantages.

Having your scans done by a service bureau means letting someone else invest in

the rapidly changing technology and in high-end scanners that exceed your budget many times over. You also leave it for them to commit the time and effort required to develop the necessary skills for creating high-quality scans. The downside is much like having labs printing your photographs; the results are subject to their interpretation of what you want and the delivery time is pretty much determined by their schedules. By the same token, their equipment in the hands of skilled operators is likely to provide scans that far surpass the quality of anything you can produce with a desktop scanner.

To do it yourself means you need to buy a scanner that is likely to become old technology within a few years. Then you have to put in not only the time to learn and master the scanning process and associated software, but also the time to do each and every scan. Of course, you get your scans when you want them and looking the way you want them—skill permitting.

If you have scans done by a service bureau, you need a medium to physically transport your digitized images. Even doing your own scans requires expandable storage to satisfy the voracious space appetite of images. Typically, this is satisfied using "ejectable" media versus hard disks. *Ejectable media* refers to disks or cartridges that slip in and out of a special drive, much like a floppy disk does, but with much greater capacities. A film-quality scan of a 35mm image requires 60 megabytes of storage capacity, so you can see that storage requirements mushroom as you accumulate digital images. (Which, by the way, also demonstrates the efficiency of—and the incredible amount of information stored on—a piece of film.)

Ejectable media come in a few basic types: compact disks (CDs), magnetic cartridges, and magneto optical disks. It's very important to talk to your service bureau, and anyone else with whom you expect to be exchanging files, to see what they're using. You can't trade files with them if you're not using compatible formats. It's worse than trying to print 4x5 negs using a 35mm carrier.

Most computers now come with CD drives built in. This makes it easy to read images from a CD for alteration and/or transfer to another storage location. Storing them again requires a CD writer or one of the other types of ejectable media. Magnetic media are the most commonly used ejectables. They won widespread acceptance because they appeared first on the market with the most appealing prices for drives and cartridges. Magnetic disks come in a wide variety of sizes and capacities. Although well suited for transferring images from one place to another, they're relatively unstable, making them unreliable for long-term storage. Although magneto optical is considerably more stable, the market share of MOs is shrinking, and they appear to be headed for obsolescence. This is largely because CD writers, commonly referred to as CD burners, have similar longevity and have become very affordable. The considerably lower cost and much greater capacity of blank CDs are making this the current medium of choice for long-term storage as well as short term.

All of this points to the ultimate problem of digital storage. No matter what you choose as your medium, it will be eventually replaced by another. Our information age is in jeopardy of becoming the lost information age as more and more information gets locked into past technologies. Have you ever tried to find a player for your old 8-track tapes or a turntable that can play 33rpm records? It's important to keep an eye on the

changes and be sure your images don't get caught in an orphaned medium.

For any images that you really care to preserve for the future, have the digital file recorded on film. It's still your best long-term storage solution.

Research and Delivery

The key to anyone finding your images on any large database, Photo CD, or CD-ROM is the keywords you have applied to your images. Agencies that have created CD-ROM catalogs use special keywording software that standardizes a tedious task. Don't overlook the importance of thorough keywording. Although time consuming, comprehensive, appropriate keywording will pay dividends. When buyers start searching through thousands of images, they rely on the keywords they use to narrow the hunt. A standard keywording system has been suggested, along the lines of the Dewey Decimal System used by libraries. But until such a standard is developed, be as thorough as you can. Agencies are responsible for keywording photographs in their files, but if you store your own images in any digital form, you have that task.

Keywording Theory by James Cook

Whether you call them keywords, indexes, or cross-references, keywording is not so much for data entry as it is for searching later on. The words that you attach to an image play a crucial role in finding the right images when conducting searches. Omitted words may prevent the most appropriate images from being found.

A good keywording system takes time and thought and cannot be constructed in haphazard fashion with expectations of great results. If you create and apply keywords well, the result is faster, more fruitful file searches.

Keywording systems fall into one of two styles.

Most commonly used, although not always the best, is the *open vocabulary*. If you look at an image and use whatever words it inspires for the keywords, you're using an open vocabulary. One day you may keyword an image as Ship, Harbor. Entered on another day, you might have keyworded the very same image as Boat, Port. Another time you might use Watercraft and Harbor.

When searching for this sort of image, who knows what you'll find or overlook because of inconsistencies in an open vocabulary. Of course, you can look for all entries that contain Harbor or Port or Anchorage or Boat or Ship or Vessel, but it's a hit-or-miss proposition that requires a vast patience or a good memory. If you find no entry for Boat, you must keep looking, trying other keywords. When you discover Ship, you move on, never discovering all the others that got listed as Watercraft.

In a *controlled vocabulary*, your keywords are limited to a specific set of words. Ideally, this list of words is printed in an index or available on a computer for your reference as you apply keywords to images.

As you make entries in your controlled vocabulary system, you should have the option to add a new keyword. If you fail to find a satisfactory keyword for an image, add a new one to fill the hole. This way the keywords build slowly and thoughtfully as the need arises. You are spared the monstrous task of building an entire keywording system before you know what you might need.

One long list of all of your keywords makes the task of locating and applying them impossible. Within your keyword index, you're going to want levels of keywords; categories and subcategories. Use the primary categories to quickly make significant distinctions within the subject matter. Use subcategories to make quick breakdowns within the category and add additional subcategories, as needed, but don't get carried away. Generally three or four levels are as far as you should go. A good breakdown makes it easier to add keywords efficiently and makes the searching easier too.

Suppose your files have lots of animal images. Start with a general category, Animals or Nature or Wildlife. Now, let's say you have lots of bears among your animals. Try a subcategory, Bears. Use yet another level for details to get down to the fine points, Brown, Grizzly, Kodiak, Polar . . . and so on. These details are hardly suitable for any other category or subcategory.

A category, Birds, could have subcategories of types of birds; maybe Eagle is one. Details for Eagle might be Bald, Golden, and *haliaeetus leucocephalus*. If you're tempted to include details like Flying, Egg, Hunting, and such, remember: These details apply to many birds. Flying, Egg, Hunting, and the like might serve better as subcategories of Birds and not just Eagles.

Limiting the number of choices increases the accuracy of new entries and expedites searches, but don't be so extreme in avoiding new terms that you diminish coverage. A happy medium exists, but it's up to you to decide where it is.

When keywording an image, look at it and think about what it really shows. What is significant in the image? Look for both the literal and the conceptual significance. A single image is likely to fit into multiple categories and subcategories, so don't think you need to apply one set of terms and that's it. Most images contain a literal subject such as a dog playing in snow. Such an image would obviously earn keywords such as Dogs, Collie, Pets, Winter, and Snow. Conceptual keywords for the same image might be Cold, Joy, and Freedom. Resist keywording every object that happens to be in the shot—Door, Tree, Mailbox, and so on—unless they play a significant enough role that someone searching for those objects would really want to see this one too.

For efficiency, use the most basic, generic terms. Don't use your keywords to show off your vocabulary skills. Your keywords should be kept to a level that is appropriate for your audience. If your images are for osteologists and paleontologists, by all means use terms like zygomatic arch and optic foramen. Don't expect the rest of the world to know what these terms mean, though.

Reduce synonyms to the single most suitable word for a category or subcategory. This narrows rather than expands your search vocabulary list. For instance, here is a list of synonyms: precipitation, condensation, downpour, deluge, cloudburst, torrent, rainfall, shower, drizzle, sprinkle, monsoon, plus all their plurals. Rather than create a category, or even a subcategory for each and every one, use a broader term, such as Rain.

And, finally, be sure of your spelling. Typos and spelling errors cause images to be missed in searches. Get it right in your master list and make sure to stay with it.

Good captions and keywords enhance the value of your images. An excellent image

that never turns up in appropriate situations is a lost cause. Keywording is an important part of successfully bringing your images to market.

Licensing and Protection

Photographs have always been susceptible to theft if someone wants to steal them. With sophisticated scanning equipment, it's now easier than ever for someone to scan a photograph from any publication. To some degree, honesty and people's willingness to be honest will always have a role in this. But there are ways to protect images. One is electronic watermarks that can be embedded in a photograph and cannot be detected until the photograph is reproduced, rendering it useless. A code must be used to remove the watermark. (Refer to "Image Protection Standards for the Digital Era," written by Roger Ressmeyer at the end of chapter 8, "Electronic Technology.")

The Internet

Not too long ago, relatively few photographers had e-mail addresses, communicated by modem, surfed the Net, or had their own Web sites. Things have changed, and will continue to change. How stock photographers adapt to and harness the new technologies needs to be addressed. Communicating with fellow photographers and asking questions is a start. Ask photographers who have Web pages how their business has been affected. Explore the Web, look at other photographers' pages, and search for forums that address stock issues. There is a wealth of information generated on the Internet, but to access it you will need a computer with a modem (the fastest you can afford and a fast, reliable Internet connection are highly recommended, especially for delivery of images). Once you start browsing, you will find information on any subject you can think of, including stock photography.

Additionally, photographers interested in creating Web pages have at their disposal a plethora of designers eager to help, authoritative books for reference (any good bookstore will carry an array of titles on the subject), and, within ASMP, colleagues who are promoting their work on the Web. As a service to members, ASMP has created a "Find a Photographer" searchable database and, through this system, buyers can link directly to ASMP members' Web sites. (Go to www.asmp.org—Find a Photographer.)

Accessing the Web

When considering Internet service providers (ISPs), keep in mind that while local service providers might be less expensive than national organizations, they will probably have fewer phone lines. In theory, unlimited access is good. But if other subscribers tie up lines for hours, you might not get access at convenient times. Inquire about the number of lines and what plans there are for expansion before signing up with a provider. Also, ask any prospective ISP or Web page host what technology is available and how transfer of large image files can be handled. Sending text via a modem is relatively simple; uploading image files is another thing entirely. Other important questions to be asked include these: Does the host have multiple routes to the Internet? How fast are its systems? And how many servers are available? Also ask about customer service.

Many companies are very willing to take your business but after-sales service is another matter. If you have problems, you want to be able to get in touch with someone to solve them for you.

Fortunately, demand usually creates larger and more efficient supply and ISPs know they have to provide good, consistent service to stay in business. This benefits photographers who want to harness the Internet.

While it's true that marketing stock on the Web is increasing as buyers become more comfortable with and adept at searching for images via the Internet, they still have to find you. Letting people know you have a home page is one way to facilitate the process. Just remember that with the multitude of choices out there, and the growing number of them, there are few chances a buyer will simply stumble onto your page.

How do you, the photographer, let people know you have a Web page(s)? Put your home page address on printed literature—in print ads, on your letterhead, promo sheets, and anything else you send clients. The fact that you have established a home page on the World Wide Web is a reason to contact clients. In short, use traditional marketing techniques to promote your Web presence and combine that with high-tech facilities, such as meta tags, being registered with Internet search engines (such as Yahoo, Excite, Alta Vista, Lycos, and the like).

Developing and maintaining a Web site is not something every photographer will want to do. There are agencies promoting the work of groups of photographers and there are advantages in being involved. For one thing it does provide a central source for potential buyers to look and your page will be linked to others. Being linked to other sites is a definite advantage. Today, having a Web site is a bit like having a fax machine a few years ago: Clients expect photographers to have one.

The Web Page Designer

Among the many professions that have appeared as a result of the technology boom is the Web page designer. Of course, many photographers have proved they are quite capable of building and maintaining their own sites, and these people don't need outside help. And then there are the others: those who do need creative, technical, and design help. If you fall into that category, here are some basic questions you should ask and some advice on what to avoid.

One of the best sources for Web page ideas are other sites. Browse the Internet and look at how other photographers display their work and promote themselves. Also, look at sites that feature photography for marketing purposes. Major corporations spend a lot of money on their promotional material, and you can be assured they have researched the most effective way of using the Web before putting their sites online. Once you have seen sites that you like, and that fit what you have in mind, contact the site owners and inquire as to who designed them. Often, the site managers' contact information will be listed on the opening page. Many ASMP members have Web sites that are linked through ASMP's "Find a Photographer" feature, and this is one way of viewing other photographers' pages.

Before building a site, or having one built, determine what you want the site to accom-

plish. Is it intended simply to be a vanity site—to show off your work—with no commercial goal in mind? There's nothing wrong with that, and a vanity site can also serve as promo site to which you can refer clients. More and more clients rely on Web sites to see if a photographer fits their assignment requirements, and an online portfolio is certainly easier and less expensive to create and maintain than a printed equivalent.

Do you want to sell stock off your site? That creates another set of design and technical issues to be addressed. How will images be delivered? How will the client pay— via online credit card or check? Can your designer incorporate those features?

One thing to be wary of is having a site that is too complex and glitzy, one whose graphics—the bells and whistles—are more important than the content. The medium should not overpower the message and a site that is graphics-heavy can take far too long to load. It's a balancing act between resolution of images—you don't want the images to be so low res that they look bad—and having so much high-tech stuff that your site is not quick to load and simple to browse. Keep in mind that developing a Web site can be exciting and fun, but maintaining the site—uploading new images and text, making changes, and keeping it fresh—is not only time consuming, it can be onerous.

Just as the professional graphic designer should be able to produce a printed piece that is clean and effective, so should a Web page designer be able to create a site that does the job and enhances your Internet presence. Many graphic designers are now accomplished Web page designers, and their experience in traditional media is proving effective in electronic media. Seeing their portfolios is simplified: Just ask for the Web addresses, URLs.

Other aspects of hiring a Web page designer fall within the realm of traditional business practices. How do they charge? What can you expect for the money? Who will maintain the site? Who owns the design? (See the following article on "Avoiding Copyright and Trademark Problems in the Internet.")

The ASMP Home Page

As mentioned previously, as a service to its members and to buyers, ASMP has created a home page on the Web with a searchable online membership directory, called "Find a Photographer." Buyers can find member photographers by name, city, state, country, and specialty. Links have been created to members' home pages to allow potential buyers to view members' work. The ASMP home page also contains much other information about the Society and has links to other useful sites. The address is www.asmp.org.

Avoiding Copyright and Trademark Problems on the Internet by Andrew Berger

Photographers are increasingly turning to Web sites to market their work. Although the Internet provides photographers with access to buyers worldwide, Web sites may also expose photographers to unanticipated problems. If you choose the wrong domain name, post material on a site that infringes another's trademark or copyright, or link to a site that you know contains pirated material, you may be subjected to embarrassing and expensive litigation. The following suggestions can help you avoid this exposure.

Domain Name Selection

You need to choose a domain name that is both distinctive and non-infringing. That will not be easy. Most distinctive names are already registered. But first, here are some naming basics. Domain names are composed of two parts: (1) a descriptive name ending in a "dot," called the second-level domain; and (2) the suffix following the "dot," called the top-level domain. For instance, the site *amazon.com* contains the descriptive name or second-level domain, "amazon," and the top level domain, "com." The descriptive name may combine letters, numbers, and some typographical symbols (but no apostrophes or spaces).

Three of the seven top-level domains are open to commercial users: com, net, and org. The other four (edu, gov, mil, and Interactive) are restricted to certain entities. The manager for Internet addresses, the Internet Corporation for Assigned Names and Numbers (ICANN), in response to pressure from business groups, may soon be adding some new top-level domains.

Naming Guidelines

After you have selected a possible name, search the Web site of one of the more than ninety domain name registrars to see if the name is available. If the name is already registered or warehoused by someone else, the search result will list similar names that you may register. For instance, search for the name "Nike," and the registrar will tell you that similar-sounding names like "aboutnike.com" and "nikebusiness.com" are available. But before you register, keep the following guidelines in mind:

1. If you choose a domain name that is the same or confusingly similar to another's famous or distinctive trademark:

 a. You invite litigation under a federal statute called the Anti-Cybersquatting Consumer Protection Act or arbitration under ICANN's dispute resolution policy;

 b. You will most likely lose your domain name to the owner of the mark if you selected that name to compete with or drain business from another's mark by confusing potential customers about the source or sponsorship of your site. For instance, if your site sells shoes made by a Nike competitor, don't pick the name *nikebusiness.com*, since a court is likely to determine that you picked that name to draw Nike customers and switch them to your brand; and

 c. Even if you do not compete with the mark, you may lose the domain name if you have never conducted business under that name; it is not the name of a person associated with your company; and you try to sell your domain name to the mark for financial gain. For example, Volkswagen was able to take the domain name "VW.net" away from Virtual Works, Inc. since that company had never conducted business under that domain name, had no trademark or other rights in the initials "VW," and confused Volkswagen customers by using that domain name.

2. If your domain name is also your name, you may be able to continue to use it,

even though it is the same as another's famous mark. But the court may set some conditions on your use. Thus, Mr. Uzi Nissan, the owner of a computer business, was permitted to use the domain name "nissan.com" so long as he did not use his site to display any automobile-related information or advertising and posted a notice on the top of his home page disclaiming affiliation with the Japanese automaker Nissan.

3. You may also be able to use a domain name that is similar to another's trademark so long as your purpose is to criticize the mark's business. For instance, a court refused to shut down a site named "ballysucks," dedicated to complaints about Bally's fitness business. The court found that a reasonably prudent person would not mistake that site for the official Bally site. Similarly, a court declined to close down a site called "lucentsucks.com" because no consumer would confuse it with a site sponsored by Lucent.

What May I Put on my Site?

Let's assume that you have selected and registered a non-infringing domain name, what can you post on your site? The following questions and answers might help.

1. Q: Do I risk copyright infringement if I scan another's wonderful photograph and post it on my site without first obtaining the consent of the copyright owner?
A: You may. You will need authorization from the copyright owner unless the photograph is in the public domain or you can justify your use as "fair use." Works in the public domain are those works not protected by copyright and free for all to use. Copyrighted works fall into the public domain by either the passage of time or the failure to observe copyright formalities. Fair use arises when you use copyrighted material for certain purposes, such as criticism, news reporting, teaching, scholarship, or research.
Before you conclude that material is in the public domain or protected by fair use, you may want to get some expert help, since these are tricky areas.

2. Q: What if one of my Web site subscribers uploads infringing material to my site. What are my responsibilities and obligations?
A: You have a few. To qualify from an exemption to liability under a new federal statute called the Digital Millennium Copyright Act (DMCA), you must: (1) not have known that the material was infringing; (2) post procedures on your site for victims of copyright infringement to follow to notify you of infringement; and (3) immediately take down or remove the infringing material on request.

3. Q: May I link to anyone's site?
A: Linking is what the Internet is all about; at the same time, some sites require your permission before you may link to them and some even require a linking agreement.

4. Q: Do I have liability if the site I link to contains infringing material?
A: You may, if you know that the linked site contains such material. For instance, hackers created software that permits users to decrypt and copy data on DVDs. If

you link to a site that you know contains this software, you may be liable for furthering or aiding infringement.

5. Q: May I "deep-link" to secondary pages on another's site?

A: Probably so. Commercial sites want visitors to "come in the front door" at the home page. Web sites place most banner ads there and key prices for those ads to the number of hits on the home page. But a recent court decision found that deep linking was not a copyright violation since there was no deception involved in sending a visitor from one site to a secondary page on another.

6. Q: May I use another's trademark in my "meta tags" (a type of HTML code designed to provide machine-readable information to search engines about the contents and display of a Web page)?

A. Not if your purpose is to "hijack" traffic from the mark's site to yours. But if you have a business relationship with the mark, such as acting as its authorized distributor, you can indicate that relationship in your meta tags. For instance, the former Playboy Playmate of the Year, Terri Welles, was permitted to use the words *playboy* and *playmate* in her meta tags, since they fairly described and identified her achievements and relationship with *Playboy*.

7. Q: May I "frame" or create a window on my Web page to view linked-to content on other sites?

A: Probably not. Framers often want the best of both worlds—to link visitors to content on another's site and then frame that content on their window. For instance, a "news aggregator" called Total News took news stories from other newspapers and framed them on its site, placing ads and the Total News logo above the frame. Total News stopped the practice in response to a suit by publishers who claimed the frames confused users about the origin of the information in the window. To avoid litigation, enter into a framing agreement with the site whose content you want to frame.

8. Q: May search engines key their banner ads to direct viewers to competitors of the site the viewers are seeking to find?

A: Yes. A court recently permitted Excite and Netscape to key their banner ads to pornographic sites whenever visitors used "playboy" or "playmate" in their search requests. The court said there was no evidence that customers would be sufficiently confused over the relationship between Playboy and a pornographic site.

9. Q: Is there any problem with the use of "cookies"?

A: Not yet. There are no cases or legislation that presently prohibit the practice of giving a "cookie" to a visitor. But in the "terms and conditions" on your site, you should advise your visitors what personal information you collect, what you do with that information, and the procedures you follow to allow visitors to either correct that information or prohibit its collection. Internet privacy is of growing concern, and legislation governing the privacy policies of commercial sites may be in the offing.

10. Q: Who owns my Web site design?

A: If you used a designer, the designer does, unless you agreed in writing with the designer to transfer the copyright to you by a signed document that specifically

states the design is a work-for-hire.

In conclusion, photographers want their Web sites to generate sales not lawsuits. These suggestions may help you achieve that objective.

(Andrew Berger is an attorney specializing in intellectual property matters. He is with the New York firm of Tannenbaum Helpern Syracuse & Hirschtritt. Phone: 212-702-3167; e-mail: berger@tanhelp.com.)

Images on WWW Are Copyrighted

Photographers are encouraged to share this information with colleagues and clients. Photographs share the same legal protection and rights on the World Wide Web as they do in other forms of print media, such as newspapers, magazines, brochures, billboards, and other media. Each of these images is protected under the Federal Copyright Act. One of the basic rights granted by the copyright law is the ability of the photographer to control the reproduction of the image. Regardless of the media or specific application, it is required, by law, for the user of the image to find the owner of the copyrighted material and seek authorization for use. Illegal usage of an image is considered copyright infringement and is a serious federal offense. Understand and respect the value of the images to the owner and get permission before usage.

Negotiating Agency Contracts

While some might dispute the contention that picking a stock agency should be done with the same care as choosing a spouse, photographers who have fallen out with their agencies would probably agree. They know full well the ramifications of this kind of breakup. The divorce can be messy.

So entering into any partnership should not be done without careful research, and an appreciation that at some stage a parting of the ways is a distinct possibility. And the photographer's contract with an agency is indeed akin to a prenuptial agreement—it must include an understanding of who owns what, the partners' responsibilities, and how the assets will be protected in a breakup.

Most businessmen know that nothing lasts forever and photographers should be aware that some day, almost surely, either they or their estate will part company with an agency. So this makes the stock contract—the prenuptial agreement—even more important in protecting the photographer's assets during the relationship and if or when it ends.

Photographers are advised to read carefully the section on "Choosing a Stock Agency," which reinforces the information here.

The contract presented by agencies is usually the same for all photographers, but the contract form is not set in stone—if you have a special concern the contract should

reflect that. While most agencies have form contracts, many will alter them for individual photographers if the request is reasonable.

Look over these agreements with an open mind, but never forget that the agency's contract was probably written by the agency's lawyer. It could be a balanced agreement you might be happy to sign, but in some cases you might find points not in your interests.

Certainly, the rights of the agency have to be respected, but most definitely the agreement must protect your own interests. Don't be intimidated by something that is presented to you. Modifications can be added. There are photographers who have created agreements that are signed by the agencies.

Some agencies, like some publishers, may adopt a "take it or leave it attitude," but when pressed, will agree to modify contracts. Determine your needs and whether you can give them up. Understand the agency's perspective but never give up anything that is a fundamental need. Ask yourself this: Is my request for a change in the contract reasonable, and is there a sound reason for requesting it?

It's not easy to extricate yourself from an agency after you've been there a few years. If the contract is not working for you, you have to make a business judgment: Do you make a stand and terminate the agreement? If you do, try to position yourself so you are not dependent on that contract and can make a living if you terminate it. There are photographers who have all their work with one agency and who want to terminate, but can't because the loss of income would be financially devastating.

Return of work after leaving an agency can be a problem. It's suggested that you have a provision in the contract for return of work in a relatively short time, such as thirty days from the agent, sixty days from subagents. Any of your work out on agency submissions should be returned to you as soon as possible. Ensure that this aspect is covered to your satisfaction. An emerging problem in conjunction with the consolidation in the stock industry is the huge number of images not being returned promptly to photographers whose work is being purged from files. Agencies are entitled to return images they consider no longer competitive; but they should make sure that these images don't languish in file cabinets or boxes for months on end, thus keeping them out of the market completely.

Determine how long the agency holds money before paying the photographer. Don't lose sight of the fact the agency owes you your money. Try to get paid monthly or in a timely fashion.

Obtain the right to audit the accounts involved in the production of your work. This will enable you to inspect the agency's books if you have any doubts about getting paid.

When you give the agency the right to sign agreements with subagents, it should be stated that the subagents abide by the terms of the contract the principal agency has with you. This includes the right to audit the subagent's accounts related to your work. ASMP does see numerous problems associated with subagents not abiding by the terms of the principal agency's contract with their photographers.

When an agency licenses the use of an image, the copyright owner should know the following: who the end user of the image is; the duration of the license; geographic limits; reproduction size; identification of the photograph used; the print run; number

of uses.

Contracts should not automatically renew. Some have a window of ninety days after a five-year period—if you miss that window, the contract is automatically renewed. You should have the same rights to terminate as the agency.

Inquire as to what is deducted from photographers' earnings. You should have the right to set limits on what is deducted from your income, and the contract should guard against this. Nor should agencies be able to hold photographs as collateral if the photographer leaves the agency.

If there's a lawsuit instituted on your behalf, be able to have a say. This could avoid situations like the one where a stock agency filed a claim against the photographer's best assignment client without consulting the photographer.

Also, if the photographer believes there is an infringement and the agency does not want to take action, the photographer should have the right to proceed on his own. At that point the agency should have the right to determine if it wants to be involved and share the legal costs. And the person bearing the costs should call the shots.

Determine who should be paying for what for duping and catalog costs. Are there volume and bulk sales? If so, the photographer should have a say in the number of images used and their duration of use for that purpose.

More agencies are seeking exclusivity. Ask what the benefits of exclusivity are to you. Does it guarantee more images in the agency's catalogs? If you are a specialist, will the agency limit the number of other photographers who do similar work? And if the agency changes its slant and your images are no longer its forte, do you have any recourse? Is it in your best interests to have an exclusive contract? If you are dubious, limiting the contract's duration could be advantageous.

Ask what constitutes a gross sale and request that sales statements show both the gross amount and the net to the agent.

Clear up such things as the following: What constitute service charges? What say do you have in catalog selection? Are there filing fees?

Is the agency involved with online services and other electronic imaging outlets? Avoid agencies that offer CD-ROM clip art disks. And if images are digitized, make sure that there is language in the contract to guarantee that you are made aware of any digitizing of your images before it can be done. Permission is not automatically granted for your images to be digitized. There are numerous questions to be answered before you enter into a contract with a stock agency. Ask those questions before the marriage. Or you might have to forever hold your peace.

The following examples of contracts are what ASMP considers the ideal for photographers. One is a suggested contract between a photographer and a stock agency, and the other is the contract written by the Media Photographers' Copyright Agency. Both are based on fairness and equitability.

Contract Between Photographer and Stock Picture Agency

AGREEMENT made this _____ day of _____, year_____, by and

between (name and address of Photographer)

(hereinafter referred to as "Photographer") and (name and address of agency)

(hereinafter referred to as "Agency").

RECITALS

Photographer is engaged in the business of creating photographic images (hereinafter referred to as "Images"). Agency is in the business of arranging for the license of such Images to interested clients (hereinafter referred to as "Clients"). Photographer and Agency have determined that it is in their mutual best interest to enter into this Agreement whereby Agency shall represent certain Images of Photographer for license to Clients upon the terms and conditions which are set forth herein.

1. Grant of Authority

(a) Photographer hereby appoints Agency and Agency hereby accepts such appointment as Photographer's agent in respect of the license of Photographer's Images. As used herein, the term "Images" shall be limited to those Images created by the Photographer as shall be delivered by Photographer to Agency and accepted by Agency pursuant to Paragraph 3, below.

(b) Agency is granted limited exclusivity hereunder as follows (check appropriate limitations):

(i) Regional U.S. as follows _____

(ii) B&W _____ Color _____ Both B&W and Color _____

(iii) Stock _____ Assignment _____ Both Stock & Assignment _____

(iv) May Agency employ Subagents? Yes _____ No _____

If yes, list permissible Subagents _____

(c) The obligation of exclusivity set forth in subparagraph 1(b) shall consist solely of Photographer's covenant not to place the Images with any other stock picture agency, picture library, or other similar selling medium of Images as limited by subparagraph 1(b). Unless otherwise provided, nothing contained herein shall in any way be deemed to prevent Photographer from engaging in assignment photography for Photographer's own account or from engaging in the sale or license of Images directly to Clients. The accounts listed on Exhibit A, attached hereto, shall be deemed "House Accounts" and serviced exclusively by Photographer for all purposes, and all fees attributable to "House Accounts" shall be Photographer's sole and exclusive property.

(d) Except as may otherwise be provided herein, Agency shall have discretion regarding the terms and conditions of any license of the Images, delivered to it by Photographer. Notwithstanding the foregoing, any license of rights in and to the Images, on a "buy-out" (i.e., a transfer of all or substantially all rights in and to an Image) or "exclusive" basis, shall require Photographer's prior written approval, not to be unreasonably withheld. Agency shall have no authority to transfer to any

client any underlying rights in the Images.

(e) Agency acknowledges that it will not license the use of any of the Images for less than _____ Dollars ($_____) without Photographer's prior written approval.

2. Term

(a) This Agreement shall commence as of the date first set forth above and shall continue for a period of three (3) years thereafter (the "Initial Period"). Agency shall have the right, at least thirty (30) days prior to the expiration of the Initial Period, to notify Photographer of its desire to renew the Agreement for an additional period of one (1) year commencing upon the expiration of the Initial Period. Agency shall thereafter have a continuing right, upon thirty (30) days' written notice prior to the expiration of each successive renewal period, to elect to extend the term of the Agreement for a one (1) year period. Notwithstanding the foregoing, Photographer may, upon receipt of any such thirty (30) days' notice, notify Agency of its desire to terminate this Agreement, and the Agreement shall thereafter terminate at the expiration of the then current Term. The Initial Period and each renewal period are collectively referred to herein as the "Term."

(b) In the event Agency has failed to derive gross billings from Photographer's Images for a period of one (1) year, Photographer shall have the right to terminate this Agreement on thirty (30) days' prior written notice to Agency.

3. Delivery of Images

(a) Promptly after the execution of this Agreement, Photographer shall deliver to Agency such Images as Photographer deems will further the purposes of this Agreement. Promptly upon receipt of such material, Agency shall review same and within thirty (30) days thereafter return to Photographer all Images, designating those Images which Agency deems appropriate for license pursuant to its Agency obligations hereunder. Images so designated shall be redelivered to Agency and the use of same shall be governed by this Agreement. Images not selected and not representing so-called "dupes" or "similars" to Images designated by Agency may be sold, licensed, or used by Photographer in Photographer's sole discretion.

(b) Images redelivered to Agency for use pursuant to the terms of this Agreement shall at all times be and remain the exclusive property of Photographer, to be held in trust by Agency solely for the limited licensing purposes described herein.

(c) All references herein to "Images" shall be deemed to refer to those Images accepted by Agency.

4. Obligations of Photographer

Photographer shall use all reasonable efforts to accurately caption all Images, and affix proper copyright notice in Photographer's name to such Images. Photographer shall indicate those Images for which a "model release" has been obtained. Upon Agency's request, Photographer will deliver a copy of any release to Agency. In the event an Image does not contain a notation concerning the existence of a model release, Agency acknowledges that no such release shall be deemed to exist and Agency assumes full responsibility for the subsequent use of such Images, and releases and indemnifies Photographer from any and all damages incurred by Agency, Photographer, or third parties in connection with such uses.

5. Warranties of Photographer

Photographer represents and warrants to Agency as follows:

(a) Photographer is the sole and exclusive owner of the Images and of the right to license such Images.

(b) The Images do not knowingly infringe copyright, trademark, right of privacy or publicity, and do not knowingly defame any third party.

(c) Photographer has the right to enter into this Agreement and perform Photographer's obligations hereunder.

6. Obligations of Agency

(a) Agency shall supply a suitable environment for long-term storage, care, and retrieval of Images, including protection from dust, heat, dampness, and overexposure to light.

(b) Agency shall use its best efforts to license the Images and to maximize the prices received by Agency for same.

(c) Agency shall diligently and carefully process all Images so as to avoid loss or damages thereto, and index the Images with reference in each case to Photographer's name. The method of indexing the Images shall be in the Agency's sole discretion, provided such method must permit location of any Image within two (2) weeks and return to Photographer within one (1) month after request for same by Photographer, subject to Paragraph 8, below. Upon the return of any Image to Agency from a Client, Agency shall promptly cause such Image to be refiled so as to ensure ready access for subsequent licensing and/or retrieval.

(d) All Images licensed by Agency shall contain copyright notice in Photographer's name as such notice has been indicated by Photographer on the face of the Images. In the event no notice is so affixed, Agency agrees to affix notice in Photographer's name before license of any Images to the Clients as follows: „ year_____ [Photographer's name], and Agency in each such case shall determine from Photographer and shall utilize the correct year to be included in said notice. Agency shall require, in all agreements with Clients, that the Images shall be protected by copyright in all uses, pursuant to applicable law or regulation.

(e) Agency shall promptly notify Photographer in the event it discovers unauthorized or infringing use of or the loss of or damage to any of the Images. Upon receipt of such notice, Photographer shall control any legal action and shall notify Agency as to the manner in which Photographer wishes to proceed in respect of such infringement, loss, or damage. Photographer shall have the right to cause Agency to be joined as a party in any litigation concerning the Images. Any recovery from such action shall, after payment of all costs (including reasonable attorney's fees), be divided between Photographer and Agency on the same basis as revenue is to be divided, as set forth in Paragraph 7, below.

(f) Agency agrees to conduct itself in all its dealing with Clients in an ethical and reputable fashion.

(g) Agency acknowledges that the Images are of a unique, fragile, and extraordinary artistic nature, which cannot be easily duplicated, and the loss or damage to any such material will result in irreparable harm to Photographer, not readily compensable by monetary reimbursement. Accordingly, Agency will use its best efforts to protect and preserve the Images, and exercise all due care in the handling of the Images.

(h) To the extent information supplied to Clients by Agency in respect of an Image differs from

the information supplied to Agency by Photographer, the accuracy of such information shall be Agency's sole responsibility.

(i) All obligations of Agency under this Agreement apply as well to all permissible subagents.

7. Compensation

(a) In consideration of the services furnished by Agency hereunder and the performance of its obligations hereunder, Agency shall be permitted to retain: _____ percent (____%) of gross billings in connection with the license of the Images. "Gross billings" shall be defined as all revenue, of whatever nature and from whatever source, derived from license of the Images, and shall include, without limitation, holding fees and interest assessed, but shall not be deemed to include so-called "service fees." The only permissible deductions from gross billings are the following:

(i) bad debts and other uncollectible sums actually incurred;

(ii) reasonable currency conversion costs.

Agency acknowledges that all sums received as gross billings from the license of the Images are held in trust for Photographer, subject only to the retention by Agency of its commission as set forth above.

(b) Agency shall remit payment and provide Photographer with a detailed statement setting forth the licensing by Agency of the Images on the following basis [select one]:

(i) Every thirty (30) days on or before the 25th day of each month.

(ii) Every sixty (60) days on or before the last day of each odd n /even n numbered calendar month.

(iii) Every ninety (90) days on or before fifteen (15) days after the close of each calendar quarter.

(c) Such statement shall include the following information:

(i) Identity of Image

(ii) Identity of Client

(iii) Rights granted

(iv) Date payment received

(v) Gross billings

(vi) Deductions from gross billings.

(d) If, during any reporting period, gross billings derived from Photographer's Images do not exceed One Hundred Dollars ($100), payment of such sums to Photographer may be deferred until the next reporting period. In no event, however, shall royalties be paid any less frequently than annually, and notwithstanding any deferral of payment, regular statements shall continue to be sent to Photographer.

(e) Photographer or a designated representative shall have the right, upon reasonable notice and during regular business hours, to inspect Agency's books and records and to make extracts thereof as same relate to Photographer's Images. In the event, as a result of such an audit, it is determined that Agency has underpaid Photographer by an amount equal to or in excess of five percent (5%) of all monies due to Photographer, then Agency shall bear all costs and expenses of such audit as well as remitting to Photographer all past due sums with interest to date. The foregoing shall not be deemed to be a waiver of or limitation upon Photographer's other rights or remedies in the event of such underpayment.

8. Retrieval of Images

(a) Upon the expiration or termination of this Agreement, Agency shall use all reasonable efforts to promptly retrieve and turn over to Photographer all the Images then in Agency's possession, no matter where such Images may be located. In no event shall such retrieval and delivery to Photographer require more than a period of (i) three (3) months after termination, in respect of Images in Agency's files; or (ii) one (1) year after expiration or termination in respect of Images in the possession of Clients or Subagencies at the time of such expiration or termination.

(b) Photographer shall have direct access to Agency's files, upon reasonable prior notice, for purposes of furtherance of Photographer's professional interests (e.g., exhibitions), or in the event Agency does not comply with its retrieval and return obligations pursuant to this paragraph.

(c) During the retrieval period after termination or expiration, Agency shall diligently return to Photographer all Images returned by Clients. If Images are still outstanding one (1) year after termination or expiration, Agency shall provide Photographer with written notification specifically setting forth: (i) identification of Image; (ii) name of Client in whose possession Image is being held; and (iii) address of Client.

9. Dupes

(a) For purposes of this paragraph, "Dupes" shall be defined as duplicates, facsimiles, or other reproductions of Images, whether created by Photographer, Agency, permissible subagents, or clients.

(b) Agency [select one] __shall __shall not be authorized to license the use of "Dupes" to clients.

(c) In the event that licensing of "Dupes" has been authorized, Agency shall not permit clients to create "Dupes" without Photographer's prior written approval.

(d) All "Dupes," regardless of which party has caused such "Dupes" to be created, shall be and remain, from the moment of creation, the sole and exclusive property of Photographer, subject only to permissible licenses.

(e) Agency shall account to Photographer for "Dupes" in all respects as if they were Images licensed under this Agreement and all provisions of this Agreement shall apply to such "Dupes."

10. Default

(a) Agency shall be deemed to be in default of its obligations upon any of the following occurrences:

(i) Breach of any of its representations or warranties contained herein or any other undertaking on its part to be performed hereunder and failure by Agency to cure such breach within ten (10) days after receipt of notice from Photographer specifying same.

(ii) Any activity by Agency outside the limited scope of the authorization issued to Agency hereunder.

(iii) If a petition in bankruptcy or for reorganization is filed by or against Agency; or if Agency makes an assignment for the benefit of its creditors; or if Agency fails to pay its general creditors in a timely fashion; or if a receiver, trustee, liquidator, or custodian is appointed for all or a substantial part of Agency's property, and the order of appointment is not vacated within thirty (30) days; or if Agency assigns or encumbers this Agreement contrary to the terms hereof.

(iv) If Agency ceases to conduct its business or sells or merges substantially all of its assets.

(b) In the event of any act of default as set forth above, in addition to any other remedy

Photographer may have, Photographer shall be entitled to immediately terminate Agency's authorization under this Agreement and shall thereupon be relieved of any continuing obligation it may have to Agency. Upon such termination, all business activity in respect of the Images shall immediately cease, and Agency will promptly retrieve and deliver to Photographer all Images as required pursuant to Paragraph 8, above.

11. Foreign Subagents

In the event Photographer permits Agency to employ the services of any foreign subagents in connection with the license of the Images, Agency may do so, subject to the prior written approval of the Photographer first having been obtained after notification to Photographer of the name and address of the proposed subagent. In no event shall Agency commission or fees, including the fees of Agency and all permissible subagents, exceed that percentage of gross billings specifically stated as Agency's compensation in Paragraph 7, above.

12. Death or Disability of Photographer

In the event Photographer shall die during the Term hereof or shall become disabled or incompetent, Photographer or, in the case of death or incompetency, Photographer's personal representative, shall have the right, exercisable by sixty (60) days' prior written notice to Agency, to cause this agreement and Agency's authorization hereunder to terminate.

13. Taxes

As between Photographer and Agency, Agency shall be solely responsible for the collection and payment of any and all taxes whether in the nature of a sales, personal property, remittance, excise, or other tax that is or may become due and payable in connection with any license of the Images pursuant to the terms of this Agreement.

14. Inability to Locate Photographer

(a) Agency shall use all reasonable efforts (including inquiries with appropriate trade associations) to locate Photographer in the event statements are returned unclaimed. To assist Agency in this endeavor, Photographer shall provide Agency with an alternate address for notice purposes on the signature page of this Agreement.

(b) In the event that, notwithstanding Agency's efforts, Photographer cannot be located, Agency shall deposit any portion of gross billings due to Photographer in a separate interest-bearing account (into which account Agency may deposit sums due to other Photographers whom Agency is unable to locate). Such sums shall remain on deposit for a period of five (5) years or such longer period of time as may be permissible by law. Six (6) months prior to the expiration of such time period, Agency shall provide the American Society of Media Photographers, 150 North Second Street, Philadelphia, PA 19106, or its successor organization, with written notice of the name and last known address of Photographer. Such notice shall be sent to the executive director by certified mail.

(c) If Agency is not contacted by Photographer or his/or personal representative before the expiration of such time period, the sums on deposit with Agency shall be treated according to the laws of the State of _____ concerning abandoned property.

15. Indemnity

(a) Each of the parties hereto agrees to indemnify and hold the other party harmless from and against all final judgments and settlements with consent (hereafter collectively referred to as "claims"), which may arise as a result of a breach or alleged breach of the party granting the indemnity (hereinafter the "Indemnitor") of any representation, warranty, or undertaking to be performed by such Indemnitor. The party being indemnified (hereinafter the "Indemnitee") shall promptly notify the Indemnitor of any such claim, and the Indemnitor shall thereupon have the right to undertake the defense of such claim. The Indemnitee shall have the right, but not the obligation, to be represented by counsel of its choice and participate in such defense at its sole cost and expense. The Indemnitee shall not settle any such claim without the prior written approval of the Indemnitor.

(b) Anything to the contrary contained herein notwithstanding, in the event Photographer is called upon to indemnify Agency pursuant to the foregoing indemnity, Photographer shall not be liable for any monetary sums in excess of the share of gross billings heretofore received by Photographer from Agency pursuant to this Agreement.

16. Miscellaneous

The parties hereto acknowledge that this Agreement is one of agency only and does not constitute an employment agreement ant that Agency is acting in the limited capacity of an independently retained agent on Photographer's behalf. Agency may not set itself out or bind Photographer contrary to the terms hereof.

17. Miscellaneous

(a) Agency may not assign this Agreement without the prior written consent of Photographer. Any assignment in contravention of the foregoing prohibition shall be deemed null and void. Photographer shall have the right to assign this Agreement to any corporation in which Photographer is a principal stockholder, and to assign Photographer's share of gross billings earned hereunder.

(b) Except as may otherwise be provided herein, this Agreement shall be binding upon and shall inure to the benefit of the respective heirs, executors, administrators, successors, and assigns of the parties hereto.

(c) This Agreement incorporates the entire understanding of the parties concerning the subject matter contained herein and may not be modified, amended, or otherwise changed in any respect except by a separate writing signed by the party to be charged therewith.

(d) This Agreement and all matters collateral thereto shall be construed according to the laws of the State of _____ and any jurisdiction of such state.

IN WITNESS WHEREOF, the parties have executed this Agreement on the day and date first set forth above.

Agency _____

Photographer _____

Principal Address _____

Alternate Address _____

Business Telephone _____

Media Photographers' Copyright Agency, Inc./Photographer Full Service Agreement

This Agreement is made this ____ day of _____ year____, by and between _____ (hereinafter referred to as the "Photographer") and the Media Photographers' Copyright Agency, Inc. (hereinafter referred to as the "Agency").

RECITALS

The Photographer is a member of the American Society of Media Photographers, Inc. ("ASMP") and is engaged in the business of creating photographic images for publication.

The Agency is a wholly owned subsidiary of ASMP and is engaged in the business of licensing the photographic images created by ASMP members, under terms and conditions established by them, to interested third parties for their use, reproduction, distribution, and/or publication.

1. Grant of Authority.

(a) The Photographer designates the Agency as the Photographer's nonexclusive agent for the purpose of negotiating the licensing of all images that are authorized by the Photographer to be licensed by the Agency on the Photographer's behalf (the "Images") as provided in paragraph (3). below. The Agency is authorized to solicit licensing opportunities on behalf of the Photographer with respect to the Images and to enter into negotiations for the licensing of the Photographer's Images. The Photographer retains the authority to make all final decisions with respect to the terms and conditions to be incorporated into any such license, including but not limited to the amount of compensation to be paid by the party granted rights to use the Images (the "Licensee"). For purposes of this Agreement, the "Licensees" shall include all actual and prospective licensees of the Photographer's Images.

(b) The geographic scope of the Agency's licensing authority shall be worldwide unless otherwise limited in writing by the Photographer.

(c) The Agency is authorized to use or employ such subagents as may be necessary to carry out the purposes of this Agreement.

(d) The Agency shall not have the right to sell or assign any of the Photographer's copyright rights in the Images unless specifically authorized to do so in writing by the Photographer.

2. Custody of and Rights in the Images.

(a) All the Images delivered to the Agency for licensing under this Agreement shall at all times be and remain the exclusive property of the Photographer and shall be held in trust by the Agency for the purposes of this Agreement.

(b) The copyright and other rights in and to the Images shall remain the exclusive property of the Photographer, and nothing in this Agreement shall be interpreted as a conveyance of any such rights from the Photographer to the Agency, other than the rights specifically enumerated in this Agreement.

145

(c) The Agency shall have the right to record any Images on or in any storage, delivery, and/or catalog system, regardless of whether such system is digital, analog, print, or photographic (the "Recorded Images").

(d) Upon the termination of this Agreement, the Agency ____shall ____shall not continue to have the right to license the Recorded Images pursuant to the terms thereof. In the event the Agency is granted such a right, its authority shall be revoked upon receiving thirty (30) days' advance written notice of revocation from the Photographer.

(e) Notwithstanding the termination of this Agreement or of the Agency's right to license the Recorded Images following termination of this Agreement, the Agency shall not be required to remove the Recorded Images from a storage, delivery, and/or catalog system referred to in sub-paragraph 2(c). above.

3. Images Eligible for Licensing by the Agency.

Unless otherwise specifically designated by the Photographer as ineligible for licensing, the Agency is authorized to license, subject to the Photographer's approval of the terms and conditions thereof as provided in paragraph 1, all the Images created by the Photographer and in which he or she retains sole ownership of the copyrights.

4. Obligations of the Photographer.

(a) The Photographer shall affix a proper copyright notice consisting of the symbol ©, the name of the Photographer, and the year of first publication or, if unpublished, the year of creation, to all copies of any Images delivered to the Agency or to the Licensees for purposes of this Agreement.

(b) The Photographer shall be responsible for accurately captioning all the Images delivered to the Agency or to the Licensees pursuant to this Agreement.

(c) The Photographer shall be responsible for obtaining all model and/or property releases that are necessary to enable the Agency to lawfully license the Images to the Licensees and shall pro-vide the Agency with copies of such releases upon request of the Agency. The Photographer shall specifically identify each Image for which all necessary releases have been obtained.

5. Warranties of the Photographer.

The Photographer represents and warrants the Agency as follows:

(a) The Photographer is the sole owner of the copyrights in the Images and has the right to license the use, reproduction, distribution, and publication of the Images to others.

(b) To the best of the Photographer's knowledge, the Images do not infringe the copyright, trade-mark, privacy, publicity, or other rights of any third party, nor do the Images defame any third party.

(c) The Photographer has obtained all necessary model and/or property releases with respect to the Images that the Photographer has identified as necessary to be released.

(d) The Photographer has the right to enter into this Agreement, and the performance of the obligations established by this Agreement will not violate any other contract or agreement to which the Photographer may be a party.

6. Indemnification by the Photographer.

The Photographer indemnifies and holds harmless the Agency from any and all claims and lia-bilities, including but not limited to the costs of defending such claims, arising from or related to

breach of the Photographer's warranties set forth in paragraph 5 above.

7. Obligations of the Agency.

(a) The Agency will attempt in good faith to license the Images on terms and conditions that maximize the benefits to the Photographer. The Agency does not guarantee or promise that its licensing efforts with respect to the Photographer's Images will be successful. The Agency represents only that it will use its best efforts on the Photographer's behalf and will communicate to the Photographer for his or her acceptance or rejection the terms and conditions of any licensing arrangement that may be entered into with a Licensee. The Agency will not, however, enter into any licensing agreement with a Licensee on the Photographer's behalf without first obtaining the approval of the Photographer of all terms and conditions contained in such licensing agreement.

(b) The Agency shall promptly notify the Photographer upon discovery of any potentially infringing use of the Images or of the loss or damage to the Images. Upon receipt of such notice, the Photographer shall be responsible for undertaking any enforcement or other legal action necessary to protect his or her rights, but the Photographer may engage the Agency, upon its agreement, to undertake appropriate legal action on his or her behalf as provided below in subparagraph 7(f).

(c) The Agency shall collect all monies paid to the Photographer by the Licensees that enter into agreements with the Agency for the use of the Photographer's Images and shall deposit all monies in a single separate account maintained for all funds collected for the Photographers who engage the Agency as their nonexclusive licensing agent.

(d) The Agency shall remit payments due to the Photographer under this Agreement on a monthly basis, unless such payments are less than One Hundred Dollars ($100), in which event payment may be deferred no longer than six (6) months or until such time as the amounts due to the Photographer exceed that amount.

(e) Each monthly payment by the Agency to the Photographer shall be accompanied by a detailed statement containing the following information:

(i) The identities of the Image(s) generating the revenues.

(ii) The identity of the Licensee(s) paying the revenues.

(iii) A reference to the licensing agreement(s) (by number, date, or other appropriate designation selected by the Agency) pursuant to which the Licensee(s) made payment.

(iv) The date the payment(s) was received by the Agency.

(v) The gross revenues collected by the Agency for the period in the form of licensing fees paid for use of the Photographer's Image(s).

(vi) The deductions from gross revenues made by the Agency pursuant to the terms of this Agreement.

(f) If requested to undertake the enforcement of the Photographer's copyright rights against one or more infringers and if the Agency agrees to undertake such enforcement action on the Photographer's behalf, the Photographer and the Agency shall enter into a separate written agreement specifying each party's rights and obligations with respect to the action to be taken against the infringer(s).

8. Compensation of the Agency.

(a) In exchange for the licensing services provided to the Photographer under this Agreement, the Agency will be entitled to be paid thirty percent (30%) of the gross revenues (as defined below) earned from the Agency's licensing of the Photographer's Image(s). Such payments to the Agency shall be made by deducting thirty percent (30%) of the gross revenues received by the Agency for

the preceding month from the licensing of Photographer's Image(s). The balance of the gross revenues, or seventy percent (70%) of those amounts, shall be paid to the Photographer in accordance with paragraph 7 above.

(b) For purposes of this Agreement, "gross revenues" shall consist of all revenues received by the Agency from the licensing of the Photographer's Images. "Gross revenues" shall include, but shall not be limited to, all holding fees, "comp" fees, and lost transparency charges attributable to the Photographer's Images.

9. Term.

This Agreement shall commence as of the date written above and shall continue until such time as either party gives thirty (30) days' advance notice of intent to terminate the Agreement to the other party. Both the Photographer and the Agency shall have the unrestricted right to terminate this Agreement for any reason.

10. Notices.

All notices given under this Agreement shall be delivered to the following addresses unless otherwise stated in writing:

For the Photographer:

For the Agency: 150 North Second Street, Philadelphia, PA 19106

11. Governing Law.

This Agreement shall be interpreted in accordance with the law of the State of Delaware.

12. Amendment.

This Agreement can be amended only in writing signed by both parties.

13. Assignment.

The rights, benefits, and obligations under the Agreement cannot be assigned to others by the Photographer or the Agency without the prior written consent of the non-assigning party.

14. Complete Agreement.

This Agreement contains the entire understanding of the parties with respect to their licensing arrangement and supersedes any prior written or oral understanding between the parties related to that subject.

WHEREFORE, the parties have evidenced their assent to the terms and conditions of this Agreement by the signatures set forth below.

MEDIA PHOTOGRAPHERS' COPYRIGHT AGENCY, INC.

[Signature of the Photographer] By:

[Printed Name of the Photographer] Title:

Ethics and the Photographer's Responsibilities

Today photographers are working in an increasingly complex and competitive arena. Rights are being eroded and obstacles encountered at every turn—massive consolidation of agencies and corporate takeovers, agencies producing in-house materials that compete with the photographers they represent, tightened budgets, work-for-hire, and the proliferation of CD-ROM clip art disks. It's important to fight vigorously to protect those rights. Our battlefield is the classic one of a free marketplace, where unfair practices abound.

It's also important to remember, however, that rights are not a one-sided issue. When we make a business deal, we also assume certain obligations. Many of these are spelled out in a contract, but others are a matter of ethics and good business sense.

The market for stock photography is intensely competitive. In this crowded field a few photographers may be tempted to cut corners to make a sale.

There are two sound reasons not to bend the rules. One is purely ethical—it's wrong. If that's not enough to deter you, consider the practical reason—it's bad business. Even though you may not always face legal repercussions, if you burn clients or stock agents through questionable practices, they will not do business with you again. Furthermore, bad news travels fast, and in a short time others will be wary of dealing with you. Even if your mistake is the result of sloppiness rather than intention (for example, your assistant sends out a photo before its time restriction is up), your reputation may still be damaged. Worse, your action brings disrepute to the industry and makes the fight for protection of rights all the more difficult for the thousands of photographers who are stringently upholding ethical standards.

ASMP believes it is in the best interests of the photographic community to examine these issues closely. In its efforts to promote good business practices and protect photographers' rights, the Society emphasizes the highest level of professional and ethical standards. The following are some of the areas in which photographers would be well advised to be meticulous in their business dealings.

Responsibility to Assignment Clients

Whether your contract is written or oral, honor its content. Keep to the spirit as well as the letter of the deal.

1. Time restrictions. Don't release pictures to your stock agency or put them in your own stock file until any time limit agreed upon with the assigning client has expired. This requires that you set up safeguards in your logging system so that photos are not inadvertently sent out ahead of time.
2. Noncompete clauses. Honor any noncompete restrictions you have agreed to and alert your agency to them by placing a warning label on the slide mount (for example, "no permission liquor ads" or "restricted construction industry use"). Even when there is no contract, use good judgment by avoiding the use of photographs by a competing client. Although you may legally be free to sell an assignment outtake to a client's competitor, you may be on very shaky ground if you do. At the

very least you'd be wise to discuss the move with the assigning client.

3. Piggybacking. When you're on location for an assignment client, how much of your time, creative thinking, and energy should be spent on that job? The ethical photographer would say "all of it." Depending on the terms of the job and the understanding with the client, shooting stock on assignment time is cheating. Just because the assignment has been "adequately" fulfilled doesn't mean the photographer has license to stop short of an all-out effort in order to skim some time—or a sunset—for personal use. Of course, there are many exceptions to this rule and there are occasions when you can shoot your own pictures without short-changing the client in any way, such as stopping for a skyline picture on the way to the airport. What is important to remember is that your first responsibility is to fulfill your obligation to the client. Your pride and self-respect as a professional require it.

Staying in Touch

Delivery agreements spell out the responsibilities of clients for handling photographs with care and returning them in a timely manner. And it is a valid business practice for a photographer to charge a holding fee when clients retain photographs too long; after all, they are keeping them out of circulation. But what about the responsibility of the photographer to retrieve his or her work when a client or photo agency is finished with it?

In one case, a photographer left a large number of slides with a client to review for a project. When the client called to have the photographer pick up his slides, they found he was away. His phone number was an answering service and his mailing address a post office box. After two months of leaving messages and sending notices, the client still had received no reply. They felt responsible for the slides in their custody and knew that their liability was increasing every day. Mailing the slides back, even via registered mail, was not a viable option without the photographer's knowledge and assent. Obviously, the photographer assumed that the client would hold onto his slides until he returned.

Photo agencies more frequently complain of this problem when they want to return photographs. Not only are some photographers casual about picking up their work, but many fail to inform their agencies when they move or change phone numbers.

The professional photographer must also work in a professional manner. Remember that regardless of what your delivery memo says, you share in the responsibility of ensuring a safe and businesslike return of your materials. You must provide an avenue for a client or photo agency to return your photographs. This means that, if you are away, you need to arrange for someone to check your answering machine or service and open your mail, and you need to check in with that person periodically or leave word of where you can be reached. And, of course, maintaining a good relationship with your photo agency requires that you keep your status with them current.

Responsibility to Stock Photo Buyers

1. Accurate captioning. Nearly every photographer has been tempted, at one time or

another, to "adjust" a caption to make a picture a little bit more salable. However, there is no justification for modifying information—either you're lying or you're not. Let's say you've got good pictures of a celebrity mayor. Maybe they were taken when he was running for city council and later he ran for mayor. A buyer wants them and your agent calls to ask if you know exactly when they were taken. The sale may depend on the date and the mayor still looks the same, so what do you do? These are the kinds of questions that every photographer is confronted with. We are honorable people, but there are those moments when some of us may think, "What harm could there be?" That's the first step on the road to self-destruction.

2. Model releases. If you don't have a model release, then you must say so. If you do have a model release, you must determine if it is valid. Let's say you take a picture of kids playing in a park and their grandmother signs the release. She's not the legal guardian, but who's going to know? Do you wait until you get sued, or do you follow up and get valid releases from the parent or guardian? It's all too easy to "adjust reality," but sooner or later it's going to backfire.

3. Exclusivity. The temptation to make a big advertising stock sale has occasionally caused photographers to mislead a buyer about their ability to guarantee exclusive usage in the buyer's market. If you have dupes of a "great" photograph in four agencies, how can you promise that they won't come head to head with the exclusive you've just sold? And checking with the agencies on the status of the picture after the sale may leave you and them in a very embarrassing position.

Responsibility to your Stock Agent

1. Accurate captioning. This is important to your agent for the same reasons it is important to the buyer. The additional point to be made here is that your agent is your representative and should not be put in the position of lying for you. If he or she finds out that your captions are misleading or just plain deceitful, you will have ruined not only a sale but an important relationship and may incur legal liability in the bargain.

2. Exclusive contract. If your contract with an agency is exclusive, don't go around the corner putting your pictures in other agencies. Some photographers have been known to use pseudonyms on photos in secondary agencies in order to circumvent their exclusive contract, which can be described as shabby behavior as well as breach of contract. If you agree to an exclusive contract, stick to it. How can an agency represent you if you are undercutting it at every turn? The result might be that you jeopardize all your agency relationships.

Responsibility to Your Models

Whether you are using professional or nonprofessional models, don't misrepresent what the project is, and how the pictures will be used. It is especially important to make clear what a stock photo file is. Pay agreed-upon model fees on time and follow up on any other promises you have made, such as sending complimentary prints or tearsheets. Relationships with models are frequently ongoing ones, and it makes good business sense to keep them well maintained.

Responsibility to Other Photographers

Every creative photographer has a personal responsibility to push his or her ability to the limits in order to make the best photographs possible. Your responsibility to other photographers is avoiding plagiarism of their work. This pernicious practice seems to have become more prevalent with the proliferation of stock agency catalogs and photography source books. These are tempting, easy sources for creative ideas, but they are not yours for the taking.

"Ripoffs" of other people's photographs usually fall into two categories—those that are actual infringements of copyright, and those that technically may not infringe but still present problems. Whether or not a photograph can be considered a legal infringement can only be decided in a court of law. Proving copyright infringement can be a long, painful, and expensive task. Even if the author of a work (in this case a photograph) and others think it is clear that another photographer has violated copyright, proving it in court is difficult. The photograph has to be "substantially similar" to the work that is plagiarized. What does "substantially similar" mean? Although each case must be decided on its own merits, generally it means that an ordinary observer would think the two photographs are one and the same.

If a photographer wants to create a photograph that substantially derives from an existing copyrighted photograph, or other work, he or she is then creating what copyright law calls a "derivative work"—which is perfectly legal so long as he or she obtains permission from the copyright holder of the original work.

Even if a photograph is not found by a court to infringe on copyright, it can be so imitative as to financially hurt the original creator and harm the reputation of both the copier and the originator. Imitative photography hurts the original photographer in two ways: It deprives that person of money from selling the original and it hurts his or her reputation. After all, if the imitative photograph is not as good, an undiscerning viewer may attribute the inferior work to the original photographer and make a subconscious judgment about the photographer's ability.

Imitative photography hurts the copying photographer too, in a subtle but pervasive way. While the imitator may be able to derive some income from this type of work, his or her career will suffer because of lack of creativity.

Many young artists, at the start of their careers, copy the works of predecessors they admire. It is a time-honored tradition for painters to copy the old masters to gain understanding of their techniques. So, too, photographers copy old and new masters to learn how they make their pictures. It is difficult to find a personal style. Style doesn't happen suddenly but evolves over a period of time. For that reason it may be acceptable to copy as an exercise, as long as you understand that you are doing it as a study and don't have the right to any remuneration for the copied work.

To put your name on a work, that work must be fully yours. It must be yours in conception and in execution. Copying another photographer's concept is unethical, even if it is not legally actionable (under copyright law, it is basically the "expression" rather than the "idea" that is copyrightable). When the copying is discovered, it generally lowers the reputation of the photographer who has done it. We have all seen photographs

that were well executed but not original and said, "I've seen that one before." Even without knowing exactly who made the original photograph, we know that whoever made the copy did something wrong.

Some photographers copy because they think that if a certain style or technique works for someone else it will work for them. Good art directors tell us, however, that if they want a certain style they will hire the original photographer, not a cut-rate imitator. Of course, there are art directors who are unsure of their own creativity and who see hiring a copycat as a sure way of getting an acceptable job done. While this happens all the time, it does not enhance the reputation of the copycat or the art director.

One photograph widely copied shows a vacationing couple in beach hats, sitting side by side on white chairs at the edge of the ocean. Their backs are to the camera, and their sense of joy and relaxation is displayed by their posture: hands folded behind their necks, elbows out, basking in the sun. Since this photograph was originally published, numerous plagiaristic copies have been made. Sometimes the copy is exact down to the size of the beach hats. Sometimes the color or the material of the chairs is changed to make it "different." In many cases the new photograph is so similar to the original that they must be compared side by side to distinguish which is the copy.

Another classic subject for copying is the executive at a desk with blinds (or maps or windows) behind. One photo agency reports having received a batch of photo returns from a client who by mistake included eight or nine virtually identical "executive" pictures—from three different agencies. Who ripped off whom—and when?

Does this mean you can't ever photograph an executive at a desk in front of a window? Of course not. Under the law, you cannot copyright an idea—only the tangible expression of an idea. Therefore the idea—an executive at a desk—is still up for grabs, but the tangible expression you make must be substantially different from what's been done before. That's the creative challenge.

All too often we hear the plaintive refrain: "What about the art director who sends me a layout with a sketch showing what he wants me to shoot? Then what am I to do?" In fact, some art directors are even so bold as to include a photocopy of a photograph they want imitated.

The answer is this: "Just say no" to plagiarism. Tell the art director that you recognize the work as someone else's and that you cannot legally or ethically copy it. Explain that if you do copy it, you could be sued for copyright infringement and so could the art director and his or her agency. Your tactful explanation will show that you are on the art director's side and are protecting both of you from a potentially nasty situation. Suggest a new approach to the same concept. The photographer should be a creative asset to the art director and help in creating a new work for the client.

Remember that, in the final analysis, copying is detrimental to your creative growth as a photographer. You become like the student who cheats on an exam and passes the test without learning how to solve the problem.

Creating a Good Impression

Photographers, like many other professionals, often have a pressing need and an inflexible deadline and sometimes are guilty of barging into a location, promising the

moon to get cooperation, and then disappearing in a wake of broken promises and strained tempers.

We have a responsibility to clean up after ourselves, to return a location to its original condition—whether that means picking up stray Polaroid papers from the floor, removing gaffer tape from furniture, putting pictures back on the wall, or anything else that's necessary, no matter how troublesome.

Creativity and good business sense aren't the only ingredients to success in photography. Attitude is just as important. Every time you photograph in a location and leave a pleasant feeling among those who helped you, you create a better climate for the next photographer who comes along. If altruism isn't your strong suit, consider that you may be that next photographer, grateful for the good will engendered by colleagues who came before you.

And so we come back to our original point: Good ethics are good business. Adhering to the spirit as well as the letter of a contract makes for a happy client, one who will want to work with you again. The benefits far outweigh any loss of what you might gain by cheating, and they reach far beyond yourself.

These days we are so caught up in a crushingly competitive environment that we may not take time for introspection, for examining our own attitudes and practices. A common attitude in our profession is "we photographers against the world." We seldom stop to see if we are doing our part—living up not just to the performance part of the bargain but to the trust as well.

Sometimes it's hard to see beyond our own needs, but it is essential that we do— that we look outward and see the needs of others as well. Ethical behavior is not just the right thing to do. It instills the pride in work that is the hallmark of a professional.

All photographers are urged to abide by the ASMP Code of Ethics

ASMP Code of Ethics

The ASMP Code of Ethics is a guide for ethical business dealings, protecting the profession, the photographer, vendors, employees, subjects, clients, and colleagues.

Responsibility to Colleagues and the Profession

1. Maintain a high quality of service and a reputation for honesty and fairness.
2. Oppose censorship and protect the copyrights and moral rights of other creators.
3. Never advance one's own interests at the expense of the profession.
4. Foster fair competition based on professional qualification and merit.
5. Never deliberately exaggerate one's qualifications, nor misrepresent the authorship of work presented in self-promotion.
6. Never engage in malicious or deliberately inaccurate criticism of the reputation or work of another photographer.
7. Negotiate licensing agreements that protect the historical balance between usage fees and rights granted.
8. Never offer nor accept bribes, kickbacks, or other unethical inducements.
9. Never conspire with others to fix prices, organize illegal boycotts, nor engage in other unfair competitive practices.

10. Refuse agreements that are unfair to the photographer.
11. Never undertake assignments in competition with others for which payment will be received only if the work is accepted.
12. Never enter commercial competitions in which usage rights are transferred without reasonable fees.
13. Donate time for the betterment of the profession and to advise entry-level photographers.

Responsibility to Subjects
14. Respect the privacy and property rights of one's subjects.
15. Never use deceit in obtaining model or property releases.

Responsibility to Clients
16. Conduct oneself in a professional manner, and represent a client's best interests within the limits of one's professional responsibility.
17. Protect a client's confidential information; assistants should likewise maintain confidentiality of the photographer's proprietary information.
18. Accurately represent to clients the existence of model and property releases for photographs.
19. Stipulate a fair and reasonable value for lost or damaged photographs.
20. Use written contracts and delivery memos with a client, stock agency, or assignment representative.
21. Consider an original assignment client's interests with regard to allowing subsequent stock use of that work by the client's direct competition, absent an agreement allowing such use.

Responsibility to Employees and Suppliers
22. Honor one's legal, financial and ethical obligations toward employees and suppliers.
23. Never take unfair advantage of one's position as employer of models, assistants, employees or contract labor.

Responsibility of the Photojournalist
24. Photograph as honestly as possible, provide accurate captions, and never intentionally distort the truth in news photographs.
25. Never alter the content or meaning of a news photograph and prohibit subsequent alteration.
26. Disclose any alteration or manipulation of content or meaning in editorial, feature, or illustrative photographs and require the publisher to disclose that distortion or any further alteration.

The Photographer's Estate: Annuity and Asset

One of the attractions of your stock file is that, if managed and exploited properly, it can earn money on its own—today while you're building it, in the future if you retire, and after your death for your heirs and beneficiaries. So no matter what your age, you should view your stock file as a potential asset and plan for its disposition after your death.

There are two main reasons for this: first, the Copyright Act of 1976 grants you ownership of the copyright to your images for your lifetime plus seventy years. Second, the result of building a stock file over the course of your photographic career is the creation of an asset that may produce income for many years after your death.

How to manage your file effectively and have it produce the most income possible—and avoid creating a tax burden for your heirs (like any other asset, the file can be taxed when bequeathed, sold, or otherwise transferred)—is where financial and estate planning can help. Only recently have photographers recognized the stock file as a valuable asset, and so there are no long-established procedures for handling this asset in estate planning. However, when general guidelines for estate planning are combined with those for managing a stock file efficiently, you can get an idea of what you need to do, and the few hours you spend considering this now can be worth a lot of money later.

A new consideration has arisen since the last time this chapter was revised. Market forces, such as increased competition, and developments like the consolidation of stock agencies and the emergence of clip art, have resulted in decreasing revenues from stock libraries for most photographers. As of this writing, there is no reason to think that downward price trend will stop or reverse itself. For that reason, in planning your estate, as well as for your retirement, you will probably want to estimate the future value and projected income from your stock file much more conservatively than in the past.

The Need for Estate Planning

First, take a look at the "Estate Planning Primer" at the end of this section, which explains the terms and some of the processes involved. Quite simply, your estate is the property you own. In terms of estate law, it is generally the property you own, and possibly the property you control, at the time of your death. What happens to that property after your death is usually determined by your will, which spells out what you want done with it upon your death and also names the person who is to handle it—your executor or personal representative. In the absence of a will, state law determines who will be appointed to dispose of your estate (your administrator or personal representative), and how it will be disposed of, which may be very different from what you would have wished. In some states, state law will also determine what happens to some of your assets, even when you have a will. The names in which your assets are held, and the exact wording of those names (e.g., "and" versus "or") will also have an effect on who receives what. The estate is an entity, a "taxpayer" like any other, and it pays estate income and other taxes. The Internal Revenue Service and/or the state taxing authority

will come in and value the property in the estate if you have not done this prior to your death, or it may contest the value you have placed on the property. In either case, the executor is going to have to take a position on the value of the property. If there is not enough money in the estate to pay tax, property may have to be liquidated or your beneficiaries may have to pay taxes out of their own pockets. That's why estate planning is so critical. Without it, you may be leaving your heirs a tax burden instead of an income-producing asset.

It should be noted that, as this chapter was being revised, there was legislation that had been passed in Congress that would have phased out of existence the federal estate tax. President Clinton vetoed that legislation. Congress did not have quite enough votes to override that veto. With a new president, it is possible that there will be legislation signed into law that will eliminate any federal estate tax applicable to your estate. In any event, however, most states impose their own inheritance taxes, so the need for tax and other planning will exist whether or not there is a federal estate tax.

Making a Stock File an Asset

Once you understand what can happen to your estate after your death, you'll see that, unlike stocks and bonds, your photo file requires unique handling in order to produce income for your heirs. Your attorney can interpret the laws for you, and your attorney, accountant, and/or financial adviser can recommend procedures to maximize the value of your files and minimize the tax liabilities for your heirs. However, it's up to you to take the necessary steps—you're the one who knows the photographic business—and these are the steps to take:

- Enriching the file
- Organizing the file
- Valuing the file
- Deciding on its disposition
- Providing for its management

Many variables can affect your decisions. In creating a file, your interest may be determined by how old you are, how many dependents you have, whether your specialties lend themselves to long-term income, and similar factors. In arranging for its management, whether you're incorporated or a sole proprietor, or whether there are family members who are involved in your business or estate and who know your stock and can market it, may all play a role in your decisions.

Enrichment of the File

What is the present contribution to your income from stock versus assignment or other photography work? More important, what type of photography do you do? Are the subject specialties strong enough to produce income without your adding to them constantly? During your later years, consider adding topics that have a longer market life. You should take a hard look at your stock file, remove any images that are weak (in terms of their estimated ability to last in the marketplace), and start adding work that you think will sell in the future.

Organization of the File

If the file is in disarray, it's almost not an asset, and in fact can create a tax crisis for your heirs and beneficiaries because it could be taxed as if all the photographs had the same value (see below). Certainly, no one else coming to the files will have a prayer of licensing anything from it unless it's properly catalogued and captioned. Tax considerations aside, having to deal with a disorganized file and make intelligent decisions about what to do with it is a nightmare for any executor, and your beneficiaries will end up paying for it, directly through increased executor's commissions or indirectly through reduced sales and/or licensing prices.

Valuation of the File

This is probably the most critical step you can take in planning your estate. To begin with, if your executor sells the entire stock file, including all rights, in an arms-length transaction, before the death tax returns are filed, the sale price will generally be the value used on the death tax return. If you direct that the file be sold, or if your beneficiaries do not instruct him to hold the file, in most states your executor is legally bound to liquidate that asset, which means selling the entire stock file and turning it into cash to be distributed under the will. If no buyer is found, or if you have stipulated that the file not be sold, the IRS will require that the file be valued in some other way.

A variety of approaches to valuation can be taken, but a crucial factor is the tax impact of valuation. The tax authorities typically want to maximize the file's value, and, hence, the taxes generated by your estate. Your executor has to decide whether to minimize the value (within justifiable limits)—and the estate taxes—or to maximize it so as to reduce the income taxes that may be paid later and/or to take maximum advantage of any tax credits and exemptions that may be available. If you leave valuation to the tax authorities, they may take their own figure—perhaps the same $1,500 lost-transparency sum often cited in the industry as a fair valuation figure—and simply multiply it by every slide in your studio—the rejects, the seconds, the similars, the dupes, everything. So you must first clean house and throw out or clearly label and separate dupes, test shots, and extras from those that are bona fide salable stock. If you're a fine art photographer, this means separating work prints from exhibition prints and, further, the signed ones from the unsigned. The family snaps should be clearly labeled and separated from your commercial work. The real value of your file to you is the income it has actually earned for you. But so far no consistent estate tax approach to valuing in this way has been established. One formula looks at use value, based on the idea that an image's value is determined by its actual use, and that a yearly average of five years' past income performance from stock would give a fair picture of the file's value. One factor here is depreciation. (Note that some stock agencies believe that an inactive stock file—to which the photographer has not contributed new material—depreciates approximately 20 percent per year for five years until it reaches a certain level of sales, depending, of course, on the type of subjects in the files and current trends.)

You can also get an expert appraiser to come in during your lifetime and appraise your work. These are private individuals used by attorneys and the IRS to determine

the value of stock files. You might consider a general consultation if your files aren't in apple-pie order, to identify those areas that are likely to have more long-term value and therefore benefit most from the time invested in cataloguing and captioning. If your files are in good shape, you can get a definitive estimate of value as of the time the appraisal is done, which can be a guideline for future work and can also be updated. An appraisal can be of inestimable value if you want the file sold outright or if your beneficiaries should want to sell it. No matter how you arrive at it, some kind of an appropriate valuation is needed so your estate planner can estimate your assets, taxes, and expenses, and can advise you on the best ways to maximize what your beneficiaries will receive.

Disposition of the File

This is simply deciding what will happen to the file—who will get it—which should be dealt with by a will and/or trust instrument. You specify whether the file should go to a beneficiary, whether it should be sold and the proceeds given to a beneficiary, or whether it should be held by a trustee.

Providing Management

No matter how you choose to dispose of the file, you should appoint someone who knows how to manage, exploit, and protect it, since amateurs simply cannot be expected to handle this very specialized task. If the file is not managed, it may be of little or no real value, just as when it isn't catalogued. There are several options for this, including using your executors, using an agency, or using a paid private manager.

Using an Executor and/or a Photographic Executor

First of all, remember that the job of executor can be burdensome and thankless, especially on a large or complicated estate. Although executors, like trustees, are entitled to commissions specified by law, you should nevertheless make sure that anyone you name is willing and qualified to take on the work. If your executor is not familiar with photography and the business of making images produce income, you should give him or her as much direction as possible concerning how you want your files treated: sold outright as a single asset, sold gradually over a period of time, distributed to your beneficiaries to manage for themselves or through a stock agency, held in trust for a period of time, and so on.

Since you can have more than one executor, you can pool multiple talents by choosing people and/or entities who can contribute in different areas. If you do, you should consider a provision in your will dividing the responsibilities (and perhaps also the liabilities), so that the photographic executor has one role and the primary executor another. Your photographic executor could go through the "firsts" in your portfolio and any other unfiled material, to select those images that will add even more value to your stock files. This person, or another you stipulate, could also see to the liquidation of your equipment on behalf of your heirs.

Using a Stock House

If you already have a good relationship with a stock house, you may want to continue the arrangement in your will. The obvious advantage for your beneficiaries is that they won't have the headache of managing your file. The disadvantage is that they may have less income and very limited control over what happens to the images. You should make your beneficiaries (if they're not knowledgeable about this) aware of the procedures of the stock house or houses that handle your work, and also provide the name of an expert adviser to help them make the decisions that come up and to guide them if the stock house closes or decides against continuing to handle the file some time in the future. If you want these procedures to be mandatory, you should include them in your will; if they are only suggestions, they can be in your will or in a separate letter of instruction. At the same time, let your stock house know the names of your executors, trustees, and beneficiaries, and instruct them as to how payments are to be made.

If you aren't using a stock house and want to make provision to transfer the file to one, you should plan ahead for that too, again informing all parties and naming expert helpers. Many stock houses are becoming overloaded and less receptive to new materials, especially if the file has been on its own and they cannot expect new material from a photographer who can be promoted in an increasingly competitive market. If you don't make advance provision, and the stock house you stipulate rejects the file, your beneficiaries could be left to fend for themselves after all. In light of the rampant consolidation that has taken place within the stock house sector in recent years, much of the above may be academic, with fewer stock houses to compete with each other, fewer and fewer seem willing to carry the work of photographers, generally, and particularly where the photographer is not continually adding new work to the file. It may well be that, except for a relatively small number of photographers, stock houses will no longer be a viable alternative when it comes time to arranging for the management of your photographic estate. You should not be reluctant to discuss this issue candidly with your stock house if you currently work with one or have one in mind. You may find that you have fewer alternatives than you had thought, but at least that information will help you focus your planning and avoid making faulty assumptions. Even for those photographers who are able to maintain their relationships with their stock houses, eroding revenues may suggest a different approach, one that does not rely on stock houses, to marketing stock files for the photographers' beneficiaries.

Using a Private Manager

If you sell your own stock, you may want to have your file in the hands of a knowledgeable manager who can either continue the business or place it with an agency.

Using a Trust

Your lawyer may recommend the creation of a trust—established during your lifetime (sometimes called a "living" or "inter vivos" trust) or under your will—for tax reasons and/or in order to keep control in the hands of a trustee other than a beneficiary. You can create a trust, either under your will or in a separate document. The stock file is then held by the trustee, as legal owner, who manages the files, collects the income, and pays the net income to your beneficiaries. This provides the benefits of the files to your

beneficiaries while imposing the management burdens on the trustee. Like the executor, the trustee may be given the power or the instructions to hire a stock house or other outside manager. Also like the executor, and like the stock house and private manager, the trustee is entitled to be paid for his or her services.

Other Options and Tax Strategies

There are other options, and the following may serve as a starting point for you and your legal and tax advisers. These tax considerations may well have changed by the time that you read this, so be sure to check with your tax and financial advisers.

1. You can give the stock file, or a portion of it, to your children while you're still alive. You can make a gift to your children, or others, tax-free up to a certain value per year. A number of photographers have followed this method in order to stave off income taxes now and estate and inheritance taxes later.

2. You can spin off and incorporate the stock part of the business. Some photographers place their stock business in a separate corporation with those whom they wish to benefit as owners. The revenues realized from the stock come into the corporation and are disbursed as income or dividends. Upon your death, the corporation will continue to exist and will continue to disburse dividends and income to these owners, who are now your beneficiaries. In this way the corporation may not be an asset of your estate and may not be subject to estate or inheritance taxes.

3. You can take a portion of your stock files and donate it, under your will or otherwise, to a charitable organization such as a museum. (But check with the institution first to be sure it is willing to accept the bequest, or you'll create a headache for your heirs. Some institutions require a fund for maintenance of a collection.) You or your estate may then qualify for a charitable deduction. Many stock photographs can be considered to have historical value, particularly if a photographer has established a reputation or has specialized in one field of endeavor.

Keep in mind, however, that devices like these are governed by highly technical rules, so it is essential to seek professional advice in these areas. In any case, it's important to take the matter of the handling of your photographic estate into account now: to begin to think ahead and make all the necessary arrangements. When you consider all the effort you've put into amassing a valuable stock file, you'll realize that planning for the future should be a natural extension of that energy and time.

This section touches on some of the issues you should be thinking about, for your sake and for your beneficiaries. Remember that estate planning is a highly complex business, requiring the professional services of lawyers and tax accountants.

Make the transition period for your beneficiaries an easy one. In many ways, every image that a photographer makes is an extension of himself or herself, and the legacy of those images should be organized in a meaningful way. Allowing stock files to fall into disuse or to become a burden to those who survive you will only tarnish what can be a beautiful legacy.

Estate Planning Primer

- An estate has two kinds of personal assets: tangible (such as jewelry, cars, photographs) and intangible (such as copyrights, bank accounts, contracts).
- When estate assets pass into the hands of another, they are ordinarily subject to tax (although there can be exceptions, such as for contributions to nonprofit institutions).
- As this is being written, there is a federal provision that gives each estate the ability to transfer up to more than $650,000 in assets to beneficiaries without being taxed. In addition, assets that go to a surviving spouse generally pass free of federal estate tax. As mentioned elsewhere, it is quite possible that the federal estate tax may have been repealed entirely by the time you are doing your planning.

An estate plan is recommended by many lawyers and financial advisers because you can reach and pass that $650,000+ exemption equivalent surprisingly quickly, especially if the Internal Revenue Service is doing the valuation. Estate planning is a process that includes a number of aspects, such as:

1. A will. This is the document describing what you're leaving to whom. In it you can pass assets directly to beneficiaries or through the use of a trust or other form of transfer. It also specifies whom you want to be in charge of various responsibilities, such as your executor.
2. An inventory of assets. This is a thorough list based on documented appraisals of the value of the assets.
3. Fiduciaries. These are defined as follows:
 a. An executor, sometimes called a personal representative, is one or more persons and/or entities (such as a bank with fiduciary powers) that you name as being responsible for seeing that the terms of your will are carried out. The executor's responsibilities include winding up your affairs, paying various taxes, and collecting and distributing your property. You may also name additional parties as literary or photographic executors to handle those special assets.
 b. A trustee is one or more persons and/or entities (such as a bank with fiduciary powers) that you name as being responsible for carrying out the terms of your trust. The trustee's responsibilities include investing trust assets and paying income from the trust as well as the trust property, to beneficiaries.
 c. The executors (These administrators are personal representatives who are appointed by the court but who are not named guardians. You may name them to manage any property passing to beneficiaries who can't manage their own affairs because of age or other condition.), and trustees are your fiduciaries, held to the highest, strictest standards of conduct for the protection of your beneficiaries. Being a fiduciary is a responsibility that carries with it the risk of being sued and significant potential liability.
4. Letters of instruction. These are sometimes used to convey requests or suggestions to executors regarding particular wishes, such as who should be consulted about liquidating photographic equipment. However, such letters are usually not legally binding, and if you wish to require—rather than merely suggest—certain proce-

dures, you should deal with such matters in your will.

5. Trusts. Trusts can be created by wills or by separate written documents, usually referred to as agreements or deeds of trust. They are devices to provide management of assets over a period of time by separating the responsibilities for property from the benefits of that property. The trustee bears the responsibilities and the beneficiaries receive the benefits. Except for trusts created to support charitable beneficiaries, all trusts must end after a period of time.

Chapter 3

Pricing and Estimating

Bruce Blank

Professional photographers are business people, or at least they should be in order for this to be a career and not just a job. It is the "photography business" and if both words are not equally important, then it's just an avocation. Paying your bills, putting food on the table, growing your business, and prospering all make it necessary for this to become a vocation. And, as business people, photographers have to know how to price their work using common sense and logic to make prosperity a reality.

Reality number one: There must be a more concrete reason for the prices you charge than, "John charges $X. I'm as competent a photographer as John so therefore I will charge as much as John does." This is one of the traps that many beginning photographers fall into and the only way it can work is if John needs to make more money each year than you do. If you charge what John charges and you have a 5,000-square-foot studio with a substantial overhead to meet when John is doing small location jobs while working from the trunk of an old car—it's only a matter of time before your business will be forced to close.

Therefore, you must apply simple economics, some basic math, and a lot of common sense to calculating your fees. It isn't difficult and you can "price with purpose."

Reality number two: You have to be completely aware of what you are selling and be capable of communicating that to your clients and your potential clients. What do you sell? First and foremost you have to realize that you probably never (or very rarely) sell pictures. In reality, you license the right(s) for the images you create to be reproduced if you are a "publication" (more commonly called commercial) photographer. On the other hand, if you are a retail photographer (weddings, portraits, events), you probably do sell pictures: 5" x 7"s, 8" x 10"s, 20" x 24"s, which your clients own and can look at whenever they please or allow others to look at as they sit, framed on the piano, in an album, or hanging on the wall. But as a retail photographer you may only occa-

sionally sell the right to reproduce the images in advertisements or on Web pages. This is a distinction that both you and your clients need to understand.

As a businessperson, your job is to sell whatever rights your clients need or want and is usually dependent on either their willingness or ability to pay your price (and your price will be fair based on a number of factors that we'll also cover later in this chapter.)

Reality number three: Photographers spend too much energy thinking about what a photograph is worth to them and not enough time evaluating how much the photograph will be worth to the people who want to actually reproduce it. And this is one of the main reasons that photographers shortchange themselves when they sit down to calculate a price.

Consider the following scenario: One afternoon the telephone rings and it's the marketing VP for a small manufacturing company. He tells you he needs a "very basic black-and-white product photograph of one of the company's latest inventions (a small industrial part) so that 10,000 catalog sheets can be printed for this new product." He trusts your judgment to pick an appropriate background once you see the product and to light it in such a way that the viewer will understand the basic shape and size. You have done this kind of assignment many times and, although you won't admit it to the VP, you can probably produce the image in less than a half an hour—start to finish. You rattle off a price of $525, including an 8" x 10" print or disk, and consider that as almost pure profit. The company accepts your price, the assignment goes without a hitch, and you get paid when you deliver the image. Your image turns out to be the most important element on the catalog sheet.

The company takes the image, prints the catalog sheets, and distributes them to everyone the marketing executives can think of who might have a need for this new widget. This catalog sheet is the only marketing tool they have for this new product and in the following eight months they sell tens of thousands of them—generating a profit of over $2 million after covering production and distribution costs, including your fee. Do you still feel that the use they made of that image is worth just $525?

Often, being able to estimate how much profit your images will generate for your clients is tantamount to gazing into a crystal ball. But every time you begin to price an assignment, the value to the client should be floating around in the back of your mind.

Reality number four: Something is worth only what someone is willing to pay for it. And one of the most difficult aspects of pricing your work as a photographer is not figuring out how much you need to make, or evaluating whether or not that is a "fair" price. The most difficult aspect of pricing is convincing the client to actually pay you what your asking. Quite simply, it is salesmanship.

In this chapter we're going to cover the nuts and bolts of calculating a fair price, realizing what "fair" means both to you and your client. Sales, which is often referred to as truly the oldest profession, is something you have to do to be successful. If a client only has $XX to spend and you're asking $XX, your job now becomes one of convincing the client that there is a compelling reason for him or her to pay you what you are asking. What are the reasons for the client to pay your price: Your experience? Your facilities? Your proximity to their location? And you become a sales person as soon as your quote is higher than their budget.

While ASMP is very good at many things, we are not going to try to teach sales—at least not in this chapter—because there are almost as many good sales courses offered in this country as there are people who should take them. On the other hand, if the idea of being a salesperson makes your blood run cold—begin looking for someone who likes doing it, is good at it, and is willing to work on commission.

Reality number five: Something very strange has happened to the photography business in the past ten or twenty years: It has become, in all probability, the only business on earth where the buyer has so much influence on determining the seller's price. Buyers have learned that they can make an offer and the seller will usually accept it. And the leverage they use is the eight other photographers who are standing behind you ready to step around you to get to your clients. If this were the case in the automobile industry, we all would have been driving luxury sports cars years ago, regardless of the asking price. We would be able to walk into the dealership, offer them $35,000 for the $75,000 turbo convertible and they would be obligated to sell it to us.

This happens because photographers let it happen. It happens because too many photographers do not understand the value of the work they produce to the people who need to use it. We can't fault the buyers—they are doing exactly what you and I do when we go to the car dealership to buy a new car. They are simply trying to get the bigger tires and CD player for free. The salesman convinces us that the CD player is worth the extra money and eventually we pay for it.

One of the most famous photographers of the twentieth (and now the twenty-first) century, when asked, "How do you command such great fees?" replied, "I ask for them." Armed with the right information and the knowledge of how to use that information, you can do the same and earn a decent living, make your business grow, and help to further the profession by pricing with purpose.

Dealing with Reality Number One

In the introduction we talked about charging what your competition is charging. "Charging what Jack charges" will make you successful only if your lifestyle, business overhead, and cost of living is less than that of the person who is, in reality, determining your fees. If your overhead, expenses, and lifestyle are more extravagant then the competitor whose pricing you mirror, your business is going to be in trouble. Logically, if you need $3,500 a month to keep a roof over your head and food on the table and your business overhead is an additional $5,000 for a total of $8,500, there is no way you can survive at that level on $6,500 for long.

It should be obvious that you need to know certain things about both your business and your personal life in order to begin pricing with purpose. The cost of anything to the end-user has always been affected by the cost of producing that product or service. So, you need to know what your business overhead is for starters. What does it cost you to open your business every day? What does it cost to have an active telephone, fax, and modem line; to have furniture, camera equipment, lighting equipment, computer equipment; to be insured; to have running water, electricity, and so forth. You need to begin a list of all business expenses in order to know your overhead.

The following spreadsheet illustrates a very efficient way to calculate what we're going to call your "target fee" or "creative fee" for each assignment. In this example the boxes (cells) that are shaded are waiting for you to plug in numbers. The remaining cells contain formulas that actually do the calculations. (A separate sheet showing the actual formulas follows. It is our hope that you will take this spreadsheet, adapt it to your particular situation, and use it to calculate you own creative fee. It is very important that the spreadsheet be adapted to your business to create an accurate calculation.)

This spreadsheet requires very detailed and accurate information to be of any value. It is not the kind of project to be taken lightly and is certainly not something that can be completed in an evening or over a rainy weekend. This spreadsheet should be erected using detailed information collected over months (if not years). You are at an advantage if you have been in business for a while and have been using your computer to track expenses and pay your bills. Your computer already contains very detailed information on your business that can be plugged into the calculator, producing very accurate information. We can't stress enough how important accuracy is to this process, so take your time, include everything and be certain of the results.

The next thing you need to realize is that this spreadsheet has two very obvious "holes" in it. The first is the big cell labeled "Personal—from personal spreadsheet." You see this is just your business overhead; you have to create another spreadsheet for your living expenses and plug that number into this sheet to create an accurate picture of your financial requirements. One of the "assumptions" we are relying on is that this sheet, when completed accurately, calculates a total of all the money you need to maintain your business (at a certain level) and your lifestyle (also, at a certain level.) The second is a calculation (a guess really) of how many assignments you can do in a given period of time—probably the biggest unknown in the whole exercise (especially for those who are just starting). So let's discuss it some:

How much shooting can you do? At one ASMP seminar, a photographer was insistent (and equally serious) that there were seven days in a week and that was how much shooting he could rely on. This kind of thinking is not realistic, to say the least. Think in terms of how much time goes into producing the average assignment. You have to take into account the work that goes on before and after the few hours you actually are exposing film. There are estimates to prepare, locations to scout, talent to book, props to acquire, film to test, assistants to schedule. On complicated shoots, this preproduction time can account for many hours, if not days. Yes, it is normal for photographers to charge a fee for preproduction work on complicated assignments, but not all assignments justify such charges. Those assignments that are the rule rather than the exception rarely justify charging a preproduction fee. Your overhead doesn't stop if you are doing what I'll call an "average" assignment—one where you can't charge a preproduction fee—and the money to cover your expenses has to come from somewhere.

In the spreadsheet below, we have plugged in 2.5 days per week as a reasonable expectation. This comes to 10 days a month or 125 days a year—based on a fifty-week year. You are entitled to plan on a two-week vacation every year and you're only hurt-

ing yourself if you don't take one. So you have to give serious thought to how much shooting you can do and be realistic in that estimation. Otherwise, you're wasting time filling out this spreadsheet.

Another consideration is the assumption that your photography business is your only source of income. Those of you who have spouses who work and produce income (or

	A	B	C	D
1	BASE FEE CALCULATOR			
2				
3	Business Expenses:	Weekly	Monthly	Annual
4	Salaries:			
5	Bookkeeper		=B5*4	=C5*12
6	Assistant		=B6*4	=C6*12
7	Total Salaries:	=SUM(B5,B6)	=B7*4	=C7*12
8	Payroll Taxes	=B7*0.1	=C7*0.1	=D7*0.1
9	Employee Benefits	=B7*0.18	=B9*4	=C9*12
10	Total Salaries, Taxes & Benefits	=SUM(B7:B9)	=SUM(C7:C9)	=SUM(D7:D9)
11	Professional Services:			
12	Legal	=D12/52	=D12/12	
13	Accounting	=D13/52	=D13/12	
14	Photographic (not billable)	=C14/4		=C14*12
15	Facilities Expenses:			
16	Rent	=C16/4		=C16*12
17	Electric	=C17/4		=C17*12
18	Telephone	=C18/4		=C18*12
19	Heat	=C19/4		=C19*12
20	Maintenance	=C20/4		=C20*12
21	other	=C21/4		=C21*12
22	other	=C22/4		=C22*12
23	Office Equipment	=D23/52	=D23/12	
24	Furniture	=D24/52	=D24/12	
25	Office supplies	=C25/4		=C25*12
26	Printing and stationary	=D26/52	=D26/12	
27	Postage / Courier		=B27*4	=C27*12
28	Advertising and promotion	=C28/4	750	=C28*12
29	Insurance	=D29/52	=D29/12	
30	Interest	=C30/4		=C30*12
31	Photography Equipment (new)	=D31/52	=D31/12	
32	Taxes (business/property)	=D32/52	=D32/12	
33	Travel (un-reimbursed)	=C33/4		=C33*12
34	Equipment maintenance	=C34/4		=C34*12
35	Business Entertainment		=B35*4	=C35*12
36	Loans and notes payable	=C36/4		=B36*12
37	Savings / contingency		=B37*4	=C37*12
38	OTHER		=B38*4	=C38*12
39	OTHER	=C39/4		=C39*12
40	OTHER	=D40/52	=D40/12	
42	TOTALS (BUSINESS):	=SUM(B10:B40)	=SUM(C10:C40)	=SUM(D10:D40)
43				
44	PERSONAL- from personal spreadsheet:	=C44/4		=C44*12
45	GRAND TOTAL:	=B42+B44	=C42+C44	=D42+D44
46				
47	SHOOTING DAYS		=B47*4	=B47*50
48				
49	BASE FEE (Creative / Production)		=D45/D47	

a trust fund left by a forward-thinking relative) can use that income to offset some of the "personal" funds required to maintain your lifestyle.

The real beauty of a spreadsheet is its ability to allow you to play the "what if" game. Let's use this flexibility to do some real financial planning. Suppose you would like to upgrade your computer system, or purchase a new medium-format or 4" x 5" camera system, or invest in digital imaging. By plugging these kinds of financial requirements into the spreadsheet, you can actually make these expansions possible. This is a much better way to grow your business (or purchase the new house, car, or put money away for college tuition) than relying on "something being left over at the end of the

week/month or year." The person who said, "Failing to plan is planning to fail" was right. Knowing how much money you need to maintain your business, grow your business, and live the lifestyle you desire is the first (maybe the only) way to price with purpose.

Once all the numbers are in place, the math is relatively simple: Your business overhead ($85,654) plus your personal overhead ($42,000) equals $127,654 (theoretically, all the money you need to maintain your business and lifestyle). If all that money has to come from shooting (in this example, 125 days in a year) simple division tells us you need to make at least $1,021.23 for each of those 125 days to be where you'd like to be, fiscally speaking. The "other " items in the sheet are for you to add your own items.

In the preceding spreadsheet, the calculations produced a "Target" (or creative) fee of $1,021.23. This is not your day rate or creative fee. It is purely statistical information you will use to begin running a successful business. It represents the "How low can I go?" number. If your business needs $85,654 to keep its head above water for a year and you can live the way you'd like to live on $42,000 a year, and if you can count on doing at least 125 assignments (or the equivalent in half days, editorial day rates, stock sales, etc.), you have to make at least $1,021.23 per day for 125 days in a year to make the money you need.

Note: I'm not going to get into the ramifications of taxes and their effect on all of this—but, as you'll soon see, we're going to actually be making more than we have to, if you follow the plan being outlined here. You will have enough to cover taxes and you have already added something to your personal spreadsheet for retirement.

This "creative fee" (or production charge, or base fee) has to be compared to what your competition is charging. If this fee is lower than what every other photographer with whom you compete is charging, good for you. Good, because we're now going to start "Charging what Jack charges" and be both competitive and profitable. If, on the other hand, most of your competition is charging less than the target fee you just calculated, then you have to think about one of two options. Either become a great salesperson and be able to convince clients that you are really worth what you need to charge them to maintain your overhead and lifestyle or you're going to have to "lower your expectations" (overhead or lifestyle) to a more realistic level. There are no other options. Personally, I'd opt for learning how to sell your abilities (or finding someone who can sell for you).

Finally, you have to realize what has to happen if, as you get into this "fiscal year," things change (and they can and do change regularly). The key word becomes flexibility. If you are not able to bring in 2.5 assignments a week (on average) or the creative fee you've calculated is met with considerable resistance, you have to be prepared to adjust. If meeting your assignment goal is proving tough, you have to spend more time selling (or getting better at selling); if your fees prove to be too high for your region (assuming the sales push isn't working), you have to rework the figures to become more realistic.

The spread sheet will help you be flexible, also help you monitor your progress; consider it a road map. You don't hop in the car and start driving without a destination in mind; there is no reason to run your business like that either. Price with purpose and

have a destination in mind.

As mentioned previously, calculating your creative fee is only part of the whole equation. I also mentioned that there would be income from other sources. But a certain amount of understanding has to be applied before the cake is iced. This creative fee (or whatever you choose to call it) should be viewed as a fee you will charge for creating custom images for your clients—a usage fee may also be applicable since clients will probably want to actually use the image after you create it for them. After all, when you complete an assignment, you are creating images that meet the specifications supplied by your client. This is custom photography. On the other hand, if you were to license an image that already exists in your file, you would not be creating a custom image, you'd be licensing usage. To put that in more common language, you'd be making a "stock sale" and stock sales are just usage; rarely do they include a "creation" fee.

Assignment = Custom photography created to client specifications (you sell creation and usage)

Stock = Pure usage (you're only selling usage)

An appropriate analogy would be computer software: You can have a programmer write an accounting package for you. It will be expensive, it will take time, but it will be written in such a way that it will allow you to run your business the way you've always run your business. If, on the other hand, you don't have the time or, probably more important, the money to have a custom accounting package written for you, you can simply go to the computer store and buy one of the already available systems off the shelf. Buying off-the-shelf software is really buying the right to use the software (normally in some limited way: on one computer or network, by one person or many, etc.). Considering the fact that computer software is also "intellectual property" and subject to the same copyright laws as photography, this is a valid analogy to illustrate my point. You don't sell pictures, you license the right for them to be reproduced.

You're going to get paid for creating completely custom images that exactly match your client's specifications and, since the client will want to actually use the images, there will be a usage fee either added to your creative fee or charged as a separate line item on your invoice. If you calculated your creative fee properly, it should represent all the money you need to continue your business, grow as you have projected, and also maintain the lifestyle you have factored into the equation. Using this pricing model you can actually make more money than you really need.

The next question you are about to ask is, "How much is usage worth?" Anything is worth only what someone is willing to pay. To some degree, this is also true in the photography business, but there are tools available to photographers that can make this easier than reaching up into thin air, grabbing a figure, and throwing it on an estimate sheet. There have been surveys done of typical prices for usage (or "stock" photography), or you can ask a few fellow photographers what they would charge. (*Note*: You have to be careful not to break the law. You are violating certain federal laws if, as a group, photographers all agree to charge $XXX for YYY. This is called price fixing and by law is not allowed. You can share information such as "I charge $XXX for advertising brochures and $YYY for billboards." Then the photographer asking the question

can determine his or her own price for that usage, armed with information.) There are books that have been published with fair usage prices, and there are computer programs. (Note: "fotoQuote," a pricing software program written by the Cradoc Corporation, is popular.) Many years ago, ASMP did surveys of its members' prices and published the results. Unfortunately, too many people began referring to these surveys as "ASMP prices" and we had to stop, for fear of violating antitrust laws. There are no such things as "ASMP rates."

It is in every photographer's best interest to share this sort of information—especially with younger, aspiring photographers who do not have the experience of seasoned professionals who have "been there and done that." Without the benefit of usage pricing information, inexperienced photographers will charge either what they think is a fair price or be more willing to accept whatever the client is offering. Communication between photographers is probably one of the best forms of business education available and should be better utilized. This is one vital benefit of ASMP membership: the network that exists among its members in forty chapters nationwide to share business and technical information.

Another aspect of doing business under a model such as this is that it affords you considerable negotiating power when dealing with clients. In this example, our model photographer needs to bring in $1,021.23 each day for 125 days a year to continue his existence. Assuming that usage should be an additional item on a photographer's invoice, he has the opportunity to begin negotiating a price that represents more than he needs to stay in a profitable business.

For example:

Calculated creative fee	$1,021.23
Average creative fee for your area	$1,250.00 (an instant "profit" of $228.77)
Usage	$ 750.00
Total quoted price	$2,000.00 ($1,250.00 + 750.00)

This example creates an instant negotiating factor of $978.77—the difference between $1,021.23 and $2,000. This is a powerful tool, especially when coupled with any mark-up you are going to add to the billable expenses such as film, Polaroids, scans, prints, models, assistants. This gives our photographer room to negotiate. He or she needs only to make $1,021.23, and a fair price for the assignment is $2,000—anything in between could be considered acceptable. A more profitable picture might be painted if the photographer is an excellent salesperson and is able to convince the client that having him or her do the job is really worth $3,000.

By now you have probably figured out where money for taxes, vacations, new homes, and cars comes from. And, doing business this way is considerably better than living on whatever funds are left over at the end of every month.

I would advise that you vary only your creative fees when negotiating price. Keep your usage fees consistent. The reason for this is that usage can be purchased repeatedly by the same client. It's important that you incorporate consistency in the way you

price your work. If the clients paid $300 for brochure usage this year, it makes sense that two years from now they are either charged another $300 for another brochure or slightly higher due to inflation (or slightly less for being a good client, paying their bills on time, and treating you with the respect you deserve as a professional). A system like this allows for creativity and flexibility.

Bids, Quotes, and Estimates

The most important aspect of preparing either a bid, a quote, or an estimate is gathering as much information as you can to avoid losing money on a job, or getting into a legal hassle.

Imagine that you're in the real estate business and someone asks a very simple question, "How much is a house?" When you think about the context and the question, you'll realize just how impossible it would be to answer that question. How many bedrooms do you require? What section of town would you like to call home? Would you like to have and maintain a swimming pool? Finished basement? One-, two-, or four-car garage? Half-an-acre or an acre-and-a-half? Before you, as a realtor, could even imagine answering the "How much" question, you would need considerably more information.

As a professional photographer, your need for information is noless important. You could never quote a price without a huge number of details. The only source for this information is the person who just asked "How much?" and it's your responsibility to get the information you need in order to prepare an accurate estimate that will make the job profitable for you.

"What's your day rate?" This is a seemingly innocent question that has passed buyers' lips for decades and has been the downfall of many a photography neophyte. This is like asking the cost of a "house" and just as impossible to answer. It's problematic because so many photographers have tried. The only possible answer is to say, "Between $XX and $XX, depending on what you're interested in buying." And realize that in reality your job as a professional photographer/businessperson is to sell them whatever they are asking for—based on their willingness or ability to pay. If they only want a little (as in a simple product shoot and usage on 5,000 brochures), the price might be quite low. If they want to buy a lot (as in a very complicated, multiday advertising illustration that is going to be run in seventeen major consumer magazines over the next two years), the price you'll calculate will be fair, but probably in the five-to-six–figure range.

Remember this: Your photographs will, in all likelihood, be the largest, the most colorful, the most important element in whatever the final product is. As such, it is probably worth almost as much as the printing costs to produce the brochure or certainly more than a fraction of a percentage of the media buy (the amount of money the end-user is spending for the advertising space in the magazines and newspapers). You, the photographer, do "powerful stuff."

So when faced with the "What's your day rate?" question, the only possible answer can be either a range from hundreds to tens of thousands of dollars. Or it can be the

simple statement that "I can't tell you 'how much' until you tell me what you want to buy. Once I know what I'm selling, I'll be more than happy to prepare a price for your project." And keep in mind that, along with film, processing, location scouts, and assistants, they will want to actually use the image(s) you produce and you need to know how much usage they want before a total price can be calculated.

The other big problem with "day rate" is the fact that it is perceived as being somehow associated with time, and over the past decade or so photographers have enjoyed being paid for their abilities, not how long it takes them to record a usable image on film. From a negotiating perspective, you are much better off charging a "creative fee" or "production fee" instead a fee for time. This has something to do with who you are dealing with. To most of your clients a "day" is eight hours (with time off for lunch and a coffee break), so they mentally equate your day rate to the same eight-hour period of time. What happens if you have quoted a "day" rate and happen to have a particularly great day and produce ten hours' work in five hours? I'll tell you what might happen: Your client might request a discount because you didn't work the full day.

A photographer I know says, "I don't have a day rate because if I did I would have to charge you as if the day you wanted were my last day on earth (in light of the fact that I have no clue which day will be my last) and don't think anyone can afford my last day."

Quote creative or production fees and keep in mind that you are selling your ability, your creativity, and your expertise—not your time.

We have to know what makes an estimate, a bid, and a quote different. And, probably more important, you and your client have to agree on what makes a bid different from an estimate, which is something other than a quote.

An estimate is a professional, educated, and calculated guess. Every estimate is simply an educated "guess" as to what the project, the production, and the reproduction rights requested might cost your client. You calculate that the assignment "will probably" cost $XX based on the information you have been given. Estimates might include a "trade variance," which means that the actual price can be either higher or lower than the quoted price, within a certain percentage. Ten percent is a nice, round number—which means the final price of a $1,000 job with a trade variance of 10 percent will be somewhere between $900 and $1,100.

A quote is something that is exact. When you prepare a quote, you must be absolutely certain you haven't forgotten or overlooked charging for anything because you're going to be held to the price quoted. If you forget anything, the costs come out of your profit. However, there is also some power in giving a quote—while you can't change the price, the client can't change the assignment, or anything directly related to it, such as the number of shots or the usage rights being purchased. If clients want extra shots or additional usage, you have to remind them that your quote was for specific photographs and usage, but that you'll be happy to amend the quote to reflect what they are now asking for (as long as someone with the proper authority can approve the revised quote). When you prepare a quote, do so carefully and accurately because you'll have to stand behind it.

On the other hand, a bid is almost exactly like a quote except that a bid is competitive. Just like an auction, you are bidding against other photographers who want to

compete for the same assignment. The most important aspect of a bidding situation is to be certain that the buyer is comparing "apples to apples." Make certain that each photographer who is preparing a bid has been given the same assignment specifications: number of shots, locations, film format, styling needs, usage license(s), and the like. It is a good idea to request that the request for a bid be in writing and make certain that everyone bidding has been given the same sheet of paper. Each photographer must base his or her bid on the same details—otherwise the person with the "short list" (and consequently the lowest bid) will always get the assignment. And when this happens, the photographer getting the assignment probably will have a misunderstanding with the client.

Also, when asked to bid, don't be afraid to ask a few additional questions, such as "Who am I bidding against?" No one knows your competition better than you and why waste time preparing a bid when you know you don't stand a chance of being awarded the assignment because you are bidding against someone who hasn't read what you're reading right now. Another good question is this: "Will this assignment be awarded to the lowest bid or will the photographer best suited to produce the assignment be given the assignment?" This is important because I doubt that you want to be awarded an assignment just because you are the cheapest photographer preparing a bid.

One thing that will help to "level the playing field" is a simple tool that accompanies almost every assignment—the layout. When asked to prepare an estimate on an advertising assignment, one of the first things you should request is a copy of the layout. Spend time discussing this with the art director, photo editor, or whomever approached you for the job. One important aspect of receiving a copy of the layout, especially in a bidding situation, is making certain that every photographer who is also bidding receives a copy of the same layout you do. That way each photographer is preparing a price on exactly the same photo or photos.

Armed with a copy of the layout, you can look for aspects of the assignment that might not be obvious when simply discussing the job over the telephone. Specifics about propping, casting, and location will be right before your eyes and these very important aspects of the assignment can be discussed with the commissioning party, who will be responsible for what can be worked out. Details about the location can be finalized. Viewing a tight layout and discussing it with your client will help to eliminate "assumptions" by either party—and possibly save you from making mistakes that might cost you thousands of dollars.

Your job, when reviewing any layout is to literally pick it to pieces and be prepared for anything that might go wrong. Ask questions when you are not absolutely certain about any aspect of the job. Don't assume anything. "Better safe than sorry" is good advice. Details are the key to preparing an estimate every time you are called upon to do so.

Details, Details

What goes into an estimate, quote, or bid? The simple answer is everything. In order to prepare an accurate price for any project you need details, details, details.

- What are you going to be shooting?
- How many shots are required?
- Where will you be shooting?
- Is there going to be any billable "prep" or "preproduction" time?
- What about travel expenses (hotels, airfare[s], location fees, meals, transportation—the list can get very long)?
- Are you going to require any additional insurance coverage?
- What about assistants, stylists, or location scouts?
- Are there models? Professional or amateur?
- Who books the models or chooses the people in the photographs?
- Who is responsible for paying the models?
- Who is responsible for negotiating usage with the models?
- Who get releases signed? And who receives usage rights on the releases (photographer and client)?
- Does the client understand the ramifications of using amateur models, which could lead to extra shooting time and, possibly, questionable results?
- What format will you be shooting? Film? Processing?
- Push/pull or expedited service?
- Polaroid tests?
- Backgrounds?
- Props?
- Wardrobe?

You, as the photographer, should determine how long it will take to produce the image(s) your client is looking for. While your clients might only want to pay for one "day" (after all, they are allowed to come to the table with a budget), your responsibility is to tell them the consequences of their budgetary restraints. A set of images that may not live up to their expectations and your being blamed could be a bad situation. They may have a budget, but you are the best person to determine if what they want is possible based on what they want to spend. Why should you risk producing a bad job because they don't want to pay for a great one?

Many photographers find it helpful to have a form—printed or on computer—that they can readily access as soon as the telephone rings. This serves a multitude of purposes—the biggest is having a list of questions in front of you that lessens the chance that you'll forget to ask a very important question.

Using ASMP forms as a guideline, develop a form that you are comfortable with and make certain that it contains terms and conditions that protect your interests. A contract that leaves something out might be worse than none at all.

Here are some of the questions you should ask, but keep in mind that this list will be too long for some assignments and too short for others. Use your own judgment and gather as much information as you can.

Logistical and Creative Considerations

Is there an underlying "concept" the client is trying to illustrate? What copy will accompany the photo?

- What are the important aspects of the product you're going to illustrate?
- Dig for adjectives like: "Quality, strength, durability, craftsmanship, convenience, etc."
- What is the target audience? Consumers, corporate, industrial, service . . .
- How is lighting going to affect the end product? Time of day? Color? Direction? Style (directional vs. soft), etc.?
- How will type be applied to the final ad, brochure, or billboard?
- Is the copy available now or will it be written after the illustration is produced?
- Where will the image(s) be created (studio, park, beach, factory, etc.)?
- If the location is not your studio, travel expenses will be involved—even if it is only mileage. Where is the shooting site?
- How "tight" is the layout? Is there room for your interpretation of the assignment?
- Will someone who has the proper "authority" be at the shoot to make decisions and approve tests?
- How large will the reproduction be and is film format a concern?
- If there are people in the shot(s), who are they? Who chooses these people?
- If your client chooses the models, you can't be blamed for making the wrong choice. If you pick the talent, make certain someone "signs off" on your choices and be sure they have the authority to do so.
- Who will pay the models, sign the vouchers and deal with the agency?
- Models are also "licensing usage"—your client needs to understand that and
- Who will be responsible for getting signatures on the releases—model and property?
- How old are the models? Male or female? Ethnicity? Height? Weight? Hair color?
- What are the people in the shots wearing? Who decides and who arranges for the wardrobe? Check with the models for size.

Looking at your copy of the layout will probably generate other questions more specific to the assignment at hand. Think—ask—confirm. Then price.

Usage: How does the client want to use the image(s)?

This is really your clients' call. Your job is to sell them what they want to buy, but you can't sell them anything until you know what it is that they want buy. Remember: You don't sell photographs, you license the right for your clients to reproduce them.

Advertising

- Print? Web? Packaging? Brochure? Catalog? Where will the image(s) appear?
- Consumer or trade? Local or international?
- How long does the client want to use the image(s)?

- What size will the image(s) be reproduced?
- What will the placement be (full page or less—cover—inside)?
- How many times will the image be reproduced? Circulation of the publications the images will appear in is very important, as is the traffic through a Web site. The circulation of *People* magazine is in the millions; *Widget Weekly* goes to only 15,000 people.

Other advertising uses of photographs include: posters, point-of-purchase, billboards, telephone directories, direct mail. The list is vast (*fotoQuote* contains hundreds of potential uses for photographs and is an excellent starting point).

Editorial

- Placement is important—A cover is more valuable than any inside usage.
- Size—How large will the image be reproduced (the larger the image appears, the higher the price the image commands)?
- Circulation—How many people will see the image?

What about expenses? Many editorial clients do not allow photographers to mark up expenses and request copies of receipts. This is a longstanding practice and can be a hardship on the photographer, especially if the invoice isn't paid until the work is published—six months to a year after the shoot. In the meantime, your credit card company is adding 8–18 percent to your statement. It is a good idea to demand that expenses, if not paid in advance, are paid on acceptance of the images. Waiting until publication can be very costly. One way around this practice of not allowing a mark-up on expenses is to quote specifics in your estimate: $XX per roll of 35mm E-6, $XX per Polaroid, $XX in hotel, airfare, meals, and rental car expenses. And, once the estimate is accepted (in writing), make certain that your invoice does not vary so much as a penny from the quoted charges for expenses (overestimating and billing less than quoted is even better). Then, if asked for receipts for film, processing, and cab fares, you can simply say, "I do not furnish receipts. I quoted my fees for expenses in my estimate, which was approved by Ms. Jones, and my invoice reflects those quoted prices exactly." Assuming you quoted price and quantity, what you pay for film or processing isn't really any of their business. Imagine their reaction to subscribers asking what paper and ink costs the magazine.

Traditionally, usage fees have always been based on three basic aspects of how the image will be used: time, size, and circulation.

These particular words might not be used—for example on the Web, "circulation" equates to "hits"—but if you keep these three words in mind, you will be able to generate more specific questions.

Corporate

- Is the project an annual report, facilities brochure, recruitment brochure, capabilities brochure, public relations piece, company newsletter, corporate magazine—

for employees or the general public?

- How many pieces are being printed and are they black and white or full color?
- How are they being distributed and to whom?
- How many photographs will be used in the project? (How many are you producing?)
- Will the client help with logistics or are you going to be given a shot list, a few phone numbers, and be on your own?
- Will you be working with an in-house design/marketing department or with a freelance designer?
- Who has the authority to approve the images?
- Will an authorized representative be at the shoot and does she have complete approval authority? Many photographers have been put in difficult situations because unauthorized personnel approved the images as they were being produced, only to find later that their superior didn't like the work. Make certain the person approving the Polaroids has the authority to do so. And, get her signature on the back of the test shots.
- What about expenses for this representative (meals, airfare, hotel)?
- Is the purchase order coming from the client or the design firm?
- Who is responsible for paying your invoice and when will that happen?
- What is the whole "timeline" for the project?
- How "flexible" is this timeline or is it "carved in stone"?

Many questions go into preparing a quote, a bid, or an estimate and you should think along those lines with every job. No two advertising, editorial, or corporate assignments are the same. Many have similar attributes, but each and every assignment is a little different and they must be handled as completely unique entities. There are similarities but even when there are, usage varies, placement varies, size of reproduction varies, circulation varies, and, therefore, all assignments vary.

Expenses and Billable Expenses

Calculating expenses is considerably easier than calculating your creative fee. Once you know everything there is to know about the assignment, you will know in your mind what the basic expenses will entail. Doing a fashion shoot of three outfits will require XX rolls of film and processing; XX sheets of Polaroid for tests, a fashion stylist, a make-up artist, transportation to the location (unless it's a studio job), preproduction for casting and location scouting, refreshments, assistant(s), and other facets.

As mentioned previously, many photographers find it advantageous to have a form handy that contains a list of possible expense items to keep them from forgetting something important. You should design your own "form" but here is a list of some of the expenses that are typical in the business.

This list is fairly comprehensive, but you should design your estimating worksheet in such a way that there is plenty of room for notes, sketches, and calculations. Once you have collected the information and crunched the numbers, it will be easy to put the

Production Report

Photography: _____ _____

_____ _____

_____ _____ $_____

Preproduction: _____ _____

_____ _____ $_____

Travel: _____ _____

_____ _____ $_____

Weather delays: _____ _____

_____ _____ $_____

Other: _____ _____

_____ _____ $_____

Casting: Fee _____

Film _____

Casting from files _____

_____ _____ $_____

Crew: Assistants _____

Home economist _____

Prod. coordinator _____

Stylists: hair _____

props _____

wardrobe _____

Trainer/animals _____

Welfare/teacher _____

_____ _____ $_____

Film Editing _____
Lab charges: Polaroid _____

Prints _____

Roll film _____

Sheet film _____

_____ _____ $_____

Page one of three

Production Report

Insurance:	Liability	_____
	Photo pac	_____
	Riders/binders	_____
	_____	_____ $_____
Location:	Scout	_____
	Film	_____
	Research	_____
	Location fee	_____
	Permits	_____
	Travel	_____
	_____	_____ $_____
Messenger/Shipping:	Messenger	_____
	Out-of-town	_____
	Trucking	_____
	_____	_____ $_____
Props:	Purchase	_____
	Rental	_____
	Food	_____
	_____	_____ $_____
Rental:	Camera	_____
	Grip truck	_____
	Lenses	_____
	Lighting	_____
	Special effects	_____
	Special equipment	_____
	_____	_____ $_____
Sets:	Carpenter/painter	_____
	Hardware/lumber	_____
	Paint/wallpaper	_____
	Set design/research	_____
	Backgrounds/backdrops	_____
	Studio materials	_____
	Surfaces	_____
	_____	_____
	_____	_____ $_____

Page two of three

Production Report

Studio: Build days _____
 Shoot days _____
 Overtime _____
 Strike _____

 _____ _____ $_____

Travel: Air fares _____
 Excess baggage _____
 Cabs _____
 Car rental/mileage _____
 Truck/car rental _____
 Motor home/dressing room _____
 Parking tolls/gas _____

 _____ _____

 Lodging, per diems (est) _____
 Hotel _____
 Meals _____

 _____ _____ $_____

Wardrobe: Costume design _____
 Seamstress _____
 Purchase _____
 Rental _____
 Special make-up/wigs _____

 _____ _____ $_____

Misc: Gratuities _____
 Long distance phone _____
 Nonprofessional talent _____
 Working meals _____

 _____ _____

 _____ _____ $_____

Model details: Number Hours Total time
 Adults _____ _____ _____
 Children _____ _____ _____
 Extras _____ _____ _____

Page three of three

information into a more formal format. From your standpoint, right now the information is considerably more important than the format it takes. Remember: Mistakes may be costly.

How much you charge for these expenses probably should be based on several factors:

- How much is your competition charging for the same items?
- How much are you going to "mark up" the expense items?
- How much is your client willing to pay?
- How much does your competition charge? This is one major aspect of being in business. If you owned a gas station, all you'd have to do is look at the sign across the street to find out what your competition was charging for gasoline. A photography studio is not a gas station, so communication with your peers becomes important.

Mark-Up

At the beginning of this chapter, we talked about certain realities. Here's another: No one will remain in business long if he sells something for what he paid for it or less. Every business that has "profit" as an important part of its financial picture "marks up" expenses (i.e., charges their customers more than was paid for materials). Your clients, especially advertising agencies and design firms, mark up your invoices. What is their justification? They took the time to choose you as the photographer, they oversaw the production of the photographs, they have the expertise to work with the images that their client may not have, and they are in business to make a profit. So are you.

When you stock film, you are providing a service for your clients. When you test an emulsion, you are performing a "quality control" function (assuring that a blue dress actually looks blue on the chromes). If you write a check to the assistant and the make-up artist (assuming the client will eventually pay for their services when they pay your invoice) and your client will reimburse you sometime in the future when they pay your bill, you are giving them a loan. Banks charge interest every time you borrow money. All these functions—the convenience of having a refrigerator full of film, testing emulsions to ensure quality, and lending money—warrant additional profit in your pocket.

And, let's not forget the amount of time it takes to do a film inventory, call your supplier, and drive over to pick up the boxes of materials. Your time is valuable.

Occasionally, a client might question your charges for expenses. "I can buy a roll of film at K-Mart for $4 and have it processed for $10—why should I pay you $42.50?" I developed a brief form I could pull out to deal with this objection. I'd tell my clients that they could buy the film (I tell them exactly what I needed and where to get it) and they could take it to the lab of their choice to be processed. But they would have to sign this form absolving me of any responsibility for: "final color rendition, exposure variances, or any other technical aspect of the photographic process that might render the final images unusable." I'd explain that I tested the film, have been dealing with my lab for years, and only if I were allowed to maintain control, could I guarantee the final result. "But, if you want to save a few bucks . . . " In almost twenty years, only one

person signed the form and supplied the film and had it processed; everyone else paid my mark-up.

The only way business people can "charge" less for the things they must buy is to make plenty of additional money elsewhere in the deal.

You have to keep in mind the fact that every assignment must meet certain minimum financial requirements:

- Usage. How the client will use the work is probably the most important aspect of pricing an assignment (and probably the only aspect of a stock sale).
- Creative or production fees. These pay your overhead and allow you to maintain your business and continue to put food on the table.
- Expenses. Someone has to pay for everything that goes into actually producing the work: film and processing, models, Polaroids, travel expenses, and the like.

So the formula is this simple: Creative Fee + Usage + Expense charges (including mark-up) = Selling Price.

Pricing your work any other way is not pricing with purpose, and you are taking the chance that you'll be able to survive on what's left over at the end of every month—assuming there is anything left over, after you pay the bills. Be smart and plan.

Chapter 4

Negotiating Fees and Agreements

Richard Weisgrau

Simply stated, negotiation is the process of balancing the interests of two or more parties in a way that is acceptable to all of them.

Photographers and their clients have both complementary and competitive interests. Both parties need a photograph or series of photographs that fulfill a need, yet are likely to have different views on compensation and rights.

Disagreements over such matters have ended many photographer/client relationships and, in a business sense, that is costly. It is more expensive and time consuming to acquire a new client than it is to retain an existing one. To retain clients, you must be able to preserve the relationship by settling disagreements whenever possible.

Disagreements can be resolved through reasonable and appropriate communication—or negotiation—between you and your clients. Through proper negotiation you can reach agreement, enhancing the complementary interests you have with your clients, while reducing the competitive interests.

The Skill of Negotiation

Good skills are the key to a successful negotiation. A good self-image is important. A confident negotiator can communicate verbally, organize thoughts, and visualize outcomes. Photographers visualize outcomes for a living, so visualizing a negotiation taking place and the desired outcome of that negotiation shouldn't be difficult.

- Negotiation involves making important decisions. Some photographers have trouble making decisions when they get into business situations, but the process is the same whether you're trying to solve a photographic problem or a negotiation problem. Just as important is being able to live with your decisions. Even if you make a bad decision, you must make good on the agreement in order to maintain your reputation as a negotiator and a business person.

- Good negotiators try to keep harmony. It's much easier to negotiate in a friendly atmosphere than in an adversarial one. Negotiations become more adversarial when resolving a disagreement after the fact. Try to avoid that by having good, harmonious relations and negotiations up front, before the work is started.
- Good negotiators are reflective. Try to be analytical in your negotiations. Look deeply into the issue, because what you hear at first is not always correct. Explore the "if-then" possibilities. If you do this, then what will they do? Try to anticipate all the alternatives.
- Good negotiators are flexible. Be ready to shift your position without changing your principles. Be flexible on those items where there is room for discussion. Fees, general range of rights, timing of the shoot, and the terms and conditions under which you will shoot are some issues where you can be flexible as long as you don't jeopardize the fundamental policies of your business.
- Good negotiators are empathetic. Try to relate to what the other side is feeling. You have to understand the other party's problems before you can deal with them.
- Good negotiators are fair-minded and option-oriented. If you try to get the best of every deal, eventually you will lose your clients because they always feel beaten down. Basically, a negotiation is simply presenting options until there are enough on the table to resolve the disagreement.
- Good negotiators are good listeners. Most people think of good negotiators as simply good speakers, but more often they are good listeners. It is from understanding the other party's position that you create options to settle any impasse. Also, with good listening come good questions. Answers to properly asked questions give you insight into what options might solve a disagreement.
- Good negotiators know the value of what they do. This is most important. If you do not know or believe in the value of your work, then you can never obtain it. You must believe that what you do has value, understand that value, and be able to justify it.

Around the world, photographers are one of the most valuable links in the communication system. If photographers started saying no to bad deals, would clients stop buying photographs? Of course not. They are extremely important to them. Therein lies the photographer's strength and value.

Consider that in some major magazines a double-page spread is about $200,000 for a four-color page. Even with frequent insertion discounts, the amounts are staggering compared with the reproduction fee charged by a photographer for that same space. If, when you're asked to quote a price for an ad in a major magazine, you know just what it's costing the client for the space, you'll feel more comfortable negotiating a fair fee.

The Necessities of Negotiation

An absolute necessity for any negotiation is that the person on the other side be willing and able to negotiate. Some people are incompetent at the process or simply refuse to negotiate. You cannot negotiate without a willing and capable counterpart.

You must be a bit of a salesperson when negotiating in a business environment. Sales is the most important division in your company, even if you are a one-person operation. If there are no sales, there is no work, no invoices, no revenues, and no income. If there is no income, you are out of business.

Two of the most vital and universal steps in sales are answering objections and closing the deal. When you consider negotiations as an extension of your sales effort, those two steps become more than necessities. They are absolutely critical.

The Wants and Needs of Negotiation

Disagreement destroys relationships. If you destroy enough of them, you're out of business. Disagreement results from having different wants, and can be resolved only through negotiations aimed at satisfying needs. Wants and needs can be demonstrated simply. I want a Leica. I need a camera. I want a Mercedes. I need a car. There is a spread between wants and needs. Your wants may be the price you ask for your services. Your needs are your bottom-line price, the one below which you cannot go. The spread between wants and needs is the negotiable range of any issue.

When you identify the wants, identify the needs, and move the wants closer to the needs, that's the process of negotiation.

The Stages of Negotiation

There are four stages in a negotiation. The first is the analytical stage, when you assess the ramifications of the problem or disagreement. The second is the alternative stage, when you develop and present alternatives to solve the problem. The third is the acceptance stage, the process of looking at alternatives and coming up with those that are acceptable to solve the problem. Finally, the fourth step is agreement, where you sign off on the deal.

Even though a negotiation might take five minutes on the phone, all of this happens. You may not realize it because it can happen with great speed. After you've done it many times, it becomes almost routine.

Within the entire process are three aspects to a negotiation: the methodical, the psychological, and the substantive. They will be discussed in detail throughout the rest of this chapter.

The Methodology of Negotiation

The methodical aspect includes things that a negotiator has to know and the tactics to be used. It centers on asking questions—*who*, *what*, *where*, *when*, *why*, and *how*.

Who will be the negotiators? You? An art director? An art buyer? A communications director? Can you clearly identify the person with whom you're going to negotiate? Is he or she authorized to negotiate, or simply carrying your message to another person who is the behind-the-scenes negotiator making all the decisions?

When will you negotiate? Right now? Next week? Choosing the time you negotiate

has a great deal to do with your ability to get your needs met. Many negotiations for photography occur immediately after some creative discussion. You sit down with the buyers of the photography, talk about the assignment, and, together, build a photo shoot or sequence of images. Your creative juices are flowing. You're feeling very giving. Then it's time to talk about money and rights. But now is the wrong time. You're in the right frame of mind to create, but the worst frame of mind to negotiate. You need to change hats, be more analytical and think about your needs. It's very easy to "give away the store" when you negotiate immediately after a creative session.

Buy some time. Try saying, "This is great. I'm glad we have arrived at what we want to do. I know it's time to talk about how much this job is going to cost and how we're going to approach this whole deal, but before we do that I'd like to have a couple minutes to get my thoughts in order."

Get psyched up for the negotiation. That doesn't mean getting angry or mean. It means getting determined that since you're trying to make a living, you need to meet your own needs.

Where will you negotiate? Many negotiations happen on the phone. The nice thing about a phone is you have the other person's undivided attention. You're talking right in his ear.

If you're going to negotiate in person, be sure to get the client away from possible distractions. Imagine this setting. You're in an art director's office or cubicle, with other offices all around you. As you talk, there is a lot of hustle and bustle. You're about to close a good deal when someone sticks his head in the door and says, "Listen, we just got a call from the photographer who shot that job last week. All the film is ruined. You're going to have to reshoot." The art director is crushed. She's desperate, and has totally lost contact with everything you've said. She doesn't give a damn about this job for the moment. You've lost all your momentum, simply because the art director was accessible to other people.

If you want to sell somebody in a negotiation, isolate him. Take him across the street to the park and buy him a hot dog. Ask if there is a conference room where you can meet. Do whatever it takes to avoid interruptions.

Why are you going to negotiate? What do you want out of this negotiation? You know you'll negotiate fees and rights. You can also negotiate money, usage, time, advances, and purchases. In fact, anything of value is fair game in a negotiation.

How can you negotiate time? Time has a value. You're booked on Wednesday and you're not about to cancel that job. You say, "Well, I'll tell you what. I'm already booked into another job on Wednesday. If I can do it on Tuesday or Thursday, it'll cost $2,000. If you really need this on Wednesday, it's going to cost $3,000. The reason is, I've got to keep everyone working for sixteen or eighteen hours. I have to bring in extra help or go into overtime. Everything costs more at that point. If you can do it a day earlier or a day later I don't incur those extra fees." You're not negotiating the fee, you're negotiating for a different day, for time.

What do you know about the agency or firm? Do their people make unreasonable demands? Do they negotiate? Are they a "take it or leave it" company? If you haven't worked with the firm, try to find people who have and ask them what they know about

the art director, art buyer, or communications director. What is their style? Are they tough on certain issues? Chances are, if they are tough on others, they'll be tough with you. The more you know about the job and the client, the better your position in dealing with them.

What do you know about the budget? Every job in the world has a budget. Try to find out what they have projected the photography will cost. Don't ask, "What's the budget on this?" That indicates you accept their budget as a limit. Maybe they have done their homework wrong. Their budget may not be adequate. Try asking, "What kind of money have you projected for the photography costs on this project?" Projections are not budgets, only educated guesses. A budget is a target, but it's their target, not yours.

As you accumulate this information, whether it's over a period of minutes or days, keep notes on it. There are many details you need to know, especially if you're talking about a production shoot. Be thorough. For a checklist of production details, refer to the Production Report form at the end of chapter 3, "Pricing and Estimating."

What is the worst-case scenario? Ask yourself this: What is the worst thing that can happen if you don't get this job? Will you be out of business or simply have lost a job? Can you find other work? Once you know the worst-case scenario, you can see if the next best alternative—finding other work—makes the loss less painful.

The bottom line is this: There is no such thing as a free lunch. You're not going to get anything of value from clients unless you perform for it, and you're not going to give up anything of value unless they pay for it. That's a fundamental concept of good business.

After you go through this process of analyzing what the job is about and what your wants and needs are, set some goals for the negotiation. These are:

- Envision the outcome.
- You're going to get X-number of dollars for so many days of shooting.
- You're going to get so much money in advance.
- You're going to grant certain rights.

Write those goals on a piece of paper. That will prevent you from changing your goals too early. Any goal that is not in some fixed form can change instantly and at will. Any goal that is written down has to be actively changed. If you change it, know why and change it on the paper.

Developing Mindset and Techniques

The psychological aspect is one of the most important factors in negotiation. Basically, there are two types of negotiators: hard and soft. Hard negotiators stare you in the face and intimidate you. They're tough. They make demands and don't cut you a break. Soft negotiators are talk softly, are laid back, friendly, accommodating, and understanding. Many people fall between those two extremes. A good negotiator can go back and forth, being hard or soft when called for, often following the lead of the other person.

You may encounter a variety of styles people take when negotiating. Here are a few

of them.

The "intimidator" is a very effective person because he often gets everything he wants. When he's allowed to be intimidating, he'll push you into a corner. Again, the way to counter is to mirror his language. If he's talking in your face, talk right back in his face. A lot of people are afraid of that. When somebody comes on really strongly, they think of this person as powerful. You have to understand that he's just another person and his style has nothing to do with who he really is. It's just his style and style doesn't resolve anything.

The "noncommittal" character is difficult to get to answer you. To deal with this type of person, present your issue in black and white. Say, "The question I am asking you is 'Will you give me one-third of the expenses in advance? Can you answer that question for me?'" Then, don't let it go. Keep asking for the answer to the question until you get it.

When dealing with "liars" and people who have truly bad memories, keep a pad of paper and keep making notes. You'll have the other person thoroughly convinced that you have a record of everything about the conversation. That helps to improve her memory because she knows you have recorded all the details.

If you know a person is an absolute liar, don't do business with her. Eventually, a liar will get you. If, however, you find yourself dealing with a liar, after you make all your notes, read them to the person. Say, "I just want to review this whole agreement with you."

Some people need detail, others do not. You'll make your best agreements with people if you deal with them the way they like to be dealt with. If the buyer is a person who likes a lot of details about how everything is going to happen, what everything costs, then you have to be prepared to give those details. If he doesn't want to be bothered with details and only cares about one thing—How much is this job going to cost?—don't bore him with the details. Get to know your clients. What are their expectations in terms of the information they want you to present? If you don't know, assume they want less information. You can always provide more if asked.

People perceive that negotiation is a power process. Granted, power enters into it at times, but it isn't always a determining factor.

There are different types of power.

Inherent power is the power of money or office. If you have $2 million or $3 million in the bank, you can go out and take any negotiating stance you want. You would not get a lot of deals, but you wouldn't care because you had a lot of money. You'd have a lot of power because you didn't need the money.

There is nothing you can do about inherent power. If you've got more money than the client has, there's nothing the client can do about it. Likewise, if your client has more money than you, there's nothing you can do about it. Ignore it; it doesn't make any difference.

The power of office is something you have to deal with. Photographers often express concern that they are going to have to negotiate with the chief art buyer, the VP of sales, or some other "title." The person with a title can select whomever she wants. But she's talking with you. That's your power. It matches hers. You can't do anything about it, so

don't let the power of office bother you.

Flexible power shifts from job to job and negotiation to negotiation. You never can tell what it's going to be. If the client calls at noon, needs a shot at 4:30 the same afternoon, and doesn't know any other photographers in your area, you have the power. However, if a person needs a shot in thirty days, you're one of twenty-five people he has in mind, and it's a picture of a clothespin on a piece of seamless paper, you're not too powerful.

Power also shifts with the amount of time there is to get a job done. Remember: Your client has a deadline. Until you get the job, you don't. *The power of time* is generally on your side. Time will frequently work to your advantage. You know how long it takes for the client to select and work with a photographer. If there isn't time to get another photographer, you're obviously in a stronger position to negotiate a good deal.

The power of competition is popular among buyers. They remind you that they can get another photographer to do the job. You have heard it countless times, in many situations. The first thing you have to ask yourself is this: "If they want another person to do the job, why did they call me?" They must have selected you for a reason. Chances are, they didn't select you because you're just one of the crowd. You were selected. That is a grant of power. If they wanted the competition, they would be talking to them, not to you.

Photographers can use competition as a tactic, too. If someone calls you to discuss a job for next Thursday, you might reply, "I've got something planned for Thursday, but it's not a done deal. Tell me what it is you're working on. I might be able to hold off." You've told him that he has competition. Don't hesitate to use the power of competition. But choose your words carefully. Instead of saying, "I have another job." Say, "I have something planned." It may be a dentist appointment or a walk in the park; you don't have to say.

The strongest power is ultimately yours. It's the power to say *no*. It stops everything. When you say *no*, that's the end of it. You always have the power to say *no* when a deal is bad for you.

Jobs are put out on bids to weaken your position through price competition. When facing a bid, ask, "How many photographers are bidding on this job?" Explain that the bid will require a great deal of analysis, and it could be a waste of your time if they have six other people also bidding. Talk about quality and price. If you discover that price is the main criterion of their bidding process, explain that you definitely need to know who you are bidding against, because if the list includes someone you know is a lot lower in price, you might opt out of the bid.

There are techniques you can use to develop a subtle kind of power. Here are a few:

Woo your clients with extra service. You may ask, "Would you like me to have my assistant pick you up at your apartment on the morning of the shoot?" You're already making the job easier for them. That's salesmanship.

Show strength in your commitment. If they are having trouble deciding whether to hire you, you might say, "I can see that you're worried about this. Maybe you're thinking my price is too high. If I don't deliver what I promised, you are going to look bad. Here's a list of my clients and their phone numbers. I will pay for the phone calls. If

you get one person on that list who tells you I don't deliver what I say, when I say, I'll do this job for half the price I just quoted you." You're making a commitment, providing the proof. You're willing to take a risk in order to demonstrate your reliability.

Ultimately, the element of risk comes into play in the power game. Business is a calculated risk. You make decisions based on your ability to take risks. Of course, risk should always be proportional to gain. You have to think about where you want to come out of the negotiation and take the risk accordingly.

In the psychology of negotiation, risk can lead to fear and panic. Here is a scenario: You're feeling good about your business and your work. Suddenly, the phone rings. A client has an assignment for you. Now, everything is different. The pressure is on. You're scared. The client is asking you to do a job, and you know you're going to have to give her a price. What if you're wrong? What if you don't get the job? In just a few minutes, your whole disposition has changed 180 degrees. You've panicked.

Panic comes from fear. There is nothing wrong with being afraid. Everyone experiences it at times. What's important is learning to confront fear. Yes, people do go out of business by saying yes to bad deals. However, when somebody offers you a bad deal, you can overcome the fear by understanding that you're not going to go out of business by saying *no*. You overcome the fear of saying *no* to bad deals and the fear of taking risks by having enough sales opportunities so that, simply based on the law of averages, you will do enough business to enable you to keep working and keep making a profit.

Some Negotiation Tactics

If the most powerful word in negotiating is *no*, the second most powerful word is yes. Sales people say that you should never ask a question that can be answered *no*. Don't ask if you can have the order. Ask how many pieces they want to order.

Try saying something like this: "In the past jobs we've done for you, we have always done our best to satisfy your clients, and I think we've accomplished that. Everything we do for you is delivered on or before the deadline, and within budget. Obviously, you want us to continue that record. We can do this new job for $5,000 plus expenses. We'll have it wrapped up in two days. Do you want us to shoot on Tuesday or Wednesday?"

First you established some "yes" thinking, then you told them you're doing the job and asked them what day they'd like you to shoot. Don't just ask, "Do I have the assignment or not?" Make the assumption that you have it. Make it hard for the other person to say no.

Here are some other popular negotiating tactics:

A red herring. This is usually an irrelevant or very minor point that you bargain for up front, in order to have it later when you need it. When negotiating, you often need to have something to concede, or trade, in order to match a concession by the other person. You trade the red herring.

An example of a red herring being used in an assignment negotiation can be illustrated best by this hypothetical scenario.

Your goals in the negotiation include receiving an advance on expenses. The client is not inclined to give advances, and you have learned this from research or from prior

experience.

The job calls for casting and hiring two models, whose fees will amount to $1,500 for the day. Normally, you would front the money for the models and pass the expense on to the client in your invoice. The job will have expenses of $4,500 and you would rather not carry that amount.

You set up the red herring in the negotiation by making the point (to the client) that you want them to pay the models directly. They (as expected) do not want to do this. After some discussion you suggest that the matter be put aside to be resolved later. Keep in mind that this example assumes that you are not concerned, in fact, about paying those fees and seeking reimbursement. Your goal is simply to get some money up front if you can.

Later, after the rights, fees, and expenses have been agreed upon, you ask for an advance on expenses. Again the client is inclined to say *no* and does.

You don't accept the *no* (graciously), and point to the fact that the direct payment of models has not been resolved. And it ($1,500) combined with other expenses ($3,000) represents $4,500 that you have to finance. Worst of all, the model fees will have to be paid quite promptly—stressing your cash flow while you wait for the client to pay your invoice.

Then you ask why they won't pay the models directly. Let's say they object to the need to set up another vendor record and payment on the job. You, in turn—with empathy for the bookkeeping hassle—suggest a solution.

You offer a compromise. You will drop your demand for direct payment of the models, if they give you an advance on expenses. This way, your cash flow problem is eased and their one vendor need is accommodated. So, each of you has satisfied a need at no added cost to the job, and no added hassle.

You have traded off your red herring for a goldfish!

Limited authority. Frequently imposed on you by the other side, this is a difficult tactic to handle. When the person you are negotiating with is not empowered to make a deal, they take your offer to someone else who refuses it. This forces you to rework the deal, even if it's already at your bottom-line price.

One way to respond is to put yourself in an equally powerful position. Say something like this: "Look, you have limits on what you can do. So do I. I won't sign off on this deal until you get an approval. I reserve the right to ask for changes if you can't get the deal we agree on approved." Now you are negotiating on the same ground.

How do you find out if a person has limited authority? Just ask. "If you and I can reach an agreement on this job today, do you have the authority to sign?" If the answer is no, you can try, "I'd like to have the opportunity to speak with someone who has the power to sign on this offer. Can I speak to that person?" If the answer is still no, respond, "In that case, I reserve the right to withdraw any part of the deal on the table."

The tactic of silence. Being able to remain quiet is a must for the successful negotiator. Listening is an art. You can't listen while you're talking. The person who asks a question and waits for an answer is in control. If they listen to the answer, the opportunity will arise to develop an option. If a person wants a buyout, ask "Why do you want a buyout?" Then wait for the answer. If you don't get the answer, repeat the ques-

tion.

The tactic of why. Never be afraid to ask *why*. Good business people usually respect your interest in their concerns and their reasons. Ask *why*. If you understand their problems, you're better able to help them find a solution. You may not find a solution, but at least you show a sincere interest in their problems.

The good-guy, bad-guy tactic. Let's say you send your rep to drive the hardest deal possible, but you also want the job badly. You sit in on all the discussions. Your rep and the buyer reach an impasse, but you know the job meets the bottom line. The rep is pushing to get something, and you say, "Look, I don't normally do this, but we haven't worked a lot with this client, and I really want to show them what we can do, so I'm going to interject here and say we'll do it for their price."

The reverse tactic. Another tactic is to plead "limited authority," saying that you have to consult someone else (such as your partner, business manager, or the photographer if you are acting as an agent) to lower the price but that, if you take it for review, all previous offers are withdrawn. The person with "authority" could either lower the price or insist on something higher than your last offer—it's the buyer's gamble.

Flinching. Giving a visual signal to the other person is a nonverbal way of saying no. This is a common tactic to let people know that you can't really handle what you are hearing. It can be unnerving to the other party.

The broken record. In this tactic, you keep asking for what you want until you get it. "I really have to have an advance. I know you said I can't have an advance, but I really have to have an advance. You don't want to give me one, but if I don't have an advance it may jeopardize the quality of this job. I must have an advance." They may give you the advance just to shut you up.

Nibbling. Nibbling isn't getting a little bit at a time until you've got the job. It's done after you've made the deal. While negotiating, you may discuss various elements, but the whole deal is wrapped up at one time. You get the job. You agree on price and rights. Then you nibble. You might say, "How about half the expenses in advance on this one?" Why wait until after the original deal is struck? Because if it's a sensitive point, you're better off waiting instead of risking the whole deal over it. You nibble. If they say no, you drop it, but you still have the job.

Funny money. This is reducing something to terms of dollars so your client can understand how feeble an offer is. An editor says, "We want to shoot this job for $400." You say, "Wow, I'm spending a half day to come here to see you, then get back to the studio and make some notes. Then I've got half a day to get equipment prepared and film tested. I'll travel for half a day and shoot for a full day. I'll spend one more day bringing film to the lab, picking it up and editing it. There will be another half day of administrative time, bookkeeping, invoicing, and phone calls. That's four days of work. You're offering me $400. That's $100 a day. Who can work for $100 a day?"

When you break the money down to understandable units of time, you show the client how the money doesn't fit the time and effort involved. Always be prepared to present facts to back up your position.

Being outrageous. It can be a good tactic on occasion. Here's an example. The client says, "I can get your competitor to do this for that price. Heck, I can get anybody

to do it for that price." At that point, pull out a list of competitors, complete with their phone numbers, and say, "I always want to be of service to people who I think are going to be good clients. If you really don't feel I'm the person for this job, here is a list of my competition. I know I'm the best person for this job, but if you don't agree, I can't argue with you. I've just failed to convince you and that's my fault. However, if you want to call my competitors, I've made it easy for you." That's outrageously calling their bluff.

Trial balloon. This is an excellent tactic. Use it to find out something without making a commitment or putting your client on the spot. For example, someone just told you all about a job and you want to get $5,000 for it. Instead of saying it will cost $5,000, you say, "What would you say if I told you this job was going to cost $5,000?" You didn't say it cost $5,000, you said "what if." By making your fee or proposal a "what if" question, you minimize the risk and leave yourself a chance to recover from it. You haven't presented it as a fact, but rather as a trial. Another example of a trial balloon is to say, "How would you feel if I asked you for all the expenses in advance?"

Avoid signs of weakness. People who don't look you in the eye when they talk to you are disturbing. Likewise, when you want to negotiate with a client, look him in the eye and talk to him. It's not a who-blinked-first contest. When you stand up and talk to a person, stand up straight and talk to him. Don't lean up against the wall like you need support and are about to fall over. Look confident. Why? It's psychological. Your image is important. These are signs of strength. Slouching in a chair, leaning over a table, or burying your head in your hands are all signs of weakness.

Don't couch your words. Don't be afraid to say it the way it is, and don't send out confusing signals. For example, if you don't like what they offer, and you have an option, tell them. Say, "No, that's really unacceptable to me, but let me offer this as a possible alternative." If it's unacceptable, it's unacceptable. Don't spend twenty sentences saying *no*. Just say *no* and offer your alternative. Also, don't say yes, *but*. It's a confusing signal. It doesn't mean yes at all; it means no or maybe.

What do you do when a client refuses to negotiate, when he says take it or leave it? First, don't see it as complicated. It's the simplest situation in business. All options and alternatives have been reduced to two. Take it or leave it; you have to choose. If it really is a take it or leave it offer, does it meet your bottom line needs? If it does, take it. If it doesn't, leave it.

Should you automatically accept that a deal is take it or leave it just because someone says it is? No, not until you test it. Just as photographers get purchase orders from agencies that have a lot of verbiage on the back that seems to be set in stone yet is negotiable in most cases, the take it or leave it offer is intended to make you think that you're not entitled to object. But if you do object, you might change it.

What you might say is, "I hate to deal with these take it or leave it deals. I think they're fundamentally unfair. Let me ask you a question. Don't you think that the best way for two people to make a deal is to make one that is fair for them both?" If the person says *no*, she's saying she doesn't believe in fair dealing, and risks losing her suppliers. Let's assume she says yes. You might respond, "Then I'm really surprised at your take it or leave it deal because, even though I know you think it's fair, you're not giv-

ing me the opportunity to explain why it doesn't meet my needs. Allow me to explain why that's so and what it would take to get this within the parameters that allow me to do this job. Then we can finish this meeting knowing we both got a fair deal."

Always try to turn the take it or leave it offer into a negotiation. If you can't open a negotiation, then evaluate the deal based on what you're being offered and what your needs are. In dealing with a firm take it or leave it offer, you have to know your bottom line, the point below which you cannot go. Once you know that, the decision is simple.

Dealing with the Assignment Issues

The two substantive issues you'll negotiate most often are usage and fees. The key to being a good negotiator of these is to understand the relationship between the two and why you need what you're asking for. To do that, you must understand the copyright/value relationship and the two great nemeses in photographic usage—work-for-hire and copyright transfers. Many photographers use those terms interchangeably. However, they are not the same.

A work-for-hire is a provision under the Copyright Act, that says that if you are the employee of a party, such as a staff newspaper photographer getting a salary, then the copyright to your work belongs to your employer because everything you do is a work-for-hire. That is a federal law. In a work-for-hire situation, the copyright belongs to the buyer or employer from the moment the picture is taken. The buyer or employer is the author; you have no rights of authorship or ownership.

Work-for-hire can exist under limited circumstances for an independent contractor. There are nine categories of work that are eligible for work-for-hire treatment. The ones that affect photographers the most are "collective works" and "derivative works."

If you are an independent contractor, a work-for-hire can exist only if you have signed a written agreement to that effect.

In a copyright transfer, you own the copyright and you transfer that ownership to the buyer. You are selling an asset—the copyright—even if it is intangible. So you have something to bargain for—the value in that copyright.

There is a provision in the Copyright Act called "recapture," which allows you to regain your copyright thirty-five years after you transfer it. If you signed a work-for-hire agreement, you have no recapture right because you never had the copyright in the first place.

In a copyright transfer, you are bargaining for the value of your copyright. Some photographers sell their copyright because they believe their work has no future value. However, you don't know what the future value will be. Future value is based on usage—how long and how often they'll use it, or for what other uses it can be licensed.

You could shoot a can of tuna fish and think the photo has no future value. The client says he is just going to use it in an advertising campaign this year, but in a poor economy more and more campaigns are being extended and rerun. Photographers who sell copyrights don't get reuse fees on any of these reruns. Photographers who retain copyright get paid again.

In addition, you can't know how valuable the photograph will be as a stock image in the future. No one can predict what images will have historical value. You may have one of the most recent pictures of a certain subject which, twenty years from now, someone might need. And, certainly, you can't predict reuse by a client.

Most photographs taken on assignment have little future value as stock. In a given stock file, only 2–3 percent of photographs will ever sell. The problem is, no one knows which 2–3 percent. If you could figure that out, you'd be very wealthy because you could corner the market by shooting a few dozen pictures a week. Still, future stock sales is another reason not to sell copyright.

Yet another reason is that it creates a precedent and a mindset by the client. Buyers begin to believe that this is the way things are always done. Suppose a client wants you to photograph a clothespin. You agree to sell the copyright to that photograph because you don't see any future value in it. A month later, the same client calls you because one of her accounts makes the paint for the space shuttle and she needs a photograph of the next launch. She's made special arrangements for you; the company's even built a tower where you can shoot. As before, she wants to buy the copyright. This time, however, you see the future value of the photograph and refuse to sell it. The client is confused and asks, "Why not? You sold me the copyright just last week."

You have a problem. You said that you sell copyright, now you won't. This is a bit ridiculous. If a photograph has no value, obviously no one would want to buy it anyway. Then, when the photograph does have value, you won't sell it. It's very inconsistent. You should have a standard policy. Don't get in a position where, in the middle of a negotiation, you must explain why you're going to sell copyright on one job and not on another.

Once you do adopt a standard policy of not selling copyright or signing a work-for-hire agreement, you'll need some explanations. Here are a few.

You could say, "I won't sign a work-for-hire agreement because it makes you the author and denies me any recognition. It's as if I don't even exist. In addition, it gives you the copyright for life, and I don't want to do that."

Or you might offer this reasoning: "I'm sure you agree that the most important thing any business person must do to stay in business is go out there and sell. Well, I'm in the visual business, and if I want to sell my services, I have to be able to promote myself. The only way I can do that is to show people what I do. If I sell the copyright to my images, I no longer have the right to use any of them. I can't display them. I can't publish them in a source book. I can't even show the work in my portfolio. I wouldn't have been able to show you the work I did to get this assignment. No, selling the copyright is the kiss of death for my business."

If you must negotiate further, at the very least be sure to secure promotional rights to the photograph. If it turns out to be a great shot, you can still use it for promotion and advertising.

Even then, you might persist and ask the client, "Why do you want the copyright?" Remember that a good negotiator uses the answers of the other party to create options to satisfy needs. Here are some possible answers to that question that you might hear from clients, and how you might reply.

To avoid future negotiations. Your client might say, "I don't want to have to negotiate for every use down the line. I'm not sure how I'm going to use this and I don't want to have to come back to you every time I do and pay another fee."

Your reply might be, "If you want to extend the use of media, you can do it anytime, and all you have to do is pay me X percent of the original fee." (Not the expenses.) By setting the price up front you may disarm the concern over negotiating a price later. The fee is guaranteed.

To protect the corporate image or a proprietary interest. You may hear something like, "These are corporate executives. One day a photographer shot a picture of our president and the next week I found it in a business magazine article that wasn't complimentary to us. We want the copyright to prevent that from happening." Or the client might say, "These pictures are of secret processes. We don't want the whole world to see them. Nobody in the world has machinery like ours. This is very confidential information and we need to control it." Or, "The letters XYZ will be on all those buildings you're shooting and we don't want the XYZ logo published without our control."

Proprietary interest and corporate image are tougher items to deal with because there are companies that want to protect certain processes and people. You might give your absolute assurance that none of the photographs they declare are proprietary will ever be used by you. You might leave the proprietary work in their custody and keep only those that are nonproprietary.

Ownership of the transparency is not ownership of the copyright. They are separate under the law. You can own a transparency and not own the copyright. Now (through custody of the original) the client's interests are met. If they want to use those images and exploit them, as copyright holder you have a right to be paid for that value.

To avoid liability. You may hear, "We want the copyright transfer because we're afraid that we might damage images and be sued. If we own the copyright, you've got nothing to sue us for."

You might alleviate the client's concern about liability by saying, "My paperwork can include language that states that payment of the fee in full is considered compensation in full for any damage. I'll cover your liability for that."

For you, this means taking a minimal risk of uncompensated damage, but would you go after the client in that kind of situation? You might have a difficult time getting a high value per transparency in court, when they paid the expense of creating the work. Remember: You have to prove a slide is worth $1,500 or whatever you claim it is. This way, you've exempted them from what might be a minimal liability in damages.

You shouldn't disregard your client's needs if you want to maintain a relationship. You've got to protect the client's interest, and you can do that without selling the copyright.

There are companies that have a policy that they must own everything. They are usually unbending on this point. If you choose to sell copyright, make sure you are paid appropriately for it, because you'll never have any residual income from it. In short, receive an equivalent value for what you sell.

Chances are, if they want the copyright, they intend to use it often. Be sure to get

paid for the value of that extensive usage. No one can insist that you shouldn't sell copyright. But everyone knows that copyright has value, so obtain that value by either holding onto the residual rights or, if you're selling the copyright, by getting paid for that residual value.

Within copyrights there are many individual rights. There are advertising rights, magazine rights, book rights, television rights, geographic and language rights. You can sell specific, exclusive rights, which means the licensee can do anything with the photographs, within the scope of those rights. The exclusive rights for advertising for an image means a client can do anything it wants in advertising. You can grant exclusive rights for a specific number of years. If the client doesn't need editorial rights, because he's not going to publish a magazine, why should he buy them? Buying specific exclusive rights is like buying a limited copyright. The photographer still owns the exclusive rights to the image for other media or for other uses, such as magazines, books, and the like, while the client has specific exclusive rights that ensure that the photo will never be sold by the photographer for a similar purpose during the term of the client's exclusive rights.

Generally, clients seek to buy more rights than they need, so you should have different prices. You should have the copyright price, the exclusive right price, the unlimited/non-exclusive right price and a limited/non-exclusive right price. If a client insists on the copyright, put that price on the table. If the client asks why it's so high, tell him it's because he wants to buy the copyright, but that you can get this down to a much lower fee if he wants to talk about limits, such as exclusive or limited rights.

Never ask your clients what rights they *want*. You want to know what rights they need. Instead of using the word "rights," which is a red flag, use the word "usage." You could simply ask, "How do you intend to use these photographs?" If they want to create an ad, ask how long the campaign will be, in what media, covering what geographic area, and so on. After you have all the information you need, explain that you will work up your fee on that basis. The clients need to use your photograph. Sell him usage.

If a client tells you she doesn't understand usage, explain it this way: "You're an advertising agency. When you place a full page, black-and-white ad in a magazine's July issue, you sign an advertising contract and pay for one month's space. If you want to run it for a year, you've got to pay more for it. It's the same with photographs. The more you want to use it, the more you must pay." The fact is, clients understand usage. They deal with it every day in terms of media space. All you're doing is using the same pricing that their other suppliers use.

Another popular refrain from clients is this: "I paid for this and I own it. I should be able to do anything I want with it." Your answer: "You pay for advertising space too but you still don't get to use it over and over again unless you pay accordingly. Usage is a fair way to charge. Perhaps you're just not used to hearing it in photography. Let me explain why I have to sell according to usage."

Now give them your reasons. If you are shooting a product for a manufacturer, you might try something like this: "You sell widgets. Suppose I bought a widget and took it home and the next day you look in the newspaper and see a story about a man who found a way to clone your widget. He turned it into ten widgets. Would you be upset?

Of course, because you were losing business that was rightfully yours."

Continuing, you say, "When I give you a photograph, you don't have to come back to me ever again for that photograph. You can reuse it over and over. If I don't control the use of my images, my volume of sales will be reduced. You don't have to clone a photograph, it's self-cloning. That's why I must charge for usage."

Another client scenario goes like this: "Listen, when I go to the stationery store and buy a box of stationery, I own it." Your reply could be, "Suppose the stationer found out that every time you took a sheet of paper out of that box, another one automatically replaced it. Instead of selling you the box outright, the store would lease you the right to use the box since you would never have to buy another one. They would be charging you for usage."

Ultimately, when negotiating copyrights, you have to convince clients that your need doesn't conflict with their interest. If it does, you'd better take a hard look at this deal because if you're hurting your client's interest, eventually you're not going to have a client. Meeting your needs and meeting the needs of your client are not irreconcilable, if both parties are open-minded.

Negotiating Fees for Assignment Photography

There is a point in every negotiation when the issue becomes money. How much will you charge for the work you are being asked to do? It is a simple question, but a difficult one to answer because there are so many factors.

Many photographers are uninformed when it comes to pricing for services. For those who have no experience or training to guide them through the process, refer to chapter 3, "Pricing and Estimating."

In general, the fee to do an assignment will include these factors:

• The basic fee. This amount accommodates total nonbillable expenses, such as electricity, depreciation, salaries, rent, and other overhead items. It is usually calculated by taking the total of these items and dividing it by the total days of shooting projected for the year. This number, in turn, is multiplied by the total days the assignment will take to shoot.

- The creative fee. This is the amount you charge to shoot the photographs. Some jobs require more skill and equipment than others, so the creative fee varies. It can be calculated per day or per job. Obviously, if you are being asked to shoot a job that is quite simple and could be done by almost anyone, you will not charge as much on this line as when you are called to do a job that requires many years of experience and/or special equipment or facilities.

- The usage fee. This is what you will charge for licensing your clients with the right to use the photographs they need. Since the value of a photograph to your client is more dependent on your creativity than your overhead, the usage fee can be calculated as a factor of the creative fee. For example, one-time magazine editorial use might be a factor of 0.5, while exclusive print media advertising use might be 3.0, and a transfer of copyright might be a factor of 6.0. These are simply examples, not recommendations. What factors you apply in your business

depends on your own and regional industry circumstances.

- Mark-up. This is a percentage of the total expenses meant to compensate the photographer for the cost of financing the expenses and the cost of securing materials, testing, stocking, and the like. Some photographers include it in their expenses. However, this is often a red flag to the buyer. Instead, place it in the fee. It constitutes what might be called a variable overhead fee. Then, the individual components, when added together, amount to the assignment fee, which you will convey to the client. Remember: Too many details simply complicate the negotiation by causing microscopic scrutiny and evaluation.

The next step is to create a range within which you can negotiate the fee. This is a relatively simple task. In the following example, the asking price is the fee you want to get, and the bottom line is the fee you need to meet your established minimums. The difference between those two numbers is the spread or negotiation range.

	Asking	Bottom Line
Basic Expense Fee	$ 500	$ 500
Creative Photo Fee	$1000	$1000
Usage Licensing Fee	$ 500	$ 300
Expense Mark-up Fee	$ 50	0
Total fee for assignment	$2050	$1800

In this example, your negotiating range is $250. The asking price is the amount you want for the job, while the bottom-line price is what you need, or the lowest fee you will agree to.

The fee you would ask the client at the start of the negotiation process is $2,050. If your client accepts it, you have fulfilled a want. There are those who would say that if your client accepts your first offer, then your price was too low. If the price you ask for is not accepted, then you must start negotiating. The key is to remember that any disagreement is the start of a negotiation, not the end of a possible deal.

It's reasonable to assume that a client will balk to some degree at the first price you offer. When that happens, it is important that you hold your ground for a while. If you are prepared to lower a price at the first objection, it is a signal that you are not confident of the true value of the job and your ability to get the price. It is also an invitation to the other person to try bringing the price down. Even though you may have to do that to secure the assignment, it is not something that should be done without discussion.

Assume that you just asked a client for a $5,000 fee for an assignment. The client objects to the price. What's your next step? Generally, it is wise to ask the client what he or she perceives as a reasonable price for that work. You could ask the question this way: "The fact that we don't see eye to eye on this makes me think one of us is missing something. Tell me, what do you think is a fair fee for this job?"

If the answer is far from what you quoted, you have to explore why the difference exists. What are you or the client overlooking or incorrectly pricing in the assignment?

Make sure you have a full understanding of the job specs, usage, and the like. Take another look at your figures and see if you miscalculated. If you didn't, ask the buyer to explain how he came to the figure he quoted. Pay attention, find out what he is overlooking, and point it out.

If there is only a slight difference between the two positions, you might simply concede the difference as a goodwill gesture, assuring the client that you'll absorb the difference to show that you want to work with him.

If the difference is simply too much to absorb, try to work through the range to a point between your quote and the client's expectation. This is when salesmanship is essential. Insist that you are worth every penny you quoted, yet find some way to come down a bit. There are different approaches.

If you are ready to give them some reduction, you can ask for a tradeoff. You might ask for the expenses in advance, as it will lessen your cash flow needs and that is worth some reduction in price. You could ask for part of the fee in advance, using the same rationale as the advance. Or, you could ask for some portion of the rights package (usage) to be altered. For example, perhaps they asked for the right to use it for three years, even though they didn't know if they would use it that long. Ask them to cut it to two years and pay the difference if and when they use it for the third year.

Whatever reason you offer, be sure it makes sense and has value close to the amount you are giving up. Explain your reason for lowering your price. That will minimize the chance that they see you playing a game to get more money. Determining what is appropriate is not always easy. After all, there are two points of view on the matter—yours and your client's. Those two points of view will not always line up close to one another. But if you understand how you arrived at your quote, you can explain it and hopefully get it or come close.

If you are not ready to lower your quote, try appealing to your client's past experience with you. Suggest that the amount you are asking him to pay is in line with your quality and reliability.

Some Simple Rules

There is no simple formula to follow in negotiating an assignment fee, but there are some simple rules you can follow.

1. Never reduce your price without giving a reason, whether it is a tradeoff for similar value, a goodwill gesture, or an acknowledged reconsideration of the assignment's demands.
2. Justify your price based on your experience, capability, creativity, and so forth. You decided on the creative portion of the fee by examining the talent, equipment, style, and other requirements of the assignment. Use those factors to sell the fee.
3. Mention other assignments of a similar nature, whether done for the same client or a different one. Demonstrate that you received a fee similar to the one quoted for the present job being negotiated. Show a tearsheet of the work.
4. Remind the client that his choice is lower price or quality, and that quality includes getting the job done on time, within the estimated price, and in a creative manner.

Remind him that quality is what you are quoting on. It's not a photograph that you are quoting on—it is reliability and quality.

5. Be direct and confident. Reassert that the fee you are offering is reasonable, and show concern if he cannot recognize that fact.

Finally, remember that there is no such thing as the right fee or the fair fee. You will get what you negotiate. If any one person could always identify the perfect fee for every photographic assignment, she would be indispensable in the industry. Fee negotiation is a balancing of interests: yours, your client's, and, in the case of an ad agency, their client's.

Still, that balancing is an act of substantial proportion. Your fee has to be relative to the value of the photograph. When an advertising client is spending $2 million for media space, why should he be able to procure the rights to an assigned photograph for $1,000? If he thinks enough of his product to buy that kind of space to advertise it, he should be ready to spend a reasonable amount of money for the right to use the photograph in that space.

Value is not only relative to the experience, creativity, capability, and reliability that you bring to the job, it is relative to the many other costs the client is prepared to incur in the project.

Negotiating Fees for Stock Photography

In stock photography, price negotiating is particularly intense because both buyer and seller have power. Although the buyer decides whether or not to "buy," it is the stock photographer who has something the buyer wants.

The first step in negotiating is gathering information. Here are some questions to ask:

1. Who is the buyer, and what does that tell me about her ability to pay?
2. What is the image, and how unique is it? Are there a hundred similar to it, or thousands? How likely is it that the buyer has an alternative already selected?
3. How will the image be used—in what media, for how long, and at what size? What will the circulation or distribution be?
4. When must the buyer use the image? Is there a deadline?
5. Where will the image be published—in what region or country?
6. Why is this particular image being pursued? What makes the buyer want it? Is it a unique solution for the buyer?
7. How much can the buyer pay, and under what circumstances will he or she pay the limit?

How do you get the answers? Some of these questions may be answered when the buyer requests an image. Others may require more detective work or hypothesizing on the basis of other information. But having the answers is important to your ability to negotiate a fair price.

A common pitfall, to be avoided at all costs, is letting a buyer insist on a price before you have all the information you need to determine a fair price. Prices are based on

evaluation of facts, and you cannot properly price your work without all the facts.

In a stock photography sale, the issue is usually the fee for the use of the work. Rights, distribution, and the term of license are usually dictated by the client's predetermined needs. Stock is for a specific application, so generally all that remains to be determined is how much it will cost.

Expectations can play an important role in negotiating stock costs. The other party probably expects to pay more than she is offering; at the same time she probably expects that you are asking for more than you will finally accept.

In addition, don't forget the most important point in negotiating a price—you must know your bottom line. What is the minimum fee that you will accept? A good negotiator knows the bottom line and lets the buyer know when he or she has reached it. When you are at that point, make it clear that you cannot go any lower. Your counterpart must now take it or leave it. Never, absolutely never, go below your bottom line.

Also, if you do change your price, don't do it in a vacuum. Give a reason for the change. Don't present yourself as a person who inflates the price so it can be cut later. That invites buyers to try for more cuts. When you negotiate, you must have a reason for every stance you take.

What reasons might you give for changing your price? It could be that you have just reexamined their specifications and realized that you have some slack. It could be that the finished reproduction offers a promotional benefit, and you are prepared to accept extra tearsheets as additional compensation. Or the client may have been fair with you in the past when the budget allowed and you are prepared to be flexible. No matter what your reason, make sure the other person knows what it is—and that you don't go below your bottom line.

To avoid pointless negotiating, it's a good idea to establish the pricing parameters on the initial contact. It can be a significant time-saver if you do not send images unless the person has a budget that can meet your minimum pricing standards.

When you price a stock photograph, what exactly are you pricing? Are you pricing a service or a commodity? Although a stock photograph bears some resemblance to a commodity, it has an intangible quality in that every stock photograph is the product of a particular vision, different from others, even when they deal with the same subject matter. Stock photographs are not a commodity.

But can they be compared to a service? After all, they have already been produced. Consider, however, that stock photographs are either outtakes from an assignment or the result of a planned effort to create the stock—a kind of self-assignment. In other words, stock photography is the result of a service with one distinct advantage: The photographer has taken the risk out of purchasing a service. In effect the stock shooter, by anticipating need, has provided a service in advance of the request, assuring the buyer a risk-free transaction. No commodity or service does that. Stock photography is unique and it needs its own pricing system—one that takes into account not only the originality of the photograph but also the lack of risk for the buyer.

Factors in Stock Photography Pricing

The first thing stock pricing must do is recover the costs of creating the photographs.

Obviously, to do that, you have to identify the costs, and the total amount of those costs. That is somewhat harder than it seems because there are two kinds of costs: fixed costs, which stay the same regardless of volume of production or sales, and variable costs, which move upward as production and sales increase. Rent, insurance, basic telephone charges, and equipment are all fixed costs. Variable costs include film, processing, taxes, and postage. Clearly, variable costs have to be estimated on the basis of projected operations. How do you do this?

Consider the potential volume of your sales and the expenses necessary to make and fulfill those sales. Then add the cost of production of new material or a portion of that cost. Your projections can be based on your own experience, the experiences of others, or industry statistics.

Next you will have to project your sales and create a base price. If you have been selling stock for some time, you probably have a sales history and can evaluate how many sales you make a year at any given level of sales.

Remember these simple formulas:

Breakeven price = All costs ÷ quantity to be sold
Selling price = Breakeven price + Profit + Added value

It is important to emphasize that this system is based on a projection of sales and expenses. If your projection is wrong, then your price base and final price are also wrong.

Be sure to evaluate your estimates over time. If they prove to be high or low, whether the change is in sales or expenses or both, you must alter your input accordingly. Readjusting your pricing is important to making profits. In time, experience will make your estimates accurate, but careful review of performance is advised.

Guides and Surveys

There are several guides to pricing stock photography. These are available in book form, and also in computer–readable, disk-based programs.

In addition ASMP conducts pricing surveys and publishes their results for the reference of its members only.

The guides reflect the opinion of experts in the stock photography field, while the survey results are statistical compilations taken from surveys conducted by ASMP among its members.

These guides and surveys can serve as an excellent way to check your pricing in relation to industry-accepted prices.

Assessing Added Value

Stock photographs can have added value from two sources. First, the photograph is worth more if it has some element of uniqueness, whether from the specialized nature of the subject matter, its limited supply, or if it was unusually expensive to produce.

Another important source of added value comes from the nature of the application:

brochure, package design, point of purchase, advertisement, editorial illustration, book cover, promotional kit, television insert, film strip, and so on. Also consider the circumstances: size of use, circulation, time limitations, geographic distribution, uniqueness of the image, quality of the image, extraordinary research time, unusually long client holding period, availability of releases.

It is generally accepted that the more important the use and the greater the prominence of the photograph, the more it will cost the buyer. A national advertising use is priced higher than a regional one, a major news magazine use higher than a textbook image. What's at issue here is how important the photograph is to the client. It is logical that the image's importance increases in direct proportion to the cost of that chosen media. But how do you set a value on all this? There is no simple formula. The knowledge comes from experience, market trends, investigation of industry standards, consultation with other photographers and stock agencies, and some seat-of-the pants insight.

In the pricing method, it is your ability to formulate the numbers, assess the added value, and negotiate the price that will determine the ultimate profitability of your stock photography business.

Always remember: If you are in business to produce an income for yourself, then you should be negotiating for a fair, competitive price that assures you an income after you have recovered all the usual expenses that are associated with a stock photography sale.

Pricing an Image

Many photographers price stock photos as if they had just produced the image. For a photograph's leasing price, they first arrive at the base expense by adding all the costs of the photograph's production to their normal overhead requirements and then add a fee for usage, a fee for time and service, and a sum for profit to the base expense. If it sounds as if they were pricing a photograph done for an assignment—you're right, it does.

Any stock photograph has the same cost structure whether it was originally produced as an assignment outtake or especially for stock. A stock photo, like an assignment photo, is a "service" provided to a client. All images are not the same, as each shows a different solution to a client's needs—widgets on the shelf couldn't do this.

Even for the same usage, the fee charged to lease a photograph of a "family" portrayed by five models will be greater than for a photograph of flowers in a field .

When pricing photographs, keep in mind the factors that differentiate one photograph from another and can determine value. Many experienced professionals view their work as falling into five categories:

1. A pleasing, technically excellent photograph of an existing situation that is not directed by a photographer. This includes some editorial shots and many scenics.
2. A pleasing, technically excellent production photograph of a situation directed by a photographer. This includes setup shots with model-released talent, props, and the like.
3. An exceptional photograph from the first category—for example, an outstanding scenic that would be difficult to reproduce due to extraordinary lighting or weather,

or an editorial photograph of a high-tech facility to which access is very difficult to obtain.

4. An exceptional photograph from the second category, such as a complex production photograph with extra talent, trained animals, special location, or helicopter fees.

5. An exceptional photograph of a unique moment or event that would be impossible to re-create.

Consider these five factors in determining whether a premium price is warranted for a particular photograph and in explaining your price to a client.

Whom to Ask about Prices

How do you find a basic minimum figure for different categories if you have no experience? How do you make sure your prices are up-to-date? Here are several approaches used by experienced photographers:

1. Consult colleagues experienced in stock. Photographers are usually happy to share their knowledge of the business.

2. Consult your stock agency if you have a non-exclusive contract. Your agent can be a helpful source of information.

3. Consult other stock agents strong in marketing. If you don't pester them with too many calls a week, many agents are willing to help with a perplexing price quote, or a base rate.

4. Refer to the guidance in this chapter for analyzing your business costs and figuring out a base price.

5. Keep informed about cost-of-living increases and business statistics published by the federal government.

6. Consult stock pricing guides.

A Photographer's Perspective on Pricing and Negotiating

To those unfamiliar with the market for stock photography, the pricing of stock photographs can be very confusing. The same picture, for example, may command different prices in different situations. Agreeing with a buyer on a price can be as simple as a ten-second phone call, or it can require several visits to the buyer's office, with review of layouts and consultations with other photographers. If the buyer is a trusted client and the use is standard—a half-page in an established magazine—pricing may be almost automatic. Other times, however, pricing becomes complicated, especially if the photograph itself is a one-of-a-kind image, or if there is a combination of different formats using the same picture.

How do you arrive at a price that satisfies both you and the buyer—the fair market price? It is a step-by-step process that begins by considering the client's budget and the specific use of a photograph. You must also consider any unique merits of the particular photograph and the individual situation of the buyer. Negotiation is the final step

that leads to agreement on a price.

A basic principle in pricing is: The larger the total budget of the entire project, the more the buyer should be able and willing to spend for the photograph. Application of this principle has divided the market for stock photographs into three broad categories, each with a developed price range of its own.

- Advertising. This is usually the highest-paying use of stock photos because of the large investment required to buy media space, the immediate profits realized, and the revenues the photograph will help create if the advertising is successful.
- Corporate/Industrial. The use of photography in company annual reports, promotional trade shows, public relations, recruitment booklets, and the like, is a less direct form of advertising and promotion than consumer advertising; thus, it usually has a more moderate budget.
- Editorial. This use is defined as photographs that run in magazines, books, or on TV for their illustrative or informational value. The budget of an entire project may be large—for example, for an encyclopedia—but a large number of pictures are usually required, so the per-page budget is relatively modest.

In sum, the three main uses for stock photos are advertising (highest paying), corporate/industrial (middle range), and editorial (low range). There are also unusual uses with their own price rationale—for example, place mats or playing cards.

Another area deserving special consideration is the usage termed "advertorial." Advertorials often appear in magazines as special sections or inserts advertising a place or service, most commonly for tourism. In this type of usage, the photographs are used to support the editorial content, but the entire section is advertising and is marked as such in accordance with federal law. Though often editorial in style, the photographs in an advertorial are part of an advertising program, and this should be considered in pricing. An additional concern is copyright notice. Since the magazine's overall copyright notice does not cover advertisements, and since many of these sections are designed to be removed from the magazine itself, photographers may want to stipulate that the copyright credit must appear adjacent to the photograph.

Five Factors in Use

A second basic principle in pricing is: Any use that increases the visibility of the photograph increases its value. After the broad use of a stock photograph has been determined, this second principle—"amount of visibility"—comes into play. Any increase in the visibility, by any means (beyond the stated minimum customarily specified for a particular use), further increases the value of the photograph to the buyer and therefore earns a higher fee for the seller. Factors to consider are physical size, circulation or print run, geographical distribution, additional versions or editions, and extensions of the time the image is used.

1. Size. Throughout the industry, the size of reproduction (such as full page or half-page) is an accepted and realistic method of measuring the photograph's value, just as size is one accepted way for magazines and newspapers to charge for advertis-

ing space. This concept carries over to billboards, exhibition prints, posters, and the like. It is important to note, however, that the relationship of size to price is not exactly proportional. If, in a hypothetical example, a full-page editorial or advertising rate is considered to be 100 percent, the fee charged for half-page use might be 70 percent (not 50 percent), and for a quarter-page, which should be the minimum base fee, it might be 65 percent (not 25 percent). The point is that there is a base fee paid for the initial reproduction rights. Size influences the price, but not in direct proportion.

2. Circulation and print run. This is an obvious way to measure how many times the photograph will be reproduced, which, in turn, is a measure of how many copies of a book or magazine may be sold, or how many potential buyers will be influenced by the photograph in a catalog. The greater the number of reproductions, the more valuable the photo probably is to the buyer, but, again, the price scale is not directly proportional. Doubling the print run of a sales brochure from five hundred thousand to a million, for example, might increase the average fee for a full page by 40, not 100, percent.

 In print advertising, it should be noted, the total circulation figure is considered to be the sum of the circulation of each magazine multiplied by the number of insertions. There are directories, such as the *Gebbie Press Directory*, which provide circulation figures for a multitude of publications. In TV advertising, the multiplier is the number of times the commercial is aired.

3. Distribution. The value of a stock photograph can be radically affected by whether the use is worldwide, national, regional, or local. In TV, a commercial on a national network has more visibility than one on a metro New York station, which, in turn, may have ten times the viewers of a St. Louis station. In the greeting-card market, worldwide rights in English, rather than the United States only, mean many more potential buyers and greater profits.

 In certain industries, such as book publishing, the value of customary and standard distribution rights is fairly well established. But the business practices of some of the more recent users of stock photography are unfamiliar, and the values of distribution rights have either not been established or seem unrelated to past pricing experience. For example, in uses that are very commercial, such as posters, packaging, and novelties, the distribution rights may be a primary basis for determining the fee.

4. Versions. If a stock photo is used in more than one published format, it is considered to have added value for the buyer. In book publishing, there might be an additional language edition or a trade paperback following the original hardcover version. In another situation, an annual report cover might be used as an institutional ad, or a national consumer ad might be reworked as a point-of-purchase display card. The accepted pricing procedure in these instances, when the extensions of usage are known beforehand, is to price the primary use fully, as if it were the only usage, and then discount each additional use a certain percentage, based on the total package.

5. Time. The length of time a photo is visible becomes a factor when, for example,

a photographic billboard is used for six months rather than the usual thirteen-week cycle. There is also an increase in visibility when a wall calendar is designed to display one photograph for the entire year compared with the "twelve-hanger" format with a different photo for each month. Time also has a dollar value when you agree to limit the visibility of the photo—for instance, if you agree to an "exclusive" on a baby food package and do not let the photo appear anywhere else for three years.

When setting your price for a stock photograph there is one simple truth that should be kept in mind, and expressed to the client as a selling point. The truth is that there is no risk to the client in stock photography. Unlike assignment photography the buyer sees exactly what the finished result will be: no guesswork, no unmet expectations, no reshoots, no delays. This absence of risk through uncertainty should be capitalized on whenever the client is turning to stock after considering the assignment option.

This truth is a weight on the seller's side of the scale. The buyer should balance the scale with a payment for that peace of mind.

A Summary on Negotiating

Negotiating is a dignified and respectable method of reaching agreements. In photography, only part of the value of a photograph can be measured in hard numbers and assigned a dollar figure; negotiating is the only practical method of taking all the factors mentioned above and translating them into a fair market price—one that both buyer and seller are willing to accept.

There are as many styles of negotiating as there are people, but here are some common negotiating principles that apply to everyone in the stock photography business:

1. Accept the process of negotiating as a normal and essential part of a stock photo sale. Become as skilled at negotiating as you are at making photographs.
2. Prepare yourself by studying and understanding the basic principles and market factors that shape stock photo prices. Knowledge is the key to comfortable and businesslike negotiating.
3. Become familiar with the relationships of prices to such variables as size, circulation, and distribution, uniqueness, risk, and the like.
4. Learn the inner workings of different segments of the market (advertising, design studios, textbook publishers, etc.) in order to understand their motivations and needs. Find out how buying decisions are made
5. Remember that in a successful negotiation both buyer and seller are satisfied. That means accepting that both have the right to back away from a deal "this time." Leave the door open for future business
6. Be friendly and frank, positive and professional in your discussions.
7. Understand that the buyer sees the value of your photograph only in terms of how it will be used in the immediate project. Don't be insulted if an average price is offered for one of your favorite photos.
8. If a buyer is inexperienced, be willing and able to explain the market factors that

affect prices.

9. Ask questions until you are completely satisfied that you know exactly how the photo will be used and precisely what rights are needed.

10. Write down information during discussions to help organize your thoughts. Categorize and save this information—it can be an invaluable reference for similar sales in the future, particularly when dealing with the same client.

11. Try to get an idea of how much negotiating leeway you have. Search for indications of the buyer's budget range. Ask how much they've paid in the past for similar projects.

12. Have a clear picture of the price range paid for such work. If you are unsure when talking with a buyer, excuse yourself, find out, and phone back. This is an acceptable practice.

13. Be cautious about quoting an exact figure when negotiations enter the "money" stage. Quote your price and encourage a response. The buyer may be willing to pay more than your figure and it's almost impossible to raise a price once you've quoted low.

14. Take time to calculate your bottom line and never go below this figure. If you sell for less than you need, you are jeopardizing your own security. If the buyer can't meet your bottom price, amicably explain why you have to walk away from the sale. This buyer may have a different budget the next time.

15. If you get bogged down in agreeing on a price, don't give in to the urge to split the difference or accept the buyer's last offer. There are other things to try. You might ask for a tradeoff, such as tearsheets for promotional mailers. Or you might offer an inducement, such as an additional usage, so the buyer will get added value for your price.

Once the negotiating is done—don't forget the invoicing. Make sure all the rights you have agreed on are clearly specified in your delivery memo and invoice.

Negotiating Tips

Investigate

Who is the client?
What image(s) do they want?
When do they need it?
Where will the image be used?
How
 - will it be used?
 - big will it be displayed?
 - many copies will be made?
 - long will it be used?
 - exclusive are the rights?

Finally, how much is the budget?

Evaluate

What does that indicate about their purchasing ability (price range)?

Might this image command a higher price?

Do they have time to shop some more?

Is the audience local, national, or international, and how does that affect price?

How is the price influenced by

- advertising, brochure, editorial, or other usage?
- 1/4 page, billboard, or other size?
- circulation, distribution, and press run quantities?
- one-time, one-month, one-year usage?
- limitations on other sales?
- How much should you ask for in light of the above?

Now negotiate

1. Be aware of these traditional tactics:
 - The red herring: making an item seem important so that you can use it as a tradeoff later.
 - The tradeoff: giving up or giving more of something in order to get something you seek.
 - Limited authority: going to someone for authorization beyond your limits. This tactic allows you to reopen an almost closed negotiation.

2. Show empathy. Always understand the other person's point of view. Tell them that you do, then ask them to understand yours. Follow with some candid talk.
3. Use candor. Let them know you really want to make a deal and you know they do; you can then move on to a compromise.
4. Don't ignore any position; deal with everything that's offered. Failing to respond indicates either a lack of concern for your counterpart's point of view or a weakness in your position.
5. Disarm with a question. Ask the other party why they are making a certain demand. Make them explain it. Sometimes they can't, and this will show them they can bend a little.
6. Listen carefully. Every answer and statement contains information you need to offer a solution.
7. Develop options. This tactic is the key to successfully concluding negotiations. A good negotiator is option-oriented and proposes alternatives until the right combination is found.

Chapter 5

Rights and Value: In Traditional and Electronic Media

Scott Highton

Most professional photographers make their living by licensing specific usage rights for the images they create to their clients. This is the case whether they are dealing in assignment photography or stock (existing) images.

Photography, by its very nature, is easily copied, and, much like music, must be licensed for use, rather than sold as a commodity or a consumable product. Today, digital technologies make high-quality copying and publishing of photography as easy as pushing a button, and every copy, from the first to the 10 millionth, can remain of equal quality to the original.

Since photography is so easily reproduced, publication photographers charge their clients for usage based on the value that a client receives from the work. Licensing fees are different for almost every client, depending on their usage. Additionally, cost factors specific to the photographer who created the work are factored into pricing and valuation.

Photographers must maintain an orderly system for assigning value to their images, ensuring themselves a reasonable profit, while not creating unfair exposure to those securing the reproduction rights. The control of the right to reproduce an image is one of the fundamental rights granted by copyright law. That right was given to copyright owners so that they could profit from their work, and thus be motivated to create more work. The connection between reproduction rights and profitability has been recognized since the days of the very first laws governing such rights, which date back to the late fifteenth century in Venice.

Usage is usage. Greater usage of a photograph by a client means receiving greater value from that image, and the photographer should be compensated accordingly. A small usage by a client, such as for a limited print collateral piece, will command smaller usage fees than will a larger use or combination of rights licensed, such as those

for major print and electronic advertising campaigns.

In this chapter, we will explore the factors that help determine value of photography and how photographers can most effectively license rights to publish their work, both in print and electronic media.

For many years, the only way to reproduce or publish photography was through various paper and ink printing processes. Rights to reproduce images were generally licensed with clearly defined terms relating specifically to the printing industry. However, the increasing penetration of video, personal computers, and the Internet into traditional publishing markets has meant that most publishers are no longer exclusively print-based. The need for electronic reproduction licenses is expanding at an exponential pace.

With each year that passes, the term "electronic rights" covers an ever-widening collection of licensable rights. As increasing amounts of media content are delivered in electronic forms, the scope of the phrase "all electronic rights" becomes even more extensive than the overly broad phrase "all print rights." Just as print rights are licensed by specific usage (example: "one-time, non-exclusive, North American consumer weekly newsmagazine rights for XYZ Publication, circulation not to exceed 100,000 copies"), so should the licensing of electronic rights also be specified in such detail.

The term "electronic rights" often includes many, if not all, existing print rights, plus the rights for electronic media uses. These may include all electronic media in existence today, as well as those developed in the future.

For clarity, we will present the following definitions used by ASMP:

Media. Tangible means for distributing an image. Generally speaking, there are three types of media.

- Print: on paper or other tangible printed material
- Electronic: digital or analog data on optical or magnetic media
- Film: celluloid-based material

Application. A particular vehicle within a given medium (magazine, annual report, promotional brochure, encyclopedia, billboard, etc.)

Product. A capture or presentation means (videotape, paper, CD-ROM, Web site, etc.)

For photographers, print and electronic media offer broad opportunities for publication. However, these opportunities are quickly diminished if the reproduction rights are not carefully defined, controlled, and priced. Most photographers would not license "all print reproduction rights" to a client unless there was a very high fee. Print rights encompass magazines, books, encyclopedias, posters, brochures, and the like. In keeping with that logic, it is unwise to license electronic reproduction rights without similar limitations.

Electronic rights may cover many products, such as videotapes, video disks, CD-ROMs, online presentations, Web sites, broadcast television, cable TV, and more. To grant reproduction rights by using only the phrase "electronic rights" is to cut off the profit-making potential of your images. While an image licensed in print might normally be used in only one application, an electronic application using that same image

can be served up in many different forms. It is not uncommon for a successful Web or online product to end up as a CD-ROM and vice versa.

Reproduction Rights Rule #1: *Never license a broad scope of media rights unless you are receiving a compensation consistent with that scope.*

Value of Content

The value of visual content in the electronic market is similar to, if not greater than, its value in the print market. Audiences have come to expect more visual information in electronic media, so the demand is higher. ASMP maintains that the newer electronic markets follow directly from the traditional print market. They should be guided by terms and conditions similar to those previously recommended by ASMP, which have become widely accepted.

Although electronic and print markets frequently overlap, they should always be considered distinct and separate, especially when licensing rights or usage. Electronic media are not replacements for, but rather, extensions of traditional markets for photographs. Therefore, the additional demand for photography in electronic media effectively increases the overall value of photography.

Determination of the values for visual content depends on a variety of factors. However, two principles of business never change:

1. Compensation should reflect the value of the image.
2. Value is relative.

In the publication marketplace (whether print, electronic, or film), image value is based on specific factors. These are:

Competition. What level of competition exists? What is the availability of similar images from other sources? If images are unique and exclusive, they should command higher fees.

Novelty. Novel (new) images are those that have a new look and have not been seen by the market at large. Freshly produced images are more valuable. Innovation by style, technique, and artistry adds value.

Importance. The intended size, placement, and repeated use of an image in an application adds value. The relative volume of images also indicates importance. If a photograph is the sole image appearing in an application, it is usually more valuable than if it were only one of 100.

Distribution Volume. Circulation, press run, disks pressed, and online accesses all influence value. Generally, the greater the distribution, the greater the value.

Application Market. Each application has a market. Consumer, trade, institutional, not-for-profit, and corporate are all specific markets. Generally, the larger the market, the greater the value. The exceptions to this are in niche market applications, where great selectivity is exercised. Here, the importance of an image is even greater, since the goal of niche marketing is maximum impact on a small, select group. In short, every Web hit or contact can have high value, since that Web page has been specifically requested by the user. This is in contrast to the hundreds of pages that might be printed and delivered

in a magazine or book, but of which only a small handful might be looked at by a reader.

Term of Use. The longer an application is in use, the greater the value.

Risk Factors. Liability is a good example. Images used in applications requiring a release (advertising, promotion, trade, etc.) are riskier to publish than editorial images. Even the best releases are contestable and subject to interpretation. A given release may be inadequate if it prohibits image alterations or additions. This increases risk to photographers (for their clients' misuse of their images). Other risks may include the physical risk required to create the image in the first place, as well as the risk of the work being devalued by publication in certain media like clip art or royalty-free systems. Increased risk generally commands increased fees.

Obviously, assessing value combines a little bit of both science and art. One can numerically determine specific size, placement, number of copies, and similar statistics. Risk can be assessed to some degree based on the use and the terms of releases. However, the level of competition and the novelty of an image are unsure things. Assessing these for value is somewhat of an art. It requires that the photographer learn how a given user values the image. The difficulty here lies in the fact that experienced photo buyers are often reluctant to share this information.

Pricing and Compensation Structures

Electronic media are simply modern forms of publication that have evolved far beyond the scope of traditional print media. Pricing for usage in any publication, be it electronic, print, or otherwise, should reflect both past and future valuation. Rights granted should be on a "one-time" basis whenever possible, unless the fees earned are far higher than traditional base fees.

Visual content creators should be wary of entering into speculative arrangements that may yield little income in the event of poor sales, or that may result in the loss of control of their copyrights. When photographers accept the risk of a small return in the event of poor sales, they should also demand a significantly greater return if sales are more successful. If content creators share the risks, they should also share the rewards.

Compensation for visual content is usually based on the following structures or combinations thereof.

Flat fee. The photographer is paid a single, fixed amount for the use of his or her photograph(s). The broader the license or the more usage extended, the higher the fee will generally be. If the usage goes beyond the original license, additional fees must be paid. This is often the simplest arrangement for both photographer and buyer.

Example: An image is licensed for up to 1/4 page, one-time, non-exclusive use in a consumer weekly magazine, with a 3 million maximum circulation for a fee of $350.00. If the final usage is 1/2 page instead, the license fee might increase to $450 or $500.

Structured tier fee schedule. A schedule of fees agreed on between the photographer and client. The photographer's fee increases when distribution of the product reaches certain levels, such as the number of online accesses, the number of CDs pressed, or the number and size of each broadcast.

Example: A photograph is reproduced as the cover of a brochure, on a non-exclu-

sive basis, with printing rights extended to the client for one year.

Up to 20,000 copies—fee is $1,000 20,001 to 50,000 copies—$250 is added. 50,001 to 100,000 copies—$150 more is added.

In this case if the buyer prints 20,000 copies or less, the photographer is paid $1,000. If an additional print run of 30,000 is made (totaling 50,000), the photographer is paid an additional $250. If an additional press run is made after the one-year term of the license, the fee reverts to the starting point.

Percentage of sales fee. The photographer receives a percentage of a stipulated amount for every sale. This could be a fee based on the selling price of every disk, publication, or book, or it could be a stipulated amount for every download or access to an application. Frequently, this would be in addition to a base or guaranteed minimum for the usage. In this manner, the photographer can accept the risk of a small return if the product is not successful, yet share in the reward if the product succeeds.

Example: A photograph is reproduced as a 11"x14" framed print for a 12 percent royalty on net sales, before taxes and delivery fees. The art might sell in a retail outlet for $60 with the wholesale price at $30. At a 12 percent royalty, the photographer receives $3.60 per unit sold. The photographer might negotiate a $1,500 minimum guarantee, paid as an advance against the first 500 units sold. Additional $3.60 royalties would then be paid to the photographer for every unit after that.

Per unit (produced or sold) fee. The photographer's fee is based on a fixed payment per unit produced or sold (units produced is the preferred method).

Example: A photograph is reproduced as a full-screen image in a CD-ROM disk for a fee of $.03 per disk pressed, with license extended for the copyright life of the product.

In this scenario, each image would be valued at three cents per disk. If the volume of disks initially pressed is 10,000, the fee is $300. As more disks are pressed, the total fee increases. Generally, in such an approach, the fee per unit decreases in steps as the volume increases. In such a case, the payment at the 50,000-unit level might be reduced to one cent per disk.

Pricing Examples

When it comes time to extract the value of images in an actual transaction, all the foregoing theory must be applied in short order. To do that, photographers have traditionally taken different approaches, depending on whether the images licensed are generated on assignment or are selected from an existing library (stock).

Assignment pricing is often complex, and the basis of pricing varies. Advertising, editorial, corporate, and architectural photography each have their own pricing peculiarities. However, licensing of stock photography has been more standardized over the years and can more readily be used to demonstrate pricing systems, taking value factors into account.

In an effort to illustrate the use of value factors, and to show a specific licensing method, we have received permission from the Media Photographers' Copyright Agency (MP©A) to publish some of its fee structures and value factors. The figures

presented here were established in 1995 and are adjusted for inflation to the year 2000. The MP©A pricing system is based on certain criteria:

- Mastering fee: payment for the right to make a master copy, from which all other copies are made. This master could be, among other forms, a printing plate, a digital file in a computer, or a film negative for a motion picture. Regardless of the media or means by which it is captured, the master is the first copy from which all copies to be distributed are made.

MP©A Category 1: Brochures, Flyers, Promo Cards, Etc.

Mastering Fee: $110 per image, plus:

License Fee = Mastering Fee + Sum of DistributionAdditives

Per Unit DistributionFees (1/4 page or less):

Volume	X	Multiplier	=	Additive Distribution Fee	Total License Fee
5,000(minimum)		$.023		$115.	$225.
Next 15,000(20k total)		.0067 ea.		101.	326.
Next 30,000(50k total)		.0034 ea.		102.	428.
Next 50,000(100k total)		.0011 ea.		55.	483.
Next 150,000(250k total)		.00056 ea.		84.	567.
Next 250,000(500k total)		.00022 ea.		55.	622.
Next 500,000(1 mil. total)		.00017 ea.		85.	707.
Next 2,000,000(3 mil. total)		.00009 ea.		180.	887.
Over 3,000,000		.00005 ea.		$50./million	–

Example:
(100,000 copies) = $110 (mastering fee) $1 +15 + $101 + $102 + $55 (distribution additives)
Total license fee = $483

MP©A Category 2: Textbooks, Encyclopedias, Trade Books, Picture Books

Mastering Fee: $110 per image, plus:

License Fee = Mastering Fee + Sum of Distribution Additives

Per Unit Distribution Fees (1/4 page or less):

Volume	X	Multiplier	=	Additive Distribution Fee	Total License Fee
10,000(minimum)		$.0056 ea.		$56.	$166.
Next 10,000 (20k total)		.0045 ea.		45.	211.
Next 20,000 (40k total)		.0034 ea.		68.	279.
Next 20,000 (60k total)		.0022 ea.		44.	323.
Over 60,000		.0011 ea.		11./ten thousand	–

Example:
(80,000 copies) = $110 (mastering fee) + $56 + $45 (distribution additives)
Total license fee = $211

- Distribution fee: payment for the total number of copies made, published, viewed, and so on.
- Multiples: factors that are used to adjust the price for value-added attributes, such as size, novelty, multiple reproductions, and the like.

The following are examples of the MP©A (inflation adjusted) price list for brochures, educational books, and editorial use. An example of how the lists are used follows each listing.

MP©A Category 3: Editorial Magazines, Newspapers, Newsletters, Etc.

Mastering Fees:

Type	Monthly	Weekly	Daily
Consumer Print	$56.	$34.	$22.
Trade Print	$45.	$22.	$11.
Corporate Print	$45.		
Institutional Print	$34.		
Micro Published Print	$11.		
Electronic (ALL)	$34.		

Distribution Fee (based on circulation, on-line accesses, units pressed, etc.):

Volume	x	Multiplier	=	Distribution Fee	Total License Fee
100		$.112		$11.	$ 11. + mastering fee
1,000		.022		22.	22. + mastering fee
5,000		.011		55.	55. + mastering fee
10,000		.0067		67.	67. + mastering fee
25,000		.0034		85.	85. + mastering fee
50,000		.0022		110.	110. + mastering fee
100,000		.0014		140.	140. + mastering fee
250,000		.0006		150.	150. + mastering fee
500,000		.00034		170.	170. + mastering fee
1,000,000		.00019		190.	190. + mastering fee
2,000,000		.00010		200.	200. + mastering fee
3,000,000		.00008		240.	240. + mastering fee
4,000,000		.000062		248.	248. + mastering fee
5,000,000		.000052		260.	260. + mastering fee
6,000,000		.000045		270.	270. + mastering fee
Over 6,000,000		.000023		Add $23. per million	–

Example: (50,000 copies, electronic)

License Fee = Mastering Fee + Distribution Fee
= $34 (Mastering fee) + $110

License fee = $144

Other Factors in MP©A Fee Structure:

License Duration Default:

The default license duration is twelve months after the date of the initial license.

Multiple Reproductions in the Same Application (Print or Electronic):

1st Time:	Original fee
2nd Time:	Additional 75 percent of original fee
3rd Time:	Additional 65 percent of original fee
4th Time:	Additional 50 percent of original fee

Printed Size	Placement:
1/4 Page:	Base fee
1/2 Page:	125 percent of base fee
3/4 Page:	150 percent of base fee
Full Page:	175 percent of base fee
Double Page:	225 percent of base fee
Cover:	300 percent of base fee

Screen (electronic) Placement:	
Regular Use:	Base amount
Section Head Use:	175 percent of base amount
Title Use:	250 percent of base amount

A New Alternative: Day Rate Against Usage

There are a variety of pricing models available, all of which have their own advantages and flaws. An ideal system has long been described as one in which the same values for usage can be applied to both assignment and stock photography.

One relatively new model that does this is based on the concept that "usage is usage is usage," and a fee for a particular usage should remain constant for a photographer's work, whether licensed through assignment or stock. For stock licensing, the usage fee alone would be the primary billable amount (research and other stock fees notwithstanding). For assignment work, the photographer's creative fee or day rate would be applied as a minimum against the fees billed for usage.

This is similar to the traditional editorial magazine model of a day rate minimum applied against a published space rate. The photographer is guaranteed a minimum day rate for an assignment, but if the number and size (space) of photos published, combined with the magazine's rate applied to space, are greater than the day rate total, the photographer gets paid the space rate.

The Day Rate Against Usage model applies this principle to *all* licensing of photography, not just editorial use, and applies to both assignment work and stock sales. If the photographer's creative fee or day rate for an assignment is greater than the combined usage fees, then the creative fee or day rate total is used as a minimum. If the value of the usage exceeds these, then the photographer bills for the larger usage amount.

For example, a photographer might charge $1,500/day (plus expenses) for a three-day corporate shoot, totaling $4,500. If the client only used a few of the resulting images for a small collateral piece, the usage fees might only add up to $2,800. In this case, the $4,500 day rate figure would be applied against the $2,800 usage total, and the photographer would bill the client $4,500 (plus expenses).

However, if the client wanted the images for trade show displays, corporate identity campaigns, and multimedia uses (on a Web site or CD-ROM), the usage fees might easily total $20,000 or more. In this case, the usage total would exceed the day rate or creative fee minimum, and the photographer would bill the client for the usage amount. Obviously, all this needs to be agreed to with a written Assignment Confirmation or contract prior to the photographer ever starting the assignment.

Again, the advantage of this system is that the different licensing fees a photographer sets for each type of usage can be applied identically to both assignment work and stock sales.

Among the first steps in this process are calculation of fair fees for each kind of usage that the photographer might license—and determination of a discount structure for clients desiring more than a single usage. While some photographers may not feel it appropriate to discount usage fees for volume, the more common practice in the industry seems to be that photographers do offer volume licensing discounts.

There are a number of commercial pricing references to consult as a starting point for determining your own usage fees. You can also talk with other photographers to help determine fees based on your particular types of photography and business needs. Once you've established a set of base figures, you can calculate all other fees and adjustments when usage varies, such as when clients change reproduction size, distribution, duration, and quantity of photos licensed.

For most of these variables, a simple square root or inverse square relationship can be used to calculate relative prices. (Note that these are calculations most photographers are already familiar with through exposure and lighting relationships.)

Example: A base rate for a particular usage might be $200 for a 1/4-page reproduction. Doubling the size to 1/2 page would increase the fee by the square root of two (1.414), totaling $283. Quadrupling the size to a full page would increase the fee by the square root of four (= 2) to $400. Halving the size to 1/8 page from the original 1/4 page would reduce the fee by the square root of .5 (= .71) to $141. A minimum fee, such as $125, could also be specified, as well.

		(Base)							
Reprod. Size:	1/16 p.	1/8 p.	**1/4 p.**	1/3 p.	1/2 p.	2/3 p.	3/4 p.	1p.	2p.
Fee:	$100	$141	**$200**	$231	$283	$326	$346	$400	$566

This can also be applied to changes in the license term or duration.

Example: a photographer might set a base fee for corporate Web use of a 1/2-screen photograph at $1,000 for three months. Doubling that term of use to six months would multiply the fee by 1.414 (the square root of 2) to $1,414. A one-year license would cost

$2,000 (the base term is multiplied by the square root of 4 [which is 2] so the price doubles).

		(Base)							
Term:	1 mo.	2 mos.	**3 mos.**	4 mos.	6 mos.	9 mos.	1 yr.	1.5 yrs.	2 yrs,
Fee:	$577	$816	**$1,000**	$1,155	$1,414	1,732	$2,000	$2,449	$2,828

Note that usage specifications can be changed in combination as well. For instance, if you were to double the term (duration) of use, as well as the reproduction size and the number of languages licensed, you would be effectively multiplying the usage by a factor of eight. The fee would therefore increase by the square root of eight, or 2.83.

One of the great advantages of this system is that you can set your base fees using any usage combination that you want, and precise usage needed by your clients will be calculated consistently. Each photographer would set his own base fees depending on his particular business structure, experience, and market demand for his work. The relationships between increasing and decreasing usage factors would remain completely consistent and predictable—which is of benefit to both photographers *and* their clients.

Such a system means that photographers would no longer give the impression that they simply pull numbers out of a hat when quoting usage fees. Gone would be the days of looking through reference tables for ranges of fees and then arbitrarily quoting a number that "feels comfortable" to a client. This system provides mathematical logic to usage fees, and allows for precision pricing, even down to an exact number of copies distributed, if so desired.

With this system, circulation or distribution changes are calculated differently than the previous usage factors, since large adjustments in circulation don't affect usage fees as much as similar changes elsewhere in usage. A slightly modified formula—the square root of the square root (fourth root) of the circulation difference—would appear to more accurately reflect today's usage-fee-to-circulation ratios.

Example: A photographer sets her base fee at $500 for 10,000 copies of a photo reproduced 1/4 page in a corporate brochure or magazine. Doubling the circulation to 20,000 would multiply the usage fee by a factor of 1.19 (the fourth root of 2) to $595. If the circulation were increased by a factor of 16 to 160,000, the usage fee would be doubled to $1,000.

				(Base)					
Circulation:	1,000	2,500	5,000	**10,000**	20,000	50,000	100K	160K	250K
Fee:	$281	$354	$420	**$500**	$595	$748	$889	$1,000	$1,118

Finally, this system allows for consistent discounting of license fees for multiple photographs and/or for multiple types of usage. Multiple photos and uses involve an inverse square (1 divided by the square root) relationship between the number of images and/or uses, and the adjusted fees calculated for each.

As an example, consider a client wanting to license multiple photographs. The first image would be licensed at the photographer's full fee for that usage. The second photograph would be charged at 71 percent of its calculated fee (1/square root of 2 = .71). The third image would be charged at 58 percent, and the fourth would be at 50 percent,

and so on. This same relationship would also be used when more than one usage was desired.

Example: A calculated usage fee is $500 for one image. The total fee for five images used at the same size, distribution, etc., would be $1,617, resulting from the sum of the discounted fees below:

Image # (or usage):	1/Sqrt(x)	Disc. Fee		Total fee
1 ($500 fee)	100 %	$500	=	$500
2 "	70.7 %	+ $354	=	$854
3 "	57.7 %	+ $289	=	$1,143
4 "	50.0 %	+ $250	=	$1,393
5 "	44.7 %	+ $224	=	$1,617
6 "	40.8 %	+ $204	=	$1,821
7 "	37.8 %	+ $189	=	$2,010
8 "	35.4 %	+ $177	=	$2,187
9 "	33.3 %	+ $167	=	$2,354

Note again that some photographers do not feel it is appropriate to discount fees for multiple uses or images, and would simply charge first image and/or usage fees for each. In the above example, this photographer would multiply the single image usage fee ($500) by the number of images (5) to total $2,500, rather than the volume discount shown above of $1,617.

Copyright Title Transfers

Copyright is an intangible asset, yet as an asset, it can be leased or sold. All of the previous examples presented here are based on the photographer retaining copyright ownership of her work and licensing the use. There are, however, cases where photographers are asked to transfer the ownership of copyright. In such cases, determining the complete value of the image(s) and copyright are of primary importance. In such cases, the photographer should note the following:

- The buyer is placing great importance on the image, since she wants the copyright.
- The image will never produce additional revenue for the photographer from this or any other client, and that revenue loss is value for which he should be compensated.

There are two common arrangements for structuring photographers' fees when copyright title transfers are involved.

Assignment of copyright ownership. Generally, an undesirable arrangement for photographers and other content creators, since it involves a complete transfer of image ownership to the buyer. The creator will lose control over the quality and use of the work, and will be unable to make any future income from royalties, residual sales, resale, or stock licensing of the material. It is also possible for photographers to dis-

cover that they are competing directly with their own work, if the client sells the images to a stock agency or decides to market the images as stock herself. There may be occasions when assignment of copyright is necessary, but, generally, the needs of most clients can be satisfied through broad usage terms and written guarantees by the photographer not to resell the material to competing clients. In the rare event that a copyright assignment is truly necessary, the photographer should negotiate an appropriate fee to compensate for all future income that she will be unable to earn from the material.

Example: A photographer whose fee for a specific package of limited rights is normally $1,500 per day, might have a quadrupled or quintupled fee of $6,000 or $10,000 per day for copyright assignment.

Work-for-hire. ASMP is opposed to work-for-hire arrangements for all independent contractors. Under a work-for-hire, the photographer not only loses the copyright to the work from the moment he creates it, but he also loses all rights to authorship. This includes loss of the right to be identified as the author of his own work. Additionally, photographers cannot recapture their copyright after thirty-five years, a right they retain when they transfer or assign it, as described above. In any situation where ownership of the copyright is absolutely required by the buyer, photographers should arrange a transfer or assignment of copyright, at a rate that fairly compensates them for the entire value they are giving up, rather than doing a work-for-hire.

Reproduction Rights Rule #2: ASMP urges all photographers to carefully consider the long-term value of copyright before agreeing to transfer ownership of that copyright to another party.

Copyright Protection

Digital and electronic technologies have made it far easier than ever before to copy photographic images. High-quality scanning, image capture, and digital reproduction devices, available at relatively low cost, have resulted in a greater risk of image appropriation and theft for the owners of copyrighted material. ASMP supports the protection of electronically distributed images through the use of watermarks, encryption, pixel-embedded copyright notices, and other effective protection schemes. These techniques should be used on all sizes of electronic files, since even the smallest files can be easily interpolated on personal computer systems to yield reproduction-quality images.

Physically protecting a photograph from unauthorized reproduction is a task separate from copyright protection. The majority of unauthorized reproductions are "innocent infringements"—usually the result of some confusion at the client level over what usage was licensed from the photographer or content provider. For this reason, photographers should request that clients destroy (or return to the photographer) all scans, separations, film, or digital files made from the original after completion of the production process or license term.

It is also important for photographers to actually register their copyrights with the U.S. Copyright Office. Copyright protection in the United States is automatic from the

moment an image is fixed in a tangible form (such as on film or in digital media). However, when violations occur requiring legal action, attorney fees and punitive damages (up to $150,000 per violation) can only be collected in court for images previously registered with the Copyright Office. Nonregistered images are still protected by copyright, but only actual value of the usage can be pursued in court.

The process of registering copyrights is fairly straightforward, and can be done for both unpublished and published images. Copyright registration is viewed by many as a reasonably cheap form of insurance for all content creators and authors. For details, contact the U.S. Copyright Office at [*http://lcweb.loc.gov/copyright/*].

Multimedia

Electronic publication, particularly of multimedia titles, represents a merging of two major industries—traditional print publishing and motion picture/television production. For decades, both industries have relied primarily on independent contractors and content providers. For the print industry, this includes writers, photographers, illustrators, and editors, while the film/TV industry adds actors, producers, directors, musicians, voiceover talent, set designers, crew, and countless others to the mix. The two industries, however, have evolved separately in their approach to acquiring content.

The traditional publishing field primarily regards content from outside (non-employee) sources as material licensed for specific use. This is how most independent still photographers have structured their businesses as well. Photography or writing done on assignment for a client is owned by the author and licensed for limited use to that client. U.S. copyright law has also focused primarily on protecting the rights of authors over the years.

The film/TV industry, however, is far more complex. The simplest documentary film can rarely be done by a single individual: At a minimum, films require a camera person, an audio technician, and an off-camera interviewer or producer. Most of these productions draw on the talents of many people, and, thus, are considered collective works. Through necessity, production companies usually hire their contractors, including photographers and cinematographers, under work-for-hire arrangements. Contribution to a collective work, as well as contribution to a motion picture or audiovisual work, are categories enumerated in the Copyright Act as qualifying for a work-for-hire—primarily due to the efforts of the film/TV industry.

Multimedia has brought a merger of these two industries, along with a conflict between them regarding rights. This has resulted in two different models for the acquisition and development of content for multimedia—the book publishing model and the film/TV model. Multimedia producers coming from the traditional print industry generally adopt the book publishing model, and are willing to license specific and limited use or consider royalty payments to photographers and other content providers working on assignment. Producers coming from the film and television side tend to use the film/TV model, wanting both to pay a flat fee for the assignment and to own all rights to the material created under a work-for-hire.

Both models have advantages, although few of those advantages favor photographers

and authors under the film/TV model. Content, particularly the ownership of that content, is a primary key in the expanding electronic market place. Large media conglomerates have repeatedly and publicly stressed the importance of content ownership to their stockholders as the industry has expanded so dramatically in recent years. ASMP once again urges all photographers to carefully consider the long-term value of copyright before agreeing to transfer ownership of their copyrights to another party.

Moral Rights

Moral rights, which are different from copyrights, give creators the right to control attribution (credit) and the integrity (alteration) of their work. Moral rights protect not only the integrity, but the paternity of the original work of an artist. These rights provide a level of sanctity to artists' original creations. Unfortunately, in the United States, there are currently no moral rights attached to images made for publication. Only fine art works, created for exhibition, and yielding 200 or fewer copies, are eligible to receive moral rights protection in this country.

Generally, the way to enforce your moral rights in the United States is through contracts governing the license of your work to your clients. There are two contractual terms that provide for this—photo credits and alteration limitations.

Photo credits. These are a key part of the compensation photographers receive for any display of their work. The inclusion of a photographer's credit and/or copyright notice in electronic media is as simple and basic as it is in print. The aesthetic values are similar as well. For visual creators, credit lines accompanying published images provide name recognition. They are a key element of one's professional reputation. Readily visible copyright notices also serve to remind the viewing audience that the images are protected under copyright law. Many of the standards for photo credits in print apply to their use in electronic media. The ease with which digital files can be copied makes the issue of photo credits more important than ever for both types of media. Placement of credits and copyright notices should always be a key element in any licensing or usage negotiation.

It doesn't do a photographer any good to have her work seen by millions of people if those people can't identify the work as having been created by that photographer. Readily visible credits and copyright notices make the difference. Proper attribution of the authorship of photography also further ensures the protection of images in the many countries outside the United States that have a greater concern and more strict laws governing moral rights.

Example: Many photographers require that their fees be tripled when their photos are reproduced without proper credits. It is important to stipulate this up front in written contractual terms, however.

Alteration. A photographer might wish to allow a client to alter her work where such alteration is customary, such as in advertising use, or to restrict alterations where they are taboo, such as in news reporting. Regardless of whether or not you will allow alteration of your work, *always insist on indemnification by the client* if the work under-

goes any alteration. Appropriate contractual language for dealing with credit and alteration can be found in chapter 6, "Formalizing Agreements."

Ethics

While there are countless new concerns that have arisen with the advent of electronic and digital technologies, many of these are identical to those that photographers and other creators have faced for years. The digital tools and electronic delivery systems available today simply provide better tools and more opportunities, both for photographers and those who wish to utilize our work. These tools also make it easier to alter and manipulate photographic images without any visual evidence that changes have been made, which can cause great damage when used for the wrong purposes.

ASMP is opposed to any alteration of the content or meaning of a news photograph. ASMP is also opposed to the undisclosed manipulation of the content of photographs presented as fact in editorial and documentary coverage, or in any other forum where photographs imply truth and fact. We urge all photographers and publishers to exercise caution when considering any alteration of photographic content.

Conclusion

With the continuing advancement of digital and electronic technologies, photographers have entered a whole new realm of usage rights. No longer are volume distribution and reproduction of photographic images limited to traditional print publishers. Electronic media, with their immediate and immense distribution capabilities, are already dwarfing those of traditional print media, and are expected to dominate the market for visual content in the years ahead.

Photographers are visual communicators, content providers, and copyright owners, and we have the responsibility to understand these technologies and to serve our clients' changing needs. We must fully comprehend the converging electronic and print markets before we can adequately license our work for publication with complete fairness to both ourselves and our clients.

Talk with your clients. Talk with each other. Learn together. It's a world of opportunity for everyone.

All prices and other data in this chapter are included for purposes of example and information, only. They should not be considered to be representative of any survey, nor should they be construed to be recommended or endorsed by ASMP, its members, or the author.

Formalizing Agreements

Victor S. Perlman, Esq., and Richard Weisgra

Every business day photographers have a need to communicate transactional information to their prospects and clients. It might be the information in an estimate, the agreement expressed in a confirmation, or the verification of a delivery of photographs. Regardless of the nature of the communication, records of your communications are important, especially when they set the terms, conditions, price, and license to use your work.

There are two types of communication: oral and written. Many of our communications are oral. No one could take the time in business to write everything down. However, some things are important enough to require a written record. Certainly, any communication defining the fees for, and licensing of, your work should be in writing.

Photographers need a written record of their dealing with services, licenses, compensation, delivery, and value. Estimates, confirmations, invoices, delivery agreements, and copyright licenses should be simple and straightforward and embody the terms under which you conduct your business.

These agreements are often expressed through the use of forms, an easy means of communication that requires less time than other written means. However, some photographers prefer to use friendlier formats like letters, while others turn to more formally drawn contracts. Regardless of which you choose, the important point is to use, and to keep a copy of, some form of written communication when you carry out your transactional dealings.

Timely communication is very important. You should begin to communicate the transactional details of an assignment, whether proposed or awarded, immediately after your first contact with the prospective client. Too many photographers rely on their invoice to set the terms of their agreements. The danger of expressing your terms on the invoice is that it arrives after the work is done. If it contains any surprises in its content, which were not discussed prior to the work being done, it will be contestable, and

could be considered an attempt to impose a contract after the fact. In such a case, some or all of the invoice's terms would not be binding on the client.

Keep in mind that you always want to present your terms, fees, etc., before the work is started. If a client has full access to your terms and other details prior to the work being started, and allows you to start and complete the work, it will be difficult for the client to protest. When a client is fully informed and proceeds with the work, it implies that a contract was in force, and that the conduct of the client (in allowing the work to proceed) amounts to a consent to your previously presented stipulations, terms, conditions, fees, and so on.

A contract is formed between parties when certain conditions exist. There must be an offer, an acceptance, and consideration. An estimate is an offer to perform work with certain stipulations. An acceptance could be a purchase order matching the estimate, a letter awarding you the work, a client-signed confirmation, or an oral OK on the telephone. It is this oral acceptance that can present a problem, if denied later. This is where consent by conduct, allowing you to do the work, can be a factor. Remember: Unless your stipulations were in the client's hands before the consent by conduct, you might not be able to enforce your stipulations. Do your paperwork in a timely fashion.

You should be aware that having the correct forms and releases is no guarantee that you will not be involved in a legal dispute. The purpose of correct paperwork is to avoid misunderstandings, to lessen the possibility of legal disputes, and to protect you and strengthen your position if they do happen.

Letter Agreements

Form letters, easily prepared and stored in your computer, are a softer way to present your paperwork. They have the advantage of appearing more personal and less aggressive than forms. The same stipulations made on form agreements can be made in form letters. However, one should exercise care not to cushion the language of the letter to the degree that the enforceability of the document comes into question. To avoid this, a transactional form letter should be specific and to the point, and not use any camouflage, or ambiguous wording. Hidden terms and ambiguity are frowned on by arbitrators and judges alike, not to mention everyday business people who want to be up front about the details of their deals.

While we had considered including a sample letter agreement in this publication, we ultimately decided not to do so. Any letter agreement that would be continually paraphrased would soon begin to take on the look and feel of a form agreement. We suggest that photographers who wish to use letters to frame their agreements do so in their own style. Then have the end result reviewed by your attorney. Additionally, in an age of computer and facsimile delivery of documentation and more and more faceless transactions, the efficiency of a form is more acceptable than ever.

Forms

For many years photographers have relied on forms to present their estimates, confirmations, invoices, delivery agreements, and other business communications. Forms

have the benefit of being quick and simple to complete. Generally, however, they have one disadvantage. They are seemingly set in stone, carry inapplicable terms and conditions, and often call for more information than one needs to present to the client. However, with the advent of the computer, it is possible to create form agreements that have only those elements that we need to convey for the specific work.

Let's take a look at some of the forms a photographer might use in his business and what purpose they serve.

The Estimate

An estimate is used to communicate the projected cost of the work to a prospective client. Additionally, it should embody other important details. An estimate is a description of the work to be done, the media usage allowed for the stated fee, and the terms and conditions that govern the transaction, performance, payment, etc.

The estimate should be sent to the client prior to starting any work. Even in cases where an estimate is provided on the telephone, you should alert your client that you are sending a written estimate confirming the telephone estimate. Send the estimate so it arrives in a timely fashion—in time for your client to review it before the work starts—and you should obtain proof of delivery. A fax machine or fax modem is an indispensable device for this purpose.

The Confirmation

After your estimate is received, negotiated, and approved, including an oral acceptance over the telephone, you should confirm the final details of the transaction. This may be done by having the client sign a copy of the estimate and return a copy to you. Or, it may be done by sending a separate confirmation to the client that embodies the details of the transaction. It may be the same form as your estimate but with a different heading, or a letter referring to the estimate and stating that the work will proceed under the details as embodied therein, and with a copy attached.

Again, the confirmation should be sent to the client prior to the start of the work, if it is to have maximum force in any dispute that might arise. Work that is properly estimated and confirmed prior to the start of work is the least likely to be contested later. The properly executed confirmation, more than any other document, is an "ounce of prevention."

The Invoice

Everyone wants to get paid, and the invoice is the classic means of presenting your request for payment for services rendered. Invoices usually end up in accounts receivable departments of companies, and, therefore, are not in files pertaining to assignments. This is another reason why the invoice is not the best place to present your terms and conditions, and licensing of rights. There is no point in having them reside only in the accounting department's files. You need these terms in the project work file in the

office of the assigning party.

Still, you should restate any stipulations on your estimate or confirmation on the invoice, or include a copy of the prior document. This emphasizes the details, and reinforces your position.

The following is a checklist of items that should be included on assignment, portfolio, and stock delivery memos

Assignment Delivery Memo

Heading: Date, Job #, P.O. #, A.D., Client, and so on

Description of contents enclosed: Number, format, color or B&W, prints or transparencies

Terms and conditions of use: (same language as Estimate, Assignment Agreement/Confirmation)

Requirements (Suggested language):

Return unselected film by (date)

Return published film by (date)

If contents are proofs

For review only

Make selection based on composition and expression

Final image will be full frame unless specific crop or proportion are indicated

Notes:

Please review the attached schedule of images

Count will be considered accurate and quality deemed satisfactory for reproduction if exceptions have not been reported within 24 hours.

Your acceptance of this delivery constitutes your acceptance of all terms whether signed by you or not

Acceptance signature and date:

Portfolio Delivery Memo

Headings

Description of contents enclosed

$ Value of contents and case

Requirements (Suggested language):

For review only

No reproduction rights granted

Images may/may not be copied for file reference only

Portfolio to be returned by (date)

Notes:

Acceptance signature and date:

Stock Delivery Memo

Headings

Terms and conditions of use (either for review or specific license.)

Description of images: Quantity, original, duplicate, format, ID number, value

Total: Count, $ value

Notes:

Acceptance signature and date:

The Delivery Memo

Never deliver your photography without a proof of delivery, and a memo presenting the terms of that delivery. Your work, whether assignment or stock photography, has value. That value should be protected for both your clients' and your interest. The delivery memo is similar in effect to a contract for a rental. It confirms that a prospective client has received something of value, and asserts the obligations of the recipient to return it or pay for it. What could be simpler and more reasonable?

When you ship assignment work, you should include an assignment delivery memo. It is like a packing slip, detailing the contents of the shipment, and the information needed for the client to match the shipment of work to its specific project. When you ship stock photography, the delivery memo serves to quantify and value the work, and the terms under which it is delivered to and may be retained by the recipient.

A properly executed stock photography delivery memo is not guaranteed to have the force of a contract. Some courts have held that the delivery memo, when preceded by a telephone conversation in which the terms and conditions of delivery could have been discussed, is a contract after the fact. Indeed, many a recipient is astonished to find out that the transparencies that they have received are worth a small fortune.

The enforceability of a stock photography delivery memo is not guaranteed. Specific facts of a given situation will determine if the document has a binding effect on the recipient. Nonetheless, one should never fail to send a delivery memo. It is better than sending nothing at all.

The Predelivery Confirmation

Some stock photographers, in an effort to protect their work, have begun to use a predelivery confirmation. This form presents the stipulations that must be agreed to before you will send the work. Generally, it is faxed to the prospect, who must sign and return it before the photographer releases the shipment of photographs for delivery. When signed by a duly authorized party, it should have a binding effect. When your work has recognized value it would seem quite advisable to use one of these forms.

The Form's Face

It is generally accepted that the face of a form has more weight than the reverse side, as does large print over small print. It is important, therefore, to have certain information on the face of the form. This information includes the job description, grant of media usage, price (fees and expenses), and payment terms and conditions. Remember that the estimate and confirmation are the most important paperwork you can have to protect your interest, and this information should be clearly stated thereon.

One very good element to employ on your paperwork is a condition precedent

regarding payment. A condition precedent is a stipulation that conditions the sale in such a way as to have a binding effect if the purchaser accepts your proposal.

Here is an example:

On the front of the estimate, confirmation, and invoice, near the statement of price, your paperwork might carry this legend.

Media Usage RIGHTS GRANTED, as defined herein, are granted conditionally upon receipt of full payment of price indicated herein. Failure to make payment voids any media usage granted, and constitutes copyright infringement.

Licensing Considerations

When writing a license or defining use, you should be as specific as possible. Various licensing considerations are presented below to assist you.

Copyright Rights—(your authority to license rights)

Copyright owners have the right to control the following uses of their works:

1. Reproduction—making copies by any means
2. Derivation—making new work(s) based on yours
3. Distribution—publication of your work (distribution to the public)
4. Performance—showing your work (by mechanical means)
5. Public Display—exhibition of your work

Examples of Copyright Rights

Reproduction	Derivation	Distribution	Performance
Display	Photocopying	Art reference	Electronic
Slide show	Exhibit	Scanning	Art rendering
Print	Compositing		

Types of Media and Application

Print	Electronic	Film	Posters
Television	Motion pictures	Brochures	Videotape
Film strip	Billboards	Laser disk	Audiovisual show
Bound pages	CD-ROM	Slide show	CD-Interactive
Magazines *	Books *	Product packaging	

* Note: Books and magazines could be print (bound pages), electronic (CD-ROM or CD-Interactive) or via electronic bulletin board services.

Factors a license should include:

1. Copyright rights involved
2. Media use
3. Specific application
4. Geographic limits
5. Quantity limits (press run/circulation)
6. Time limits on rights

7. Size and placement of work.

For a checklist of additional considerations see the following page.

Example: *Images to be reproduced and distributed in print version of Hooplah Magazine, one time only, between January and March, 2001. Circulation not to exceed 1 million copies in North America only. Images to be used inside magazine and up to 1/4 of a page per image.*

Checklist of considerations for licensing use of images:

I. Grant of Rights

 1. term

 a. period of years

 b. life of product

 c. copyright life of product

 2. extension

 a. versions

 b. additional pressings

 c. revisions

 3. exclusivity

 a. non-exclusive

 b. limited exclusivity

 c. full exclusivity

 4. territory

 a. limited

 b. unlimited

 5. restrictions

 a. mechanical (to press disks)

 b. on-screen only

 c. print with the product

 d. advertising/promotion of product

 e. public display

 f. broadcast

 g. derivative

 h. alteration

 i. file storage size per image

 j. transmission

 k. printout from disk or screen

II. Define Application

 1. type (disk, online, cable TV, etc.)

 2. title(s)

 3. quantity

 4. labeling

 5. encryption

 6. protection of images

III. Compensation

 1. flat fee

 2. fee stepped to quantity

> 3. advance plus royalty
>
> 4. advance against royalty
>
> 5. royalty

IV. Conditions

> 1. warrantees
>
> 2. obligations
>
> 3. remedies
>
> 4. status of provider digital files

V. Miscellaneous

> 1. designation of agent
>
> 2. settling disputes
>
> 3. audit rights
>
> 4. definitions

Specifying Usage

The following are examples of common usage situations for which you would construct a license to grant rights. Always keep in mind, however, that each situation is unique. In book usage, for example, such factors as chapter openers, frontispiece, hard- or soft-cover, and book club editions could be part of a license.

A license of rights for such uses as audiovisual, wall murals, postcards, posters, greeting cards, and art decor should specify the limitations on size, number, time, location, and any other factor relating to the particular use to avoid questions or disputes that might otherwise arise later.

New uses for photography arise daily, but the following samples should help you in constructing licenses for your own business. Do it well so that both the seller's and the buyer's rights are understood.

Advertising Rights Granted

One-time, non-exclusive usage by (client) as (1/4, 1/2, full-page, or spread) image for (consumer or trade) ad, limited to (number) insertions for (national or regional) circulation in (color or B&W), as (define media and application types) for (number of months, years, or unlimited). Subject photograph is of (description) and is copyrighted by (photographer). All rights are reserved except those noted on this invoice.

Annual Report or Brochure Rights Granted

One-time, non-exclusive usage by (client) in (title of annual report or brochure), limited to a print run of (number) as (cover or inside), used no larger than (page, spread, or wraparound) in (color or B&W). Subject photograph is of (description) and is copyrighted by (photographer). All rights are reserved except those noted on this invoice.

Magazine Rights Granted

One-time, non-exclusive (e.g., English, French) language rights for editorial usage in (name of magazine), with a printed circulation of (number), for (month or edition

and year) for distribution in (country or region), to be published only as (cover or inside, portion of page, number of pages). Subject photograph is of (description) and is copyrighted by (photographer). No rights granted for advertising or promotion of cover or inside pages. All rights are reserved except those noted on this invoice.

(Note: Define whether the media is print, electronic, or both.)

Terms and Conditions

Another important part of your form agreements, after the specific details of the work, price, and rights, will be the terms and conditions that you use to govern the transaction. There are many possible combinations of these elements, depending on the nature of the work. This text has been prepared so that you can customize your terms and conditions depending on your own needs in general or specifically. That is, you can use this information to customize standard forms or to construct forms made to order for each use.

Conditions on the Front Side of your Assignment Form

The front of your form agreements should contain the most important conditions you are imposing as a part of your offer to perform work or acceptance of work. We have listed seven conditions that we see as extremely important.

These seven conditions are placed prominently to avoid any claim that the client did not see or was not aware of them. The conditions operate as follows:

1. Allows a variance in estimated expenses.
2. Makes the transfer of usage rights conditional upon payment in full.
3. Makes the use specified the only use allowed, and requires written additions.
4. Sets payment terms, and imposes a rebilling fee for unpaid invoices. (Some might prefer to charge interest for unpaid invoices.)
5. Requires that advance payments be received before you begin assignment.
6. Refers the client to the other terms and conditions on the reverse side. (See below.)
7. Forms an agreement by the client's conduct if you are allowed to do the work.

Many ASMP members have asked ASMP to develop a set of terms and conditions that are "softer and more client friendly." After much consideration, we decided not to do this. ASMP's responsibility is to provide the best protection, in its judgment, for you and your business. Softer, friendlier terms are generally weaker terms. While the individual photographer may choose to take this path, we thought it inappropriate to lead the way. Straightforward, factual, and fair terms are nothing to shy away from.

Signed or Unsigned

There are two approaches taken with these forms. On one we provided a sample of language to be used if you are going to get your paperwork signed. We recommend that you get signed paperwork, as it is the most enforceable.

However, we understand that some clients will refuse to sign anything. So we have attempted to make the acceptance language on the bottom of the forms as enforceable

as possible whether signed or not. Still, a signature is best if you can get it.

Terms and Conditions on the Reverse Side of your Forms

The terms and conditions on the reverse side of the forms serve very useful business and legal purposes. You should understand these terms, when to apply them, and what options are available. The following section is intended to provide the photographer with insight into the protective language used on the reverse side of the forms, and when to apply it.

The best way to prepare your forms is to customize them to your specific policies and for the specific job. To do this you should have a firm understanding of what each term establishes by its presence, and when each applies. This is not a place for guesswork. If you are not sure, get competent advice. If you are still in doubt as to whether a term applies, it is better to include it than to exclude it. Printed here are the terms and conditions that are normally found on the reverse side of a form. These specific terms are meant to be used with the specific terms and conditions that appear on the front of the form. These terms are discussed in the preceding section.

Term #1

Question: Are you supplying images in some form? If yes, use term #1.

[1] Definition: "Image(s)" means all viewable representations furnished by Photographer, whether captured, delivered, or stored in photographic, magnetic, optical, electronic, or any other media.

This term defines "images" in a manner to include all visuals furnished by you regardless of medium. The word "images" appears throughout the terms and conditions, and use of this definition is critically important to protect your interest.

Term #2

Question: Do you intend to own the processed film, prints, etc., and the copyright to the work? If yes, then use term # 2.

[2] Rights: All Images and rights relating to them, including copyright and ownership in the media in which the Images are stored, remain the sole and exclusive property of Photographer. Unless otherwise specifically provided elsewhere in this document, any grant of rights is limited to one (1) year from the date hereof and to usage in print (conventional non-electronic and nondigital) media in the territory of the United States. Unless otherwise specifically provided elsewhere in this document, no image licensed for use on a cover of a publication may be used for promotional or advertising purposes without the express permission of Photographer and the payment of additional fees. No rights are transferred to Client unless and until Photographer has received payment in full. The parties agree that any usage of any Image without the prior permission of Photographer will be invoiced at three times Photographer's customary fee for such usage. Client agrees to provide Photographer with three copies of each published use of each Image not later than fifteen (15) days after the date of first publication of each use.

This term establishes that you retain ownership to: (1) the tangible images (prints,

disks, transparencies, etc.), and (2) the copyright to the images.

The term also sets defaults on the use of the images, if you do not specify other limits in the usage specifications, to: (1) a maximum of one year, to conventional print usage, and (2) to the United States only. It also excludes uses for promotional and advertising purposes unless you are paid additional fees. Note that it grants a license only upon your receipt of payment in full.

Term #3

Question: Do you want to hold your client responsible to return your images in good condition, and in a reasonable period of time? If yes, then use term # 3.

[3] Return of Images: Client assumes insurer's liability (a) to indemnify Photographer for loss, damage, or misuse of any Images, and (b) to return all Images prepaid and fully insured, safe and undamaged, by bonded messenger, air freight, or registered mail. All Images shall be returned within thirty (30) days after the later of: (1) the final licensed use as provided in this document, and (2) if not used, within thirty (30) days after the date of the expiration of the license. Client assumes full liability for its principals, employees, agents, affiliates, successors, and assigns (including without limitation independent contractors, messengers, and freelance researchers) for any loss, damage, delay in returning, or misuse of the Images.

This term places responsibility on the client for:

1. protecting your interest for any loss, damage, or misuse of the images;
2. returning the images by specified means;
3. returning the images by specified deadlines; and
4. for any losses, misuse, etc. by any party receiving the images from the client.

Term #4

Question: Do you want to set a default for the value of your work? If yes, then use term # 4. However, be sure to attach the required schedule(s) if they apply.

[4] Loss or Damage: Reimbursement by Client for loss or damage of each original photographic transparency or film negative ("Original[s]") shall be in the amount of One Thousand Five Hundred Dollars ($1,500), or such other amount if a different amount is set forth next to the lost or damaged item on the reverse side or attached schedule. Reimbursement by Client for loss or damage of each other item than an Original shall be in the amount set forth next to the item on the reverse side or attached schedule. Photographer and Client agree that said amount represents the fair and reasonable value of each item, and that Photographer would not sell all rights to such item for less than said amount. Client understands that each original photographic transparency and film negative is unique and does not have an exact duplicate, and may be impossible to replace or re-create. Client also understands that its acceptance of the stipulated value of the Images is a material consideration in Photographer's acceptance of the terms and prices in this agreement.

This term sets the traditional $1,500 value per item for your original photographic images, unless you specify otherwise on the front or on a separate list. The value of non-original items are to be specified on the front or an attached schedule.

Note: If you are routinely supplying dupes, scans on disk or tape, etc., you should include the value of such items in the clause. Keep in mind that any declared value must be reasonable and provable if it is to be accepted by a court.

Term #5
Question: Are you requesting a copyright credit line with your images? If yes, then use term # 5 and be sure to specify the placement.

[5] Photo Credit: All published usages of Images will be accompanied by written credit to Photographer or copyright notice as specified on the reverse side unless no placement of a credit or copyright notice is specified.

This term requires that a credit line be given as stated on the front of the form and in the place specified. No credit is required if no placement is specified.

Note: If you are doing work in applications where credit lines are not normally given, you can leave the placement blank or remove the term from your form. Copyright credit is not required to retain your copyright, but is desired and has specific advantages if used.

Term #6
Question: Does the work you are doing require alteration of the image you supply to the client? If yes, use option # 6C. If no, use option # 6A or 6B.

[6] Option A: Alterations: Client will not make or permit any alterations, including but not limited to, additions, subtractions, or adaptations in respect of the Images, alone or with any other material, including making digital scans, unless specifically permitted on the reverse side.

[6] Option B: Alterations: Client may not make or permit any alterations, including but not limited to, additions, subtractions, or adaptations in respect of the Images, alone or with any other material, including making digital scans unless specifically permitted on the reverse side, except that cropping and alterations of contrast, brightness, and color balance, consistent with reproduction needs may be made.

Terms 6A or B should be inserted when you will not allow the client to alter the image in any way.

[6] Option C: Alterations: Client may make or permit any alterations, including but not limited to, additions, subtractions, or adaptations in respect of the Images alone or with any other material, including making digital scans, subject to the provisions as stated in [7] below.

Term 6C permits the client to make alterations but makes them responsible for any consequences to those alterations, in accord with term [7].

Note: Some applications for images, like advertising, require that images be altered. It would seem necessary to give the client permission to make such alterations provided that you are protected from any consequences of the alteration.

Term #7
Question: No question here at all. Use this term on all your paperwork. It's the

safest way.

[7] Indemnification: Client will indemnify and defend Photographer against all claims, liability, damages, costs, and expenses, including reasonable legal fees and expenses, arising out of any use of any Images or arising out of use of or relating to any materials furnished by Client. Unless delivered to Client by Photographer, no model or property release exists. Photographer's liability for all claims shall not exceed in any event the total amount paid under this invoice.

This protects you if the images are used in an application requiring a release, and you have not supplied same, and for images altered by the client. It also establishes that there is no release unless you have supplied it.

Note: Some releases protect better than others. If you want to transfer the responsibility for assessing the force of the release to the client, you might consider adding this optional clause to the term's language:

Copies of any available model release are attached hereto. Determining the suitability of same for any application is the sole responsibility of the client.

If you add this language you must attach copies of the actual release(s) for the work.

Term #8

Question: Is your client supplying props or other items for the shoot? If yes, use term # 8.

[8] Assumption of Risk: Client assumes full risk of loss or damage to or arising from materials furnished by client hereunder and warrants that said materials are adequately insured against such loss, damage, or liability. Client shall indemnify Photographer against all claims, liability, damages, and expenses incurred by Photographer in connection with any claim arising out of use of said material hereunder.

This term is intended to transfer responsibility for any client-supplied materials, props, etc. on the assignment. The principle is meant to transfer the bailee responsibility you have for another's property while it is in your care. It is not a substitute for insurance, but an added safeguard to protect your interest.

Term #9

Question: No question here. Use this term on all your paperwork for maximum protection.

[9] Transfer and Assignment: Client may not assign or transfer this agreement or any rights granted under it. This agreement binds client and inures to the benefit of Photographer, as well as their respective principals, employees, agents and affiliates, legal representatives, successors, and assigns. Client and its principals, employees, agents, and affiliates are jointly and severally liable for the performance of all payments and other obligations hereunder. No amendment or waiver of any terms is binding unless set forth in writing and signed by the parties. However, the invoice may reflect, and Client is bound by, oral authorizations for fees or expenses that could not be confirmed in writing because of insufficient time. This agreement incorporates by

reference Article 2 of the Uniform Commercial Code, and the Copyright Act of 1976, as amended. To the maximum extent permitted by law, the parties intend that this agreement shall not be governed by or subject to the UCITA of any state.

This term prevents the client from assigning responsibility for the agreement to another party. It also limits changes to the agreement to those made in writing, unless they are made by the client during the assignment. Finally, it specifies the application of certain laws to the agreement, as a means of reinforcing the agreement's strength.

Term #10

This provision gives you the option of deciding whether to have disputes resolved through arbitration or litigation. Use this term in all your paperwork, and be sure to insert the required geographic information. You may have to check with your local small claims court to find out the maximum amount of its jurisdiction.

[10] Disputes: Except as provided in [11] below, any dispute regarding this agreement shall, at Photographer's sole discretion, either:

(1) be arbitrated in [PHOTOGRAPHER'S CITY AND STATE] under rules of the American Arbitration Association and the laws of [STATE OF ARBITRATION]; provided, however, that the parties are not required to use the services of arbitrators participating in the American Arbitration Association or to pay the arbitrators in accordance with the fee schedules specified in those rules. Judgment on the arbitration award may be entered in any court having jurisdiction. Any dispute involving $____[LIMIT OF LOCAL SMALL CLAIMS COURT] or less may be submitted without arbitration to any court having jurisdiction thereof. OR

(2) be adjudicated in [PHOTOGRAPHER'S CITY AND STATE] under the laws of [STATE].

(3) In the event of a dispute, Client shall pay all court costs, Photographer's reasonable legal fees, and expenses, and legal interest on any award or judgment in favor of Photographer.

Term #11

Question: No question here, use this on all your paperwork. It is the law.

[11] Federal Jurisdiction: Client hereby expressly consents to the jurisdiction of the Federal courts with respect to claims by Photographer under the Copyright Act of 1976, as amended.

This clause makes the federal courts the forum for a copyright infringement case. This is in keeping with the federal copyright law itself, which defines the federal courts as the courts of proper jurisdiction for such action.

Term #12

Question: Do you pay freelance and staff overtime? If yes, consider using term # 12.

[12] Overtime: In the event a shoot extends beyond eight (8) consecutive hours, Photographer may charge for such excess time of assistants and freelance staff at the

rate of one-and-one half their hourly rates.

This term sets eight consecutive hours as a standard day, and reserves the right for you to charge overtime fees for your staff and assistants.

Term #13

Question: Do you want to be paid for a reshoot demanded by a client? If yes, use term # 13.

[13] Reshoots: Client will be charged 100 percent fee and expenses for any reshoot required by Client. For any reshoot required because of an act of God or the fault of a third party, Photographer will charge no additional fee, and Client will pay all expenses. If Photographer charges for special contingency insurance and is paid in full for the shoot, Client will not be charged for any expenses covered by insurance. A list of exclusions from such insurance will be provided on request.

The charges for a reshoot are established in this term. If the reshoot is required by the client, it sets 100 percent of the original fee and expenses as the payment. It requires expenses only when a reshoot is required because of the act of a third party or an act of God. It also allows that no expenses covered by insurance will be charged to the client if it has paid a fee for the coverage.

Note: This clause does not absolve you from having to reshoot at your own expense if your negligence is the cause of a reshoot.

You should consider deleting the statements about insurance if you do not make such contingency insurance available to your clients.

Term #14

Question: Do you want to establish a cancellation policy? If yes, use term # 14.

[14] Cancellations and postponements: Client is responsible for payment of all expenses incurred up to the time of cancellation, plus 50 percent of Photographer's fee. If notice of cancellation is given less than two (2) business days before the shoot date, Client will be charged 100 percent fee. Weather postponements: Unless otherwise agreed, Client will be charged a 100 percent fee if postponement is due to weather conditions on location and 50 percent fee if postponement occurs before departure to location.

This term sets up a cancellation policy and speaks clearly for itself.

Note: You might want to consider the use and language of this term in light of your own policy before you accept this specific language as a default.

Releases and Permissions

Model Release Forms

Model releases are important to avoid lawsuits. This "release" is a document that says that the person being photographed has given consent to the use of the image.

The purpose of the release is to protect the photographer against an invasion-of-privacy lawsuit. Generally these actions arise when an image is used without authoriza-

tion for purposes of "trade or advertising." In addition, a release may protect the photographer against a libel suit. Libel suits generally allege that the person in the image has been subjected to some form of embarrassment, loss of status, etc., by virtue of the image's publication. The risks in these areas are extremely serious. Legal actions, when instituted, often involve claims of many hundreds of thousands of dollars.

Another difficult area involves images reproduced in exhibitions, books, and the like. Most legal opinion holds that the use of such images is as protected as that of any subject pertaining to current events, politics, and so on. (The commercial sale of individual fine art photographs may not enjoy such protection.) There is however, some opinion indicating that the First Amendment was primarily intended to protect social, political, economic, and similar commentary, and that the further one gets from that, the greater the need for a release.

Libel

On the question of libel, as distinguished from the right of privacy, a different legal question is posed. The primary issue is not whether the nature of the usage was protected, but instead whether the person in the image was depicted in a truthful and non-defamatory manner.

In portraying public figures, the courts will allow more leeway about inaccurate associations, provided that the publication is not both (a) substantially false and (b) published as knowingly false or in reckless disregard of the truth.

In some of the gray areas, the type of medium used may also be important. For example, courts sometimes recognize that there is only a short time for checking information available to newspaper publishers, while a longer lead time is available to book or magazine publishers.

The gray area between protected "news or editorial" uses and unprotected "advertising or trade purposes" can be confusing. In many jurisdictions, a magazine or book cover is as protected as the contents, even though the cover is used, in effect, to "sell" the publication. But if that same image is used to advertise any other product aside from the publication itself, then that additional use will be considered an unprotected advertising purpose.

Other interesting contrasts abound. In one case, a manufacturer's purely instructional manual was held to be an unprotected promotional publication (despite its being, at least in large part, substantially for educational purposes). On the other hand, editorial "service" material (e.g., fashion items) in regular news media have been considered protected in some cases.

Sample Release Forms

Included here are various model release forms, including an adult model release, a minor model release, a property release, a simplified release, and a pocket model release

Adult Model Release

This is an all-encompassing release, and the one generally recommended. It covers a wide range of areas, including a waiver by the subject to inspect or approve any finished image, the right of the photographers and their assigns to alter or distort the image and a complete "hold harmless" clause if there is a liability from any use of the image whatever.

Simplified Model Release

This form is one that many professional photographers use. It does not afford the overall protection of the general release, but if the use of the image is to be a rather restricted one, it may be easier to obtain a signature on this form than on the longer one. However, note the wording:

" . . . if the use is to be a rather restricted one . . . " In other words, get the longer release signed, if possible.

Minor Model Release

The minor release has substantially the same language as the adult release, except that it provides for the signature of a parent or guardian of the minor, required by virtually all states. Of course, you or your attorney should check the statutes in your state on what age constitutes a minor. Also, be warned that parents may not have the legal authority to guarantee that their release will be completely binding. In a legal action over the release, a court could hold that the parents did not have the authority to bind the minor. While this is unlikely to happen in the case of paid professional models, it cannot be ruled out, especially when nonprofessional models are involved.

Pocket Model Release

The pocket model release affords reasonable protection with a minimum of words. Use the longer release forms whenever possible, however.

Assignment Model Release

Even in situations where someone is photographed for a very specific assignment and client, a release is needed. This minimal release simply acknowledges that the model allowed the photo to be taken. This release gives no rights for other uses to the photographer or the client than those specified on the face of the form. Frequently, it is the only type of release that a professional model will sign.

Property Release

A property release, signed by the owner or agency for the owner, may be required for places that are photographed. Some photographers also use this release for pets, automobiles, works of art, and similar property. Courts have recognized that the owners have a commercially valuable right in exploiting the depictions of their property. When the property can be clearly identified from the image by the owner, it is important to have a property release. As with model releases, property releases are required

when the images are used for trade or advertising purposes. As with model releases, it is always smart to protect yourself from a variety of claims by obtaining a signed property release wherever you are shooting. Another potential concern is if a property changes hands. Depending on the terms of the sale and other factors, the original property release might no longer be valid. It is advisable to ascertain the current ownership of a property if a photograph is going to be published, particularly if the intended use is in advertising.

Indemnification Agreement

There are times in your work when a party you contract with has to take a risk. It might be a model being asked to sit on the edge of a roof of a tall building, or being asked to pose with a lion. In each of these situations, the photographer is at special risk. If the lion, trained as it might be, gets spooked and bites the model, or a gust of wind causes the model to lose balance and fall off the roof, you might be held liable for the damages.

Obviously, the best way to deal with risk is to insure for it. However, it is prudent to secure an indemnification agreement from those parties who might be at risk, while rendering services to you, on your shoot. We have included a sample indemnification agreement in our grouping of sample forms. This, like all agreements, will be influenced by state law and court decisions. Having this form reviewed by your attorney for its enforceability under your state laws is a good idea.

Keep in mind that you are responsible for injury to your employees, and you cannot be indemnified by them under law. You are supposed to carry worker's compensation insurance for this purpose. It would not be uncommon for an injured freelance assistant or model to claim that she was your employee if she signed such an indemnification agreement. If the authorities found her to be an employee, you would be liable, in spite of the agreement. Here is one case in which an independent contractor's agreement is in order.

Independent Contractor's Agreement

All too often, ASMP sees photographers caught up in cases in which their freelance assistants, and often models, claim to have been employees. They do this when they run out of work and seek unemployment benefits, or when they are injured on a job and not covered by insurance.

The problem is that government agencies seem to go out of their way when reviewing these cases to make the claimant an employee. We expect it is because they don't like to deny citizens claims when there is someone there to pay for them. You, the photographer, could be held responsible if you do not have the proper insurance, or have not treated the claimant's payments as wages.

We also see problems where state and federal tax examiners hold freelance assistants, models, and other service providers to be employees of photographers, and then tax and

penalize the photographers for failure to withhold the proper taxes. This is good for the government treasury and bad for the photographers, and you can't insure against it

While there is no guaranteed way to protect yourself from this danger, we suggest that you have independent contractors execute an agreement acknowledging their status with you. A sample form to this effect is included in the packet of sample forms. Again, a legal review is recommended, as state laws will have a major bearing on the enforceability of such an agreement.

We have added a condition precedent to the agreement, which is intended to fend off the cases of the kind we have described above. Still, there are no guarantees in business.

The Terms and Conditions and other language on the front and back of forms and other sections of this chapter are available on Macintosh and PC disks. Users will have to format their own forms and insert the terms and conditions as required. There will be a nominal fee for the disk. Please note, the disk can be used only in conjunction with the information in this book. For information about this, please get in touch with ASMP National at (215) 451–2767, and specify whether you require Mac or PC format.

ADULT RELEASE

In consideration of my engagement as a model, and for other good and valuable consideration herein acknowledged as received, I hereby grant to _____ ("Photographer"), his/her heirs, legal representatives, and assigns, those for whom Photographer is acting, and those acting with his/her authority and permission, the irrevocable and unrestricted right and permission to take, use, re-use, publish, and republish photographic portraits or pictures of me or in which I may be included, in whole or in part, or composite or distorted in character or form, without restriction as to changes or alterations, in conjunction with my own or a fictitious name, or reproductions thereof in color or otherwise, made through any medium at his/her studios or elsewhere, and in any and all media now or hereafter known for illustration, promotion, art, editorial, advertising, trade, or any other purpose whatsoever. I also consent to the use of any published matter in conjunction therewith.

I hereby waive any right that I may have to inspect or approve the finished product or products and the advertising copy or other matter that may be used in connection therewith or the use to which it may be applied.

I hereby release, discharge, and agree to save harmless Photographer, his/her heirs, legal representatives, and assigns, and all persons acting under his/her permission or authority or those for whom he/she is acting, from any liability by virtue of any blurring, distortion, alteration, optical illusion, or use in composite form, whether intentional or otherwise, that may occur or be produced in the taking of said picture or in any subsequent processing thereof, as well as any publication thereof, including without limitation any claims for libel or violation of any right of publicity or privacy.

I hereby warrant that I am of full age and have the right to contract in my own name. I have read the above authorization, release, and agreement, prior to its execution, and I am fully familiar with the contents thereof. This release shall be binding upon me and my heirs, legal representatives, and assigns.

DATE

NAME

WITNESS

ADDRESS

SIMPLIFIED ADULT RELEASE

For valuable consideration received, I hereby grant to _____ ("Photographer") the absolute and irrevocable right and unrestricted permission in respect of photographic portraits or pictures that he/she had taken of me or in which I may be included with others, to use, reuse, publish, and republish the same in whole or in part, individually or in any and all media now or here-after known, and for any purpose whatsoever, for illustration, promotion, art, editorial, advertising, and trade, or any other purpose whatsoever without restriction as to alteration; and to use my name in connection therewith if he/she so chooses.

I hereby release and discharge Photographer from any and all claims and demands arising out of or in connection with the use of the photographs, including without limitation any and all claims for libel or violation of any right of publicity or privacy.

This authorization and release shall also inure to the benefit of the heirs, legal representatives, licensees, and assigns of Photographer, as well as the person(s) for whom he/she took the photo-graphs.

I am of full age and have the right to contract in my own name. I have read the foregoing and fully understand the contents thereof. This release shall be binding upon me and my heirs, legal representatives, and assigns.

DATE

NAME

WITNESS

ADDRESS

MINOR RELEASE

In consideration of the engagement as a model of the minor named below, and for other good and valuable consideration herein acknowledged as received, upon the terms hereinafter stated, I hereby grant to_____ ("Photographer"), his/her legal representatives and assigns, those for whom Photographer is acting, and those acting with his/her authority and permission, the absolute right and permission to take, use, reuse, publish, and republish photographic portraits or pictures of the minor or in which the minor may be included, in whole or in part, or composite or distorted in character or form, without restriction as to changes or alterations from time to time, in conjunction with the minor's own or a fictitious name, or reproductions thereof in color or otherwise, made through any medium at his/her studios or elsewhere, and in any and all media now or hereafter known, for art, advertising, trade, or any other purpose whatsoever. I also consent to the use of any published matter in conjunction therewith.

I hereby waive any right that I or the minor may have to inspect or approve the finished product or products or the advertising copy or printed matter that may be used in connection therewith or the use to which it may be applied.

I hereby release, discharge, and agree to save harmless and defend Photographer, his/her legal representatives or assigns, and all persons acting under his/her permission or authority or those for whom he/she is acting, from any liability by virtue of any blurring, distortion, alteration, optical illusion, or use in composite form, whether intentional or otherwise, that may occur or be produced in the taking of said picture or in any subsequent processing thereof, as well as any publication thereof, including without limitation any claims for libel or violation of any right of publicity or privacy.

I hereby warrant that I am of full age and have every right to contract for the minor in the above regard. I state further that I have read the above authorization, release, and agreement, prior to its execution, and that I am fully familiar with the contents thereof. This release shall be binding upon the minor and me, and our respective heirs, legal representatives, and assigns.

_____	_____
DATE	FATHER, MOTHER, GUARDIAN
_____	_____
MINOR'S NAME	ADDRESS
_____	_____
MINOR'S NAME	WITNESS

POCKET RELEASE

For valuable consideration received, I hereby grant to _____ ("Photographer") and his/her legal representatives and assigns, the irrevocable and unrestricted right to use and publish photographs of me, or in which I may be included, for editorial, trade, advertising, and any other purpose and in any manner and medium; to alter the same without restriction; and to copyright the same. I hereby release Photographer and his/her legal representatives and assigns from all claims and liability relating to said photographs.

_____	_____
NAME (PRINT)	DATE
_____	_____
SIGNATURE	PHONE
_____	_____
STREET ADDRESS	CITY/STATE/ZIP
_____	_____
IF MINOR, SIGNATURE OF PARENT/GUARDIAN	WITNESS

PROPERTY RELEASE

For good and valuable consideration herein acknowledged as received, the undersigned, being the legal owner of, or having the right to permit the taking and use of photographs of, certain property designated as_____ , does grant to _____ ("Photographer"), his/her heirs, legal representatives, agents, and assigns the full rights to take and use such photographs in advertising, trade, or for any purpose.

The undersigned also consents to the use of any printed matter in conjunction therewith.

The undersigned hereby waives any right that he/she/it may have to inspect or approve the finished product or products, or the advertising copy or published matter that may be used in connection therewith, or the use to which it may be applied.

The undersigned hereby releases, discharges, and agrees to save harmless and defend Photographer, his/her heirs, legal representatives, and assigns, and all persons acting under his/her permission or authority, or those for whom he/she is acting, from any liability by virtue of any blurring, distortion, alteration, optical illusion, or use in composite form, whether intentional or otherwise, that may occur or be produced in the taking of said picture or in any subsequent processing thereof, as well as any publication thereof, even though it may subject the undersigned, his/her heirs, representatives, successors, and assigns, to ridicule, scandal, reproach, scorn, and indignity.

The undersigned hereby warrants that he/she is of full age and has every right to contract in his/her own name in the above regard. The undersigned states further that he/she has read the above authorization, release, and agreement, prior to its execution, and that he/she is fully familiar with the contents thereof. If the undersigned is signing as an agent or employee of a firm or corporation, the undersigned warrants that he/she is fully authorized to do so. This release shall be binding upon the undersigned and his/her/its heirs, legal representatives, successors, and assigns.

_____ _____

DATE NAME

_____ _____

WITNESS ADDRESS

INDEMNIFICATION AGREEMENT

(MODEL) hereby agrees to protect, defend, indemnify, and hold harmless (PHOTOGRAPHER) from and against any and all claims, losses, liabilities, settlements, expenses, and damages, including legal fees and costs (all referred to collectively as "Claims"), which (PHOTOGRAPHER) may suffer or to which (he/she/it) may be subjected for any reason, even if attributable to negligence on the part of (PHOTOGRAPHER) or any other entity, arising out of or related to any act, omission, or occurrence in connection with the creation, production, or use of any image or the performance of any service relating to this Agreement or its subject matter. This provision shall apply to Claims of every sort and nature, whether based on tort, strict liability, personal injury, property damage, contract, defamation, privacy rights, publicity rights, copyrights, or otherwise. (MODEL's) obligations under this provision shall survive the performance, termination, or cancellation of this Agreement.

_____ _____

DATE NAME

_____ _____

WITNESS ADDRESS

INDEPENDENT CONTRACTOR AGREEMENT

AGREEMENT entered into as of the _____ day of _____, 20____, between _____ located at _____ (hereinafter referred to as the "Photographer") and _____, located at _____ (hereinafter referred to as the "Contractor").

The Parties hereto agree as follows:

1. Services to be Rendered. The Contractor agrees to perform the following services for the Photographer.

2. Schedule. The Contractor shall complete the services pursuant to the following schedule:

3. Fee and Expenses. The Contractor shall be paid as follows:

The Photographer shall reimburse the Contractor only for the listed expenses.

4. Payment. Payment shall be made as follows: _____

5. Condition precedent to Agreement. Contractor does not consider himself eligible for nor has any intention to, and will not, apply for unemployment or worker's compensation benefits in a claim against the Photographer.

6. Relationship of Parties. Both parties agree that the Contractor is an independent contractor. This Agreement is not an employment agreement, nor does it constitute a joint venture or partnership between the Photographer and Contractor. Nothing contained herein shall be construed to be inconsistent with this independent contractor relationship.

7. Proprietary Rights. The proprietary rights in any work produced in conjunction with this Agreement shall be vested solely and exclusively in the Photographer.

8. Miscellany. This Agreement constitutes the entire agreement between the parties. Its terms can be modified only by an instrument in writing signed by both parties, except that oral authorizations of additional fees and expenses shall be permitted if necessary to speed the progress of work. This Agreement shall be binding on the parties, their heirs, successors, assigns, and personal representatives. A waiver of a breach of any of the provisions of this Agreement shall not be construed as a continuing waiver of other breaches of the same or other provisions hereof. This Agreement shall be governed by the laws of the State of _____

IN WITNESS WHEREOF, the parties hereto have signed this as of the date first set forth above.

_____ _____

PHOTOGRAPHER CONTRACTOR

Straight Shooter Studio, Inc.

123 Anystreet, Hometown, ZX 12345 • Telephone: 123-555-1212 • Fax: 123-555-2121

ESTIMATE

THIS ESTIMATE IS VALID FOR NINETY DAYS FROM THIS DATE OF ISSUE:_____ REFERENCE #

Client:

Assignment DESCRIPTION

Description:_____

Usage Specifications:

Estimated Price: FEES_____ EXPENSES_____ TOTAL_____

 Note: For details of fee structure and expenses, refer to attached schedule.

Advance Payments: FEES_____ EXPENSES_____ TOTAL_____

Conditions of Transaction:

1. The copyright to all images created or supplied pursuant to this agreement remain the sole and exclusive property of the photographer. There is no assignment of copyright, agreement to do work-for-hire, or intention of joint copyright expressed or implied hereunder. The client is licensed the above usage specifications in accord with the conditions stated herein. Proper copyright notice, which reads: © 20__ Straight Shooter, must be displayed with the following place-ment:_____ . Notice is not required if placement is not specified. Omission of required notice results in loss to the the photographer and will be billed at triple the invoiced fee.

2. All expense estimates are subject to normal trade variance of 10 percent.

3. Usage specifications above convert to copyright license only upon receipt of full payment.

4. Usage beyond that defined above requires additional written license from the licensor.

5. Invoices are payable on receipt. Unpaid invoices are subject to a rebilling fee of _____.

6. Advance payments must be received at least 24 hours prior to assignment commencement.

7. The sale is subject to all terms and conditions on the reverse side hereof.

8. If you order the performance of any services required to complete the above described assignment, that act constitutes your acceptance by conduct of the terms on both sides of this estimate in their entirety, whether signed by you or not.

_____ _____

SUBMITTED BY Date

_____ _____

ACCEPTED BY Date

Straight Shooter Studio, Inc.
123 Anystreet, Hometown, ZX 12345 • Telephone: 123-555-1212 • Fax: 123-555-2121

ASSIGNMENT CONFIRMATION

Date assignment to begin: _____ Reference # _____ Date of Confirmation _____

Client:

Assignment Description:

Usage Specifications:

Estimated Price: FEES_____ EXPENSES_____TOTAL_____
 Note: For details of fee structure and expenses, refer to attached schedule.

Advance Payments: FEES_____ EXPENSES_____TOTAL_____

Conditions of Transaction:

1. The copyright to all images created or supplied pursuant to this agreement remain the sole and exclusive property of the photographer. There is no assignment of copyright, agreement to do work-for-hire, or intention of joint copyright expressed or implied hereunder. The client is licensed the above usage specifications in accord with the conditions stated herein. Proper copyright notice, which reads: © 20__ Straight Shooter, must be displayed with the following placement:_____ . Notice is not required if placement is not specified. Omission of required notice results in loss to the photographer and will be billed at triple the invoiced fee.

2. All expense estimates are subject to normal trade variance of 10 percent.

3. Usage specifications above convert to copyright license only upon receipt of full payment.

4. Usage beyond that defined above requires additional written license from the licensor.

5. Invoices are payable on receipt. Unpaid invoices are subject to a rebilling fee of _____.

6. Advance payments must be received at least 24 hours prior to assignment commencement.

7. The sale is subject to all terms and conditions on the reverse side hereof.

8. *If you order the performance of any services required to complete the above-described assignment, that act constitutes your acceptance by conduct of the terms on both sides of this confirmation in their entirety.*

This confirms the details of the assignment that you have awarded to Straight Shooter Studio, Inc. Thank you for selecting us to fulfill this important need.

Straight Shooter Studio, Inc.

123 Anystreet, Hometown, ZX 12345 o Telephone: 123-555-1212 o Fax: 123-555-2121

INVOICE

Date of Invoice:_____ Reference #_____ Your P.O.# & Date

Client:

Assignment Description:

Usage Specifications:

Price FEES_____ TOTAL PRICE_____

 EXPENSES _____ LESS ADVANCES_____

 SALES TAX _____ BALANCE DUE_____

 PLEASE REMIT $_____

Conditions of Transaction:

1. The copyright to all images created or supplied pursuant to this agreement remain the sole and exclusive property of the photographer. There is no assignment of copyright, agreement to do work-for-hire, or intention of joint copyright expressed or implied hereunder. The client is licensed the above usage specifications in accord with the conditions stated herein. Proper copyright notice, which reads: © 20__ Straight Shooter, must be displayed with the following placement:_____ . Notice is not required if placement is not specified. Omission of required notice results in loss to the licensor and will be billed at triple the invoiced fee.

2. All expense estimates are subject to normal trade variance of 10 percent.

3. Usage specifications above convert to copyright license only upon receipt of full payment.

4. Usage beyond that defined above requires additional written license from the licensor.

5. Invoices are payable on receipt. Unpaid invoices are subject to a rebilling fee of _____.

6. The sale is subject to all terms and conditions on the reverse side hereof.

7. *Our having ordered the performance of any services required to complete the above-described assignment, and/or accepted delivery of any Image created in connection with that assignment, constituted your acceptance by conduct of the terms on both sides of this invoice, in their entirety.*

Provider E.I.N. or S.S. # Work Delivered Via

Date Work Delivered Work Delivered To

Terms and Conditions for Reverse Side of Assignment Estimate, Confirmation, Invoice

[1] Definition: "Image(s)" means all visual representations furnished to Client by Photographer, whether captured, delivered, or stored in photographic, magnetic, optical, electronic, or any other media.

[2] Rights: All Images and rights relating to them, including copyright and ownership rights in the media in which the Images are stored, remain the sole and exclusive property of Photographer. Unless otherwise specifically provided elsewhere in this document, any grant of rights is limited to a term of one (1) year from the date hereof and to usage in print (conventional non-electronic and nondigital) media in the territory of the United States. Unless otherwise specifically provided elsewhere in this document, no image licensed for use on a cover of a publication may be used for promotional or advertising purposes without the express permission of Photographer and the payment of additional fees. No rights are transferred to Client unless and until Photographer has received payment in full. The parties agree that any usage of any Image without the prior permission of Photographer will be invoiced at three times Photographer's customary fee for such usage. Client agrees to provide Photographer with three copies of each published use of each Image not later than 15 days after the date of first publication of each use.

[3] Return of Images: Client assumes insurer's liability (a) to indemnify Photographer for loss, damage, or misuse of any Images, and (b) to return all Images prepaid and fully insured, safe and undamaged, by bonded messenger, air freight, or registered mail. All Images shall be returned within thirty (30) days after the later of: (1) the final licensed use as provided in this document, and (2) if not used within thirty (30) days after the date of the expiration of the license. Client assumes full liability for its principals, employees, agents, affiliates, successors, and assigns (including without limitation independent contractors, messengers, and freelance researchers) for any loss, damage, delay in returning, or misuse of the Images.

[4] Loss or Damage: Reimbursement by Client for loss or damage of each original photographic transparency or film negative ("Original[s]") shall be in the amount of One Thousand Five Hundred Dollars ($1,500), or such other amount if a different amount is set forth next to the lost or damaged item on the reverse side or attached schedule. Reimbursement by Client for loss or damage of each item other than an Original shall be in the amount set forth next to the item on the reverse side or attached schedule. Photographer and Client agree that said amount represents the fair and reasonable value of each item, and that Photographer would not sell all rights to such item for less than said amount. Client understands that each Original is unique and does not have an exact duplicate, and may be impossible to replace or re-create. Client also understands that its acceptance of the stipulated value of the Images is a material consideration in Photographer's acceptance of the terms and prices in this agreement.

[5] Photo Credit: All published usages of Images will be accompanied by written credit to Photographer or copyright notice as specified on the reverse side unless no placement of a credit or copyright notice is specified.

OPTION: [6A] Alterations: Client will not make or permit any alterations, including but not limited to additions, subtractions, or adaptations in respect of the Images, alone or with any other material, including making digital scans unless specifically permitted on the reverse side. OR

[6B] Alterations: Client may not make or permit any alterations, including but not limited to additions, subtractions, or adaptations in respect of the Images, alone or with any other material, includ-

ing making digital scans unless specifically permitted on the reverse side, except that cropping and alterations of contrast, brightness, and color balance, consistent with reproduction needs may be made. OR

[6C] Alterations: Client may make or permit any alterations, including but not limited to additions, subtractions, or adaptations in respect of the Images alone or with any other material, including making digital scans, subject to the provisions as stated in [7] below.

[7] Indemnification: Client will indemnify and defend Photographer against all claims, liability, damages, costs, and expenses, including reasonable legal fees and expenses, arising out of the creation or any use of any Images or arising out of use of or relating to any materials furnished by Client. Unless delivered to Client by Photographer, no model or property release exists. Photographer's liability for all claims shall not exceed in any event the total amount paid under this invoice.

[8] Assumption of Risk: Client assumes full risk of loss or damage to or arising from materials furnished by Client and warrants that said materials are adequately insured against such loss, damage, or liability. Client shall indemnify Photographer against all claims, liability, damages, and expenses incurred by Photographer in connection with any claim arising out of use of said material hereunder.

[9] Transfer and Assignment: Client may not assign or transfer this agreement or any rights granted under it. This agreement binds Client and inures to the benefit of Photographer, as well as their respective principals, employees, agents, and affiliates, heirs, legal representatives, successors, and assigns. Client and its principals, employees, agents, and affiliates are jointly and severally liable for the performance of all payments and other obligations hereunder. No amendment or waiver of any terms is binding unless set forth in writing and signed by the parties. However, the invoice may reflect, and Client is bound by, Client's oral authorizations for fees or expenses that could not be confirmed in writing because of insufficient time. This agreement incorporates by reference Article 2 of the Uniform Commercial Code, and the Copyright Act of 1976, as amended. To the maximum extent permitted by law, the parties intend that this agreement shall not be governed by or subject to the UCITA of any state.

[10] Disputes: Except as provided in [11] below, any dispute regarding this agreement shall, at Photographer's sole discretion, either:

(1) be arbitrated in [PHOTOGRAPHER'S CITY AND STATE] under rules of the American Arbitration Association and the laws of [STATE OF ARBITRATION]; provided, however, that the parties are not required to use the services of arbitrators participating in the American Arbitration Association or to pay the arbitrators in accordance with the fee schedules specified in those rules. Judgment on the arbitration award may be entered in any court having jurisdiction. Any dispute involving $____[LIMIT OF LOCAL SMALL CLAIMS COURT] or less may be submitted without arbitration to any court having jurisdiction thereof. OR

(2) be adjudicated in [PHOTOGRAPHER'S CITY AND STATE] under the laws of [STATE].(3) In the event of a dispute, Client shall pay all court costs, Photographer's reasonable legal fees, and expenses, and legal interest on any award or judgment in favor of Photographer.

[11] Federal Jurisdiction: Client hereby expressly consents to the jurisdiction of the Federal courts with respect to claims by Photographer under the Copyright Act of 1976, as amended.

[12] Overtime: In the event a shoot extends beyond eight (8) consecutive hours,

Photographer may charge for such excess time of assistants and freelance staff at the rate of 1-1/2 their hourly rates.

[13] Reshoots: Client will be charged 100 percent fee and expenses for any reshoot required by Client. For any reshoot required because of an act of God or the fault of a third party, Photographer will charge no additional fee, and Client will pay all expenses. If Photographer charges for special contingency insurance and is paid in full for the shoot, Client will not be charged for any expenses covered by insurance. A list of exclusions from such insurance will be provided on request.

[14] Cancellations and postponements: Client is responsible for payment of all expenses incurred up to the time Photographer receives actual notice of cancellation, plus 50 percent of Photographer's fee. If notice of cancellation is given less than two (2) business days before the shoot date, Client will be charged 100 percent fee. Weather postponements: Unless otherwise agreed, Client will be charged 100 percent fee if postponement is due to weather conditions on location and 50 percent fee if postponement occurs before departure to location.

SCHEDULE OF FEES AND EXPENSES

CLIENT: _____ DATE: _____ REFERENCE # _____

Photography:	_____	_____	$_____
Preproduction:	_____	_____	$_____
Travel:	_____	_____	$_____
Weather delays:	_____	_____	$_____
Other:	_____	_____	$_____
Casting:	Fee	_____	
	Film	_____	
	Casting from files	_____	
	_____	_____	$_____
Crew:	Assistants	_____	
	Home economist	_____	
	Prod. coordinator	_____	
	Stylists: hair	_____	
	props	_____	
	wardrobe	_____	
	Trainer/animals	_____	
	Welfare/teacher	_____	
	_____	_____	$_____
Film and	Editing	_____	
Lab charges:	Polaroid	_____	
	Prints	_____	
	Roll film	_____	
	Sheet film	_____	
	_____	_____	$_____
Insurance:	Liability	_____	
	Photo Pac	_____	
	Riders/binders	_____	

_____ _____ $_____

Location: Scout _____
 Film _____
 Research _____
 Location Fee _____
 Permits _____
 Travel _____

_____ _____ $_____

Messenger/ Messenger _____
Shipping Out-of-town _____
 Trucking _____

_____ _____ $_____

Props: Purchase _____
 Rental _____
 Food _____

_____ _____ $_____

Rental: Camera _____
 Grip truck _____
 Lenses _____
 Lighting _____
 Special effects _____
 Special equipment _____

_____ _____ $_____

Sets: Carpenter/painter _____
 Hardware/lumber _____
 Paint/wallpaper _____
 Set design/research _____
 Backgrounds/backdrops _____
 Studio materials _____
 Surfaces _____

_____ _____ $_____

Studio Build days _____
 Shoot days _____
 Overtime _____
 Strike Set _____

_____ _____ $_____

Travel: Air fares _____
 Excess baggage _____
 Cabs _____
 Car rental/mileage _____
 Truck/car rental _____
 Motor home/dressing room _____
 Parking tolls/gas _____

_____ _____

	Lodging, per diems (est)	_____
	Hotel	_____
	Meals	_____
	_____	_____ $_____

Wardrobe:	Costume design	_____
	Seamstress	_____
	Purchase	_____
	Rental	_____
	Special make-up/wigs	_____
	_____	_____ $_____

Miscellaneous	Gratuities	_____
	Long distance/phone	_____
	Nonprofessional talent	_____
	Working meals	_____
	_____	_____ $_____

Model details:

	NUMBER	HOURS	TOTAL TIME
Adults	_____	_____	_____
Children	_____	_____	_____
Extras	_____	_____	_____

Get it in writing!

Photographers need a written record of their dealing with services, licenses, compensation, delivery, and value. Estimates, confirmations, invoices, delivery agreements, copyright licenses, should be simple and straightforward and embody the terms under which you conduct your business.

Straight Shooter Studio, Inc.

123 Anystreet, Hometown, ZX 12345 • Telephone: 123-555-1212 • Fax: 123-555-2121

PREDELIVERY CONFIRMATION FACSIMILE

RETURN VIA FAX TO: 111-111-1111

To: _____

Fax No: _____

Transmission Date: _____

Transmission Time: _____

Thank you for requesting a submission of stock imaging of the following subject(s):

We will prepare and release our submission for your consideration upon receipt of a signed copy of this confirmation of certain terms and conditions precedent to delivery. Your review and acknowledgment will help to avoid misunderstandings.

Should you require an explanation of any of these terms and conditions, please call us at the above phone number. After reviewing, please sign the form in the space provided below and fax the signed copy to the return fax number listed above.

[1] "Image(s)" means all viewable renditions furnished by Photographer hereunder, whether captured or stored in photographic, magnetic, optical, or any other medium whatsoever.

[2] After fourteen days, the following holding fees are charged until return: Five Dollars ($5.00) per week per color transparency and One Dollar ($1.00) per week per print.

[3] Submission is for examination only. Images may not be reproduced, copied, scanned, projected, or used in any way or medium without (a) express written permission on Photographer's invoice stating the rights granted and the terms thereof and (b) full payment of said invoice. The reasonable and stipulated fee for any other use shall be three times Photographer's normal fee for such usage.

[4] Reimbursement by Client for loss or damage of each original photographic transparency or film negative shall be in the amount of One Thousand Five Hundred Dollars ($1,500), or such other amount if a different amount is set forth next to said item on the attached schedule. Reimbursement by Client for loss or damage of each other item shall be in the amount set forth next to said item on the attached schedule. Photographer and Client agree that said amount represents the fair and reasonable value of each item, and that Photographer would not sell all rights to such item for less than said amount. Client understands that each original photographic transparency and film negative is unique and does not have an exact duplicate, and may be impossible to replace or re-create.

[5] Additional terms and conditions regarding the use, return, and responsibilities of the parties accompany the images when delivered.

I have reviewed the above terms and conditions and acknowledge my acceptance of them with the understanding that my responsibility for the shipment will begin at the time they are received by me or my company. I also acknowledge that I am authorized to make such a commitment for my company. I also acknowledge that my acceptance of delivery of any Image created in connection with the above-described assignment constitutes my acceptance by conduct of the terms and conditions on both sides of the delivery memo that accompanies delivery of the Image, in their entirety, with or without my signature.

_____ _____ _____

SIGNED TITLE DATE

Straight Shooter Studio, Inc.

123 Anystreet, Hometown, ZX 12345 • Telephone: 123-555-1212 • Fax: 123-555-2121

ASSIGNMENT PHOTOGRAPHY DELIVERY MEMO

Date assignment to begin: _____ Reference # _____ Date of Confirmation_____

Client: _____

Assignment Description: _____

Usage Specifications: _____

Estimated Price: FEES_____ EXPENSES_____ TOTAL_____

 Note: For details of fee structure and expenses, refer to attached schedule.

Advance Payments: FEES_____ EXPENSES_____ TOTAL_____

Conditions of Transaction:

1. The copyright to all images created or supplied pursuant to this agreement remain the sole and exclusive property of the photographer. There is no assignment of copyright, agreement to do work-for-hire, or intention of joint copyright expressed or implied hereunder. The client is licensed the above usage specifications in accord with the conditions stated herein. Proper copyright notice, which reads: © 20__ Straight Shooter, must be displayed with the following placement:_____ . Notice is not required if placement is not specified. Omission of required notice results in loss to the licensor and will be billed at triple the invoiced fee.

2. Usage specifications above convert to copyright license only upon receipt of full payment.

3. Usage beyond that defined above requires additional written license from the licensor.

4. The sale is subject to all terms and conditions on the reverse side hereof.

5. The client's having ordered the performance of any services required to complete the above-described assignment constitutes an acceptance by conduct of the original estimate in its entirety.

Please review the attached schedule of images. Count shall be considered accurate and quality deemed satisfactory for reproduction if said copy is not immediately received by return mail with all exceptions duly noted. Your acceptance of this delivery constitutes your acceptance of all terms and conditions on both sides of this memo, whether signed by you or not.

_____ _____
Acknowledged and Accepted Date

Terms and Conditions for Assignment Photography Delivery Memo

[1] Definition: "Image(s)" means all visual representations furnished to Client by Photographer, whether captured, delivered, or stored in photographic, magnetic, optical, electronic, or any other media.

[2] Rights: All Images and rights relating to them, including copyright and ownership rights in the media in which the Images are stored, remain the sole and exclusive property of Photographer. Unless otherwise specifically provided elsewhere in this document, any grant of rights is limited to a term of one (1) year from the date hereof and to usage in print (conventional non-electronic and nondigital) media in the territory of the United States. Unless otherwise specifically provided elsewhere in this document, no image licensed for use on a cover of a publication may be used for promotional or advertising purposes without the express permission of Photographer and the payment of additional fees. No rights are transferred to Client unless and until Photographer has received payment in full. The parties agree that any usage of any Image without the prior permission of Photographer will be invoiced at three times Photographer's customary fee for such usage. Client agrees to provide Photographer with three copies of each published use of each Image not later than fifteen (15) days after the date of first publication of each use.

[3] Return of Images: Client assumes insurer's liability (a) to indemnify Photographer for loss, damage, or misuse of any Images, and (b) to return all Images prepaid and fully insured, safe and undamaged, by bonded messenger, air freight, or registered mail. All Images shall be returned within thirty (30) days after the later of: (1) the final licensed use as provided in this document, and (2) if not used, within thirty (30) days after the date of the expiration of the license. Client assumes full liability for its principals, employees, agents, affiliates, successors, and assigns (including without limitation independent contractors, messengers, and freelance researchers) for any loss, damage, delay in returning, or misuse of the Images.

[4] Loss or Damage: Reimbursement by Client for loss or damage of each original photographic transparency or film negative ("Original[s]") shall be in the amount of One Thousand Five Hundred Dollars ($1,500), or such other amount if a different amount is set forth next to the lost or damaged item on the reverse side or attached schedule. Reimbursement by Client for loss or damage of each item other than an Original shall be in the amount set forth next to the item on the reverse side or attached schedule. Photographer and Client agree that said amount represents the fair and reasonable value of each item, and that Photographer would not sell all rights to such item for less than said amount. Client understands that each Original is unique and does not have an exact duplicate, and may be impossible to replace or re-create. Client also understands that its acceptance of the stipulated value of the Images is a material consideration in Photographer's acceptance of the terms and prices in this agreement.

[5] Photo Credit: All published usages of Images will be accompanied by written credit to Photographer or copyright notice as specified on the reverse side unless no placement of a credit or copyright notice is specified.

OPTION: [6A] Alterations: Client will not make or permit any alterations, including but not limited to additions, subtractions, or adaptations in respect of the Images, alone or with any other material, including making digital scans unless specifically permitted on the reverse side. OR

[6B] Alterations: Client may not make or permit any alterations, including but not limited to additions, subtractions, or adaptations in respect of the Images, alone or with any other material, includ-

ing making digital scans unless specifically permitted on the reverse side, except that cropping and alterations of contrast, brightness, and color balance, consistent with reproduction needs may be made. OR

[6C] Alterations: Client may make or permit any alterations, including but not limited to additions, subtractions, or adaptations in respect of the Images alone or with any other material, including making digital scans, subject to the provisions as stated in [7] below.

[7] Indemnification: Client will indemnify and defend Photographer against all claims, liability, damages, costs, and expenses, including reasonable legal fees and expenses, arising out of the creation or any use of any Images or arising out of use of or relating to any materials furnished by Client. Unless delivered to Client by Photographer, no model or property release exists. Photographer's liability for all claims shall not exceed in any event the total amount paid under this invoice.

[8] Assumption of Risk: Client assumes full risk of loss or damage to or arising from materials furnished by Client and warrants that said materials are adequately insured against such loss, damage, or liability. Client shall indemnify Photographer against all claims, liability, damages, and expenses incurred by Photographer in connection with any claim arising out of use of said material hereunder.

[9] Transfer and Assignment: Client may not assign or transfer this agreement or any rights granted under it. This agreement binds Client and inures to the benefit of Photographer, as well as their respective principals, employees, agents, and affiliates, heirs, legal representatives, successors, and assigns. Client and its principals, employees, agents, and affiliates are jointly and severally liable for the performance of all payments and other obligations hereunder. No amendment or waiver of any terms is binding unless set forth in writing and signed by the parties. However, the invoice may reflect, and Client is bound by, Client's oral authorizations for fees or expenses which could not be confirmed in writing because of insufficient time. This agreement incorporates by reference Article 2 of the Uniform Commercial Code, and the Copyright Act of 1976, as amended. To the maximum extent permitted by law, the parties intend that this agreement shall not be governed by or subject to the UCITA of any state.

[10] Disputes: Except as provided in [11] below, any dispute regarding this agreement shall, at Photographer's sole discretion, either:

(1) be arbitrated in [PHOTOGRAPHER'S CITY AND STATE] under rules of the American Arbitration Association and the laws of [STATE OF ARBITRATION]; provided, however, that the parties are not required to use the services of arbitrators participating in the American Arbitration Association or to pay the arbitrators in accordance with the fee schedules specified in those rules. Judgment on the arbitration award may be entered in any court having jurisdiction. Any dispute involving $____[LIMIT OF LOCAL SMALL CLAIMS COURT] or less may be submitted without arbitration to any court having jurisdiction thereof. OR

(2) be adjudicated in [PHOTOGRAPHER'S CITY AND STATE] under the laws of [STATE]. (3) In the event of a dispute, Client shall pay all court costs, Photographer's reasonable legal fees, and expenses, and legal interest on any award or judgment in favor of Photographer.

[11] Federal Jurisdiction: Client hereby expressly consents to the jurisdiction of the Federal courts with respect to claims by Photographer under the Copyright Act of 1976, as amended.

E-MAIL COVER

To: From:
E-mail: Date:
Phone: Pages:
Re: cc:

Attached to this cover please find the:

___ Assignment Estimate ___ Assignment Invoice

___ Stock Estimate

___ Stock Invoice ___ Predelivery Memo

___ Delivery Memo

___ Other

In order for us to proceed with your project in a timely manner and in order to meet your scheduling requirements, we need to request that you review these documents as quickly as possible.

You can indicate your acceptance of the prices quoted, the terms under which we will proceed and the schedule we anticipate by simply replying to this e-mail. Once we receive your e-mailed reply, we will begin production.

BY REPLYING TO THIS E-MAIL, YOU ARE INDICATING YOUR ACCEPTANCE OF ALL TERMS AND CONDITIONS, PRICES, AND SCHEDULES ASSOCIATED WITH THIS PROJECT AND THE ATTACHED PAPERWORK UNDER THE ELECTRONIC SIGNATURES IN GLOBAL COMMERCE ACT OF 2001.

Thank you in advance for your timely reply and please contact us immediately via telephone if you have any questions.

Straight Shooter Studio, Inc.
123 Anystreet, Hometown, ZX 12345 • Telephone: 123-555-1212 • Fax: 123-555-2121

STOCK PHOTOGRAPHY DELIVERY MEMO

Date shipped: _____ Reference # _____ Return Images by _____

Client

Description of Images:

Orig.(O) Qty.	Dupl.(D)	Format	Photograph Subject/ID No.	Value (if other than $1,500/item) In event of loss/damage

Total Count: _____

Title in the copyright to all images created or supplied pursuant to this agreement will remain the sole and exclusive property of the Photographer. There is no assignment of copyright title, agreement to do work-for-hire, or intention of joint copyright expressed or implied hereunder. The client is licensed only by subsequent written license on an invoice. Proper copyright notice, which reads: © 20___ Straight Shooter, must be displayed with the following placement: _____. Notice is not required if placement is not specified. Omission of required notice results in loss to the licensor and will be billed at triple the invoiced fee.

Check count and acknowledge receipt by signing and returning one copy. Count shall be considered accurate and quality deemed satisfactory for reproduction if said copy is not immediately received by return mail with all exceptions duly noted. Photographs must be returned by registered mail, air courier or other bonded messenger that provides proof of return.

SUBJECT TO ALL TERMS AND CONDITIONS ABOVE AND ON REVERSE SIDE

_____ _____

Acknowledged and Accepted Date
(Please sign here)

Your acceptance of this delivery constitutes your acceptance of all terms and conditions on both sides of this memo, whether signed by you or not.

Terms and Conditions for Stock Photography Delivery Memo

[1] Definition: "Image(s)" means all visual representations furnished to Client by Photographer, whether captured, delivered, or stored in photographic, magnetic, optical, electronic, or any other media.

[2] Rights: Submission is for examination only. All Images and rights relating to them, including copyright and ownership rights in the media in which the Images are stored, remain the sole and exclusive property of Photographer. Unless otherwise specifically provided elsewhere in this document, any grant of rights is limited to a term of one (1) year from the date hereof and to usage in print (conventional non-electronic and nondigital) media in the territory of the United States. Unless otherwise specifically provided elsewhere in this document, no Image licensed for use on a cover of a publication may be used for promotional or advertising purposes without the express permission of Photographer and the payment of additional fees. No rights are transferred to Client unless and until Photographer has received payment in full. The parties agree that any usage of any Image without the prior permission of Photographer will be invoiced at three times Photographer's customary fee for such usage. Client agrees to provide Photographer with three copies of each published use of each Image not later than 15 days after the date of first publication of each use.

[3] Return of Images: Client assumes insurer's liability (a) to indemnify Photographer for loss, damage, or misuse of any Images, and (b) to return all Images prepaid and fully insured, safe, and undamaged, by bonded messenger, air freight, or registered mail. All Images shall be returned within thirty (30) days after the later of: (1) the final licensed use as provided in this document, and (2) if not used, within thirty (30) days after the date of the expiration of the license. Client assumes full liability for its principals, employees, agents, affiliates, successors, and assigns (including without limitation independent contractors, messengers, and freelance researchers) for any loss, damage, delay in returning, or misuse of the Images. After fourteen (14) days, the following holding fees are charged until return: Five Dollars ($5.00) per week per photographic transparency or negative and One Dollar ($1.00) per week per print.

[4] Loss or Damage: Reimbursement by Client for loss or damage of each original photographic transparency or film negative ("Original[s]") shall be in the amount of One Thousand Five Hundred Dollars ($1,500), or such other amount if a different amount is set forth next to the lost or damaged item on the reverse side or attached schedule. Reimbursement by Client for loss or damage of each item other than an Original shall be in the amount set forth next to the item on the reverse side or attached schedule. Photographer and Client agree that said amount represents the fair and reasonable value of each item, and that Photographer would not sell all rights to such item for less than said amount. Client understands that each Original is unique and does not have an exact duplicate, and may be impossible to replace or re-create. Client also understands that its acceptance of the stipulated value of the Images is a material consideration in Photographer's acceptance of the terms and prices in this agreement.

[5] Photo Credit: All published usages of Images will be accompanied by written credit to Photographer or copyright notice as specified on the reverse side unless no placement of a credit or copyright notice is specified.

OPTION: [6A] Alterations: Client will not make or permit any alterations, including but not limited to additions, subtractions, or adaptations in respect of the Images, alone or with any other material, including making digital scans unless specifically permitted on the reverse side. OR

[6B] Alterations: Client may not make or permit any alterations, including but not limited to additions, subtractions, or adaptations in respect of the Images, alone or with any other material, including making digital scans unless specifically permitted on the reverse side, except that cropping and alterations of contrast, brightness, and color balance, consistent with reproduction needs may be made. OR

[6C] Alterations: Client may make or permit any alterations, including but not limited to additions, subtractions, or adaptations in respect of the Images alone or with any other material, including making digital scans, subject to the provisions as stated in [7] below.

[7] Indemnification: Client will indemnify and defend Photographer against all claims, liability, damages, costs, and expenses, including reasonable legal fees and expenses, arising out of any use of any Images or arising out of use of or relating to any materials furnished by Client. Unless delivered to Client by Photographer, no model or property release exists. Photographer's liability for all claims shall not exceed in any event the total amount paid under this invoice.

[8] Assumption of Risk: Client assumes full risk of loss or damage to or arising from materials furnished by Client and warrants that said materials are adequately insured against such loss, damage, or liability. Client shall indemnify Photographer against all claims, liability, damages, and expenses incurred by Photographer in connection with any claim arising out of use of said material hereunder.

[9] Transfer and Assignment: Client may not assign or transfer this agreement or any rights granted under it. This agreement binds Client and inures to the benefit of Photographer, as well as their respective principals, employees, agents and affiliates, heirs, legal representatives, successors, and assigns. Client and its principals, employees, agents, and affiliates are jointly and severally liable for the performance of all payments and other obligations hereunder. No amendment or waiver of any terms is binding unless set forth in writing and signed by the parties. However, the invoice may reflect, and Client is bound by, Client's oral authorizations for fees or expenses which could not be confirmed in writing because of insufficient time. This agreement incorporates by reference Article 2 of the Uniform Commercial Code, and the Copyright Act of 1976, as amended. To the maximum extent permitted by law, the parties intend that this agreement shall not be governed by or subject to the UCITA of any state.

[10] Disputes: Except as provided in [11] below, any dispute regarding this agreement shall, at Photographer's sole discretion, either:

(1) be arbitrated in [PHOTOGRAPHER'S CITY AND STATE] under rules of the American Arbitration Association and the laws of [STATE OF ARBITRATION]; provided, however, that the parties are not required to use the services of arbitrators participating in the American Arbitration Association or to pay the arbitrators in accordance with the fee schedules specified in those rules. Judgment on the arbitration award may be entered in any court having jurisdiction. Any dispute involving $____[LIMIT OF LOCAL SMALL CLAIMS COURT] or less may be submitted without arbitration to any court having jurisdiction thereof. OR

(2) be adjudicated in [PHOTOGRAPHER'S CITY AND STATE] under the laws of [STATE]. (3) In the event of a dispute, Client shall pay all court costs, Photographer's reasonable legal fees, and expenses, and legal interest on any award or judgment in favor of Photographer.

[11] Federal Jurisdiction: Client hereby expressly consents to the jurisdiction of the Federal courts with respect to claims by Photographer under the Copyright Act of 1976, as amended.

Straight Shooter Studio, Inc.

123 Anystreet, Hometown, ZX 12345 • Telephone: 123-555-1212 • Fax: 123-555-2121

STOCK PHOTOGRAPHY INVOICE

Date of invoice: _____ Reference # _____ Your P.O.# and Date _____

Client:

Description of Images:

Usage Specifications:

Price:

USE FEES _____ TOTAL PRICE _____

RESEARCH FEE _____ SALES TAX _____

HOLDING FEES _____ TOTAL _____

SHIPPING _____

OTHER _____

PLEASE REMIT $ ____

Conditions of Transaction:

1. The copyright to all images created or supplied pursuant to this agreement remain the sole and exclusive property of the photographer. There is no assignment of copyright, agreement to do work-for-hire, or intention of joint copyright expressed or implied hereunder. The client is licensed the above usage specifications in accord with the conditions stated herein. Proper copyright notice, which reads: © 20__ Straight Shooter, must be displayed with the following placement:_____ . Notice is not required if placement is not specified. Omission of required notice results in loss to the photographer and will be billed at triple the invoiced fee.

2. Usage specifications above convert to copyright license only upon receipt of full payment.

3. Usage beyond that defined above requires additional written license from the photographer.

4. Invoices are payable on receipt. Unpaid invoices are subject to a re-billing fee of _____.

5. The license is subject to all terms and conditions on the reverse side hereof.

6. Your acceptance of delivery of any image described above constitutes your acceptance of all terms and conditions on both sides of the delivery memo that accompanied the delivery and of this invoice, in their entirety.

Terms and Conditions for Stock Photography Invoice

[1] Definitions: "Image(s)" means all visual representations furnished to Client by Photographer, whether captured, delivered, or stored in photographic, magnetic, optical, electronic, or any other media.

[2] Rights: All Images and rights relating to them, including copyright and ownership rights in the media in which the Images are stored, remain the sole and exclusive property of Photographer. Unless otherwise specifically provided elsewhere in this document, any grant of rights is limited to a term of one (1) year from the date hereof and to usage in print (conventional non-electronic and nondigital) media in the territory of the United States. Unless otherwise specifically provided elsewhere in this document, no image licensed for use on a cover of a publication may be used for promotional or advertising purposes without the express permission of Photographer and the payment of additional fees. No rights are transferred to Client unless and until Photographer has received payment in full and has issued a separate license to Client. The parties agree that any usage of any Image without the prior permission of Photographer will be invoiced at three times Photographer's customary fee for such usage. Client agrees to provide Photographer with three copies of each published use of each Image not later than 15 days after the date of first publication of each use.

[3] Return of Images: Client assumes insurer's liability (a) to indemnify Photographer for loss, damage, or misuse of any Images, and (b) to return all Images prepaid and fully insured, safe, and undamaged, by bonded messenger, air freight, or registered mail. All Images shall be returned within thirty (30) days after the later of: (1) the final licensed use as provided in this document, and (2) if not used, within thirty (30) days after the date of the expiration of the license. Client assumes full liability for its principals, employees, agents, affiliates, successors, and assigns (including without limitation independent contractors, messengers, and freelance researchers) for any loss, damage, delay in returning, or misuse of the Images.

[4] Loss or Damage: Reimbursement by Client for loss or damage of each original photographic transparency or film negative ("Original[s]") shall be in the amount of One Thousand Five Hundred Dollars ($1,500), or such other amount if a different amount is set forth next to the lost or damaged item on the reverse side or attached schedule. Reimbursement by Client for loss or damage of each item other than an Original shall be in the amount set forth next to the item on the reverse side or attached schedule. Photographer and Client agree that said amount represents the fair and reasonable value of each item, and that Photographer would not sell all rights to such item for less than said amount. Client understands that each Original is unique and does not have an exact duplicate, and may be impossible to replace or re-create. Client also understands that its acceptance of the stipulated value of the Images is a material consideration in Photographer's acceptance of the terms and prices in this agreement.

[5] Photo Credit: All published usages of Images will be accompanied by written credit to Photographer or copyright notice as specified on the reverse side unless no placement of a credit or copyright notice is specified.

OPTION: [6A] Alterations: Client will not make or permit any alterations, including but not limited to additions, subtractions, or adaptations in respect of the Images, alone or with any other material, including making digital scans unless specifically permitted on the reverse side. OR

[6B] Alterations: Client may not make or permit any alterations, including but not limited to additions, subtractions, or adaptations in respect of the Images, alone or with any other material, including making digital scans unless specifically permitted on the reverse side, except that cropping, and alterations of contrast, brightness, and color balance, consistent with reproduction needs may be made. OR

[6C] Alterations: Client may make or permit any alterations, including but not limited to additions, subtractions, or adaptations in respect of the Images alone or with any other material, including making digital scans, subject to the provisions as stated in [7] below.

[7] Indemnification: Client will indemnify and defend Photographer against all claims, liability, damages, costs, and expenses, including reasonable legal fees and expenses, arising out of any use of any Images or arising out of use of or relating to any materials furnished by Client. Unless delivered to Client by Photographer, no model or property release exists. Photographer's liability for all claims shall not exceed in any event the total amount paid under this invoice.

[8] Transfer and Assignment: Client may not assign or transfer this agreement or any rights granted under this agreement. This agreement binds Client and inures to the benefit of Photographer as well as their respective principals, employees, agents, and affiliates, heirs, legal representatives, successors, and assigns. Client and its principals, employees, agents, and affiliates are jointly and severally liable for the performance of all payments and other obligations hereunder. No amendment or waiver of any terms is binding unless set forth in writing and signed by the parties. However, the invoice may reflect, and Client is bound by, Client's oral authorizations for fees or expenses which could not be confirmed in writing because of insufficient time. This agreement incorporates by reference Article 2 of the Uniform Commercial Code, and the Copyright Act of 1976, as amended. To the maximum extent permitted by law, the parties intend that this agreement shall not be governed by or subject to the UCITA of any state.

[9] Disputes: Except as provided in [11] below, any dispute regarding this agreement shall, at Photographer's sole discretion, either:

(1) be arbitrated in [PHOTOGRAPHER'S CITY AND STATE] under rules of the American Arbitration Association and the laws of [STATE OF ARBITRATION]; provided, however, that the parties are not required to use the services of arbitrators participating in the American Arbitration Association or to pay the arbitrators in accordance with the fee schedules specified in those rules. Judgment on the arbitration award may be entered in any court having jurisdiction. Any dispute involving $____[LIMIT OF LOCAL SMALL CLAIMS COURT] or less may be submitted without arbitration to any court having jurisdiction thereof. OR

(2) be adjudicated in [PHOTOGRAPHER'S CITY AND STATE] under the laws of [STATE].

(3) In the event of a dispute, Client shall pay all court costs, Photographer's reasonable legal fees and expenses, and legal interest on any award or judgment in favor of Photographer.

[10] Federal Jurisdiction: Client hereby expressly consents to the jurisdiction of the Federal courts with respect to claims by Photographer under the Copyright Act of 1976, as amended.

Chapter 7

Copyright

Victor S. Perlman, Esq., and Richard Weisgrau

Copyrights are intangible assets that usually have monetary value. The Copyright Act of 1976 made clear that photographers are the copyright owners of their images, except when those images were made as an employee, or when the photographer has conveyed the copyright to another party in a written and signed agreement.

Copyright is a legal right to control the copying, reproduction, distribution, derivative use, and public display of your photographs, and to sue for the unauthorized use (infringement) of your work.

Copyright is earned the moment you fix your photographic expression in a tangible form; that is, when you create the latent image on film. Registration with the Copyright Office or placement of a copyright notice on the image is not required, although it is advisable.

Although most images are copyrightable, some are not. To be copyrightable, images must be original. Originality is essential to copyright. If you copy a photograph exactly, the copy cannot be copyrighted, since it has no originality. (In fact, if the first photograph is copyrighted, you would need the original photographer's permission to copy it.)

Making a substantially similar copy of someone else's copyrighted image without authorization constitutes copyright infringement. It is usually necessary to show that the alleged infringer had access to the original work—but the images may be so closely identical that no explanation other than copying is possible.

Ideas, themes, and concepts are not copyrightable. Only the original expression of those ideas, themes, and concepts in some tangible form, like a photograph, can be copyrighted. You might have an idea for a great photograph, but you get no copyright until you make the actual photograph. An art director might have a great concept, but that concept cannot be copyrighted. Having an idea or concept does not entitle one to

a share of the copyright of the photograph. The copyright belongs to the one(s) who author the tangible expression of the concept or idea.

Copyright Notice

ASMP recommends that all photographs carry a copyright notice, even though it is no longer required by law. The lack of notice could provide an infringer with a defense of "innocent infringement." This defense could seriously limit the recovery of damages in an infringement claim.

Copyright notice is a way of saying: "This is my work—if you want to use it, ask me." This stance reinforces the value of your work and alerts everyone that you are prepared to protect that value.

There are three ways to display a copyright notice:
* © 2001, Pat Photographer
* Copyright 2001, Pat Photographer
* Copr. 2001, Pat Photographer

Although all three are acceptable, it is generally thought that © 2001, Pat Photographer is the most widely recognized internationally.

A word of caution is called for on the subject of notice. When typing, word processing, or using some computer programs, some people use a "c" in parentheses—(c)—as a substitute for a ©. To the best of our knowledge, this form of notice has never been rejected by a court, but there is no guarantee that a court would uphold a (c) as proper notice. The law calls for a © or the word "Copyright" or the abbreviation "Copr."

Copyright Registration

A copyright owner can register the copyrighted work with the Copyright Office in Washington, D.C. There are excellent reasons for registering your copyrights. The cost of prosecuting a copyright infringement case may be very high, particularly when an alleged infringer can afford a rigorous defense. Outspending the copyright owner is a tactic that is often used to break a photographer's determination to enforce his rights. Most infringers know that photographers have limited resources and will not be able to spend all that is necessary to prosecute a well-fought case. They are also aware that without timely registration, an award of attorney's fees will be out of reach, further limiting the potential resources of the photographer, since most lawyers will not take such a case on a contingency fee basis. On the other hand, infringers are much more likely to settle out of court when confronted with the probability that they will likely have to pay your legal fees, as well as theirs, on top of an award of statutory damages.

Statutory damages are limited by law to a maximum of $100,000 per infringement. Many people construe this to mean that infringements often receive awards near this amount. In fact, that is not the case. A survey of recent cases shows that awards for statutory damages are made after evaluating certain factors, including willfulness, extent of unauthorized use, and the commercial value of the unauthorized use(s). An award could be for $500, $5,000, or $50,000, or any other amount, at the discretion of the court. Still, since the attorney's fees are also covered, any award will exceed the

monetary cost of prosecution.

The copyright law treats published and unpublished photographs differently, in relation to registration as a prerequisite for infringement remedies.

The law prohibits awards for statutory damages or attorney's fees for any infringement of copyright

a) of an unpublished work, occurring before the date of its registration; or

b) after the first publication of a work and before the effective date of its registration, unless such registration is made within three months after the first publication of the work.

Under copyright law, the word *published* is defined as follows: the distribution of copies of a work to the public by sale, other transfer of ownership, by rental, lease, or lending. Offering to distribute copies to people or businesses for purposes of further distribution, public performance, or public display constitutes publication. Therefore, when you send images to your stock agencies, which will do further distribution (submission and licensing), you have legally published your work. A public performance or display, in and of itself, does not constitute publication. Exhibiting your photographs in public does not constitute publication, unless you exhibit them through another party, such as a gallery, which offers them for sale (for further distribution).

A simple restatement of the law is that you can't collect attorney's fees and statutory damages unless you have registered an unpublished work before the infringement, or unless you registered a published work within three months after its first publication. Note: For published work, the law does not speak about three months after *any* publication, but rather, three months after its *first* publication.

You can register a published work at any time following three months after first publication, but that registration will only preserve remedies of attorney's fees and statutory damages for infringements that occur after the registration.

The law is written with a three-month allowance after first publication to allow you time to learn of the publication, obtain copies, and file the registration.

The following two examples will help clarify the application of the law.

Example 1: You shoot a brochure cover and the brochure with the image cover is published for the first time on July 1. You register the image on September 30. Later, you discover that the image was infringed on August 31. Since you registered within three months of first publication, you may seek an award of attorneys' fees and statutory damages, even though the infringing began a month before the date of registration.

Example 2: You shoot a brochure cover and the brochure with the cover image is published for the first time on July 1. You register the image on December 1. Later you discover that the image was infringed on August 31 and January 15. You are not fully protected for the August 31 infringement, since you failed to register within three months after first publication. You are fully protected for the January 15 infringement, since it happened after registration.

At ASMP we find that few unpublished works are infringed, and that most infringements are of published works, and, as such, they occur six months, a year, or even longer after a photo's first publication. Obviously, this leads one to the conclusion that, to be well protected, you have to register either immediately after publication or before

it.

In summary, it is important to remember that although the copyright law of the United States does not require a photographer to register her works to own the copyright to them, timely registration will serve the photographer's interests if the registered work is infringed by providing eligibility for attorney's fees and statutory damages. Your opponent's knowledge that these remedies are available to you will often enable you to negotiate a settlement without filing suit, or within a reasonable period of time after filing suit. Registration should be made before or immediately after publication.

How to Register

Registration is simply the process of filing copies of photographs accompanied by an accurate and complete registration form with the U.S. Copyright Office, and receiving a certificate of registration to show that such a deposit has been made. Any copyrightable work can be registered—a motion picture, a book, a painting, a CD-ROM, a slide show, and, yes, photographs. But, just as the copyright law treats published and unpublished works differently, so do the regulations that govern registration. We'll examine these differences a little later on.

There is a $20 fee for registering a copyrighted work. Obviously, the greater number of photographs included in one registration, the less expensive the registration costs per image. If you consider that on a given day a photographer can produce hundreds of separately copyrightable images, it becomes clear that registration could cost thousands of dollars unless it's done in some bulk fashion.

Registration can be made of single images or of groups of images. The single image registration is much the same for published and unpublished work. A photographer completes Copyright Registration Form VA, adds two copies of a published work or one copy of an unpublished work, and the $20 filing fee. This is sent to the Copyright Office in Washington, D.C. (See Copyright Office information and how to register your copyright at the end of this chapter.)

When registering a group of photographs, things become more complicated. There are options for photographers; again, the options are divided by published or unpublished. And the relative ease of the process is influenced by whether the work has been published or not.

Published photographs will be accepted by the Copyright Office for registration in groups under the following narrow conditions only:

1. Each photograph in the group was first published as a contribution to a collective work within a twelve-month period. (A collective work is a magazine, a periodical, etc.)
2. The author is an individual photographer, not an employer or other party for whom the photograph was made as a work-for-hire.
3. If published prior to May 1, 1989, each photograph as first published contained a separate copyright notice that names the applicant as the copyright owner.
4. Copies of the collective work(s) in which the group of photographs appeared must be filed with the registration (this is called the deposit).

As you can see, only a few published images meet these criteria. One could readily draw the conclusion that group registration of published photographs is not very feasible as a safeguard system to protect one's rights.

Still, there is a bright light of opportunity in the remaining option—the group registration of unpublished images. This opportunity lies in the regulations governing such registration, which are much broader than those for published works.

Group registration of unpublished works are allowed under the following five conditions:

1. All the photographs must be by the same photographer.
2. They cannot have been published (as defined previously herein).
3. Copies of the photographs must be in an acceptable form of deposit (which we will define).
4. Each collection must be given an identifying title (any name will do, e.g., Photographs of Pat Photographer 2001).
5. The entire copyrightable subject matter of each photograph has to be visible (full frame).

That's it. There are no other restrictions. A photographer can register thousands of unpublished images in a single application and for a single $20 fee. There is no time limit—the unpublished photographs could have been taken yesterday or over the last twenty years. These rules are very liberal when compared to the regulations for published works.

To make a bulk registration of unpublished images, a photographer must submit a completed Form VA with the $20 fee. Also required is one copy of a deposit containing all the images to be registered. The deposit can be in any one of the several forms described below:

1. A group of individual transparencies in protective plastic pages.
2. A group of contact sheets (color or black & white).
3. A group of positive contact sheets made from slides ganged together, as when placed in protective plastic pages.
4. A group of color laser copier reproductions of slides, ganged together as in 3 above.

 And finally, after discussions with ASMP, the Copyright Office has officially approved,
5. A videotape on VHS format containing as many images as the tape can hold while preserving the visibility of each image for a least two seconds per image. This means a 120-minute tape could hold 30 images per minute for a total of 3,600 images per tape. Again, the full frame of the original must be visible.

Note: Each tape requires its own Form VA and $20 registration fee.

With this officially approved deposit form, photographers now have a simple, affordable, easily managed system to register their unpublished images.

Note: An example of a completed Form VA, registering a videotaped bulk registration is included at the end of this chapter. A blank copy of Form VA is also included.

It may be photocopied and used to register your work.

Preparing for Registration

Before establishing a system for registering your unpublished photographs, certain analysis is in order. First, one must recognize that most of a photographer's work is unpublished, and, at some point, all work is unpublished. Now the simple fact is that any infringement is likely to be of a published work. So by registering all unpublished work, you will be protecting any photograph that is to be published later.

Second, one must recognize that many times, particularly in stock work, the photographer doesn't know which images have been published for months after that publication. When you add to that fact the difficulty of group registration of published work, it seems clear that the easiest, least expensive, and most timely choice is to register your unpublished work.

If you decide to register your unpublished work, you will have to consider that unpublished work is divided into four categories.

1. Inventory of images on hand but not considered viable for eventual publication (rejects).
2. Inventory of images on hand that is part of your stock file and is likely to be sent to your stock agency. (Remember: The sending of work to your stock agency constitutes publication, as offering your work to a party for further distribution.) You should apply for registration before you send your submission to your stock agency.
3. Assignment photographs that will be, as outtakes, sent into inventory.
4. Assignment photographs that will be sent to the client for possible use.

While you might reasonably decide not to register images that fit into category 1, above, categories 2, 3, and 4 seem important to register.

There are no serious logistical problems for dealing with category 2 and 3 images. Regardless of the way that you create the deposit, you have time to get the work done. However, category 4 images—those waiting to go to a client for a job—present a greater problem because the time available for creating the deposit is limited.

For the most part, if you are shooting black-and-white or color negative film, a color contact sheet can be made to serve as the deposit for registration. But when you have photographed with transparency film, the task of making the deposit is harder to plan.

Although a color contact sheet or a color laser copy of a group of transparencies is an acceptable form of deposit, the equipment to produce these is not readily available. The cost of these methods on a per image basis is high, since only twenty 35mm slides can fit on one sheet, and less when larger formats are used.

Clearly, a videotape deposit offers some distinct advantages. Not only does it reduce the cost per image registered (with the ability to put up to 3,000 images onto a tape, which can cost as little as $5), but it also can be done by any photographer who owns either a video camera and recorder or a camcorder. There are various devices readily available to those who want to build dedicated systems to record their work. They range

from self-contained copy devices, such as Tamron's Fotovix, to inexpensive attachments for a slide projector, such as the Vivitar Slide Duplicator. Many photography and video magazines contain ads for such devices.

The final consideration is to reduce the time it takes to create this registration deposit to avoid delays in delivering the edited photographs to your client. This process can be kept to a minimum by using the video option for a deposit.

Obviously, assignment photographs will have to be edited, and if the video registration deposit can be made immediately after processing, there will be little loss of time.

If the video recording is to be done after the edit, it is important to remember that those images to be sent to your client should be put on tape first, then sent on their way to the client. After that, the remainder of the images can be added. The final act is completing Form VA and sending the tape off to the Copyright Office.

Duplicates and Similars

Many photographers create in-camera duplicates of photographs that they take. Inasmuch as these photographs are identical to one another, only one of them needs to be registered to protect the group of duplicates.

However, similars—those photos that are like but not identical to another image—should be registered as unique images. While one could academically debate the extent of similarity and therefore the need to register some similars, it makes no sense to risk a loss of copyright protection when one considers the economy of bulk registration.

We strongly suggest that similars be registered with your bulk application.

Registering Your Copyright and Obtaining Forms

See information at the end of this chapter for complete information on registering your copyright with the U.S. Copyright Office.

Licensing the Right to Use Your Photographs

As the copyright owner, you have to license someone to use your image before she can legally do so. A license is simply a permission to use the photograph within the licensed parameters.

An exclusive license must be in writing. A non-exclusive license does not have to be granted in writing—although ASMP strongly urges all photographers to grant licenses in written form. This avoids subsequent disagreements about the terms of the license. In the absence of a written license, the photographer and client are in an awkward position. If a dispute over usage arises, differing recollections of rights granted can only be resolved by negotiation or legal action. Legal action is certainly costly and to be avoided if possible. Negotiation, while suitable to resolve disagreements, is best done before use begins, not after the fact. Negotiate the license, then confirm the usage rights in a written copyright license.

Under the copyright law, an "exclusive" grant of rights means a transfer of all or part

of copyright. Avoid these words, unless you intend to transfer some copyright owner-ship to the client.

If a client insists, or you wish to offer exclusive rights, consider limiting the rights as you would limit any other grant of rights. That is, you should properly grant the exclusive rights for a certain time period, a certain geographic area, and a certain media, such as advertising, books, etc. By applying limitations to the exclusive license, you are narrowing the transfer of copyright. By setting a time period, you are ensuring the expi-ration of the transfer.

The rights that you license should be based on the outcome of the negotiations that you have conducted with your client. Generally, you will grant rights to meet the par-ticular uses for which the client wants the work. The fee will usually increase as rights granted increase.

Buyouts and All Rights

"Buyout" and "all rights" are confusing terms and are thought by some to mean a trans-fer of copyright. However, these terms have inconsistent trade definitions, depending on personal understanding, and consequently are not reliable in licensing terminology.

We urge you not to use such terms in licensing clients the rights to your photographs. It is better to clearly state whether or not the copyright is being transferred.

An all rights agreement without a transfer of copyright is a permission to a client to use your image as desired, while the copyright remains with you. This gives the client the widest range of rights for the time allowed in the license without a transfer of copy-right ownership.

Transfer of Copyright

You can transfer copyright ownership to another party. Copyright, like any asset, can be bought and sold. The only requirement in the law is that a transfer of copyright own-ership be in writing and signed by the copyright owner. Photographers should exercise care in signing client purchase orders. ASMP has seen many examples of purchase orders that have a copyright transfer included in the terms and conditions. Signing such a purchase order would result in the loss of your copyright.

There is no law that says you have to transfer copyright to a client. Remember: Even though the client might be the originator of the concept or idea, this does not entitle him to the copyright of the photograph that you, the photographer, originate.

Work-for-Hire

Work-for-hire is another way the client can become the copyright owner. The dif-ference between work-for-hire and a copyright transfer is rather simple. In the case of a copyright transfer, you own the copyright until you transfer it. In a work-for-hire sit-uation, you never own the copyright. It is owned by the client from the moment the work is created, and the client is by law the author of the photograph. The photogra-

pher is denied authorship and is treated as a tool of the client.

Work-for-hire exists automatically in the case of an employee taking photographs for an employer. As provided in the copyright law, no agreements are required.

An independent contractor ("freelancer") can do a work-for-hire only in certain circumstances. First, the work must be commissioned—that is, specifically ordered by someone, and, if it is commissioned, it can be a work-for-hire only if the photograph comes within one of the nine specific categories enumerated in the Copyright Act as qualifying for a work-for-hire:

- Contribution to a collective work
- Contribution to a motion picture or audiovisual work
- Translation
- Supplementary work
- Compilation
- Instructional text
- Test
- Answer material for a test
- Atlas

The category most frequently involving photographers is a contribution to a collective work such as a magazine or other periodical.

The work-for-hire agreement must be signed by the photographer and by the commissioning party. The agreement must be executed before the work commences.

Work-for-Hire and Copyright Differences

Although many see work-for-hire and copyright transfer as the same thing, they are not.

Under the law, if you transfer the copyright, you can get it back after thirty-five years. This "recapture" provision of the law was designed to allow photographers the eventual control over their body of work. Also, when negotiating a copyright transfer, you have the ownership and can bargain for the price of the copyright.

In a work-for-hire situation, you never have the copyright. You have no recapture right at any time. You are simply selling your services for a fee. That fee should reflect the present and the future value of the copyright. If you signed a work-for-hire agreement and later want the copyright to the work, the only way you can get it is to negotiate with the copyright owner to transfer it to you.

Finally, a work-for-hire will, by law, apply to all photographs taken on the assignment, not just to those used by the client. A transfer of copyright can be customized and apply to all the photographs or some portion thereof, such as only those used by the client.

Fair Use

The copyright law allows someone to copy your work without penalty in certain cases. This is called "fair use." In order to qualify for "fair use," the photograph would usually have to be copied for educational, classroom, news reporting, or other educational

or public interest purposes. Fair use is always subject to interpretation. There is no simple rule to apply to determine when an unauthorized use is "fair use." Each case has specific facts that must be examined before such a determination can be made. This is one reason why it is important to consult with a knowledgeable copyright attorney before jumping to conclusions about infringement.

Copyright and Collections

In recent years the trend has been to invoice the client with terms stating that the grant of rights to use the photograph is not in force until the invoice is paid in full. It should be understood that, under this provision, nonpayment may constitute both a breach of the client's contractual obligation and an infringement of the copyright. This can create a legal question about the best way to enforce your rights—a question best answered by competent legal counsel.

It is important to understand that such terms conditioning rights grants by payment must generally have been presented to the client as a condition preceding the sale. In other words, when such a condition is presented only after the work is done, it is less likely to be enforceable.

Definitions From the Copyright Act of 1976

"Audiovisual works" are works that consist of a series of related images that are intrinsically intended to be shown by the use of machines or devices such as projectors, viewers, or electronic equipment, together with accompanying sounds, if any, regardless of the nature of the material objects, such as films or tapes, in which the works are embodied.

A "collective work" is a work, such as a periodical issue, anthology, or encyclopedia, in which a number of contributions, constituting separate and independent works in themselves, are assembled into a collective whole. A contribution to a collective work can itself be copyrightable.

A "compilation" is a work formed by the collection and assembling of preexisting materials or of data that are selected, coordinated, or arranged in such a way that the resulting work as a whole constitutes an original work of authorship. The term compilation includes collective works.

A "derivative work" is a work based on one or more preexisting works, such as a translation, a musical arrangement, a dramatization, a fictionalization, a motion picture version, a sound recording, an art reproduction, an abridgment, a condensation, or any other form in which the underlying work may be recast, transformed, or adapted. A work consisting of editorial revisions, annotations, elaborations, or other modifications, which, as a whole, represent an original work of authorship, is a "derivative work."

A "joint work" is a work prepared by two or more authors with the intention that their contributions be merged into inseparable or interdependent parts of a unitary whole. Each joint copyright owner can grant non-exclusive licenses to third parties subject to a duty to account to the other joint owner(s) for their share and profits.

"Motion pictures" are audiovisual works consisting of a series of related images, which, when shown in succession, impart an impression of motion, together with accompanying sounds, if any.

A "transfer of copyright ownership" is an assignment, mortgage, exclusive license, or any other convenience, alienation, or hypothecation of a copyright or of any of the exclusive rights comprised in a copyright, whether or not it is limited in time or place of effect, but not including a non-exclusive license.

Registering Your Copyright and Obtaining Forms

Registration is handled through the:

> Register of Copyrights
>
> Library of Congress
>
> Washington, DC 20559
>
> Phone: (202) 707–3000

The 24-hour hotline for obtaining registration forms is (202) 707–9100.

Samples of the Form VA, the basic form for registering all works in the visual arts, appear at the end of this chapter. In addition to photographs, as such, this form should also be used for registering the following items when they are primarily or exclusively photographic in nature: books, advertising materials, and most single contributions to periodicals. When these items consist primarily of text, they should be registered in class TX.

If first publication occurs in a separately copyrighted work, such as a magazine, you can still register the copyright in class VA as a contribution to a collective work, thus securing the advantages of statutory damages and legal fees in an infringement case. This procedure is safer than relying on the registration of the collective work itself.

An Emerging Alternative: Collective Administration of Copyright Rights

(This is excerpted from a paper written by ASMP executive director Richard Weisgrau. The entire paper, which outlines the history of collective administration of copyright rights and ASMP's role in this field, can be seen at www.asmp.org under Information Services—White Papers.)

The collective administration of copyright rights is well established in some segments of the copyright industries, particularly music and art, but it is a relatively new means of transacting business in the media photography business.

This is emerging as an alternative to an agency system in which a variety of companies represent a number of photographers. While some are fully aware of the difference between collective administration systems and this existing agency system's approach to licensing rights, others do not recognize the seemingly imperceptible, but quintessential, difference: control of the license fee. This control is not evident on the surface. In fact, it is of little consequence to anyone except the photographer and the

FORM VA
For a Work of the Visual Arts
UNITED STATES COPYRIGHT OFFICE

REGISTRATION NUMBER

VA VAU

EFFECTIVE DATE OF REGISTRATION

Month Day Year

DO NOT WRITE ABOVE THIS LINE. IF YOU NEED MORE SPACE, USE A SEPARATE CONTINUATION SHEET.

1

TITLE OF THIS WORK ▼

NATURE OF THIS WORK ▼ See instructions

PREVIOUS OR ALTERNATIVE TITLES ▼

PUBLICATION AS A CONTRIBUTION If this work was published as a contribution to a periodical, serial, or collection, give information about the collective work in which the contribution appeared. **Title of Collective Work ▼**

If published in a periodical or serial give: **Volume ▼** **Number ▼** **Issue Date ▼** **On Pages ▼**

2

a

NAME OF AUTHOR ▼

DATES OF BIRTH AND DEATH
Year Born ▼ Year Died ▼

Was this contribution to the work a "work made for hire"?
☐ Yes
☐ No

AUTHOR'S NATIONALITY OR DOMICILE
Name of Country
OR { Citizen of ▶
 Domiciled in ▶

WAS THIS AUTHOR'S CONTRIBUTION TO THE WORK
Anonymous? ☐ Yes ☐ No
Pseudonymous? ☐ Yes ☐ No
If the answer to either of these questions is "Yes," see detailed instructions.

NATURE OF AUTHORSHIP Check appropriate box(es). **See instructions**
☐ 3-Dimensional sculpture ☐ Map ☐ Technical drawing
☐ 2-Dimensional artwork ☐ Photograph ☐ Text
☐ Reproduction of work of art ☐ Jewelry design ☐ Architectural work
☐ Design on sheetlike material

NOTE

Under the law, the "author" of a "work made for hire" is generally the employer, not the employee (see instructions). For any part of this work that was "made for hire" check "Yes" in the space provided, give the employer (or other person for whom the work was prepared) as "Author" of that part, and leave the space for dates of birth and death blank.

b

NAME OF AUTHOR ▼

DATES OF BIRTH AND DEATH
Year Born ▼ Year Died ▼

Was this contribution to the work a "work made for hire"?
☐ Yes
☐ No

AUTHOR'S NATIONALITY OR DOMICILE
Name of Country
OR { Citizen of ▶
 Domiciled in ▶

WAS THIS AUTHOR'S CONTRIBUTION TO THE WORK
Anonymous? ☐ Yes ☐ No
Pseudonymous? ☐ Yes ☐ No
If the answer to either of these questions is "Yes," see detailed instructions.

NATURE OF AUTHORSHIP Check appropriate box(es). **See instructions**
☐ 3-Dimensional sculpture ☐ Map ☐ Technical drawing
☐ 2-Dimensional artwork ☐ Photograph ☐ Text
☐ Reproduction of work of art ☐ Jewelry design ☐ Architectural work
☐ Design on sheetlike material

3

a

YEAR IN WHICH CREATION OF THIS WORK WAS COMPLETED This information must be given ◀ Year in all cases.

b

DATE AND NATION OF FIRST PUBLICATION OF THIS PARTICULAR WORK
Complete this information ONLY if this work has been published.
Month ▶ Day ▶ Year ▶ ◀ Nation

4

COPYRIGHT CLAIMANT(S) Name and address must be given even if the claimant is the same as the author given in space 2. ▼

See instructions before completing this space.

TRANSFER If the claimant(s) named here in space 4 is (are) different from the author(s) named in space 2, give a brief statement of how the claimant(s) obtained ownership of the copyright. ▼

DO NOT WRITE HERE
OFFICE USE ONLY

APPLICATION RECEIVED

ONE DEPOSIT RECEIVED

TWO DEPOSITS RECEIVED

FUNDS RECEIVED

MORE ON BACK ▶ • Complete all applicable spaces (numbers 5-9) on the reverse side of this page.
• See detailed instructions. • Sign the form at line 8.

DO NOT WRITE HERE
Page 1 of _____ pages

EXAMINED BY	FORM VA
CHECKED BY	

☐ CORRESPONDENCE
Yes

FOR
COPYRIGHT
OFFICE
USE
ONLY

DO NOT WRITE ABOVE THIS LINE. IF YOU NEED MORE SPACE, USE A SEPARATE CONTINUATION SHEET.

PREVIOUS REGISTRATION Has registration for this work, or for an earlier version of this work, already been made in the Copyright Office?

☐ **Yes** ☐ **No** If your answer is "Yes," why is another registration being sought? (Check appropriate box) ▼

a. ☐ This is the first published edition of a work previously registered in unpublished form.

b. ☐ This is the first application submitted by this author as copyright claimant.

c. ☐ This is a changed version of the work, as shown by space 6 on this application.

If your answer is "Yes," give: **Previous Registration Number** ▼ **Year of Registration** ▼

5

DERIVATIVE WORK OR COMPILATION Complete both space 6a and 6b for a derivative work; complete only 6b for a compilation.
a. Preexisting Material Identify any preexisting work or works that this work is based on or incorporates. ▼

b. Material Added to This Work Give a brief, general statement of the material that has been added to this work and in which copyright is claimed. ▼

6

See instructions
before completing
this space.

DEPOSIT ACCOUNT If the registration fee is to be charged to a Deposit Account established in the Copyright Office, give name and number of Account.
Name ▼ **Account Number** ▼

7

CORRESPONDENCE Give name and address to which correspondence about this application should be sent. Name/Address/Apt/City/State/ZIP ▼

Area Code and Telephone Number ▶

Be sure to
give your
◀ daytime phone
number

CERTIFICATION* I, the undersigned, hereby certify that I am the

check only one ▼

☐ author

☐ other copyright claimant

☐ owner of exclusive right(s)

☐ authorized agent of _____
 Name of author or other copyright claimant, or owner of exclusive right(s) ▲

8

of the work identified in this application and that the statements made
by me in this application are correct to the best of my knowledge.

Typed or printed name and date ▼ If this application gives a date of publication in space 3, do not sign and submit it before that date.

Date▶ _____

☞ Handwritten signature (X) ▼

Mail certificate to:	Name ▼	**YOU MUST:** • Complete all necessary spaces • Sign your application in space 8
Certificate will be mailed in window envelope	Number/Street/Apt ▼	**SEND ALL 3 ELEMENTS IN THE SAME PACKAGE:** 1. Application form 2. Nonrefundable $20 filing fee in check or money order payable to *Register of Copyrights* 3. Deposit material
	City/State/ZIP ▼	**MAIL TO:** Register of Copyrights Library of Congress Washington, D.C. 20559-6000

9

March 1995—300,000

☆U.S. COPYRIGHT OFFICE WWW FORM: 1995

Filling Out Application Form VA

Detach and read these instructions before completing this form.
Make sure all applicable spaces have been filled in before you return this form.

BASIC INFORMATION

When to Use This Form: Use Form VA for copyright registration of published or unpublished works of the visual arts. This category consists of "pictorial, graphic, or sculptural works," including two-dimensional and three-dimensional works of fine, graphic, and applied art, photographs, prints and art reproductions, maps, globes, charts, technical drawings, diagrams, and models.

What Does Copyright Protect? Copyright in a work of the visual arts protects those pictorial, graphic, or sculptural elements that, either alone or in combination, represent an "original work of authorship." The statute declares: "In no case does copyright protection for an original work of authorship extend to any idea, procedure, process, system, method of operation, concept, principle, or discovery, regardless of the form in which it is described, explained, illustrated, or embodied in such work."

Works of Artistic Craftsmanship and Designs: "Works of artistic craftsmanship" are registrable on Form VA, but the statute makes clear that protection extends to "their form" and not to "their mechanical or utilitarian aspects." The "design of a useful article" is considered copyrightable "only if, and only to the extent that, such design incorporates pictorial, graphic, or sculptural features that can be identified separately from, and are capable of existing independently of, the utilitarian aspects of the article."

Labels and Advertisements: Works prepared for use in connection with the sale or advertisement of goods and services are registrable if they contain "original work of authorship." Use Form VA if the copyrightable material in the work you are registering is mainly pictorial or graphic; use Form TX if it consists mainly of text. **NOTE:** Words and short phrases such as names, titles, and slogans cannot be protected by copyright, and the same is true of standard symbols, emblems, and other commonly used graphic designs that are in the public domain. When used commercially, material of that sort can sometimes be protected under state laws of unfair competition or under the Federal trademark laws. For information about trademark registration, write to the Commissioner of Patents and Trademarks, Washington, D.C. 20231.

Architectural Works: Copyright protection extends to the design of buildings created for the use of human beings. Architectural works created on or after December 1, 1990, or that on December 1, 1990, were unconstructed and embodied only in unpublished plans or drawings are eligible. Request Circular 41 for more information.

Deposit to Accompany Application: An application for copyright registration must be accompanied by a deposit consisting of copies representing the entire work for which registration is to be made.

Unpublished Work: Deposit one complete copy.

Published Work: Deposit two complete copies of the best edition.

Work First Published Outside the United States: Deposit one complete copy of the first foreign edition.

Contribution to a Collective Work: Deposit one complete copy of the best edition of the collective work.

The Copyright Notice: For works first published on or after March 1, 1989, the law provides that a copyright notice in a specified form "may be placed on all publicly distributed copies from which the work can be visually perceived." Use of the copyright notice is the responsibility of the copyright owner and does not require advance permission from the Copyright Office. The required form of the notice for copies generally consists of three elements: (1) the symbol "©", or the word "Copyright," or the abbreviation "Copr."; (2) the year of first publication; and (3) the name of the owner of copyright. For example: "© 1995 Jane Cole." The notice is to be affixed to the copies "in such manner and location as to give reasonable notice of the claim of copyright." Works first published prior to March 1, 1989, **must** carry the notice or risk loss of copyright protection.

For information about notice requirements for works published before March 1, 1989, or other copyright information, write: Information Section, LM-401, Copyright Office, Library of Congress, Washington, D.C. 20559-6000.

LINE-BY-LINE INSTRUCTIONS

Please type or print using black ink.

1 **SPACE 1: Title**

Title of This Work: Every work submitted for copyright registration must be given a title to identify that particular work. If the copies of the work bear a title (or an identifying phrase that could serve as a title), transcribe that wording *completely* and *exactly* on the application. Indexing of the registration and future identification of the work will depend on the information you give here. For an architectural work that has been constructed, add the date of construction after the title; if unconstructed at this time, add "not yet constructed."

Previous or Alternative Titles: Complete this space if there are any additional titles for the work under which someone searching for the registration might be likely to look, or under which a document pertaining to the work might be recorded.

Publication as a Contribution: If the work being registered is a contribution to a periodical, serial, or collection, give the title of the contribution in the "Title of This Work" space. Then, in the line headed "Publication as a Contribution," give information about the collective work in which the contribution appeared.

Nature of This Work: Briefly describe the general nature or character of the pictorial, graphic, or sculptural work being registered for copyright. Examples: "Oil Painting"; "Charcoal Drawing"; "Etching"; "Sculpture"; "Map"; "Photograph"; "Scale Model"; "Lithographic Print"; "Jewelry Design"; "Fabric Design."

2 **SPACE 2: Author(s)**

General Instruction: After reading these instructions, decide who are the "authors" of this work for copyright purposes. Then, unless the work is a "collective work," give the requested information about every "author" who contributed any appreciable amount of copyrightable matter to this version of the work. If you need further space, request Continuation Sheets. In the case of a collective work, such as a catalog of paintings or collection of cartoons by various authors, give information about the author of the collective work as a whole.

Name of Author: The fullest form of the author's name should be given. Unless the work was "made for hire," the individual who actually created the work is its "author." In the case of a work made for hire, the statute provides that "the employer or other person for whom the work was prepared is considered the author."

What is a "Work Made for Hire"? A "work made for hire" is defined as: (1) "a work prepared by an employee within the scope of his or her employment"; or (2) " a work specially ordered or commissioned for use as a contribution to a collective work, as a part of a motion picture or other audiovisual work, as a translation, as a supplementary work, as a compilation, as an instructional text, as a test, as answer material for a test, or as an atlas, if the parties expressly agree in a written instrument signed by them that the work shall be considered a work made for hire." If you have checked "Yes" to indicate that the work was "made for hire," you must give the full legal name of the employer (or other person for whom the work was prepared). You may also include the name of the employee along with the name of the employer (for example: "Elster Publishing Co., employer for hire of John Ferguson").

"Anonymous" or "Pseudonymous" Work: An author's contribution to a work is "anonymous" if that author is not identified on the copies or phonorecords of the work. An author's contribution to a work is "pseudonymous" if that author is identified on the copies or phonorecords under a fictitious name. If the work is "anonymous" you may: (1) leave the line blank; or (2) state "anonymous" on the line; or (3) reveal the author's identity. If the work is "pseudonymous" you may: (1) leave the line blank; or (2) give the pseudonym and identify it as such (for example: "Huntley Haverstock, pseudonym"); or (3) reveal the author's name, making clear which is the real name and which is the pseudonym (for example: "Henry Leek, whose pseudonym is Priam Farrel"). However, the citizenship or domicile of the author **must** be given in all cases.

Dates of Birth and Death: If the author is dead, the statute requires that the year of death be included in the application unless the work is anonymous or pseudonymous. The author's birth date is optional but is useful as a form of identification. Leave this space blank if the author's contribution was a "work made for hire."

Author's Nationality or Domicile: Give the country of which the author is a citizen or the country in which the author is domiciled. Nationality or domicile **must** be given in all cases.

Nature of Authorship: Catagories of pictorial, graphic, and sculptural authorship are listed below. Check the box(es) that best describe(s) each author's contribution to the work.

3-Dimensional sculptures: fine art sculptures, toys, dolls, scale models, and sculptural designs applied to useful articles.

2-Dimensional artwork: watercolor and oil paintings; pen and ink drawings; logo illustrations; greeting cards; collages; stencils; patterns; computer graphics; graphics appearing in screen displays; artwork appearing on posters, calendars, games, commercial prints and labels, and packaging, as well as 2-dimensional artwork applied to useful articles.

Reproductions of works of art: reproductions of preexisting artwork made by, for example, lithography, photoengraving, or etching.

Maps: cartographic representations of an area such as state and county maps, atlases, marine charts, relief maps, and globes.

Photographs: pictorial photographic prints and slides and holograms.

Jewelry designs: 3-dimensional designs applied to rings, pendants, earrings, necklaces, and the like.

Designs on sheetlike materials: designs reproduced on textiles, lace, and other fabrics; wallpaper; carpeting; floor tile; wrapping paper; and clothing.

Technical drawings: diagrams illustrating scientific or technical information in linear form such as architectural blueprints or mechanical drawings.

Text: textual material that accompanies pictorial, graphic, or sculptural works such as comic strips, greeting cards, games rules, commercial prints or labels, and maps.

Architectural works: designs of buildings, including the overall form as well as the arrangement and composition of spaces and elements of the design. **NOTE:** Any registration for the underlying architectural plans must be applied for on a separate Form VA, checking the box "Technical drawing."

3 SPACE 3: Creation and Publication

General Instructions: Do not confuse "creation" with "publication." Every application for copyright registration must state "the year in which creation of the work was completed." Give the date and nation of first publication only if the work has been published.

Creation: Under the statute, a work is "created" when it is fixed in a copy or phonorecord for the first time. Where a work has been prepared over a period of time, the part of the work existing in fixed form on a particular date constitutes the created work on that date. The date you give here should be the year in which the author completed the particular version for which registration is now being sought, even if other versions exist or if further changes or additions are planned.

Publication: The statute defines "publication" as "the distribution of copies or phonorecords of a work to the public by sale or other transfer of ownership, or by rental, lease, or lending"; a work is also "published" if there has been an "offering to distribute copies or phonorecords to a group of persons for purposes of further distribution, public performance, or public display." Give the full date (month, day, year) when, and the country where, publication first occurred. If first publication took place simultaneously in the United States and other countries, it is sufficient to state "U.S.A."

4 SPACE 4: Claimant(s)

Name(s) and Address(es) of Copyright Claimant(s): Give the name(s) and address(es) of the copyright claimant(s) in this work even if the claimant is the same as the author. Copyright in a work belongs initially to the author of the work (including, in the case of a work made for hire, the employer or other person for whom the work was prepared). The copyright claimant is either the author of the work or a person or organization to whom the copyright initially belonging to the author has been transferred.

Transfer: The statute provides that, if the copyright claimant is not the author, the application for registration must contain "a brief statement of how the claimant obtained ownership of the copyright." If any copyright claimant named in space 4 is not an author named in space 2, give a brief statement explaining how the claimant(s) obtained ownership of the copyright. Examples: "By written contract"; "Transfer of all rights by author"; "Assignment"; "By will." Do not attach transfer documents or other attachments or riders.

5 SPACE 5: Previous Registration

General Instructions: The questions in space 5 are intended to find out whether an earlier registration has been made for this work and, if so, whether

there is any basis for a new registration. As a rule, only one basic copyright registration can be made for the same version of a particular work.

Same Version: If this version is substantially the same as the work covered by a previous registration, a second registration is not generally possible unless: (1) the work has been registered in unpublished form and a second registration is now being sought to cover this first published edition; or (2) someone other than the author is identified as a copyright claimant in the earlier registration, and the author is now seeking registration in his or her own name. If either of these two exceptions apply, check the appropriate box and give the earlier registration number and date. Otherwise, do not submit Form VA; instead, write the Copyright Office for information about supplementary registration or recordation of transfers of copyright ownership.

Changed Version: If the work has been changed and you are now seeking registration to cover the additions or revisions, check the last box in space 5, give the earlier registration number and date, and complete both parts of space 6 in accordance with the instruction below.

Previous Registration Number and Date: If more than one previous registration has been made for the work, give the number and date of the latest registration.

6 SPACE 6: Derivative Work or Compilation

General Instructions: Complete space 6 if this work is a "changed version," "compilation," or "derivative work," and if it incorporates one or more earlier works that have already been published or registered for copyright, or that have fallen into the public domain. A "compilation" is defined as "a work formed by the collection and assembling of preexisting materials or of data that are selected, coordinated, or arranged in such a way that the resulting work as a whole constitutes an original work of authorship." A "derivative work" is " a work based on one or more preexisting works." Examples of derivative works include reproductions of works of art, sculptures based on drawings, lithographs based on paintings, maps based on previously published sources, or "any other form in which a work may be recast, transformed, or adapted." Derivative works also include works "consisting of editorial revisions, annotations, or other modifications" if these changes, as a whole, represent an original work of authorship.

Preexisting Material (space 6a): Complete this space **and** space 6b for derivative works. In this space identify the preexisting work that has been recast, transformed, or adapted. Examples of preexisting material might be "Grunewald Altarpiece" or "19th century quilt design." Do not complete this space for compilations.

Material Added to This Work (space 6b): Give a brief, general statement of the **additional** new material covered by the copyright claim for which registration is sought. In the case of a derivative work, identify this new material. Examples: "Adaptation of design and additional artistic work"; "Reproduction of painting by photolithography"; "Additional cartographic material"; "Compilation of photographs." If the work is a compilation, give a brief, general statement describing both the material that has been compiled **and** the compilation itself. Example: "Compilation of 19th century political cartoons."

7,8,9 SPACE 7,8,9: Fee, Correspondence, Certification, Return Address

Deposit Account: If you maintain a Deposit Account in the Copyright Office, identify it in space 7. Otherwise leave the space blank and send the fee of $20 with your application and deposit.

Correspondence (space 7): This space should contain the name, address, area code, and telephone number of the person to be consulted if correspondence about this application becomes necessary.

Certification (space 8): The application cannot be accepted unless it bears the date and the **handwritten signature** of the author or other copyright claimant, or of the owner of exclusive right(s), or of the duly authorized agent of the author, claimant, or owner of exclusive right(s).

Address for Return of Certificate (space 9): The address box must be completed legibly since the certificate will be returned in a window envelope.

existing agencies.

For media photographers, the issues of increasing concern are the control of the value, alteration, and subsequent nature of the use of images. Collective administration offers this control.

ASMP has strategic plans to introduce collective licensing into four major areas. These are:
- Licensing of residual publication rights in existing photography
- Licensing of rights to reuse previously licensed photography
- Licensing of rights to make copies of published photography
- Licensing of publication rights to commissioned photography

Once these goals have been accomplished, the media photographer can concentrate on making images, while copyright rights to her works are administered by a collective from the moment of creation to the moment copyright protection expires. This cradle to grave approach will take years to implement, but it is the inevitable, and currently the only, means of allowing media photographers to protect the value of their work in the marketplace.

Once systems are individually completed and operational for the areas listed above, they will be tied together. Collective administration of rights will be pervasive in the field of media photography. Photographers will have their rights administered from point of creation and throughout the useful life of the work. Photographs created on assignment will be available for automatic reuse by the client, and, if available for licensing remaining rights, photographs will automatically be entered into online marketing services for further distribution. Published assignment and stock images will be identifiable as to source of rights. Users of photography will be able to obtain licenses with automated ease. Photographers will be able to concentrate on creating images. Collective licensing will bring better profitability to user and provider. Collective licensing is the inevitable solution to administering media photographers' rights in the information age.

ASMP's vision of a new model for licensing copyright rights of photographers is one in which the photographer, as copyright proprietor, actually retains and exercises the substantial control allowed by virtue of that ownership. For example, the photographer can state how and where, and for what minimum fee, an image can be used. This type of extra control is not standard in traditional photography/agent arrangements. In this model, the collective would handle administration, including providing for the licensing of copyright rights for both initial publication and republication rights of commissioned photography and for the licensing of the residual rights in non-commissioned photography.

This model, like any, is built to meet certain needs and, within certain specifications, dictated by practices of the trade with the industry. To have a thorough understanding of the model, one must understand the terminology to be employed. The definitions that follow are either current terms of art or have been fashioned to provide terminology where none has developed due to minimal experience of the trade.

Collective licensing. A system of cooperative administration of copyright rights

with noncooperative pricing, in which rights holders combine to share the burden of administration while retaining the freedom to establish the licensing fees for the use of their works.

Primary rights. Copyright rights of higher value by virtue of use, for example, an advertising or editorial illustration appearing in consumer, trade, or educational media.

Secondary rights. Copyright rights of lower value by virtue of use, for example, a photocopy or "quick" printed materials usually appearing in very small circulation or lesser media.

Image file. An image or duplicate of same, regardless of the media in which captured.

License. A permission to use certain of the copyright rights in an image.

First-generation publication right. The right to reproduce an image from an image file delivered to the user (licensee) by the provider (licensor), for instance, a photograph in a magazine or on a Web site made from an image file delivered by the photographer or agency.

Second-generation right. The right to reproduce an image captured by copying by any means from a first-generation licensed application, for example, a copy of a photograph acquired by scanning a printed page or downloading a digital file from an electronic application.

Reuse right. The right to use a photograph published under a prior license for subsequent additional use, such as the republication of a photograph in a subsequent press run of a brochure, or in another application such as product packaging.

ASMP is concentrating on information services and collective licensing as its central missions to fulfill its advocacy purpose. This action was made easier as a direct result of a beneficial alliance formed between the ASMP and the Society's licensing entity, the Media Photographers' Copyright Agency, MP©A, and CCC, Copyright Clearance Center, the nation's largest reproduction rights organization. The CCC had been ruled out as a possible ally in prior years, but due to certain policy and management changes and new strategic directions, it became a near-perfect ally. CCC was already heavily engaged in the business of collective administration of copyright rights. It had an existing business with twenty years of history, and it was preparing to take its first steps toward diversifying from secondary rights administration only by adding the administration of primary rights.

When the alliance was first agreed to, MP©A represented about 400 ASMP photographers. Today, the MP©A program of ASMP represents about 650. About 70 percent of these photographers placed images into the CCC's online and marketing system, MIRA, which has recently been acquired by the photographers' and illustrators' cooperative, Creative Eye, as its stock photography division.

The ASMP, recognizing how long it took to establish flourishing collective rights administration in the music business, is nothing less than pleased that in a few short years it has helped established viable collective administration of media photographers' rights. With the fervor of a true zealot, ASMP is continuing its fifty-seven–year history of protecting and promoting the interests of media photographers, by making the establishment of collective licensing systems for photographers its highest priority. The bat-

tle for control is not ending. It is just beginning.

Chapter 8

Electronic Technology

James Cook, Allen Rabinowitz, Roger Ressmeyer, and Richard Weisgrau

I f you're not using a computer in your business, whether for correspondence, accounting, tracking sales, invoicing, mailing lists, Internet communications, or image manipulation, you're probably not as efficient as you could be.

The digital revolution has had, and will continue to have, a major impact on commercial photography as both a creative and a business tool. From creating unique imagery to keeping the books straight, the computer has become indispensable to many photographers. This chapter will deal with the basics of buying and maintaining a digital work station, how the computer can help in a number of business applications, and the ramifications of the digital revolution on stock and copyright. The changes in technology make it impossible to have the latest information on what's available in a book like this. The key to making the most of the technology that is available is to determine your needs, research what is available to help you meet those needs, and either become proficient in using the technology or understand its capability so you can employ others to meet your requirements.

Regardless of your standard of computer literacy, be prepared to take full responsibility for the research that is absolutely essential to the final selection of hardware and software programs. Also, don't underestimate the time and commitment required to learn and master software, whether business or imaging. And if you delve into computer imaging, don't think that technology is a replacement for talent. The computer is simply a useful tool to make you more efficient and better at what you do.

Before going any further, digest this advice.
- Write down your needs and try to match them with software.
- Make sure any software you buy is returnable after a trial period if it doesn't meet your expectations. If demonstration software is available, get it first.
- Don't expect computer sales people to make your decisions for you. If you were

buying a new car, you would read reviews on performance and seek the advice of friends and associates—computerization demands at least this degree of commitment to research.

- Subscribe to some leading computer magazines, even if only for about six months. You won't need to understand all of the articles but it will provide an excellent overview of available technologies and trends applicable to our industry.

- Don't be afraid to ask questions of associates or acquaintances who use com puters in similar creative businesses. Provided you don't abuse the privilege, most professionals who are well versed in computers will quickly share hard ware and software experiences.

- Most computer questions and problems can be resolved from within user groups that can be either casual or structured organizations of compatible individuals. Try to find one in your community and join. Membership fees are usually quite low.

- Seek out a competent computer consultant who understands your software and your goals. Use the consultant on an hourly basis to help set up your business and creative systems.

- You will get greater satisfaction from your computer if you become "keyboard literate"—in other words, learn to touch type. There are plenty of programs available to help you learn. It will be one of the best investments you will ever make.

Some Basics

First, two important—if simplistic—definitions. The computer system is made up of "hardware" and "software." The hardware is the physical equipment—the central processing unit, the keyboard, the monitor, and such peripherals as a scanner, a printer, and/or other input and output devices, as well as floppy disk drives and storage media containing the software. More ethereal than material, the software (also called "the program") is actually the magnetized data contained on disks that tells the computer how to operate and what to do when a command is entered. Think of the hardware as the camera and the software as the light acting on film.

While the variation between how assorted models of cameras operate is negligible—any two 35 mm cameras will make images with the same film—there is a world of difference between computer brands. For example, a software program designed to run on an Apple Macintosh system will not necessarily work on PC system. This, however, may be a non-issue in the not-too-distant future when the next generation of computers appears on the market. These computers will be able to run any program designed for a multitude of operating systems.

With whatever software is used, be aware of the power and memory requirements necessary to run it on your system. A personal computer uses two different types of data storage or memory, either hard disk or random access memory (RAM). The more memory available, the more powerful the computer. RAM contains information the computer uses to run the system. Think of it as short-term memory contained on a chip,

as well as the working space or temporary storage area for the program being run or on the screen. When you turn off the computer, information in RAM is erased.

The measurement unit for memory is the "byte," which is the amount of space needed to store a single character—whether it's a number, letter, or code. The amount of data storage is usually given in either kilobytes (KB), which equals 1,024 bytes, or megabytes (MB),which is over one million bytes. The memory requirements for software will be listed for hard disk and RAM.

Business

Like other business people, photographers have found the computer to be an essential and invaluable tool for everything from keeping books in order to compiling lists for promotional mailings.

Most photographers initially become involved with computers as a means of better organizing and managing business functions. The computer helps you view your business in ways you never would have imagined before. Information that might have taken hours to find and figure out with paper, pencil, and an adding machine can now be discovered within minutes by virtue of the right software and a few keystrokes. Such factors as profitability or materials purchase comparisons from year to year, or quarter to quarter, become more easily attainable.

Not only can you know more about internal business workings, but you can also keep detailed histories on clients with a digital biographical file—listing information ranging from past dealings to which soft drink they like to drink on a shoot—which can be brought up on your computer screen within seconds. In a business based on personal bonds, having that information quickly at hand can go a long way toward cementing relationships.

After becoming somewhat proficient with operating a computer, you might venture into exploring its creative side. You might be curious about creating digital imagery or manipulating existing photography, and with the help of some basic software, possibly interested in expanding your business into this area. However, after a certain point, a decision must be made about obtaining a second computer. While some photographers frown on running both business and imaging applications on the same computer, there are systems with multitasking capabilities to facilitate the same system being used for both business and imaging. Keep in mind that creative applications require huge amounts of memory and unless your system has the speed and memory to switch from one program to another with little delay, it might be preferable—if you can afford it— to have one computer dedicated to imaging and one to business.

The decision to expand computer capability, or acquire a second system, like the initial decision to acquire a computer, should primarily be a financial one. If your time is better spent on the creative end of computing, then an office manager or other assistant can be productive on the business side. Although it is to your benefit to have a good working knowledge of business applications, it's advantageous to spend the time productively creating unique images. When acquiring a second computer, consider, for example, a "notebook" or portable model that offers the option of having computing

ability at hand when on location or in a client's office. However, be aware that a note-book computer might not the best kind to run your entire business. Hard drive capacity might more limited, as is memory expansion, and generally laptops are slower than desktops. While the portables are very useful if you travel a lot and want computing capability on the road, a more modest desktop, which will cost less, is usually a better choice for business applications.

Determine the kind of software that will best serve your business needs and proceed from there. Before purchasing software, research the various business programs available. Ask friends and colleagues—particularly those who are also owners of photography businesses—about the software they use. The best testimonial any product can have is favorable reviews from users. Software manuals, in general, are not easy to follow. And while it's logical to invest time trying to make sense of a manual to get the most out of your software once you've bought it, a better source of information—before you buy a program—is often a book or magazine articles. A bookstore or library will have these books, which usually provide accurate, down-to-earth information. You'll save a lot of money if you read a book, and then decide if you want the program.

Determine your needs and goals before buying software. Expandability is one of the important factors you need to look for in a software package. When purchasing a program, it's wise to consider business goals a year or two down the road rather than where they stand today.

Choose programs that tie various components of your business together. Business flows through the day, and you are constantly navigating in and out of various aspects of that current. Being able to have immediate access and the ability to change hats instantly is a time saver. Ask such questions as:

- Is the software designed to grow with the user's business?
- Does the software have multi-user options if employees are added?

Like most industries, photography has vertical market software written specifically for it. Though general business programs are adequate for many of a photographer's needs, software specifically created for photo studio management will allow you to get right to the root of what it takes to keep your business on track. Unlike generic programs, which offer such features as billing, receivables tracking, materials reports, and basic accounting functions, these programs contain features specific to the photo business, such as managing a stock photo library, estimating, tracking studio inventory, organizing client data, creating mailing lists, and making label lists.

When buying software, find out about what kind of technical support will be available. Varying degrees are offered, ranging from none to unlimited free support. Some vendors offer a limited amount of free support with purchase and then charge for additional time, while others charge from the first question. If this is an important criterion, then the degree of support offered should be weighed before making any purchase.

Some photographers may be tempted to write programs that relate to their specific needs. Although an experienced programmer might be able to take an off-the-shelf database program and customize it for a specific purpose, for most people, it's a time-consuming, difficult process. You might have to invest hundreds of hours on a project that

might have an overall negative impact on your photography business.

Under no circumstances should you copy software for use by anyone but yourself. As concerned as photographers are about copyright infringement, they should recognize and respect the copyright of the software's creator. No matter how basic the program might be, it's covered by the same intellectual property laws that protect your work.

When choosing hardware, remember that what you are looking for is speed, memory, and capability, not necessarily a name brand. Many of the components in clones are identical to those in name-brand computers. But the manufacturer's track record is important, and time should be spent researching a system. Ask around; talk with colleagues.

Although state-of-the-art may be better for quality creative work, for most business applications, an older model might suffice. Many can run up-to-date software and the programs that were current when the computer was new.

A fact of life you'll have to face—probably at the most inconvenient time—is that something will fail. Like film, disks can have physical flaws, and every hard disk degrades over a period of time. In fact, every hard disk is rated for an MTBF (mean time between failures) factor. Rather than lose everything in a crash, take steps to protect data. Back-ups should be done on a regular basis—a good rule of thumb is to do a back-up anytime you've done something you don't feel like doing again. Some photographers express a dislike of back-up programs, stating that they discourage people from actually going through the process of making back-ups. The old system of backing up using floppy disks is still possible but it's antiquated and slow by comparison with CD-ROMs, Zip disks and other newer technologies. Inquire from colleagues what is the best back-up system. Regardless of what you use, make sure that backing up files becomes part of your routine.

It's important to maintain your paper files. Even the biggest proponents of the technology feel that vital documents such as contracts, invoices, and estimates should be outputted as hard copy. Not only will the client's accounting department want to keep such documents on paper, but it's also necessary for tax purposes.

Communications

Using a modem, which is simply a device that connects your computer via telephone systems to other computers, provides the opportunity to communicate with colleagues and clients almost instantly. A modem also provides access from your computer to electronic bulletin boards and information services. The speed with which a modem operates is its baud rate, and the more complex the material you are sending and receiving, the faster your modem should be. Today, most photographers are accessing the World Wide Web, and many have their own Web pages, or are considering developing one, and technology to facilitate easier and quicker access to the Internet is improving all the time.

Most newer computers have internal modems as standard features and numerous models of external modems and communications software are available. As with other

computer equipment, the best advice you can get on modems and communications software will be from others who use them. This is where a computer user group can be an invaluable source of information. Electronic bulletin boards and forums via networks and ListServs allow you to gather and exchange information via your computer.

Still a useful communications tool is the fax machine, which can, in a few seconds, transmit or receive letters, forms, layouts, and composites. Fax/modem software, which allows you to send and receive fax messages from your computer, is also handy. Faxes via modem are of high quality and if you want to capitalize on this quality, use a laser printer to print messages. However, it's not recommended that your fax/modem be the primary business fax machine. If it were, your computer would have to be on all the time, tying up your resources and also subjecting the computer to potential problems, such as lightning strikes. The ideal situation is to have a separate fax for the office, preferably on a dedicated phone line, and also have the capability to send faxes from your computer. And if you have a portable notebook computer with an internal modem you can have fax capability and access to electronic mail on the road with just a connection to a phone line.

Stock and Keywording

Computers have both simplified and complicated the task of organizing a collection of photographs. There is no disputing that computers have simplified labeling slides, and numerous programs to perform that task are available. Also available, and often integrated into powerful studio management programs, is software for preparing delivery forms, invoices, and tracking and pricing stock photos. And there are programs that will generate bar code information for even more sophisticated tracking of stock images. Labeling slides is a basic essential. Computerizing other facets of managing your stock library is more complex, and, as with other aspects of computers in your business, you have to consider the advantages and disadvantages of computerized and manual systems.

Technology has made it possible to deliver images via such electronic media as compact disks or online networks to a greater number of prospective clients. It's also become a trickier proposition to make sure the client gets the exact picture he needs. At a time when stock photography is becoming an art director's growing choice for photo illustration, photographers need to be ahead of the pack in giving that client the easiest path toward making a selection. More than just the arranging of images, computerization of the cataloging process has forced stock shooters to reconsider not only how they organize their files, but additionally what they shoot and how they describe it.

Since a number of top stock agencies have committed large chunks of inventory to CD-ROM, getting images on these disks has become competitive. In this new environment, the photographer who is attuned to such factors as having the kinds of images being sought and giving them the proper identifiers is more likely to get noticed. Unfortunately, too many have overemphasized the importance of the technology delivering the imagery and have underemphasized the property itself. Before loading the first piece of information about an image onto whatever medium, it's up to you to make a

mature, disciplined analysis of the material being delivered.

When dealing in the digital environment, give careful consideration to the type of photos submitted to a stock agency. Given the cost of scanning images onto disks or files for online networks, cleaning up the scan and coming up with the right keyword, use discretion before getting too deeply into the digital process.

The computer can be a useful tool for everyday organizational purposes. If a particular shoot produces a number of images that you believe are worth saving, yet not of the quality to submit for stock usage, put some effort into using the computer for labeling the images and indexing them into some broad, general categories so they can be found easily if a need for them arises. Realize, however, that the vast majority of these images will probably never be used.

Once the photos are selected, they need to be distinguished by the choice of identifiers called "keywords." In searching through electronic media, the client enters a few select words, which produce a directory of possible images to fill that requirement. For your own cataloging purposes, you need only a few choice terms to help find an image. But, in the marketplace, the right keywords can make the difference between a successful image and one that just takes up space on a disk. If the digital universe contains over 1 million possible images, the person doing the search will narrow that process down or else be overwhelmed with responses. The photographer who wins out is the one who gives the criteria essential to winnowing the search down to very specific types of responses.

Though stock agencies are primarily responsible for assigning keywords to images, you should put pressure on your agency to gain input into the process, or, at the very least, get to view the keywords and proofread them to make sure nothing has been left out that you feel is significant before they're placed on the CD-ROM. Once on there, they can't be changed. The art and/or science of choosing the right keywords is constantly evolving. The trick is to choose words that convey the essence of the photo in a way that a client will quickly connect to his concept. Ideally, the keyword is more to sell a photo than to describe it. You can verbally portray a photo in ways that have no value for selling that image and will only clutter up search procedures. When two people are talking visually, the continuity of language is very important if they don't have the same image in front of them. If the photo is of a Caribbean island, for example, the keywords should be geared toward a client's needs rather than the photographer's intent. You might choose such keywords as "Jamaica," or "beach," or "palm trees." But the same photo also conveys such ideas as "leisure," "vacation," or "the good life."

Give a client a sufficient number of options. No matter what words you believe best match the image, they may not be the words the art director would use to call up the same image. Make sure that the keywords include both singular terms and plurals as well as all the words that have the same meaning.

It's important to be a part of this keywording process in order to recognize the type of photos needed to succeed in the new world of stock. By thinking about the keywords that will help sell the image, you can better anticipate and prepare for future shoots in terms of concepts. By getting involved with the keywording process, you become more aware, and therefore, more productive.

Creative

Most photographers who have seen examples of what can be accomplished with the aid of digital technology are curious to see its impact on their work. They see the digital future and are eager to explore it, viewing the computer as neither a threat nor a creative miracle, but rather as a tool which enhances photography.

Though a useful instrument, computers may not be for every photographer. Determine why you want to get involved before purchasing the first piece of equipment or software. If the answer is to do the kind of work that will help you grow as an artist and attract new business, or to accomplish goals not attainable via traditional photographic means, you've taken the first step on the road to the digital future. A popular misconception is that the only kind of work that can be done on the computer is avant-garde, surrealistic photography. Using a computer, it's indeed easier to generate imagery, or adapt and manipulate existing images and accomplish unusual things that you otherwise might not have been able to do. More than anything, however, digital technology allows you to do what you already do better. Just because you have the use of this new tool doesn't mean you should throw out your sensibilities.

The three basic creative applications for which photographers acquire computer equipment are retouching, image enhancement, and image manipulation—primarily cutting and pasting elements of a photo or the combination of two or more images. Before making the investment of time and money, determine whether you want to do this kind of work or if you should farm it out.

Especially with cutting-and-pasting or image combination, it might benefit both the photographer and client to send such work to traditional prepress operators. However, be aware that whoever does the work might have claim on the copyright for the final image, as a derivative created by her. This can be controlled by proper purchasing paperwork in which you reserve the rights to all works derived from your work. But you should still have a working knowledge of what can be accomplished with sophisticated prepress systems and software so you can plan shoots accordingly and produce photos that can be easily manipulated for the client's use.

If only a small amount of retouching is going to be done, it's hardly worth the investment of money and time to do it yourself. However, if you can see that you will be doing a lot of this kind of work, it will probably be worth it to invest in the equipment and expand your services accordingly. As the cost of computers goes down, this becomes more economically viable. But if you can offer this service in-studio as part of the overall photo project, this ability will make you more valuable to clients.

Having decided to explore this digital route, the next step is gaining the knowledge to begin working. In addition to getting information from books and magazines on the subject, take classes on computers and specific software applications and seek out photographers working in the area. Talk to art directors and designers to get their input on what works best for the kind of work they like or want to do.

Trade shows, where most of the leading manufacturers exhibit, are another good source of information. You can inspect the equipment, talk with the representatives, and take the time to explore both hardware and software. Since the reps will push the system's strengths and not talk about weaknesses, ask pointed questions and carefully

weigh all information afterward. The reps will gladly ply you with all kinds of sales literature, which you can take home to compare specifications. The more knowledge you acquire before making a purchase, the better prepared you'll be to choose the right equipment and software for your purposes.

Getting Started in Digital Imagery

After ascertaining your goals in acquiring computer technology, research the specific system needed to create your own brand of digital imagery.

One of the first choices is which platform will serve as the work station. There is continuing debate about which system is best for digital imaging and, while Apple Macintosh emerged as the system of choice for most designers and art directors, advancements are leveling the playing field between systems. In addition, become familiar with such items as scanners and output devices. These peripherals might influence your choice of platform.

A basic question is which comes first—the hardware or the software? Determine which software will best serve your creative purposes and then select a platform that can run it.

The pace of change in software design is rapid, and today's standard may be tomorrow's discount bin remainder. Purchases of hardware and software require that you know what you need and what's available. In other words—educate yourself and buy with your eyes open.

The choice of a system should be based on more than what's the latest—or "coolest"—thing, and instead depend on such factors as finances, the kind of business being done, and your capabilities. The trick is to not overbuy, but rather to buy the things you will really use and the things that will generate revenue.

Above all, you must work through a fairly complex business decision with a serious estimate of what effects this investment will have on your bottom line. Realize that the money outlay is continual, and because of the changes in technology and additions that come on the market, investment in a computer is never really finalized. Although photographers—like other creative types—are not always the best people for this kind of assessment, you have to leave the creative mode and assume a business person's frame of mind. In order for the computer to successfully help you grow your business, you must consider the financial aspects of this purchase and your own aptitude in learning to use and apply these tools.

You can become familiar with computers and software before purchasing by leasing a computer or renting time on a system. If you have a special relationship with a lab or a retoucher, they might provide you the opportunity to become familiar with the technology.

Acquiring a System

Armed with reams of information culled from newspaper and magazine articles, notes taken during discussions with colleagues and clients, pamphlets and brochures from trade shows and a wealth of instructional books, you're ready to acquire a system. But

where is the best place to get the hardware and software necessary for entering the digital imaging arena? Chances are, the local computer retailer will not have the special equipment you need. A better bet is to find a representative for a company that specializes in prepress work stations, or contact companies that specialize in supplying color separators and/or service bureaus with their hardware. The vendor's track record for technical support is a key determinant in choosing where to buy. The dealer should be reputable and capable of helping with inevitable problems.

Some companies will lease equipment on a short-term or month-to-month basis. That's a good way to get used to working on a computer and be up to speed when it comes time to purchase a system. Because of the way technology advances, the chances are the rented system will be outdated by the time you're ready to buy.

When people purchase a sound system for their home, they usually take a tape or compact disk they're familiar with to the retailer to hear how it sounds on a number of systems and components. The same approach needs to be taken when testing computer systems.

Take an image or two to a digital service bureau, and have the technicians there scan them onto a file or a Photo CD. In addition to having something to test on the system, you can also get a practical demonstration of the steps necessary to open and work on a file. Although the scan or CD will cost some money, it's far cheaper to pay for it, and the output, than to discover that a large sum has been spent on the wrong computer. The sales person probably will try to substitute the canned demonstration of the system's capabilities, but insist on a demonstration using your file as well. After the disk is loaded onto the computer, ask the sales person to demonstrate four or five real-life applications you are interested in accomplishing. After the presentation, ask if the system is capable of outputting the result to the type of digital file format or media you would use.

Though used to purchasing photo gear, photographers need to gain a different perspective on costs when dealing in digital equipment. While there isn't a large gap in cost between the cheapest and most expensive cameras and accessories, you'll find a wide disparity in computer prices. Generally, the equipment you want most and that best suits your needs is out of your price range.

Before purchasing any piece of equipment, calculate whether acquiring this new tool will:
- Pay for the hardware and software in a reasonable time. Because computer equipment becomes outdated quickly, two years is suggested by some practitioners.
- Pay for the time it will take to learn the computer.
- Pay for the additional time spent on each job.
- Make a profit on top of all that in exchange for the risk.

Like every other business decision, getting involved with new technology is a matter of balancing profit to risk.

Whether or not to match up software with that of your clients is another issue to address. If your goal is to produce finished art, then good equipment needs to be acquired. If the application is to communicate with clients and provide an on-site serv-

ice where art directors can inspect work in progress, the system need not be top of the line.

A point to remember is this: One only needs a basic computer system with some sort of external storage medium, such as a removable magnetic or hard drive, so that scans and prints can be done by a service bureau. It's when the photographer adds imaging peripherals to the basic system, such as a scanner, a film recorder, and a dye-sublimation printer, that it gets very expensive and complicated. Also, the photographer may opt not to do the imaging work but, once familiar with the technology, can direct others.

Though the computer is an expensive investment, it's also an investment that may need to be repeated in a short time. Because of the pace of change with technology (there are usually upgrades in software about every six months), figure that a system will be out of date within two years. In fact, just at the very second you're finally feeling comfortable with your system, a company has just put the finishing touches on a new bigger, better, faster and cheaper piece of equipment or software, which has made your computer nearly obsolete.

While computers can be upgraded and additional memory can be added, be resigned to purchasing a new state-of-the-art system to stay competitive. When working out the financial details of purchasing a computer, keep this information in mind. After all, it doesn't make much sense to take out a long-term loan for a system that will be obsolete and putting you at a competitive disadvantage before the last coupon is torn from the loan book.

Digital Cameras

In addition to powering equipment for image manipulation, computer chips are also becoming an integral part of image capturing. Many of today's cameras rely on computer circuitry to control and guide essential operations, but, in some cameras, the chip has become the recording medium for images. Increasingly, innovations such as still video and digital cameras are used in areas such as news gathering and catalog work.

Digital cameras, which have become a useful tool for catalog photography, convert images to data just as conventional photographs are scanned to make separations, but there is no film, no processing, and no scanner. If your business involves making a large number of images that don't need to run very large—and you have the money to invest—digital photography may be worth exploring. Digital cameras involve more than just photography. The client can bypass a separator and other prepress steps if the system is used on a job and this should be figured into a photographer's fee. Also, while generally the image quality from digital cameras does not equal film's, the images that some of the more expensive digital cameras and backs are capable of producing, and at reasonably large magnifications, are equal to film. Weigh carefully the economics of investing in this equipment.

If image quality is not a major consideration, digital cameras provide several advantages. Not only do you have a nonchemical (and pollution-free) way of creating an image, but, additionally, you save time between capturing the image and having it in

someone's hands.

However, be aware of the limitations in using digital cameras for certain kinds of work. While it's impossible to know exactly what the future holds in digital imagery, invariably, technology has a way of meeting demand and one day digital photography could come to equal—and perhaps surpass—the quality of silver-based film.

The Learning Curve

After researcihing, exploring, and, finally, purchasing a digital work station, you're ready to start producing—or are you? Just like getting started in anything else, there's a tremendous amount of knowledge to be assimilated, and hours of practice, before you're ready to market this new service. All this education, however, needs to take place while you're still earning a living. Even mastering simple retouching, for instance, might require three nights a week of trial and error for three or four months before you became proficient enough to do it for a client's job. To gain sufficient proficiency in one of the imaging programs, however, might require a much larger investment of time.

For someone doing a significant amount of billing and whose time is valuable, it may pay to go through a training seminar even before purchasing a computer. In addition, instructional videos are available for some Macintosh programs. However, a caveat is in order: As with anything associated with computers, research these training videos. It's best to ask other photographers if such material has been truly helpful. It's been noted that some videos have passed along incorrect information. Though photographers are usually the kind of active people who may not spend much time reading, studying the software manuals or reading other authoritative material should be at the top of your "things to do" list. They might not be the most exciting reads, but these publications contain material you would never discover alone. There are other factors that go into the learning curve. For example, you'll learn that the picture on a computer's monitor can differ from the image on film as much as a Polaroid can.

Using the Computer as a Tool

Once you and your computer system are up and running, the next step is turning it into an income generator. Initially, your rate structure should be reassessed to justify the cost of the equipment and factor in this new expertise. Computer work needs to priced differently from traditional jobs.

Because the digital marketplace is already highly competitive, realize that just because a state-of-the-art piece of equipment has been added, clients will not necessarily beat a path to the studio door.

Not only will a promotional effort be needed to inform existing and potential clients about this new capability, but you need to get these clients to think of you as both an image creator and an image manipulator. Along with the additional billable services you offer clients, the way jobs are estimated and billed needs to be reviewed. Determine how many new jobs per month can be done with the new equipment and how your time will be divided. One fallacy to overcome is that the computer will enable you to do more jobs in less time. In fact, you'll probably spend more time on each job because

of the fiddling with little details that were never considered before you acquired a computer.

Time should be spent thinking about how much more can be earned on jobs unobtainable before. A reasonable estimate should be determined of how much time can be billed on the work station each week without overbooking and overloading yourself. Though clients are usually glad to see the addition of new capabilities in a photographer's studio, they often don't like paying for it. However, if the same service is being provided by an outside vendor, the client would think nothing of approving it on an expense sheet. It's up to you to explain how this new addition helps produce a more cost-efficient or higher-quality job for the client. An important selling point is that the client's image manipulation needs can now be handled in the studio, saving time and the hassle of going to outside vendors.

In order to determine a reasonable price, find out what suppliers in the market are charging for such services and adjust your fees accordingly. This should be reflected in your price, but under two different schedules—one for photographic work and the other for postproduction. If clients are used to paying just for the photograph, it may be necessary to spell out on the bill the time used for postproduction. This can be listed as "system work" or "system time." Since clients are used to paying for this service under these terms, listing it as a routine expense they're used to paying for helps get it through with a minimum of red flags.

Maintenance, Storage, and Back-up

While technical mishaps are inevitable, there are steps you can take to ensure that all is not lost in case of something as major as a system crash. Proper maintenance begins with the purchase of the computer and ascertaining service and technical support.

One preventive maintenance method is to use utilities to defragment the hard disk on a regular basis. This moves all the data from each file onto contiguous sections of the disk so that the access head does not have to travel far, which speeds the process up. A hard drive crashing in the middle of the job is a major problem. However, all might not be lost since there are utilities that can retrieve data. So, if this misfortune befalls you, don't toss the computer away. Seek help from a consultant or a local user group and, depending on the type of crash your computer sustained, you might be able to retrieve your data.

To prepare for those disasters, it's to your benefit to back up files often. Make sure you have a back-up copy of the files you are working on—and all of your other files—stored somewhere other than on your harddrive. Once the job is complete, a back-up of the finished file, with all the pertinent steps in between, can be made. Some photographers believe that if they keep the original photo, it isn't vital to have back-up files of the steps needed to get to the final image, since the original film will always be there. Remember though, if the tweaking and manipulating in PhotoShop was extensive, you are going to have to repeat all of the steps, if you lose the file and don't have back ups. With the proliferation of technology publications and online resources, there should be

no difficulty in ascertaining and acquiring the best storage or backup system for your needs.

Some photographers feel that the lab or service bureau that does their output is the best place to store their files, so a copy can be obtained simply by calling. However, most service bureaus charge a fee for both the storage and the media used.

Outputting and Service Bureaus

Once the work is completed on the digital image, you may need something tangible for the client. This is accomplished by a number of output devices, such as dye-sublimation printers or laser-jet or ink-jet printers.

If a high-quality, high-resolution transparency is needed, an output device can be quite expensive, with film recorders often costing in the six-figure range. The solution is to take a file to a service bureau, just as you would take film in for processing.

In addition to graphics arts service bureaus, many photo labs have added digital equipment and are now positioning themselves as full-service bureaus for all forms of image processing. If you are satisfied with the quality of service the lab has provided for film, it might be best to stick with this lab for digital imaging too. The lab's technicians will most likely know your preferences and tastes. If a level of comfort and trust has been established between you and the lab, there's no reason to look elsewhere if that lab can also accommodate your digital processing needs.

Selecting a place for digital image processing is much like choosing a lab. Ask other photographers and clients who they use and inquire about the kind of equipment they have and its capabilities. Communication is another important factor in choosing a service bureau. Because some service bureau operators are more computer- than image-oriented, they may not understand your instructions and needs. Photographers must realize that since computer operators have different backgrounds and reference points, bridges allowing smooth communication need to be built. You need to feel that the people handling your files are both capable and sensitive to the unique needs of a particular image. The ideal person is someone capable of speaking both the language of computers and that of photography.

A file of the image should be brought in and, after processing, carefully inspected to make sure it's satisfactory. It might be useful to have a print of the image handy for comparison. During the processing phase, ask questions of the technician to ascertain his talents and knowledge. While looking over the technician's shoulder, be aware of certain things and ask the technician:

• Is the work station calibrated?

• Is the monitor accurate in terms of color balance?

If you're satisfied with a service bureau, make sure your equipment is calibrated to theirs. A good service bureau will help regular customers with this process. If you bring a "tryout" file, to some service bureaus, and explain to them that you are using the file as a test to acquaint yourself with the service bureau's capabilities, some of them may offer you a discounted rate for processing, or may do it at no charge.

When to Upgrade

Just when you're really comfortable with the computer and using it to its optimum, the realization will come that there are shortcomings because it's not fast enough or it doesn't have sufficient memory. Or, there's new software or a new effect worth trying, but due to the limitations of the system, it can't be done on existing equipment. Perhaps the computer is not capable of producing work quickly enough to satisfy the standards that clients have come to expect. Because of that, you are losing jobs to those with more state-of-the-art equipment. At that point, the obvious solution is to buy a new computer.

As with the initial purchase, this is a decision that must be weighed carefully, with assessments of both the financial and creative ramifications. A key factor should be whether any upgrade will increase business or revenue capabilities. If you believe a more powerful computer will provide better service for clients, then the choice is easy.

Some photographers buy their initial system with the idea that it will need to be upgraded within a short time. Of course, there are software upgrades, and new peripherals become available. You should keep abreast of all these developments by word of mouth, reading publications, and visiting retailers and trade shows.

Once a new system is up and running, what should be done with the old one? The odds are it's more out of date than useless. It can be transformed into a dedicated function, such as printing labels or for e-mail, be used for personal work or as the "kid's computer," or donated to any number of educational or charitable institutions where it can still serve a useful purpose.

New Markets

Electronic technology has opened both new markets and marketing systems for photographers and many are already capitalizing on these opportunities. Obviously, the Internet and World Wide Web have revolutionized the way business can be done and photographers now have presentation and delivery systems at their disposal that were unheard of not too long ago.

If there is one certainty, it's that change is inevitable and photographers should realize that the emergence of new technologies will make obsolete electronic tools that were once revolutionary. As example, photographers were quick to use CD-ROMs as a medium for stock catalogs and self promotion and many still do. However, the ease with which images can be displayed and updated on Web sites has resulted in an increasing number of photographers harnessing the Web as part of their marketing and sales efforts. On the subject of CD-ROMs, a downside has been that they have also become an outlet for clip art disks, and ASMP has urged photographers not to license their work to these disks, which give users virtually unlimited usage with small returns per image to the photographers.

When introduced, the CD-ROM technology created another avenue for photographers who were producing books and used CD-ROMs as spin-offs. One of the first and most successful ventures into this area was by Rick Smolan whose book From *Alice to Ocean* became a popular CD-ROM.

CD-ROMs have been very useful for self-promotion, and with CD-ROM drives now standard in new computers, this medium has become a cost effective way of presenting or delivering images to clients.

Other potential markets are on-line interactive education programs and entertainment games, and a huge demand for photographs in this area is predicted.

Some photographers who have mastered desktop publishing software, such as Quark Xpress™ or PageMaker™, and using Photoshop™ or similar to import photographs, are using desktop color printers to produce small quantities of their own printed promotional materials. This capability also makes it simple for photographers to produce such things as personalized promotional sheets or invoices.

The new technologies also make it possible for photographers to broaden their range of service, either independently or in alliance with others, such as designers. Photographers who are strong in design can offer expanded services by becoming conversant in all facets of pre-press production. Others could consider forming an alliance with a designer to become a production shop.

If you do expand your capabilities and are able to provide a broader range of pre-press services, bear in mind the added value you give your client—charge accordingly. You must be able to profit from your investment in new equipment and your skills.

Copyright

Though the computer may be considered a great creative tool, its use in photography has opened a Pandora's box in terms of copyright. Like all innovations in communications and media, from the phonograph to radio to television to satellites, the digital revolution has advanced the frontier of copyright law. It should be remembered that when the first U.S. copyright law was written in 1790, the birth of photography was almost a half-century away. Currently, lawmakers are examining and drafting legislation that will update the copyright laws to deal with digital technologies.

What can a photographer do to protect against copyright infringement? The new environment means not only additional opportunities for image creation, but also additional openings for unscrupulous individuals to take advantage of and usurp reproduction rights to images. The climate calls for both a good working knowledge of digital imaging and increased vigilance on the part of photographers.

The ability to manipulate and combine images complicates the question of what constitutes copyright infringement. Infringement is a use of a copyrighted work without the copyright holder's permission.

An act of copyright infringement is determined by:

- Proof of access by the alleged infringer to the image in question (If there is a great similarity between the two images, access might be assumed).
- An "ordinary observer" test. Would an ordinary observer believe one image is indeed copied from another?
- How much of the total work is used.
- Whether the use results in commercial harm.

Joint copyright is another issue brought to the forefront by the digital revolution. When two or more images are combined (see Definitions from the Copyright Act of 1976 in chapter 7, "Copyright"), all creators possess a copyright to the new work. Each has an unrestricted right to use the image, but all copyright holders must share any proceeds equally.

The widespread use of CD-ROM catalogs also opens up potential problems in many photographers' minds. Their feelings center on the idea that an electronic copy of an image might yield something of the same quality as the original photo. The growth of online networks also fuels their fears.

The CD-ROM catalog is not the only technology that is open to abuse. An original image from a magazine, brochure, stock catalog, or other source can be scanned into a computer and digitally altered without the copyright holder ever knowing this was being done.

The Internet and World Wide Web have created much more opportunity for photographers to have their work seen by global audiences but they have also made it easier for people to steal their work. Some of these "thefts" are the result of ignorance by people who think that anything on the Web is free to download, but more damaging is the blatant commercial use of images stolen from photographers' Web sites. Elsewhere in this book, methods of protecting images on the Web are mentioned, but photographers should be aware that there are software programs that not only prevent unauthorized downloading but also post warnings when anyone attempts to download or print an image from the Internet.

Another potential rights problem for photographers is the practice of magazines storing the scans they make of photos. There are no guarantees that the photo will not be reused, perhaps manipulated without the photographer's authorization and without additional payment.

Given the potential for abuse, how can you best protect your copyrights in this new digital world? Some suggestions include the placement of an electronic watermark in the form of a copyright symbol on all images incorporated on CD-ROM catalog or online networks. As mentioned previously, there are software programs that protect images on the Internet. There is also encryption, a scrambling of the digital content that requires special keys to decode. (See "Image Protection Standards for the Digital Era" at the end of this chapter.)

However, don't overlook protection provided by traditional means. Write language into such documents as contracts, estimate forms, and delivery memos clearly defining allowable usages for a particular image, with precise wording on the length of time the image may be used and the specific way the client can use it. Include a statement clearly declaring that the image may not be manipulated and/or altered electronically without the copyright holder's express written permission.

All paperwork given to the client should stipulate that if the photo is scanned, those scans must either be destroyed or erased once the agreed-upon usage is completed and paid for. Because of the expense involved, don't expect the user to mail back an electronic file with the scans of the images.

While any documents should contain this information, an invoice may not be the

best place to define the client's photo usage rights. Copyright stipulations on the invoice could easily be considered contracts after the fact, meaning you would have a difficult time enforcing the agreement. In addition, most invoices are sent to the client's accounts receivable department. The people responsible for the image's use and welfare may never get to see the invoice. Copyright stipulations should be sent to the client before the work is done or the sale is made. This makes those stipulations a condition of the sale and much more enforceable.

Before signing any contracts submitted by a client, inspect them carefully to discover what they might say about electronic reproduction rights. This language might be buried in a section of the contract for other nondigital uses. Before submitting any images to a stock agency for a CD-ROM or an online network, ask the agency a number of questions about the project, such as:

- Does the agency intend to register the copyright for all images being used?
- How large will the digital file containing photo information be?
- Will the image file on the disk produce a high-resolution, high-quality image?

If the agency does not provide this information, look elsewhere. The most important thing photographers can do to protect their copyrights is step up their vigilance, which in today's electronic technology era is more important than ever before. When you have dealings with a client, track the possible venues where the client might use her image. Get on any mailing lists the client might have. Also try to acquire any brochures or other printed material the client may produce as well as the company's annual report.

Although the chance for unauthorized use is greater in the digital environment, photographers need to balance this against a rapidly expanding market for such imagery that will provide more opportunities. Although problems exist with regard to copyright, they're primarily extensions of what has existed before. Realize that the electronic realm is simply another medium that has its own problems.

The best way to retain copyrights in light of new technology is to be more precise in the language of communications with clients and continue the practices you've used in the past to safeguard your rights. No matter what the future may hold in the way of newer and more amazing technologies, paying attention to the basics of good business will still be the key to staying on top of the copyright situation.

Image Protection Standards for the Digital Era

© 1994, 1997, 2000 by Roger H. Ressmeyer

(The guidelines presented here first appeared in an image security report prepared by photographer Roger Ressmeyer for the MP©A board and have since been endorsed by ASMP. Many of these guidelines have been adopted by various photo agencies. Mr. Ressmeyer is now a vice president at Getty Images, Inc. However, the recommendations presented here reflect Mr. Ressmeyer's personal views and not necessarily those of Getty Images.)

This report focuses on the challenge of protecting images in the much more vulner-

able environment of cyberspace. Whatever protection the photographer uses today must remain effective for ten, twenty, or one hundred years, since a digitally stored image might last for centuries after the original negative or transparency has faded into oblivion. Modern technology evolves so rapidly that encryption, watermarking, and other high-tech protections will possibly be defeated almost as soon as they are applied. As a bottom line, we strongly recommend a low-tech approach that can't be defeated by present or future technology: Before release to a client or into any environment (such as the Internet) where copying is possible, each and every digital image should have a copyright notice, credit, and unique identifying number embedded (bit-mapped) into it, in pixel form as part of the image itself.

Keep in mind that from both the freelance photographer's and the photographer agent's point of view, it is imperative that image ownership be protected at all times. When selecting a digital photo agency or when having your images scanned, make sure that the organization understands this basic requirement: To protect the image, a clearly legible statement of authorship (credit) and also of copyright ownership (legal notification) must be attached to the image before any distribution, and preferably from the moment of scanning.

Since there are literally hundreds of image file formats as well as format conversion programs, whatever convention you use for copyright and credit notification should continue working any way the image is viewed or stored now or in the future. We cannot assume that any single image format will become the standard in the future, and we cannot assume that images scanned and originally stored in one format will be viewed and used in that same format.

Therefore, we recommend our "low tech" solution. Don't be confused by technicians and art directors who have different ideas: Your credit must be stored in the image bitmap itself for full protection. Information can also be stored in "channels," "layers," "headers," or in attached databases. However, information stored these other ways can too easily be stripped away and discarded without notice when conversion programs open the image. Face it: In thirty years a researcher will be happy enough just to get the image open, and will not be concerned about hidden data stored in some obsolete format. Try opening word processing documents from just a dozen years ago, and you will understand the implications of obsolete formats.

We also recommend that this bit-mapped credit should not lie on top of the image, where it would destroy otherwise usable picture area. We recommend treating it like an artist's signature line beneath the image, but still within the bit-mapped file. Using the language of Photoshop™, the canvas size of the image needs to be increased, leaving a black bar at the bottom with reversed, white type for the copyright notice. The black bar with reversed type makes it clear that the credit data is an integral part of the image area.

To make the copyright credit legible, the height of this bar depends on the file size. Since ASMP supports adjacent, readable credit lines, we recommend the following sizes:

Thumbnails (192 x 128 pixels) and preview images (384 x 256 pixels): bar 12 pixels high, type 10 pixels high.

Screen Resolution (640 x 480 pixels) and Comps (1280 x 1024 pixels): bar 36 pixels high, type 30 pixels high. Print Resolution (3072 x 2048 pixels) and Full 35mm Resolution (6144 x 4096): bar 72 pixels, type 60 pixels.

Of course, the user can crop out any bit-mapped credit. But as long as the photographer or image provider always includes the credit and copyright notice within the image, the legal burden of copyright protection is placed more squarely on the user who receives that image.

When adding a text-based credit line in Photoshop or other image processing programs, the © symbol is easy to insert: option G makes a © when using the Macintosh; CTRL + ALT + C does the same thing in Word for Windows. Copying the symbol from Word into Photoshop™ is a simple matter.

We also recommend that inclusion of one other type of data in the image bitmap: an image serial number to identify the picture and to enable access to unique image information regarding rights control issues, restrictions, model releases, and captions. Without this number, the scanned image could become unusable, since publishing without knowledge about image restrictions and model releases puts both the photographer and the user at legal risk. (This is not the case when all images are model released and free of all restrictions. Unfortunately, that is not the nature of most picture collections.)

Imagine how much easier it is to "misfile" photos in the digital age! When an art director has selected an image, it will most likely be converted into another format for use in a layout or multimedia product, breaking the connection to the original file. Months or years later, a rights-protected image file without proper identification could be used in any number of unauthorized ways or accidentally confused with broad rights, royalty-free images stored on the art director's drive from a previous project. Everyone benefits from a bit-mapped copyright notice, credit, and serial number when positive identification is required. Adding a permanent URL or e-mail address to the bitmap is another consideration, making it easier to track down the image's author.

Watermarking and encryption also provide valuable safeguards, but they can be vulnerable as technology evolves. Such schemes may be broken, and must never be relied on as the only form of protection. In the future, fail-safe protection may very well be developed. For now, more than one simultaneous approach is advisable.

Nor does low-resolution distribution protect images. Some image publishers will say, "But your image is safe if we only release a low-resolution copy." This logic is absolutely false. No matter how small the file size, no image is safe without some form of protection.

Pixels can be "interpolated" or electronically multiplied, doubling or quadrupling the size of any image. Interpolation will only get better as new fractal and wavelet technology is developed. Therefore, we must conclude that low resolution does not guarantee image protection. It will only get worse in the future, and today's small images will already be out there.

We recommend using encryption and/or watermarking for all images that are screen resolution (640 x 480 pixels) or larger, so clients are forced to register for permission (and pay a fee) before they receive clean copies of higher-resolution images. Also, at the lower resolutions, which are typically used as "thumbnails" and "previews" during

picture searches (192 x 128 and 384 x 256 pixels), we suggest watermarking a large copyright symbol directly into the image, on top of the picture for unregistered viewers. (Using a program such as Photoshop™, this is accomplished in RGB mode by first changing the foreground color to 128 value for red, green, and blue. Select the text tool, and type in a © that is at least 100 pixels high. While the text selection is floating, center it in the picture and change the opacity value to 50 percent.) On the screen, such a watermark is barely visible, but when the image is copied, color separated, printed, film recorded, enhanced, or transmitted, the copyright sign remains with the file and the symbol often becomes more visible.

The example illustrates how the copyright notice, credit, and serial number can be bitmapped onto the image.

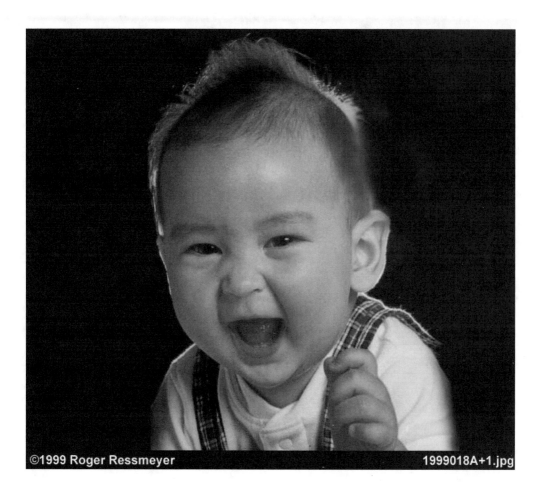

©1999 Roger Ressmeyer 1999018A+1.jpg

Chapter 9

Business and Marketing Strategies

Bruce Blank (creating a business plan), Ira Mark Gostin (15 tips for success), Maria Piscopo (marketing yourself; the joys of telemarketing; publicity to help sell photography; finding the names of potential clients), Mark Tucker (independent contractor or employee), Richard Weisgrau (getting work; the art of selling), Elyse Weissberg (art directors do's and don'ts; ten New Year's resolutions for self-promotion; reinventing yourself; qualifying clients)

Creating a Business Plan

A word of advice before you start reading this section on developing a business plan: Every business, regardless of size, should have a written operations document. You might think that just because you're a one- or two-person business there's no need for a plan. Right? Wrong! The principles of a business plan apply to any size business. The complexity and magnitude might differ but the purpose is the same.

An analogy is planning a trip. How are you going to get there if you don't know where you're going? Taking the time to chart your course before you start—right now—is very important.

The time invested in preparing a solid, well-thought-out business plan will make running a photography business (or any business, for that matter) considerably easier. It is also necessary if success will be a reality rather than a pipe dream. Unfortunately, entrepreneurs are "doers" rather than proposal writers by nature. They would much rather be in the trenches than the command center. Also, much of what is floating around their heads will be difficult to put on paper and articulate to others. Many of these business concepts have become second nature (like knowing that you should overexpose 1/4 stop when you need a little more shadow detail). Photographers may even have a more difficult time than other business people, considering their creative nature (right vs. left brained; creative vs. analytical). One advantage is the fact that you entire career has been spent solving problems. So let's solve a few problems.

Why?

Here's one of the most useful aspects of a well-thought-out business plan: It will allow you to make mistakes on paper instead of in real life. You will use it to develop ideas

about how the business will be run, what your management philosophy will be, where the money will come from and where it will go. It will be your chance to examine this new entity from all perspectives: marketing, operations, finance, and so on. It will be a model that will allow you to do some cerebral testing prior to risking time and limited financial resources.

In addition, a business plan will give you something to measure the business' actual success and performance against over time. For example, the financial projections can be used as a foundation for an operating budget that is more than an educated guess. Just as budgets will need to be adjusted as time passes, the plan should also be used to evaluate operations, philosophy, and management on an ongoing basis.

Don't waste your time drafting a business plan and allowing it to collect dust. Use it. Annually (perhaps during the week between Christmas and New Year's) you should spend time reflecting, remembering, and dreaming. Take this week (business will be slow anyway) to reread the last published plan and rewrite it using all the experience you've gained in the last twelve months. Then use it again.

During the next year, periodically pull the plan out to see how you're doing—what is working, what's not working, where the money is coming from, what you can do to keep more of it, and so on. Don't keep this plan a secret! Let others read it and welcome their input. Two heads are better than one! Undoubtedly, someone else will see something you've missed. And another, completely different perspective could save your neck. The plan is an ongoing project and an important tool to chart not only the start-up, but also the continued existence of, "the studio."

Historically, business plans have been used to raise money. This is what most people think of when they hear the words "business plan." If you are seeking funding, your plan will have to excite investors, convey a genuine sense of optimism, and be accurate. You'll need to walk a fine line between content and tone, risks must be addressed (but not dwelled on), numbers must be realistic, and the presentation has to be professional and easy to comprehend. The tone should be businesslike: Use graphics, clear type, and a professional-looking binder. Spelling and grammar must be impeccable. Always keep in mind who is going to read it (bankers, venture capitalists, etc.), so be wary of being too schmaltzy or promising too much. Realism is more important than hype. The plan has to create a bridge between "Madison Avenue and Wall Street," so be wary.

Since a business plan will be changed and reviewed, do it on a word processor (or have it done by someone else and keep the disk). Keep your copy in a three-ring binder with room for additions and handwritten notes. (The copies for bankers and prospective investors can be made to look pretty— yours is the working model). Make sure that each copy is clearly dated and you know which is the most recent—you don't want to give your banker a copy with two-year-old financials. Also, keep a log with names of who received copies, what version they got, and when they got it. There will be people who you will want to keep current, so knowing who has what copy of the plan will make that easier to manage. There will be others who may need to see your business plan occasionally (i.e., leasing companies, important creditors such as labs for large projects, equipment and material suppliers).

Considering that planning of this type is probably more important to small companies than larger companies (a smaller company is less likely to survive a disaster than a larger company with more resources), an accurate, up-to-date business plan is essential. It will help to maintain consistency in management and operations as time passes and is probably the first chance a start-up has to do serious strategic planning.

How?

Keep in mind that outside professionals will be able to take your ideas, plans, and concepts and mold them into a polished plan. It is important to get help and seek professional advice once the basic plan is outlined. Let's face it: No one knows what's on your mind better than you. You have to start the process, but help can be obtained from your accountant and attorney. You do need one or both. They can give you ideas about where to start, what information to include, how to calculate financial projections, and they will probably ask many questions—which should generate even more ideas. Once the plan is started and is on paper, they will see aspects you missed, be able to make suggestions, and help create the finished piece.

In the plan, answer the questions raised by those who read the drafts. Your job is to anticipate and educate—not everyone knows exactly what a photographer does. If questions cannot be answered immediately, make sure this is admitted in the plan. This shows that you are aware of the issue and it isn't something that has been overlooked. You will not write a business plan over a four-day weekend—be prepared for it to take weeks, even months. And remember: It's never completely finished! Before you start writing, consider these factors:

- What will the business actually do? It may sound like a stupid question, but remember that Aunt Martha thinks photographers only shoot brides and babies. She hasn't a clue where the ads in the magazines come from, and, believe me, there are a lot of Aunt Marthas out there.
- Who will steer this ship and, and what makes that person the right person for the job? This is a good time to look inward and do some serious evaluating of your own psyche and motives.
- If you want to get rich, are you really willing to work twenty-hour days and weekends?
- What makes you so much better than the rest of the photographers already out there?
- You are going to sell your services, so what makes them special?
- Can you solve problems?
- Are you the only one in the area who knows how to use the latest lighting gadget?
- What other experiences can you bring to the business?
- How will you market what you do, and who's out there waiting to buy?
- What does your book look like?
- Is there a big enough client base to support your expectations?
- Where are the clients and how do you plan to reach them?
- Will you advertise in source books?
- Use mailers?

- Rely on established contacts?
- Can you really afford to do this?
- Do you have the resources available or will you need financing?
- How much do you need to make after you've invested in equipment and promotional materials?
- What is the revenue potential (be realistic!) versus the day-to-day costs?
- How many billable days a month do you think you will have? And what will you do when your expectations are not met?
- What are other start-up costs besides, rent, electric, telephone, insurance, office supplies, furniture, leasehold improvements, advertising, equipment, equipment repairs, materials used for promo shots (remember that clients are typically billed for materials used for assignments), employee expenses, professional fees (accountant, lawyer, etc.), taxes, business licenses, and permits?

What?

The following are the basic components of a real business plan. You should elaborate on them as much as possible. Remember: The more complete the plan is, the better prepared you will be.

I. Executive summary (*This is not a mere outline of what's in the pages to follow. It should be about two to four pages long, emphasize the key elements in the plan, and show the company's "reason for being."*)

 A. The purpose of the plan
 1. Revenue procurement
 2. Detail an operational plan for controlling the business
 3. Test financial feasibility of a business concept
 B. Define the company
 1. Define what the company will do
 2. Explain what needs the company will satisfy
 C. Market analysis
 1. Define the target market
 a. Geographic
 b. Demographic
 c. Size
 2. Evaluate competition
 D. Marketing and sales activities
 1. Marketing plans and strengths
 2. Sales strategies
 3. Keys for overcoming competition
 E. Company organization and personnel
 1. Important managers and owners
 2. Important operational personnel
 3. Utilization of outsourced personnel
 F. Financial information
 1. Source and use of funds

2. Historical information (if available)

3. Explanation of how financials were prepared (Note: The executive summary is typically followed by a Table of Contents)

II. Company description

This is just an overview since much will be explained in detail elsewhere.

A. Nature of the business
1. What needs exist
2. How the company will satisfy these needs

B. The company's strengths
1. Ability to better serve markets needs
2. Service efficiencies
3. Personnel
4. Geographic/demographic strengths

III. Market analysis

This section should demonstrate your knowledge of the industry and your particular market.

A. Industry description and outlook
1. Describe the photo industry
2. Define the size of the industry
 a. Historically
 b. At present
 c. In the future (five and ten years from now)
3. Industry characteristics and trends
 a. Historical, present, future

B. Target markets
1. Narrow market to a manageable size
 a. Define characteristics of the market
 b. What are the market's needs and how are those needs being met now?
 c. Define purchasers and decision makers
 d. Define seasonal and cyclical trends
2. Primary market size
 a. Number of potential customers
 b. Yearly spending for services your company will offer
 c. Growth potential for defined market
3. Current market penetration
 a. Existing similar businesses vs. potential client base
4. Methods for identifying specific members of target market
 a. Directories
 b. Business publications
 c. Business networking
5. Methods to be used to reach identified members of target market
 a. Source books

 b. Direct mail

 c. Portfolio presentations

 d. Past contacts

6. Important trends and anticipated changes within your primary target market.

7. Potential secondary markets

 a. Define potential

 b. Explore future needs

C. Marketing test results

 1. Number of potential customers contacted

 2. Information supplied to potential customers

 3. Potential customer reactions

D. Competition

 1. Identify by product/service and market segment

 a. Existing competition

 b. Potential competition (how long will you have an edge?)

 c. Direct vs. indirect competition

 2. Competitive advantage

 a. Customer needs

 b. Track record/reputation

 c. Market share

 d. Revenue resources

 e. Support staff

 f. Facilities

 3. Weaknesses (disadvantages)

 a. Customer needs

 b. Track record/reputation

 c. Market share

 d. Revenue resources

 e. Support staff

 f. Facilities

 4. How important is your target market to your competition?

 5. What could prohibit your competition

 a. Finances/cost of start-up

 b. Time

 c. Facilities/support staff

 d. Customer loyalty

IV. Products and services

Do not try to make this section an operations manual for the business. Excess detail will have a negative impact on readers. Detail is appropriate for your copy.

 A. Detailed service description (users' standpoint)

 1. Specific benefits of your service

 2. Your ability to meet needs

 3. What advantages do you present over competition?

B. Copyrights and trade secrets
 1. Existing copyrights with marketability
 2. Anticipated copyrights
 3. Aspects of your service that could be considered trade secrets
 4. Existing agreements with employees/clients
C. Research/development and continued education
 1. Activities in process
 2. Future activities
 3. Anticipated result of R&D
 a. New products/services
 b. Improvements on current products/services
 c. Complimentary products/services
 4. R&D of others in the industry
 a. Technological advances
 b. Industry trends

V. Marketing and sales activities

Here you will need to include both general and specific information. The objective will be to prove that your marketing efforts will bring sales that are capable of supporting your projections in the financial section that follows.

A. Marketing Strategy (Overall)
 1. Market penetration objectives
 a. Large market share vs. competitors
 b. Elevated profitability
 2. Growth plans and strategy
 a. Increased sales over time
 i. reputation
 ii. increased client base
 iii. additional services to meet needs
 3. Increased distribution potential
 a. additional sales staff (rep)
 b. additional markets
 4. Marketing communication
 a. Promotional activities
 i. Mailers
 ii Source book pages
 iii Other
 b. Public relations
 c. Personal selling
 i. Portfolio presentations
 ii Reputation/word-of-mouth
B. Sales strategy
 1. Sales force
 a. Internal

 b. Independent sales staff

 c. Size of sales force

 d. Compensation

 2. Seeking new leads

 a. Identifying prospects

 b. Qualifying prospects

 c. Prioritizing prospects

 3. Sales activities

 a. Number of sales calls per period

 b. Average number of sales per call

 c. Dollar amounts of average sale

VI. Operations

Here, again, too much detail is fine for internal copies of the plan, but try to keep details to a minimum for external copies. Only you need know who's supposed to lick stamps!

 A. Management procedures

 B. Production procedures

 C. Production capacities

 D. Competitive advantages

 1. Facilities/equipment

 2. Staff experience

 3. Availability of outside resources

 E. Suppliers

VII. Management and ownership

The owners' and managers' skills and talents are key elements in the equation. If the plan is being used to raise funding, remember that, to investors, people are as important as, if not more important than, ideas.

 A. Legal structure

 1. Sole proprietorship

 2. Partnership

 3. Corporation

 B. Owners/partners/directors

 1. Names

 2. Positions

 3. Involvement

 4. Expertise

 C. Key people in the equation

 1. Name/position

 2. Responsibility and authority

 3. Previous experience/education

 4. Unique skills and talents

 D. Planned additions to management team

 1. Advisors/paid professionals
 2. Additional key staff

VIII. Organization

The objective is to define who will do what and where responsibilities will be placed.
 A. Descriptions of positions
 1. Primary duties
 2. Authority
 3. Compensation
 B. Anticipated human resource requirements

IX. Funds required and the use of these funds
 A. Current funding requirements
 1. Amount
 2. Timing
 B. Funding requirements—next five years
 1. Amounts
 2. Timing
 C. Use of funds available
 1. Capital expenditures
 2. Working capital
 a. The rule of thumb is six months' working capital.
 D. Impact of new capital on company's financial position (if seeking funding)
 E. Long-range financial strategies

X. Financial data

This section translates into numbers the information presented in all the other sections. All sorts of information may be included, if appropriate.
 A. Historical information (previous three years)
 1. Income statement
 2. Balance sheet
 3. Statement of changes in financial position
 4. CPA involvement in the above
 a. Audit
 b. Review
 c. Compilation
 B. Future financial projections (five years)
 1. Next year (by month or quarter)
 a. Income statement
 b. Balance sheet
 c. Cash flow statement
 d. Capital expenditure budget
 2. Final four years (by quarter or year)
 a. Income statement

 b. Balance sheet

 c. Cash flow statement

 d. Capital expenditure budget

 3. Type of prospective financial data

 a. Forecast (owner's best estimate)

 b. Projection ("what if" scenarios)

 4. CPA involvement

 a. Audit

 b. Review

 c. Compilation

 5. Analysis/explanations of financial data

XI. Exhibits and Appendices

Any additional detailed of confidential information that will add credibility to the plan. You may want to keep these separate and include them on an "as needed" basis.

 A. Resumes of key people

 B. Professional references

 C. Samples of work (photographs)

 D. Market studies for the proposed area

 E. Important published information

 F. Significant contracts

 1. Leases

 2. Partnership/ownership agreements

 3. Insurance contracts

 4. Miscellaneous

A comprehensive business plan is a huge undertaking, but so is owning and managing a photography business. The preceding outline is a guide to be adapted to your situation. Before you start writing anything, enlist the help of an accountant experienced in creating business plans. He can guide you, and help customize this outline to suit your needs.

There may also be help available through the business school at a local college or university. Explore that possibility. Also, many larger, nationwide accounting firms have "new business services" departments. One resource is the Ernst & Young Entrepreneurial Services Group. Ernst & Young is one of the largest accounting firms in the country, with over 100 offices nationwide. Much of the information in this section came from its Entrepreneurial Services Group, which assists potential new business owners in planning their start-ups.

With the proliferation of computers, many software packages have been written to aid in the formation of a business plan. One of these packages might help get you started. However, a software package should not replace a qualified accountant or attorney. Since the computer industry is changing at a brisk pace, research software at a local computer outlet. There are publications that list software packages, and these lists are updated regularly. Your local computer store will probably have one of these books

and can help you find the right package.

Don't discount the local library and bookstores. Although not as "high tech" as using a computer to write your business plan, there are many books on this subject (and they're probably much less expensive than software).

Creating your business plan will take a tremendous amount of work, but the result could prove invaluable. Use the plan—now and in the future.

The Marketing Consultant

One of the biggest challenges facing self-employed photographers is developing and maintaining an effective marketing program. There are many things you can do yourself, and in this chapter you will find advice from numerous authorities in the field. However, invariably photographers will need some help in creating a marketing program and assembling the tools to be incorporated into the campaign. The money spent on working with a specialist—a marketing consultant—could prove to be a very good investment. But before hiring a consultant, do some research yourself and try to develop specific goals so you have a game plan in mind. Have realistic expectations and don't expect a marketing consultant to create the magic bullet for you. As in any creative endeavor, the marketing aspect is best approached with teamwork in mind.

Consultant Elyse Weissberg suggests that you make a list of the areas in which you feel you need help, such as marketing, negotiating, or portfolio preparation and presentation. She advises that you ask the following questions:

1. What is the consultant's experience in the business? It is important to choose a consultant who has hands-on experience in the industry. Has the consultant been successful?
2. If you need help with marketing, you need to know if the consultant has ever spent her own money on marketing. What were her strategies? Were her efforts successful?
3. If you need help with negotiating, look for a consultant who has negotiated locally, regionally, nationally, and internationally. It is easy to "create rules" for negotiation, but real life negotiating is very different.
4. Ask if the consultant can look at your portfolio and help you define your market. Can she show you how to reach that market?
5. Does the consultant understand the needs of your potential client?

Learn as much as you can about the person you are considering hiring as a consultant. Get references. Although the prices vary from consultant to consultant, the real money is spent on investing in the advice they give you. Call a few different consultants; sometimes personalities just click.

Marketing Yourself

Unfortunately, most promotion is done on a sporadic basis (or worse, when sales are already down!) and without the supporting efforts that could make those advertising

dollars more effectively spent. Who is your target market? How do you know anyone has seen your ad or direct mail?

Today, you don't have the luxury of being just a photographer. Today, you own a photography business. All successful businesses have a written marketing plan. So, today's the day to (finally) write your plan or update the one you have written.

Cost-effective and successful promotion of your photography requires a marketing plan for three basic areas. These are advertising, public relations, and personal selling. It is important to understand how closely they can work together and how poorly they work alone. Imagine an umbrella in three sections: advertising, public relations, and personal selling. This umbrella is your overall marketing strategy. One-third or even two-thirds of an umbrella will not work for you as well as the whole umbrella.

Advertising is a nonpersonal, scattershot form of marketing because it is designed to reach large groups of people simultaneously without your personal time and attention. When you can't pinpoint your buyers, buying a display ad in a creative source book makes sense.

The best reason to advertise is that it is more efficient to reach all your potential clients at once than to call them one at a time. If you have a unique style to tell the world about, it's more efficient to expose thousands of people to the style so they can contact you when they have a project for that style. It's difficult (if not impossible) to call art directors and ask, "What are your needs for stylistic images?" Your display ad allows thousands of clients to see the work and identify themselves as potential clients.

The reason a photography client is looking at photographers' ads is that he is looking for something he doesn't already have. Your design objective for the ad is to give clients a strong and distinct impression and to ask people to respond to the ad. Be sure to build in the umbrella factor. For example, if people respond to your ad, add them to your mailing list. Make your advertising work with your direct mail and selling, not independent of them!

Direct mail is another form of advertising popular with photographers and buyers. If you can clearly identify your client base—perhaps your style is more unusual—then direct mail is a better investment. Please don't be dissuaded from direct mail because some clients tell you they throw mailers away. If 90 percent of your clients toss out your piece, you should be ecstatic! That means 10 percent have responded, about three times higher than the average response. But direct mail is becoming more and more sophisticated. Strong design and powerful copy are necessary, not optional.

Four important factors will determine the success of your direct mail.

1. The mailing list must have the current name of the client or buyer for the firm you wish to work with. The firm is not the client—the true client is the art director, the marketing director, or the person who chooses the photographer. Someone has to keep this list up-to-date. This could be the time to hire a marketing assistant.

2. The mailing list must be composed of people who buy your kind of photography. If you can't clearly identify potential clients by what they buy, such as food or fashion photography, then you'll find it difficult to be as successful with direct mail. Display ads might be a better buy. To tie your advertising into your direct mail, try to get a mailing list from the publications you advertise in.

3. A response mechanism (such as a toll-free phone number or a reply card) is essential. It's impossible to call everyone you mail to; have people call you.

4. Regular mailings are important to build the exposure you need to reach the people you want to work with. One-shot mailings do not work as well as regular mailings planned around your other efforts, such as ads and press releases. Don't forget about the visual impression you must make! Buyers will need to see your logo, company name, and any other visual message you want to communicate six to sixteen times before they recognize who you are and what you do. Plan your advertising and direct mail, and work the plan.

Getting Work

"What is the best way to get work?" That is probably a question photographers ask themselves, and others, more often than any other. There is a complex, though simply stated, answer to that question—you get work by selling. You sell your talent, services, experience, and capability. It's not enough to be a good photographer. The people who get work are those who sell themselves to the client.

Essentially a photography business consists of these steps:
- Prospecting: finding the potential buyers.
- Selling: converting each prospect to a client
- Photographing: performing the service
- Financing: being compensated for the service.

As most successful photographers will confirm, it is the first two steps that take the most time and effort, and require the greatest efficiency. If you spend most of your time tending to the last two steps it is like the tail wagging the dog. One thing is certain: Without sales there is no business, and without prospects, there are no sales.

Prospecting is locating the individual, qualified buyer. Finding the names of agencies and firms is not prospecting, but it is the first step. After you have the names of the companies, you have to get the names of the individuals who hire photographers. It doesn't matter if you buy that list, find it in a book, or get it by calling all the listings in the Yellow Pages. The only important factor is that the list is current.

Having targeted your prospective clients, you have to get their attention, then make appointments and sell to them.

These efforts are helped by promotion. Promotion, often confused with selling, is a complementary process. Most photographers create visual promotional pieces, then mail them to prospects; some buy advertising in marketing directories; some do both.

For the average photographer, a direct-mail promotion is probably the best way to maximize the promotional dollar. You get individual space, and can direct the promotion to a specific person known to you. (Advertising books are effective, but your competition is in the same book and the publisher picks the people to whom it is sent.)

Numerous promotional pieces are produced each year. Art directors are inundated with them, so if yours is to work, you have to make it stand out. It has to be worth a second look or it will be trashed. If you make it worth a third look, it might even end

up on the art director's wall.

To sell someone, you have to speak with her, and in some markets (e.g., advertising agencies; audiovisual, film, and video firms; and some galleries) this is preferably done face to face. So you should have a strategy to get an appointment.

The best way to get an appointment is to ask. One way is to write, another is to call. A telephone call is frequently accepted, especially if you are known to the person whom you are calling. Hopefully, the promotional piece you sent will be remembered and your name along with it. Still, you can reinforce the promo piece by writing a simple letter and telling the person that you intend to call in a couple of days to set up an appointment.

The Art of Selling

Writing a letter in advance of calling does not necessarily get your call accepted, but it does get your name in front of the prospect, and each time you do that you are a bit closer to being remembered. Persistence pays off if you don't become a pest. Take a break between contacts. Sooner or later you will succeed. Then, if you present your case just right, you will get an appointment.

When you get an appointment, you will begin with the selling process. The art of selling can be broken down into two parts: presentation and closing. You have to do both to have a consistently effective sales program.

The presentation is when you get a chance to show your "wares" to the prospect. If you have done your homework, your portfolio will contain shots that are representative of the type of work the agency commissions. Keep the portfolio manageable. The prospect has limited time and wants to see the best you have, not everything you have. If you have tearsheets of published work, show them, but only if they are good. Poor samples hurt you, even if they are a result of poor use of good photographs. You'll probably get ten to fifteen minutes, so limit the quantity to something that can be looked at in half that time. Too large a stack will prompt the viewer to hurry through the images, which is likely to undervalue the work.

Don't talk about the specific photographs. They have to speak for themselves. Tell clients about yourself, your background, the type of assignments you have worked on, or your clients. Make them like you. It is easier to buy from someone you like. Ask questions about them: People like you when you take an interest in them. Most of all, ask them to try you on some small job so you can have a chance to prove yourself.

During the closing portion of your sales presentation, always ask for work. That is what you are there for, and that is what you should ask for. Many photographers don't do this. They rationalize the failure to specifically ask for work with an excuse that the obvious reason for the visit was to get work. In selling, the one thing that should never go unsaid is that you want the person in front of you—the prospect—to contract for your services. If you want work, ask for it.

Finally, when someone has taken the time to see you and your work, he deserves a thank you. Not just a "thanks" when you're leaving the door, but a letter expressing it in a sincere and warm way, which is also a way of reinforcing the recognition of your

name in his mind. Remember: Every time your name comes before him in a meaningful way, he is a little closer to remembering it.

You have to develop strategies for following up with art directors and buyers that will not create resentment on their part. They have busy schedules, coupled with tight deadlines. Wasting their time is surely going to get a negative reaction. The best way to avoid being perceived as a nuisance is to ask yourself if there is a good reason to make contact. Do you have something new to show? If so, you have reason to call. Generating new samples through your own test shooting is a good way to produce a constant flow of images that an art director has not yet seen. But the photos have to show something new, not just in subject, but in technique or treatment. If what you show does not introduce some new element, you run the risk of being perceived as boring. Developing a variety of material for your portfolio is important. It allows you to keep coming back with something new. It keeps them interested and, if it is original or creative enough, it might even convince them that you are one of those bright, new talents.

None of this comes easily. There are a lot of would-be photographers out there. What separates the "would be's" from the "will be's" is the commitment to do not only what is required to survive but also what is required to excel. You have to shoot for excellence if you are to stand out and be noticed. Therein lies the key: Excellent marketing, sales, photography, and business practices will make potential clients want to work with you.

Art Directors Voice Their Do's and Don'ts

In a national survey, consultant Elyse Weissberg asked art directors to list their "Do's" and "Don'ts" when working with photographers. Here are some suggestions:

Do
- Include promotional pieces with your work to reinforce who you are.
- Keep things flowing on the shoot (the meter is always running).
- Be easygoing and have a sense of humor.
- Show enterprise. Many times the assignment is obvious—but when a photographer can go beyond what's expected and surprise me with an original visual solution, I will go back to them again.

Don't
- Be disorganized. It interferes with my shoot.
- Show little interest in the job, as mundane as it may be.
- Have a messy studio.
- Give me a reason a picture won't work—before the picture has been made. I can't print excuses.
- Call me as a follow-up to a mailer. If I am interested, I'll call you.
- Call me just because we have landed a new tobacco account to tell me you have shot cigarettes. That does not interest me. What I am seeking is vision.
- Feel you need to tell me how difficult each shot was as I am looking at your book. If I am interested, I will ask.

- Think you have to show tearsheets.
- Call an associate of mine and tell him/her I recommended you if I didn't.
- Leave lengthy solicitations on my phone mail.

To sum up, an art director had this to say: "Hiring photographers is the result of how well a combination of things impresses me—the book, the photographer or rep's personality, and the knowledge each has about how to get things done from several different angles. For a photographer to get more business from me, it depends on how smooth the first shoot went, how the images looked, and how the photographer followed up after the images were delivered."

Ten New Year's Resolutions for Self-Promotion

1. Call every client you worked with and wish them a "Happy New Year." Then tell them you are looking forward to working with them next year.

2. Look through your portfolio and edit out those "filler" images. Less is more; keep your strongest pictures in the book.

3. Keep your portfolio looking fresh. Replace those worn mats, damaged laminations, and scratched plastic sleeves.

4. Create an identity for yourself. This can be accomplished with a creative logo that best represents your style of photography.

5. Design a new promotion piece. Create a fresh look for your mailer or leave-behind.

6. Plan a promotional strategy for the next year, even if it is on a minimal scale, such as sending a promotional card to all your past clients on a quarterly basis. This will help your clients remember you.

7. Send out or drop off your book to one new client a week. Be proactive!

8. Make an effort to get more editorial work. The rates are low, but the credit lines are good exposure.

9. Make a wish list. Keep it a manageable size. Choose five new clients with whom you want to work and go after them.

10. Keep a positive attitude. Remember: Your talents are both needed and valuable.

Reinventing Yourself

- When was the last time you took a hard look at your portfolio? Do the images in your book best represent the style you are currently shooting? Is it well edited? Does the presentation look current? Is it positioned toward the type of assignments you want to shoot? If you answered *no* to one of these questions, then it is time to reinvent your portfolio. Your competition means business. They are not "making do" with their portfolio, so neither should you. Although pricing may be

a factor in choosing a photographer, it is your portfolio that often makes the final hiring decision.

- Do the images in your book best represent the style you are currently shooting? Ask yourself: Does your photography have a specific style? Although you may be a generalist (shooting still life, people, and location), there should be a concise style to your photography. That style should be carried across into your portfolio presentation, promotion, and company identity. Having one "look" for your total package will position you and your company in the way you want to be thought of.

- Is it well edited? As you know, bad self-editing can weaken a portfolio. Make sure the pictures in your book are your strongest "photographic" images—as opposed to images you like for personal reasons. A portfolio with "mixed styles" may be confusing. Many photographers do shoot different styles (depending on the client and subject matter). The best way to present a variety of images in your portfolio is to support each style with five to six strong images. That will show the viewer that you are well versed in each area. Another common mistake is having too many pieces in the book. A good number of pieces for a general book ranges between fifteen and twenty-five images. If you present in 35mm, six to eight slide sheets is a good amount.

- Does the presentation look current? If your portfolio has had the same look for the past three to five years, then you should think about making some changes. The changes do not have to be drastic. Adding new images—whether they be test shots or personal work—can bring more of your point of view to the portfolio. Take chances. Don't try to second guess what you think clients may want to see. Go with beautiful, well-lit photography. Isn't that why you became a photographer in the first place? When it comes to format, I have found that clients find it easier and more comfortable to look at prints as opposed to chromes. (Although in some markets, agencies request "seeing a sample of the film" for lighting purposes, so don't file your chromes away.)

- Most art directors are bothered by the little care some photographers take with the "upkeep" of their portfolio. Portfolios that are falling apart and those with worn boards and badly scratched plastic pages and plastic sleeves do not look professional. Your portfolio needs constant maintenance.

- Is your portfolio positioned toward the type of assignments you want to shoot? Looking through magazines, annual reports, and other visual material in search of "I wish I shot that" images will help you to define your market. I ask photographers whom I consult with to keep a file like this. It helps them to see how their potential clients are using photography and shows them the type of ads that are being produced. Then ask yourself if the images that exist in your portfolio relate to the way your potential clients are shooting. If they don't, it's time to shoot some tests. Use the materials that you have collected to inspire you to create your own new images.

Qualifying Clients

Before you drop off your portfolio or send a direct mail piece, you should research the client to ensure that you are targeting the right person. How do you find out who is working on what and how they find photographers to hire? Ask them! Here is a list of questions to use when qualifying potential clients.

1. Do you use photography? (Stock or assignment?)
2. How often do you shoot? (two times a month, four times a month?)
3. Are you the person who makes the final decision about hiring a photographer?
4. a) Referring to photography as a category, do you use still life photography? (People, kids, location, fashion, etc.?)
 b) Referring to photography as a style, do you prefer an editorial style of shooting? Do you use a graphic style?
5. Do you make appointments or do you prefer portfolio dropoffs?

Keep your conversations short; time is precious and often these people will not be able to stay on the phone as long as you might like. Sometimes, you will get answers only to the first three questions. But remember: You are not trying to make friends. The call is to gather information. If you get the feeling that it is not a good time for the person to talk, get off the phone immediately.

Quickly going over the information gathered previously to show them that you have done your homework is a good idea too.

Once you have qualified a client, go after him. Try for an appointment or drop off your portfolio and send promotion. Don't stop. This process may take a while. It will probably be a combination of these and other efforts that will get your portfolio called in for a job.

The Joys of Telemarketing

Telemarketing scripts are vital to the success of your phone calls to arrange portfolio appointments. You may have the greatest advertising and direct mail campaign, but you still have to talk to clients.

These calls can't be impromptu. Why? Because today's market requires you to make better use of your time and get more information about what clients want so you have the best chance to get jobs. If you are happy with the amount of business and work you are getting, stop reading here. If it is not broken, don't fix it. This is for photographers who want to get more out of precious time on the phone. Telemarketing scripts are not "canned" presentations. They are a technique to improve the effectiveness of your personal and telephone presentations. The technique is simply to write down the anticipated conversation as you would like it to evolve. Be sure to plan for all contingencies. No matter what a client's response, you must have prepared your reply. Not only will this technique help you get more out of every call, but you will approach the entire chore with more motivation and inspiration. You may even like it, but this is not required for effective telemarketing. All that is necessary is that you pick up the phone and do it.

Steps for Script Writing

1. First, find out what the client does, then make the phone call. Talk food photography to food clients, corporate photography to corporate clients.
2. Open with a brief and specific introduction of your services. First get people's attention, then tell them what you want.
3. Come up with something interesting. After all, you are most likely trying to replace another photographer. Why should they switch?
4. Anticipate objections and questions about your services and have very concise answers available. Never hang up the phone without achieving some specific objective. Get an appointment or a piece of information. Successfully accomplishing your objective keeps you motivated to continue telemarketing.
5. Always use sentences beginning with *How, Who, What, When, Where*, and *Why* to facilitate your information gathering, to reduce the time you spend on the phone, and to reduce the dead ends that come with a *no*!

Don't expect these new techniques to feel comfortable initially. Anything not practiced usually is quite uncomfortable. You will feel like you are "pushing" yourself. What you are actually doing is "pulling" out the information needed to get the work. Besides, if being comfortable was important, you wouldn't have become a photographer. Now, you need to be a business owner. Let's look at some typical scripts of situations most common to photographers.

Getting an Appointment

"Hello, I am a food photographer and my name is _____. We are interested in the XYZ restaurants' account and would like to show our portfolio to you this week. When would be a good time to come by?"

The key word here is when. It gives you more options to continue a conversation than if you had asked, "May I come and show my portfolio?" The easy answer to that question is *no*, and doesn't give the client time to seriously consider your request (and their needs).

Showing the Portfolio

Ask these open-ended questions to get information, confirm the information and verify agreements you have reached:

- How often do you use a new photographer?
- What other photography needs do you have?
- When will you be looking at bids on that job?
- Who else in the office buys this kind of photography?

Follow-up

- When would be a good time to check back on that job?
- How do you feel about a follow-up call in three weeks?
- What will you look for in the bids on that job?
- Who will have final approval on the photographer?

Scripts do not have to be elaborate, but they do have to be written with all possible responses (yours and the photo buyer's) indicated. It is simply a matter of thinking through what you want to communicate and what you want to learn from the other person. You will find your communications and presentations not only easier, but more effective. If you have ever completed any phone call and thought afterwards, "Why didn't I think of that?" or "Why didn't I mention that!" then scripting is the way to go.

Publicity to Help Sell Photography

Public relations is an excellent but underappreciated form of promotion for photographers. In a tight economy, being known and having credibility can give you an important edge. First, let's dispel a myth. You don't get publicity just because you're a good photographer. You get it because you ask to be considered for it!

For example, an image in *Communications Arts* magazine may prompt someone on your mailing list to finally call you. Or, your name in the local paper may get someone (even someone who is in a meeting) to come to the phone when you call. Publicity can be the final key to a successful marketing plan.

The most common tool of public relations is the press release. The press release is a standardized form of communicating some newsworthy item to the editors of publications. Be sure to check (today!) that your media list is up-to-date with the editor's names of your client's publications (trade publications), local newspaper, and your local ASMP chapter newsletter (if you are an ASMP member). Client publications seem an obvious choice. In addition, everyone reads the local paper and, because the goal of public relations is repeated exposure of your name and firm, some of this more general exposure could influence a buyer.

If you are an ASMP member and are not sending your press releases to your chapter newsletter—why not? That one additional mailing could lead to an important job referral. Everyone should know what you do as a photographer, so they can tell their friends. If you're not sending in regular releases, please don't complain about the lack of chapter benefits. ASMP works when you do.

Here are some examples of newsworthy items that could generate a press release to any media—client, community, peer:

1. You relocate or open your studio.
2. You add personnel to your staff.
3. You celebrate the anniversary of your firm.
4. You finish a big, important job or work with a name client.
5. You win an award for your photography.
6. You expand with additional services for clients.
7. You participate in a community service project.
8. You are elected to a chapter board of directors.

Finally, you can publicize, build name recognition, and help clients get to know you by joining their professional associations. Membership in these client or industry groups offers the following benefits to photographers:

1. Personal, nonselling contact at meetings with potential clients.
2. Advertising (very expensive) in their newsletter.
3. Free listings in their membership directory.
4. Publication of press releases in their newsletter.
5. Opportunities to participate in community service projects.

Even though this networking can take the form of personal contacts, it is important to remember that you are not selling anything. You are simply increasing the number of contacts with your target market, their awareness of your services, and your chances of getting work. Some other areas to look at for additional publicity are entering award competitions, writing articles, and giving seminars. Most of these will generate additional press releases as well as provide their own public relations benefits.

Finding the Names of Potential Clients

Tracking down names of potential clients is easy when you know where to look.

Target marketing involves narrowing down to a manageable size the vast world of potential clients and then pinpointing (by name) the actual "targets" in that market. Don't let a fear of being locked into one style of design or illustration keep you from targeting a market. When you begin to feel locked in, you can always explore another market. By the same token, it doesn't matter how many different kinds of work you do; prospective clients are only interested in what you can do for them. Successful target marketing is simply matching one of your many skills and portfolios to a client's needs.

The first step in target marketing is to define a specific market. You can do this by deciding who you want to work for or what you want to do. If you are an illustrator, for example, a logical choice for a target market might be an advertising agency because it buys photographs for many different kinds of clients. Every ad agency has a roster of clients for which it buys photography services, and its objective is to find the right photographer for each job. That will be someone who has experience with the type of product and/or service the client has given the agency to promote. For example, an agency with food clients will be looking for an illustrator with food illustration experience.

Another way to define a market is to categorize your work by subject or type of work you do. The simplest way to categorize your illustration work is to break it down into two categories: product or people illustration. Product illustration has many areas (markets) to explore, such as computers, electronics, food, fashion—to name a few. People illustration is needed by service industries, such as banking, real estate, insurance, medical, educational, and financial institutions.

Once you identify some markets that interest you, you will need to pinpoint the names of firms, ad agencies, or corporations in those markets. Some places to find names include:

1. The local library. The library has many resources, including the librarian. You can ask where to find the names of, say, insurance firms in your area. No matter what you are seeking as a client leads list, the library should have it and someone to help you find it.

2. Trade and market directories. They list names, addresses, and phone numbers of firms. Some are cross-referenced by type of product of service offered or by a geographic reference. For example, if you want the names of advertisers, *The Standard Directory of Advertisers* and *The Standard Directory of Advertising Agencies* are comprehensive sources for agencies located across the country. *The Adweek Directory of Advertising Agencies* covers five regions of the United States in five volumes, listing the top 50 ad agencies in the nation and 200–550 agencies billing $1 million a year, depending on the region. The membership roster of the American Marketing Association also includes addresses of ad firms. Be sure to check the new online directories, keyworded by industry.

 Other fields have their own directories. The graphic and industrial design edition of *The Design Firm Directory* contains a state-by-state listing of over 1,500 design firms and their major clients. General market directories like *Artist's Market* and *Photographer's Market* are updated annually and list markets alphabetically. Check your library reference section for these and other trade directories.

3. The daily newspaper. Look in the business section for new products, services, and mergers, and you will find clients who need illustration for new promotional material. Don't overlook weekly business newspapers. They often profile new businesses in the community as well as including general lists of top firms in different industries.

4. Trade shows. A great place to gather leads as well as view a firm's current brochures and other literature that use design and illustration.

5. Trade or business publications. A magazine article on the top publicly held firms, for instance, is an excellent source for annual report clients. Some magazines concentrate on a particular market—such as medicine—and offer information on prospective clients as well as trade shows, mergers, etc.

With a little digging you can come up with sources of leads that aren't published, but are well worth your time pursuing. Chambers of commerce, local business organizations, and local chapters of trade associations all may be able to supply you with client information.

People prefer to work with people they know, and one of the best ways to find and meet potential clients is to participate in an organization. Most groups have special "associate" memberships available and the cost is minimal compared to the potential gains. Often, the membership directory you receive upon joining may be helpful for learning names. If you can go to regular meetings, you can meet and get to know people who could become potential clients or contacts. Contacts such as other designers or illustrators may refer clients they can't accommodate when they have too much work, when they don't have your particular expertise, or when they simply don't do the kind of work needed. One of the best ways to sell your work is to establish relationships with potential clients, and joining an organization is a good way to begin building those relationships. You should not "sell" at this stage, however, but you can gather leads. Furthermore, since your aren't selling, it is a fairly relaxed and nonthreatening situation for you to be in.

After you have the name of a firm, you will need to identify the person who would be your actual client. The important thing to remember is that the company is not your client per se, and an individual buyer is. In any given company, there may be many clients for your services, and you would be wise to contact each one. Never assume that because you are working with one client in a company that potential clients in other departments or divisions will know who you are and what you can do for them.

With most companies, you can tell the buyer by her job title. In ad agencies, it is the creative director, art director, or art buyer. In corporations, it is the marketing manager, sales manager, product manager, or corporate communications manager. Don't overlook firms with their own in-house advertising departments.

A simple phone call can identify the name of your potential client. Once you have a name, you have a target, and then you can begin to sell.

Fifteen Tips for Success

Planning is the key to success in today's rapidly changing business environment. If you think you don't need a plan for your photography business, please read this! Success = Planning + Business Strategy + Photographic Talent! And if you are an established professional photographer, emerging professional, or delving into market expansion, the following are important and relevant tips to keep your business on the right track.

1. Structure. First and foremost, you are no longer someone with a camera. You must consider yourself a small business owner. With the current downsizing and restructuring of resources taking place in corporate America, operating as a small business is mandatory to be competitive and guarantee survival.

2. Associate. You must associate with people who do what you do. Strength in numbers is an old saying, but highly applicable in this context. Whether you join a trade association, attend meetings, or join an online organization, it is imperative that you associate with others in your specialty. Until we, as the photographic industry, stop looking at each other as the enemy, and start looking at each other as colleagues, true success will elude us. Joining is not enough—you must participate. You can only get out of any association what you put into it.

3. Ask. Don't be afraid to ask for help. Most newspapers have a business section and many have small business sections. Your local chamber of commerce may also have resources that you can use, whether you are a member or not. Keep an eye out for companies that produce small business workshops and seminars and call the local number for the Small Business Administration for numbers of other resources. Build your own resource network to assist you.

4. Time management. One of the drawbacks of not having a structured, traditional job is the loss of the structure itself. Do not let self-employment translate into taking it easy. Being self-employed means working long hours. Some type of time and day planner is critical. Whether it is a notebook calendar system like the Day Runner, or a computer or electronic organizer system, you must have a way of planning and tracking your time. If you are not sure how to set up your time management system, check with some of your resources or your office supply repre-

sentative. Network with your peers, and see what works for people you respect.

5. Personal time. This is definitely easier said than done. However, burnout can cause your photography to suffer as well as the image that you project. No matter how rough things are or how stressed or tired you may be, you have to project yourself as energetic and ready to take on the world. Allow yourself some time to relax, exercise, get fresh air, and in general, just wind down a little and recharge. Schedule this time as you would an appointment so you are sure to do it.

6. Learn the laws. Learn what it takes to be in business in your community. Do you need a business license? A business phone line? A city business license? Your resource network will be able to help answer these questions. Give everyone you come in contact with your business card!

7. Use professionals. Evaluate your strong and weak points. If you are not good at bookkeeping and accounting, hire someone. Capitalize on your personal strengths. If you can't write a press release to save yourself, hire someone, or find a small agency interested in trading out photography for publicity work. Tradeouts in this area work well, but make sure you are consistent with the value of your photography. Don't ever give it away.

8. Plan your business strategies. When planning a vacation you would never just jump in the car and drive off. You would at least get a map, decide where you want to go, and then pick your route. In business, many photographers print business cards, and the next thing you know, they're in business. It's crucial to sit down, and figure out a plan. The plan is very simple in that it contains goals, and the strategy is to accomplish those goals. Within the business plan itself, there should be a marketing plan. The business plan also contains financial information, deadlines, and overall strategies as to working the business. The business plan should give an outsider a concise and accurate look at to what you want to do, how you are going to do it, what your marketing strategies are, who you want to sell to, and your overall goals for success. There are numerous places to find assistance with the business plan, including books, as well as seminars, computer programs, workshops and professional marketing consultants.

9. Marketing—the plan. For most photographers, this is the critical document. The marketing plan is what separates the "guys with cameras" from the successful business owners. If you are a photographer who shoots location, industrial, and products in the studio, those are two different goals, and in most cases would have two completely different strategies. The marketing plan should have each goal listed separately. Following the goals should be the specific strategies—what your business's message will be, the marketing tools that you will use to convey that message to your target market, a conclusion, and then a schedule of implementation. The main key to a successful marketing plan, is not to just write it and put it on a shelf. It is a document that needs to be reviewed regularly, updated regularly, and revised as necessary.

10. Know your market. To whom do you want to sell your photographic services? Are you going to market yourself nationally, regionally, locally? By carefully charting out your target market(s), you will ensure that your marketing dollars are not

wasted. For instance, if you want to photograph small products in your studio, do not waste money on direct mail by sending your cards to art directors from ad agencies that specialize in marketing children's clothing.

11. Budget marketing time and money. The best plans in the world are worthless if an adequate budget is not allocated as well as the necessary time to implement the strategies outlined in the marketing plan. A realistic budget should be set after a complete review of all aspects of the marketing plan. Once a budget is set, it should be carefully implemented to initiate the entire campaign. You will need to create and support an advertising or marketing campaign. Time needs to be allocated as well. Make sure that you stay on your marketing schedule by allocating a few hours per week to ensure that work keeps coming in.

12. Promote yourself. Once you've got your business established, your business plan written, your marketing plan outlined, your schedule set, and your money allocated, it's time to promote yourself. Don't use the shotgun approach. As anyone who has purchased advertising will attest, you can't just buy an ad and wait for the phone to ring. Does your answering machine or voice mail say what you do? Do your business cards? Do people who know you understand exactly what kind of photography you do? Be gospel about it, and make those around you excited about what you do!

13. Be image consistent. All your printed materials should project a consistent look and message. Make sure that the typefaces and graphics convey the proper image. You want your name and promotional message to be recognized immediately when your materials hit a prospective client's desk. Hire a designer, get a consultation from an image specialist. All these things will help associate your name to what you do.

14. Follow through. Make sure that you follow through on commitments. If you tell prospective clients that you will be at their office at 2:00 p.m., be there a few minutes early! If you receive a job lead from someone, send a thank-you note, whether you get the job or not.

15. Appreciate and accept the value of your services. Finally, do not underestimate what you provide to your clients. If you see yourself as "just a photographer," they will as well. However, what will they see if you present yourself as the president of a company that provides imaging and consulting?

It doesn't take as much work as this may sound. Spend a few hours every Monday working on marketing. Check your white board for the month's marketing deadline and schedule time to complete the needed tasks. If you work the marketing as a campaign, it all falls into place. Then, you are no longer cold-calling prospective clients, just reintroducing yourself. Now, get out there and promote!

Avoiding Potential Pitfalls

There's enough to worry about in trying to make a living from professional photography without having your life complicated by legal or tax problems. Accordingly, if you

have any doubt about any accounting or tax matter, seek professional advice. You are urged to read the information in chapter 11, "Professional Services." We at ASMP deal with a variety of problems encountered by photographers. Many of these could have been avoided by simply getting everything in writing. But two major areas of concern— and ones which are very confusing—are sales tax and the independent contractor or employee dilemma. Photographers must be aware of these matters. Another potential problem is overextending credit and trying to pay off too much debt. The following items might help you avoid these problem areas.

Don't Carry Too Much Debt

Many businesses make the mistake of trying to carry too much debt, reasoning that any debt is simply an added operating cost. Overlooked is the fact that repaying debt eats into your profit. The more money you owe, the more you will have to earn, often just to maintain your financial status quo.

As an example, a studio owner might add another $1,500 a month to overhead by borrowing to buy expensive new equipment and rationalize the added burden by claiming that another day's billing will take care of it. Actually, the studio will have to generate $1,500 extra profit each month, something very different from simply billing an extra $1,500, to meet that extra debt. If your net profit is 33 percent, you will need to bill an additional $4,500 to meet a $1,500 monthly loan payment.

An experienced studio owner who has seen how too much debt can cripple a business offers this advice:

- Be aware that operating expenses and repaying debt are not the same thing.
- Average your business' revenues over at least three or four months—preferably a year—to determine how much debt you can safely carry. Don't base the business' debt-carrying capability on one good month's revenues.
- If you find you're overextended, rather than trying to get bigger to pay down the debt, go the other way and cut down on expenses. Invariably, there will be costs that can be cut.
- Before incurring more debt, carefully weigh your financial situation to determine if your business will really benefit as a result. How long will it take to recover the costs of the equipment you are financing? Ask yourself: Is this extra debt really worth it?
- Above all, keep reminding yourself that extra debt comes out of your profit.

Sales Tax

If there is a subject both complex and complicated, it's the state run sales taxes. There are differences from state to state on how much and under what circumstances sales tax should be charged. Overall, state sales tax laws are very confusing but it is an area within which potentially lurks a large liability for the photographer. Many photographers can tell horror stories of being confronted with large tax bills for not collecting sales tax—in their state or in others they've done business in. Usually, they found themselves in this predicament through misunderstanding the state's tax codes, not trying to

avoid the tax.

Here are some basic steps you should take regarding sales tax:

- Ask an accountant with which authority you should register your business and get your sales tax registration number.
- Obtain that authority's guidelines on sales tax. Clarify any matter you're unsure about.
- Generally, charge sales tax on the full amount of an invoice.
- If resale exemptions apply, make sure you get a copy of the client's resale certificate.
- If you are doing business in other states, or have a rep in another state, get professional advice on your sales tax liability.
- If you have any doubts about sales tax matters, seek professional advice immediately. That way you will be taking steps to avoid any surprise, and probably costly, tax bills.

Is Your Assistant an Independent Contractor or an Employee?

This is a dilemma that continues to confront small businesses. Historically, commercial photographers have regarded freelance assistants as independent contractors. At the end of the year, if the assistant has earned more than a certain amount (at this writing $600) the photographer sends the assistant a 1099 Form. From that point on, the assistant takes care of paying taxes.

But the issue is clouded, and photographers are advised to treat this matter carefully. There have been attempts to have the relevant laws changed and this could happen. After all, it is not just photographers who are affected.

The laws concerning independent contractors or employees vary from state to state, but the following twenty common-law factors might help photographers determine their assistants' status. If any one of these suggests an employer/employee relationship, you probably should treat the situation as such. It is also suggested that you refer to the Independent Contractors' Agreement information and form in chapter 6, "Formalizing Agreements."

1. Instructions. Has the employer retained the right to require the worker to comply with instructions regarding when, where, and how the work is to be performed?
2. Training. Has the right to provide training with regard to methods of performing work been retained by the employer?
3. Integration. After determining the scope and function of the employer's business, see if the services of the worker are merged into it.
4. Services rendered personally. Does the employer require the worker to perform the work personally; or does the worker have the right to hire a substitute without consulting the employer?
5. Hiring, supervising, and paying assistants. Hiring, supervising, and paying wages of assistants usually shows control over all individuals on a job.
6. A continuing relationship. This usually indicates an employer/employee relationship, even though the arrangement contemplates that the services are part-time; that is, they are to be performed at frequently recurring but irregular intervals (such

as the employee being on call, or whenever work is available).

7. Set hours of work. When an employer establishes set hours of work, this indicates control because it prevents workers from being "master of their own time," which is a right of an independent contractor.

8. Full-time required. This restricts workers from doing other work. On the other hand, independent contractors are free to work when and for whom they choose. However, "full-time" does not necessarily mean an eight-hour day, five days a week—the definition may vary with intent of the parties and nature of work.

9. Doing work on employer premises. This kind of arrangement implies control by the employer because the worker is physically under the employer's direction and supervision. However, there is also control when an employer has the right to direct a person to travel a designated route, or to work at specified places at certain times.

10. Order or sequence set. Employer has control if he retains the right to set patterns of work for his employees.

11. Oral or written reports. These indicate control because workers are compelled to account for their actions.

12. Method of payment. Payment by the hour, week, or month usually indicates an employer/employee relationship—while payment by the job or on a straight commission basis signals that the worker may be an independent contractor.

13. Payment of business or travel expenses. If employer pays worker's expenses, the worker is usually an employee; employer retains the right to control worker's activities in order to control expenses.

14. Furnishing tools and materials. If employer furnishes tools and materials, this indicates an employer/employee relationship. Employer can control the tools the worker uses and, to some extent, in what order. There are numerous exceptions, however; for example, carpenters, auto mechanics, barbers, and the like, who often furnish their own tools.

15. Significant investment. Investment by the worker in facilities used to perform work for another may tend to establish the worker as an independent contractor. Lack of investment, however, may indicate the worker's dependence on the employer, and that an employer/employee relationship exists.

16. Working for more than one firm. Generally, this is evidence of an independent contractor status. However, it is possible for a person to work for a number of firms and be an employee of one or all of them.

17. Making services available to the general public. Individuals who make their services available to the general public are usually independent contractors. Some tests are:

 Do they have an office or place of business?

 Do they hire?

 Are they listed in business section and/or yellow pages?

 Do they advertise in newspapers, trade journals, radio, and the like?

 Do they run their own business, or act in managerial capacity for another firm?

18. Right to discharge. This strongly indicates an employer/employee relationship.

Control is implicit in the power to discharge. An independent contractor normally cannot be fired except for failure to produce results, per her contract.

19. Right (of worker) to terminate. An employee generally has right to resign at any time without incurring any liability; by contrast, an independent contractor agrees to complete a specific job, and is responsible for its satisfactory completion or incurs legal liability for failure to complete.

20. Realization of profit or loss. Persons who can realize a profit or loss as a result of their services are generally independent contractors; and persons who cannot are generally employees.

Chapter 10

Book Publishing

Bill Hurter

t some time most photographers contemplate publishing a book and many have, successfully. It can be both prestigious and lucrative. While new electronic technology has opened up other potential markets, the traditional business principles of book publishing still hold true. There are several approaches to getting started.

Proposing the Idea

1. The photographer can originate an idea that he or she proposes to illustrate and/or write.
2. A photographer and writer can propose a book project jointly, working as a team. How the income and expenses are divided is a matter of individual negotiation between the parties.
3. A writer or publisher can request a photographer to illustrate all or part of a book. In these cases, the photographer should receive a separate contract, advance, and royalties from those of the author.
4. A photographer can be assigned to shoot the pictures for a book. A flat fee is the usual mode of payment, although royalties (which are potentially more lucrative) can often be negotiated.
5. A photographer can license his or her own photographs directly to the author or publisher, or through a stock agency that represents his or her photography.

Elements of the Book Proposal

Editors are looking for material that is fresh, creative, and professional. Editors are also looking for individual reliability—that is, someone who won't drive them crazy. The

quickest way to get rejected is to submit inappropriate material. Know the publishing company and the type of books it normally publishes, and submit material accordingly.

In order to have a book published, the photographer must come up with a salable idea, which requires a knowledge of both the subject and the market. Always query the publisher first. Write one or more publishers a detailed description of the kind of book you want to do, the number of pictures you feel it would require, and any other details that would help them decide if they want to see an outline, which you should offer. Include a proposed title and a list of your previous publishing experience.

Ethically, you may send simultaneous queries to various publishers. You are merely asking if they are interested in your project; you are not promising them anything. It is advisable to say something like, "I am currently querying five publishers to expedite my efforts." If your idea is salable, you'll get a request to see sample photographs and an outline. Note: If a publisher requests a submission that includes photographs, you should make clear in your cover letter that (1) the images are provided solely for the purpose of the publisher's consideration of the photographer's book proposal; (2) ownership of the images, and of the copyright in them, remains with the photographer; and (3) the publisher is obliged to return the images within a prescribed period of time. If original transparencies are submitted, the photographer should assign a reasonable value to them in the event that they are damaged or lost. It is preferable to send duplicates (or digital files with a corresponding proof sheet) initially and originals if required later. Ideally, these requirements would be set forth in a short, simple agreement that you and the publisher would both sign. If that is not possible, then the photographer should either include a signature line on the cover letter for the publisher to acknowledge its agreement to the terms, or at least state specifically in the letter that failure to object to the terms constitutes acceptance of them. Bear in mind that if the publisher does not agree in writing to be bound by the terms of your submission, it may be difficult to enforce those terms against the publisher in the event of a dispute.

With the advent of high-quality duplication and storage of your original images by digital means, it is often preferable to submit photographs on a CD or other transfer disk. Be sure to include notice of copyright on your digital files, as well as a brief text file on the desktop of the CD that outlines your rights and ownership of the images. Be advised that different publishers have drastically different publishing requirements, so in preparing the digital files, subscribe to the publisher's guidelines for preparation of digital files.

After an initial positive reaction from the publisher, the idea should be presented in the form of a proposal, which should consist of a cover letter, visuals, sample text, a table of contents (i.e., an outline), and a partial dummy, if possible and practical. The dummy is possibly the most important element of the "serious" proposal, because it shows the publisher the visual and aesthetic concept of the book. A dummy is a handmade "skeleton" of your book, with sample (typeset) copy and photocopied photos laid out on sample pages. The biggest asset of a dummy is that it guarantees that you and your publisher are both talking about the same book.

There are differing points of view on the value of a dummy. David R. Godine, a major publisher of photo books in the Boston area, for instance, wholeheartedly believes

in the dummy. He prefers that a photographer outline each image, size, and cropping, to produce a "tight dummy, done to size, with every image laid out, as the photographer would want it to appear." The more complete the dummy, according to Godine, the fewer communication problems will occur throughout the publishing process. Although he appreciates the ways other publishers put together a book, Godine prefers to call on the artistic instincts of great photographers. "I have found that the better the photographers, the more they like the challenge of putting together a series of sequenced spreads, which is what a book really is. They like it because it gives them that much more control, and, if they are real artists, the book almost always comes out better as a result of their effort."

Although your dummy may be complete, a publisher may reserve the right to alter, edit, or otherwise redesign your material in almost any fashion desired, depending on the terms of the contract. The elements of the contract are discussed elsewhere, but you should think carefully about whether granting the publisher complete authority to alter or redesign your work is something you can live with later in the editing process. You may feel more comfortable carving out some limitations on the publisher's authority in this regard, or at least insisting that you be consulted before your material is altered or redesigned.

Lou Jacobs, Jr., a photographer who has vast experience in photo-book publishing, on the other hand, reasons that a dummy is unnecessary and impractical. He maintains that most publishers prefer to devise their own layouts. He says, "In the majority of cases I know, dummies were not followed, and the work could have been avoided." Further, he maintains that "No worthwhile publisher should fail to visualize a book if your pictures are excellent and the theme is salable."

Jacobs suggests making a partial dummy, approximately twelve pages, to show the publisher/editor the kind of presentation you have in mind. At the same time, one could submit twenty to forty slides or prints as samples of your work on the specific theme, perhaps in some sort of order, with caption data. Keep in mind that some books, such as large-format, coffee-table photo books, might require a dummy while others might not.

A salable idea must be one that is original and that does not compete with too many existing titles. Study the book market, and, in particular, the niche you wish to fill; that is, children's books, coffee-table photo books, how-to photography books, and so on. Books in Print, available as a library reference, annually lists published books by subject, author, and title. Use it to decide if your proposal idea is unique.

A comprehensive listing of publishers and their subject categories can be found in *Literary Market Place*, a library reference, as well as *Writer's Market* and *Photographer's Market*. *Photographer's Market* will be most worthwhile to those photographers interested in selling existing photographs to publishers.

Elements of the Book Contract

The following section includes a series of headings with which you should be familiar. They are the essence of your book contract, but they're spelled out in layman's terms.

The value of an attorney or agent who specializes in publishing contracts cannot be overemphasized when evaluating the publisher's complex list of rights, terms, and conditions. It is better to know what you are agreeing to before you sign a contract than to be informed about it later on. Since the income from a book may be small—a few thousand dollars—make an arrangement up front with an attorney for a modest fee for a few hours of advice. It is most unwise to sign any book contract without first consulting a knowledgeable expert to advise you specifically on what you are agreeing to, and what your rights and obligations are under the contract. The meaning of a few simple words ("shall" is very different from "may") often has a significant impact on your rights and obligations.

Publication Rights

There are many types of rights that can be negotiated as part of your book contract. One basic principle to remember is that by granting limited publication rights to the publisher, you are not conveying your copyright. Publication rights are simply one aspect of your copyright. Think of publication rights as a license to the publisher to utilize one part of your copyright—which you still own. Here are a few of the many types of publishing rights you may encounter:

• All rights. Publisher receives all rights to your materials. In effect, this is a transfer of your copyright, and, unless specified elsewhere in the contract, you retain no rights at all in your material. Not only is this excessive and unnecessary in most cases, a broad grant of "all rights" will prevent you from using the images in the book for other purposes. This can be avoided by limiting the grant of rights by references to some benchmark, such as the right to publish and sell your material in books only (or in one book specifically), or for a certain period of time, or within a specified geographic area.

- Worldwide publication rights. These rights are similar to all rights because you grant the publisher unlimited use of your materials worldwide. If these rights are granted, they should be limited in some way, such as in certain media (e.g., books only), or for a limited duration.
- U.S. publication rights. A territorial right to market your materials within the boundaries of the United States.
- First North American publication rights. Another territorial right, but only the initial (i.e., first) right to market your materials.
- Foreign publication rights. Another territorial right; it too should be limited to books only or specified for a time period.
- Serial publication rights. This is the right to excerpt or otherwise serialize your work in magazines or other publications. This is often done as a promotional effort to publicize the book.
- Reprint publication rights. This refers to cases when a book is reprinted. The standard allocation of profits from reprint rights is 50–50, half for the publisher, half for the author.

- Paperback publication rights. Another form of reprint rights; that is, a second publication of the book in paperback form.

You should understand what each term means in order to best determine which rights you want to grant the publisher. For instance, a publisher may wish to purchase worldwide publication rights to your material for a specified period of time. This condition not only takes your images out of circulation for the specified time period, but it may mean that the images could be packaged and sold to a foreign publisher without your receiving additional income.

Most times, the publisher demands exclusive publication rights and all subsidiary rights, such as reprint (second, third, and any subsequent editions) rights, serial rights, syndication, advertising, and publicity rights. These rights are usually deemed necessary by the publisher to effectively promote the sale of the book, and to guarantee its perpetuity. The definition of these rights can vary from contract to contract. As you negotiate your contract, bear in mind that virtually everything is negotiable. Also remember that different types of rights each have a unique monetary value to you and the publisher. For instance, syndication of all or part of your book might have great value to both parties because of the tremendous publicity syndication would generate for the book.

Be particularly wary of an all-rights provision. This, in effect, transfers all rights to your material and to other works derived from your material, to be used in any form deemed appropriate by the publisher. You may not wish, for example, to see your original portrait of the President of the United States, done as part of a book on fine portraiture, used on T-shirts or posters. Not only might that be aesthetically objectionable, but it might also be financially punitive.

Publishers now routinely include clauses covering electronic media rights. These rights might cover such uses as educational software or CD-ROM books, in which you follow along with the images and narration on a TV or computer. Alternatively, electronic media rights may include the right to reproduce or transmit in digital form some or all of the photographs in a book on a computer network. Rick Smolan, publisher of the first CD picture book, Alice to Ocean (an Apple CD and a Kodak Photo CD are packaged with every book), believes that CDs are the wave of the future in publishing. At this time, electronic rights, and particularly Photo CD licensing, don't add much financially to the value of the book contract. These rights potentially have high future value, which you must consider before signing. At the very least, insist on some form of compensation (i.e., a royalty) for granting the publisher any sort of electronic media rights, rather than letting those potentially valuable rights go for "free."

In order to protect yourself from unauthorized use of your images that may come in the form of an unspecified right, you should insist on a clause in your contract guaranteeing that all unspecified rights that you have not specifically granted to the publisher in writing are reserved by you.

Delivery and Return of Materials

When the original images leave your hands and are sent to the publisher, you must be guaranteed that the images will remain safe and be treated carefully for the duration of their stay with the publisher. Always send original images by a traceable form of mail delivery, such as registered or certified mail, or by a reputable overnight-delivery firm, such as Federal Express or Airborne. It's always a good idea to insure your images when mailing them.

Each image should have an individual file number by which you can list, track, caption, and otherwise retain order. If you do not use a numbered filing system for your images, devise one for your book projects. Black-and-white and color prints need numbers as well.

Once the images are received, the publisher should be required to agree in writing to take responsibility for them. The publisher should insure the pictures against loss or damage while they are in the publisher's possession. This time frame includes all stages of production. Be certain that your images are protected by specifying such responsibility in your book contract. You should ask that original transparencies and negatives be insured for some mutually agreed-upon value. Also, specify a value for reproduction-grade duplicates, if used in the book. All images should be insured for both loss and damage. Some of your original images may be worth much more than others. Determine if there are any provisions for such highly valuable originals. Again, be sure that such items are clearly understood by both parties, and are included in your book contract.

The point at which your images are to be returned to you must be determined. A more-or-less standard time frame for the return of your materials is sixty days after publication. Make sure that the photographs will be returned in a safe and insured manner.

Copyright

Copyright is extremely important. The book should be copyrighted in the photographer's name, not in the publisher's. If the book is a joint effort between you and a writer, the book can easily be copyrighted in both names simply by denoting that the text is copyrighted by the author, and the photos are copyrighted by you.

When using other people's pictures that you license or that are given to you to use, the contract should stipulate that such photographs will be listed as copyrighted in the name(s) of the photographer. If you are using the photographs of others, it is important to have a written understanding with the owner of the copyright in those images as to the scope and terms of the publication rights granted (i.e., for what publications, appropriate credit, royalties, return, and liability for slides, etc.).

Approval

Many first-time authors and photographers do not make a provision for design approval, and end up being extremely dissatisfied with the book in its final form. Can you negotiate any right of approval? Certainly. At a minimum you can request and be given the periodic right of inspection, while the book is in the design and production phases. Don't be disappointed later: Ask for the right of approval or inspection up front, and

spell it out in the contract! But keep in mind that approval and inspection are different.

If you had submitted a dummy as part of your original book proposal, and it was accepted, at least in concept, then you have grounds for periodic inspection and approval rights. Detailed discussions in advance of the design and production phases can eliminate many potential problems.

The other side of this coin is that many publishers expect the average photographer to "stick to f-stops," and while input on design may be useful to both sides, it may not be any more than conversation. Still, one can ask for or insist on approval, depending upon your convictions on the matter. If you negotiate for the rights of approval and/or inspection, make sure that those rights are clearly spelled out in your book contract.

Warranties

Warranties are a type of disclaimer that both the photographer gives to the publisher and the publisher gives to the photographer. The photographer warrants that, to the best of his knowledge, he has the rights to publish the photographs as required by the contract, and that he has the right to enter into a legal contract with the publisher. Remember that this warranty extends not only to your photographs but also to those of others that may be included in the book under your authorization. Further, the photographer/author warrants that the words to his manuscript are his own, and that there has been no plagiarism.

The publisher, in turn, must guarantee that the photographer will not be liable for any legal actions arising from information inserted into the book without the photographer's approval. Warranties should be spelled out clearly in your book contract.

Advances

An advance is money paid up front to the photographer/author to ensure the successful completion of the book. Advances are usually charged against royalties that the book will eventually earn.

Some publishers may agree to pay expenses separately from an advance (so that the expenses do not have to be earned via royalties, as does an advance); others may increase the size of the advance to make a project more feasible, but require all monies to be earned by the author via royalties. If you anticipate high expenses in producing the photos for your book, it is advisable to ask for a nonreturnable allowance for expenses. Usually, however, publishers expect photographers to pay their own expenses as part of the cost of production.

Normally, the advance is paid in either two or three portions: on signing the contract, on delivery (and subsequent acceptance) of the content, and on publication of the book. It is preferable, however, to be paid on signing and acceptance. *Acceptance* means when all photographs and/or writing has been corrected or revised in accordance with the editors' wishes. This may take four to six months from the date of the delivery of manuscript and photos. To be paid on publication is not advisable, as the actual publication date may be as much as a year after you have submitted the book to the publisher and it has been revised and accepted.

The amounts of advances vary widely. They vary with the sales potential and type

of book, the publisher, and your status as a published photographer/author. Advances can be meager—$2,000 to $4,000—or they may be extravagant—in the $20,000 to $40,000 range. Advances are usually negotiable. Remember: If you are being paid an advance against royalties, the bigger the advance, the longer it will be before you see your first royalty check. However, get the largest advance you can, because you may not see any more money if the book doesn't sell well, and the contract should provide that no portion of the advance must be returned even if royalties do not reach the level of the advance.

An advance can be thought of as an investment by the publisher. Without an advance, you are out all of the money required to produce the book. If the book is then rejected, you will be further frustrated. When the publisher advances you funds, the company is making an investment in and a commitment to the product, and as such is sharing some of the publishing risk.

Royalties

Royalties are a percentage of sales that go to the author/photographer. Often, royalties are figured against the retail price of the book, but more often, they are determined on a wholesale or net rate. As an author, the latter arrangement is not necessarily desirable, unless great sales volume is anticipated. However, most publishers seem to be paying on the net price of the book, and since so many people want books published, it's an economy publishers find easy to enforce.

Royalties work on a sliding scale. For example, if you are both the photographer and the writer, you may receive 10 percent of the proceeds on the first 10,000 books sold, 12-1/2 percent for the next 10,000, and 15 percent for anything over 20,000 copies. Additional royalties might include paperback editions (7-1/2 percent), foreign sales (5 percent) direct response sales (5 percent), book-club sales (7-1/2 percent), and so on. These are only examples, since the actual figures vary with the type of book and publisher. Of course, like almost everything else in your book contract, royalties are negotiable, and the more prestige you bring to the book by your status as an author or photographer, the better your bargaining power. If you combine efforts with a writer, you should negotiate for a fair share of the royalties.

Royalties on softcover books tend to be lower than those on hardcover editions. Publishers say their profit margin is lower. Royalty percentages vary greatly on the paperback edition of a hardcover book. If a book using photographs is published in hardcover only, the publisher will usually try to retain softcover rights for itself. In the case of how-to photography books, hard- and softcover versions may be published simultaneously. Occasionally a hardcover publisher of a picture book may offer softcover rights to another publisher, and traditionally, the publisher and the photographer share 50–50 in the proceeds from the sale of such paperback rights. In some cases, the photographer's percentage may increase with higher sales.

Royalties and sales statements are usually mailed at the same time to authors—usually twice a year.

Fees

It is generally not beneficial for you as a photographer to accept a flat rate on a book project unless you are being contracted to supply only a portion of the photographs. If, for instance, you accepted a flat fee for a book, and it became a runaway bestseller, you would be giving away thousands or even hundreds of thousands of dollars in income.

If you are assigned to photograph a portion of the book or its cover, you should be charging a fair rate plus expenses. If you are assigned to shoot a small number of photographs for the book, you may want to negotiate a flat fee that covers your rate, plus expenses. If you are assigned to shoot a large portion of the photos for the book—say, 20–25 percent—you should try to get an advance plus a royalty, based on a percentage of the royalty of the main supplier of photographs.

Photographer's Free Copies

As part of your contract, you should be guaranteed a number of free copies of your book. Ten copies is standard, but you may find that if you can use the book for self-promotion, many more copies (fifty or a hundred) would be beneficial. Usually, the publisher will offer you additional copies at a substantial discount, usually 40 percent. You can also try to make the additional copies a condition of your contract, keeping in mind that you may have to bend on other issues in order to get what you want. Some photographers arrange to buy hundreds or even thousands of copies of the book so that they may sell them independently. In these cases, the discount may be even greater.

Publishers will often make arrangements to give you a discount on books used for promotion. Sometimes, the publisher will charge you as little as 20 percent of the cover price for books sent to reviewers and other possible sources of promotion. However, in most instances, publishers will absorb the cost of sending out review copies and related press materials, as it is in their best interest.

Collaborating with Writers

Because most talented photographers are not, at the same time, talented writers, it is often wise to team up with a good writer to execute a book project. In fact, the collaboration can be much more than just a division of labor. Ideally, the pair should provide input, assistance, and research into the tasks of the other, making the collaboration a true joint venture.

Generally, if both parties contribute roughly 50 percent of the work, then all financial gains—advances and royalties—should be split 50–50. Expenses, on the other hand, usually amount to more for the photographer than for the writer, and some provision to address that inequity should be provided for in the contract.

It is advisable for the writer and the photographer to have separate contracts with the publisher. In fact, before a contract agreement is entered into, it is important for the team to have their own written, photographer-author agreement, separate from their agreements with the publisher. This photographer-author agreement would cover such things as copyright ownership, costs, advances and royalties, and credit, a very important point. In the mind of the public, the name that appears first on the book is usually the name associated with authorship. There are countless ways in which credit can be

shared, so that the names appear more or less equally, but remember that the name that comes first usually sticks in the public eye.

If the pair is using a literary agent or attorney, it should be decided whose interests that person primarily represents. If the photographer agrees that the writer's literary agent should handle all negotiations, then the photographer should be certain that her interests are represented fairly. The ideal is an agent or attorney contracted by both to represent both equally in the negotiations. In some circumstances, however, the photographer may wish to have her own agent or attorney to ensure that her interests are not compromised by joint representation of both photographer and writer.

Discontinuance

Your contract should include a publication date that is binding to both parties. Extensions by either party are usually a necessary part of the process, and are not all that unusual. However, the contract itself should protect you against a publisher that goes bankrupt, or after having accepted and approved all of the materials for your book, fails to publish it. In the sample contract that follows, paragraph 6 covers the failure to publish, and provides that in such cases, all rights to all materials revert back to the photographer immediately upon written notification. Furthermore, if a book goes "out of print" in an untimely manner, before you have had a chance to reap a reasonable amount of royalties, you should be able to acquire the plates, photomechanical film, or computer files used to produce the book at scrap rates, and/or excess copies at unit cost.

Self-publishing

Publishing your own photography book is an area of great potential risk. But the rewards for a successfully self-published book are equally great, since there are no middlemen—you are, at the same time, author, photographer, publisher, typesetter, designer, layout artist, printer, binder, and, perhaps worst of all, distributor of your own book.

Self-publishing offers you, the artist, complete control over the finished product. When you submit your book to a publisher, you are, to some degree, at the publisher's mercy as to what the book will contain, how it will look, how it is marketed, and how it will inevitably sell. The control of self-publishing is complete, but you are also vulnerable: One or more bad decisions could result in disaster.

If you are not skilled at design, enlist the help of a graphic designer. It will be money well spent. You can spend anywhere from $2,000 to $10,000 on the design and layout alone, but it may make all the difference when it comes to potential sales. The best way to find a good graphic artist is by word of mouth. Talk to someone who has worked on a similar type of project with the graphic artist. Find out what kinds of problems were encountered and how they were solved.

Rick Smolan, *Day in the Life* founder and now president of Against All Odds Productions, says that the key ingredient in the sale of any photo book is how good the pictures look. Smolan is essentially a self-publisher and book packager, and, as such, critically oversees the printing and design process even to the point where he spends

time on press in Japan, where his books are printed, making sure that the printed photos are as dynamic and rich as the originals. Smolan also believes the key to the success of any photo book is how well it is designed. He normally works with a designer from the inception of the project, and usually pays him approximately five times the going rate for book design, in order to guarantee the quality he is after.

Before you self-publish your own book, you need to acquire the following: ISBN number (International Standard Book Number), EAN and UPC bar codes (if the book is going to be sold in chain bookstores), LCC number (Library of Congress number—if you want your book sold to libraries), and CIP (Cataloging in Publication information, which provides you with standardized classifying information that is printed on the copyright page). You would also want your book listed in R. R. Bowker's *Forthcoming Books in Print* and *Books in Print*, two volumes that give wholesalers access to the latest titles. Information on each of these items can be obtained as follows:

- ISBN information: R.R. Bowker ISBN Agency, 121 Chanlon Road, New Providence, NJ 07974; phone: (877) 310–7333, *www.Bowker.com/standards*
- Machine-readable guidelines for the U.S. book industry as well as bar code prints and negatives obtainable, free, from: GGX Associates, 10 Maguire Road, Building 3, Suite 322, Lexington, MA 02421; phone: (781) 372–1100; fax: (781) 372–1101, *www.ggx.com*
- Library of Congress number and information on Cataloging in Publication program from: Cataloging and Publication Division, Library of Congress, Washington, DC 20540; phone: (202) 707–6372, *www.lcweb.loc.gov*
- Registration for R. R. Bowker's twice-yearly Forthcoming Books in Print: Advance Book Information, R. R. Bowker, P.O. Box 31, New Providence, NJ 07974; phone: (877) 310–7333, *www.Bowker.com/standards*
- Self-Publishing: Self-Publishing Resource Center, Wise Owl Books, P.O. Box 29205, Bellingham, WA 98228; phone: (360) 671–5858, *www.wise-owlbooks.com/publish*
- Copyright: U.S. Copyright Office (USCO), Register of Copyrights, Library of Congress, Washington, DC 20559; *www.lcweb.loc.gov/copyright*

Distribution is by far the most difficult aspect of self-publishing. There are three basic ways to distribute self-published books: (1) wholesalers, (2) distributors, and (3) self-distribution, which can be nothing more sophisticated than packing up your car with as many copies of your book as you can carry, and visiting every bookstore and library within driving distance. Even then, you are selling the books on consignment, meaning that you don't get paid until the books are sold.

Wholesalers fill orders for libraries and the trade. They don't do any marketing or promotion, and they won't warehouse copies of the book for you. Basically, all a wholesaler will do is fill orders, and take a small percentage for their efforts.

Bona fide book distributors, on the other hand, may help in the sale and promotion of a book, and will sometimes work with small publishers in producing a more marketable product. It is also possible to work with a combination of wholesalers and dis-

tributors, as well as independent sales reps, who carry select titles for various publishers. Another possibility is to sell the book via mail order. This requires an advertising budget, lots of time, and patience.

Another way to distribute your own book is via a Web site—either one exclusively devoted to the book title, or on your own personal Web site. Promotion via the Internet is not difficult, but it can be time-consuming. Fulfillment is a matter of processing the orders that come in through the Web site and sending out the book. Be sure to include postage and handling on the Web order page, and allow time to process and ship orders.

A slightly different approach to self-publishing is to work with a book packager. In this case, you sell the idea to a publisher who then commits to purchasing a set number of copies. The publisher then distributes the books through its normal distribution channels. The advantages of this strategy are that you still retain the creative freedom of self-publishing—you write, photograph, design, and supervise the production of the book—but you do not then have the headaches of distribution. You get an advance on signing and get the rest of the money when the book copies are delivered to the publisher.

One such success story is Frank Van Riper, who self-published *Faces of the Eastern Shore* in 1992, a popular coffee-table picture book about Maryland's eastern shore. Van Riper is also the author of *Down East Maine/A World Apart* (1998), which was nominated for a Pulitzer Prize. Van Riper, a former journalist and author, was committed to self-publishing the project, but because of his knowledge of the book publishing field, decided not to pursue an advance with a publisher. All he wanted was the assurance of a good distribution network. He chose Thomasson-Grant, of Charlottesville, VA, a publisher that said they would be happy to include the title on their fall list and be the distributor. With that potential problem removed, he arranged for printing in Tokyo. Nothing happened with this book that Van Riper did not want to happen. He chose the best for every phase of production—Pat Marshall Design in Washington, DC, designed the book, Dai Nippon of Tokyo printed it. Both designer and author wanted to be on press, but it was totally impractical and they had to rely on press proofs, which, according to Van Riper, presented some surmountable problems the first time around. Van Riper learned as he went along, describing the printing problems in photographer's terms, and the printer was patient. Everyone involved in the process wanted the book to be the best it could be, and, ultimately, it was just that.

Since the distributor had very little to do with the book, other than its distribution, Van Riper became the sole source of promotion and publicity. He arranged for TV coverage, gallery-opening publicity, excerpts, and reviews. He wrote all the press releases, and sent them to all sizes of publications and newspapers. He sent out dozens of free copies and made countless phone calls. The promotion of the book was an endless task, but one that Van Riper believes is the most important ingredient in the successful marketing of a self-published book. Some advice Van Riper offers to others interested in self-publishing: Secure distribution, work with a small publisher whose reps will be more likely to get behind your title if they believe in it, and promote the daylights out of it. "No one will flog a book better than you, if it's your book."

Short-run and E-publishing

Technology, and especially new and accelerating developments on the Internet, has introduced new elements to book publishing. Short-run printing services have facilitated publication of books in quantities that once would have been uneconomical by traditional printing methods. No longer is it necessary to print and sell thousands of copies of a book to break even and go on to make a profit.

Short-run, or "on demand," book printing has created new potential for authors, with sophisticated copy machines printing books in any quantity within days of the order being placed. The author can expect to pay a setup fee, which will vary depending on factors such as bound-book size, number of pages, and the company's fee structure, but the cost should be lower than traditional printing. Another advantage, from a creative and ownership aspect, is that the author maintains control over such things as content, design, price, and copyright.

However, if you are contemplating doing a book, be aware that self-publishing using print on demand or any other form of electronic publishing is no magic bullet—success and profits are not guaranteed. But there are advantages, and this avenue is definitely worth exploring.

Electronic Books

The Internet has created so many potential outlets for creators that it's hard to keep up with new developments or evaluate their worth. ASMP's advice is to search the Internet and take your time evaluating if and how you can tap this area. For example, numerous Internet companies offer authors an outlet for stories, illustrated features, and books—or any other written or illustrated material. One must be Internet- and computer-savvy to take advantage of online publishing (or employ someone who is), but the potential is there.

Internet publishing companies charge nominal monthly fees for featuring work on their sites and also charge a commission or royalty—most seem to be around 50 percent—and let the authors set their own prices. As in any other form of Internet commerce, don't expect the world to beat a path to your online material without additional marketing. Internet publishing companies, such as Fatbrain.com, provide considerable support and advice on the best way to present your work, how to reach markets, and even how to establish pricing guidelines.

Electronic Publishing Rights

A Position Statement by the Authors Guild and the American Society of Journalists and Authors—Issued October 18, 1993

Writers today must take a strong stand to prevent the erosion of their traditional rights in the new era of electronic publishing. Some publishers have routinely asked writers to sign away—without compensation—all rights to electronic use of the work they have created. Indeed, many have sought the right to make writers' work available

in "any medium yet to be invented."

Writers and their professional organizations must resist this attempt to seize creators' rights.

Publishing technology is changing fast, and a writer's work can now be made available in many forms—on databases, as CD-ROM disks, and on CD-Interactive (CD-I) disks, among others. New technologies make it easy to combine works of journalism, literature, art, photography, music, and film and video in multimedia and interactive formats. Publishers' costs for making a work available in electronic formats are far lower than for traditional publishing.

The optimal position for writers is to retain full electronic rights, thus protecting their creative investment and retaining the ability to control its future use completely.

If a writer instead decides to sell electronic rights, three conditions are essential:

1. Fair compensation on the traditional advance and royalty basis; that is, payment per use or sale.
2. When rights are licensed from another party, such as the print publisher, the writer should be compensated by the licensor on the traditional basis of a literary agent's commission, with the writer receiving 85–90 percent.
3. No use of a work should be made without the writer's approval of medium, format, and content.

The Authors Guild and the American Society of Journalists and Authors therefore recommend that the following basic principles be consistently applied:

Writers should control the disposition of the electronic publishing rights to their works. Electronic publishing is likely to undergo a series of rapid and radical transformations. To respond to these changes, writers should carefully control the disposition of their electronic rights.

Writers should strive to retain all of their electronic rights and negotiate to secure those rights up front, when they negotiate their advance. The simplest way for writers to control their electronic rights is to retain those rights. Writers are then free to evaluate specific electronic publishing opportunities that arise. Writers should bear in mind that electronic rights are valuable and should only be given up in exchange for substantial additional compensation. By negotiating for these rights before the publisher prepares the first draft of a contract, writers will retain the credible threat of taking the work elsewhere, maintaining maximum leverage in attempting to secure the rights.

Writers unable to retain their electronic rights should negotiate for the following safeguards in the grant of those rights:

The Print Publisher as Electronic

Allow the print publisher to issue the work in electronic form only on the condition that terms be negotiated immediately prior to electronic publication. Writers should not be expected to negotiate terms for electronic publication when they sign a print publishing contract. The value of those rights and the entire electronic publishing industry are likely to change radically in the near future.

The Print Publisher as Electronic Rights

Divide the proceeds of the licensing of electronic rights to reflect the print publisher's role as agent for the sale of those rights. Publishers have found acceptable a 90–10 split in favor of the writer for the licensing of electronic rights. Writers with agents traditionally retain subsidiary rights, such as film rights, that involve the transformation of the work into a new medium. Where publishers are granted such rights, publishing contracts usually provide the publisher with an agent's percentage for selling those rights. Many electronic formats will be more like films than like books, with producers pulling together audio, visual, computer programming, and text components to make the electronic product. Writers are entitled to 85–90 percent of the proceeds from the licensing of electronic rights, with publishers retaining the usual agent's fee of 10–15 percent.

Retain the right of approval over all electronic licenses. Writers should be able to insist that the electronic work be equal in quality (including the packaging, marketing, and advertising for the work) to that of the printed work. The reputation and standards of electronic publishers vary as greatly as in print publishing. Only by retaining a right of approval can writers monitor the quality of the electronic work.

The Print Publisher as Electronic Publisher or Licensor

Grant electronic rights only on an advance and royalty basis. Electronic books are books—writers should insist on royalties for electronic "sales" of the work, including an access fee for works on database services. The royalty percentage should escalate significantly after relatively few sales, since nearly all electronic-publishing costs are incurred in producing the first electronic copy of a work. Compared to duplication, storage, and transportation costs for printed books, those costs for electronic works are minimal.

Grant the right to issue electronic versions of the work only in specified, existing formats, preferably on a non-exclusive basis. Granting the right to issue the work in all electronic formats now existing or to be developed in the future is granting too much. Existing and future formats have the potential to undermine the integrity and value of the work. Until the electronic publishing market matures, writers should be wary of granting exclusive rights to any publisher for any format. Many companies and formats will fail to penetrate the developing electronic market.

Retain control over any abridgment or anthologizing of the work and over any illustrations, sound, text, or computerized effects added to the work. Writers' reputations ride on their published works. If an electronic publisher seeks to do anything more than a direct transposition of the printed work, then the writer should have a right of approval over the form and context of the electronic work. Retaining control over the illustrations, sound, text, and computerized effects added to a work, if writers carefully exercise that control, could help avoid legal conflicts with other subsidiary rights.

Electronic publishers should give reasonable assurance that the work will not be copied without authorization. Without copy protection, fast, cheap, and perfect electronic duplication could severely damage the value of a work. Licensees should be required to prominently display copyright warnings and to use the best available means to prevent unauthorized copying.

Unexploited electronic rights should revert to the writer. The principal value of a

work could be in its electronic licensing. If, after a specified period of time, a publisher fails to exploit the rights in any of the electronic formats granted to the publisher, the rights to the unexploited formats should revert to the writer.

Electronic Publishers of Periodical Articles

Grant periodical publishers the right to republish an article electronically only in the same form and context as the original article. This grant should be non-exclusive. In electronic formats, the line between books and periodicals can be blurred by a few keystrokes. To assure that the grant of electronic serial rights does not effectively become the grant of electronic book rights (allowing, for example, a publisher to issue an electronic anthology of a writer's work or a special edition of articles on a single subject), the electronic rights granted a periodical should only extend to the periodical format, in exactly the form that the article originally appeared.

Insist that periodical publishers pay an additional fee at the time of electronic republication, following traditional industry practice with syndication. That fee should be an advance plus a royalty. Just as a publisher would pay a writer if an article were picked up for syndication, so should a publisher pay a writer for the electronic republication of an article. The vague border between electronic books and electronic periodicals requires that writers be paid on an advance and royalty basis. To the extent that readers access the electronic version of an article, electronic publication may deplete the market for a print anthology of a writer's work. Writers should be paid a per-access royalty to offset this.

Other Book Contract Issues

Publishers should indemnify writers for all claims arising from illustrations, text, sound, or other materials added to writers' works. The materials added to the electronic version of a writer's work could be libelous, obscene, invade privacy rights, or infringe copyrights. Writers should bear no legal responsibility for the content of these additional materials.

For the purposes of "Out of Print" clauses, electronic and print rights should be treated separately. A work should not be considered "in print" just because electronic versions of the work are available, since a work could remain available on a database indefinitely, at minimal cost to a publisher. Traditionally, writers can ask that print rights revert when a work is not available in print form in the United States in a major edition. Similarly, electronic rights should revert when electronic usage falls below a specified minimum.

Securing electronic publication permissions for any copyrighted materials incorporated in the work should be the publisher's responsibility. Writers often secure limited print rights in copyrighted materials, such as photographs, illustrations, and text, that appear in their works. The electronic rights to these materials could be expensive. If a publisher seeks the electronic rights to a work, then the publisher should bear the additional costs of securing the electronic rights in any copyrighted materials included in the work.

Accounting for electronic sales of a work should be detailed, clear, and verifiable.

Electronic versions of a work can be produced in an instant and disappear just as quickly, so publishers will have to be particularly diligent in monitoring electronic sales. Royalty statements should contain accurate records of production runs, the number of units sold or accessed, returns, copies distributed free of charge, and copies remaining in the warehouse. Audit clauses should expressly permit the writer's representative to review the databases that compute these figures.

Suggested Electronic Rights Clauses

The Authors Guild and the ASJA strongly recommend that writers retain their electronic rights. Where writers are unable to do so, we suggest the following clauses, granting limited electronic rights for books and articles:

Book Contract

Author grants Publisher the right to license the publication of nondramatic electronic versions of the Work only in the following formats: [list formats, for example, Macintosh CD-ROM, CD-I, online database] (the "Authorized Formats"). Author retains the rights to all other electronic technologies and formats, whether now existing or developed in the future. Publisher's right to license electronic versions of the Work is subject to Author's approval of the license, such approval not to be unreasonably withheld, but in no event shall Author be required to approve a license: (1) issued on a flat fee (rather than an advance and royalty) basis; (2) that permits the abridgment or anthologizing of the Work or the addition of illustrations, sound, text, or computerized effects (such as animation, voiceovers, or hypertext links) to the Work or the distribution of the Work with any other product; (3) in which the licensee does not provide reasonable protection against unauthorized copying of the Work; (4) in which licensee obtains the exclusive rights to any format; or (5) that in any way diminishes or prejudices the dramatic electronic rights retained by the Author (collectively, the "Approval Conditions").

Publisher shall retain an agent's percentage of 10 percent of the proceeds from the licensing of electronic rights. Publisher shall pay Author the remaining 90 percent of the proceeds within thirty days of Publisher's receipt thereof.

Author grants Publisher the right to publish nondramatic electronic versions of the Work only in the Authorized Formats, on terms to be negotiated with the Author in good faith, subject to Author's consent with respect to the Approval Conditions. If Publisher does not license or otherwise exploit the electronic rights in any of the Authorized Formats within eighteen months of publication of the Work, the rights to each such unexploited Authorized Format shall revert to Author.

Periodical Contract

Writer grants Publisher the non-exclusive right to electronically publish or license the electronic publication of the Article only in the same form and context as the printed Article (that is, only with the entirety of the printed issue in which the Article appears, without the abridgment or anthologizing of the Article or the addition of illustrations,

sound, or computerized effects—such as animation or hypertext links—to the Article). Publisher agrees to take reasonable steps to secure reasonable protection against unauthorized copying of the Article. Publisher shall pay the writer an advance of $ _____ at the time it republishes or authorizes the republication of the article, and shall pay the writer a royalty of $ _____ each time the article is accessed on a database and $_____ for each sale of an electronic version of the issue of the publication containing the Article.

American Society of Journalists and Authors, 1501 Broadway, Suite 302, New York, NY 10036; (212) 997-0947. *www.asja.org*.

The Authors Guild, 330 West 42nd Street, 29th Floor, New York, NY 10036. Phone: (212) 563–5904; fax: (212) 564–5363; *staff@authorsguild.org; www.authorsguild.org*.

Agents and Attorneys

Book contracts may be incredibly complex, and it's not inconceivable for you to sign something you don't understand. Ask any published authors/photographers if they understood everything in their first book contract. The answer will undoubtedly be that the author would do it again differently.

Although it is not necessary, it is nonetheless advisable for photographers to have a negotiating representative, either an attorney or a literary agent. Choosing the agent or attorney is important. That person should be knowledgeable in the area of contract law and, specifically, book publishing, where it pertains to photography. How does one find such a person? One suggestion is that if you are represented by a stock agency, seek its advice. Picture agency personnel usually know of experienced and knowledgeable agents and attorneys.

Literary agents usually work on a commission basis, usually 15 percent, but, again, they may save you that much, or enhance the value of the contract by more than that amount, so it is usually a worthwhile investment. The downside to literary agents is that they often don't know enough about picture books to be helpful. Stock agents, on the other hand, may be more knowledgeable. A stock agent may not charge for some useful advice, since a book will promote the photographer's reputation, which can increase stock sales.

The greatest advantage of an independent negotiator is that the agent/attorney is dispassionate about the negotiation. His job is merely to get you the best deal and protect your rights. But that person will not become emotionally involved in the negotiations, as you would. For further information about literary agents, picture agents, and attorneys, see *Guide to Literary Agents & Art/Photo Reps*, published by Writer's Digest's books. Also see *www.AAR-Online.org* and *LiteraryAgent.Com*. Both sites will provide invaluable information as well as help you to look for agents' Web sites.

Sample Photographer's Book Agreement

The following agreement is hypothetical. It is unlikely that your book contract will look exactly like this, but it is important that you understand the terms outlined here, before you move on to sign an actual book contract. Many of the items you see here might not

be included in your book contract, but perhaps they should be. You should at least be aware of their existence. This document represents the ideal, so don't treat it as gospel, but, rather, use it as an exercise for the safe navigation through your first successful book-contract signing.

Agreement made this _____ day of _____ , 20 _____ , by and between
_____corpo-
ration (hereinafter referred to as "the Publisher") and_____
_____ , (hereinafter referred to as "the Photographer").

Witnesseth:

1. Grant of Rights

The Photographer hereby grants to the Publisher, and the Publisher hereby accepts, a limited license to reproduce, publish, and vend a hardcover (softcover) edition of a book, tentatively titled _____ (hereinafter referred to as "said Book"), containing certain photographs by the Photographer (hereinafter referred to as "said Photographs") upon the following terms and conditions:

2. Delivery of Photographs

On or before _____ 20 _____ , the Photographer shall submit to the Publisher _____ photographs (_____ black-and-whites, _____ color transparencies, _____ color prints, _____ digital files). The Publisher shall then have _____ month (s) from the receipt of said Photographs within which to select the photographs to be used in said Book. Those photographs not selected will be returned immediately to the Photographer, together with the notice of those photographs selected. A list of such photographs to be used shall then be incorporated into this agreement by reference thereto. All photographs not selected shall be excluded from the scope of this agreement, and the Photographer shall have the right to utilize such photographs in any manner whatsoever, without restriction.

All photographs so selected by the Publisher for use in said Book will be returned to the Photographer no later than sixty (60) days after the successful completion of the manufacturing (printing and binding) phase of publication. Successful completion of the manufacturing phase will be by_____ 20 _____. Said Book is to be published and distributed no later than _____, 20 _____, with a minimum of _____ copies so published and distributed.

The Publisher shall not acquire any right, title, or interest in or to said Photographs, and shall not make, authorize, or permit any use of said Photographs other than as specified herein. Without limiting the generality of the foregoing, said Photographs may not be used in any way, including, without limitation, projection, layouts, sketches, and photostats, except under the terms specified herein.

3. Use of and Return of Photographs

The Publisher shall be responsible for the safe handling and return of all photographs to the Photographer and shall indemnify the Photographer against any loss or damage to such photographs (including those not selected for use in said Book) in transit or while in the possession of the Publisher, its agents, employees, messengers, printers, or assigns.

The monetary sum for loss or damage of an original transparency or original black-and-white or

color negative (hereinafter referred to as said original Photograph) shall be determined by the value of each individual photograph. The Publisher and the Photographer agree that the fair and reasonable value of each lost or damaged said original Photograph shall be One Thousand Five Hundred ($1,500) Dollars per photograph. The Publisher shall be liable for all acts of its agents, employees, messengers, printers, or assigns for all loss, damage, or misuse of the materials submitted by the Photographer hereunder. Any such payment shall not, however, be construed to be transfer to the Publisher of any right, title, or interest in or to said materials so lost or damaged.

4. Subsidiary Rights

The following subsidiary rights are agreed to and may be licensed by the party indicated. The proceeds will be divided as specified herein.

Subsidiary Right	Licensee	Proceeds
(i.e.) foreign	Publisher	7.5% / 92.5%*
(i.e.) book club	Publisher	5% / 95%
(i.e.) serial newspaper	Photographer	60% / 40%
(i.e.) serial newspaper	Publisher	40% / 60%

(*Note: In this hypothetical example, the Photographer's portion of the proceeds is listed first.)

If the division of proceeds for any subsidiary right changes after the sale of _____ copies of said Book, indicate which right and the secondary division of proceeds here:

Any subsidiary right not set forth in this paragraph is retained by the Photographer.

5. License and Territory

The license granted to the Publisher hereunder is solely for the Publisher's hardcover (softcover) edition of said Book. The license granted hereunder is for one-time, non-exclusive, reproduction use of said photographs in English-language printings in the following countries:

6. Publication

The Publisher agrees to publish said Book within _____ months of the delivery of the approved photographs (and manuscript). Any failure to so publish said Book shall give the Photographer the right to terminate this agreement ninety (90) days after giving written notice to the Publisher of the failure to make timely publication. In the event of such a termination, the Photographer shall have no obligation to return any monies already received from the Publisher.

7. Approval and Inspection

The Publisher shall publish and distribute said Book at its own expense, in the style and manner and at the price which it shall deem best suited to its sale. Before publication, said Book shall be submitted in its entirety to the Photographer, including, without limitation, the text, its title, its photographs, and the contents of its covers. The Photographer will have the right to correct, modify, and otherwise change any element of said Book without limitation.

8. Advance

The Publisher shall pay to the Photographer, or his/her duly authorized representative specified in writing by the Photographer, upon execution of this agreement, the following nonreturnable

advance, which shall be charged against the Photographer's royalties set forth in paragraph 9 (nine) hereof: $_____. One-half of the agreed-upon royalties shall be paid upon execution of this contract by both parties. The remainder shall be paid upon delivery and acceptance of manuscript and photographs.

9. Royalties

The Publisher shall pay to the Photographer the following percentages of the Publisher's U.S. suggested retail list price:

- Ten percent (10%) on the first 10,000 copies sold;
- Twelve and one-half percent (12.5%) on the next 10,000 copies sold;
- Fifteen percent (15%) on all copies sold in excess of the aforesaid 20,000 copies.

It is understood that the suggested retail list price shall be deemed to be not less than $_____ for the purpose of computing the royalties to be paid hereunder.

10. Copyright

Said Book shall be published with due notice of copyright in the name of the Photographer and shall be duly registered by the Publisher in the Copyright Office of the United States of America. Without limiting the foregoing, all copyrights under the Berne Convention, the Universal Copyright Convention, and the Buenos Aires Treaty will be secured; it being specifically agreed that in no event shall said Book be published without a copyright of the photographs in the name of the Photographer. The Publisher shall take all steps necessary, without cost to the Photographer, to effect such copyrights, including any renewal copyrights, if applicable.

11. Photographer's Free Copies

The Publisher agrees to furnish the Photographer with twenty (20) copies of said Book as published, free of any cost or charge to the Photographer whatsoever, for the Photographer's own use. If the Photographer requires copies in addition to the above, the Publisher agrees to furnish such additional copies to the Photographer at a discount of forty percent (40%) from the retail selling price or at the Publisher's actual publishing cost for same, whichever is less.

12. Credit

The Photographer shall receive credit on the dust jacket, cover, title page, and interior of said Book, as well as in advertising under the control of the Publisher, all in size, type, and prominence not less than that afforded any other person or party appearing thereon, and all subject to the Photographer's final and absolute approval. It is a material part of this agreement that no books or other matter be issued without the Photographer's credit as approved by him or her.

13. Accounting

Payment of accrued royalties, accompanied by detailed statements of all sales, licenses, accrued royalties, and deductions, will be made to the Photographer semiannually, within thirty (30) days after June thirtieth and December 31 in each calendar year. The Publisher shall keep books of accounts containing true and accurate records of all transactions in its place of primary business, involving the subject matter of this agreement and of all sums of money received and disbursed in connection therewith. The Photographer or his/her duly authorized representative shall have the right at any time and without limitation to check, inspect, and audit the Publisher's books, records,

and accounts in order to verify or clarify any and all such statements, accountings, and payments. The expense of such examination shall be borne by the Photographer unless errors of accounting equal or exceed five percent (5%) of the total sums paid or payable to the Photographer shall be found to his/her disadvantage, in which case the expense of such examination shall be borne by the Publisher.

Anything in this paragraph to the contrary notwithstanding, any sum of One Thousand Dollars ($1,000) or more, which may become due to the Photographer (after the Publisher shall have recouped its advance hereunder, and not including regular royalty payments), shall be paid by the Publisher to the Photographer within thirty (30) days after the Publisher receives such payments, accompanied by a copy of the statement of account provided by such licensee to the Publisher.

14. Notices

All notices which either party may desire to or be required to send to the other shall be sent by prepaid registered mail and addressed to the parties as follows:

Publisher: _____

Photographer: _____

15. Discontinuance

If, after the initial printing and distribution of said Book, the Publisher decides to discontinue any further publication of said Book, it shall give immediate notice of such determination to the Photographer, and the Photographer shall have the option of purchasing from the Publisher the photomechanical plates and/or film, and/or computer disks for said Book at scrap rates. If the Photographer shall not take over the said plates (and film), engravings, illustrations, and/or copies of said Book and pay for same within ninety (90) days, then the Publisher shall destroy the items not taken and shall furnish the Photographer with an affidavit of destruction thereof. In any event, the Publisher's obligation for payments hereunder to the Photographer shall nevertheless continue.

For the purposes of this agreement, said Book shall be deemed "in print" only when copies are available and offered for sale in the United States through normal retail channels and listed in the catalog issued to the trade by the Publisher. Said Book shall not be deemed "in print" by virtue of the reproduction of copies by reprographic processes or if it is available by any medium or means other than the hardcover (softcover) edition referred to above.

If the Publisher fails to keep said Book in print, the Photographer may at any time thereafter serve a request on the Publisher that said Book be placed in print. Within sixty (60) days from receipt of such request, the Publisher shall notify the Photographer, in writing, whether it intends to comply with said request. If the Publisher fails to give such notice, or, having done so, fails to place said Book in print within six (6) months after receipt of said request by the Photographer, then, in any event, this agreement shall automatically terminate and all rights granted to the Publisher shall thereupon automatically revert to the Photographer.

16. Warranties and Indemnities

The Photographer warrants that it owns the copyright in and to the photographs provided to the Publisher under paragraph 2 hereof. Photographer makes no other warranty, express or implied, under this Agreement. Photographer agrees to indemnify and hold harmless the Publisher against any and all claims, losses, costs, damages, or expenses, including reasonable attorneys' fees, aris-

ing from or related to the defense against a claim that said Photographs infringe or otherwise violate the rights of any other party. The Publisher warrants that none of the material that it contributes to the Book will infringe or otherwise violate the rights of any other party. The Publisher agrees to indemnify and hold harmless the Photographer and his/her representations, agents, successors, and assigns against any and all claims, losses, costs, damages, or expenses, including reasonable attorneys' fees, arising from or related to the publication of the Book, except to the extent that such claim, loss, cost, damage, or expense arises from or relates to the photographs themselves.

17. Infringements

If there is an infringement by a third party of any rights granted to the Publisher hereunder, the Photographer and the Publisher shall have the right to participate jointly in an action for such infringement. If both parties participate, they shall share the expenses of the action equally and shall recoup such expenses from any sums recovered in the action. The balance of the proceeds shall be equally divided between the two parties. Each party will notify the other of infringements coming to its attention. If the Photographer declines to participate in such action, the Publisher may proceed and will bear all costs and expenses, which shall be recouped from any damages recovered from the infringement, and the balance of such damages shall be divided equally between the parties. Nothing in this paragraph shall be construed as an obligation on the part of the Photographer or Publisher to take action against an infringer of all or part of the Book.

18. Arbitration

Any controversy or claim arising out of or relating to this agreement or the breach thereof shall be settled by arbitration in _____ (state), in accordance with the rules of the American Arbitration Association, and judgment upon the award rendered by the Arbitrator(s) may be entered in any court having jurisdiction thereof.

19. Independence of Parties

Nothing contained in this agreement shall be deemed to constitute the Publisher and the Photographer as partners, joint venturers, or fiduciaries, or to give the Publisher a property interest, whether of a legal or an equitable nature, in any of the Photographer's assets.

20. Waivers

A waiver by either party of any of the terms and conditions of this agreement shall not be deemed or construed to be a waiver of such terms or conditions for the future, or any subsequent breach thereof. All remedies, rights, undertakings, obligations, and agreements contained in this agreement shall be cumulative, and none of them shall be in limitation of any other remedy, right, undertaking, obligation, or agreement of either party.

21. Reservation of Rights

All rights not specifically granted herein to the Publisher are reserved by the Photographer and without any limitations whatsoever, regardless of the extent to which same are competitive with the Publisher or the license granted hereunder. This includes, without limitation, the exercise by the Photographer of all copyright rights in the photographs, such as reproduction, distribution, and publication of individual photographs.

22. Defaults and Terminations

This agreement shall immediately terminate in the event of the Publisher's bankruptcy, insolvency, or assignment of assets for the benefit of creditors. In the event of termination of this agree-

ment, the Publisher shall grant and convey all rights in said Book back to the Photographer.

Time is of the essence in the performance by the Publisher of its obligations hereunder. If the Publisher fails to pay promptly under the royalties hereunder, or if the Publisher fails to conform or comply with any other terms or conditions hereunder, the Photographer shall have the right, either personally or by his duly authorized representative, to advise the Publisher of such default; and if fourteen (14) days elapse after the sending of such notice without the default having been rectified, this license shall thereupon terminate without affecting the Photographer's rights to compensation or damages in connection with any claims or causes of action the Photographer may have.

The Photographer shall also have the right to terminate this agreement as provided in paragraph 6 and paragraph 15 of this agreement.

23. Successors and Assigns

This agreement and all its terms and conditions, and all rights herein, shall insure to the benefit of, and shall be binding upon, the parties hereto and their respective legal representatives, successors, and assigns.

24. Miscellaneous

The titles of the paragraphs of this agreement are for convenience only and shall not in any way affect the interpretation of any paragraph of this agreement, or the agreement itself.

25. Governing Law

This agreement and all matters or issues collateral thereof shall be interpreted under, and governed by the laws of the State of _____.

26. Promotion

The Photographer consents to the use of his or her name, and picture for promotion and advertising of said Book. The use of the Photographer's name and photograph should be consistent with the Photographer's reputation.

27. Changes and Modifications

This agreement constitutes the entire agreement between the parties hereto and cannot be changed or terminated orally; and no changes, amendments, or assignments thereof shall be binding except in writing signed by both parties.

This agreement is not binding on the Photographer unless and until a copy thereof actually signed by both the Photographer and the Publisher is delivered to the Photographer and payment of the advance is made.

In witness whereof, the parties hereto have executed this agreement as of the day and year first above written.

(Publisher)

By: _____

Title: _____

(Photographer)

Professional Services

Allen Rabinowitz

Photographers rely on the help of such people as assistants, camera and lab technicians, prop makers, and stylists to guarantee that their images are on the money; the advice and expertise provided by accountants, attorneys, and other professionals help ensure that the business side of photography is also in focus. Whether for a particular problem or a long-term relationship, such professional service providers can make an important difference in the financial health and security of a business.

Choosing the right professional service provider for a particular need is a crucial decision that should be made with care. This chapter will outline the factors that should go into such a decision as well as some personal actions that can help control the cost of these services.

In addition to the professional services that follow, photographers may also need the services of a marketing consultant (see chapter 9, "Business and Marketing Strategies") a representative (see chapter 1, "The Business of Assignment Photography") or a Web page designer (see chapter 2, "The Business of Stock Photography").

Attorney

Whether it's for help in writing or reviewing a contract, or representation in resolving a dispute, photographers depend on the advice and assistance of an attorney. Although a photographer might be a skilled negotiator, there will be times when an attorney's training is invaluable. In dispute resolution, the general rule is this: If a business problem exists, the best possible result can be achieved with the assistance of a knowledgeable, effective attorney. The attorney can advise you about the parameters of the law, what might represent a reasonable settlement, and how to use leverage in terms of your legal position to extract a higher settlement. If your attempt to arrive at a businesslike solution to the problem fails, and legal action is required, you are less likely

to have prejudiced your case, and your attorney can better handle it having been in on it from the start.

Identifying the specific legal situation for which an attorney's talents and knowledge are most needed is the first step in choosing one. If, for example, you encounter a constant series of problems relating to copyright infringement, someone with that particular expertise should be sought. Just as an art director wouldn't consider a tabletop specialist to shoot fashion photos, neither would a photographer hire a tax attorney to handle a problem involving copyright.

Most people, however, prefer to have an attorney who is knowledgeable about them, is familiar with how their business is conducted, and, most important, is someone whom they can go to with a variety of legal problems. The most important criteria are feeling comfortable with the attorney, trusting in his expertise and judgment, and feeling confident that if the problem lies outside the attorney's area of expertise, referrals to attorneys with that specialized knowledge and experience can be provided.

Whether the attorney is a sole practitioner, with a small firm, or part of a large, multifaceted firm should not make a difference. Be aware, however, you're not hiring a firm, but, rather, an individual attorney. The support that the attorney has within the firm may be a consideration in some instances, such as in the context of complex litigation or a transaction requiring tax, pension, and corporate law expertise. But in most situations, the individual attorney's own professional qualifications and expertise should be the controlling consideration. ASMP can refer a member's attorney to specialists for consultations and advice.

Word of mouth is usually a good first step in finding an appropriate attorney. Inquiring among friends and colleagues, as well as reps and clients, can often lead to an attorney with a good understanding of the workings of the photo business. Another good method is to ask attorneys in the community to recommend an attorney with the desired specialized knowledge. If you need to learn more about an attorney you're considering retaining, the legal directories published by Martindale-Hubbell are a good resource. Found in most libraries, these directories list such information about attorneys as where they went to school, associations and professional societies they belong to, and articles they've published. The directories grade attorneys on the basis of technical skills and ethics. Seek attorneys rated A–V; that is, an "A" in technical skills and a "V" for very high ethics.

At a preliminary, get-acquainted meeting, the attorney should be asked certain questions. Whether the meeting is to hire that attorney on a one-time basis for a specific case or to establish a long-term relationship, it's important to clarify such issues as:

- The scope of the work.
- The hourly rate as well as the rates of the other attorneys who may be involved and lend assistance.
- The billing cycle for service, whether it is monthly, quarterly, or whatever suits both parties.
- What costs and disbursements the client will be responsible for, and the need for them to be itemized on the bill.
- Requiring that the bills be specific to the tasks performed, the amount of time

spent on each task, the specific attorney or legal assistant performing each task, and the hourly rate associated with each segment of work.

Defining who is responsible for expenses becomes especially critical during litigation. Since costs may be substantial during the course of a litigation, whether the photographer will be responsible for them as they're incurred (and billed on an agreed-upon basis), or the attorney will be advancing these costs to be paid out of any settlement or judgment, needs to be ironed out in advance.

If the attorney is working on a contingency basis, where the fees are paid out of a final judgment or settlement, this needs to be clarified in advance and set forth in writing so there's no ambiguity or uncertainty later. Though attorneys usually receive one-third of the settlement or judgment in contingency agreements, this percentage may vary depending on the case and the risk being taken.

After the initial meeting, a retainer agreement spelling out the terms of the relationship should be drawn up. If an attorney refuses to do so, it's advisable to go elsewhere. It should be understood from the beginning of the relationship that the attorney will be billing for any time spent handling legal affairs. This means that even the shortest phone conversation will be reflected in the bill. If you are working on a tight budget, that should be made clear to the attorney, and authorize a limited number of hours to be spent on the case. You can also request to be periodically informed about the amount of time being spent on the case and to receive a weekly accounting. In some cases you might consider placing a cap on the upper limit of expenditures on the case.

Undertaking litigation can be an expensive proposition with a substantial investment in legal fees. Litigation is extremely time-consuming, especially if the photographer is the defendant in a case. In the context of litigation, request the attorney to prepare a projected litigation budget, and monitor how closely it is followed.

There are, however, alternatives to going to court. First, determine if the situation or dollar amount in question warrants the investment in attorney's fees.

In disputes with a low dollar value, small claims court is often a viable option. Many states will put a dollar-amount ceiling on such proceedings, so the photographer must check with the individual state about that amount. For a minimal filing fee, it's possible to get a quick hearing on the dispute, usually within a matter of weeks rather than months. Although attorneys are not required for such hearings, if the photographer is incorporated, the particular state law might require representation by legal counsel. Remember, however, that small claims courts have no jurisdiction in matters of federal law, such as copyright.

In certain disputes, consideration should be paid to arbitration or mediation. In arbitration, both parties present their side of the dispute and the arbitrator makes a decision on how it should be resolved. In some situations, that decision is binding and final; in others, the arbitrator's decision is preliminary and can be challenged in court.

In mediation, by contrast, an outside party helps the parties negotiate a solution to the problem, but does not make any independent determinations as to what the solution should be. The mediator's role is that of a facilitator, not a decision maker.

In both cases, a person who is knowledgeable about the law, though not necessarily

an attorney or judge, will perform the services of a mediator or arbitrator. Usually, these routes are taken when both sides have reached an impasse in their discussions, but choose to have an independent party either resolve or assist them in resolving the issue without having to go to the expense and trouble of court proceedings. Arbitration might be specified in a contract as a method of resolving any dispute under that contract. Organizations such as the American Arbitration Association have established procedures and can make people available to arbitrate disputes. Mediation, too, can be a remedy provided for in a contract. But before agreeing to binding arbitration in a contract, consult with the attorney about the pros and cons of doing so.

Including a binding arbitration provision in a contract may serve the photographer's interests in some situations. But in others, such as copyright infringement, a binding arbitration provision will remove access to the courts where more effective remedies may be available.

Whether attorneys should be present at a mediation is up to the disputing parties. If both sides believe they can reach agreement better without their attorneys, they can be excluded. At an arbitration, both sides are generally represented by counsel.

When should one method be chosen over another? If a good relationship existed with the party in dispute, mediation might be preferable. A good faith approach to the situation is required from both parties, and they must genuinely desire to reach an amenable resolution.

In arbitration, the situation has usually reached a point where the parties cannot amicably resolve their dispute and require an outside party to make a decision. Be aware, however, that many arbitrators tend to reach a middle ground where both sides receive something from the decision. If a victory where the winner gets all is desired, then litigation should be pursued.

Along with being unbiased, the arbitrator needs to be someone mutually acceptable to the parties. Though not necessarily an attorney, the arbitrator should be someone with training in dispute resolution who has an understanding of what the applicable legal precedents are in order to arrive at an equitable solution. It may make sense to choose someone who does not possess detailed knowledge of the photo business, as that person will not have preconceived ideas about who might be in the right and can reach a decision based on the merits of the case.

Estate Planning

Estate planning is not a topic that comes frequently or easily to people's minds. Although many photographers put a lot of time, thought, and energy into growing their businesses, few devote much consideration to what will become of those businesses after they pass away. Failure to do adequate estate planning during your lifetime, however, could mean a wealth of problems for your heirs rather than the kind of financial security you'd prefer as a legacy. (Note: See also "The Photographer's Estate: Annuity and Asset" in chapter 2, "The Business of Stock Photography.")

Like other owners of small businesses, photographers' estates usually consist of

more than just property, cash, and securities. Along with equipment, a stock photography library, and, possibly, a studio, the business itself is an asset, along with the good name and goodwill garnered through the years. In order to have survivors benefit, care must be taken to prepare the proper documentation.

Probate laws vary from state to state, but some basic rules should be followed. Prime among them is drafting a will and/or trusts that contain detailed language about the disposition of the estate. Where the estate includes a closely held business, these documents give the executors, personal representatives, or trustees the power to deal effectively with the property.

Failure to include detailed language enabling the executor or trustee to make such changes in the structure of the business, such as buying and selling assets, could handcuff the estate. In most states, an executor might have to get the court's permission to perform such duties as continuing the business, selling off assets, or making other changes. The first step to ensuring a trouble-free estate is enlisting the aid of an attorney who is competent and experienced in the area. Along with referrals from friends, colleagues, and clients, the Martindale-Hubbell directory, which lists attorneys along with their educational background and specialties, is an important source. Look for experience in estate planning, estate administration, probate, trusts, and estates. Additionally, see that the attorney's firm contains other attorneys with expertise in copyright or intellectual property law. As in all cases, an attorney (and firm) rated "A" in technical skills, and "V" for very high ethics is one to seriously consider.

At a preliminary meeting to discuss the relationship, inquire about how the attorney charges for services. Without being asked, the attorney may not volunteer this information or make it clear at the first meeting. Paying for estate planning services is one area where people truly get what they pay for. When it's done right, you and your family are better off, even if these services cost more than you think they should. In the past, attorneys wrote wills as loss leaders, hoping to make bigger fees administering the estate. They would charge for estate administration based on the worth of the estate, rather than on the basis of the work performed. The approach today is moving toward billing on the basis of time spent for both planning and administration. Though you may feel you're paying too much up front, your spouse and children, will usually end up paying considerably less.

At a preliminary meeting with the attorney, the following details should be spelled out:

- How fees will be calculated, including whether payment will be on the basis of time spent on the planning and administration of the estate.
- Which attorney at the firm will be working on the file and what the hourly rates are. You should not have to pay a partner's fee if a junior associate, for instance, is assigned to your estate.
- If billing is to be on a time basis, then a ceiling might be imposed on the fees. More likely, the law firm will present an estimated informal range of fees that similar services have cost for others. Realize that such figures might not necessarily apply in every case.

Although there are a number of books and software programs that claim to allow you to write your own will without an attorney's assistance, using them is not in your best interest. Like the client who owns a state-of-the-art camera and doesn't use a photographer for a job, the shooter who writes his or her own will is letting an amateur take the place of a professional, with a similar outcome in quality. These programs and books are designed for universal usage, meaning there's little chance they can work well for any one particular application. The photographer who writes his or her own will runs the risk of creating problems that will cause heirs to pay more to straighten them out than the up front cost of legal advice would have been.

Dealing with trust and estate documents is an exercise in using precise and proper language. By writing your own will, you're leaving the door open to have your words misinterpreted or applied in conflicting ways by someone else reading the document. Additionally, your sense of what a word means may be quite different from what courts have traditionally held it to mean.

One of the major bequests a photographer makes to heirs are the copyrights to a career's worth of images. Under current copyright law, these rights are good for seventy years beyond the photographer's life in most cases. If you've taken the proper steps to protect these copyrights, there should be no problem with their transfer to heirs or beneficiaries. However, if you've been negligent, your heirs will inherit nothing but problems. Internal organization is the key to a successful transfer. Since your surviving spouse or executor will have to go into your office and make sense of what's been left behind, you can help the cause by leaving a blueprint that helps everyone. If the images are well-organized and filed, and copyright records are clearly placed on a computer database, life will be easier and more financially productive for the estate and its beneficiaries. Will and trust documents should make provisions for professional management of these images and their rights. Having some kind of agent in place or at least arranged for in the will or trust will maximize revenue for heirs. Choosing an executor (sometimes called a personal representative) is one of the most important decisions in estate planning. Along with trustees, such overseers of an estate are collectively referred to as fiduciaries and are held to the highest standard of behavior imposed by law with a mandate to act in the best interests of the estate and/or its beneficiaries. They cannot act in their own interest and may be barred from acting in the face of any possible conflicts of interest.

If such potential conflicts of interest exist—if, for example, another photographer may be named as executor—the documents will have to deal with how that will be handled. If, for instance, a surviving partner/executor wants to buy out the other's interest in the business from the estate, the terms and rules for that need to be spelled out.

A prime candidate for a fiduciary position is someone you trust, and who might also be familiar with the photo business. It's not uncommon, however, to have two executors, one being a close family member, such as a spouse or child, and the other someone who brings expertise to the table. A professional executor, such as a bank or trust company, might be chosen to manage the estate. In selecting such a fiduciary, choose one experienced in handling estates holding small or closely held businesses. The executor's term of responsibility usually lasts one to three years, after which the respon-

sibility for handling assets, if they haven't all gone to the ultimate beneficiaries, usually goes to the trustees.

When setting up the documents, it's important to give the estate's management as much flexibility as possible and to specify the powers fiduciaries should have. If you have specific ideas about how your photos should be used, these instructions need to be written into the documents. However, this should be done in a way that neither handcuffs nor restricts the management of these images, since it can't be predicted how future developments might affect the images or their best use.

This is done by putting into the document language referred to as "precatory," meaning it expresses an intention or wish, but is not legally binding or enforceable. Alternatively, these intentions can be left out of the will, but communicated in the form of a letter of guidance to whoever will handle the stock. Some photographers may choose to leave their stock library in the form of a charitable bequest to a university, museum, or other nonprofit organization. When this is done, the recipient should handle the images as it would a cash bequest and work with the photographer and her attorney ahead of time to make sure it gets the gift in a way it wants.

It's wise to periodically review the will or trust documents, especially if there's been a significant change, such as an altering of the tax laws, a difference in the family situation (such as marriage, divorce, or the birth of a child), a revision of the copyright laws or modification of the structure of the business. As the will or trust is altered to reflect these new realities, you should also review any other relevant financial documents to see how these might impact on the estate plan.

Accountant

Often the difference between photographers' success or failure is not aesthetic taste or visual talents, but rather, how they conduct their business. To best deal with the myriad of rules involved in state, local, and federal tax laws, the expertise of a certified public accountant is a necessity. The choice of an accountant who is also a well-versed business advisor can mean the difference between a prosperous studio and one where the photographer spends more time dealing with the taxman than creating quality images.

The best place to start the search for an accountant is with colleagues or business associates. Word of mouth is usually a good indicator of whether an accountant has done a good job in helping another shooter get his financial house in order. In addition, stylists, proppers, designers, and other self-employed craftspeople might be able to suggest possible accountants.

When choosing an accountant, be particularly concerned that candidates for the job have industry experience, particularly in the sales tax area. Since these complicated laws vary from state to state, most accountants are not familiar with the sales tax implications relative to photographers and the rendering of photographic services.

If the accountant doesn't possess photo-industry experience, however, inquire if she has a background in art or art-related fields. The candidate should be familiar with some of the terminology, and, at the very least, have service businesses as clients. If she has only dealt with such businesses as doctors, manufacturers, or nonprofit organizations,

look elsewhere.

When interviewing a potential accountant, ask if he is aware of mark-up procedures, billing procedures, and studio systems and controls. Ask if the accountant has knowledge in:

• State sales tax and payment procedures.

• Payment procedures to freelancers or employees and the distinction between independent contractors and employees. The IRS provides guidelines for contractors/employees but your accountant should be aware of state interpretations, too.

• Terminology and knowledge of the component parts that go into a job, such as props, wardrobe, stylists, etc.

The accountant should also be asked about how she bills and what other services will be rendered along with the customary service of preparing an annual tax return. Chief among these services should be tax planning and the preparation of an annual financial statement.

The annual financial statement, generally done on an accrual basis as opposed to the cash basis for the tax return, is a critical tool in tracking business. Not only can it be used in obtaining loans to help the studio grow, but it can also be used to compare the studio's financial performance against industry models.

A successful annual financial statement will show or track:

• Growth in revenue.
• If expenses are increasing or decreasing as a function of revenue.
• If too much is being spent in a particular area.
• If the company is building net worth and the capability to expand.
• How much income was truly earned on an annual basis.

The financial statement doesn't need to be a tight, formal document, but it should be written down, scrutinized, and analyzed from year to year. This statement can also help you and the accountant prepare a reasonable budget that enables the studio to grow.

In general, the accountant should be called on for tax and financial information and advice, but not such activities as payroll. If there are two or more employees, that task may be best handled by an outside payroll service. These companies produce payroll checks, do quarterly payroll tax returns, prepare W-2 forms, and take care of deposits with the appropriate regulatory agencies.

Tax planning is another key service provided by an accountant. Rather than a flurried activity that occurs at the beginning of April, the successful photographer/accountant team will have the tax situation well in hand in advance of deadlines.

A knowledgeable accountant will schedule a planning meeting with you about nine months into a year, at which you'll discuss what needs to be done before year's end to reduce any huge tax burden. In addition to this meeting, you should meet with your accountant at the end of the year to prepare the tax return and annual financial statement and budget for the subsequent year. Additionally, any time a major financial decision needs to be made, meet with your accountant, or, at the minimum, discuss it over the phone.

You can help the accountant and save on billing by keeping accurate records and preparing relevant information. Summarize monthly cash receipts by category, listing how much was collected in photo fees versus the job expenses billed out and sales tax. At the end of the year, prepare a list of open accounts receivable and open accounts payable.

Having the appropriate paperwork in order can help both you and your accountant. Make a concerted effort to organize such documents as

- All disbursements: all paid invoices should be on file.
- All payments to independent freelancers.
- Petty cash files: all items over $25 need to be documented.

In the case of independent freelancers, be especially wary. There are times when a part-time worker, such as an assistant, might be considered an employee rather than an independent contractor. Instead of just issuing a 1099 form at the end of the year (if the person was paid more than $600), you may need to take out withholding and contribute payroll taxes for that individual.

A general rule of thumb is that if you control the destiny of an individual (tell them when to come in, when to leave, provide tools of the trade, and give direction during the day) that person is an employee and not a freelancer. Since there are penalties when someone deemed an employee is treated as a freelancer, consult with your tax advisor on dealing with that situation.

Sales tax, as mentioned earlier, often provides photographers with their biggest tax headaches. In order to better deal with the situation, keep the following general rules in mind:

- Although sales tax rules vary from state to state, most of the time, sales tax is imposed on the full amount of a billing, not just the photo fee or expenses.
- If a client tells you that he's not supposed to pay sales tax, obtain either a resale certificate and/or an exemption certificate from the client.
- Generally, out-of-state services are nontaxable if billed and rendered out of state. (If, for example, a New York photographer does a job in California for a company in that state, the photographer does not have to charge New York sales tax; but, the company might have to pay a California use tax.)
- Labor, facility, and equipment costs are generally nontaxable. Job expenses such as wardrobe, sets, and film are generally exempt if bought for resale. You must present a certificate to the vendor stating that the material will be sold or will be part of a job billed to a client.

It is up to you to have the correct sales tax information. If you're doing a job out of town, consult your accountant on the sales tax rules that apply in that locale.

Getting audited by the Internal Revenue Service is a situation that people dread. If such a notice comes, the first thing you should do is not panic. The second is to call your accountant and prepare for the audit. Generally, the IRS notice will pertain to a particular area, such as expenses. It's rare for the IRS to question an entire return. Focus on the area in question and pull out all documentation and review the return. Although

you might be able to personally deal with the IRS in some matters, you might feel more comfortable with your accountant on hand. The key to a successful audit is doing the necessary homework and not walking into it unprepared.

You should be accompanied to the audit by a professional who is authorized to represent taxpayers before the IRS. Tax attorneys and CPAs are automatically entitled to provide such representation, while other tax preparers, unless they've received special designation, cannot. If the situation becomes serious or if a significant amount of money is involved, seek an attorney who specializes in tax law. An accountant is not allowed to represent a client in tax court.

If you and your accountant have worked together to produce a sensible business plan and manner of tackling any tax problems, these audits will not be the "encounters from hell" that photographers experience in their worst nightmares.

Insurance

Unfortunately, for insurance purposes, most of what goes into the job description "photographer" touches on almost every exclusion in every existing business insurance policy. Whether shooting from helicopters or on boats, going out of the country or even out of state, the things photographers do in the course of a working day put them in a problematic area for acquiring the basic insurance coverage their businesses need.

Finding a source of insurance is a hard task. Step One is finding an insurance broker who can handle all needs, but, because of the way the insurance industry is structured, brokers and/or agents either fall in the life and health area, or in the category of property and casualty. Since a broker who deals in disability, for example, may not know much about health or professional coverage, find specialists in the different insurance categories to arrange for coverage.

Like most buyers of insurance, photographers don't know what they're buying until there's a loss; and if they haven't properly prepared, by then it's too late. A self-employed person should carry the following coverages at a minimum:
- Health
- Disability
- Non-owned and hired auto liability
- Workers' compensation (if there are employees)
- General liability (especially if your business is not incorporated)

Although it's a wise thing to carry, life insurance is not necessarily mandatory. While most photographers will take out insurance on their cameras, few stop to consider the importance of having coverage in the previous five areas. If $20,000 in equipment is lost, for example, at least you're aware of what's gone. But, those other areas contain the potential for catastrophic loss. If something should go wrong and you don't have adequate insurance protection, the resulting claims might wipe you out financially. Disability insurance is an area that often presents difficulty. Insurance companies prefer not to issue a disability policy to self-employed individuals because it's difficult for the company to tell if that person will work again, since many self-

employed people work out of their homes.

Therefore, many self-employed people receive poor definitions of the meaning of "disabled." Where an insurance company might offer a doctor or an attorney a disability policy that pays for the entire benefit period (usually up to age sixty-five) regardless of whether that individual can teach or do something else, photographers would probably receive a policy offering benefits for two years if they could not perform their occupation, and thereafter if they could not secure any gainful employment.

In addition, since disability is based on age and occupation, you may end up paying more per $100 of coverage than a same-age attorney or doctor because insurance companies have determined that a photographer has much more of a chance of becoming disabled.

What can be done in this and other instances? The best bet is to find an agent who has an understanding of the photo business. Such a person can then attempt to find a company that will write a disability policy that takes your career situation into consideration.

Workers' compensation is another area where special notice should be taken. Although you may think hiring freelancers, such as assistants, frees you from needing to purchase Workers' Compensation coverage, in fact, the definition of what constitutes an employee is solely up to an individual state's Workers' Compensation Board.

In some cases, a person hired for just one day may be defined as an employee. If a freelancer were to get injured in the course of an assignment where she was told by you what time to report to work, what to do on the job, and you supplied all the materials necessary to do the job, the Workers' Compensation Board may rule that the person was an employee. In that case, if you do not have sufficient Workers' Compensation coverage, the results could be financially disastrous.

There are several factors by which you can feel reasonably comfortable that a freelancer will not be defined as an employee:

• If the person is incorporated, and performs the service for parties other than you.

• If he provides a certificate of insurance to show that he has his own Workers' Compensation insurance.

Workers' Compensation is paid based on payroll, and all employees must be covered by such insurance. You can be more aggressive in your posture by stating that not all of the people whom you work alongside are employees and therefore can pay the premium based on a lower payroll. However, if the Workers' Compensation Board rules that a person is an employee, all premiums must be paid retroactively.

Also be aware that your workers' compensation policy will not cover people hired in some states and foreign countries. If you're hiring people in Ohio, Nevada, North Dakota, Washington, West Virginia, or Wyoming, contact that state's insurance commission or Workers' Compensation Board for information on obtaining coverage.

Health insurance is another area where the self-employed usually have great difficulty obtaining appropriate coverage. When exploring health insurance programs, inquire how long the carrier has been in business. Try to go with an established company—one that will be there if medical problems arise. If the company goes under and you are left uninsured, it could turn into a financial disaster.

Consider a high deductible and either unlimited coverage or a $2 million lifetime maximum. A limited policy with a low deductible is another option to investigate. In general, people tend to get better value for their dollar with a high deductible, which makes the coverage more catastrophic.

There are several pitfalls to be avoided when getting health insurance. Make sure any policy is noncancelable in case the carrier decides to drop its health coverage program. (Note: A noncancelable policy isn't guaranteed to be noncancelable. The carrier might opt to cancel all such policies in a state, but, more likely, the insurance companies might sell all such policies to another carrier.) Also, in a number of self-insured programs, the company retains the right to exclude coverage if it finds that claims are running too high in any particular area. Stay away from such a policy.

If health insurance benefits are extended to employees, realize the obligation you're taking on yourself. If the program is not administered properly, problems might lead to expensive lawsuits. Rather than offer health insurance, consider giving employees a lump sum of money to acquire their own health insurance.

Photographers (and, in reality, most others) have difficulty understanding commercial general liability insurance coverage. It protects your legal liability against lawsuits for bodily injury or property damage that occur within the United States or Canada to other people or other people's property, but does not cover any of your property. It also excludes other people's property in your care, custody, or control (you should have bailee coverage for this exposure).

Other important exclusions in this coverage include:
- People eligible for disability benefits under a state statute.
- People considered to be employees covered under Workers' Compensation.
- Anything having to do with an automobile, aircraft, or watercraft.
- Claims resulting from improper models releases, invasion of privacy, infringement of copyright or trademark, infringement of patent, libel, or slander.
- Anything having to do with pollution.
- Any international act.
- Discrimination or sexual harassment.
- Claims by someone other than an employee to recover damages paid to or sought from a former or existing employee.

In order to have sufficient coverage in the event of claims made in excluded areas, you can purchase policies that provide the necessary protection. These policies include:
- Fire damage legal liability for your space as an endorsement to the policy.
- Bailee, which protects you for property damage to other people's property in your care, custody, or control, including property being moved or photographed. There are exclusions for scratching, chipping, marring, and breakage to antiques, jewelry, furs, and silverware (but riders can be obtained).
- Rental equipment coverage.
- Props coverage—which will cover props, wardrobe, and a limited amount of third party property damage.

Since general liability excludes any benefits paid by Workers' Compensation, you may benefit by purchasing a Workers' Compensation policy before general liability. You may incorporate to give some protection from general liability claims, but you can't protect personal assets against failure to have Workers' Compensation.

Non-owned and hired auto insurance, while it excludes your own vehicle, is also important coverage to have. This will cover you for vehicular accidents caused by others in your employ driving their own cars or for accidents caused by rental cars under their control. The insurance does not cover physical damage to the car being driven but, rather, bodily injury or property damage to other people's property.

In addition to coverage required for most businesses, investigate policies relating to situations specific to photography. These would include coverage that protects negatives from fire, theft, and water damage. Policies can lab and stock insurance. Though most lab policies will give back unexposed film, you can obtain negative also be written that protect you in the case of faulty film stock, errors, and camera malfunction. These policies will cover the expenses involved in recreating the image; but not if someone else paid them. Insuring a stock library also presents a problem. Although $1,500 is usually given as the value of an image, if you tried insuring every photo in your stock library at that amount, the premium for coverage would be enormous. Although people might insure their homes for large sums, few choose to do that for their stock. There are several ways to determine a fair value for a stock library for insurance purposes:

- Figure out the sales value of the entire collection, divide by number of images and come up with a price per image.
- Determine the value of time and expense it would take to recreate the library and divide by number of images and come up with a value per image.
- Hire a qualified photograph appraiser to assess the value. Experts recognized by the courts could serve this purpose.

Though figuring out insurance policies is often a time-consuming and confusing task, making the effort to obtain the best possible coverage will help you in the event of any major problems.

Bibliography

This Bibliography was edited by Don Luce and Jean Miller and compiled by Bruce Cline, Don Luce, Neil Sapienza, Garie Waltzer, and James Cook. It was updated by Don Luce and Connie Wolfe. The authors regret any inadvertent omissions or errors. The authors thank the ASMP members who suggested useful Web sites.

Books and Articles

Adams, Paul. 155 *Legal Do's (and Don'ts) for the Small Business*. New York: John Wiley & Sons, 1996.

Advertising Photographers of America. *National Member's Handbook*. Los Angeles: APA, 1993.

Allen, Kathleen. *Launching New Ventures*. 2nd ed. Boston: Mifflin Co., Inc., 1998.

American Society of Media Photographers. *On Buying Photography*. New York: ASMP, 1992. Pamphlet.

_____. *White paper on copyright registration*. Princeton Junction, NJ: ASMP, 1993.

_____. *The ASMP Business Bible*. Princeton Junction, NJ: ASMP, 1994.

_____. Commissioning Architectural Photography: *A Buyer's Guide For Working With Architectural Photographers*. Princeton Junction, NJ: ASMP, 1996.

_____. *Prosurance*. Insurance material package for photographers. Call Taylor & Taylor at (800) 922–1184 for individualized printout.

American Society of Media Photographers staff. *Assignment Photography*. New York: ASMP, 1991.

Anthony, Joseph. *Kiplinger's Working for Yourself*. Washington, DC: Kiplinger's Books, 1995.

Attard, Janet. *The Home Office and Small Business Answer Book*. 2nd ed. New York: Owl Books, 2000.

Bacon, Mark S. *Do-It-Yourself Direct Marketing*. 2nd ed. New York: John Wiley & Sons, 1997.

Baczynsky, Mark. *How to Get a Loan for Your Studio*, Vol. 30. 1988. Available through Amazon.com.

Baczynsky, Mark. *Photographic Grant Sources*, Vol. 51. 1986. Available through Amazon.com.

Baty, Gordon B. *Entrepreneurship for the Nineties*. Englewood Cliffs, NJ: Prentice Hall, 1990.

Berg, Roger. *Profitable Portrait Photography*. Amherst, NY: Amherst Media, 1998.

Boursier, Helen. *Marketing and Selling Black and White Portrait Photography*. Amherst, NY: Amherst Media, 2000.

_____. *Photographers and Their Studios*. Amherst, NY: Amherst Media, 2001.

Brackman, Henrietta. *The Perfect Portfolio*. New York: Amphoto, 1984.

Brown, Dean W. *How to Incorporate in Any State*. Kings Park, NY: Consumer Publications, 2000.

Bury, Don. *The Buyer's Guide to Business Insurance*. Central Point, OR: PSI Research, 1994.

Busch, Richard. "Be a Photographer's Assistant." *Popular Photography* (February 1976): 94–99, 131–134. A surprisingly good article; worth looking for.

Butler, Susan P. *Business Legal Kit for Dummies*. Book and CD-ROM. St. Paul, MN: Hungry Minds, Inc., 2000.

Card, Emily. *Business Capital for Women*. St. Paul, MN: Hungry Minds, Inc., 1996.

Castle, Paul. *Promoting Portraits*. Soulsbyville, CA: Studio Press, 1988.

Chapman, Elwood N. Human Relations in Small Business. Menlo Park, CA: Crisp Publishing, 1996.

Chapnick, Howard. *Truth Needs No Ally: Inside Photojournalism*. Colombia: University of Missouri Press, 1994.

Copyright Office, Library of Congress. *Copyright Basics* (Circular #1). Washington DC: U.S. Government Printing Office, 1992. Free pamphlet. Call (202) 512–1800 and request information kit #115: General Visual Arts.

Cornish, Clive G. *Basic Accounting for the Small Business*. Bellingham, WA: Self-Counsel Press Inc., 1992.

Crawford, Tad. *Business and Legal Forms for Photographers* (revised CD and edition). New York: Allworth Press, 1997.

_____. *Legal Guide for the Visual Artist*. 4th ed. New York: Allworth Press, 1999.

Daily, Frederick. *Tax Savvy for Small Business*. 4th ed. Berkeley, CA: Nolo Press, 1999.

Dicks, J. W., Esq. *The Small Business Legal Kit and Disk*. Holbrook, MA: Adams Publishing, 1997.

DuBoff, Leonard. *The Law (in Plain English) for Photographers*. New York: Allworth Press, 1995.

Eastman Kodak Co. *Conservation of Photographs*. Rochester, NY: Saunders PhotoGraphic, Inc., 1985. Kodak Publication #F-40.

Engh, Rohn. *Sell and Resell Your Photos*. Cincinnati: Writers Digest Books, 1997.

_____. Sell.Photos.Com. Cincinnati: Writers Digest Books, 2000.

Evans, Art. *Careers in Photography*. Redondo Beach, CA: Photo Data Research, 1992.

Farace, Joe. *The Digital Imaging Dictionary*. New York: Allworth Press, 1996.

_____. *The Photographer's Internet Handbook*. New York: Allworth Press, 1997.

_____. *Re-Engineering the Photo Studio: Bringing Your Studio Into the Digital Age*. New York: Allworth Press, 1998.

_____. *Stock Photo Smart: How to Choose and Use Digital Stock Photography*. Gloucester, MA: Rockport Publications, 1998.

_____. *Part-Time Glamour Photography: Full-Time Income*. Rochester, NY: Silver Pixel Press, 1999.

Fisher, Roger. *Getting to Yes: Negotiating Agreement Without Giving In*. 2nd ed. Boston: Houghton Mifflin, 1991.

Fishman, Stephen. *Consultant & Independent Contractor Agreements*. Berkeley, CA: Nolo Press, 2000.

_____. Hiring *Independent Contractors: The Employer's Legal Guide*. Berkeley, CA: Nolo Press, 2000.

Freeman, Michael. *The Photographer's Studio Manual*. New York: Amphoto, 1991.

Fry, Fred L., and Charles R. Stoner. *Strategic Planning for New & Emerging Businesses*. Chicago: Dearborn Trade, 1999.

Giolas, John. *How to Operate a Successful Photo Portrait Studio*. Buffalo: Amherst Media, 1999.

Grant, Daniel. *The Business of Being an Artist*. 3rd ed. New York: Allworth Press, 2000.

Graphic Artist's Guild. *Handbook: Pricing and Ethical Guidelines*. 10th ed. New York: GAG, 2001.

Haas, Ken. *The Location Photographer's Handbook*. New York: Van Nostrand Reinhold, 1990.

Harroch, Richard. *Small Business Kit for Dummies*. St. Paul, MN: Hungry Minds, Inc., 1998.

_____. *Business Contracts Kit for Dummies* (with CD-ROM). St. Paul, MN: Hungry Minds, Inc., 2000.

Heron, Michal. *Stock Photography Forms*. New York: Allworth Press, 1991.

_____. *How to Shoot Stock Photos That Sell*. rev. ed. New York: Allworth Press, 1996.

Heron, Michal, and David MacTavish. *Pricing Photography: The Complete Guide to Assignment & Stock Prices*. rev. ed. New York: Allworth Press, 1997.

Highton, Scott. *Rights and Value in Traditional and Electronic Media*. Princeton Junction, NJ: ASMP, 1996.

Hollenbeck, Cliff. *Big Bucks, Selling Your Photography*. 2nd ed. Buffalo: Amherst Media, Inc., 2000.

Hollenbeck, Cliff, and Nancy Hollenbeck. *Freelance Photography Handbook*. Buffalo: Amherst Media, 1999.

Ireland, Susan. *Complete Idiot's Guide to the Perfect Resume*. Falls Church, VA: Alpha Books, 2000.

Jacobs, Lou, Jr. *The Big Picture: The Professional Photographer's Guide to Rights, Rates and Negotiation.* Cincinnati: Writers Digest Books, 2000.

Johnson, Bervin. *Opportunities in Photography Careers.* Vgm Career Horizons, 1998.

Kamoroff, Bernard. Small Time Operator: *How to Start Your Own Business.* Willits, CA: Bell Springs Publishing, 2000.

Kelley, Victor. *How to Get Into the Business of Photography.* Palm Springs, CA: ETC Publications, 1981.

Kieffer, John. *The Photographer's Assistant.* rev. ed. New York: Allworth Press, 2001.

Kirk, Marguerite. *10 Commandments of Small-Business Success.* Navarre, FL: Bookhome Publishing, 1999.

Kravitz, Wallace R. *Bookkeeping the Easy Way.* 3rd ed. Hauppauge, NY: Barron's Educational Series Inc., 1999.

Lane, Megan, ed. *2000 Photographer's Market: 2000 Places to Sell Your Photographs.* Cincinnati: F&W Publications, Inc., 2000.

Leland, Caryn. *Licensing Art and Design.* New York: Allworth Press, 1990.

Lilley, Edward R. *The Business of Studio Photography.* New York: Amphoto, 1997.

Light, Ken, ed. *Witness in Our Time: Working Lives of Documentary Photographers.* Washington, DC: Smithsonian Institution Press, 2000.

Lister, Kate. *Finding Money: the Small Business Guide to Financing.* rev. ed. New York: John Wiley & Sons, 1995.

Lonier, Terri. *Working Solo Sourcebook: Essential Resources for Independent Entrepreneurs.* New York: John Wiley & Sons, Inc., 1998.

_____. Working Solo: *The Real Guide to Freedom & Financial Success With Your Own Business.* New York: John Wiley & Sons, Inc., 1998.

McDonald, Tom. *The Business of Portrait Photography.* New York: Watson-Guptill Publications, Inc., 1996.

McKeever, Mike. *How to Write a Business Plan.* 5th ed. Berkeley, CA: Nolo Press, 2000.

Merriam Webster Editors. *Merriam Webster's Guide to Business Correspondence.* 2nd ed. Book and CD-ROM. Springfield, MA: Merriam Webster Inc., 1996.

Michels, Caroll. *How to Survive & Prosper as an Artist: Selling Yourself Without Selling Your Soul.* 4th ed. Cambridge, MA: Henry Holt, 1997.

Milano, Carol. Hers: *The Wise Woman's Guide to Starting a Business on $2000 or Less.* New York: Allworth Press, 1998.

Milling, Bryan. *How to Get a Small Business Loan.* Sourcebooks Trade, 1998.

Miner, Nanette. *101 Media and Marketing Tips for the Sole Proprietor.* Bradley, IL: BVC Publishing, 1998.

Mitchell, Carolyn. *Business Insurance.* Chicago: Dearborn Trade, 2000.

Monteith, Ann. *The Professional Photographer's Management Handbook.* Norfolk, NE: Marathon, 1999.

Oberrecht, Kenn. *How to Start a Home-Based Photography Business.* 3rd ed. Guilford, CT: Globe Pequot Press, 2000.

Persky, Robert S., and Susan P. Levy. *The Photographer's Guide to Getting & Having a Successful Exhibition.* New York: Consultant Press Ltd., 1987.

Pickerell, James. *Negotiating Stock Photo Prices.* 4th ed. Rockville, MD: Stock Connection, 1995.

Pinson, Linda, and Jerry Jinnett. *The Woman Entrepreneur.* Dover, NH: Upstart Publishing Co., Inc., 1993.

_____. *Anatomy of a Business Plan.* Chicago: Dearborn Financial Publishing, Inc. 1999.

_____. *Steps to Small Business Start-Up.* 4th ed. Chicago: Dearborn Financial Publishing, Inc., 1999.

_____. *Keeping the Books.* 5th ed. Chicago: Dearborn Financial Publishing, Inc., 2001.

Piscopo, Maria. *The Photographer's Guide to Marketing and Self-Promotion.* 2nd ed. New York: Allworth Press, 1995.

Poehner, Donna, ed. *2001 Photographer's Market: 2000 Places to Sell Your Photographs.* Cincinnati: Writers Digest Books, 2000.

Proulx, Matt. *The Photographer's Assistant Handbook.* Woburn, MA: Focal Press, 2000.

Ragan, Robert C. *Step-By-Step: The Complete Handbook for Small Business.* New York: Sterling Publishing Co., 1992.

Remer, Michael, and Richard Weisgrau. *ASMP Copyright Guide for Photographers.* New York: ASMP, 1991. Pamphlet.

Remer, Michael D., Esq. *Valuation of Lost or Damaged Transparencies.* New York: ASMP, 1992.

Savage, Michael. *Don't Let the IRS Destroy Your Small Business.* Perseus Publishers, 1998.

Sebastian, Liane. *Electronic Design and Publishing*: Business Practices. New York: Allworth Press, 1995.

Seuss, Bernhard J. *Mastering Black-and-White Photography.* New York: Allworth Press, 1995.

Shaw, John. *Business of Nature Photography.* New York: Watson-Guptill Publications, Inc., 1996.

Shaw, Susan D., and Rossol, Monona. *Overexposure: Health Hazards in Photography.* New York: Allworth Press, 1991.

Smith, Cynthia. *A Woman's Guide to Starting Her Own Business: How to Turn Talent Into Profit.* New York: Carol Publishing Group. 1994.

Snyder, Jill. *Caring For Your Art.* rev. ed. New York: Allworth Press, 1998.

Society of Photographer and Artist Representatives. *Do-It-Yourself Kit.* New York: SPAR, 1989. Call to order: (212) 779-7464.

Steingold, Fred. *Legal Guide for Starting & Running a Small Business.* 5th ed. Berkeley, CA: Nolo Press, 1999.

Stewart, Marcia. *Leases and Rental Agreements.* Berkeley, CA: Nolo Press, 1998.

Strong, William S. *The Copyright Book: A Practical Guide.* 4th ed. Cambridge,

MA: The MIT Press, 1999. (Also, e-copy available for download TK WEB
ADDRESS)

Tabet, Joseph, and Jeffrey Slater. *Financial Essentials for Small Business Success*.
Dover, NH: Upstart Publishing Co. Inc., 1994.

Taylor, Russel R. *Exceptional Entrepreneurial Women: Strategies for Success*.
Westport, CT: Greenwood Publishing Group, 1988.

Trautmann, Carl O. *The Language of Small Business*. Dover, NH: Upstart
Publishing Co., Inc., 1994.

U.S. Department of Commerce. *Basic Facts About Trademarks*. Washington, DC:
U.S. Government Printing Office, 1996. Free pamphlet.

Uva, Michael, and Sabrina Uva. *The Grip Book: Or How to Become a Motion
Picture Film & Video Technician*. Valencia, CA: Butterworth-Heinemann, 1997.

Vitali, Julius. *The Fine Artist's Guide to Marketing and Self-Promotion*. New York:
Allworth Press, 1997.

Willins, Michael. *The Photographer's Market Guide to Photo Submissions and
Portfolio Formats*. Cincinnati: F&W Publications, Inc., 1997.

Wilson, Lee. *The Copyright Guide*. rev. ed. New York: Allworth Press, 2000.

Wylie, Peter, and Mardy Grothe. *Problem Employees: How to Improve Their
Performance*. Dover, NH: Upstart Publishing Co., Inc., 1991.

Wyman, Jack. *Married . . . in Business: What You Must Know to Thrive in
Partnership*. Scottsdale, AZ: Doer Publications, 1999.

Xiradis-Aberle, Lori. *How to Computerize Your Business*. rev. ed. New York: John
Wiley & Sons, 1995.

Yate, Martin. *Resumes That Knock 'Em Dead*. Holbrook, MA: Adams Media
Corporation, 2000.

Zuckerman, Laurie B. *On Your Own: A Woman's Guide to Building a Business*.
Dover, NH: Upstart Publishing, 1993.

Publishers and Book Sources

Allworth Press, 10 East 23rd Street, Ste. 510, York, NY 10010; (800) 491–2808.
Phone orders accepted. *www.allworth.com*

Amherst Media, 155 Rano Street, Suite 300, Buffalo, NY 14207; (800) 622–3278.
www.amherstmedia.com

Amphoto (see Watson-Guptill)

Art Direction Book Co. Inc., 456 Glenbrook Road, Glenbrook, CT 06096-1800;
(203) 353–1441

Eastman Kodak Co. (see Saunders Press)

Focal Press (imprint of Butterworth-Heinemann), 225 Wildwood Avenue, Unit B,
Woburn, MA 01801; (781) 904–2500. *www.bh.com*

Nolo Press, 950 Parker Street, Berkeley, CA 94701; (510) 549–1976; (800)
992–6656. *www.nolo.com*

Peachtree Publishers, 494 Armour Circle NE, Atlanta, GA 30324; (404) 876–8761;

(800) 875–8909

Saunders Photo, 21 Jet View Drive, Rochester, NY 14624; (716) 328–7800. *www.saundersphoto.com*

Silver Pixel Press (see Saunders Photo)

Upstart Publishing Company, 7211 Rockridge Road, Baltimore, MD 21207; (410) 484–1781

Watson-Guptill Publications, Inc., 1515 Broadway, New York, NY 10036; (212) 536–5110;

(800) 451–1741. *www.creativepro.com*

Periodicals

Advertising Age, Crain Communications, Inc., 740 Rush Street, Chicago, IL 60611; (312) 649–5200. *www.adage.com*

Adweek, BPI Communications, Inc., 770 Broadway, 7th Floor, New York, NY 10003; (646) 654–5223; (800) 722–6658. *www.adweek.com*

Afterimage, 31 Prince Street, Rochester, New York 14607; (716) 442–8676. *www.rit.edu/~vswwww/afterindex.html*

American Photo, Hachette Fillpacchi Magazines, Inc., 1633 Broadway, 43rd Floor, New York, NY 10019; (212) 767–5800. *www.hfmmag.com*

Archive, 915 Broadway, New York, NY 10010; (212) 673–6600

Art Direction, 10 East 39th Street, 6th Floor, New York, NY 10016; (212) 889–6500

Art Education Journal, National Art Education Association, 1916 Association Drive, Reston, VA 22091; (703) 860–8000. *www.naea-reston.org*

Art Marketing Handbook, ArtNetwork, 18757 Wildflower Drive, Penn Valley, CA 95946; (530) 470–0862. *www.artmarketing.com*

ASMP Bulletin, American Society of Media Photographers, Inc., 150 North Second Street, Philadelphia, PA 19106; (215) 451–2767. *www.asmp.org*

B to B, Crain Communications, Inc., 740 North Rush Street , Chicago, IL 60611-2590; (312) 649–5200. *http://netb2b.com*

Communication Arts, 110 Constitution Drive, Menlo Park, CA 94025; (650) 326–6040. *www.commarts.com*

Creativity, Crain Communications, Inc., 711 Third Avenue, New York, NY 10017-4036; (212) 210–0100. *www.adage.com*

Digital Imaging, Cygnus Publishing, 445 Broad Hollow Road, Mellville, NY 11747; (631) 845–2700. *www.digitalimagingmag.com*

Digital Imaging Digest, 3000 Picture Place, Jackson, MI 49201; (517) 788–8100. *www.pmai.org*

Digital Graphics, 2800 West Midway Boulevard, Broomfield, CO 80020; (303) 469–0424. *www.nbm.com/digitalgraphics*

DoubleTake, 55 Davis Square, Somerville, MA 02144; (617) 591–9389. *www.dou-bletakemagazine.org*

Electronic Photography News, Photofinishing News Inc., 10915 Bonita Beach Road,

Bonita Springs, FL 34135; (941) 992–4421. *www.photo-news.com*

Electronic Publishing, 10 Tara Boulevard, 5th Floor, Nashua, NH 03062; (603) 891–9159. *www.electronicpublishing.com*

Emigre, 4475 D Street, Sacramento, CA 95819; (916) 451–4344. www.emigre.com

Exposure, Society for Photographic Education, P.O. Box 2811, Daytona Beach, FL 32120; (904) 255–8131. *www.spenational.org*

The Future Image Report, 520 South Camino Real #206A, San Mateo, CA 94402; (650) 579–0493. *www.futureimage.com*

Graphic Design: USA, Kaye Publishing Corp., 79 Madison Avenue, Suite 1202, New York, NY 10016 ; (212) 534–5500. *www.gdusa.com*

Graphis (USA), 307 Fifth Avenue, 10th Floor, New York, NY 10016; (212) 532–9387. *www.graphis.com*

Guilfoyle Report, AG Editions, Inc., 41 Union Square, West Suite 523, New York, NY 10003; (212) 929–0959. *www.gronline.com*

LensWork, 909 3rd Street, Anacortes, WA 98221; (360) 588–1343; (800) 659–2130. *www.lenswork.com*

Mediaweek, BPI Communications, Inc., 770 Broadway, 7th Floor, New York, NY 10003; (646) 654–5115. *www.mediaweek.com*

The Natural Image, Lepp and Associates, P.O. Box 6240, Los Osos, CA 93412; (805) 528–7385. *www.leppphoto.com*

News Photographer, National Press Photographer's Association, 1446 Conneaut Avenue, Bowling Green, OH 43402; (419) 352–8175. *www.nppa.org*

Outdoor Photographer, Werner Publishing Corp., 12121 Wilshire Boulevard, Suite 1220, Los Angeles, CA 90025; (310) 820–1508. *www.outdoorphotographer.com*

Photo Bulletin, *PhotoLetter*, *PhotoMarket*, *PhotoStockNotes*, PhotoSource International, Pine Lake Farm, 1910 35th Road, Osceola, WI 54020; (715) 248–3800. *www.photosource.com*

Photo District News, BPI Communications, Inc., 770 Broadway, New York, NY 10003; (646) 654–5800. *www.pdn-pix.com*

Photo Electronic Imaging, PPA Publications and Events, Inc., International Towers, 229 Peachtree Street NE, Suite 2200, Atlanta, GA 30303; (404) 522–8600. *www.peimag.com*

Photographer's Forum, Serbin Communications Inc., 511 Olive Street, Santa Barbara, CA 93101 (805) 963–0439; (800) 876–6425. *www.serbin.com*

Photographic Magazine, emap usa, 6420 Wilshire Boulevard, Los Angeles CA 90048; (323) 782–2000, *www.emapusa.com*

Photo Life, Camar Publications Ltd., 130 Spy Court, Markham, Ontario L3R 5H6 Canada; (905) 475–8440. E-mail: *nstn2107@fox.nstn.ca*

The Photo Review, Photo Review, 301 Hill Avenue, Langhorne, PA 19047; (215) 757–8921. *www.photoview.org*

Photo Trade News, Cygnus Publishing, 445 Broad Hollow Road , Mellville, NY 11747; (631) 845–2700. *www.ptnonline.com*

Picture, 126 University Place, 5th Floor, New York, NY 10003; (212) 353–2700.

Popular Photography, Hachette Fillpacchi Magazines, Inc., 1633 Broadway, New York, NY 10019; (212) 767–6578. *www.hfmmag.com*

PRC Newsletter, Photographic Resource Center, Boston University, 602 Commonwealth Avenue, Boston, MA 02215; (617) 353–0700. *http://web.bu.edu/PRC*

Print, RC Publications Inc., 104 Fifth Avenue, 19th Floor, New York, NY 10011; (212) 463–0600. *www.printmag.com*

Professional Photographer, PPA Publications and Events, Inc., International Towers, 229 Peachtree Street NE, Suite 2200, Atlanta, GA 30303; (404) 522–8600. *www.ppmag.com*

PSA Journal, 3000 United Founders Boulevard, Suite 103, Oklahoma City, OK 73112; (405) 843–1437. *www.psa-photo.org*

Publishers Weekly, 245 West 17th Street, New York, NY 10011; (212) 463–6824. *www.publishersweekly.com*

Rangefinder, Rangefinder Publishing Co., 1312 Lincoln Boulevard, #1703, Santa Monica, CA 90401 (310) 451–8506. *www.rangefinder-network.com*

Shots, P.O. Box 27755, Minneapolis, MN 55427; e-mail: shotsmag@juno.com; *www.afterimage.com/shots.htm.*

Shutterbug, Primedia Inc., 5211 South Washington Avenue, Titusville, FL 32780; (407) 268–5010. *www.shutterbug.net*

Single Image, Scott & Daughters Publishing, Inc., 940 North Highland, Avenue, Los Angeles, CA 90038; (213) 856–0008. *www.workbook.com*

SPAR Newsletter, Society of Photographer and Artist Representatives, 60 East 42nd Street, #1166, New York, NY 10165; (212) 779–7464.

Stock Photo Report, Brian Seed & Associates, 7432 North Lamon Ave., Skokie, IL 60077; (847) 677–7887. e-mail: *bseed@wwa.com*

Studio Photography & Design, Cngyus Publishing Co., 445 Broad Hollow Road, Suite 21, Melville, NY 11747; (631) 845–2700. *www.spdonline.com*

Taking Stock, 110 Frederick Avenue, Rockville, MD 20850; (301) 251–0720. e-mail: *jim@chd.com*

WPPI Photography Monthly, Rangefinder Publishing Co., 1312 Lincoln Boulevard, # 2003, Santa Monica, CA 90401; (310) 451–0090.

The Wolfman Report, Hachette Fillpacchi Magazines, Inc., 1633 Broadway, New York, NY 10019; (212) 767–6000. Report on the photo industry. *www.hfmmag.com*

Zoom Magazine, P.O. Box 1270, New York, NY 10156; (800) 535–6745. *www.zoom-net.com*

Computer Software

Colleague (business management for Macintosh), Colleague Business Software, 11606 DK Ranch Road, Austin, TX 78759; (512) 258–6023.

fotoBiz (business management for Macintosh or Windows), fotoQuote (stock pho-

tography pricing program for Macintosh or Windows), Cradoc Corporation, P. O. Box 10899, Bainbridge Island, WA 98110; (800) 870–2650. *www.cradoc.com*

GearTrack (equipment inventory management for Windows), *www.spectracomputing.com/geartrack.html*

Grip (business management for Windows), Grip Software, 420 North Fifth Street, No. 707, Minneapolis, MN 55401; (612) 332–0052. *www.gripsoftware.com*

InView (business management for Macintosh or Windows), HindSight Ltd., 9249 South Broadway, Suite 200, Highlands Ranch, CO 80126; (303) 791–3770. *www.hindsightltd.com*

MacStock Express (stock Photography Management Software), Photo Agora, Hidden Meadow Farm, Keezletown, VA 22832; (540) 269–8283. *www.photoagora.co*

PhotoTracker Pro (photo studio and stock software), (800) 530–9689.

Silent Partner (business management for Macintosh or Windows), The MediGroup, 1308 Egypt Road, Oaks, PA 19456; (610) 666–1955. *www.mediagroupltd.com*

StockView (stock caption and tracking for Macintosh), HindSight Ltd., 9249 South Broadway, Suite 200, Highlands Ranch, CO 80126; (303) 791–3770. *www.hindsightltd.com*

Videotapes and Audiotapes

The Business of Images (videotape). ASMP and the Newhouse School, Syracuse (NY) University, with the support of Eastman Kodak Co. Available from ASMP (215) 451–2767.

Get it in Writing! American Society of Media Photographers. 90-minute audiotape by Richard Weisgrau. New York: ASMP, 1992.

How to Find Clients and Get Paid (four videotapes) by Maria Piscopo. Turner Communications, (800) 382–9417.

Techniques of the Masters. Eastman Kodak.

Working Solo (two audiocassettes) by Terri Lonier. Audio Prod., ISBN 1-8832282-90-X.

Web Sites of Professional Organizations

Advertising Photographers of America, APA: *www.apanational.com*

The American Institute of Graphic Arts, AIGA: *www.aiga.org*

American Society of Journalists and Authors: *www.asja.org*

The American Society of Media Photographers, ASMP: *www.asmp.org*

Australian Institute of Professional Photographers, AIPP, e-mail: *colombus@ica.net.au*

The Authors Guild: *www.authorsguild.org*

Canadian Association of Photographers & Illustrators in Communications, CAPIC: *www.capic.org*

Editorial Photographers, EP: *www.editorialphoto.com*

National Press Photographers Association, NPPA: *www.nppa.org*
Picture Agency Council of America, PACA, e-mail: *paca@earthlink.net*
Professional Photographers of America, PPofA: *www.ppa.com*

School and Workshop Web sites

Art Center College of Design: *www.artcenter.edu*
Brooks Institute of Photography: *www.brooks.edu*
The Maine Photographic Workshops: *www.meworkshops.com*
Photoworkshop (an online community of photographers) *www.photoworkshop.com*
Rhode Island School of Design: *www.risd.com*
Rochester Institute of Technology, School of Photographic Arts and Sciences:
 www.rit.edu/~rckpph
Santa Fe Workshops: *www.sfworkshop.com*
Southern Illinois University, Applied Arts Department: *www.siu.edu:80/depart-
 ments/ctc/apartphp*

Photographer Databases Online

www.photographers.com
www.eWork.com
www.freeagent.com
www.met-media.com
www.artwanted.com
www.ezindex.com/phosite.htm
www.apogeephoto.com/buyguide/access/accessories.shtml
Find a photographer: *www.asmp.org*
Portfolio hosting Web site: *www.portfolios.com*

Sites with Comprehensive Photo-Related Links

www.geocities.com/Paris/Rue/2830/photo.html
www.hindsightltd.com/links.html
www.michaelschwarz.com/links.html
www.photojournalism.org/searchh.html

Photoshop™ Related Sites

Adobe Systems, Inc. (software solutions for Web and print publishing),
 www.adobe.com
The action exchange—free and shareware actions for Photoshop™:
 http://xenia.mit.edu/axc
Plug-ins for Photoshop™ (all brands): *www.pluginsource.com*
RBG conversion to CMYK firm: *www.colorcentric.com*
World expert in color corrections in Photoshop™:

www.ledet.com/margulis/index.html

Keep up with the newest releases of Mac software: *www.versiontracker.com/*

Online Quicktime training movies for learning software and CD purchase of same: *www.virtualtrainingcompany.com*

Scanning and Printer Supplies Online

Scanning tips and hints: *www.scantips.com*

Information on performance capabilities of film scanners: *www.halftone.co.uk*

Forum for digital and scanning issues: *www.peimag.com/free_for_all/index.shtml*

Epson Printer Listserve, subscribe at: *www.leben.com*

Ink-jet printer supplies: www.digitalartsupplies.com, *www.PhotoInkJet.com,* www.redriverpaper.com, www.dygraphics.com, *www.inkjetart.com,* www.tssphoto.com/sp/dg/index.html, www.inkjetmall.com, *www.inksupply.com*

A site that rates the archival attributes of ink-jet ink and paper: *www.wilhelm-research.com*

Topical Sites of Interest

www.artdirection.com

Dast Library of Photography is a photo resource on a variety of topics: *www.good-net.com/~tibbits*

Publishing links: *www.bookmasters.com/services/resource_links.htm*

World Wide Art Resources is the only complete registry of arts information on the Internet. Over 7,800 artists and over 100,000 other arts resources are listed: *www.wwar.com*

Photo District News Forum: *www.pdn-pix.com/cgi-bin/webbbs/config.pl*

The Photo News Network is a set of specialized forums and discussion groups where photography subjects and issues are discussed: *www.photonews.net/forums*

Net Magazines

The Digital Journalist: *http://digitaljournalist.org*

Netlook: *www.netlookmag.com*

Photo District News: *www.pdn-pix.com*

Photo Magazine: *www.photomagazine.com*

Photo Resource Magazine: *www.photoresource.com/*

Stock Resources

Creative Eye, Photographers' Cooperative: *http://creativeeyecoop.com*

Media Image Resource Alliance, MIRA: *www.mira.com*

Stock Solution's Photo site of the week: *www.tssphoto.com/foto_week.html*

Stockphoto Network Web site: *www.S2F.com/stockphoto*

Online guide for stock photography pricing: *www.sethresnick.com/price/price.html*

Guide for Web stock photo pricing: *http://stockphotoindex.com*
Help in calculating stock prices: *http://photographersindex.com/stockprice.htm*

Copyright

Association for the Protection of Internet Copyright, APIC Worldwide; *www.a-w.org/*
Clever Content (protecting images online), *www.clevercontent.com*
Copyright Clearance Center, Inc.: *www.copyright.com*
The Copyright Holder's Directory: *www.chd.com/*
Digital watermarking: *www.digimarc.com/index.shtml*
U.S. Copyright Office. Download copyright forms and instructions; learn rules and
 procedures: *http://lcweb.loc.gov/copyright/*

Other

Time: Get the correct time from a really good clock: *tycho.usno.navy.mil/cgi-
 bin/timer.pl*
Sun tracking software: *www.wide-screen.com/Pages/sunPATH.html*
Sun or Moon Altitude/Azimuth Table: *http://aa.usno.navy.mil/AA/data/docs/AltAz.html*
WeatherNet: the Internet's premier source of weather information. Providing access to
 thousands of forecasts, images, and the Net's largest collection of weather links:
 cirrus.sprl.umich.edu/wxnet
Intellicast.com provides extensive specialized weather information to help plan all
 outdoor and weather-sensitive activities: *www.intellicast.com*
Postage rates and information on postal services; download as PDF file:
 www.usps.gov/consumer/domestic.htm#priority
Find anyone's zip code: *www.usps.gov/ncsc/*
Maps to anywhere: *www.mapquest.com*
Travel: *www.johnnyjet.com*
Digital photography equipment rental, digital capture systems, and related issues:
 www.prorental.com
Directory of film commissions: *www.team.os.com/links/filmcommissions*
SpellTools, free Mac spell check utility: *www.newertech.com/software/index.html*
Useful information on pricing: *www.johnharrington.com.*
A helpful Web reference when negotiating with nonprofit organizations:
 www.guidestar.org/index.html
Survey information on the graphic arts/communications industry: *www.trend-
 watch.com*
Per diem rates in the United States: *www.govexec.com/travel/perdiems/usdiem99.htm*
Business tips from photo marketing consultant Maria Piscopo: *www.mpiscopo.com*
Eastman Kodak Information Center (800/242–2424): *www.Kodak.com/go/professional*
Fuji Film Information Center: *www.fujifilm.com/*

Directories

Creative Directories

The Alternative Pick, 1133 Broadway, Suite 1404, New York, NY 10010; (212) 675–4176. *http://altpick.com*

American Showcase, Corporate Showcase, Showcase Stock, KliK! Showcase Photography, New Media Showcase, American Showcase, 915 Broadway, 14th Floor, New York, NY 10010; (212) 673–6600. *www.americanshowcase.com*

Art Director's Index to Photographers, Rotovision SA, Watson-Guptill Publications, Inc., 1695 Oak Street, Lakewood, NJ 08701; (800) 451–1741.

California Image, Serbin Communications Inc., 511 Olive Street, Santa Barbara, CA 93101; (805) 963–0439; (800) 876–5425. *www.serbin.com*

Colorado Creative Sourcebook, 428 East 11th Avenue, Denver, CO 80203; (303) 832–4919.

The Creative Black Book, The Creative Black Book Photography Listings, The Creative Black Book Portfolio Edition, Annual Reports 100, Black Book Marketing Group, 10 Astor Place, 6th Floor, New York, NY 10003; (800) 841–1246. *www.blackbook.com*

Corporate Source, Corporate Source Wilcord Publishing Ltd., 194 Merton Street, Suite 300, Toronto, Ontario, Canada M4S 3B5; (416) 487–7414.

Creative Sourcebook: Photography and Illustration, Sumner Communications, Inc., 4085 Chain Bridge Road, Fairfax, VA 22030; (800) 800–9413. e-mail: *sumcomm@cais.com*

Digital Directory, 301 Cathedral Parkway, #2-N, New York, NY 10026; (212) 864–8872. *www.digitaldirectory.com*

Direct Stock, Direct Stock, Inc., 10 East 21st Street, New York, NY 10010; (212) 976–6560. *www.directstock.com*

The European Creative Handbook, Reed Information Services Ltd., Windsor Court,East Grinstead House, East Grinstead, West Sussex RH191XA, England; 44 03 4 2–32–6972.

Eye, N.Y. Gold, New York Gold, Inc., 10 East 21st Street, 14th Floor, New York, NY 10010; (212) 254–1000. e-mail: *nygb@aol.com*

Eyes: The Sourcebook for Black and White Art, Eyes Publishing, 6 Clark Court, Suite 101, Kendall Park, NJ 08824; (908) 821–3937.

Green Book, Blue Book, AG Editions, Inc., 41 Union Square, West Suite 523, New York, NY 10003; (212) 929–0959. *http://ag-edit.lightlink.com/ageditions.html*

LA 411, 7083 Hollywood Boulevard, #501, Los Angeles, CA 90004; (213) 460–6304. *www.la411.com*

Madison Avenue Handbook, The Image Maker's Sourcebook, Peter Glenn Publishing, 42 West 38th Street, #802, New York, NY 10018; (212) 869–2020.

Pittsburgh Creative Sourcebook, 1671 New Haven, Pittsburgh, PA 15216; (412) 343–9749.

San Diego Creative Directory, Blue Book Publishers, 7807 Girard Avenue, Suite 200, La Jolla, CA 92307; (619) 454–9665. *www.sdcreative.com*

The Workbook: The National Directory of Creative Talent, Regional Workbook

Directories: East, Midwest, South, West, Stock Workbook 9, Single Image, Scott & Daughters Publishing, Inc., 940 North Highland Avenue, Los Angeles, CA 90038; (213) 856–0008. *www.workbook.com*

Industry Directories

Art Galleries and Dealers, American Business Directories Inc., 5711 South 86th Circle, Omaha, NE 68127; (402) 593–4600.

Artist's Market, Photographer's Market, Writer's Digest Books, F&W Publications, Inc., 1507 Dana Avenue, Cincinnati, OH 45207; (513) 531–2222; updated annually.

The Design Firm Directory, Wefler & Associates, P.O. Box 1167, Evanston, IL 60204; (708) 475–1866.

Gale Directory of Publications, Gale Group Inc., 835 Penobscot Building, Detroit, MI 48226; (313) 961–2242; (800) 877–4253. *www.galegroup.com*

Gebbie Press All-In-One Directory, Gebbie Press, P.O. Box 1000, New Platz, NY 12564; (914) 255–7560. *www.gebieinc.com*

The Guide to Photography Workshops and Schools, Shaw Guides, Inc., 10 West 66th Street, #30H, New York, NY 10023; (212) 799–6464. *www.shawguides.com*

O'Dwyer's Directory of Public Relations Firms, J. R. O'Dwyer Co., 271 Madison Avenue, New York, NY 10016; (212) 679–2471.

PACA Stock Agency Directory, P.O. Box 308, Northfield, MN 55057; (507) 645–6988

Photographers—Commercial; Photographers—Portrait, American Business Directories Inc., 5711 South 86th Circle, Omaha, NE 68127; (402) 593–4600.

Photographer's Market, Writer's Digest Books, 1507 Dana Avenue, Cincinnati, OH 45207; (513) 531–2222.

Photography Market Place, R. R. Bowker, 1180 Avenue of the Americas, New York, NY 10036.

Professional Photo Source, A/S/M Communications, Inc., 1515 Broadway, New York, NY 10036; (212) 536–5222; (800) 669–1002. Resource directory, updated annually. *http://photosource.netsville.com*

SPAR Membership Guide, Society of Photographer and Artist Representatives, 60 East 42nd Street, #1166, New York, NY 10165; (212) 779–7464.

Standard Directory of Advertisers, Standard Directory of Advertising Agencies (The Red Books), National Register Publishers, P.O. Box 31, New Providence, NJ 07974; (908) 464–6800; (800) 521–8110. *www.redbooks.com/Content/index2.asp*

Standard Periodical Directory, Oxbridge Communications, Inc., 150 Fifth Avenue, New York, NY 10011; (212) 741–0231; (800) 955–0231.

Standard Rate and Data Service, 3004 Glenview Road, Wilmette, IL 60901; (708) 256–6067; (800) 323–4601. *www.srds.com*

Stock Photo Deskbook, Photographic Arts Center, Ltd., 163 Amsterdam Avenue, Suite 201, New York, NY 10023; (212) 838–8640.

Stock Photo Fees in Europe, Presse Informations Agentur GmbH, Stefanienstr. 25,76530, Baden-Baden, Germany, 07221-25348; English edition.

Thomas Register of Manufacturers, Thomas Publishing Co., 1 Penn Plaza, New
 York, NY 10001, (212) 695–0500; *www4.thomasregister.com*
Ulrich's International Periodicals Directory, Reed Reference Publishing, P.O. Box
 31, New Providence, NJ 07974; (908) 464–6800.
Who's Who in Professional Imaging, PPA Publications and Events, Inc., 229
 Peachtree Street NE, Suite 2200, Atlanta, GA 30303; (404) 522–8600,
 www.ppa.com
Working Press of the Nation, Reed Reference Publishing, P.O. Box 31, New
 Providence, NJ 07974; (908) 464–6800; (800) 521–8110.

Organizations

Professional organizations are listed as marketing resources and for the identifica-
tion of professional services.

Accountants

American Accounting Association, 5717 Bessie Drive, Sarasota, FL 34233
(941) 921–7747. *www.rutgers.edu/Accounting/raw/aaa*
American Institute of Certified Public Accountants, 1211 Avenue of the Americas,
 New York, NY 10036; (212) 596–6200. *www.aicpa.org*
American Society of Women Accountants, 60 Revere Drive, Northbrook, IL 60062;
 (847) 205–1029. *www.aswa.org*
National Association of Black Accountants, 7249A Hanover Parkway, Greenbelt,
 MD 20770; (301) 474–6222. *www.nabainc.org*

Advertising Agencies

American Advertising Federation, 1101 Vermont Avenue NW, Suite 500,
 Washington, DC 20005; (202) 898–0089. *www.aaf.org*
American Association of Advertising Agencies, 405 Lexington Avenue, New York,
 NY 10174; (212) 682–2500. *www.aaaa.org*

Communication Specialists

International Association of Business Communicators, 1 Hallidie Plaza, Suite 600,
 San Francisco, CA 94102; (415) 433–3400.

Galleries

Art Dealers Association of America (ADAA), 575 Madison Avenue, New York, NY
 10022; (212) 940–8590. *www.artdealers.org*
Association of Artist-Run Galleries, 591 Broadway, Suite 2A, New York, NY
 10012; (212) 924–6520.

Association of International Photography Art Dealers, 1609 Connecticut Avenue, Suite 200, Washington, DC 20009; (202) 986–0105.

Council on Fine Art Photography, Address unknown since 2000, Former address: c/o Lowell Anson Kenyon, 5613 Johnson Avenue W., Bethesda, MD 20817; (301) 897–0083.

Graphic Designers and Art Directors

American Center for Design, 325 West Huron, Chicago, IL 60610; (312) 787–2018. *www.ac4d.org*

American Institute of Graphic Arts (AIGA), 164 Fifth Avenue, New York, NY 10010; (212) 807–1990. *www.aiga.org*

Art Director's Club, 104 West 29th Street, New York, NY 10001; (212) 643–1440; *www.adcny.org*

Association of Professional Design Firms, 450 Irwin Street, San Francisco, CA 94107; (415) 561–2733. *www.apdf.org*

Design Management Institute, 29 Temple Place, Boston, MA 02111; (617) 338–6380. *www.dmi.org*

Graphic Artist's Guild (GAG), 90 John Street, New York, NY 10038; (212) 791–3400. *www.gag.org/newyork*

Society of Newspaper Design, 129 Dyer Street, Providence, RI 02903; (401) 276–2100. *www.snd.org*

Society of Publication Designers, 60 East 42nd Street, Suite 721, New York, NY 10165; (212) 983–8585. *www.spd.org*

Illustrators

Society of Illustrators, 128 East 63rd Street, New York, NY 10021; (212) 838–2560. *www.societyillustrators.org*

Insurance

Independent Insurance Agents of America, 127 South Peyton, Alexandria, VA 22314; (703) 683–4422. *www.independentagent.com*

National Association of Insurance Women International, P.O. Box 4410, Tulsa, OK 74159; (800) 766–6249. *www.naiw.org*

National Association of Professional Insurance Agents, 400 North Washington Street, Alexandria, VA 22314; (703) 836–9340. *www.pianet.com*

Labs

Association of Professional Color Imagers (formerly Association of Professional Color Laboratories), 3000 Picture Place, Jackson, MI 49201; (517) 788–8146.

Marketing

American Marketing Association, 311 South Wacker Drive, South 5800, Chicago, IL 60606; (312) 542–9000. *www.ama.org*

Photo Retailers

Photo Marketing Association International (PMA), 3000 Picture Place, Jackson, MI 49201; (517) 788–8100. *www.pmai.org*

Photographic Educators

Photo Imaging Education Association, 3000 Picture Place, Jackson MI 49201; (517) 788–8100 *http://bobcat.tamu-commerce.edu/~stang/PIEA/*
Society for Photographic Education (SPE), P.O. Box 2811, Daytona Beach, FL 32120; (904) 255–8131. *www.spenational.org*
Society for Photo Workshop Education, 317 East Winter Avenue, Danville, IL 61832.
Society of Teachers of Photography , 8029 Edgefield St., Dayton, OH 45439.

Photographic Equipment Repair

National Association of Photographic Equipment Technicians, 3000 Picture Place, Jackson MI 49201; (517) 788–8100. *www.pmai.org*

Picture Editors, Researchers, and Archivists
American Society of Picture Professionals (ASPP), 409 South Washington Street, Alexandria, VA 22314; (703) 229–0219. *www.aspp.com*

Professional Photographers

Advertising Photographers of New York (formerly Advertising Photographers of America), 27 West 20th Street, New York, NY 10011; (212) 807–0399. *www.apny.com*
American Photographic Artisans Guild, P.O. Box 1373, Tacoma, WA 98401; (253) 942–8433. *www.apag.net*
American Society of Media Photographers (ASMP), 150 North Second Street, Philadelphia, PA 19106; (215) 451–ASMP. *www.asmp.org*
Association for Multi-Image International, Inc., 10008 North Dale Mabry Highway, Suite 113, Tampa,, FL 33618; (813) 960–1692.
Editorial Photographers (EP), P.O. Box 591811, San Francisco, CA 94159–1811 . *www.editorialphoto.com*
National Press Photographers Association (NPPA), 3200 Croasdaile Drive, Suite 306, Durham, NC 27705; (919) 383–7246 (800) 289–6772. *www.nppa.org*

Professional Photographers of America (PP of A), 229 Peachtree Street NE, Atlanta, GA 30303; (404) 522–8600. *www.ppa.com*

Professional Women Photographers, c/o Photographics Unlimited, 17 West 17th Street, New York, NY 10011; (212) 726–8292.

University Photographers Association of America, c/o Jim Dusen, SUNY at Brockport, 350 New Campus Drive, Brockport, NY 14420; (716) 395–2133.

Wedding and Portrait Photographers International, 1312 Lincoln Boulevard, P.O. Box 2003, Santa Monica, CA 90406; (310) 451–0090. *www.wppi-online.com*

Public Relations

Public Relations Society of America, 33 Irving Place, 3rd Floor, New York, NY 10003; (212) 995–2230. *www.prsa.org*

Sales Representatives

Society of Photographer and Artist Representatives (SPAR), 60 East 42nd Street, New York, NY 10165; (212) 779–7464

Stock Agencies

Picture Agency Council of America (PACA), P.O. Box 308, Northfield, MN 55057; (507) 645–6988; (800) 457–7222. *www.pacaoffice.org*

Women in Business

National Association of Women Business Owners, 1411 K Street NW, Washington, DC 20005; (202) 347–8686. *www.nawbo.org*

Writers/Authors

American Society of Journalists and Authors, 1501 Broadway, Suite 302, New York, NY 10036; (212) 997–0947. *www.asja.org*

The Authors Guild, 31 East 38th Street, 10th Floor, New York, NY 10016; (212) 563–5904. *www.authorsguild.org*

ASMP Information

The American Society of Media Photographers. Inc. (ASMP)

150 North Second Street, Philadelphia, PA 19106
Phone: (215) 451–2767; Fax: (215) 451–0880
E-mail: Info@ASMP.org Web site: www.asmp.org

The History of ASMP

The American Society of Media Photographers (originally the Society of Magazine Photographers and later the American Society of Magazine Photographers) is a trade organization that promotes photographers' rights, provides information to photographers to help them develop better business practices, and produces business publications for photographers. It was founded in 1944 by a handful of the world's leading photojournalists at a time when photographers were forced to shoot on speculation and credit lines were unheard of. ASMP was born out of need, and that need has driven it for more than half a century.

Within a few years, the ranks of the Society swelled. Most magazine photographers of reputation were members. Standards were established and speculative shooting was replaced with guarantees. Credit lines began to appear more regularly. Photographers began to retain ownership and control of their images. In a few short years, the Society had become the champion of photographers' rights.

As magazine photographers began to diversify, so did the Society. Growth continued throughout the years, from the original eight founders to more than five thousand members today, including many of the world's greatest photographers, in forty chapters nationwide. The Society has changed over the years in many ways. One thing has not changed, however: The ASMP is still the champion of photographers' rights and is recognized internationally for its leadership role. ASMP maintains a tradition of photographers helping photographers.

The Purposes of ASMP
- To protect and promote the interests of photographers whose work is for publication.
- To promote high professional standards and ethics.
- To cultivate friendship and mutual understanding between photographers.

ASMP has brought together photographers from every discipline. Advertising, annual reports, architecture, corporate, editorial, fashion, medical, special effects, sports, and stock are but a few of the over twenty-five specialties listed by members in the ASMP membership database.

Regardless of discipline or specialty, photographers share common problems. Copyright and business concerns do not vary greatly. Specialties require special adjustments to major themes. ASMP provides guidance to all by calling on the wealth of knowledge possessed by its most successful members in every discipline and asking them to share their knowledge with others.

ASMP publishes information for its members on a regular basis. It designs and stages seminars across the country through its network of chapters in most major cities.

The Society takes a strong advocacy position against state and federal laws that have detrimental effects on photographers. It has been effective in changing tax laws and right of privacy laws, and in shaping proposed legislation. It has participated in legal actions to defend photographers' rights and caused major changes in the applicability of federal laws through court action. ASMP filed one of the briefs in the Supreme Court that helped limit the application of work-for-hire to photographers.

ASMP is highly recognized in the industry as the association of photographers that has the determination and the clout to make change happen.

ASMP fosters the belief that while photographers are competitive, they have complementary interests, which are best advanced by complementary action. Through its chapters, bulletins, newsletters, Internet presence, meetings, and seminars, ASMP offers forums in which members can share ideas, concerns and fellowship.

The ASMP Advantage

Credibility. ASMP membership is recognized worldwide as a commitment to professionalism, quality, ethics, and as a sign of proven experience. This credibility makes a difference in the buyer's mind.

Communication. We start in the business by learning from others, and we can grow in the business in the same way. Continuing dialogue between photographers is an indispensable element in an orderly industry. ASMP provides the setting through its local chapters for photographers to meet and share experiences, solutions, and ideas.

Alliance. Corporate America has discovered the strategic alliance—a means of tapping into the expertise, resources, knowledge, and assistance of others. ASMP is the strategic ally of professional photographers, organized to improve their interests by pooling resources in a unique organization working uniquely for you.

Education. Being informed isn't enough. Knowing what, isn't knowing how. ASMP is committed to the education of its members. Whether through chapters nationwide or through its educational foundation (the ASMP Foundation), ASMP provides the educational opportunity to learn how to do what you have to do.

Information. The technology revolution requires photographer evolution, which is not possible without timely, accurate information. ASMP is the industry clearinghouse for the information you'll need to keep abreast in an ever-changing business.

Advocacy. ASMP helps its members when they are in need of sound advice, solid representation, and decisive action. In buyers' conference rooms, in the halls of federal and state legislaturess, and in the courts, ASMP reaches the agreements, drives the amendments, and sets the precedents that protect you. Some of our current action items include: trademark restrictions on photography, consolidation in the stock photography field, and copyright registration simplification. The Society has established a Legal Action Fund for special legal initiatives and for photographers who need assistance with significant cases.

Benefits of ASMP Membership

ASMP Bulletin. The Society's magazine, published ten times a year, presents news and features, free to all members and affiliates.

The ASMP Business Bible. A guide for professional media photographers, this publication is packed with the kind of information that the professional publication photographer needs to run a business. This guide for professionals is available only to ASMP members—as a service.

ASMP on the World Wide Web. A database of members, searchable by region and specialty, membership information, news, publications, features, a members-only forum, and links to other important sites are all on the ASMP Web site. Buyers and clients can locate ASMP members through the Find a Photographer feature on this site.

White Papers. Special publications dealing with specific concerns of photographers, such as copyright, form agreements, magazine photography, stock photography, rights, values, business planning, and other topics.

Special Interest Groups. In order to address needs and concerns unique to certain fields, ASMP has created special interest groups in areas such as architecture and underwater photography.

Chapter Affiliation. The ASMP chapter network now covers forty cities, states, and regions plus an array of foreign cities. These local chapters provide a wide range of seminars, workshops, and local news, as well as the opportunity to exchange views and information with your colleagues. Networking is a major benefit of ASMP membership.

Education. ASMP is committed to furthering education for photographers of all levels through its publications and through the programs of the ASMP Foundation.

Insurance. Life, comprehensive medical, major medical, and disability insurance are all available. ASMP offers an accidental death and dismemberment plan. The Society pioneered the development of Prosurance, a liability and camera insurance policy

designed for professional photographers. Coverage may also be obtained for workers' compensation, weather, animal mortality, cast/models, and umbrella liability. A program is also available to members only to insure funds for losses incurred through incorrect processing by labs.

Other Benefits. ASMP Press Cards, car rental discounts, travel discounts, air courier services, x-ray protection labels, and access to discounted overnight delivery services and stationery supplies.

Good Offices. Members receive consultation and advice on business problems and concerns from expert staff at ASMP's national office.

Membership Categories

General. Photographer must be actively and professionally engaged in publication photography with three or more consecutive years of experience from date of first published work. This publication must generate the major portion (over 50 percent) of earned income. General Members are the only voting members of the Society and receive all publications and benefits of the society at no charge. A review of publication experience is required and applicants must be sponsored by two General Members.

Partner/Spouse. Photographer must meet all requirements for General membership and there must be a legal connection (lawful marriage; legal business partnership) to a principal General Member who pays full dues. A review of publication experience is required and applicants must be sponsored by two General Members.

Associate. Photographer must be actively and professionally engaged in publication photography with at least one year but less than three years of experience from date of first published work. This publication must generate the major portion (over 50 percent) of earned income. Associate Members receive all publications and benefits of the society at no charge. A review of publication experience is required and applicants must be sponsored by two General Members.

International. Photographer who meets the requirements of General membership and who resides outside the United States. International membership is a non-voting membership.

Regular Affiliate. Individuals who do not qualify for other categories of membership but who are photographers earning less than a majority (under 50 percent) of their earned income from publication of their own work and have less than one year of publication experience; or who are full-time teachers of photography; or who are assistants to photographers and who wish to be "affiliated" with ASMP. Applicants must by sponsored by two General Members.

Sustaining Affiliate. Individuals in professions associated with photography. This affiliation is for members of organizations employed to supply or sell to photographers in some way: lab owners, stock agency owners, manufacturer's representatives, and photographer's representatives. Applicants must by sponsored by two General Members.

Student Affiliate. Full-time students at the college level or above majoring in the visual communications field. Written proof of full-time college enrollment from a department head, admissions office, class schedule, etc., on official school letterhead

About the Authors

Andrew Berger, an attorney with the New York firm of Tannenbaum Helpern Syracuse & Hirschtritt specializes in intellectual property matters.

Bruce Blank, a Philadelphia, Pennsylvania, photographer, formally was head of ASMP member operations and managing director of the ASMP Foundation. He conducted numerous seminars on business topics.

James Cavanaugh, was for many years a director and vice-president of ASMP. He is based in Tonawanda, New York, where he operates an architectural and aerial photography business and licenses images for stock uses.

James Cook, a Denver, Colorado, ASMP member is an editorial photographer and software producer and authority on Internet and imaging technology.

Ira Mark Gostin, an ASMP member from Reno, Nevada, is a leading advertising and corporate-industrial photographer who writes and lectures on marketing and business topics.

Scott Highton, is an officer and national director of ASMP who is based in the San Francisco Bay area. He is the author of a number of industry white papers and writes frequently about digital photographic technologies. He is also recognized as a pioneer in the field of photographic virtual reality and works extensively in the multimedia industry.

Bill Hurter, a veteran photography industry writer/editor who has written several books on photography, is editor of *Rangefinder* magazine.

Pamela Kruzic, an ASMP affiliate, is a freelance assistant based in Knoxville, Tennessee.

Don Luce, for many years an ASMP director and vice-president, is a commercial photographer and educator based in Cleveland, Ohio.

Jean Miller, a freelance editor in Cleveland Heights, Ohio, has an extensive background in education and editing.

Annette Laabs Paajanen, is a Shorewood, Minnesota, writer/editor who specializes in corporate communications.

Victor S. Perlman, Esq., an attorney experienced in the photography industry and copyright law, is ASMP's general counsel and managing director.

Maria Piscopo, an artist's and photographer's representative, consultant, and author is based in Santa Ana, California.

Allen Rabinowitz, an Atlanta-based writer, had been writing for many years on photography and other visual communications topics.

Roger Ressmeyer, a leading magazine and editorial photographer and former ASMP director, is a vice-president at Getty Images, Inc.

Peter Skinner, a writer/photographer with an international background in newspaper, magazine, and corporate journalism, is ASMP communications director and editor of the ASMP Bulletin and of the 5th and 6th editions of the ASMP Professional Business Practices in Photography.

Richard Steedman, a founder and former president of The Stock Market agency which was acquired by Corbis, has been a leading authority on the stock photography industry for many years. He is director of photographer relations for Corbis.

Susan Turnau, former president of Sharpshooters, Inc., a leading Miami, Florida, agency which was acquired by Corbis, is a past president of the Picture Agency Council of America.

Mark Tucker, an ASMP member and former chapter president is an editorial and fashion photographer in Nashville, Tennessee.

Richard Weisgrau, ASMP executive director and author of numerous white papers and publications, is a respected authority on the business of photography.

Elyse Weissberg, a representative and creative consultant for photographers, is based in New York. She writes a popular marketing column for the ASMP Bulletin and also conducts seminars on marketing and promotion.

Index

BOOKS FROM ALLWORTH PRESS

How to Shoot Stock Photos that Sell, Third Edition
by Michal Heron (paperback, 8 x 10, 224 pages, $19.95)

Pricing Photography: The Complete Guide to Assignment and Stock Prices,
Third Edition by Michal Heron and David MacTavish (paperback, 11 x 8½
160 pages, $24.95)

Business and Legal Forms for Photographers, Third Edition
by Tad Crawford (paperback, with CD-ROM, 8½ x 11, 180 pages, $29.95)

ASMP Professional Business Practices in Photography, Sixth Edition
by the American Society of Media Photographers (paperback, 6¾ x 10,
416 pages, $29.95)

The Photographer's Internet Handbook, Revised Edition
by Joe Farace (paperback, 6 x 9, 232 pages, $18.95

Photography: Focus on Profit by Tom Zimberoff (paperback, 6¾ x 9⅞,
416 pages, $35.00)

**Re-Engineering the Photo Studio: Bringing Your Studio into
the Digital Age** by Joe Farace (paperback, 6 x 9, 224 pages, $18.95)

The Photographer's Assistant, Revised Edition by John Kieffer
(paperback, 6¾ x 9⅞, 256 pages, $19.95)

Mastering the Basics of Photography by Susan McCartney
(paperback, 6¾ x 10, 192 pages, $19.95)

Travel Photography, Revised Edition by Susan McCartney
(paperback, 6¾ x 10, 360 pages, $22.95)

The Photojournalist's Guide to Making Money by Michael Sedge
(paperback, 6 x 9, 256 pages, $18.95)

Mastering Black-and-White Photography: From Camera to Darkroom
by Bernhard J Suess (paperback, 6¾ x 10, 240 pages, $18.95)

**Historic Photographic Processes: A Guide to Creating Handmade Photographic
Images** by Richard Farber (paperback, 8½ x 11, 256 pages, $29.95)

Photography Your Way: A Career Guide to Satisfaction and Success
by Chuck DeLaney (paperback, 6 x 9, 304 pages, $18.95)

Please write to request our free catalog. To order by credit card, call 1-800-491-2808 or send
a check or money order to Allworth Press, 10 East 23rd Street, Suite 510, New York, NY 10010.
Include $5 for shipping and handling for the first book ordered and $1 for each additional book.
Ten dollars plus $1 for each additional book if ordering from Canada. New York State residents
must add sales tax.

To see our complete catalog on the World Wide Web, or to order online, you can find
us at www.allworth.com.